PAUL ROBESON SPEAKS

Paul
Robeson

Speaks

**WRITINGS · SPEECHES · INTERVIEWS
1918-1974**

Edited, with Introduction and Notes, by
PHILIP S. FONER

BRUNNER/MAZEL Publishers **New York**

TITLE PAGE: *Addressing dinner for Henry A. Wallace, New York, September 12, 1949*

PICTURE CREDITS: Title, 241, 496, 623—Wide World Photos; 2, 47, 242, 586, 590—United Press International; 25, 26, 65, 78, 133—Radio Times Hulton Picture Library, London; 48, 134—Rutgers, The State University of New Jersey; 66—Schomburg Center, The New York Public Library; 459 —Henry Grant, London; 460—Paul Robeson Archives, German Democratic Republic; 483—Photoworld; 495—Camera Press, London

Copyright © 1978 by
BRUNNER/MAZEL, Inc.
19 Union Square, New York, New York 10003

Library of Congress Cataloging in Publication Data

Robeson, Paul, 1898–1976.
 Paul Robeson speaks.

 Bibliography: p. 587
 Includes index.
 1. Robeson, Paul, 1898–1976. 2. Afro-Americans—
Biography. 3. Afro-American arts—Collected works.
4. Afro-Americans—Civil rights—Collected works.
5. Afro-Americans—Politics and suffrage—Collected
works. 6. Blacks—Civil rights—Collected works.
I. Foner, Philip Sheldon, 1910– II. Title.
E185.97.R63 790.2'092'4 78-17590
ISBN 0–87630–179–0

MANUFACTURED IN THE UNITED STATES OF AMERICA

PREFACE

It was one of my greatest privileges that I knew Paul Robeson and shared the platform with him on more than one occasion.

Those who knew or simply came in contact with this giant of a man during his lifetime never forgot him—whether as the great all-around college athlete and All-American football end, as the actor personally chosen by Eugene O'Neill for his *Emperor Jones* or acclaimed for his magnificent, record-breaking *Othello,* as the singer of Negro spirituals and the folk songs of all nations, or as the early and lifelong fighter for peace, for socialism, and for the liberation of his own and all oppressed people.

By the time of his death on January 23, 1976, at the age of 77, Paul Robeson had already become a legend to thousands upon thousands of Americans, despite persecution and suppression. He was equally or even more well known in scores of countries throughout the world where he had spoken and sung and where his records were familiar to millions.

From the vantage point of history, the full impact of his life's work, the far-ranging scope of his interests, are only now beginning to be appreciated as more and more people are becoming aware of his early and tremendous contributions to many of the struggles still under way today.

Two years after Robeson's death, on the occasion of his 80th birthday in April 1978, the United Nations Special Committee Against Apartheid held a three-hour public tribute to Robeson "for his contributions in the fight for colonial independence in Africa and the liberation struggle in South Africa"—a meeting addressed by colleagues and representatives of governments, trade unions, and peace organizations.

At the same time in Detroit—the city where in 1940 Robeson participated in the successful CIO campaign to organize Ford—a full Commemorative Week of entertainment and educational programs was held under the joint sponsorship of Wayne State University and the Afro-American Museum of Detroit. In announcing the event, Mayor Coleman A. Young said:

> Paul Robeson gave all of himself to the struggle for equality, freedom and peace. His artistry and his genius, together with his indomitable courage established him as one of our greatest Americans.

v

Those who still recall that soul stirring voice, who still remember the dramatic impact of his stage presence and who still recollect the vigor and the steadfastness with which he maintained his principles will want to join in keeping alive the spirit and the memory of Paul Robeson. For those who know only his name, it is more important than ever that they become acquainted with and understand the magnificent legacy he has left . . .

It was to make available this "magnificent legacy" that I began several years ago to prepare this annotated collection of Paul Robeson's writings and speeches. While it is impossible for any single volume to encompass the full richness of this remarkable life, I have endeavored to provide a selection representative of the many aspects of Robeson's thoughts and activities and of the broad range of causes and issues to which he dedicated his life. To understand Paul Robeson, one must read what he himself said and wrote, and it should become clear to the reader why, increasingly, Robeson is being referred to as "The Great Forerunner."

Along with Robeson's own words, I have included interviews and news reports which show the changing attitudes of the press as his public statements became more radical and antithetic to the establishment. Except for the correction of obvious typographic errors in the originals, no changes have been made. The word "Negro" therefore appears with a capital "N" or a small "n" according to its contemporary source.

During his lifetime, Paul Robeson was attacked and, as Andrew Young put it, "buried alive politically" in his own country for his steadfast stand in behalf of peace and freedom—not only for his own people but for the working people and the oppressed throughout the world.

Now it is time to let him speak again for himself.

PHILIP S. FONER

May 1978
Lincoln University, Pennsylvania

ACKNOWLEDGMENTS

The compilation of this volume would have been impossible without the kind cooperation of the staffs of many historical societies and libraries. I wish to take this opportunity to express my gratitude first to Brigitte Boegelsack, director, and the staff of the Paul Robeson Archives, Berlin, German Democratic Republic, for kindly permitting free and unlimited access to the vast collections of the Archives when I was in the German Democratic Republic, and furnishing me with copies of materials requested. I also wish to thank the staffs of the Schomburg Collection of the New York Public Library, the British Museum, the Library of Columbia University, the Library of Congress, the Libraries of Howard, Fisk, Atlanta, Princeton, Wayne State, Rutgers, and Harvard Universities, the Tamiment Institute of the Library of New York University, and the Library of the University of California-Berkeley, as well as Crystella Kauka, Interlibrary Loans Librarian, Hawaii State Library, Honolulu, Hawaii, and Tillie A. Pevzner, Institute for Retired Professionals of the New York School for Social Research. I am grateful also to Harriet Williams, director, Interlibrary Loan Department, Langston Hughes Memorial Library, Lincoln University, Pennsylvania, for assistance in obtaining materials from various parts of this country and Europe, and to other members of the staff of the library for their cooperation. Thanks also to my brother, Henry Foner, for his help in the preparation of the manuscript and for having read the manuscript and made valuable suggestions, and to Ella Mazel, who took several months away from her own work to design, edit, and produce this book because she loved Paul Robeson.

CONTENTS

IN THE FIFTIES

THE LAST YEARS

APPENDIX

LIST OF ILLUSTRATIONS

Addressing meeting of American Crusade to End Lynching at Lincoln Memorial, Washington, D.C., September 24, 1946

PAUL ROBESON
Great Artist, Great American

By Philip S. Foner

In presenting Paul Robeson to the audience of the Twelfth Herald-Tribune Forum in New York City on November 19, 1943, Mrs. Ogden Reid, publisher of the *New York Herald-Tribune,* said: "Our next speaker has distinguished himself in four separate fields—as scholar, athlete, singer and actor." After describing Robeson's achievements in each of these fields, she continued:

> While playing in London he became interested in the African people and through his study of the plight of colored peoples in other parts of the British Empire as well as the rest of the world, he reached the conviction that the problems of all backward people, white or colored, were interrelated.
>
> Later on, following his first visit to Russia, he was so impressed with what the Soviet system had done for those who were underdeveloped, that he said, "This showed me that they can operate at the same level of culture as anyone else if they are given the opportunity."
>
> After that he plunged into the struggle for freedom in earnest. From 1937 until the outbreak of the war he practically gave up his professional career, and joined with those who had started to fight the growing Fascist menace. We are thankful that he has now come back to his own country, and we are proud to present to you today the hero of *Othello,* a great artist and great American, Paul Robeson.[1]

Mrs. Reid correctly noted that Robeson's radicalism antedated his first visit to the Soviet Union, and that his radical stance on political and economic issues was largely shaped under the influence of the British working class. In a 1960 London interview Robeson pointed out: "I came here unshaped. Great parts of my working class roots are here."[2] Unfortunately, during the era of McCarthyism, Robeson's detractors either ignored or distorted these facts. In that shameful intellectual and political climate, this "great artist and great American" became practically a nonperson in almost every commercial newspaper in the United States, including the *Herald-Tribune.* When he endorsed Henry A. Wallace for president on the Progressive Party

ticket in 1948 and played a leading role in the campaign, he was subjected to sharp and scurrilous criticism. This changed to cruel harassment following the Paris Peace Conference of April 1949 where he stated that it "is inconceivable that American Negroes would fight with those who have oppressed them for generations against the Soviet Union, which, in a generation, has raised them to a position of equality," and his life was threatened by vigilantes and hoodlums in the Peekskill riots of August-September 1949.

Paul Robeson became anathema to the American Establishment, and it harnessed all forces to persecute him. The persecution intensified with the advent of the fifties—the "scoundrel time" so aptly named by Lillian Hellman in her memoir,[3] when events were dominated by an ignorant demagogue and when many "toads" groveled before House and Senate Committees, naming as many names as they could remember and even dreaming up names, in order to save their well-paying positions in the entertainment industry. As Robeson refused to succumb, theater doors and concert halls were closed to him, his books were removed from libraries, and his records no longer played over the air. The State Department's refusal to grant him a passport in 1950 deprived him of the opportunity to perform abroad. Unable to act or sing in the commercial centers of culture, or to appear on radio or television, or to make recordings, or to travel, Robeson saw his income plummet during the years of the McCarthy witch-hunts from over $150,000 annually to $3,000. It is worth remembering that it all got under way with the following announcement in *Time* Magazine of April 18, 1949: "The South African Broadcasting Corp., a semi-official company under a race-conscious government, banned all recordings of Negro Actor-Singer Paul Robeson."

State Department files recently made accessible through the Freedom of Information Act[4] reveal that, beyond revoking Robeson's passport and forbidding him to leave the continental United States from 1950 to 1957, officials of the United States government also sought to influence public opinion against Robeson; to discourage another government "from honoring Robeson as a great humanitarian and activist for human rights"; to prevent Robeson's employment abroad in a non-political area; and to undermine his political impact by issuing anti-Robeson news releases, and using or soliciting statements of other black leaders to discredit him.

On January 9, 1951, for example, Roger P. Ross, the U.S. Vice Consul in Accra, Ghana, wrote a lengthy memo to the State Department in Washington in which he suggested that an American, "preferably an American Negro devoted to his race," write a seemingly sympathetic but basically antagonistic article about Robeson, that it be inserted in a U.S. periodical, and that it then be reprinted and distributed in Africa. Ross then outlined in three single-spaced pages exactly what the article should say, how it "must pay genuine homage to the man's remarkable talents as an artist, must take pride in his achievements," and then "must go on to detail his almost pitiful (for so

robust and seemingly dignified a person) accommodation to the Communist line. . . ."

Ross's original memo, stamped "Classified," also bears another stamp reading "Action Taken," followed by the handwritten notation, "article on Robeson, The Crisis 11–51." The reference is to the article "Paul Robeson—the Lost Shepherd" by "Robert Alan" published in *The Crisis,* official NAACP organ, in November 1951. The journal described "Robert Alan" as "the pen name of a well known New York journalist."

Following Vice Consul Ross's advice to the letter, the article justifies the canceling of Robeson's passport on the ground that "his activities in recent years were clear indication that he had become a Communist propagandizer first, and a singer second." "Robert Alan" was confident that "Africans will understand" the real reason for the cancellation of Robeson's passport once it "is stated earnestly and clearly." The State Department did its part by having copies of the article widely distributed throughout Africa.

On March 17, 1958, Ambassador Ellsworth Bunker, of the American Embassy in New Delhi, notified Secretary of State John Foster Dulles that Prime Minister Nehru's daughter, Indira Ghandi, was organizing a national committee to aid her in sponsoring a "Paul Robeson Day" in Delhi. Bunker assured Dulles that the Embassy would do everything it could to stop the proposed celebration. But efforts to achieve this goal were complicated when India's Prime Minister Jawaharlal Nehru endorsed the "All-India Paul Robeson Celebration." Nevertheless, American Consul General Turner of Bombay approached Minister Chagla, Chief Justice of Bombay and president of the celebration committee, and informed him that Americans would view the celebration as Communist-inspired and even anti-American, "and that many would regard the celebration as evidence that India was going Communist." When this failed and Chagla refused to cancel the event, the State Department summoned India's Ambassador to the United States and told him point-blank that "Robeson was an unfortunate selection for an American to be so honored in India and that the movement in India, or elsewhere, could well have been inspired originally by Communist groups." Here again the effort failed, but Ellsworth Bunker reported to Dulles that "All-India Radio and the Indian press had been instructed to play the celebration down. . . ."

In 1962, when the American Embassy in Accra, Ghana, learned that Robeson was being considered by Ghana's President Kwame Nkrumah for an appointment as a lecturer at the University of Ghana's Institute of African Studies, it immediately took steps to block the appointment. The Embassy in Ghana informed the State Department that it had warned an official close to Nkrumah that "appointment of a man who had espoused the Communist cause and turned his back on his own country would have most unfavorable repercussions in the United States and suggested [the] official express [this] to anyone who asked his opinion." The effort to block the appointment failed, but Robeson,

who was "delighted and honored" at the offer to teach at Ghana, had to decline because of ill health.

Of course, the State Department would not have engaged in such un-American activities and Robeson would have been forgiven if he had only denied his high regard for the Soviet Union or the New China and altered his convictions to suit the witch-hunters. But, as Robeson explained: "I was not raised that way and neither the promise of gain nor the threat of loss has ever moved me from my firm conviction."[5]

Mount Robeson stands majestically in the U.S.S.R., and the Paul Robeson Archives are maintained in the German Democratic Republic—yet, in 1958, no regular American publisher would touch *Here I Stand,* the autobiography of this Phi Beta Kappa American, twice winner of All-American football honors at Rutgers University, graduate of Columbia Law School, recipient of honorary degrees from Rutgers, Hamilton, Morehouse, and Howard, honorary lifetime member of several national trade unions, awarded the Abraham Lincoln Medal in 1943 for the most notable and distinguished service in human relations in New York and the Spingarn Medal in 1945 by the NAACP for outstanding Negro achievement, hailed for three decades as one of the greatest singers and actors in the world, a man fluent in more than twenty languages, a man said to have been better known internationally than nearly all Americans aside from Franklin D. Roosevelt. The book was issued, instead, by "Othello Associates," created especially for the purpose. Indeed, not until 1971, when it was reissued in cloth and paper by Beacon Press, could one find copies in most bookstores throughout the nation. A frustrated black American who wished to purchase the book in 1958 complained bitterly to the *Pittsburgh Courier* that he had visited every leading bookstore in that city and had found not a single one that had even heard of *Here I Stand.*[6]

By the time Beacon Press released *Here I Stand,* Robeson's renaissance was under way and he was no longer "the forgotten black hero." Several of his old films were revived, black students named their centers at school for him (Paul Robeson Rutgers-Newark Students' Center); a three-part series on Robeson, sponsored by National Educational Television, won an "Emmy" award; he received the National Urban League's Whitney M. Young Memorial Award and the 1972 Award of the Black Psychiatrists' Association; and *Ebony,* in its August 1972 issue, proclaimed Robeson one of the "ten most important black men in American history."[7] Even black Americans who had never mentioned his name or had spoken it only in whispers now conceded that millions of their people, especially the youth, had been deprived by the hysteria of the McCarthy period of firsthand acquaintance with one of the major personalities in the history of the performing arts, and the influence of the ideas of a great artist-activist.

In April 1977 the Senate Judiciary Sub-Committee on Internal Security went out of existence. With its counterpart, the House

Committee on Un-American Activities, which was disbanded in 1975, the subcommittee had conducted widely publicized investigations of alleged Communist infiltration of the United States government in the 1950s. Although its methods attracted a great deal of attention and brought ruin to the careers of persons called before the committee for questioning about their beliefs, its work did not result in a single criminal prosecution of a government employee. This was precisely the point Paul Robeson made in 1946 before the legislative hearing of the Tenney Committee, the California version of HUAC, and before the House Committee itself in 1956—that if the committees believed he was involved in any international conspiracy or had broken any laws of the United States, they should prosecute him. As he put it in *Here I Stand:*

> The truth is: *I am not and never have been involved in any international conspiracy or any other kind, and do not know anyone who is.* It should be plain to everybody—and especially to Negroes—that if the government officials had a shred of evidence to back up that charge, you can bet your last dollar that they would have tried their best to put me *under* their jail! But they have no such evidence, because that charge is a lie. . . . [8]

In his introduction to the reprint of Robeson's testimony before the House Un-American Activities Committee in 1956, Eric Bentley points out: "Where Robeson the activist shows himself really significant is in siding not with Ralph Bunche but with the Communist Councilman Ben Davis. That had significance, and probably some value, but the truly significant alignment was with the future—Paul Robeson was a brother of Malcolm X, Stokely Carmichael, Rap Brown, Huey Newton, Eldridge Cleaver, before they were there to take his hand."[9] Even biographer Edwin P. Hoyt, who persistently and often churlishly criticized Robeson's associations with American Communists and his praise of the Soviet Union, and attributed them to a personality quirk, concedes in his 1967 book, *Paul Robeson: The American Othello,* that Robeson was a forerunner of the Black Power movement.[10] The reader will find ample justification for this designation in the pages that follow, but one has only to read Paul Robeson's 1946 warning to President Truman that unless the U.S. government began to protect black Americans from lynchings, blacks would take the necessary steps of self-defense, to see how Robeson preceded Malcolm X, Robert Williams, the Deacons for Justice, and the Black Panthers.[11]

Paul Robeson was a forerunner, too, of what is now called "détente." In recent years, "revisionist" historians have contributed new insights and evidence to the story of the origins of the Cold War. It is becoming increasingly apparent that the Cold War was not the inevitable product of expansionist Communism, and that, contrary to earlier

appraisals, American leaders played the major role in determining the shape of the postwar world.[12] Looking back to 1945, the year World War II ended, with our perceptions altered by the work of these historians, we can appreciate how farsighted Paul Robeson was when he denounced the Truman Administration for refusing to take the road of postwar international cooperation with the Soviet Union, which would have forestalled a nuclear arms race, and how correct he was in condemning the cold warriors who maintained that "the only argument the Russians understood was force," and in emphasizing that the Cold War was not primarily a struggle for power with the Soviet Union, but rather a conscious attempt by the United States to crush the Left in this country and to destroy the anticolonial movements in Africa and Asia.

Robeson took very seriously the American tradition of freedom of thought, enunciated most clearly by Mr. Justice Jackson when, speaking for the majority of the U.S. Supreme Court in its 1943 decision in *West Virginia State Board of Education v. Barnette,* he said:

> If there is any fixed star in our constitutional constellation, it is that no official, high or petty, can prescribe what shall be orthodox in politics, nationalism, religion, or other matters of opinion or force citizens to confess by word or act their faith therein.

But Robeson also knew from his study of American history and constitutional law that the mere enunciation of this tradition, even by the Supreme Court, was no assurance that it would be observed. He often pointed to the jailing of Jeffersonian Republicans under the Alien and Sedition Acts of 1798, to the destruction of the civil liberties of black and white abolitionists, and to the imprisonment and other forms of harassment meted out to Socialists and pacifists during World War I. He knew, too, that to safeguard the freedom of thought required vigilance, struggle, and even sacrifice. He believed with Frederick Douglass, who had said in 1857: "If we ever get free from the oppression and wrongs heaped upon us, we must pay for their removal." But he also believed, as did Douglass, that if the struggle was waged persistently and continued long enough, it would be successful.

In his speeches and writings, Robeson repeatedly pointed out that the witch-hunt of the 1950s sprang from two sources. One was a continuation into the postwar period of the prewar opposition to the New Deal, carried out by anti-labor, anti-Semitic and racist Congressmen under the banner of "anti-Communism." The other source was Truman's reversal of foreign policy from wartime collaboration with the Soviet Union to the Cold War hostility toward the former ally, combined with opposition to national independence movements by former colonies and semi-colonies, which he characterized as manifestations of alleged Communist aggression. Robeson pointed out that in order to make this reversal of American policy acceptable to the American people, it was necessary to label as unthinkable the ideas of

peace and friendship with the USSR. Thus, Truman's policies laid the groundwork for the repressive measures of the 1950s. In 1947, he both initiated the Cold War and issued Executive Order 39835, which called for a loyalty investigation of federal employees and authorized the Attorney General to furnish the names of organizations or associations designated as "totalitarian, Fascist, Communist or subversive." Membership in, or affiliation or "sympathetic association" with, such groups was ground for dismissal.

Recent Congressional disclosures reveal what the government was actually doing behind the "anti-Communist" smokescreen: FBI disruption of civil rights organizations; CIA plots to assassinate heads of state and "destabilize" and overthrow democratically elected governments; and direct American military intervention, as in the Dominican Republic and Vietnam. In opposing this Cold War policy at its birth, Paul Robeson sacrificed his career and made his name anathema in the media.

More and more historians today have come to agree with Paul Robeson's argument at the time that McCarthyism was only Trumanism carried to its logical conclusion. For example, David Caute vindicates Robeson's foresight when he writes that Truman's executive order of March 1947 launching the loyalty program ranks as the single "most sinister and destructive departure in postwar domestic politics, one which was to ramify far beyond the federal service and poison wide areas of American working, education and cultural life."[13]

Paul Robeson was also a forerunner in the campaign to educate the American people concerning the truth about Africa. He studied linguistics and African languages at the School of Oriental Languages in London, learned Swahili, Zulu, Mende, Ashanti, Ibo, Efik, Edo, Yoruba, and Egyptian, and, as early as the 1930s, wrote scholarly articles on African culture and linguistics. "Africa," he emphasized in a 1936 interview, "has a culture—a distinctive culture—which is ancient, but not barbarous."[14] In the same interview, he stressed the oral tradition of African culture, and noted that his ancestors in Africa considered sound of particular importance. Thus, they produced "great talkers, great orators, and where writing was unknown, folktales and oral tradition kept the ears rather than the eyes sharpened. I am the same. . . . I hear my way through the world." This was forty years before Alex Haley's *Roots*.[15]

In 1937, Robeson co-founded and served actively as chairman of the Council on African Affairs, to aid the national liberation struggle on that continent. For nearly two decades (until it was witch-hunted into oblivion in 1955), the Council on African Affairs was the most important organization in the United States working for African liberation. W. Alphaeus Hunton, who served as secretary of the Council for years and was its administrative and intellectual mainstay, wrote: "The Council on African Affairs for many years stood alone as the one organization in the United States devoting full-time attention to the problems of the people of Africa."[16]

It was at the Council's 1944 conference, over which Robeson presided, that a young student from Ghana, Francis Nwi-Kofi Nkrumah, participated as a representative of the African Students Association. The conference was called to draft a program for Africa's postwar liberation and advancement. The Council's program was six-fold:

1. To give concrete help to the struggle of the African masses.

2. To disseminate accurate information concerning Africa and its people; in that, to wake up Americans to what is happening in Africa, the one continent where undisguised colonial slavery is still practiced.

3. To influence the adoption of governmental policies designed to promote their advancement and freedom and preserve international peace.

4. To smash the iron curtain of secrecy and double-talk surrounding the schemes for intensified imperialist exploitation of Africa and its people.

5. To prevent American loans and guns from being used to crush the freedom struggle of Africans and other subjected peoples.

6. To strengthen the alliance of progressive Americans, black and white, with the peoples of Africa and other lands in the common struggle for world peace and freedom.[17]

Through mass rallies, conferences, workshops, cables, declarations, press releases, and advertisements, through financial and food aid to alleviate famines in Africa, by hosting nationalist leaders and delegations, and meeting with major members of the U.S. government and of the U.N. Secretariat and delegations, Robeson and the Council contributed to the cause of African freedom. In a tribute to Robeson's work on the Council, Alex La Guma, the South African scholar and writer, declared: "Until then, I believe, most Americans thought in terms of Edgar Rice Burroughs' stories of Tarzan and the Apes, whenever they heard the continent of Africa mentioned." La Guma emphasized that blacks in South Africa would never forget that in 1950, when workers were shot down by the police at a May Day demonstration, Robeson spoke out against the terror of the "fascist Malan regime," and warned: ". . . It is later than they think in the procession of history, and that rich land must one day return to Africans on whose backs the proud skyscrapers of the Johannesburg rich were built."[18] These were truly prophetic words!

In 1934, Robeson declared: "In my music, my plays, my films, I want to carry always this central idea; to be African. Multitudes of men have died for less worthy ideals; it is even more eminently worth living for."[19] He was not always able to combat imperialist propaganda and to present the African with dignity in his films, but he did achieve his goal in at least one film, *Song of Freedom* (1937). The film about a successful black singer who, after discovering his aristocratic African origins, returns to England to take over leadership of the freedom

struggle, was a rare exploration of the history, aspirations, and culture of the African roots. Kwame Nkrumah, who had worked closely with Robeson in Great Britain, selected the film for showing at the second anniversary celebration of his Convention People's Party in 1950. He was later to offer Robeson a visiting professorship of drama and music at the university in independent Ghana, a post which Robeson's health did not permit him to accept.

One of the features that distinguished Paul Robeson from some of his contemporary black artists was the fact that he never denied his blackness. "Sometimes I think I am the only Negro living who would not prefer to be white," he said in the 1930s. "I am going back to my people in the sense that for the rest of my life I am going to think and feel as an African—not as a white man. . . . Frankly, years ago, I would not have said—as I do now—that I am proud to be a Negro."[20] Robeson, moreover, refused to believe that he could serve the black masses by becoming a positive role model and thereby uplift the race. Unlike many successful blacks, Robeson did not fool himself with the rationalization that the achievement of a visible position of prominence in the white world would help ghetto blacks and sharecroppers move into the middle class. He knew that most of them would remain in the ghetto and in rural peonage, living in abject poverty, unless a militant and even violent struggle was waged to change these conditions. He knew, too, that many poor blacks wondered whether blacks who had "made it" could truly represent their concerns and mount struggles on their behalf, and he was determined to prove that he, for one, could and would. He preached and practiced the concept advanced by Frederick Douglass, the great nineteenth-century black American, whom he admired immensely and whose writings and speeches he studied avidly: "If there is no struggle, there is no progress."[21]

Eric Bentley argues that "Robeson the artist" was not only recognized as "one of the notable Americans of his time" but "was generally accepted as such," and that it was only Robeson "the political activist" who brought down upon himself the wrath of America's ruling circles.[22] But this ignores the fact that Paul Robeson never separated his role as an artist from that of political activist. He coined the slogan, "My song is my weapon," and he used that weapon in every cause to which he was committed. He never failed to point out that the Negro spirituals he brought into the concert halls of the United States and Europe were songs which had strengthened the slaves' determination to survive, and while they had given the slaves a certain measure of joy, they had also raised the collective spirit of an oppressed class. He always introduced "Go Down Moses" by explaining that it had helped the slaves in their preparations to escape to freedom in the North, and that the heroic freedom fighter, Harriet Tubman, was identical with the figure of Moses in the spiritual, for, as an escaped slave herself, she had returned to the South again and again to rescue others who were still in bondage.

Robeson, of course, was not the first to discover this rich cultural

heritage of the Negro people. Beginning in 1871, the choir from Fisk University, the black institution in Nashville, Tennessee, had brought the Negro spirituals to audiences in the United States and Europe. Thereafter, other black colleges established choirs and systematically performed these songs. But Robeson was the first soloist to devote an entire program to spirituals. On Sunday, April 19, 1925, at the theatre of the Provincetown Players, and with the encouragement of his accompanist and musical adviser, Lawrence Brown, he gave a performance consisting entirely of Negro spirituals—a revolutionary cultural development for that period. Critics hailed both the songs and the singer, and it was acknowledged that Robeson had shattered the concept that Negro music was inferior and that the Negro song could not be considered as an art.

W. E. B. Du Bois put it well when he wrote that "Robeson . . . more than any living man has spread the pure Negro folk song over the civilized world."[23] Through his dedication to Negro folk art, and his growing understanding of the interrelationship between African culture and the folklore of the Afro-Americans, Robeson became increasingly conscious of the fact that there was a universal bond linking the folk songs of all people. He discovered the beauty of the lovely folk songs of the British Isles, and he noted that, as he sang these melodies, he felt that "they, too, were close to my heart and express the same soulful quality that I knew in Negro music."[24] More and more, he devoted himself seriously to studying the folk songs of various peoples, as well as their languages, so that he could sing the songs in the language of the country of their origin. To his repertoire of folk songs and "lieder" of all nations, he added progressive songs of his own day, such as the "Thaelmann Column" of the Spanish Loyalists' International Brigade, the "Song of the Peatbog Soldiers" of the anti-Nazi struggle, and "Joe Hill," Earl Robinson's song dedicated to the IWW songwriter and organizer who had been framed on a murder charge in Salt Lake City and executed by a firing squad,[25] which was Robeson's special favorite. Paul Robeson became the voice of the cultural heritage, not only of the Afro-American people, but of the entire international working class. So far as this country is concerned, we may consider him the father of the American political song of the contemporary era.

Thus it was as an artist as well as a political activist that Paul Robeson had to be silenced. And Robeson knew exactly why the government was determined to silence him. In a chapter of *Here I Stand,* entitled "Our Right to Travel," he insisted that he was the victim of persecution because of his fight for the rights of his people, a fight which he argued "was at the heart" of the government's denial of his passport. Robeson pointed specifically to the candid confessions in State Department briefs submitted to justify preventing him from exercising the right to travel. One such brief declared that Robeson, "during his concert tours abroad had repeatedly criticized the conditions of Negroes in the United States." Another not only referred to his

"recognized status as spokesman for large sections of Negro Americans," but went on to allude to "appellant's frank admission that he has been for years extremely active politically in behalf of independence of the colonial people of Africa."[26]

But these were only two of many ideas of Paul Robeson that frightened the American Establishment. The reader who studies the pages of this volume will quickly understand why those high in government circles concluded that he had to be silenced.

Paul Robeson saw the black liberation struggle in the United States as part of the vast world-wide struggle of the colonial world for freedom. In addition, he was profoundly conscious of the need to base any struggle, national or otherwise, on the working class. This consciousness emerged from a deep and abiding knowledge of and faith in the working class. He repeatedly emphasized that he came from working-class people. Although he said that his twelve years in England had shaped his mind in a decisive manner, he also emphasized that "my career as an artist in America and abroad, my participation in public life, the views which I hold today—all have their roots in the early years. . . ."[27]

Born in Princeton, New Jersey, on April 9, 1898, Robeson came from a long line of working people. As a lad of thirteen, his father had run away from his slave owner in North Carolina, and, after serving in the Union Army during the Civil War and studying at Lincoln University in Pennsylvania, had become a minister in Princeton. During the years of the great migration north of Southern blacks, which got under way in 1915,[28] many of Robeson's father's relatives and friends from North Carolina came to live in Princeton. Young Paul soon found himself surrounded by a great number of close relatives, all of them former sharecroppers and laborers, and now industrial workers. This extended family became very close after the early death of his mother, and he grew up in the midst of the black working class.

For some years, he remained in that class. Although he became a well-known scholar, graduating Phi Beta Kappa from Rutgers University, and at the same time winning twelve varsity letters in sports and becoming All-American end on Walter Camp's football teams of 1917 and 1918, he had to work as a kitchen boy and waiter for many summers in order to get through college. After graduating from Rutgers, Robeson attended and graduated from Columbia University Law School. But while going to school in Morningside Heights, and meeting and marrying Eslanda Goode, Robeson lived in Harlem. There, among the poorest of America's poor, he went to Harlem rent parties and sang blues, jazz, and ragtime for his people.[29]

Robeson spent twelve years—from 1927 to 1939—in Europe. While there, he came to know the working class and to participate in their struggles. In the mid-1930s he began to give concerts for the working people. He even gave up performing mainly in the fashionable West End theaters of London to appear in motion picture houses and music

halls frequented by workers. Joining Unity Theatre, which was established by the British Labour Party, he performed for working men and women.[30] Recalling that period, he wrote: "I gave up two years of my time then—way back in 1936–37—to help build workers' theatres in Great Britain to help develop a working class culture in the full meaning of that term."[31]

But it was in Spain during the Spanish Civil War that Robeson saw the real armed struggle between working people and their oppressors:

> I went to Spain in 1938, and that was a major turning point of my life. There I saw that it was the working men and women of Spain who were heroically giving their "last full measure of devotion" to the cause of democracy in that bloody conflict, and that it was the upper class—the landed gentry, the bankers and industrialists—who had unleashed the fascist beast against their own people.[32]

In 1939, Robeson became a part of the labor movement in Britain. The miners of Wales—workers he especially loved and with whom he made one of his greatest films, *Proud Valley*—pointed out to him that the class struggle lay at the heart of the workers' struggles, "and that although I was famous and wealthy, the fact was that I came from a working-class people like themselves and therefore, they said, my place was with them in the ranks of labor."[33] At the same time, he came into contact with workers of all races and from all continents on the London docks. While he met students and intellectuals from Africa (including Jomo Kenyatta) at the universities, colleges, and cultural centers, he also met African seamen whose outlook did not in any way differ from that of the white British dockworkers. All this helped Robeson extricate himself from a narrow nationalist viewpoint that the struggle of the people was fundamentally a racial one.[34]

Little wonder, then, that one of the themes that runs through this book is Robeson's view that his life was bound up with the lives of black and white working people in America. In 1952, he summed up this concern in these words:

> I have been in many labor battles. It has seemed strange to some that, having attained some status and acclaim as an artist, I should devote so much time and energy to the problems and struggles of working men and women.
> To me, of course, it is not strange at all. I have simply tried never to forget the soil from which I spring.[35]

More than any other black activist, Robeson centered his activities in the freedom movement around two mass-based organizations—the black churches and the labor unions. After he returned to America in 1939, he plunged into the organizing campaigns then under way to recruit black workers into the CIO.[36] At the same time, he sought to educate white workers to an understanding that black workers suffered super-exploitation and faced a special oppression, and that their

problems therefore had to have top priority. He was confident that, despite racist influences of long standing, the white workers would come to understand this crucial issue and join in the fight for freedom of the black people. His experience at the second Peekskill concert, where hundreds of white trade unionists joined blacks in protecting him from fascist vigilantes, fully convinced Robeson that this confidence was justified.

Black-white labor unity was thus a key element in Robeson's concept of the freedom movement, but one must add that he was firm in the belief that the coalition had to be under *black* leadership. Once a black-white working class coalition, under black leadership, emerged, "our day of freedom is not far off."[37]

To Robeson, the persecution of black Americans and other racial minorities in the United States was both a racial and a class question, but more so the latter than the former. He therefore opposed every effort to separate or isolate the struggle of black Americans from that of the entire American working class, or to bring about a split between white and black workers. Yet he knew that black-white unity would not come automatically; it had to be fought for, and it was the special duty of black workers to show white workers the need to fight against racism, to remind them of the truth of Karl Marx's trenchant observation in Volume I of *Capital:* "Labor with a white skin cannot emancipate itself where labor with a black skin is branded."[38] Hence, Robeson urged:

> You must rally your white fellow workers to support full equality for Negro workers; for their right to work at any job; to receive equal pay for equal work; for an end to Jim Crow unions; for the election of qualified Negroes to positions of union leadership; for fair employment practices in every industry; for trade union educational programs. to eliminate the notions of "white superiority" which the employers use to poison the minds of the white workers in order to pit them against you.[39]

In this single paragraph, Paul Robeson outlined the program of progressive forces in the American labor movement for years to come!

Robeson was never content to merely outline a program and voice his theoretical opinion; invariably, he placed his entire art and personality at the service of the principles in which he believed. It was this which lay behind his decision in 1938 to go to Spain and to use his songs in the support of the democratic forces fighting reaction and fascism. His experiences in the anti-fascist struggle there convinced him that he had to return to the United States in 1939 in order to promote, together with other black Americans, the cause of the labor movement in the land of his birth. A headline in the *CIO News* of April 12, 1943, read: "U.S. Future Depends on CIO, says Robeson." The article, datelined Fort Wayne, Indiana, went on: "Expressing the belief that the CIO is the only national organization that has a complete

program in the real interest of the common people of the nation, Robeson said that 'the future of America depends largely upon the CIO's progressive program.'" On December 13, 1943, the *CIO News* headlined the fact that "Robeson Praises CIO Race Policy," and quoted him as saying: "The future of the Negro lies with labor, and especially with the CIO. Some 98 per cent of the Negroes of America are workers. Under the leadership of progressive organizations like the CIO, Negroes can take part with white workers in fighting reactionary elements like the Ku Klux Klan which would enslave them and keep them both in a hopeless position." The *CIO News* noted further that this "outstanding leader of the Negro people" warned that if labor failed to follow through in developing "better understanding and cooperation between the races, the way will be left open for American fascism in the post-war world." Robeson added:

> I feel that labor will have to go more than half way because the Negro feels battered about. The temper of the Negro has changed and will remain changed—he is helping to fight a world-wide war for the right of people to be free and will resist any attempt to keep him tied down to a reactionary status quo.

Seven years later, when the CIO, following the pattern set by the AFL, demonstrated indifference to the needs of black workers, and devoted more attention to organizing the Cold War witch-hunts against progressive trade unions than to organizing the unorganized, Robeson joined in founding the National Negro Labor Council. He spoke at the National Labor Conference for Negro Rights in Chicago in 1950, where the foundations of the new movement were laid, and he delivered the keynote address at the Negro Labor Council's founding convention in Cincinnati in 1951. He headed the Performing Artists' Division of the NNLC, and supported strikes of black workers in every part of the country, visiting the areas at his own expense, joining the picket lines, and publicizing the struggles of the workers.[40]

If there was one belief that Robeson cherished, it was his full faith in the possibility and power of a united working class in the United States. This is the way he put it in 1950:

> For if 15 million Negroes, led by their staunchest sons and daughters of labor, and joined by the white working class, say there shall be no more Jim Crow in America, then there shall be no more Jim Crow!
>
> If 15 million Negroes in one voice demand an end to the jailing of the leaders of American progressive thought and culture and the leaders of the American working class, then their voice will be strong enough to empty the prisons of the victims of America's cold war.
>
> If 15 million Negroes are for peace, then there will be peace![41]

Robeson's maturing political understanding was greatly influenced by his grasp of the inhuman nature of fascism. In 1933, he gave a special performance of "All God's Chillun Got Wings," the proceeds of which he donated to the first Jewish refugees who had escaped the fascist terror in Germany. In 1934, Robeson and his friends were assaulted by Hitler's brown shirts in Berlin, an event which made a deep impression on him. He recognized then, as he made clear later in a radio broadcast, "that the struggle for Negro rights was an inseparable part of the anti-fascist struggle."[42]

If Paul Robeson became a confirmed anti-fascist during the Spanish Civil War and World War II, then during the Cold War he became a confirmed anti-imperialist. He gave the reason in 1958, quoting Charles Baylor, the black attorney from Providence, Rhode Island, who said at the turn of the century: "The American Negro cannot become the ally of imperialism without enslaving his own race."[43] In the context of post-World War II America, Baylor's admonition required black Americans to take a stand in the conflict between the national liberation of colonial peoples and the emergence of the United States as the world's No. 1 imperialist power.[44] Robeson argued that his people should side with the oppressed peoples, not with their government. Why this choice? Because, as he explained, black Americans and colonial peoples faced the *same oppressors*.[45] Because of this, black Americans knew more about what imperialism is all about than most white Americans:

> The Negro—and I mean American Negroes as well as West Indians and Africans—has a direct and first-hand understanding, which most other people lack, of what imperialist exploitation and oppression is. With him, it is no far-off theoretical problem. In his daily life he experiences the same system of job discrimination, segregation and denial of democratic rights whereby the imperialist overlords keep hundreds of millions of people in colonial subjection throughout the world.[46]

Despite a rising chorus of condemnation which included voices of the American Establishment, both black and white, Robeson continued to insist that not only would black Americans refuse to support American imperialism, but they would oppose it. "What are the best interests of Negro Americans in this matter?" he asked repeatedly with respect to Africa, and particularly Southern Africa. "Can we oppose White Supremacy in South Carolina—and not oppose the vicious system in South Africa?"

In 1952, Robeson reframed his Paris statement as a question he was to propose time and time again for years to come:

> Now, I said more than three years ago that it would be unthinkable to me that Negro youth from the United States

should go thousands of miles away to fight against their
friends and on behalf of their enemies . . .

Well, I ask you again, should Negro youth take a gun in
hand and join with British soldiers in shooting down the
brave people of Kenya? . . .

I ask you, shall I send my son to South Africa to shoot
down Professor Mathews' son on behalf of Charles E.
Wilson's General Motors Corporation?[47]

And as early as 1954, Robeson sounded the alarm on the U.S.
government's involvement in Indo-China:

I'm talking about Vietnam, and it seems to me that we
Negroes have a special reason for understanding what's
going on over there. . . .

Now, when France wants to call it quits, Eisenhower,
Nixon and Dulles are insisting that Vietnam must be
re-conquered and held in colonial chains. "The Vietnamese
lack the ability to govern themselves," says Vice-President
Nixon.

Vast quantities of U.S. bombers, tanks and guns have
been sent against Ho Chi Minh and his freedom-fighters;
and now we are told that soon it may be "advisable" to send
American GI's into Indo-China in order that the tin, rubber
and tungsten of Southeast Asia be kept by the "free
world"—meaning White Imperialism. . . .

Again Robeson repeated his well-known question:

I ask again: Shall Negro sharecroppers from Mississippi
be sent to shoot down brown-skinned peasants in
Vietnam—to serve the interests of those who oppose Negro
liberation at home and colonial freedom abroad?"[48]

Who can disagree with Lloyd L. Brown, Paul Robeson's official
biographer, when he said in 1971: "Just imagine how much loss of life,
how much devastation would have been averted had his countrymen
heeded Robeson then, at the very first sign of U.S. intervention in
Vietnam!"[49]

Even today there are Americans, black and white, who, while
admiring most of what Robeson stood for, cannot forgive him for
having so warmly embraced the Soviet people and their government.
Yet this is both a logical and essential feature of Robeson's creed. As
he explained more than once, it was an African who had directed his
attention to something he had observed on a visit to the Soviet Union.
The African had traveled to the eastern parts of the socialist state and
had seen the Yakuts, "a people who had been classed as a 'backward
race' by the Czars." The African had been struck by the resemblance
between the tribal life of the Yakuts and that of his own people in East

Africa. Robeson and his African friend both wondered whether social-
ism could eradicate the racism of the Russian people: "What would
happen to a people like the Yakuts now that they have gained freedom
from colonial oppression and were part of the construction of a socialist
society?" And so Paul Robeson and his family went to the Soviet Union
in 1934 to seek the answer for themselves. And he saw how the Yakuts
and the Uzbeks and all the other formerly oppressed nations were
"leaping ahead from tribalism to modern industrial economy, from
illiteracy to the heights of knowledge." And this had not taken a
thousand years. "No. Less than twenty."[50]

Robeson noted that other black Americans—including Dr. William
E. Reed, dean of the school of agriculture at the Agricultural and
Technical College in North Carolina—had discovered the same thing.
As a new system of society, socialism could eradicate racism. He also
discovered what other black Americans who had visited the Soviet
Union could say with him: "In Russia, I felt for the first time like a full
human being—no color prejudice like in Mississippi, no color prejudice
like in Washington."[51]

Over the years, he learned that the Soviet Union, and later the other
socialist countries (China, the German Democratic Republic, Hungary,
Czechoslovakia) aided colonial liberation, while his own government
opposed it and aided the imperialists. He saw early that this conflict
over imperialism lay at the *heart* of the Cold War:

> "Stop Russia!" the brass voices cry in chorus, and the men
> behind the voices hope that the people will be afraid and will
> turn against their wartime ally. Their frantic cries mask the
> program of imperialist aggression which these men them-
> selves are seeking to impose upon the world.
> The "Stop Russia" cry really means "Stop the advance of
> the colonial peoples of Asia and Africa toward indepen-
> dence; stop the forces of the new democracy developing in
> Europe; stop the organized workers of America from trying
> to hold their ground against their profit-greedy employers;
> stop the Negro people from voting and joining trade unions
> in the South." "Stop Russia" means *Stop progress;* maintain
> the *status quo.* It means let the privileged few continue to
> rule and thrive at the expense of the masses.[52]

He boldly challenged the reactionaries to prove that it was un-
American to stand for peaceful relations with the Soviet Union. Just a
few months after these forces had incited mob violence against him in
Peekskill, he declared:

> To those who dare to question my patriotism, who have
> the unmitigated insolence to question my love for the true
> America and my right to be an American—to question me,
> whose father and forefathers fertilized the very soil of this
> country with their toil and with their bodies—to such people

I answer that those and *only* those who work for a policy of friendship with the Soviet Union are genuine American patriots. And all others who move toward a war that would destroy civilization, whether consciously or unconsciously, are betraying the interests of this country and the American people.[53]

It was because he continued to believe firmly in this principle and continued to see the Soviet Union in the role of an ally and supporter of the colonial peoples' struggle for liberation that Robeson never yielded to the tendency to condemn the socialist state, even after the revelations of the cruel excesses of Stalinism in 1956. Like it or not, he believed that to join in the campaign of those who were determined to weaken the Soviet Union was to join the forces of those bent on crushing the liberation movements in Africa, Asia, and other parts of the colonial world.

Whatever defects existed in the Soviet Union and other socialist states, they never altered Robeson's conviction that socialism was the best of all social systems. All people had the right to choose the social system under which they wished to live, and he was convinced that once they saw through the curtain of propaganda erected by the detractors of socialism, and when they could compare the nature of capitalism with that of socialism, the colonial peoples, and even black Americans, would choose socialism.[54] Ossie Davis, the well-known black actor, director, playwright, essayist, and political activist, a man who knew Paul Robeson well and is, in fact, himself much like Robeson, put it this way:

> Black he was, through and through, in feeling, thought, and act; maintaining by choice, at whatever the cost, his position, his far forward position, in the struggle for Black Liberation—a struggle which had long ago become the central fact of his existence, and for which he had a strategy—a black strategy.
>
> Paul concluded, after much searching and searching, that *Black Liberation would never come to his people short of Socialism* . . . that Socialism, and Socialism alone, was our hope and our salvation. It was this conviction that governed all his choices.[55]

The Paul Robeson of the post-World War II era is a man still difficult for some to accept today on his own terms. Even some young black and white progressives and radicals who are amazed to learn for the first time with what courage Robeson stood by his principles, and who grow furious over the vicious campaign of government officials, business leaders, black establishment leaders, and liberals against him because he refused to join the "toads" (as Dalton Trumbo labeled the collaborators with McCarthyism), squirm at some of Robeson's fundamental concepts. They either shake their heads in bewilderment at his

consistent and persistent defense of the Soviet Union, or ignore it, and/or explain it away as political naivete. Moreover, some black radicals either ignore or distort Robeson's continual call in the 1950s for unity of black and white labor as the key to black liberation.

This tendency is also reflected in the seminal study, "'I Want To Be African': Paul Robeson and the Ends of Nationalist Theory and Practice," by Sterling Stuckey, the eminent black scholar. In what is probably the most insightful study of aspects of Robeson's ideological development, based, in the main, on what he actually wrote and said rather than on hearsay, Stuckey's emphasis is almost entirely on the influence of the black cultural heritage in the United States and Africa on Robeson's ideas. He writes, for example, that even critics and historians who are beginning to concede that Robeson "is a towering figure of our era" are, almost without exception "oblivious to the fact that he was for nearly a half century, the only Afro-American to fashion a philosophy grounded almost completely in the heritage of his people in the U.S. and in Africa."[56]

Yet later Stuckey concedes that Robeson's views were deepened by his visits to the Soviet Union where he "witnessed the potential of 'backward races' being realized. Within twenty-five years the peoples east of the Urals, the Yakuts, the Uzbeks and others, under the influence of socialism, had compressed time; they were running their own factories and directing their own theatres and universities, their ancient cultures were 'blossoming' in their new and greater richness. 'That showed me,' Robeson remarked, obviously with the Afro-Asian world in mind, 'that the problem of 'backward peoples' was only an academic one.'"[57] Robeson did have the "Afro-Asian world" especially in mind, but he also had the entire population of the Soviet Union in mind. For he makes it quite clear that he was impressed by the fact that Russian people, too, who had been illiterate peasants a few years before, were now, under Socialism, making vast contributions to the building of a new and more advanced society. Women too! In an interview published in the *Irish Workers' Voice,* February 23, 1935, just after his first visit to the Soviet Union, Robeson told the Dublin reporter that while "the development by the Soviet Government of the cultures of the formerly oppressed nationalities" won his greatest "admiration," he was also very impressed by the advances made by all Soviet workers. "The theatres and opera-houses [are] packed every night by workers. On the trams you see men and women studying works on science and mathematics." His visit to the Soviet Union had shown him how "Marxism was to co-ordinate a cultural sweep that was already amazing."

Later Stuckey asserts that Robeson had "not come by his socialism through the Soviets. His socialist views owed more to the influence of the British Labour Party than to Russia. It was through following developments on the labor front in England that his apprenticeship in socialism began in earnest."[58] It is interesting that in this meticulously footnoted article, there is no reference for this sweeping assertion.

Nor could there be. For Robeson never said that his views on socialism were fashioned by the British Labour Party; he stated that his interest in socialism and Marxism was kindled by his experience in England and by the British Labour Party. It was the Soviet Union that fully strengthened his interest in socialism, and it is significant that he began to study Marxism only after his first visit to the Soviet Union.

Stuckey also fails to see how Robeson's study of Marxism and his association with black Communists like William L. Patterson and Benjamin Davis, Jr., influenced his ideological development. Thus he fails to point out that it was his understanding of Marxism that led Robeson to advance from being a champion of African nationalist movements to advocacy of African national liberation movements— that is, movements concerned with the socio-economic content of political independence. Nor does he properly assess the effect of his experiences in Spain during the Civil War in that country. He views it as a "natural development, a logical extension of his broadening interest in the political and cultural condition of oppressed peoples of other lands."[59] True, of course. But in addition it is important to note that his experiences in the Soviet Union and Spain, along with his experiences with Welsh miners and London stevedores, influenced Robeson in reaching the conclusion that the black liberation move- ment in the United States and the colonial liberation struggle in Africa required the unity of black and white workers. His reading of Marxism and his relations with black Communists deepened and strengthened this conviction. But this is one aspect of Robeson's ideology Stuckey shies away from. For how could he analyze this important segment of Robeson's thought and state categorically: "Robeson's philosophy was on balance, for all his admiration for European socialism, vastly more non-western than the theoretical formulations of any black thinker of note to emerge in the New World in this and in the previous centuries."[60] It is not without significance that Stuckey ends his study with the beginning of the Cold War, and has not even a sentence on Robeson's writings and speeches during the entire decade of the 1950s.[61]

But the victory of the Vietnamese people, the triumph of Cuban Socialism, the liberation from colonialism and neo-colonialism of the people of Guinea-Bissau, Angola, and Mozambique, and the advances scored by black Americans since the 1960s, should teach even those who are reluctant to face facts, how true, how valid, how far in advance of his day, were the fundamental concepts voiced by Paul Robeson in his speeches and writings during the entire post-World War II era.

"That was an unusual man," C. L. R. James, author of *The Black Jacobins,* said of Robeson in 1970. "I've met a lot of people in many parts of the world and he remains, in my life, the most distinguished and remarkable of them all."[62] Exactly what kind of a man was Paul Robeson? In the words used by Mark Antony to epitomize Brutus, "the

elements so mix'd in him that Nature might stand up and say to all the world, 'This was a man!'"[63] Ossie Davis went further:

> Paul was a man and a half, and we have no category, even now, to hold the size of him. Something about him escapes our widest, most comprehensive embrace, and we've never been able to put our finger on exactly what it is. Athletic champion, yes; Phi Beta Kappa scholar, singer, actor, spokesman, activist, leader—yes! Africanist, socialist, black Nationalist—all that, too, but something more, something new, something different.
>
> Paul spoke 25 languages not as an exercise but as a source through which he could absorb the many cultures into which he had not been born, but to which he was instinctively determined to belong. He consumed a language for the cultural essences it contained, and became in practice, in custom, and in habit, a loyal member of all the groups whose songs he sang. He had studied many life styles till they became his by second nature, was himself transfigured by what he learned, and became by *accident* what socialist societies are meant to produce by design.
>
> It just may be that Paul is Socialist Man![64]

In a perceptive article entitled "Paul Robeson Revisited," which is mainly a review of the reissue of *Here I Stand* and which appeared in the *New York Times Book Review* of October 21, 1973, Sterling Stuckey wrote: "Until he is restored to his rightful place in the land of his birth, his treatment will represent in the future, as it has in the past, the single most striking example, in our time, of America's vulnerability on the question of human freedom." It is my hope and belief that PAUL ROBESON SPEAKS will help achieve this goal. But important as this is, there is still another function that I hope the present collection will perform, and that is to fill a gap in American historiography. For the truth is that in nearly all accounts of recent black history, the political activist Paul Robeson is a virtual nonperson. Thus, the multi-edited *Blacks in America: Bibliographical Essays,* published in 1971, has room only for works dealing with Paul Robeson as an actor and singer.[65] That he was also a forerunner of the black civil rights and Black Power movements of the 1960s is something readers of the work would never suspect. The same is true of Richard Kluger's *Simple Justice: The History of Brown v. Board of Education and Black America's Struggle for Equality,* published to wide acclaim in 1976. In the detailed analysis of the struggle of black Americans for equality in the 1940s and 1950s, leading up to the historic Supreme Court decision of 1954, in pages devoted to the campaign against lynching, the poll tax, segregation, to black victims of judicial frame-ups, and to other aspects of the civil rights movement, the name of Paul Robeson does not appear once. Nor, for that

matter, is there a single mention of the Civil Rights Congress, under the directorship of William L. Patterson, with which Robeson was associated—an organization which played an important role in the defense of victims of racism. It would be simple justice if, in a revised edition, the omissions were corrected.

The same may be said of *Black Protest in the Twentieth Century,* edited by August Meier, Eliott Rudwick, and Francis L. Broderick. These three scholars, one of whom (Broderick) is a black historian, could not find a page in the more than 650-page anthology for a single statement by Paul Robeson on critical issues facing black Americans in the late 1940s and the entire decade of the 1950s[66]—years during which, despite harassment and the blackout imposed by the government and the commercial press, Robeson continued to present the voice of black protest in speeches, articles, and interviews.

Even the 1971 article by Mark Solomon, "Black Critics of Colonialism and the Cold War," hostile though it is to the Cold War, treats Robeson casually, mentioning him only twice, and briefly. And the fine 1978 study by Mary Sperling McAuliffe, *Crisis on the Left: Cold War Politics and American Liberals, 1947-1954,* does not even mention Robeson.[67] Yet, as will be seen in this volume, Paul Robeson was in many ways the most important authentic voice of America in the era of the Cold War.

In his modesty, Paul Robeson said of himself: "I am only a folk-singer."[68] But as PAUL ROBESON SPEAKS makes abundantly clear, he was a great political thinker with a mind both original and profound, qualities further enhanced by a fine literary style. He wrote and spoke as he sang—in the words of Pablo Neruda in "Ode to Paul Robeson"—

> not only for Negroes,
> for the poor Negroes,
> but for the poor,
> whites,
> Indians,
> for all peoples.

Portrait, March 1938

A PAUL ROBESON CHRONOLOGY

With Eslanda, leaving England for Hollywood, March 5, 1933

A Paul Robeson Chronology

Read to class

1898

April 9—Paul Leroy Robeson born, youngest of five children of William Drew Robeson and Maria Louisa Bustill Robeson. In Princeton, New Jersey, where father is pastor of Witherspoon Street Presbyterian Church.

1904

Mother dies of burns in accidental household fire. Father raises family.

1906

Father loses ministerial post in church dispute, becomes coachman for southern college students.

1907

Family moves to Westfield, New Jersey, where Paul attends integrated public school.

1909

Family moves to Somerville, New Jersey, where Reverend Robeson has been appointed pastor of St. Thomas A. M. E. Zion Church.

1911

Paul enters Somerville High School, one of two blacks enrolled. Plays title role in Shakespeare's *Othello,* sings in glee club, and plays football—all in spite of principal's opposition.

1915

Takes competitive examination for four-year scholarship at Rutgers College, New Brunswick, New Jersey.

Graduates from Somerville High School as honor student at age of seventeen. Participates in statewide oratorical contest delivering "Toussaint L'Ouverture" by Wendell Phillips. Comes out third but learns he has won scholarship to Rutgers.

Summer—Works as waiter in Narragansett, Rhode Island, with brother Ben.

Fall—Enters Rutgers. Tries out for varsity football and meets racist hostility. Nose broken and right shoulder dislocated by players who don't want Negro on team. Returns to try-out after visit from brother and makes varsity.

1917

Walter Camp, foremost authority on football, lists Robeson first on roster of college stars. No official All-American team picked because of war.

1918

May 17—Father dies at age of seventy-three.

Chosen by Walter Camp for his All-American team.

Awarded (through 1919) twelve varsity letters in sports at Rutgers, including basketball, baseball, discus, shot put and javelin as well as football. Also elected member of both prestigious Phi Beta Kappa Society and Cap and Skull, honor society of Rutgers seniors.

1919

May 29—Submits senior thesis, "The Fourteenth Amendment, the Sleeping Giant of the American Constitution."

June—Wins Ann Van Nest Bussing Prize in Extempore Speaking.

June 10—Delivers graduating class oration, "The New Idealism," at Rutgers 153rd Commencement. Graduates with high honors and receives wide attention in New Jersey press for accomplishments in athletics and scholarship.

July—Moves to Harlem in New York City.

1920

February—Enters Columbia University Law School, working at odd jobs and playing some professional football to earn tuition money.

Makes acting debut playing lead role in *Simon the Cyrenian,* one of *Plays for a Negro Theater* by white poet Ridgely Torrence. Congratulated by members of Provincetown Players in audience at Harlem YMCA.

1921

August—Marries Eslanda Cardozo Goode, then studying chemistry at Columbia and soon to become first black woman to head a pathology laboratory. Eslanda, called Essie by her friends, is granddaughter of Francis L. Cardozo, distinguished black Secretary of State of South Carolina during Reconstruction.

1922

April—Plays role of African in Mary Hoyt Wiborg's play *Taboo.*

Summer—While still student at Columbia Law School, goes to England to appear in production of *Taboo* (renamed *Voodoo*) with Mrs. Patrick Campbell. Meets Lawrence Brown at Regents Park Road flat of John Payne, American Negro singer. Tours British provinces with Mrs. Campbell.

1923

Spring—Graduates from Columbia Law School, and seeks work in law firms. Meanwhile works as singer in Harlem's famed Cotton Club.

1924

Offered lead in two plays by Eugene O'Neill—*All God's Chillun Got Wings* and revival of *The Emperor Jones.* Accepts roles, having quit position at downtown law firm because secretary refused to take dictation from him.

May 5—Threatened by Ku Klux Klan if he appears in *All God's Chillun,* in which a white woman will kiss his hand.

May 15—Opens in *All God's Chillun* in role of Jim Harris and is immediate success.

June—Stars in *Rosanne* in Philadelphia.

Fall—Makes silent movie *Body and Soul* for Oscar Michaux, independent black film-maker.

1925

Stars in *The Emperor Jones* as Brutus Jones, role made famous by Charles Gilpin. Alternates with playing in *All God's Chillun.*

March—Goes with Lawrence Brown to Greenwich Village home of James Light, director of Provincetown Players. Sings arrangement of Negro spirituals by Brown; Light suggests a concert.

April 19—Gives concert with Lawrence Brown, made up solely of Negro music—three groups of spirituals and one group of secular and dialect songs. Concert is resounding success and brings Negro spirituals to prominent place in music world.

September 11—Opens in *The Emperor Jones* in London to critical acclaim.

October—Victor Records advertises recording of Negro spirituals.

1926

January 5—Launches tour with Lawrence Brown under auspices of James B. Pond, singing Negro spirituals to packed audiences across U. S.

March 3—Tribute by Elizabeth S. Sergeant appears in *New Republic.*

October 6—Opens in *Black Boy* in New York to rave reviews for performance though play about black prizefighter is not well received.

1927

October—Returns to Europe to give concerts with Lawrence Brown.

November 2—Son Paul, Jr., (called Pauli), born in New York.

Voted in "All Time All-American College Eleven."

Included in books about famous Americans and famous Negroes such as Mary White Ovington's *Portrait in Color.*

1928

March—Plays role of Crown in *Porgy,* play by DuBose and Dorothy Heyward, replacing Jack Carter.

April—Opens in *Show Boat* by Jerome Kern and Oscar Hammerstein 2nd, and becomes overnight sensation singing "Ol' Man River."

April—Gives recital with Lawrence Brown at Albert Hall in London. Also sings spirituals at Sunday afternoon concerts at Drury Lane.

September 29—*New Yorker* magazine publishes "Profile of Robeson" by Mildred Gilman in which he is called "the promise of his race," "King of Harlem," and "idol of his people."

1929

Tours Central Europe and the British provinces. Despite invitations by top London society, encounters racial discrimination and is refused admission to London hotels (through 1930). Creates furor and major hotels state they will not refuse admission or service to Negroes.

November 5—Returns to U.S. to sing at jammed Carnegie Hall.

1930

May 29—Opens to great acclaim in role of Moor in Shakespeare's *Othello* at Savoy Theatre in London and has twenty curtain calls. Is first American Negro since Ira Aldridge to play role.

June—Performs in *The Emperor Jones* in Berlin.

Philadelphia Art Alliance refuses permission to display Tony Salemme statue of nude Robeson in Rittenhouse Square.

Appears in film *Borderline* with Eslanda, made in Switzerland.

First biography, *Paul Robeson, Negro* by Eslanda Goode Robeson, published in New York by Harper & Brothers.

Head sculpted by Jacob Epstein, leading British sculptor.

Appears in British *Who's Who* (never listed in *Who's Who in America*).

Separates temporarily from Eslanda and they live apart.

1931

May 11—Opens in *The Hairy Ape* by Eugene O'Neill at Ambassador Theatre in London.

1932

Receives Honorary Master's Degree from Rutgers University.

Eslanda plans to sue for divorce, but problems are resolved and couple is reunited.

1933

May—Returns to New York to star in movie of *The Emperor Jones.*

August—Returns to England and studies singing and languages. Becomes acquainted with African students in London, among them Kwame Nkrumah and Jomo Kenyatta. Paul and Essie made honorary members of West African Students' Union.

August—Plays benefit of *All God's Chillun* for Jewish refugees at urging of Marie Seton, British writer who is later to write biography of him. In retrospect Robeson is to state that this benefit marked the beginning of his political awareness.

September—Asked to speak at Socialist Club of Cambridge University.

1934

May—Plays role of Bosambo, a tribal chief, in film version of Edgar Wallace's *Sanders of the River.* Is enraged by addition to film, without his knowledge, of scenes praising British colonialism.

Extends repertoire beyond Negro spirituals to include Mexican, Scottish, and Russian songs. Continues to study languages and eventually masters 25, from Chinese to Arabic.

Alexander Woollcott, well-known essayist and raconteur, extols Robeson in *While Rome Burns.* In chapter called "Colossal Bronze" Woollcott says: "Of the countless people I have known in my wanderings over the world, he is one of the few of whom I would say that they have greatness . . . by what he does, thinks and is, by his unassailable dignity, and his serene, incorruptible simplicity, Paul Robeson strikes me as having been made out of the original stuff of the world. In this sense he is coeval with Adam and the redwood trees of California. He is a fresh act, a fresh gesture, a fresh effort of creation."

Takes course at London School of Oriental Languages and starts studying West and East Coast African languages.

Invited to Soviet Union to discuss with Sergei Eisenstein making film, *Black Majesty,* dealing with rebellion leading up to establishment of Haiti. En route to Soviet Union with Essie and Marie Seton, has chilling experience in Nazi Germany when they are threatened by Storm Troopers. At entrance to Soviet Union, officials at first refuse to allow party to cross border because

visas are not in order, but recognize Robeson from his voice and enthusiastical-
ly allow them to enter.

In Moscow, meets William L. Patterson, black lawyer, who tells him of
struggle involving Scottsboro Boys in U.S. and urges him to return home to
help in fight for Negro causes.

Has discussions with Eisenstein. Is deeply impressed by fact that all
schoolchildren in Soviet Union are educated against racism. *Black Majesty* not
produced, but Robeson determines to return annually.

Goes back to London to continue work in films and theatre. Begins study
of writings on Marxism and socialist system in the Soviet Union.

1935

May 9—Opens in *Stevedore,* play on black-white labor unity by Paul
Peters and George Sklar which had appeared in New York in 1934 under
auspices of Theatre Union.

September 25—Sails for United States to make film of *Show Boat.*

1936

Receives rave reviews for singing of "Ol' Man River" in *Show Boat.*

March—Performs role of Toussaint L'Ouverture in play by C. L. R.
James.

August—Appears in *The Song of Freedom,* film about Africa which he
feels is first true one he has done about that continent. It portrays a black
singer who, after discovering his aristocratic African origins, returns to take
over leadership of his people.

September—Films *King Solomon's Mines,* based on book by H. Rider
Haggard.

December (through January 1937)—Visits Soviet Asia and Caucasus
and is deeply impressed by great progress made by so-called backward people
in these areas, especially racial minorities.

December 31—*New York Times* reports from Moscow that Robeson will
place his nine-year-old son in school there "instead of America so the boy need
not contend with discrimination because of color until he is older and his
father can be with him."

1937

Co-founder (with Max Yergan) and chairman of Council on African
Affairs, formed to aid national liberation struggles in Africa.

January—Stars in *Big Fella,* film based on Claude McKay's novel *Banjo.*

February—Plays in film entitled *Jericho* (released in U.S. as *Dark
Sands*), about an American soldier, Jericho Jackson, who remains in Africa
after World War I. Goes to Egypt for shooting, his first visit to Africa.

May—*Song of Freedom* opens and receives praise even from previously
critical American Negro press.

June 24—Sings and speaks at benefit concert for Basque refugees at
Albert Hall in London. Declaring stand on side of Republican Spain, states:
"The artist must elect to fight for freedom or slavery. I have made my choice. I
had no alternative."

August-September—Sings at numerous concerts for Spanish Republican
cause.

October—Polls first place as singer most popular with British radio
listeners. Announces intention of retiring from commercial entertainment.

December 19—At rally in support of "arms, food and justice for demo-

cratic Spain," changes words of "Ol' Man River" from "I'm tired of livin' and feared of dyin'" to "I must keep fightin' until I'm dyin'."

To reach working-class and less affluent audience, starts singing in large music halls and cinemas in provinces, with admission prices from 6d.

1938

January 23—Goes to Madrid to sing in hospitals for troops of International Brigade.

February—Returning from Spain, announces intention to produce film in which he would play Oliver Law, a Negro commander of the Lincoln Battalion in the International Brigade, who was killed in battle. Film never produced.

June—Appears in *Plant in the Sun,* a play by Ben Bengal dealing with sit-down strikes and union organizing in U.S., produced by Unity Theatre under auspices of British Labour Party.

June—Sings for International Peace Campaign, and for Memorial Meeting for Welsh members of International Brigade in Spain.

November—After almost two years of refusing roles from major film companies, announces he will play in *Proud Valley,* film being produced by small independent company, Ealing Studios, about life of Welsh miners.

1939

January—Sings at great mass meeting at Empress Hall in London to greet survivors of two British battalions that had fought for Republican Spain.

June 3—Returns to U.S. and appears in short run of revival of *The Emperor Jones.*

July 1—Gives first song recital after return at Mother A. M. E. Church in Harlem where brother Reverend Benjamin Robeson is pastor.

August—Refuses to open in *John Henry* in Washington, D.C., because theater is segregated. Opens in New York instead.

October—Arriving for tea to which he has been invited at leading New York City hotel, is told to use freight elevator.

October 27—Signs contract with Columbia Artists for role in *Ballad for Americans,* based on *The Ballad of Uncle Sam* by John Latouche (renamed by Norman Corwin), with music by Earl Robinson.

November 5—Premiere on CBS Radio of *Ballad for Americans* with Earl Robinson's American People's Chorus leads to greatest audience response since Orson Welles' famous Martian scare program. Studio audience cheers for twenty minutes after performance.

Through 1942—Crosses country many times, appearing at regularly scheduled concerts, except in deep South or before segregated audiences.

1940

January—Criticized by some newspapers for refusal to participate in fund-raising affair for Finns in Russo-Finnish War.

February—Appears in twenty-minute opera version of *The Emperor Jones* by Louis Gruenberg with Eugene Ormandy and Philadelphia Orchestra.

March—Buys house, "The Beeches," in Enfield, Connecticut, after inquiries show there will be no difficulties with neighbors.

Receives honorary degree from Hamilton College.

July—Refused service in fashionable San Francisco restaurant; sues owner for $22,500 under California Civil Code barring discrimination in public places on basis of race or color.

July 23—Sings *Ballad for Americans* to 30,000 people jamming Hollywood Bowl in Los Angeles.

August—Called by *Collier's* magazine "the favorite male Negro singer" of concertgoers and "America's No. 1 Negro entertainer."

September—Appears with pianist Hazel Scott and novelist Richard Wright at benefit for Negro Playwrights Company before 5,000 people at Golden Gate Ballroom in Harlem.

Active throughout year in Committee to Aid China, Joint Anti-Fascist Refugee Committee to Aid Spanish Refugees, and Council on African Affairs.

1941

May 19—Speaks at United Auto Workers rally in downtown Detroit to aid Ford organizing campaign.

July 7—Made honorary member of National Maritime Union.

September 29—Sings and speaks at rally of Citizens Committee to Free Earl Browder, head of American Communist Party, before 20,000 at Madison Square Garden.

1942

Devotes time and talent to war effort, touring war plants, performing at War Bond rallies, and recording programs for American and Allied soldiers. Gives recitals, many at no fee, for such groups as Washington Committee for Aid to China, Russian War Relief, Ford Workers Victory Chorus, Labor Victory Rally at Yankee Stadium, Concert for Negro Soldiers.

February 20—Headline in *Kansas City Call* reads, "Paul Robeson Stops in Middle of Concert to Protest Municipal Auditorium Jim-Crow. Famous Baritone Blasts Segregation in Public Building." Has discovered he is singing before segregated Kansas City audience and announces before second half of program that he is continuing only under protest.

March 7—Speaks at Bethel A. M. E. Church at St. Antoine and Kirby in Detroit on behalf of black families of Sojourner Truth Housing Project at request of Sojourner Truth Citizens Committee. Urges fighting back against Ku Klux Klan elements.

April 8—Addresses mass meeting in New York City's Manhattan Center called to "mobilize Negro and colonial people in the fight against Fascism".

May—Narrates documentary film *Native Land,* dealing with 1938 findings of La Follette-Thomas Senate Civil Liberties Committee supporting union organizing.

May—Addressing Yankee Stadium meeting of 51,000 workers, calls for second front to shorten war.

June—Appears at Lewisohn Stadium, New York City, at Interracial War Bond Rally.

August 10—Opens in his first U.S. *Othello* at Brattle Hall in Cambridge, Massachusetts, under direction of Margaret Webster.

August—In last commercial film, appears with Ethel Waters as sharecropper in final episode of *Tales of Manhattan,* six stories connected through travels of a dress coat.

September 15—Speaks and sings for workers at Englewood, California, plant of North American Aircraft at invitation of Local 887, UAW-CIO.

September 18—At Los Angeles press conference, praises CIO unions for being "in the forefront of the fight to smash barriers of social discrimination in hiring. . . ."

Earl Schenck Miers publishes novel *Big Ben,* based on life of Robeson.

1943

January—Receives Abraham Lincoln Medal for notable and distinguished service in human relations in New York.

June 2—Receives honorary degree of Doctor of Humane Letters from Morehouse College, Atlanta, Georgia.

June 7—Speaks and sings at Negro Freedom Rally at Madison Square Garden.

October—Opens on Broadway in Theatre Guild production of *Othello* to tremendous critical and audience acclaim.

November 12—Honorary lifetime membership in International Longshoremen's and Warehousemen's Union conferred by union president Harry Bridges after action by convention.

November 16—Speaks as chairman of Council on African Affairs at first session of New York *Herald-Tribune* Forum on Current Problems.

December 3—As part of Negro delegation, presents plea for removal of ban against Negroes in major leagues at Hotel Roosevelt in New York before Baseball Commissioner Kenesaw Mountain Landis and league officials.

1944

January—Made honorary member of State, County and Municipal Workers of America, CIO.

March—Cancels recital in Baltimore because Lyric Theatre is refused for unsegregated audience.

April—7,000 persons attend 46th birthday party at 17th Regiment Armory in New York City given by Council on African Affairs.

April 14—Chairs Conference on "Africa—New Perspectives," under auspices of Council on African Affairs.

May—Jerome Beatty, in article "America's No. 1 Negro" appearing in *American Magazine,* says: "Paul Robeson broke the back of prejudice to command recognition as a football star, lawyer, concert singer, and actor. Today he has won top triumphs for his magnificent portrayal of Shakespeare's Othello."

May 8—State, County and Municipal Workers, CIO, establish Paul Robeson Scholarship Fund at New York University to train black students in business management.

May 19—Receives Medal for Good Diction on the Stage from American Academy of Arts and Letters.

June 30—*Othello* closes in New York after record run of 296 performances and 494,839 paid admissions.

July 4—Receives *Billboard's* first annual Donaldson Award for Outstanding Lead Performance for role in *Othello.*

September—Begins cross-country tour of *Othello,* with Southern states omitted except for Negro colleges and unsegregated audiences.

1945

April 25—Ends 45-city tour in Chicago, where *Othello* opens for month's run at Erlanger Theatre.

June—Receives Doctor of Humane Letters honorary degree from Howard University, Washington, D.C.

June 25—Speaks at Madison Square Garden Rally for a Permanent Fair Employment Practices Committee (FEPC), against poll tax, and for elimination of other obstacles toward equality for Negro people.

August—Goes to Europe as part of first racially-mixed overseas USO-sponsored camp show for troops, accompanied by Lawrence Brown and violinist Miriam Solovieff. Sings for troops in Germany, France, and Czechoslovakia. Is deeply moved and upset by visits to Nazi concentration camps, also disturbed by growing hostility to Soviet Union in Allied High Command.

October—Awarded NAACP Spingarn Medal, highest honor given each year to a black man.

November 25—Addressing Central Conference of American Rabbis, declares that United States has taken over role of Hitler, and now "stands for counter-revolution all over the world." Urges United States to share secrets of atomic bomb with Soviet Union, predicting it would be "the greatest guarantee against another war."

1946

January 7—Appears with Marian Anderson at rally for South African famine relief held under auspices of Council on African Affairs at Abyssinian Baptist Church in Harlem.

June 6—Speaks at mass meeting "for African freedom" at Madison Square Garden sponsored by Council on African Affairs.

July 17—Marches on picket line in support of Dodge workers' strike in Windsor, Ontario.

September—Joins in sponsoring Crusade Against Lynching, representing coalition of some 50 organizations. As delegate to Washington, asks President Harry F. Truman to issue "formal public statement" that would make clear his views on lynching, and urges him to establish a "definite legislative and educational program to end the disgrace of mob violence." Addresses mass meeting and speaks on radio against lynching.

October—Elected vice-president of Civil Rights Congress of which William L. Patterson is executive secretary.

October 7—Appears before California Legislative Committee on Un-American Activities (Tenney Committee) as co-chairman of National Committee to Win the Peace. Asked if he is member of Communist Party, says he is not but praises Communists as fighters for democracy and declares "I characterize myself as an Anti-Fascist."

October 10—Speaks at waterfront strike meeting in San Francisco under auspices of Committee for Maritime Unity, as co-chairman of National Committee to Win the Peace.

1947

January—Testimonial dinner in Robeson's honor sponsored by Local 600, UAW (Ford Motor Company local), in Detroit.

January—Stands on picket line in St. Louis to protest segregation of Negroes in American theater.

March—After singing "Joe Hill" by Alfred Hayes and Earl Robinson at University of Utah, Salt Lake City—the city where Joe Hill was executed in 1915—announces, "You have just heard my final concert for at least two years, and perhaps for many more. I'm retiring here and now from concert work. I shall sing now for my trade union and college friends. In other words, only at gatherings where I can sing what I please."

April 3—Prevented from appearing in Peoria, Illinois, when Shriners cancel contract for use of Shriner Mosque and mayor refuses to allow use of City Hall for concert.

May 9—Board of Education of Albany, New York, denies permission for

Robeson concert at Philip Livingston Junior High School. Supreme Court Justice Isadore Bookstein orders school be made available and concert is held.

June—Gives four concerts in Panama for United Public Workers of America, CIO, who are trying to unionize Panamanian workers, predominantly blacks. Ten thousand turn out.

June 29—Speaks for Local 22, Food and Tobacco Workers, mainly blacks, in Winston-Salem, North Carolina.

September 22—Speaks at National Maritime Union convention, last to which he is invited, as union leadership under Joseph Curran turns anti-Communist and supports Cold War.

October—Receives award from Artists, Writers, and Printing Workers Congress of Bucharest, Rumania.

December 20—Announces support of Henry A. Wallace as independent candidate for President of the United States in opposition to Cold War policies of Truman Administration. Later attends meeting to form Wallace for President Committee out of which emerges Progressive Party.

1948

January 1—James Hicks, editor of *Amsterdam News,* tears up negative of photograph of Robeson shaking hands with Ralph Bunche at New Year's assembly at Renaissance Ballroom in Harlem so that Bunche will not be compromised politically by having picture published. (Later, in the 1960s, Hicks admits that Robeson was saying what the Negroes as a group would not begin saying for another five years, not saying loudly for another decade.)

February-March—Max Yergan, secretary of Council on African Affairs, tries to align Council with American Cold War policies and is forced out, but charges Communist domination of Council.

March—Transport Workers' Union for first time in ten years withdraws invitation to have Robeson attend its convention despite his honorary life membership.

March—Tours Hawaiian Islands for International Longshoremens' and Warehousemens' Union accompanied by Lawrence Brown and Earl Robinson.

April—West Virginia authorities ban *Paul Robeson: Citizen of the World,* a young people's biography by Shirley Graham, from public libraries.

April—At meeting held in Chicago to form Progressive Party, is proposed for Vice-President but refuses.

April-July—Barnstorms for Progressive Party and its presidential candidate, Henry A. Wallace.

May-September—Seeks appointment with President Truman to confer on anti-poll tax, anti-lynching, and fair employment legislation but repeated requests rejected.

June—Appears before U.S. Senate Committee holding hearings on Mundt-Nixon Bill drafted by House Un-American Activities Committee which calls for registering of Communist Party members and "Communist Front" organizations. Opposes measure as violating rights of American citizens. When asked if he would fight in a war with Soviet Union, replies, "That would depend on conditions." Also refuses to answer question as to Communist Party membership.

June 23—Speaking at Manhattan Center dinner sponsored by *Masses & Mainstream* magazine, urges all artists and writers to oppose Mundt-Nixon Bill. (Bill is not brought to vote in Senate.)

July—At Progressive Party convention in Philadelphia, which nominates Henry A. Wallace for President and Senator Glen H. Taylor for

Vice-President, pledges to help ticket with all his power. In course of speech says: "What mockery! Our high standard of living for a minority in the richest country of the earth! Absentee ownership still rules supreme. One per cent of the population owns as much wealth as one-third of the ill-housed, ill-fed whom Roosevelt so feelingly described. The spectacle of the Pews and Grundys, the Sullivans and Dulles' in full view on the Republican side, and the Du Ponts, House of Morgan, Dillon-Reed, Forrestal on the Democratic side shows the contempt of big business barons for the great majority of the American people."

July-August—Touring South with Henry Wallace, is threatened with lynching but speaks out for racial equality.

November—Election results disappointing to Wallace supporters, but continues to support Progressive Party and its program against Cold War and for rights of labor and minorities. (In 1950 Wallace leaves Progressive Party, and voices regret for having criticized Truman on Cold War.)

1949

January 28—Tells protest meeting called by newly organized Negro Youth Builders Institute, Inc., that "the suppression of the Negro in the United States varies only in degree in New York, New Jersey, Georgia and Alabama," that the public must be "aroused" to poor school conditions in Harlem and Brooklyn, inadequate housing, "police brutality in the North, generally," which would include "the railroading to the electric chair of six Negro youths in New Jersey (the Trenton Six)." Comparing what he terms "children in cotton fields in the South, children on tobacco plantations and exploited children all over," with the "neglected children of the North," says conditions are "of the same pattern—evidence of a colored minority in a hostile white world."

February—Starts concert tour in England.

March 25—Leads protest against racist policies of South African government organized by South African Committee of India League in cooperation with League of Coloured Peoples, West African Students Union, and East Africans Students' Union, attended by 3,000 at Friend's House, London.

April 20—At World Congress of Partisans of Peace in Paris, with delegates from 60 countries including Dr. W. E. B. Du Bois from the United States, delivers speech in which he says, "It is unthinkable that American Negroes will go to war in behalf of those who have oppressed us for generations . . . against a country [the Soviet Union] which in one generation has raised our people to full human dignity of mankind." Speech is distorted and quotation reported out of context by news reporters in dispatches to their papers in the U.S.

April 23—Chairman of State Development Commission of Connecticut requests that State Police Commissioner keep Robeson out of Connecticut if he should try to visit his home in Enfield, but request is denied.

April 30—Walter White, Executive Secretary of NAACP, attacks Robeson for Paris speech.

May—Visits Poland's Warsaw Ghetto, which makes deep impression.

June 14-16—Three-part series, "Two Worlds," published in *Komsomolskaia Pravda,* Journal of Communist Youth in USSR. In "First Joy," he describes impressions of first visits to Soviet Union in 1934 and 1936. In "My Name Is Robeson," relates some episodes of his life. In "Ten Years of Struggle," talks of fight for peace, against war, and for better life for American people.

June 16—Returning to New York from four month tour of Europe and Soviet Union, calls trial of eleven Communist leaders "a type of domestic fascism" and denounces Wall Street's "war policy."

June 19—Speaks to 5,000 New Yorkers at Welcome Home Rally held at Rockland Palace in Harlem under auspices of Council on African Affairs.

June 19—Paul Robeson, Jr., is married to Marilyn Paula Greenberg, a white student also studying at Cornell.

June 27—*Time* magazine publishes interview in which he praises beauty of Moscow, is confident from Soviet experience that Africans will liberate themselves in near future, and emphasizes "that the Negro people must come to identify themselves with the workers. . . ."

June 29—Speaks at protest rally in Madison Square Garden held by Civil Rights Congress.

July 13–14—Negro spokesmen testifying before House Un-American Activities Committee declare Robeson did not speak for his race at Paris. Witnesses include Manning Johnson, who testifies Robeson dreamed of becoming a "Black Stalin" but is so incoherent even reporters concede he has said nothing truly meaningful. NAACP announces it opposes hearings.

July 18—Jackie Robinson, first Negro major league baseball player, tells Committee that Robeson's statement in Paris sounded "very silly to me," but also says U.S. Negroes "were stirred up long before there was a Communist Party and they'll stay stirred up long after the party has disappeared—unless Jim Crow has disappeared by then."

July—Baltimore *Afro-American,* one of America's leading black newspapers, advises Jackie Robinson to stick to baseball and stay out of politics.

August 4—Pickets White House with members of CIO United Public Workers to protest employment discrimination by Bureau of Engraving and Printing.

August 27—Peekskill riots begin when Robeson concert is attacked and Robeson prevented from singing as many in audience are injured by rock throwers. Robeson announces, "I'm going to sing wherever the people want me to sing. My people and I won't be frightened by crosses burning in Peekskill or anywhere else."

August 28—Jackie Robinson bitterly attacks Peekskill riot in interview in Brooklyn Dodgers dugout.

September 4—Second concert held successfully but turned into nightmare as lawlessness breaking out after concert results in injuries to at least 140 persons, some serious, while state troopers either do nothing to prevent attacks or, in some instances, encourage mob. Robeson denounces attack as "fascist."

September 9—Cancels trip to Mexico City Continental Congress for Peace. Eslanda Robeson speaks instead to 1,000 delegates.

September 12—National Maritime Union convention considers motion that name be stricken from union's honorary membership list; motion withdrawn.

September 20—All-China Art and Literature Workers Association and All-China Association of Musicians of Liberated China protest Peekskill attack on Robeson.

September 20—Appears at trial of eleven Communist leaders but is barred from saying anything other than that he knows the defendants.

September 25—Starts singing and speaking tour sponsored by Council on African Affairs, often at considerable personal risk since American Legion and Veterans of Foreign Wars picket concerts and stir up crowds.

October—Soviet Union names Mount Robeson in his honor.

November 10—Speaks out in favor of peaceful relations with Soviet Union at banquet sponsored by National Council of American-Soviet Friendship at Waldorf-Astoria Hotel in New York City.

1950

February—Visits Chicago for meeting of Progressive Party leadership.

March 13—NBC bars appearance on Mrs. Franklin D. Roosevelt's TV program scheduled for March 19. Charles R. Denny, NBC Executive Vice-President, declares "no good purpose would be served in having him speak on issue of Negro politics."

May 6—Selection announced for *Afro-American* 1950 National Honor Roll, sponsored by Afro-American Newspapers. Citation reads: "Actor, singer extraordinary, who has chosen to leave these peaceful arts in which he gained fame in order to throw himself into the political fight in which he hopes to win human dignity and equality for the common people."

May 27—In *Nation* article, Earl Schenck Miers writes: "As a product of his times, Robeson today is perhaps more All-American than he was as member of his college."

June 10—Speech to meeting of National Labor Conference for Negro Rights, attended by 900 delegates in Chicago, later published as pamphlet entitled *Forge Negro-Labor Unity for Peace and Jobs.*

June 28—Speaks out against U.S. participation in Korean War.

July 28—On advice of attorneys, refuses to hand over passport as demanded by agents of State Department. At the time had completed arrangements for trip to Europe to attend several meetings and to fulfill speaking engagements in a number of countries, as well as to give several concerts in Italy and England and to make recordings.

August 1—Robeson's lawyers write to State Department asking for explanation of order.

August 7—Chief of Passport Division replies: "The action was taken because the Department considers that Paul Robeson's travel abroad at this time would be contrary to the best interests of the United States."

August 28—Visits State Department and demands to see Secretary of State Dean Acheson. Offered passport back if he will sign statement that he will not make any speeches while abroad. Refuses.

August 29—Madison Square Garden refused to Council on African Affairs for rally.

September—Convention People's Party in Ghana selects Robeson's films, *King Solomon's Mines, Jericho,* and *Native Land* for showing on occasion of second Anniversary.

October 11—Mayor James B. Hynes bans exhibition of Robeson's portrait anywhere in Boston.

November—First column in Robeson's monthly newspaper, *Freedom,* appears. (Paper continues publication in Harlem with column, "Here's My Story," appearing in most issues until August 1955.)

December 19—Sues Secretary of State Dean Acheson in Washington, D.C., to prevent cancellation of passport.

1951

January 31—Is sponsor with Thomas Mann and others of "American Peace Crusade," which issues statement in New York announcing a "Peace Pilgrimage" to Washington on March 1.

☆ February—Walter White, NAACP executive secretary, bitterly attacks Robeson in *Ebony* in article entitled "The Strange Case of Paul Robeson."

April 20—U.S. District Court for District of Columbia rules against Robeson by asserting it has no power to act in his case, but also denies government's motion that he be compelled to turn in canceled passport. (In the summer, Paul Jr.'s application for passport to attend 1951 Youth Festival in Berlin is denied.)

June 29-July 1—Speaking at "American Peoples Congress for Peace" before 7,000 people in Chicago, criticizes U.S. action in Korea.

August 16—Appeals April dismissal of passport suit.

November 5—Addresses opening session of Conference for Equal Rights for Negroes in the Arts, Sciences, and Professions held in New York City.

November 15—With Soviet Ambassador Alexander S. Panyushkin and Corliss Lamont, addresses "world peace rally" sponsored by National Council of American-Soviet Friendship in New York City.

November—*The Crisis*, official organ of NAACP, publishes "Paul Robeson—The Lost Shepherd" by "Robert Alan." (Later revealed that article resulted from request from U. S. Vice Consul in Accra, Ghana, for special story to lessen Robeson's influence in Africa.)

December 17—Heads New York delegation presenting petition to UN by Civil Rights Congress charging genocide against Negroes of United States on ground that "15 million black Americans are mostly subjected to conditions making for premature death, poverty, and disease."

1952

January 31—Attempts to cross American border to Canada, where he has been invited to speak to meeting of Mine, Mill and Smelter Workers' Union in Vancouver, B. C., but is advised by State Department representative that if he leaves United States, he will be subject to five years' imprisonment and $10,000 fine. Speaks and sings to meeting by telephone from Seattle.

April 6-June 2—Makes birthday tour to raise $50,000 to aid National Negro Labor Council, Council on African Affairs, and *Freedom*.

May 16—Senior Bishop William J. Walls of AME Zion Church, at 34th quadrennial conference, comes out for return of Robeson's passport.

May 18—Sings to estimated 40,000 listeners at Peace Arch Park on U.S.-Canadian border.

October 15—Becomes vice-chairman of newly-created Peace Liaison Committee for Asian and Pacific Peace chaired by Madame Sun Yat Sen.

November 11–18—Civic and "patriotic" groups protest Hartford, Connecticut, concerts scheduled as part of People's Party presentation at public school.

December 22—Awarded 1952 Stalin Peace Prize.

December—Othello Recording Corporation issues album "Robeson Sings," which includes "Wandering," "Four Rivers," "Witness," "My Curly-Headed Baby," "Night" (in Russian and English), and "Hassidic Chant." With recording companies refusing to issue his records or record new ones and all concert halls, theaters, etc., closed to him, Robeson, who had been listed among top ten highest paid concert artists of 1941, sees his income dwindle from a high of over $100,000 in 1947 to about $6,000 in 1952.

December—Concert scheduled in Chicago is called off because mortgage holders on church where it is to be held threaten that if he sings, they will demand immediate payment or foreclose. Some Negroes holding federal jobs have been threatened with firing if they attended.

1953

January—*First Book of Negroes—A child's history of the Negro,* by Langston Hughes, published by Franklin Watts, does not mention either Paul Robeson or W. E. B. Du Bois.

January 29—National Church of Nigeria names Robeson "Champion of African Freedom." Award granted for "selfless service to Africa."

February 11—Joins with six others in appeal to parole board for freedom of Benjamin J. Davis, black Communist imprisoned under Smith Act.

April—Sings and speaks to 6,000 in Detroit at Sacred Cross Baptist Church under sponsorship of Freedom Associates of Detroit.

April 13—Issues statement urging protest against jailing of black leaders in Kenya.

May 23—Sings at religious concert at Calvary Baptist Church in Detroit sponsored by Mrs. Vera Smith, chairperson of the Church's Evangelistic Commission.

May 31—Begins second nation-wide concert tour with appearance at Greater St. Peter's Baptist Church in Detroit. Sponsored by Freedom Associates, tour spans five months and takes him to West and Deep South.

August—Applies for passport to travel to England, France, Norway, Sweden, and Denmark. Request denied by Passport Office.

July 5—Sings at concert in Washington Park, Chicago, before 25,000 under auspices of Freedom Associates of Chicago.

September 23—Presented with 1952 Stalin Peace Prize by Dr. W. E. B. Du Bois at ceremonies at New York's Theresa Hotel.

December—Sells home in Connecticut.

1954

June 1—All-India Peace Council circulates plea for return of passport.

November 27—Denied passport to attend Soviet Congress of Writers Conference in Moscow.

1955

March—Gives two sold-out concerts in auditorium of First Unitarian Church of Los Angeles.

April—Sends message to Asian-African Conference in Bandung, Indonesia.

April 30—Sings and talks at Swarthmore College, Pennsylvania, under sponsorship of Forum for Free Speech.

June—Council on African Affairs disbanded because "continuing Government harassment made it work impossible."

July 10—Pays farewell tribute to Leslie McFarland, Negro member active in work of International Longshoremen's and Warehousemen's Union in Oakland, California.

August 16—Federal Judge Bunita S. Matthews refuses to order State Department to issue passport to Robeson. Implies one can be issued if he signs non-Communist oath. Robeson refuses.

1956

February 18—Sings in Massey Hall, Toronto, to packed audience.

March 11—Taped message read to "Let Paul Robeson Sing" meeting at Lesser Free Trade Hall in Manchester, England.

July 13—Appears before House Un-American Activities Committee and tells them, "You are the Un-Americans."

November—Name omitted from 1956 edition of *College Football and All-American* list of players on 1918 Walter Camp All-American team.

1957

April 28—British Actor's Equity Association votes to "make representation in whatever quarters may have influence in allowing him (Robeson) to perform in this country."

May 4—*Manchester Guardian* reports letter signed by 27 members of Parliament and British Actors' Equity Association joining campaign to invite Robeson to England to sing.

May 17—Appears at Prayer Pilgrimage for Negro rights in Washington, D. C., celebrating court desegregation decision of 1954.

May 26—Sings on new co-axial cable to audience of 1,000 in England at conference sponsored by National "Let Paul Robeson Sing" Committee. *Manchester Guardian* reports: "American Telephone & Telegraph and the General Post Office in London last night helped Paul Robeson make the U.S. Department of State look rather silly."

August 1—Robeson Comeback Concert at Third Baptist Church in San Francisco packed.

September 23—Urges U.S. government to defend Constitution against racists in Little Rock, Arkansas.

October—Quoted by Carl Rowan in *Ebony* magazine article, "Has Paul Robeson Betrayed the Negro?" as saying: "I am honestly convinced that China and Ghana would not be free today, that Negroes in Montgomery would not be so near freedom, had the Communists not come to power in Russia."

December—Invited by Welsh miners to be honored guest at 1957 Eisteddfod. Appeal to Supreme Court for passport turned down, but is able via trans-Atlantic hookup between New York and Porthcawl, Wales, to sing on schedule.

1958

February 7—Delivers Negro History Week Oration before Local 6 of International Longshoremen's and Warehousemen's Union.

March 17—Ambassador Ellsworth Bunker of American Embassy in New Delhi, India, informs U.S. State Department that Prime Minister Nehru's daughter, Indira Ghandi, is organizing national committee to sponsor a "Paul Robeson Day" in Delhi. State Department fails in frantic effort to prevent celebration of Robeson's birthday in India.

March 30—American Actors' Equity Association, a year after British Actors' Equity Association, passes resolution to consider assisting Robeson in passport fight.

April 9—60th birthday celebrated in Berlin, German Democratic Republic, in Moscow, in Peking, and in many African nations.

May 10—Gives first New York concert in ten years at sold-out Carnegie Hall. At end tells cheering audience passport battle has been won. Critics acclaim his singing.

June 25—Announces plans for trip to London and concerts in Prague, Berlin, and Soviet Union, but makes it clear he is not "deserting the country of my birth."

July 11—Arrives in London, and signs for TV concert series.

August 4—Sings in National Eisteddfod in Ebbw Vale, Wales.

August 15—Hailed in Moscow and begins Soviet tour.

August 17—Appears on Moscow TV.

August 18—Sings at Moscow sports palace.

August 26—With Premier Nikita Khrushchev near Yalta in Crimea.

August—*Here I Stand* published: London, Dennis Dobson; New York, Othello Associates; Bucharest, Editura Politica; Berlin, Congress-Verlag; Moscow, Molodaia Guardiia; Moscow, Pravda. No leading American publisher would publish Robeson's autobiographical work.

September 14—Made Honorary Professor, Moscow State Conservatory of Music.

September 17—Starts tour of German Democratic Republic.

October—Presented with Miners Lamp by miners of Wales. Will Paynter, president of South Wales area, tells large audience they are "honoring a great man and great artist."

November—Climaxes English concert tour with appearance at St. Paul's Cathedral. First black person to stand at lectern of Cathedral, he sings to 4,000 persons seated inside and 5,000 standing outside.

1959

January 1—Welcomed at Kremlin New Year's Ball by Premier Nikita Khrushchev.

January—Falls ill, is confined to Moscow hospital. During next four years is in an out of hospital many times because of deteriorating disease of circulatory system. Doctors say "absolutely no" to idea of stage appearance.

February—Permitted by doctors to appear in *Othello* in London if he keeps physical activity to minimum and performs fewer than customary eight performances weekly.

February 14—Wins tax fight of several years to avoid paying $9,655 in federal income tax on $25,000 Stalin Peace Prize received in 1953. Internal Revenue now takes position that prize belongs in same category as Nobel and Pulitzer prizes.

February 22—Performs in Moscow in first appearance since illness.

April—Appears in *Othello* at Stratford-on-Avon.

May 11—Elected Vice-President of British-Soviet Friendship Society.

August 4—Speaks in Vienna at International Youth Festival attended by 17,000 from 82 countries. Criticizes U. S. foreign and domestic policies.

October 29—Model of Othello is presented "To Paul Robeson with grateful thanks from the Tyler Street Boys Club, Stratford-on-Avon."

1960

January 24—Sings and speaks to plant workers in Moscow.

January 30—Attends theatre production with Premier Khrushchev marking 100th anniversary of Chekhov's birth in Moscow.

May 1—Guest of honor at Miners Gala on May Day in Edinburgh, Scotland, acclaimed as Paul Robeson's Day. In short speech says: "My people were hewers of wood and drawers of water all over the Western World. Today on the Continent of my forefathers, we are saying it is time for us to live a new life, time to be free. The struggles of Labor and the struggles of my people have always, in my mind, been joined." Receives Scottish Miners Lamp inscribed: "From the Scottish Miners to Paul Robeson."

October 12—Given honorary degree by Humboldt University, German Democratic Republic.

November—Last concert tour takes him to Australia and New Zealand. In Adelaide, Australia, tells reporters: "I sing folk music because it covers the whole world. I am interested in all peoples. I am deeply concerned in the

problems of the people who were here before you—the indigenous people of Australia. I don't call them the aborigines. I call them indigenous peoples."

1961

April 15—Reenters hospital in Moscow. Spends much time in hospitals and nursing homes. When news comes he is being considered by Ghana's President Kwame Nkrumah as lecturer at University of Ghana's Institute of African Studies, U.S. State Department fails in attempt to block appointment but is too ill to accept.

1963

January—Paul Robeson Choir established in Berlin, German Democratic Republic.

July 25—Close friend Harry Francis, denying Robeson is disillusioned with Socialist countries, calls report "sheer nonsense."

August 27—Interviewed at London airport in connection with March on Washington, declares: "The turning point has come for the American Negro people."

September 15—Paul, Jr., denies report that father has become disillusioned with communism and is being involuntarily detained in East Berlin.

December 1—Brother Reverend Benjamin C. Robeson, pastor for twenty-seven years of Mother African Methodist Episcopal Zion Church in Harlem, dies at age of seventy.

December 20—*New York Times* announces "Robeson Will Return to U.S. to Retire."

December 22—Arriving in New York after five years and five months absence from U.S., is met by Paul, Jr., and daughter-in-law, Marilyn. Asked by reporters "would he take part in the civil rights program," replies, "Yes, I've been part of it all my life." *New York Times,* without slightest evidence, headlines story, "Disillusioned Native Son: Paul Robeson."

1964

February—Welcomed back to America by *Freedomways,* quarterly review of "the Negro Freedom movement," which calls him a great voice for freedom over many years.

March—Issues first public statement after returning, on anniversary of 1963 March on Washington: "We're moving."

August 27—Speaks at funeral of Benjamin J. Davis, Communist leader in Harlem and close friend.

October 25—Issues statement praising German Democratic Republic on 15th anniversary of its founding.

1965

Winter—Publishes "The Legacy of W. E. B. Du Bois" in *Freedomways.*

April 22—*Freedomways* Salute to Paul Robeson at Hotel Americana, chaired by Ossie Davis and Ruby Dee, packed with admirers. James Baldwin notes that "in the days when it seemed that there was no possibility in raising the individual voice and no possibility of applying the rigors of conscience, Paul Robeson spoke in a great voice which creates a man."

October—Found lying unconscious in clump of weeds near Highbridge Park in Washington Heights section of New York City and rushed to hospital.

December 13—Eslanda Robeson dies of cancer at age of sixty-eight.

1969

April 2—Paul Robeson Music and Arts Lounge dedicated in new student center at Rutgers University.

1970

April—Paul, Jr., speaks at affair in honor of father sponsored by Eastern Region of Alpha Phi Alpha Fraternity and Rutgers Student Center.

November—*Black World* publishes "Paul Robeson: Black Star," a tribute by C. L. R. James.

November 15—Presented with Zhitlovsky Award by Zhitlovsky Foundation for Jewish Education. Accepted by Paul, Jr., at New York Hilton ceremonies.

November 29—Local 1199, Martin Luther King, Jr., Labor Center, celebrates opening of new 15-story headquarters with cultural program entitled "A Tribute to Paul Robeson" produced by Moe Foner. Hosts for evening are Ossie Davis and Mary Travers. Paul Robeson, Jr., delivers tribute and Dizzy Gillespie closes show. Two auditoriums needed because of great response.

December—Head football coach and president of Rutgers University criticize failure of National Football Foundation to select Paul Robeson, twice All-American, for its Hall of Fame.

1971

Beacon Press reissues autobiography *Here I Stand* with preface by Lloyd Brown.

April—First Quarter of *Freedomways* devoted to "Paul Robeson, The Great Forerunner."

April 8–9—Two-day Paul Robeson symposium held in Berlin, German Democratic Republic. Speakers from U.S. include William L. Patterson and Lloyd Brown.

April 9—Dr. Edmund J. Blaustein, president of Rutgers University, delivers dedication speech at Newark-Rutgers student center named after Paul Robeson.

December 27—Lawrence Brown, noted black composer and vocalist, famous recreator of Negro spirituals and folk songs, and Robeson's accompanist and companion for many years, dies in Harlem Hospital.

1972

April—Receives Black Psychiatrist Association's Annual Award.

August—Proclaimed by *Ebony* magazine one of "ten most important black men in American history."

August 6—Sunday Arts and Leisure Section of *New York Times* features article by Loften Mitchell entitled, "Time to Break the Silence Surrounding Paul Robeson?"

September—Receives National Urban League's Annual Whitney M. Young Memorial Award.

1973

April 15—"Salute to Paul Robeson" on 75th birthday packs Carnegie Hall, New York City.

April 16—Salute to Paul Robeson Exhibition opens at Gallery 1199 of Drug and Hospital Workers' Union.

June 3—Awarded Doctor of Law by Lincoln University, Pennsylvania, first black college in U.S. and the one from which father graduated. Paul, Jr., accepts award.

September—Emmy award granted Robeson series on National Educational TV.

October 21—*New York Times Book Review* review of *Here I Stand* (Beacon Press, 1971) is first in major commercial paper in fifteen years.

1974

June—Honored by Actors' Equity Association, AFL-CIO, as first recipient of annual award named for him. Message accepting award is last public statement.

1975

December 28—Admitted to Presbyterian Medical Center in Philadelphia after mild stroke. Condition grows more serious daily.

1976

January 27—Dies at age of seventy-seven.

January 28—5,000 attend funeral service at Mother AME Church in Harlem.

Addressing Paris Peace Conference, April 22, 1949

At Rutgers University, ca. 1917

Review of the 1917 Football Season

Rutgers Alumni Quarterly, 1918—Reprinted in George J. Lukac, *Aloud to Alma Mater,* New Brunswick, New Jersey, 1966, pp. 120–27

The season of 1917 is over, but the memories thereof will fire the hearts of Rutgers men as long as football is football. For the team, fighting as only a Rutgers team can fight, and inspired by the indomitable spirit of that greatest of football mentors, George Foster Sanford,[1] rose to the greatest heights, and stands not only as one of the best teams of the year but as one of the greatest of all time. Coach Sanford says that it is the nearest to the Yale '91 team he has ever seen, and this perhaps is the greatest compliment received, when we consider that this Yale team was composed of such men as Sanford, Heffelfinger, Hinkey, McClung, and other stars of like calibre.

The season started none too conspicuously. Only three veterans were left from last year, Rendall, Robeson, and Feitner, and the incoming material was an unknown quantity. However the team which took the field against Ursinus, though necessarily a bit crude, showed signs of power. The Ursinus men played hard football and were finally subdued by a score of 25–0.

The next contest, that with Fort Wadsworth, was not a real test of the strength of the Scarlet eleven, as the team ran wild and won by a score of 90–0.

The next Saturday, confident of victory, the squad traveled to Syracuse. And we should have won. A few unfortunate breaks, however, lost a big opportunity. Syracuse had a far more experienced team and the advantage of home surroundings, and really put up a sterling game. But the Rutgers aggregation played a splendid uphill contest and, after scoring one touchdown in the last quarter, started for another and victory but was stopped by lack of time. So the up-state boys were returned the winners by a score of 14–10. It was a bitter pill for the team to swallow, but a more bitter one for Coach Sanford, who had hoped for a season with no defeats; and it was a rather sad lot who boarded the train for Jersey.

Against Syracuse, the team showed some serious faults. It wasn't a Sanford line that allowed the opposing backs to rip through for five

and eight yards at a clip! It wasn't a Sanford backfield that wouldn't run! This was shown at Easton, the following week, when the Pennsylvanians were unable to gain at all against the rejuvenated Scarlet forwards and would have been whitewashed but for a pretty sixty-yard run by Sigel from a crisscross formation. Meanwhile our backs ripped the line of the Eastonians to shreds and piled up a safe lead of 33 points to our opponents' six. This was a sweet victory, as Lafayette had claimed that Rutgers had never defeated her in anything. But now we are of the opinion that this state of affairs will be reversed.

It looked as though the team had arrived, but the followers were unwilling to accede too much to the eleven until it had faced a real test, which was at hand in the game with Fordham, a team undefeated and with a superabundance of fighting spirit. The New York papers conceded the Fordhamites an even chance. But the Rutgers steamroller was too much for the footballers from old Gotham, and they were buried under a 28–0 score. This settled it. The old college on the bank of the Raritan had a great team, a team with a varied, smashing attack and an impenetrable defense.

Then came one of the biggest games of the season. West Virginia, near conquerors of Pittsburgh and conquerors of Dobie's Navy team, arrived, a slight favorite, to take the measure of the New Brunswick eleven. A very large crowd attended the contest, which was "some battle." In the first period our team ran the West Virginians all over the field and scored one touchdown by straight line hitting. This score seemed enough to win until the third period, when a bad break gave the opposing team a chance to score. A long punt by King, the visitor's halfback, rolled to Rutgers' one-yard line and stopped. Whitehill's kick was partially blocked and went out of bounds on the 12-yard line. Rodgers, the much-heralded back, took it over in two rushes. Rutgers had one chance to score thereafter, but a forward pass over the goal line failed and the last chance was gone. It was a great game, full of thrills and of every variety of football. The score ended 7–7, leaving the supremacy of the two teams still unsettled, as last year's score was 0–0.

Stung by its failure to win the best game on the schedule up to that time, the eleven came back the next week and delivered to the Springfield team the most crushing defeat ever suffered by an aggregation from that school. The Scarlet backs plunged and sliced through the line for long gains, and when the game ended the score stood 61–0. A most remarkable feature of the game was that the Rutgers team, having once received the ball, never relinquished it until a touchdown had been scored.

The next contest was with the U.S. Marines from Philadelphia, headed by the great Eddie Mahan. The leader, unfortunately, was unable to play, owing to an injured leg, but it was a strong, rugged bunch of men who took the field against Rutgers. Our team did not play with its usual snap and vigor, but won easily, 27–0.

Then to the Rutgers eleven came the greatest opportunity ever afforded a college team. A game was arranged with Cupid Black's

Naval Reserves at Ebbet's Field, Brooklyn, for November 24. The Reserve team was composed of the greatest players of the past couple of years. It included Barrett of Cornell, Black and Callahan of Yale, Schlachter of Syracuse, Gerrish of Dartmouth—all All-American selections—and a number of All-Western men. Here was a team of experienced men, of highest recognized football ability, in condition and coached by Dr. Bull, the famous Yale Coach, a team which had defeated Brown, conquerors of Colgate and Dartmouth, by a score of 35–0. And opposing them was "little" Rutgers with an eleven averaging slightly over nineteen years in age and outweighed at least ten pounds to a man. To all football followers there could be but one result. Rutgers didn't have a chance. But Coach Sanford and the Rutgers team felt differently, and the team which trotted on the field in Brooklyn on that Saturday afternoon late in November was full of confidence in its ability to conquer the famed opponents. And they proved it. Never did a team fight like that one. From flagfall to finish it was all Rutgers, and the final score, 14–0, fails miserably in telling just how superior the wearers of the Scarlet were to the great All-Americans.

How could such a thing happen? Anyone who visits Neilson field on a fall afternoon will understand. It lies in the fact that football is method and not men and that Rutgers has the best of methods taught by the greatest of football coaches, George Foster Sanford. At last has this wonderful man received his just due from all parts of the country. The consensus of opinion is that there is none greater. Consider that there were only three veterans to start with, that the team consisted of green freshmen and two men who never played football before, that practice hours were very short, that only one real scrimmage was held all year, and one can realize the wizardry of Coach Sanford. Of course, he will stand an imposing figure in Rutgers history and dear to the hearts of every Rutgers man. But by those who have been his pupils, who have listened to his inspiring talks, who have received an impetus toward higher and better things of life through observance of his character, he will never be forgotten. A wonderful coach, yes, but more, a wonderful man, an adviser, the guardian and molder of the characters of the young men under his supervision! An advocate of clean play, not only on the football field but also in life!

The one thing which determined most the successful season was the teamwork and team spirit of Rutgers. There was no individual brilliancy, but every man did his best for a common cause under the leadership of one of Rutgers' greatest captains, "Thug" Rendall. His "never say die" spirit was felt by every member of the team, and his command to "get into the game" was always heeded. Rendall was chosen on several All-American teams, an honor which he richly deserved.

Kelly, uninjured throughout the season, gave an exhibition of halfback play seldom equalled. Ever fearless, always giving all he had, he tore up every line he faced. His exhibition against the Naval Reserves will stand out always in the minds of those who witnessed the

game. A wonderfully shifty back on offense and an exceptionally strong defensive halfback! He also received places on a number of All-Star teams.

Baker, who had the benefit of a year's tutelage under Mr. Sanford, developed into the best quarterback of which Rutgers can boast and one of [the] foremost in the country. In generalship he was splendid at all times, and, furthermore, he proved himself a fine open-field runner in returning kicks and a fine tackler. When it comes to gameness and grit, none of them has anything on "Bake."

Feitner, our captain-elect, played a steady, dependable game all year and rose to his truest form against Black's eleven, when he smashed their off-tackle plays before they were started. A fighter from start to finish, who will lead Rutgers to an even greater success next year, he was chosen by [the] New York *Sun* as one of the leading tackles of the year.

Whitehill more than lived up to his promise of last year. It was old "Mike" who could break through any line for the precious yards, who could pass the ball like a rifle shot into the waiting hands of his ends, who time and again booted the pigskin out of dangerous territory. "Mike" stood among the first five players in touchdowns scored this season. A heady, aggressive player, who was recognized as one of the country's leading fullbacks by numerous football writers!

Breckley, a fine athlete, but who never played football before, under the close eye of Coach Sanford developed into a first class end and received a place on the *Sun's* Honor Roll.

Neuschaefer, formerly an end, developed such a high degree of proficiency in guard play that he showed Schlacter, All-American guard for two years, a number of new points about said position. "Neu" played a fine grade of ball all year and merits the distinction given him by the New York *Sun* as one of the season's best guards.

Rollins, picked for several All-American teams, played "Cupid" Black off his feet and stands as one of the foremost guards on the gridiron. "Rolly" is only a freshman, so we can expect even greater things in the future.

Gray and Francke were two fine centers, reliable in passing, quick in opening holes, and dependable on defense. Both admirable examples of Mr. Sanford's wonderful coaching ability!

Gardner and Gargan are two of the best halfbacks developed by Coach Sanford at Rutgers. The former, weighing 180 pounds, could butt any line, and any one who tackled him usually realized he had tackled a real "he." A wonderful future! Gargan was smaller but the speediest man on the team, and his winding, twisting runs were beautiful to watch.

Dunham, Redmond, Francisco, Hand, when given an opportunity, showed promise and will bear watching when next year's team is picked.

Sutton, a short, sturdy type of end, played a fine game all year, both on offense and defense.

Coaches Wittpenn and Nash deserve great credit for their unselfish efforts in the development of the team. Both gave all they had to their successors and also furnished sturdy opposition when it was needed.

The scrubs, while not so strong as usual, played valiantly, and to them belongs a lot of honor. They stood the brunt of battle without giving away an inch, and it was their team which helped make such a glorious name for Rutgers.

Only one man, Captain Rendall, is lost from this year's team. With Coach Sanford again at the helm and with the same team spirit as characterized the play this year, Rutgers bids fair to eclipse all previous efforts and stand undisputed as one of the best teams in the East.[2]

The Fourteenth Amendment: "The Sleeping Giant of the American Constitution"

Thesis submitted May 29, 1919, Rutgers University

I. History of the Amendment
 1. Introduction
 2. Causes leading to the adoption of the Amendment

II. Construction and Interpretation of the first Section of the Amendment
 1. Citizenship is defined
 2. The Phrase "Subject to the jurisdiction thereof"
 3. The Privileges and Immunities of United States Citizens
 4. Due Process of Law
 (a). As related to Procedure
 (b). As related to Police Power
 (c). As related to Public Callings
 (d). As related to Taxation
 5. "The Equal Protection" of the Laws

III. Conclusion

Section I. All persons born or naturalized in the United States and subject to the jurisdiction thereof, are citizens of the United States and of the State where-in they reside. No state shall make or enforce any law which shall abridge the privileges or immunities of citizens of the United States; nor shall any State deprive any person of life, liberty, or property, without due process of law; nor deny to any person within its jurisdiction the equal protection of the laws.

Of all the forces that have acted in strengthening the bonds of our Union, in protecting our civil rights from invasion, in assuring the perpetuity of our institutions and making us truly a nation, the Fourteenth Amendment is the greatest.[1] The civil war and the following days of Reconstruction demonstrated clearly to the people that the unrestrained power of the States to alter their constitutions as their interests or passions might impel, greatly endangered their fundamental rights. Under this amendment, therefore, we find the essential rights of life, liberty, and property placed under the ultimate protection of the national government. What a change we find here from the spirit of 1787 when the Federal Constitution was adopted. At the time the States were exceedingly jealous of their rights and desired to limit as far as possible the activities or rather sphere of activity of the Central Government. Thus the proposal of the first ten amendments which were applicable to the Federal Government only and not to the States.

The States, however, might exercise oppressive or spoilative legislation without fear of redress by the victims as the only constitutional provisions protecting fundamental rights in the States were those of Article IV, Sections 2 and 4. The first entitles the citizens of each State to all the Privileges and Immunities of citizens in the several States and guarantees to every State a Republican form of government. But these were too vague to provide sufficient protection. The only real check upon state agents were the provisions forbidding bills of attainder and laws impairing the obligation of contracts, and the passage of ex post facto laws, the latter of which according to Calder and Bull applies only to criminal cases. But there were rights, considered essential in our system of government and vested as matter of right in each individual which could be abridged by state legislature or judiciary with no appeal to higher authority. In this possible arbitrary exercise of power by the States lay the danger and grave menace to the perpetuity of our Union. This was the inherent weakness in our original system of dual government. The cure for this weakness was the Fourteenth Amendment, placing, as it does, these great republican principles of liberty and equality before the law on a secure foundation.

During the war of the rebellion the Supreme Court had decided in "Texas and White" that this was an indestructible Union of indestructible States; that no state could secede.[2] The Southern states on the restoration of peace, therefore, wanted to conduct their internal affairs as before the war. The controversy arising herefrom caused a pronounced split between the executive and legislative branches of our government, President Johnson[3] siding with the South. Further the rebellious States, instead of calming down, proceeded to pass laws virtually reducing the negro once more to slavery[4] and assumed such a defiant attitude that some action had of necessity to be taken.[5] There are four (4) sections of the Amendment in question other than the one quoted referring respectively to representation in Congress,[6] exclusion

from office of Confederates, validity of publi
the assumption of claims for loss of slaves or a
debt, and right of Congress to exercise neces
legislation. The first Section, however, is the comp
and we shall devote our attention thereto.

The first clause of this Section provides: Al
naturalized in the United States, and subject t
thereof, are citizens of the United States and of tl
they reside.

Before the adoption of the Fourteenth Amendment, the Constitution
contained no definition of citizenship, either of the United States or of
a State. It referred to a citizenship of the United States as a qualifica-
tion for membership in the two houses of Congress and for the
presidential office, but it did not declare what should constitute such
citizenship. Prior to this, no one could be a citizen of the United States
unless a citizen of a State according to the state constitution and laws
according to leaders of states-rights parties and suggested by the
United States Supreme Court in the Dred Scott decision which
declared that a man of African descent could not be a citizen of a State
or of the United States as the United States had not the power to make
him so.[7]

We see, therefore, a reversion of the previously adopted principle.
Now, citizenship is primarily of the United States; secondarily of the
various states. Citizenship, both of the United States and of the States,
is thus conferred by the Constitution of the United States and the laws
of Congress made in accordance therewith. The States can neither
confer nor withhold citizenship of the United States. A citizen of the
United States is now, ipso jure, a citizen of the state in which he may
fix his residence. This distinction between United States citizenship
and State citizenship is well brought out by Justice Miller in the
Slaughter House Cases.[8]

The Phrase "subject to the jurisdiction thereof" has occasioned
considerable difficulty. If the parents of a child born in the United
States were citizens, the meaning was clear. But several cases arose,
the chief of which were Elk and Wilkins[9] and the United States v.
Wong Kin Ark,[10] to test the meaning. It was stated in the first case
that the phrase in question meant not merely subject in some respect
or degree to the jurisdiction of the United States, but completely
subject to their political jurisdiction, and owing them direct and
immediate allegiance. Therefore, an Indian born a member of one of
our Indian tribes still existing and recognized as such, even though he
had voluntarily separated himself from his people and taken up his
residence among the white citizens, but who did not appear to have
been naturalized or taxed, was not born in the United States "subject
to the jurisdiction thereof" and was not a citizen. In the latter case the
Supreme Court held that a child born in this country of Chinese
parents domiciled here is a citizen of the United States by virtue of the
locality of his birth. Thus all persons born in the United States of alien

permanently domiciled here, except the children of the diplo-
matic representatives of foreign powers, are citizens of the United
States.

The second sentence of Section I provides that "No state shall make
or enforce any law which shall abridge the privileges or immunities of
citizens of the United States." The question comes forward to us: What
are these privileges and immunities? Surely they are those which
attach to citizens of the United States as such and not as citizens of any
particular State or Territory embraced within the Union; those which
belong to them as citizens under the government established by the
Constitution of the United States and regulated by the laws of
Congress. Among these are the fundamental rights of the individual
mentioned in the first eight amendments including free exercise of
religion; freedom of speech and of the press; security against double
jeopardy; due process of law; speedy public trial, etc. Justice Miller[11]
confines these privileges and immunities to those which are funda-
mental; which belong of right to the citizens of all free governments.

In the case of Bradwell and the State, and Minor v. Happerset it was
decided by the Supreme Court that although women clearly were
citizens of the United States by virtue of the Fourteenth Amendment,
yet, neither the right to practice law nor to vote was a privilege or
immunity of the United States citizens.[12] These decisions have their
importance in pronouncing that the Fourteenth Amendment did not
add to the privileges or immunities of a citizen of the United States,
but simply furnished an additional guaranty for such as already
existed, and prohibited the States from abridging them.

Nor shall any state deprive any person of life, liberty, and property
without due process of law. This phrase embodies one of the broadest
and most far-reaching guaranties of personal and property rights. As
Justice Matthews says in Yick Wo v. Hopkins,[13] the term is one of
those "monuments showing the victorious progress of the race in
securing to men the blessings of civilization under the reign of just and
equal laws so that the government of the commonwealth may be a
government of laws and not of men." The general scope of the
provision is to secure to every person, whether citizen or alien, those
fundamental and inalienable rights of life, liberty, and property,
which are inherent in every man, and to protect all against the
arbitrary exercise of governmental powers in violation and disregard
of established principles of distributive justice. This protection is the
object and essence of free government, and without it true liberty
cannot exist.

In the reasoning of Hintado v. California[14] we find that "due process
of law" means the "law of the land." And M. Webster[15] in the
Dartmouth College Case says, "By the law of the land is most clearly
intended the general law; a law which hears before it condemns; which
proceeds upon inquiry, and renders judgment only after trial." Judge
Story in his book on the Constitution[16] defines "due process of law" as
such an exertion of the powers of government as the settled maxims of

law permit and sanction, and under such safe-guards for the protection
of individual rights as those maxims prescribe for the class of cases to
which the one being dealt with belongs."

It is important to appreciate that "due process of law" is process
according to the system of law obtaining in each State and not
according to the general law of the United States. In ascertaining and
determining such law regard should be had to the usages, public
policy, and modes of proceeding existing in the respective States, and
these should fully control unless shown to be wholly unsuited to the
subject matter. As was said in Missouri and Lewis[17]: "The Fourteenth
Amendment does not profess to secure to all persons in the United
States the benefit of the same laws and the same remedies, great
diversities in these respects may exist in two States separated only by
an imaginary line. On one side of this line there may be a right of trial
by jury, and on the other side no such right. Each State prescribes its
own modes of judicial proceeding." In Hintado and California the
Court declared, "In the Fourteenth Amendment by purity of reason, it
refers to that law of the land in each State, which derives its authority
from the inherent and reserved powers of the State, exerted within the
limits of those fundamental principles of liberty and justice which lie
at the base of our civil and political institutions, and the greatest
security for which resides in the right of the people to make their own
laws and alter them at their pleasure." What would be a fair and just
provision in one state might be oppressive and grossly arbitrary
elsewhere. Each state has its peculiar interests and traditions that
may call for distinct legislative policies.

Since its incorporation into the Constitution the Fourteenth Amend-
ment has been the basis of numerous cases; especially the clause of due
process of law. We may divide the cases arising under this clause
under four heads and following Wambaugh's order: Procedure, civil
and criminal; the police power; public callings or taking of private
property for public use; the power of taxation. These are the particular
branches of state legislation which affect the personal liberty and the
property rights of the individual.

In respect of procedure, civil and criminal, due process of law must
depend upon the nature of the procedure employed, as well as the
object of the law. It is only when, under one pretext, or another, the
State seeks to work spoilation, when it crosses the line which separates
regulation from confiscation, when under the guise of legal procedure,
the fundamental rights of the individual are invaded, that relief can
be sought under the amendment, and full protection found beneath the
strong hand of the Federal Courts.

We find in Murray's Lessee vs. Hoboken[18] that due process does not
mean in all cases judicial proceedings or a regular proceeding in a
court of justice. In Kennard[19] and Morgan the Court held that when a
party has had a fair trial according to the modes of proceeding
applicable to the case, [he] has not been deprived of property without
due process. Other forms of trial even than jury trials can be held, as

such are recognized by the common law, and except when jury trial is guaranteed the form of trial may be determined by law. Legislative bodies may punish persons for contempt without a jury trial (Eilenbecker vs. Plymouth County). Likewise by special proceedings and for proper cause an attorney may be disbarred and the right to practise his profession cut off without a jury trial (Ex parte Wall). In Hurtado vs. California the Court decides that due process of law does not necessarily require indictment by grand jury in criminal cases. Walker and Savinet[20] reduces the number of petit jurors without violating the clause. Twining and New Jersey[21] holds that immunity from self-incrimination is not secured to the individual in a state by due process of law.

We may conclude from a consideration of these cases on procedure that the systems and forms of legal procedure regularly adopted by the States and impartially administered will usually be held by the Supreme Court to be due process of law as far as the Fourteenth Amendment is concerned. Of course, if the legislature provides a system of laws for the government of the courts which secures to the parties the necessary constitutional protection, mere enor by the courts in administering the law gives rise to no federal question. Where, however, under the pretence of altering or regulating the mode of enforcing the remedy, the statute clearly invades some substantive right, or when a statute harmless on its face is systematically enforced in violation of fundamental rights, or when a court, transgressing its functions, attempts to render a judgment without jurisdiction of the subject matter or notice to the party, the procedure is not due process of law, and may be declared void and set aside by the courts under the jurisdiction conferred by the Fourteenth Amendment.

Now the Amendment and the Police Power. The term "police power" is used to designate that most important function of securing the largest practicable measure of well-being to those who live together in the social organization. It includes such measures as are appropriate or needful to protect the public morals, the public health, or the public safety, and to promote the good order and domestic peace of the community. The police power lies within that great body of powers reserved to the states, and not conferred upon the Federal Government. In considering the validity of an enactment of a State legislature under the police power, the inquiry is whether the regulation or classification has been designed to subserve some reasonable public purpose, or is a mere device or excuse for an unjust discrimination, or for the oppression or spoilation of a particular class. Any regulation of the internal affairs of a State fairly subserving a valid purpose and reasonably exercised for the benefit of the community at large, will be upheld; but if it be arbitrary and have no substantial relation to the health, morals, peace, or welfare of the community, it will be nullified. However, no precise limits should be placed upon the police power of a state, for no one can forsee what regulations the welfare of the community may require.

Wambaugh begins his cases under police power with Bartemeyer and Iowa which dealt with the liquor traffic. It was held here that no provision of the Fourteenth Amendment inhibits the States from regulating the liquor traffic within their boundaries. It was intimated, however, that the regulations imposed could not go to the extent of destroying property employed in that business. In Migler vs. Kansas, however, a statute prohibiting the manufacture or sale of intoxicating liquors, and authorizing the summary destruction of property devoted to such manufacture, was upheld as a valid exercise of the police power.

The legislation of the State of Illinois regulating the charges of warehousemen was sustained by the Supreme Court in Munn vs. Illinois.[22] Such legislation was regarded as a branch of the police power. It was decided that where property has been clothed with a public interest, the legislature may fix a limit to that which shall in law be reasonable for its use. It is now well established that the federal courts will intervene and set aside a regulation of charges which is unreasonable, and that the reasonableness of the regulation is a judicial question. With respect to matters of purely local concern and internal traffic the question as to what police or governmental regulations are appropriate, necessary, or wise is confided in great measure to the discretion of the State legislatures. Such was the decision in Powell and Pennsylvania involving the validity of the Oleomargarine Acts. Justice Harlan[23] said, "If all that can be said of this legislation is that it is unwise, unnecessarily oppressive to those manufacturing or selling wholesome oleomargarine, as an article of food, their appeal must be to the legislature or the ballot box, not to the judiciary." In Holden and Hardy[24] it was held that statutes of a State limiting the period of employment of workingmen in underground mines to eight hours a day, were a valid exercise of the police power. It was held, however, Lochner vs. New York,[25] that similar legislation concerning men working in bake-shops was invalid as an arbitrary exercise of police power.

Taxation is the next branch of "due process of law" including the taking of private property for public use without just compensation. Taxes have been defined by an eminent authority to be burdens or charges imposed by the legislative power upon persons or property to raise money for public purposes. The taking of property in the form of a tax while not in itself a taking without due process of law, may become such by reason of the purpose for which, or the manner in which, the tax is levied, assessed, and collected. Due process of law obliges the United States as well as the individual states, in the exercise of their taxing powers, to conform to the following rules:

(1). That the tax shall be for a public purpose.

(2). That it shall operate uniformly upon those subject to it.

(3). That either the persons or property taxed shall be within the jurisdiction of the government levying the tax.

(4). That, in the assessment and collection of the tax, certain

guaranties against injustice to individuals shall be provided, such as notice and opportunity.

A tax being in the eye of the law an enforced contribution from persons or property to raise money for a public purpose, it follows that where this public purpose is absent, the contribution sought to be enforced cannot be justified as a tax but amounts to an attempt to take property without due process. The Court, however, will, in deference to legislative judgment, construe the purpose to be a public one if it is at all possible to do so. In Loan Association and Topeka[26] it was settled that the State legislature cannot authorize cities and towns to levy special taxes or contract indebtedness in aid of private enterprise, which though beneficial in a measure to the public, is not clothed with sufficient public interest. Also, a statute would not be valid which should authorize cities and towns to raise money by borrowing or by taxation, to be loaned to private owners to improve their property (Lowell vs. City of Boston).

On the other hand, there are many purposes for which money may be properly raised and used which are deemed public although incidental private advantages result therefrom. Thus bounties may be given for military service, pensions awarded, as being inherently of public benefit, in obtaining men for the army and treating loyalty to the government. It was held, however, in Norwood and Baker,[27] that special assessment on property for public improvement in substantial excess of benefits derived, was a violation of the Fourteenth Amendment. And in Davidson and New Orleans,[28] it was decided that assessments for local improvements may be levied on abutting owners, and that the fact that their property is assessed twice for the same improvement and only part of it benefited, does not invalidate the assessment if the owner has had notice and an opportunity to object. The determination of the persons benefiting by a local improvement and of the extent to which they are benefited, depends largely upon the discretion of the legislature. A man has no complaint merely because the enforced collection of a tax does not benefit him as much as others. So also the State may, if it chooses, exempt certain classes of property from any taxation at all, such as churches, libraries, and the property of charitable institutions. It may impose different specific taxes upon different trades and professions, and may vary the rates of excise upon various products; it may tax real estate and personal property in a different manner; it may tax visible property only, and not tax securities for payment of money; it may allow deductions for indebtedness or not allow them. Such was the reasoning in Bells' Gap Railroad Company and Pennsylvania.[29]

A very interesting case in this category is that of Magonn and Illinois[30] in which it was held that an inheritance tax was not one on property but on the right to inherit, and hence the States might tax this privilege. A corresponding Federal case is Knowlton vs. Moore.[31]

The distinctive and characteristic feature of the American system is equality before the law. The first declaration of the American people

upon asserting their independence as a nation was "that all men are created equal." As Justice Brewer[32] says in Magonn vs. Illinois, "Equality in right, in protection and in burden is the thought which has run through the life of this nation and its constitutional enactments from the Declaration of Independence to the present hour." By the Fourteenth Amendment, the principle of equality before the law, a principle so vital and fundamental in American institutions, ceased to be a mere theory or sentiment and became incorporated into the organic law as the fundamental right of every individual. And further, although the wrongs of the colored race may have furnished the immediate occasion for the Fourteenth Amendment, it was not intended that the protection of its beneficent provisions should be limited to that race; and, accordingly, protection against unequal laws has been sought and found under the shield of the Fourteenth Amendment by persons of every race, rank, and grade. The "equal protection of the laws" has been authoritatively declared to mean that all persons subject to legislation shall be treated alike, under like circumstances and conditions, and in the liabilities imposed.

In Strander vs. West Virginia,[33] and Neal vs. Delaware the Supreme Court held that a "denial to citizens of the African race, because of their color, of right to participate as jurors was a denial of equal protection of the laws."

The Civil Rights Cases[34] held that the Federal Government could not legislate upon subjects within the domain of the State, under the Amendment, but could provide modes of relief against arbitrary legislation by the State.

Two principal classes of questions arise under the constitutional requirement of equal laws; the one relates to the power of classification, and [the] other of these two heads is the power of taxation. Many statutes have been sustained as proper classification, which selected particular classes of corporations or particular trades or businesses or kinds of property for taxation or regulation not imposed upon other classes of property. Thus in Munn vs. Illinois, Home Insurance Company vs. New York, Powell vs. Pennsylvania, Holden vs. Hardy, and others. In Barbier vs. Connolly we find that a regulation requiring that the laundry business within the thickly settled portions of the city shall not be conducted in wooden buildings is valid because such a regulation is protection to the people. But in Yick Wo vs. Hopkins the Court maintained that restriction of the laundry business to certain classes of people is unconstitutional because it is not founded upon any reasonable ground as to the qualification of different classes of persons to pursue that particular business.

The general rule is reasonable and necessary. But classification cannot be arbitrary; it must be just. Whether or not the classification is permissible under the Federal Constitution must always be a judicial question for the Federal Courts.

That the equal protection phrase applies to taxation has been well established. If the best interests of the States are to be consulted, the

legislature will always levy equal and uniform taxes. In considering the problems of taxation we must remember that the science of government and the principles of taxation are intimately connected and interwoven. The highest attribute of the sovereignty of governments is the taxing power; the power to tax is not only the strongest and most pervading of all powers of government, but is the most liable to abuse. We must not, in our zeal, place the burden of taxation upon any one class or wrongfully discriminate as to the distribution of taxes. The observance of the principle of equality which has built up such a great and prosperous nation must continue. Justice Cooley in The People vs. Salem well expresses the danger of unequal and class legislation: "The discrimination by the State between different classes of occupations, and the favoring of one at the expense of the rest, is an invasion of that equality of right and privilege which is a maxim in State government. The State can have no favorites. Its business is to give all the benefit of equal laws."

In the Fourteenth Amendment we have as a heritage a "new Magna Charta"[35] in the words of Justice Swayne in the Slaughter-House Cases.[36] "There is today a growing tendency to invade the liberty of the individual and to disregard the rights of property, a tendency manifesting itself in many forms. The hope of the American people lies in the strength of the Fourteenth Amendment." So long as the Constitution of the United States continues to be observed as the political creed, as the embodiment of the conscience of the nation, we are safe. State constitutions are being continually changed to meet the expediency, the prejudice, the passions of the hour. It is the law which touches every fibre of the whole fabric of life which surrounds and guards the rights of every individual; which keeps society in place; which in the words of Blackstone,[37] "is universal in its use and extent, accommodated to each individual, yet comprehending the whole community". This Amendment is a vital part of American Constitutional Law and we hardly know its sphere, but its provisions must be duly observed and conscientiously interpreted so that through it, the "Sleeping Giant of our Constitution," the American people shall develop a higher sense of constitutional morality.

The New Idealism

Oration delivered at Rutgers graduation, June 10, 1919—*The Targum*, June 1919, pp. 570–71

Today we feel that America has proved true to her trust. Realizing that there were worse things than war; that the liberties won through long years of travail were too sacred to be thrown away, though their continued possession entailed the last full measure of devotion, we paid again, in part, the price of liberty. In the fulfillment of our

country's duty to civilization, in its consecrating of all resources to the attainment of the ideal America, in the triumph of right over the forces of autocracy, we see the development of a new spirit, a new motive power in American life.

We find an unparalleled opportunity for reconstructing our entire national life and moulding it in accordance with the purpose and ideals of a new age. Customs and traditions which blocked the path of knowledge have been uprooted, and the nation in place of its moral aimlessness has braced itself to the pursuit of a great national end. We can expect a greater openness of mind, a greater willingness to try new lines of advancement, a greater desire to do the right things, and to serve social ends.

It will be the purpose of this new spirit to cherish and strengthen the heritage of freedom for which men have toiled, suffered and died a thousand years; to prove that the possibilities of that larger freedom for which the noblest spirits have sacrificed their lives were no idle dreams; to give fuller expression to the principle upon which our national life is built. We realize that freedom is the most precious of our treasures, and it will not be allowed to vanish so long as men survive who offered their lives to keep it.

More and more has the value of the individual been brought home to us. Superficially, it would seem that we have acted regardless of individual human lives. But hardly a soldier has fallen who has not left a niche which can never be filled. The humblest soldier torn from his community has left a gap therein, for he was an integral part of it. Through the labors, sacrifices, and devotion, the nation has realized that its strength but reflects the strength and virtue of its members, and the value of each citizen is very closely related to the conception of the nation as a living unit. But unity is impossible without freedom, and freedom presupposes a reverence for the individual and a recognition of the claims of human personality to full development. It is therefore the task of this new spirit to make national unity a reality, at whatever sacrifice, and to provide full opportunities for the development of everyone, both as a living personality and as a member of a community upon which social responsibilities devolve.

We must realize that this has been a conflict, not only immense in area and volume, but profound and complex in issues. It is not now a question of what nations shall survive, but what institutions shall survive. It is not a question of who is the strongest but of what form of life is the strongest. Willingly have the sons of America sacrificed their lives upon the altar of a great and common cause; that through us that larger and more altruistic form of life might retain a place in the world. We must not betray their trust. In the words of Lincoln, we must take increased devotion to that cause for which they gave the last full measure of devotion. "These dead must not have died in vain."[1] For if their loyalty means anything in the sight of God or man it means that it will find its equal in our loyalty, which growing in that larger knowledge and patriotism which makes human action but the reflec-

tion of the divine, will carry to successful fruition the ideals for which these honored ones have sacrificed.

We of the younger generation especially must feel a sacred call to that which lies before us. I go out to do my little part in helping my untutored brother. We of this less favored race realize that our future lies chiefly in our own hands. On ourselves alone will depend the preservation of our liberties and the transmission of them in their integrity to those who will come after us. And we are struggling on attempting to show that knowledge can be obtained under difficulties; that poverty may give place to affluence; that obscurity is not an absolute bar to distinction, and that a way is open to welfare and happiness to all who will follow the way with resolution and wisdom; that neither the old-time slavery, nor continued prejudice need extinguish self-respect, crush manly ambition or paralyze effort; that no power outside of himself can prevent man from sustaining an honorable character and a useful relation to his day and generation. We know that neither institutions nor friends can make a race stand unless it has strength in its own foundation; that races like individuals must stand or fall by their own merit; that to fully succeed they must practice their virtues of self-reliance, self-respect, industry, perseverance and economy.

But in order for us to successfully do all these things it is necessary that you of the favored race catch a new vision and exemplify in your actions this new American spirit. That spirit which prompts you to compassion, a motive instinctive but cultivated and intensified by Christianity, embodying the desire to relieve the manifest distress of your fellows; that motive which realizes as the task of civilization the achievement of happiness and the institution of community spirit.

Further, the feeling or attitude peculiar to those who recognize a common lot must be strengthened; that fraternal spirit which does not necessarily mean intimacy, or personal friendship, but implies courtesy and fair-mindedness. Not only must it underly the closer relations of family, but it must be extended to the broader and less personal relations of fellow-citizenship and fellow-humanity. A fraternity must be established in which success and achievement are recognized, and those deserving receive the respect, honor and dignity due them.

We, too, of this younger race have a part in this new American Idealism. We too have felt the great thrill of what it means to sacrifice for other than the material. We revere our honored ones as belonging to the martyrs who died, not for personal gain, but for adherence to moral principles, principles which through the baptism of their blood reached a fruitage otherwise impossible, giving as they did a broader conception of our national life. Each one of us will endeavor to catch their noble spirit and together in the consciousness of their great sacrifice consecrate ourselves with whatever power we may possess to the furtherance of the great motives for which they gave their lives.

And may I not appeal to you who also revere their memory to join with us in continuing to fight for the great principles for which they

contended, until in all sections of this fair land there will be equal opportunities for all, and character shall be the standard of excellence; until men by constructive work aim toward Solon's[2] definition of the ideal government—where an injury to the meanest citizen is an insult to the whole constitution; and until black and white shall clasp friendly hands in the consciousness of the fact that we are brethren and that God is the father of us all.

Portrait (undated)

With Mary Blair in Eugene O'Neill's All God's Chillun Got Wings, *1924*

IN THE TWENTIES

Paul Robeson Talks of His Possibilities

Interview, *New York Herald-Tribune,* July 6, 1924

"Well, and after 'All God's Chillun,'[1] what?"

Robeson smiled ruminatingly and hummed in his resonant bass: "I got wings, you got wings, all God's chillun—you know the song."

We were in the tiny dressing room in the cellar of the Provincetown Playhouse after the last curtain of O'Neill's play. Despite the heat, despite the somber theme, that last curtain had fallen on an exuberant, enthusiastic crowd, who had recalled the giant negro actor and Miss Blair time and again.

"How do you mean—the song?" we asked.

"I mean we've all got possibilities, capacities for attainment. I don't in the least minimize what I am up against as a negro. And yet, as an actor, I think I have less to buck against than as a lawyer. You see, I started out to be a lawyer. I may be a bit optimistic, but I think if I'm a good enough actor"—Robeson put it very earnestly and modestly—"I can go pretty far. All actors are limited by their physique. A slender five-footer can't play a giant; a buxom, heavyweight lady can't play an ingenue. Well, I've got limitations, too—size and color. Same limitations as other actors have, plus."

It seemed like a very sportsman-like way of putting it, just the way you would expect a scholar and a gentleman, an all-round student, an honor man at college, a first rate athlete to put it. For Robeson is all of these things. But biography must wait for another time. Robeson continued:

"Jim is the third part I have played this year. I was in 'Rosanne,' I played the Emperor Jones, and now this part. It's been an interesting start. As for my development and future as an actor, I couldn't have had a better start than the direction of James Light. For me it beat several full-length courses in a dramatic school. When a negro does any good work as an actor every one begins to talk of Othello. Of course, I think about Othello, but as a sort of culmination. I think of other parts, too. I hope the time will come when a negro actor will not be limited to negro parts. The trend away from realism in the theater should help here. And the theater folk, as artists, should—and do—make things easier than they are in other professions."

We spoke of the all-negro companies, playing straight plays to

67

all-negro audiences. They interest Robeson. He wants the negro actor to have a chance at all the parts in the great human repertoire of dramatic literature—not merely the race repertoire.

And we spoke of the general negro problem. Robeson talks of it without embarrassment, without bitterness—merely as a thoughtful man who has put much thought on a vital theme.

"I'm pretty young," he said, "and for the present I can do no better than to do my own work and develop myself to the best of my ability. It was a happy fate that connected me with the Provincetown for just this. Next year, whatever I am doing, I shall come down here and watch the directing of plays. Incidentally, if I do become a first-rate actor, it will do more toward giving people a slant on the so-called negro problem than any amount of propaganda and argument."

We left fully convinced that "all God's chillun got wings."

An Actor's Wanderings and Hopes
The Messenger, October 1924, p. 32

About 1915, from a rather secluded spot in New Jersey—Somerville to be exact—I read of the interesting debut of Negroes upon the serious dramatic stage of America. Of the four plays by Ridgely Torrence, one, "Simon the Cyrenian," was of unusual interest.[1] Just a short time before, I, as the "Pastor's" son and Sunday School superintendent, had talked at great length about just that man and had pointed out many obvious lessons. Some five years later, after being literally dragged into rehearsal by Mrs. Dora Cole Norman, the honored president and very fine directress of the Colored Players' Guild, I thrust my 215-pound frame upon the small stage of the Y.M.C.A. in the role of that same Simon. At the end, I was congratulated and greatly encouraged by Mr. Torrence, Mr. K. McGowan, Mrs. Hapgood and others, but the "Law" called, and in the mazes of various John Does vs. Richard Roes, I soon forgot my stage experience.[2]

Fate, however, was still conspiring to draw me away from the learned profession, and in the middle of the year I was offered a part in Miss M. Hoyt Wilborg's "Taboo," a play of "Voodooism." After a short run here, "Taboo" was taken to England,[3] where I had the privilege of playing all summer with Mrs. Patrick Campbell.[4] A most interesting experience this, and I received more encouragement from this noted actress.[5]

Coming back I worked for a time in a law office—still the old urge—then came "Emperor Jones" and "All God's Chillun Got Wings." I managed to get in two weeks of "Rosanne"—which I enjoyed immensely. A very fine play I think—and if ever it is revived there awaits a marvelous "Rosanne" in Rose McClendon. Now I'm back again to "Brutus Jones" the "Emperor,"[6] and perfectly happy. It's been

most thrilling—this acting. So much so, that I'm going to keep on trying to do it.

What are the opportunities? Just what I will make them. As I have met people in various circles I find they are pulling for me. Especially my friends at the Provincetown.[7] I honestly feel that my future depends mostly upon myself. My courage in fighting over the rough places that are bound to come—my eagerness to work and learn—my constant realization that I have always a few steps more to go—perhaps never realizing the desired perfection—but plugging away.

I've heard this cry of "the chance" all my life. But I've heard of Aldridge[8] and seen Burleigh,[9] Hayes,[10] Gilpin[11] and Williams.[12] In the field of musical comedy I've seen Sissle[13] and Blake,[14] Miller[15] and Lyles, and now Florence Mills,[16] who, I believe, is in a class by herself. So I have plenty of hope.

True—plays are not easy to get, but they come from most unexpected sources. Before they appeared, who saw an "Emperor Jones" and "All God's Chillun Got Wings"—a "Rosanne." And there is an "Othello" when I am ready. And if I reach the continent, which I hope to do some day, I may play any role. I am unable to comprehend whether they be Negro or otherwise. Perhaps that may come to pass in America. Of course, it is all uncertain. But, tell me, pray, what is life?

One of the great measures of a people is its culture, its artistic stature. Above all things, we boast that the only true artistic contributions of America are Negro in origin. We boast of the culture of ancient Africa. Surely in any discussion of art or culture, music, the drama and its interpretation must be included. So today Roland Hayes is infinitely more a racial asset than many who "talk" at great length. Thousands of people hear him, see him, are moved by him, and are brought to a clearer understanding of human values. If I can do something of a like nature, I shall be happy, I shall be happy. My early experiences give me much hope.

We who start on this rather untrodden way need all the support and encouragement we can possibly get. I approach the future in a happy and rather adventuresome spirit. For it is within my power to make this unknown trail a somewhat beaten path.

Reflections on O'Neill's Plays

Opportunity, December 1924, pp. 368–70

All this seems so very strange to me—writing about the theatre. If, three years ago, someone had told me that I would be telling of my reactions as an actor I would have laughed indulgently. Even now the whole chain of events has a distinct dream-like quality. To have had the opportunity to appear in two of the finest plays of America's most distinguished playwright is a good fortune that to me seems hardly credible. Of course I am very, very happy. And with these things there

has come a great love of the theatre, which I am sure will always hold me fast.

In retrospect all the excitement about "All God's Chillun" seems rather amusing, but at the time of the play's production, it caused many an anxious moment. All concerned were absolutely amazed at the ridiculous critical reaction. The play meant anything and everything from segregated schools to various phases of intermarriage.

To me the most important pre-production development was an opportunity to play the "Emperor Jones," due to an enforced postponement. This is undoubtedly one of "*the* great plays"—a true classic of the drama, American or otherwise. I recall how marvelously it was played by Mr. Gilpin some years back. And the greatest praise I could have received was the expression of some that my performance was in some wise comparable to Mr. Gilpin's.

And what a great part is "Brutus Jones." His is the exultant tragedy of the disintegration of a human soul. How we suffer as we see him in the depths of the forest re-living all the sins of his past—experiencing all the woes and wrongs of his people—throwing off one by one the layers of civilization until he returns to the primitive soil from which he (racially) came. And yet we exult when we realize that here was a man who in the midst of all his trouble fought to the end and finally died in the " 'eighth of style anyway."

In "All God's Chillun" we have the struggle of a man and woman, both fine struggling human beings, against forces they could not control,—indeed, scarcely comprehend—accentuated by the almost Christ-like spiritual force of the Negro husband,—a play of great strength and beautiful spirit, mocking all petty prejudice, emphasizing the humanness, and in Mr. O'Neill's words, "the oneness" of mankind.

I now come to perhaps the main point of my discussion. Any number of people have said to me: "I trust that now you will get a truly heroic and noble role, one portraying the finest type of Negro." I honestly believe that perhaps never will I portray a nobler type than "Jim Harris" or a more heroically tragic figure than "Brutus Jones, Emperor," not excepting "Othello."

The Negro is only a medium in the creation of a work of the greatest artistic merit. The fact that he is a Negro Pullman Porter is of little moment. How else account for the success of the play in Paris, Berlin, Copenhagen, Moscow and other places on the Continent. Those people never heard of a Negro porter. Jones's emotions are not primarily Negro, but human.

Objections to "All God's Chillun" are rather well known.[1] Most of them have been so foolish that to attempt to answer them is to waste time. The best answer is that audiences that came to scoff went away in tears, moved by a sincere and terrifically tragic drama.

The reactions to these two plays among Negroes but point out one of the most serious drawbacks to the development of a true Negro dramatic literature. We are too self-conscious, too afraid of showing all

phases of our life,—especially those phases which are of greatest dramatic value. The great mass of our group discourage any member who has the courage to fight these petty prejudices.

I am still being damned all over the place for playing in "All God's Chillun." It annoys me very little when I realize that those who object most strenuously know mostly nothing of the play and in any event know little of the theatre and have no right to judge a playwright of O'Neill's talents.

I have met and talked with Mr. O'Neill. If ever there was a broad, liberal-minded man, he is one. He has had Negro friends and appreciated them for their true worth. He would be the last to cast any slur on the colored people.[2]

Of course I have just begun. I do feel there is a great future on the serious dramatic stage. Direction and training will do much to guide any natural ability one may possess. At Provincetown I was privileged to be under the direction of Mr. James Light.[3] I'm sure even he thought I was rather hopeless at first. I know I did. But he was patient and painstaking, and any success I may have achieved I owe in great measure to Mr. Light. I sincerely hope I shall have the benefit of his splendid guidance in the future.

What lies ahead I do not know. I am sure that there will come Negro playwrights of great power and I trust I shall have some part in interpreting that most interesting and much needed addition to the drama of America.

Paul Robeson and the Theatre

Interview by William P. Frank, *Every Evening,* Wilmington, Delaware, October 4, 1926

Paul Robeson is one of "God's chillun." Educated at Columbia to become a lawyer, he cast his lot with the theatre, because of the lucky breaks. He wants to excel in whatever work he undertakes and he confesses it would have taken time and effort, and work, and grind, grind, and grind to become a good lawyer—good enough to win the faith of the wealthy Harlemites.

He knows he can sing, but at times wonders if his reputation as an actor is not sometimes far ahead of his actual ability.

"I can hear myself sing," he said in an interview at The Playhouse, while waiting for his cue at the rehearsal of his latest play, "Black Boy." "But the producers say I can act. Well, maybe they know."

He may go back to law and if he does, he will, in all probability, practice in New Jersey. But, at present, he is heart and soul in the theatre. He likes it, enjoys it. The footlights, it seems, fascinate him.

Robeson is a dreamer. Many times he has thought of playing Shakespeare's "Othello," but he believes he lacks the temperament. He enjoys such vehicles as Eugene O'Neill creates—something that will

bring out the Negro spirit, something that smacks of the soil, of the people.

He also dreams of a great play about Haiti, a play about Negroes, written by a Negro, and acted by Negroes.[1] He dreams of a moving drama that will have none of the themes that offer targets for race supremacy advocates. There is a wealth of material in the Negro's past, and, above all, Robeson fears the stereotyped format of plays that will imitate "Lulu Belle" and even the play he now appears in.[2] He also fears the commercialization of the Negro's characteristics and talents, but while fearing this, he seems to accept its coming as inevitable in the American theatre.

Robeson wishes to retain the simplicity of the Negro, of the life of his people which is close to the soil. The savior of his race from commercialization and from the stereotyped forms, in his opinion, is the artist or the actor himself. The actor, he said, should decide whether plays offered to him will tend to uplift, degrade, or create wrong impressions of the Negro.

Almost every day, Robeson receives manuscripts from white and Negro writers with themes that afford Negroes the leading roles. Some are bad and some are good, he said, but thus far, the Negro writer has not entered with any sort of firm standing into the playwright field.

There was one question on which he spoke with interest: The advance of the Negro as the leading man in good plays and the reaction of the audience to such plays. In his estimation, it is a far cry from the Uncle Tom's Cabin production[3] to the present type as "Emperor Jones," or "All God's Chillun Got Wings." The ability of the Negro is being discovered by the whites, he said. The talents of the Negro are being brought to the fore and at last, he added, the shackles of intellectual slavery are being severed.

Robeson places no stock in the statements that Negro acting and concerts of spirituals are fads. He admitted that faddists were interested but he has faith in qualities of his people that in the coming years, the whey will vanish and the rich cream will remain. He also protested against the presumption that the intellegentsia of Harlem were like that of other sections of New York.

"They can't be the same," he said. "We have a race temperament. We are different. To say otherwise would be as foolish as to presume that Bombay was the same as Vienna or Paris."

Before leaving for the rehearsal, Robeson paid high compliments to Carl Van Vechten's book, "Nigger Heaven."[4] He said it was excellently written and judicially presents life in Harlem.

Then, he hurried to the stage and soon, one could have heard him singing "Jack O'Diamonds," or some other folk song the Negro chants in the cotton fields or on the railroad tracks. And, if one could have seen him, he would see a cherubic twinkle in his eye and a naive smile on his face or later, discover a minor note in his voice as he says:

"You are my pale moon in a black sky. You are the day and I am the night. I shall follow you forever and ever."

The Source of the Negro Spirituals

Interview by Sulamith Ish-Kishor, *The Jewish Tribune,* July 22,
1927—Subtitled: Paul Robeson, the Famous Baritone, Tells of the
Drama in the Old Testament That Has Given Birth to the Negro
Songs

It was at a concert given for the benefit of a certain Jewish reconstruc-
tion organization that Paul Robeson received his formal introduction
to the music-lovers of the Jewish race. A big, broad-shouldered man, as
involuntarily pleasing as children are, the colored baritone (who only a
few years ago discovered that he had a voice, and thereupon turned
from the lure of a career as a professional football player or a career as
a lawyer), glided into the goodwill of the audience with extraordinary
ease.

His success before this audience was not due entirely to his large,
rich voice, or to his remarkable skill in using it. Part of his appeal was
unintentionally made by the nature of the songs which he sang. These
songs are called negro spirituals. Their text is largely based on the Old
Testament. Their charm was therefore as universal, compelling as the
Bible stories. Framed in melodies, sometimes amazingly beautiful,
with Mr. Robeson's lovely voice to express them, and having the added
grace of the naivete of the colored race, it was unlikely that a Jewish
audience would fail to delight in them.

Paul Robeson, lawyer and Phi Beta Kappa man, was very willing to
say what he thought was the explanation of the nature of these songs,
and how much and in what respects the colored race had drawn
inspiration and comfort from the Old Testament. Trying to tuck his six
foot three of self into an ordinary-size armchair at his apartment on
upper Broadway, he picked up a large green-and-white book of music
and held it on his knee as he talked.

"It's a curious thing, that the Bible has been the sole law for two
contrasting races—its originators, men of fiery action and inspired
thought, and the enslaved negroes, who were far too meek and mild
and child-hearted. They were just the opposites of the ancient He-
brews; the Hebrews were so war-like, so resentful of domination. The
captive negroes of America took that race as their model, in a way, at
least, by having such a complete and absorbing interest in their
history, yet they somehow never moved a finger to free themselves!"

"But after all, the Jews, all through the Egyptian captivity, had
their memories of former glory and freedom to inspire them with the
hope of future freedom. It is much easier to pick oneself up from a fall,
than to get up when one has always lain supine."

"Yes, I suppose that's so. The Bible was the only form of literature
the captive negroes could get at, even those who could read. It was
natural for their quick imaginations to find a pathetic similarity

between their condition and that of the enslaved Hebrews; I believe that's why the Bible made such a tremendous appeal to the negroes. They saw their own history reflected in it, and they saw their own vague hopes given a sort of false glow of possibility. They felt that their freedom also would depend on some miracle happening, so they had to have intense faith in what they read, or heard read, of the Old Testament. You'll notice, by the way, that comparatively few of the negro spirituals are based on the New Testament. Except for 'Were You There,' which is really very good, and a few others, most of the inspired melodies have been given to the Old Testament themes."

"Is it perhaps because there is so much more drama in the Old Testament?"

"Not only that—of course, almost the whole dramatic action in the New Testament begins and ends in the story of the life of Jesus—but also that the stories of the earlier part were closer to their own lives. What a vision of hope for them the story of Moses was! One of the most beautiful of the spirituals, 'Go Down, Moses,' is based on that."

He hummed the words in that extraordinarily moving, noble voice of his:

> "Go down, Moses, way down in Egypt's land,
> Tell old Pharaoh, 'Let My people go!
> If not, I'll smite your firstborn dead.
> Let My people go!'"

The dignity and slow grace of this melody can only be felt by those who have heard it sung with the feeling that Mr. Robeson puts into it.

"It was really their own plight that they were describing in words and music," he went on. "And by the way, it's a curious thing that these songs were largely written *not* in the negro dialect, but in a language caught from the Bible itself. The negro preachers mostly got their language from the Bible, and not from the ignorant negroes around them. There's the force and swing of the Bible in all they wrote. They made their songs in the same spirit as they read the Bible. And listen to this," he said eagerly as a new thought struck him.

And he hummed, "Rock me, Rock me," with its long, wailing refrain.

"Why, that refrain is like Jewish synagogue music!" I said.

"Yes, isn't it?" he smiled. "Now, I wonder where they could have got that from? It's a song of the negroes of New Orleans."

"Perhaps they did get it from the synagogue," I suggested. "There was quite a large Jewish community in New Orleans. Several of its members were noted Abolitionists. Maybe the negroes there heard them singing in the synagogues."[1]

"That sounds likely," he admitted. "Anyway, the liberation theme struck so deep—the Moses story, the Daniel story, the Joseph story— well, not that one so much—the Joshua story. These stories were so colorful, and they felt so much similarity there to their own plight. It's rather strange, after all, that the negroes didn't catch some of that spirit of the old Patriarchs rather than accept, in action, the precepts of

humility and sufferance taught in the New Testament. You know, Moses wasn't really a meek man. But then, I suppose, that's a case of racial difference. The Hebrews are a war-like people," he laughed. "The colored people do like peace better than most anything. I never was a kid that liked to fight, myself."

For a flash I saw the bowed figure of a magnificent bronze prize-fighter, seated on a low chair, on the stage—the last scene of "Black Boy," in which Mr. Robeson acted last year—and heard that disconsolate voice say, as if quoting himself, "Yas, ah do like singin' better'n fightin'."

"I wonder what they would have done, if they hadn't had the Bible to read their own glorification into," said Mr. Robeson. "It must have been quite a comfort. I don't suppose most of them understood it at all; they grasped the ideas, in the main, and then had to put them into a simpler form, which is quite distinctive. Here's what I mean."

He gave me the big green-and-white-covered book of spirituals, and pointed out three songs; his large hand somehow reminded me of the long clean roots of a forest-tree, with its long joints and rhythmic shape.

The songs he had indicated were, "Joshua Fit de Battle of Jericho," and "Who'll Be a Witness for My Lord," and "Little David."

> "Joshua fit de battle of Jericho, Jericho, Jericho,
> Joshua fit de battle of Jericho,
> And de walls came tumbling down
> That morning!
> You can talk about your king of Gideon,
> You can talk about your man of Saul,
> There's none like good old Joshua
> At de battle of Jericho!
> Up to the walls of Jericho
> He marched with spear in hand,
> 'Go blow dem ram's horns,' Joshua cried,
> 'For de battle am in my hand!' etc."

"See how the negroes took the story, and to make it more vivid for themselves, reduced it to the simplest terms. Naturally, they didn't improve it, but they took it to their hearts! Then there's 'Who'll Be a Witness For My Lord,' which recounts the high lights in the stories of Methuselah, Samson, and Daniel, and 'Little David.' The group who composed these songs were naturally artistic, and they were able to translate the grand epics of one people into naive terms for their own inspiration."

Not all the negro folk-songs are spirituals. A large proportion of them are songs of their own experiences. One of the grandest of these is "Water-Boy," a song of the negro chain-gangs. In these, too, the almost primitive rhythms and musical phrases of the spirituals are employed with great effect. But, for some reason, none of these folk-songs reach quite the same heights of dignity and beauty as does,

for example, "Deep River" (where the voice of Robeson at the phrase, "Oh, don't you want to go there, to that promised land, where all is peace," seems to burst into hot bloom like the sudden sunlight on a hillside of tropic flowers), or "Stand Still, Jordan," where Mr. Robeson carries the melodic line in one tense, molten flow of gold.

Of this remarkable singer a brilliant young woman editor of wide experience uttered one of the best criticisms. "This man is an aristocrat," she said. "I would not have believed it possible that, so early as 1927, the negro race should produce so highly developed a character. I enjoy him more than X—(she mentioned a famous foreign artist)—because X embroiders and trims his art, but Robeson is truly simple. X seems to consider his art a thing within himself, which he has developed, while Robeson is humble, like a priest, before the temple which he conceives his art to be."

Robeson in London
Can't Explain His Success

Interview, *London Evening News and African World*—Reprinted in *Baltimore Afro-American*, September 22, 1928

We sat looking out over Regent's Park where little children were playing merrily under the trees and girls in pretty frocks were rowing on the glittering water.

But though I saw all these attractive sights each time my eyes strayed that way my ears were filled with the sound of the gorgeously rich and flexible voice of Paul Robeson, the Negro singer and actor who is now appearing in London. With striking simplicity he was telling me about himself.

Black as the ace of spades, immensely tall, his broad shoulders and great torso filled the chair in which he sat. But it was the broad high forehead, broader than most Negroes have, the almost gentle expression of his curiously light brown eyes, and his long, slim hands that most attracted the attention.

"I don't know what it is," he said. "Perhaps I never shall, but there is something within me that all my life has caused me to succeed whenever I appeared before the public far beyond what my experience, training or knowledge deserved."

I have heard many famous people discuss themselves and indulge in a little introspection, but never have I heard a man talk of himself and his gifts with the detachment, the almost childlike simplicity of this giant Negro genius whose father started life as a slave.

"I haven't ever been nervous of the public or frightened of appearing before a lot of people. I suppose I should have been—most other boys are. But I remember when I was only nine years old, just a child, I used to recite in the church where my father was minister. One day I forgot

the text of my piece—I think it was 'The Charge of the Light Brigade.'
I didn't become excited nor did the people laugh at me. I just waited
and they just waited until I had picked up the lost lines.

"Then I went to college and there joined the debaters. It was at that
period that I first noticed the attitude of my audiences towards me. I
debated for my university against others all over America and won
each time.

"I played American football and became pretty good. I remember
that in a big match for my college the other side protested when I, a
coloured man, walked on the field to play against them.[1] The protest
did not worry me a lot, though, of course, it hurt. For all we coloured
folk in America work with the heavy yoke of colour as a life load.

"I played in that match and I played hard. I wasn't unnecessarily
rough, but I was rough and I handled some of their men absolutely
without mercy!

"When it was over I could have fainted with surprise. Every man in
the enemy pack filed in front of me and shook my black hand!"

He smiled his slight boyish smile again.

"Often I have wondered just what is this spirit inside of me that
makes me do things right. But I have nearly given up; it is beyond me.
I studied law at college and passed out into a solicitor's office. I was
keen to be a lawyer. I thought this gift of getting people to listen to me
would probably be a great help.

"I was getting on very well when I was asked by some friends to act
in a play—just once—that they were getting up. At school I had acted
just like other boys. I didn't particularly care for acting, but I agreed to
act in this play, just for the fun of it.

"Well, it happened that Eugene O'Neill, the American dramatist,
was in the house. He came round to see me afterwards and told me I
should act and that I should play the part of Emperor Jones in his
great play which was to be produced in London. I laughed at the idea,
though, of course, I appreciated his interest, and went back to my law
work.

"O'Neill and others repeatedly asked me to do the 'Emperor.' I didn't
want to. I was too interested in the law. At last, however, I fell for it. I
played the 'Emperor,' and the London critics said I was one of the great
actors!

"Soon after that I was persuaded to sing in public. I did after much
discussion. Immediately I was proclaimed one of the great singers!"

The handsome Negro shook his head.

"I had never sung in public before; I had never had a lesson in
singing in my life!

"I simply couldn t understand it. I didn't sing these spirituals in any
tradition, because I didn't even know any tradition. I knew the songs
from the time I was a child and they were mostly songs sung in unison
by a lot of people. I just sang them as I felt their meaning."

He leaned towards me and a candid, hearty smile lit up his face. His
beautiful voice fell almost to a whisper.

"There can never be any likelihood of my getting a swelled head, conceited; of my perspective being warped by success or anything utterly nonsensical like that; but my immediate success as a singer and an actor seemed to me [illegible]. How could I be when I knew nothing of either art?

"I go on training my voice and learning all I can, but always I find myself guided by instinct when I get on the platform to sing, and presumably I always shall.

"I shall only act in plays very rarely now, for I feel that I can achieve more by singing one single song than by doing my best in even a good play. There are so many distractions in a play, so many influences."

He smiled as I rose to go. "I shall probably never know my guardian angel, and though once I sought him earnestly, now I don't want to know him."

Scene from Sanders of the River, *later denounced by Robeson*

Paul Robeson Speaks
about Art and the Negro

Interview by T. Thompson, *The Millgate,* London, December 1930, pp. 157–58

Most of us have heard Paul Robeson sing spirituals on the wireless or the gramophone,[1] but to hear him in person is a great and moving experience. To see him act is even more stirring. His magnificent stature and terrific intensity make him undoubtedly one of the impressive personalities on the stage to-day. His "Othello" has been one of the events of the season.[2]

I met him in his dressing-room at the Palace Theatre, Manchester, where he had been giving a selection of negro spirituals and the first act of Eugene O'Neill's "Emperor Jones."[3] He was still in the uniform of that forbidding "monarch"; but I found him ready to talk on any matter concerning his art—and his race. Paul Robeson is proud of his race and deeply concerned with its progress.

I mentioned that Sir Richard Terry[4] wrote with some disparagement of negro spirituals, and Robeson smiled. "Sir Richard Terry and other critics seem to miss the point," he said. "Negro spirituals have the same value as other folk songs, and there are many excellent melodies amongst them. But they are also an expression of the yearnings of a child-like people to be delivered from bondage. There seemed to be no signs of a good time on this earth for the negro, and the Bible held our promise of better times in the next world. But in Africa the negro has a music of his own." (Here he drew himself up and his eyes glowed). "Let me tell you. I shall come back from Africa within five years with a music that is as revolutionary as other phases of negro art. The negro in Africa is not tied down to half or quarter tones, or any European musical conventions."

"About modern sculpture and painting," said I. "That is a fine head that Epstein[5] has done from you. I fancy the negro has had his share in the forming of modern ideas in art."

"Epstein is a great sculptor," said Robeson. "In Africa (the true home of the negro, not America) German and French explorers found pieces

of sculpture—mainly in wood—equal, if not superior, to anything done by the ancient Greeks. The Greeks were mainly concerned with bodily perfection, and this ideal was reflected in their sculpture—so long held up as a pattern. The negro reached forward to his gods and his conception of spiritual essentials. If his sculpture expressed the intensity of his feelings he did not care whether his carvings looked like human beings or not. Ancient negroid sculpture profoundly impressed sculptors like Epstein and painters—notably Matisse[6]— who found themselves unsatisfied with the mere copying of Nature. Modern French art is especially indebted to the creative art of the negro."

"Are there signs that dramatic art will absorb these modern ideals?" I asked. "I can conceive a drama expressed in symbols rather than the older-fashioned realism."

"Drama has already moved that way. Dramatists like Eugene O'Neill refuse to be held down to the old idea of how a play ought to be written. And plays tend to be more episodic—as life really is—rather than a story written up to fit three acts and so many scenes."

"How far is propaganda compatible with art? I note a tendency of political parties to form dramatic groups."

"In so far as a play reflects some social aspect there would seem to be nothing wrong from the artistic point of view. But I do not think it is the business of the stage to force an audience to accept distorted opinions."

"What do you think of the amateur?"

After due reflection he answered: "I think the amateur movement is the most important factor in dramatic art to-day. I began as an amateur myself in Provincetown."

Paul Robeson insisted that the negro was progressing, even in the United States. Indeed, in America, people were falling over themselves to see negro plays like "Green Pastures,"[7] which we in England consider to be blasphemous, because the primitive God of the coloured man appears on the stage. If they are misunderstood in England it will not be the fault of Robeson. Off the stage he is the charming man of culture. On the stage he is the voice of one crying for his people. There is a memorable picture in "Emperor Jones" where a giant swashbuckling negro swaggers through a door to face death in a magnificent uniform—and a "top" hat! That is one phase of the negro character.

Then there is a great shy man in a dress-suit singing dreamy songs about Jesus and "Ole Man River" with a voice of rare beauty. There is something magnetic in these crooning melodies and the way they are sung. A passionate burst of song and a whole people voices its surging appeal:—

O, Moses, the cloud shall cleave the way,
 Let My people go;
A fire by night, a shade by day.
 Let My people go.

Go down, Moses,
Way down in Egypt land,
Tell ole Pharaoh,
Let My People go.

If there are critics who think there is nothing in the negro spiritual let them hear Paul Robeson sing. They will soon change their minds.

Paul Robeson and Negro Music

Interview, *The New York Times,* April 5, 1931

Paul Robeson's farewell concert in America before leaving for England, where he is to play the lead in Eugene O'Neill's "The Hairy Ape,"[1] is his appearance at the County Centre, White Plains, on Thursday evening, April 16, singing with the Westchester Negro Choral Union as guest soloist. According to Mr. Robeson, the occasion is of more than passing significance, since it places him on the stage with some 700 members of his own race, all singing old spirituals. And the peculiar importance of this, he explained in an interview on the subject, is that in the effective organization of so large a body of Negro spiritual singers lies the hope of preserving the unique contribution of his race to the music of America.

"If the American Negro is to have a culture of his own he will have to leave America to get it, unless more such groups as that in Westchester arise all over the land to cherish and develop our old spirituals. It is refreshing to come back to New York to discover that here, within an hour of the metropolis, is a band of 700 singers, rehearsing and training under capable leadership, devoting their time to the singing of the spirituals.

"Throughout the country, with few exceptions, I found a contrary condition to be true. I found a special eagerness among the younger and, I am sorry to say, the more intelligent Negroes, to dismiss the spiritual as something beneath their new pride in their race. It is as if they wanted to put it behind them as something to be ashamed of—something that tied them to a past in which their forefathers were slaves."

Expanding on this idea, Mr. Robeson said that wherever large Negro audiences welcomed him there was a demand for the inclusion of the German, French and Continental classics on his program. He went on:

"It always makes me unhappy to do this. I prefer a program entirely made up of spirituals, because I know that therein lies our sound and enduring contribution. I know that in the concession to the music of other peoples in our Negro programs, magnificent and masterly though they may be, lies the eventual obliteration of their own folk-music, the musical idioms of our race. By accepting the white man's music we are passing out of the scene as creators and interpret-

ers of the finest expression and the loftiest we have to offer. Either we
must encourage more groups like that in Westchester to preserve our
folk-music, or we must leave this country, those of us who want to see
our music preserved, and go to Africa, where we can develop indepen-
dently and bring forth a new music based on old roots."

Thoughts on the Colour Bar

The Spectator,[1] London, August 8, 1931, pp. 177–78

In reviewing my own experience of the Colour Bar, and the convictions
which that experience has done much to form, I think I can lay claim to
an impartiality which is—not altogether surprisingly—rare among
those whose contact with racial problems has been, by the accident of
birth, the same as mine. For me, detachment is possible because my
life as a coloured man has been fortunate in many ways. In my early
life I escaped all those ugly things which break or embitter so many of
my race in America. I was born in the North, in New Jersey. My father
was a clergyman, and in the town where we lived the people deeply
respected him. I went to a good school; the other children there were
mostly white, but they were fair and kind to me, and so were their
families. I was happy there, and I did well. It was the same at college.
Intellectually and athletically I was the equal of and often ahead of the
boys of my age; they respected me for winning the distinctions which
we all prized, and I think they liked me. Afterwards I found that,
thanks to certain gifts which I happened to possess, I was still able, as
it were, to stand on my own feet—to make a name for myself in a way
which people appreciated. Though I was sometimes hurt, there was
nothing in my youth to plant the seeds of hatred and fear in me as they
are planted in the less fortunate of my race. Moreover, my environ-
ment as a child—my natural, matter-of-course relations with white
people—saved me from that ingrained self-consciousness which is
often an unacknowledged obstacle in the intercourse between black
and white. At the same time I remained in the closest contact with my
people, absorbing their background and developing a just pride in their
achievements.

I say this to suggest that I am able to discuss the Colour Bar dis-
passionately—that I have no personal grievance to air in propaganda.

The large negro community in the Southern States has always
represented a very difficult problem. Deeply rooted—even to-day—in
the Southerner's attitude towards the negro who was once his slave are
the twin ideas of domination and fear. A Chief Justice of the Supreme
Court of the United States once said: "The negro has no rights which
the white man is bound to respect,"[2] and that conception, though few
Americans would express it to-day, still underlies many of the dealings
of the white race with the black. In many places the negro still endures
conditions of peonage which are akin to slavery.[3] His rights to

representation are still often overlooked or over-ridden.[4] It is only recently, and in certain places, that he is beginning to receive—usually through his own efforts—the education he deserves.[5] In its economic bearings the problem has actually grown more acute during these last two years of depression. In the face of widespread unemployment the "poor white" is now eager to take on jobs which he formerly considered beneath him and fit only for a negro.[6]

Economically, the negro problem is mainly the South's problem. Socially, though it involves the whole of the United States, it is in a different sense the South's problem, too, and for this reason. An exchange of ideas goes on all the time between North and South. But it is not, in this instance, a fair exchange. In the North the negro moves with comparative freedom: enjoys most civic rights: learns—and even teaches in mixed secondary schools—side by side with the white: and generally maintains a high standard of living.[7] In short, the North's attitude towards the negro, though it can hardly be described as friendly, is much more capable of tolerance than the South's, which is based on very strong, very old traditions and informed by a certain instinctive, unbending fanaticism. One white Southerner, at Washington or elsewhere, can influence the decisions of a roomful of Northerners. His feelings are fierce, deep, and strong: he has a cause to fight for. They have none. There is not sufficient impulse—how should there be?—behind the vague ideals of tolerance to drive them through the barriers of bigotry, which in this case custom has hallowed with respectability. There is an analogy in my own experience with London hotels. The English hotels—the hotels kept for English people—take me in gladly and treat me with the greatest consideration. But there are difficulties if I want even to dine in any of the places where rich Americans come to stay. The intolerance of the few, or the risk of it, carries the day against the wider humanity of the many.

In America the most absurd results can be produced, not merely by prejudice itself, but by respect for prejudice. A short time ago a number of American mothers who had been bereaved in the War were sent, at the expense of the U.S. Government, to visit the graves of their sons in France. The negro mothers were segregated from the rest[8]—that was insult enough. But it was hard that they should have been sent over to Europe in poor ships with inferior accommodation, for the negro troops did very fine work in the War. To turn to lighter but not less revealing examples, there are one or two rather ridiculous things about my own position as a serious artist. I have had great difficulty in making films in America. There is the possibility that Southern audiences might object to me, not as a film actor (I suppose I could do small parts) but as a film *star*. They would resent the knowledge that a negro was enjoying the social and economic advantages of the star's position. Again, in certain towns it is impossible for me to sing, because the municipal authorities refuse to "hire the hall." One manager (in New York) even had doubts about booking me for the wireless. He said that he would have to investigate. My singing of

their well-loved Southern songs—or, more accurately, the knowledge that I was being paid highly for singing them—might, he was afraid, offend the listeners in the South.

These are small things, perhaps. But it is the *atmosphere* of which they are symptomatic which is the greatest evil of the Colour Bar in its present stage of development. As things stand to-day, even the luckiest negro must always feel alien in the country to which he is more truly indigenous than 90 per cent of his white "compatriots." A brilliant negro essayist[9] has suggested that the negro's greatest gift to America is his creation in the American white of a very deep-rooted "superiority complex," and that those qualities of American self-confidence which too often find unworthy expression in bumptiousness and an aggressive reluctance to be disciplined are partly founded on the consciousness, which is the birthright of every American, that, however poor a fellow he may be, there is always a caste, a whole race of men, to whom he has inherited a contemptuous superiority. It may be well at this point to recall the verdict of a very distinguished Englishman on that caste. In his great treatise on the American Commonwealth Lord Bryce gives it as his opinion that no portion of the human race had made so swift a progress in so short a time as the negroes of America since their emancipation.[10]

Now, as to the most important part which, in my opinion, the negro is qualified to play in the American scene. I would define it as "cultural," with emphasis upon the spiritual aspect of that culture. With the passing of the Indians, the negroes are the most truly indigenous stock in North America. They have grown up with the country, becoming part of the soil itself. They have had a better chance than any other of the races which have come to America to identify themselves with the atmosphere of the place, if only because they have been there much longer. They have been unhappy and badly treated, but they have retained (though they have not been allowed fully to express) their best and most characteristic qualities: a deep simplicity, a sense of mystery, a capacity for religious feeling, a spontaneous and entirely individual cheerfulness; and these have found expression in the only culture which Americans can point to as truly belonging to their country.

Their folk-lore and folk music (though the latter has in recent years been assiduously prostituted all over the civilized world) are still a strong and living tradition. Their rich and colourful life has provided the deepest sources for dramatic treatment in prose or poetry (e.g., *The Emperor Jones, Porgy, Green Pastures, All God's Chillun*). In fact the whole of American culture is deriving from negro culture those qualities which appeal most directly to the intelligent European who values a depth of native tradition in art. These cultural actualities and potentialities have survived years of repression, but they can develop only with great difficulty in a hostile environment.

As one interested primarily in the arts and in the individual, I would much rather see a world striving for deep cultural and spiritual values

which acknowledge no narrow national, racial, or religious boundaries. In this present age, with proper encouragement, some such impulse might well be given by a people upon whom nature has bestowed, and in whom circumstances have developed, great emotional depth and spiritual intuition, comparable indeed to that of another race, whose faith was nurtured upon African soil—the ancient Hebrews.

Robeson Spurns Music He "Doesn't Understand"

Interview, *New York World-Telegram,* August 30, 1933

LONDON, Aug. 30.—Paul Robeson, who made the part of "Emperor Jones" synonymous with his name, may soon be singing to his audiences in Russian, Hebrew or Chinese—but he will never sing again in either French, German or Italian.

"I will not do anything that I do not understand. I do not understand the psychology or philosophy of the Frenchman, German or Italian. Their history has nothing in common with the history of my slave ancestors. So I will not sing their music or the songs of their ancestors," he said.

"But I know the wail of the Hebrew and I feel the plaint of the Russian. I understand both, as I do the philosophy of the Chinese, and I feel that both have much in common with the traditions of my own race. And because I have been frequently asked to present something other than Negro art I may succeed in finding either a great Russian opera or play, or some great Hebrew or Chinese work, which I feel I shall be able to render with a necessary degree of understanding."

It is part of the inferiority complex of the American Negro, he added, to consider that it is an achievement for a Negro singer to sing in a white man's opera house.[1]

"Why shouldn't any Negro who has a good enough voice sing in an opera and in any language? But what does that prove? Merely that he or she has a good voice and may be a good actor."

It is only possible to render well in art what one understands thoroughly, according to Robeson.

"I fail to see how a Negro can really feel the sentiments of an Italian or a German, or a Frenchman, for instance. So I really can't see where the achievement is in singing in an opera in any of those languages. Of course, if there were a great opera written by a Negro on an African theme,[2] I should say it would be just as insignificant an achievement for a white opera singer to give a credible performance of it.

"I believe that one should confine oneself to the art for which one is qualified. One can only be qualified by understanding, and this is born in one, not bred."

The Culture of the Negro

The Spectator, London, June 15, 1934, pp. 916–17

Critics have often reproached me for not becoming an opera star and never attempting to give recitals of German and Italian songs as every accomplished singer is supposed to do. I am not an artist in the sense in which they want me to be an artist and of which they could approve. I have no desire to interpret the vocal genius of half a dozen cultures which are really alien to me. I have a far more important task to perform.

When I first suggested singing negro spirituals for English audiences, a few years ago, I was laughed at. How could these utterly simple, indeed, almost savage songs interest the most sophisticated audience in the world? I was asked. And yet I have found response amongst this very audience to the simple, direct emotional appeal of negro spirituals. These songs are to negro culture what the works of the great poets are to English culture: they are the soul of the race made manifest. No matter in what part of the world you may find him the negro has retained his direct emotional response to outside stimuli; he is constantly aware of an external power which guides his destiny. The white man has made a fetish of intellect and worships the God of thought; the negro feels rather than thinks, experiences emotions directly rather than interprets them by roundabout and devious abstractions, and apprehends the outside world by means of intuitive perception instead of through a carefully built up system of logical analysis. No wonder that the negro is an intensely religious creature and that his artistic and cultural capacities find expression in the glorification of some deity in song. It does not matter who the deity is. The American and West Indian negro worships the Christian God in his own particular way and makes him the object of his supreme artistic manifestation which is embodied in the negro spiritual. But, what of the African negro? What is the object of his strong religious sense, and how does his artistic spirit manifest itself? These are the questions I have set myself to answer.

As a first step I went to the London School of Oriental Languages and, quite haphazardly, began by studying the East Coast languages, Swahili[1] and the Bantu group which forms a sort of Lingua Franca of the East Coast of Africa.[2] I found in these languages a pure negro foundation, dating from an ancient culture, but intermingled with many Arabic and Hamitic[3] impurities. From them I passed on to the West Coast Negro languages and immediately found a kinship of rhythm and intonation with the negro-English dialect which I had heard spoken around me as a child. It was to me like a home-coming, and I felt that I had penetrated to the core of African culture when I began to study the legendary traditions, folksong and folklore of the

West African negro. I hope to be able to interpret this original and unpolluted negro folksong to the Western world and I am convinced that there lies a wealth of uncharted musical material in that source which I hope, one day, will evoke the response in English and American audiences which my negro spirituals have done; but for me this is only one aspect of my discovery.

Culturally speaking, the African negro, as well as his American and West Indian brothers, stands at the parting of the ways. The day is past when they were regarded as something less than human and little more than mere savages by the white man. Racial tolerance and political equality of status have taken the place of oppression and slavery for the greater part of the negro race. But the sufferings he has undergone have left an indelible mark on the negro's soul, and at the present stage he suffers from an inferiority complex which finds its compensation in a desire to imitate the white man and his ways; but I am convinced that in this direction there is neither fulfilment nor peace for the negro. He is too radically different from the white man in his mental and emotional structure ever to be more than a spurious and uneasy imitation of him, if he persists in following this direction. His soul contains riches which can come to fruition only if he retains intact the full spate of his emotional awareness, and uses unswervingly the artistic endowments which nature has given him.

It is astonishing and, to me, fascinating to find a flexibility and subtlety in a language like Swahili, sufficient to convey the teachings of Confucius,[4] for example, and it is my ambition to make an effort to guide the negro race by means of its own peculiar qualities to a higher degree of perfection along the line of its natural development. Though it is a commonplace to anthropologists, these qualities and attainments of negro languages are entirely unknown to the general public of the Western world and, astonishingly enough, even to the negroes themselves. I have met negroes in the United States who believed that the African negro communicated his thoughts solely by means of gestures, that, in fact, he was practically incapable of speech and merely used sign language!

It is my first concern to dispel this regrettable and abysmal ignorance of the value of its own heritage in the negro race itself. As a first step in this direction I intend to make a comparative study of the main language groups: Indo-European, Asiatic and African, choosing two or three principal languages out of each group, and indicate their comparative richness at a comparable stage of development. It may take me five years to complete this work but I am convinced that the results will be adequate to form a concrete foundation for a movement to inspire confidence in the negro in the value of his own past and future.

I Want to Be African

In *What I Want From Life,* E. G. Cousins, Editor,
London, 1934, pp. 71–77

I am a Negro. The origin of the Negro is African. It would therefore
seem an easy matter for me to assume African nationality.

Instead it is an extremely complicated matter, fraught with the
gravest importance to me and some millions of coloured folk.

Africa is a Dark Continent not merely because its people are
dark-skinned or by reason of its extreme impenetrability, but because
its history is lost.[1] We have an amazingly vivid reconstruction of the
culture of ancient Egypt, but the roots of almost the whole remainder
of Africa are buried in antiquity.

They are, however, rediscoverable; and they will in time be rediscov-
ered.

I am confirmed in this faith by recent researches linking the *culture*
of the Negro with that of many peoples of the East.

Let us consider for a moment the problem of my people—the African
Negroes in the Occident, and particularly in America.

We are now fourteen millions strong—though perhaps "strong" is
not the apt word; for nearly two and a half centuries we were in chains,
and although to-day we are technically free and officially labelled
"American Citizen," we are at a great economic disadvantage, most
trades and many professions being practically barred to us and social
barriers inexorably raised.

Consequently the American Negro in general suffers from an acute
inferiority complex; it has been drummed into him that the white man
is the Salt of the Earth and the Lord of Creation, and as a perfectly
natural result his ambition is to become as nearly like a white man as
possible.

He is that tragic creature, a man without a nationality. He claims to
be American, to be British, to be French—but you cannot assume a
nationality as you would a new suit of clothes.

In the country of his adoption, or the country that ruthlessly adopted
his forebears, he is an alien; but (herein lies his tragedy) he believes
himself to have broken away from his true origins; he has, he argues,
nothing whatever in common with the inhabitant of Africa to-day—
and that is where I believe he is wrong.

It may be asked "Why disturb him if he is happy in his present
state?"

There are two sufficient answers to that; one that he is *not* happy,
except in so far as his natural gaiety of disposition overcomes his
circumstances—and the fact that a sick man laughs is surely no reason
for not attempting to cure his sickness; and the other is that there is a
world-necessity above and beyond his immediate needs.

This world-necessity is for an understanding between the nations and peoples which will lead ultimately to the "family of nations" ideal.

To this world-community every nation will contribute whatever it has of culture; and unless the African Negro (including his far-flung collaterals) bestirs himself and comes to a realization of his potentialities and obligations there will be no culture for him to contribute.

At present the younger generation of Negroes in America looks towards Africa and asks "What is there *there* to interest me? What of value has Africa to offer that the Western world cannot give me?"

At first glance the question seems unanswerable. He sees only the savagery, devil-worship, witch-doctors, voo-doo, ignorance, squalor, and darkness taught in American schools.

Where these exist, he is looking at the broken remnants of what was in its day a mighty thing; something which perhaps has not been destroyed, but only driven underground, leaving ugly scars upon the earth's surface to mark the place of its ultimate reappearance.

We know that in China there was a great and mighty culture—mighty in the sense not of pomp but of potency. An exiled Chinese to-day, at University in Manchester or Birmingham, might look towards China and ask the self-same question—"What has that chaos of conflicting misgovernments and household gods and superstitions to offer me?"—but we know enough of history to be aware that great cultures do not completely die, but are soil for future growths.

That portion of China that is only Buddhist is negligible, the publicized part, the unscratched surface; below are the vast depths of spirituality of which Taoism[2] in its present-day form is the broken relic.

Somewhere, sometime—perhaps at the Renaissance, but I think much earlier—a great part of Religion went astray. A blind groping after Rationality resulted in an incalculable loss in pure Spirituality. Mankind placed a sudden dependence on that part of his mind that was brain, intellect, to the discountenance of that part that was sheer evolved instinct and intuition; we grasped at the shadow and lost the substance . . . and now we are not even altogether clear what the substance was.

Now the pendulum is swinging back. Preaching in London not long ago, Father Bede Frost is reported to have said:

> The epoch that began at the end of the sixteenth century is now ending. You can see the tiles fall from the roof, the walls beginning to crack. . . .
> During that epoch men's minds have been influenced by three dogmas:
> The perfectability of man in himself,
> The inevitability of progress towards a golden age,
> The infallibility of physical science.

Mankind is gradually feeling its way back to a more fundamental, more primitive, but perhaps truer religion; and religion, the orienta-

tion of man to God or forces greater than himself, must be the basis of all culture.

This religion, this basic culture, has its roots in the Far East, *and in Africa.*

What links the American Negro to this culture? It would take a psycho-anthropologist to give it a name; but its nature is obvious to any earnest inquirer.

Its manifestation occurs in his forms of religion and of art. It has recently been demonstrated beyond a possibility of doubt that the dances, the songs, and the worship perpetuated by the Negro in America are identical with those of his cousins hundreds of years removed in the depths of Africa, whom he has never seen, of whose very existence he is only dimly aware.

His peculiar sense of rhythm alone would stamp him indelibly as African; and a slight variation of this same rhythm-consciousness is to be found among the Tartars and Chinese, to whom he is much more nearly akin than he is to the Arab, for example.

Not long ago I learned to speak Russian, since, the Russians being so closely allied through the Tartars to the Chinese, I expected to find myself more in sympathy with that language than with English, French, or German. I was not disappointed; I found that there were Negro concepts which I could express much more readily in Russian than in other languages.

I would rather sing Russian folk-songs than German grand opera—not because it is necessarily better music, but because it is more *instinctive* and less *reasoned* music. It is in my blood.

The pressing need of the American Negro is an ability to set his own standards. At school, at university, at law school, it didn't matter to me whether white students passed me or I passed them. What mattered was, if I got 85 marks, *why didn't I get* 100? If I got 99, *why didn't I get* 100? "To thine own self be true" is a sentiment sneered at to-day as merely Victorian—but upon its observance may well depend the future of nations and peoples.

It is of course useful and even necessary from an economic and social standpoint for the Negro to *understand* Western ideas and culture, for he will gain nothing by further isolating himself; and I would emphasize that his mere physical return to his place of origin is not the essential condition of his regeneration. In illustration of this take the parallel case of the Jews.

They, like a vast proportion of Negroes, are a race without a nation; but, far from Palestine, they are indissolubly bound by their ancient religious practices—*which they recognize as such.* I emphasize this in contradistinction to the religious practices of the American Negro, which, from the snake-worship practised in the deep South to the Christianity of the revival meeting, are patently survivals of the earliest African religions; *and he does not recognize them as such.*

Their acknowledgment of their common origin, species, interest, and attitudes binds Jew to Jew; a similar acknowledgment will bind Negro and Negro.

I realize that this will never be accomplished by viewing from afar the dark rites of the witch-doctor—a phenomenon as far divorced from fundamental reality as are the petty bickerings over altar decorations and details of vestment from the intention of Christ.

It may be accomplished, or at least furthered, by patient inquiry. To this end I am learning Swahili, Tivi,[3] and other African dialects— which come easily to me *because their rhythm is the same as that employed by the American Negro in speaking English;* and when the time is ripe I propose to investigate, on the spot, the possibilities of such a regeneration as I have outlined.

Meanwhile in my music, my plays, my films I want to carry always this central idea: to be African.

Multitudes of men have died for less worthy ideals; it is even more eminently worth living for.

Negroes—Don't Ape the Whites

Daily Herald, London, January 5, 1935—Reprinted in *Chicago Defender,* January 26, 1935, under the title "I Don't Want to Be White"

Sometimes I think I am the only Negro living who would not prefer to be white.

It has been said that I am to leave Europe and go back among my own people. That does not mean that I am to abandon my career. Though I shall visit Africa, and perhaps spend months among the Africans, I shall return to Europe.

Where I live is not important. But I am going back to my people in the sense that for the rest of my life I am going to think and feel as an African—not as a white man.

Perhaps that does not sound a very important decision. To me, it seems the most momentous thing in my life.

Only those who have lived in a state of inequality will understand what I mean—workers, European Jews, women . . . those who have felt their status, their race, or their sex a bar to a complete share in all that the world has to offer.

All these people will understand what it is that makes most Negroes desire nothing so much as to prove their equality with the white man—*on the white man's own ground.*

All these can feel for the Negro, but only a few will recognize that the very impulse which drives them to copy those with the desired status, is killing what is of most value—the personality which makes them unique.

Let us take a concrete example. What would have become of the genius of Marie Lloyd[1] if she had been ashamed of being Cockney? Would Robert Burns[2] have been as great a poet if he had denied his ploughman speech and aped the gentlemen of his day?

Do not misunderstand me. Do not think I am trying to say that those

born to inequality cannot become cultured people. I mean exactly the reverse. I am attacking the impulse which drives such people to hide their true value under a false foreign culture, applied from the outside, when, instead, they could encourage a graceful, natural growth from within.

It is not as imitation Europeans, but as Africans, that we have a value.

Yet the brains of the best Negroes have been applied to turning themselves into imperfect imitations of white gentlemen, while it has been left to the astute white man to pick up and profit by what has been cast aside.

Why was it a white man who wrote "Green Pastures"[3] and made a fortune from it?

While Negro musicians have been labouring with Beethoven[4] and Brahms[5]—composers quite foreign to their temperament—Stravinsky has been borrowing from Negro melodies.

In a popular form, Negro music, launched by white men—not Negroes—has swept the world.

While Negro artists attempt pale copies of Western art, Epstein derives inspiration from ancient Negro sculpture. No Negro will leave a permanent mark on the world till he learns to be true to himself. Yet no Negro—nor any other person in a similar position—is going boldly to set a value on his own inherent qualities until something has happened to restore his respect for them.

Frankly, years ago, I would not have said—as I do now—that I am *proud* to be a Negro. I did not know that there was anything to be proud about. Since then I have made many discoveries.

They began when I was still a student. I came in contact with Russians at college. I heard them sing their native songs and was struck by their likeness to Negro music. What was wrong with our despised music if it was akin to the revered Russian? Had we a value that had been passed by?

Were the outcast Negroes, who were struggling to assimilate fragments of the unsympathetic cultures of the West, really akin to the great cultures of the East? It was a fascinating thought.

I began to make experiments. I found that I—a Negro—could sing Russian songs like a native. I, who had to make the greatest effort to master French and German, spoke Russian in six months with a perfect accent, and am now finding it almost as easy to master Chinese.

I discovered that this was because the African languages—thought to be primitive because monosyllabic—had exactly the same basic structure as Chinese. I found that Chinese poems which cannot be rendered in English would translate perfectly into African.

I found the African way of thinking in symbols was also the way of the great Chinese thinkers.

I found that scientists had been puzzled by the strange similarity between ancient African and Chinese art.

I found that I, who lacked feeling for the English language later than Shakespeare,[6] met Puschkin,[7] Dostoievsky,[8] Tolstoi,[9] Lao-tsze,[10] and Confucius on common ground. I understood them. I found myself completely at home with their compatriots.

Now there is an important thought here.

With the coming of the Renaissance something happened to Europe. Before then the art, the literature, the music were akin to Asiatic cultures.

With the Renaissance reason and intellect were placed above intuition and feeling. The result has been a race which conquered Nature and now rules the world. But the art of that race has paid the price. As science has advanced, the art standards of the West have steadily declined. Intellectualised art grows tenuous, sterile.

This is a serious thought. To what end does the West rule the world if all art dies? Jesus, the Eastern, was right. "What shall it profit a man if he gain the whole world and lose his own soul."

That is what the West has come very near to doing, and the catastrophe may yet come. The price of science's conquest of the world has been the loss of that emotional capacity that alone produces great art. Where are the Westerners now who could paint an Old Master, compose a Gregorian chant, or build a Gothic cathedral?

Is there no one to bring art back to its former level? This, I think, is where the Negroes and the great Eastern races come in. Now that the West has conquered Nature, visionaries dream of a world run by scientists who would live like artists. But the Westerners do not know how to live like artists any more. Consequently, they have brought misery with their machines.

The race which first learns to balance equally the intellectual and the emotional—to use the machines and couple them with a life of true intuition and feeling such as the Easterns know—will produce the supermen.

No one can tell from what root that race will come. Probably all will contribute—when he learns to be true to himself the Negro as much as any man.

But the Negro will remain sterile until he recognises his cultural affinity with the East. He must take his technology from the West. But instead of coming to the Sorbonne and Oxford, I would like to see Negro students of culture go to Palestine and Pekin. I would like to watch the flowering of their inherent qualities under sympathetic influences there.

I believe that Negro students who wrestle vainly with Plato[11] would find a spiritual father in Confucius or Lao-tsze. I believe that when they find cultures which command world-wide respect, yet which do not deny the emotional and intuitive approach which is typically Eastern and African, there will not only be world-famous Negro sculptors, writers, and musicians, but you will have a race which understands the whole art of living—fully, deeply and efficiently.

His immense emotional capacity is the Negro's great asset. In the

West this is at a discount. Given guidance and an outlet who can say what it might not achieve?

So that is what I really mean when I say I return to my people. I return to my spiritual fathers, whither all Negroes can follow me. I intend to visit Russia, China, Africa, Tibet.

I shall study, and talk, and write. . . .

In between, to remind the world that a Negro has something to offer, Paul Robeson will act and sing.

"I Am at Home," Says Robeson at Reception in Soviet Union

Interview by Vern Smith, *Daily Worker,* January 15, 1935

MOSCOW, U.S.S.R.—"This is Paul Robeson, the greatest American sing-er!" declared the famous film director, Eisenstein,[1] introducing Robe-son to a reception in his honor, attended by nearly all the celebrities in Moscow's theatre and art world.[2] The reception was given in the "House of the Kine," palatial club house of the workers of the movie industry.

I repeat the words of Eisenstein, master of ceremonies at the reception, not by way of informing the public as to who Robeson is, for that is well enough known, but to show the tone of the feeling of the workers and the artists of the Soviet Union towards this visiting Negro singer, son of a slave in the United States—to show the wholehearted appreciation of these Russian sons of serfs who now are freed by their own efforts.

The reception was long and brilliant and lasted until about 2 a.m. But somehow in the course of it, Robeson found time to answer a few questions from the *Daily Worker* correspondent.

I began with the obvious: "Have you noticed a race question in the Soviet Union?"

An undercurrent of laughter rumbled under Robeson's big mellow voice as he answered: "Only that it seems to work to my advantage!"

And then he explained. He has been studying the Soviet Union for two years, studying the Russian language also for that length of time, has been a regular reader of the *Pravda* and *Isvestia* for months, and knows something about the solution of the race question here. He knows that the Soviet theory is that all races are equal—really equal, socially equal, too, as well as economically and politically. He expressed delight but no surprise when I informed him of the election to the Moscow Soviet of the American Negro, Robinson, working in the First State Ball Bearing Plant here.

But what he admitted he had not been expecting was the simple, wholehearted, affectionate welcome that lay in store for him. Robeson declares himself that he knows he has made a sufficient place for

himself by his singing and acting, that even in the capitalist world some of the bitterest aspects of Jim-Crowism[3] and white chauvinism are not applied to him. But it is just this feeling that a condescending exception has been made of him that is missing here. Here there is just the enthusiastic joy of Russian workers and artists, they or their fathers also once slaves of capitalist and landlord, who now welcome in addition a man they feel is a brother artist from abroad, coming with a real desire to honestly know and understand the new life they have made for themselves.

"I was not prepared for the happiness I see on every face in Moscow," said Robeson. "I was aware that there was no starvation here, but I was not prepared for the bounding life; the feeling of safety and abundance and freedom that I find here, wherever I turn. I was not prepared for the endless friendliness, which surrounded me from the moment I crossed the border. I had a technically irregular passport, but all this was brushed aside by the eager helpfulness of the border authorities. And this joy and happiness and friendliness, this utter absence of any embarrassment over a 'race question' is all the more keenly felt by me because of the day I spent in Berlin on the way here, and that was a day of horror—in an atmosphere of hatred, fear and suspicion."

Commenting on the recent execution after court-martial of a number of counter-revolutionary terrorists, Robeson declared roundly: "From what I have already seen of the workings of the Soviet Government, I can only say that anybody who lifts his hand against it ought to be shot!

"It is the government's duty to put down any opposition to this really free society with a firm hand," he continued, "and I hope they will always do it, for I already regard myself at home here. This is home to me. I feel more kinship to the Russian people under their new society than I ever felt anywhere else. It is obvious that there is no terror here, that all the masses of every race are contented and support their government."

Robeson commented on the absence of slums, on the huge building of workers' apartments in the factory districts, such districts as are invariably slums in capitalist cities. He declared that he will make an extensive study of the club life of the Soviet worker, especially as the clubs are centers of instrumental and vocal musical training, and of dramatic art.

Robeson has developed a theory, based on his knowledge of Central Asian folk music and drama, and on his recent three months experience in Africa in connection with the filming of a motion picture scenario based on African life,[4] that a new vehicle of expression, not drama, and not opera, can be evolved from these arts of primitive peoples. He sees certain underlying consistent bases in all this art of primitive civilizations. He hopes to supplement his observations by a study of Chinese folk music and drama.

He has selected the Soviet Union as a most proper center from which

to conduct his researches, and as the only country giving him unstint-
edly the social and other environment in which he can systematically
complete his research and work towards this new form of artistic
expression. He says that he intends to remain in the Soviet Union until
about the middle of January, then will have to return to England for
the final completion of the film of African life and to wind up his other
affairs there. Then sometime during 1935 he will come with his whole
family to the Soviet Union for a prolonged stay, working on his
researches and on the first steps of the new form of drama and opera,
meanwhile singing and acting in the Soviet theatres and moving
pictures.

At the reception given in his honor here, Robeson sang, besides
several Negro workers' songs and spirituals, four selections in the
Russian language: two from the opera "Boris Godunov," one old folk
song and a Cossack lullaby. Hearty applause and the voiced opinion of
those present testified to his progress in the rather difficult Russian
language.

He has deliberately and for a long time been laying plans and
preparing to move to the U.S.S.R. as the most suitable center for the
important work of artistic innovation which he has in mind, and
because he had decided on the basis of much evidence that it is a place
where a man may do such work with greatest freedom and facility. He
said in his interview that he is more than satisfied that the Soviet
Union is just such a place.

I Want Negro Culture

London News Chronicle, May 30, 1935

All the world knows by now that I have faith in the future of the negro.
I believe that negro culture merits an honourable place amongst the
cultures of the world. I believe that as soon as negroes appreciate their
own culture, and confine their interest in the European to learning his
science and mechanics, they will be on the road to becoming one of the
dominant races in the world.

But the trouble is that the negro has lost faith in himself. Slavery
and the white man's machines have been too much for his confidence.
He has repudiated the best in himself, tried to find salvation by
imitating Europeans. In the nature of this imitation he has made a
most serious mistake.

Realising, quite rightly, that a nation is ultimately judged not by its
might but by its culture, he has set out to try to absorb Western arts.
What he has not understood is that culture cannot be put on from the
outside. A certain artificial grace may be achieved by such means, but
only at the cost of strangling the natural creative impulses. That is too
big a price to pay, and the race which pays it can never be an
influential people.

That is the tragedy of the negro at the moment. It could cease to be his tragedy tomorrow if something gave him back his self-respect. Nothing would do that so quickly as to find himself being accorded respect by Europeans.

At present white men are apt to take him at his own estimation. It is true that certain people of discrimination have freed themselves from prejudice and pronounced with respect and even enthusiasm upon negro music and negro art. But these are still too few to affect world opinion. The mass of people does not know them. Least of all does the negro know them. He continues to accept the valuation of the ignorant mass.

The one way to change his views is to demonstrate his worth practically and win world recognition for it. That was my problem. How best demonstrate to the world the quality and possibilities of negro culture? Well—being an actor—my thoughts flew to the theatre.

If one could make a start by establishing before the whole world a permanent negro theatre giving performances whose quality the critics recognised, the seeds of negro self-respect might be planted and the great swing back to African traditions begun.

Now, whenever I make that statement, I find that people misunderstand me. They imagine that I am advocating a return to grass huts and the jungle. Nothing is further from my mind. I want to see my people win a place among the great nations as educated equals, not as some quaint survival of more primitive times.

I want to see them master the European's machines and learn his control over nature. I want to see them use these to win the wealth and power which bring that liberty and leisure in which a great culture can flower. When they have that liberty and leisure they will not need to strain after the white man's culture—they have their own complete traditions developed to a stage perhaps comparable with that of England before the Reformation and Renaissance.

Out of these traditions will grow with spontaneity and power an art perhaps comparable with that of Elizabethan England—but unique art, negro art, yet as far removed from the negro art we know as modern British poetry is from that of Chaucer.[1]

I do not think this is an impossible dream. Once remove the initial barrier—the negro's lack of faith in himself and his traditions—and anything might be achieved.

Russia is staggering the world by the results of harnessing her immense vitality to technical and industrial development but she is only doing this that she may win that liberty and leisure for her people in which she believes a great culture can flower.

I think that in this there is a lesson for the negroes. They are right in aiming at culture, but instead of trying to borrow someone else's they must develop their own. Mechanical technique can be borrowed because it is an external thing—but culture is the essence and expression of a man's own soul.

Therefore, let us learn the world's technique, but stick to our own arts. Once we have won freedom from the domination of nature,

art—living and individual—will come singing and flowing spontaneously of itself.

I regard my theatre as the first step on this road. Through it we aim to win world recognition for negro productions and so help the negro back to self-respect. I intend shortly to launch this theatre in the West End.

We do not intend to confine ourselves to negro plays. That would be defeating our object. We want to produce some of those classics written by Europeans but which deal with man, the human being, irrespective of his colour, caste, or creed. We want also to produce negro plays by Europeans, negro plays by negroes, and a few plays calling for a mixed cast.

We want to do revue, and we shall aim at producing some purely African plays—plays which may hold in them the seed of a new dramatic form, since they consist of a perfect welding of drama, music and ballet such as has never been achieved on the Western stage.

To the African, dancing, singing and acting are not separate and divorced from life as they are among Western people. They are a spontaneous expression of different sides of his personality, and rank as naturally in his life as eating, drinking and sleeping.

This gives his stage performance a naturalness and ease comparable with that of the Russian, and, when disciplined, gives his playing a power extremely moving to those used to the artificiality of the West.

The nearest thing London has so far seen to what we aim at achieving was provided by the "Ohel" Hebrew players last year.

For a start we shall recruit our players from those negroes already in London, but later we hope to draw them from all over the world. We may even bring a whole company from the heart of Africa. Naturally, it will take time to build up a disciplined core of first-class actors, but I am confident that we can do it, and in so doing make a decisive step towards winning the negro a new place in the world.

Paul Robeson on Negro Race

Jamaica Daily Gleaner, British West Indies, July 17, 1935

The *Manchester Guardian* of June 29 published the following article from a correspondent which will be read with a good deal of interest here, Paul Robeson being known to many personally and to thousands more by means of the screen—he is a famous movie and stage actor and singer.

Paul Robeson was so kind as to talk to me about the problems of negro life. We were under the painful impression of the Scottsboro trial,[1] in which seven negro boys are accused of attacking white women. "How can you explain," I asked, "the cruelty of this trial? For three years the boys have been dragged from one court to another, always in danger of

the death sentence. And how is it possible that a civilised country like
the United States allows negroes to be lynched?"

"All this is possible because negroes have virtually no human rights
which the white man respects. This was said in 1860, before the Civil
War, by the chief judge of the highest court in the United States,[2] and
it is still true."

"But do not the negroes possess political rights?"

"Negroes have to-day no right of voting in the Southern States.
From the negro state of Mississippi only white representatives are sent
to Washington, only once in 50 years has a negro representative been
seen in Washington, and he did not come from the South but from
Chicago."[3]

"You speak of negroes as a whole. What about the social differences
among them?"

"The rich and educated classes among the negroes do their utmost to
achieve assimilation to the whites. A negro merchant made a great
deal of money by inventing means of smoothing the curly hair of
negroes. Our doctors, writers, clergymen are all alike in this urge
towards assimilation.

"They have developed a deep inferiority complex. The poorer negroes
imitate the educated ones, but even these latter are not happy. As soon
as a negro becomes rich he is surrounded by hatred and envy. If a
white man injures a negro in the street and the negro retorts in kind
he will be lynched—and later on it will be declared that he attacked a
white woman.

"In the Northern States of America there is no direct persecution,
but perhaps the position of the negroes there is even worse than in the
South, because the urge to assimilation is much stronger than in the
South. Our intellectuals try to suppress in the negro papers every
element of our own culture in favour of the so-called higher values of
white culture. Negro workers cannot be members of the proletarian
movement. Officially American trade unions are open to negroes, but
in practice the doors are closed against them."[4]

"Have you, Mr. Robeson, suffered personally in this way?"

"Yes; to make this clear let me tell you something of my own life. I
did well at school, and then studied law.

"I had to find a solicitor's office to get some practice in my profession.
It was likely to be a desperate search, but I was lucky; a white friend of
mine liked me because I was a good footballer, and took me into his
office.

"But what happened? His partners were furious. 'What is a negro
doing here?' The American typist refused to take down from my
dictation. I left the place, and not only the place but the profession, for
we negroes cannot get the necessary experience at the Bar.

"Even if I had remained at the profession I could not have defended
my brethren the Scottsboro boys. The white judges would not listen to
my speech.

"So with the medical profession. There are only three good negro

hospitals in the country. Everywhere—among doctors, nurses, patients—there is race segregation. That is why many negroes with diplomas and men of good education are working as porters, door-keepers, sleeping-car stewards.

"My own brother graduated in Pennsylvania University, and is now working as a railway porter. When I had qualified for my liberal profession I worked for some time as a waiter. On one occasion I happened to act in an amateur performance. I sang, and someone noticed me. I started a new life, that of an artist.

"Only the singer, artist, and writer are able to break the ban in America. I can now go in America wherever I like, where before I should simply have been thrown out. Not that I do or will go where as a human being I should not be allowed to go and where to this day they would not admit my brother."

"How do you hope to awaken the self-consciousness of the black man?"

"We must remember that outside America there are three other centres of negro population: the Caribbean Islands (Jamaica, Haiti, &c), Brazil, with the whole of South America, and Africa. In these various regions negroes speak different languages, but in spite of that even the American negroes feel instinctively in sympathy with their own blood, the black men of the whole world."

"How do you imagine, say in the next hundred years, the negro race will develop?"

"It is impossible to be optimistic. For a long time Africa will still be under the control of Europeans. But in all countries negroes must stand in one camp, fighting for freedom and social justice. We have not the slightest idea of Africa, as a united continent of negroes, ever standing against the other races. No, all our hope lies in the develop-ment of freedom in the world. But meanwhile negroes should unite and systematically develop their own culture. The world to-day is full of barbarism, and I feel that this united negro culture could bring into the world a fresh spiritual, humanitarian principle, a principle of human friendship and service to the community."

"I Breathe Freely"

Interview in Moscow by Julia Dorn, *New Theatre,* July 1935, p. 5

Paul Robeson, looking for a medium and a starting-point from which to determine the true African culture, has found in Soviet Russia the closest and most friendly attitudes to his own. The internationally known Negro singer and actor, at the end of his first visit to the Soviet Union early this year, said, "In Soviet Russia I breathe freely for the first time in my life. It is clear, whether a Negro is politically a Communist or not, that of all the nations in the world, the modern Russians are our best friends."

Since he speaks Russian, Robeson was able to talk directly with

children, peasants and workers. Everywhere, in tramways, buses, streets and parks, he met with the same reaction from the people, he told this interviewer. "I was rested and buoyed up by the lovely, honest, wondering looks which did not see a 'negro,'" he said. "When these people looked at me, they were just happy, and interested. There were no 'double looks,' no venom, no superiority. . . ."

Looking for roles and songs, he has reached the same conclusion as Professor Kislitsan, the Russian sociologist, who has announced facts to prove that all races are related in culture, differing in the degree of their development only so far as they are affected by natural resources or the hindrances of exploitation.

"I find," declared Paul Robeson, "that the handicraft of certain periods of the Chinese and African cultures are almost identical; and that the Negro is more like the Russian in temperament and character."

Robeson has taken a keen interest in the Soviet minorities, their culture and the policy on national minorities. During his short stay in Moscow, he talked with representatives of the Commissariat of Public Education, and saw the policy in action. He plans to return to the Soviet Union to make a serious study of minority groups, which is to be linked with his intensive researches into Asiatic and African culture. He has insisted, in answer to press comments labelling his interest in Africa "jingoistic," that he is not trying to "escape" race oppression in America and Europe by taking a nationalist attitude.

"I came here," he says, "because the Soviet Union is the only place where ethnology is seriously considered and applied. . . . Africa does not realize that it has something to contribute, that it has a culture as clear as the European. The Africans, instead of preserving their own culture, are fighting the idea of 'be what you are,' and go European as soon as they can. . . . The African and American Negro problem is not purely racial. These cultures must be freed, formulated, and developed, and this cannot be done without a change in the present system. The Negro cannot develop his culture until he is free."

Africa must be taught to be proud of its contributions. "Stalin speaks of the cultures of the different nationalities of the Soviet Union as 'socialist in content and national in form.' . . ."[1]

Mr. Robeson was interested in the Eastern and Russian music, which he believes African music strongly resembles.

"The Negro folk songs and African music strongly resemble Eastern and Russian music. When I approached Russia, I found that I was interested in the Eastern part. I can't read Turgeniev,[2] whose language is influenced by France and the West," said Mr. Robeson, who reads and speaks Russian fluently, "but I am interested in Gogol[3] and Pushkin, who show more Eastern and Tartar influence. . . ."

Paul Robeson is vitally interested in the efforts of the Western Negroes to free themselves. He stated, "I believe there is no such thing in England and America as inter-racial *cooperation* from the NAACP point of view.[4] Our freedom is going to cost so many lives that we mustn't talk about the Scottsboro case as one of sacrifice. When we talk

of freedom, we don't discuss lives. Before the Negro is free, there will be many Scottsboros. The Communist emphasis in that case is right."[5]

Becoming more personal, Mr. Robeson spoke of needing something to sing outside of Negro and English folk songs, and Western peasant folk material, and of discovering, about four years ago, the Hebrew and Russian songs. He learned the two languages, finding that they were both quite easy for him.

"There is little audience in England and America for the things I feel like singing or playing. They want Negro religious songs from which they take, not the suffering, but the comfort of the resignation they express (not heeding that the song's cry for heaven is only a reflex from the Negro's having suffered hell on earth). . . ."

Although he did not give any concerts during this visit, Mr. Robeson sang some of his most popular songs to the workers of the Kaganovitch Ball Bearing Plant, where he was applauded by a group including a great many foreign and American workers. He also broadcast; and on his return, he plans a concert tour of folk songs, and there is talk of a film with Eisenstein. He said, "The most important development in Soviet culture I have seen is in the moving picture field."

Among the theatres he visited, Mr. Robeson was most interested in the Moscow Children's Theatre, and the Realistic Theatre. At the former, he was pleased by *The Negro Boy and the Monkey,* a popular play about a little African who comes to the Soviet Union and is guided by his Pioneer comrades. The production method of Oxlopkhov (regisseur of the Realistic Theatre) impressed him with its similarity to motion picture technique, which he feels is best adapted to the tempo of life in the Soviet Union. Its plan, with the audience surrounding the stage platform, and participating in the performance, agrees with his own feeling that the artist should be in close contact with his audience.

Paul Robeson's activities have been put, with the enlargement of his interests, on an international scale, including studies and experiments in. Eastern cultures along with his participation in African and American affairs. In correlating racial cultures, he sets a standard of awareness, saying, "The Negro must be conscious of himself and yet international, linked with the nations which are culturally akin to him."

Robeson Finds a Natural Link to the Songs of African Tribes

Interview by Marguerite Tazelaar, *New York Herald-Tribune,* October 27, 1935

Paul Robeson, who is singing here after a concert tour in England and France, will go to Hollywood early next month to appear in "Show Boat" for Universal Pictures. At the penthouse of friends in the West

Fifties, Robeson discussed his plans, his recent visit to Russia and racial problems. Well over six feet tall, with the build and easy stride of a football player, he has natural poise and at the same time that high-strung, nervous quality so often a trait of the artist, expressed in his rapid, cascading speech and the intensity of his opinions.

Behind him rows of books lined the handsome, dark-paneled library, and through the passageway, across the terrace the New York silhouette hung somberly. Once Mrs. Robeson came into the room, a light-colored, slender woman with a gracious manner.

While Robeson's life story has been familiar to the public since his early performances in "Emperor Jones" and "All God's Chillun Got Wings," it does not explain the many facets of his personality— personality which has made it possible for him, son of a former slave, to enter Rutgers University on a state scholarship, attain Phi Beta Kappa, become an All-American football player, be graduated from Columbia Law School (he practiced law a few months), win acclaim from the critics almost overnight by his magnetic performance in Eugene O'Neill's "Emperor Jones," and then become perhaps the foremost singer of Negro music.

Robeson, this simple Negro boy from Princeton, N.J., has sung and acted before celebrated audiences in most of the capitals of the world. His Othello in London a few years ago took the city by storm, as did his performance here in 1922 during a revival of "Show Boat."

The explanation for this success did not come so much in his actual words as expressed in the vitality with which he expressed them.

"'Show Boat' is the most interesting thing I have done," he said, "and I am glad to have the opportunity of playing it in pictures.[1] I like that medium very much—I did both 'Emperor Jones' and 'Sanders of the River'[2] for the screen. It is an intimate type of art which I enjoy.

"But when I finish 'Show Boat,' I want to go back to Russia. I visited there just before my last concert tour in England, and it is the one place in the world today where one can live as a human being without prejudice entering into the scene at all.

"In Russia you feel the vitality of a people who are building a new world; in comparison, other countries are dead. I hope in a few years to be independent of the box office, free to do as I choose, and then I want to live for several months in East Russia among the Caucasians, to learn their songs and explore their music.

"I should also like to live for a time in Africa, where I have my roots. Curiously, I felt this ever so strongly when I was in Africa making 'Sanders of the River,' for I learned in just a few weeks certain tribal dialects, and have retained them. They seemed to come to me effortlessly. I want to go back and become thoroughly acquainted with their folk songs and customs. I believe it would be a good thing for the American Negro to have more consciousness of his African tradition, to be proud of it. Africa has contributed great culture to the world, and will continue to do so."

Robeson hopes to have a theater of his own, with a complete Negro

cast. At present his official residence is in London; during his stay here, he and his wife have been with friends. Their eight-year-old son is in school in Canada.

"I want the boy to be brought up in an atmosphere like the Soviet's, if possible," Robeson said, "that is, to be brought up as a free human being. I don't see why he should have to bear the burdens of racial prejudice—the world is too big for that today.

"In France, in England and in fact here in America, too, I have no difficulty personally. Yet France and England have definite deadlines racially and while New York is better than Georgia in this respect, I feel that as long as this burden of race is borne by any of my brothers, I, too, bear it."

Robeson Visions an Africa Free of Rule by Europeans

New York Herald-Tribune, January 12, 1936[1]

An Africa freed of foreign domination was predicted today by Paul Robeson, Negro singer and actor, when he sailed on the *Ile de France* for England, where he will make a concert tour and appear in a motion picture based on Portuguese exploitation of Africa.[2]

"Naturally I am interested in the Ethiopian situation,"[3] Mr. Robeson said, "although mine is not a political job. And just as naturally, my sympathy is all with the Ethiopians. It would seem that those people could get along without the kind of 'civilizing' that European nations do with bombs and machine guns. There may be serious problems— slavery, for example—but Ethiopia could work out her own problems in time. There is no reason to believe that Italy can work them out for her.

"I have great faith in Africa. I feel that the people of the African continent will seek out their own destiny. Two hundred million people, armed with virility and intelligence, will not fail. They have been held back, it is true, but their educational facilities are increasing steadily. The Africans, basically, are no more savages than are the American Negroes in the South.

"I believe that the African states will be free some day. It may come about through partial withdrawal of European power, or there may be a sudden overturn. Differences between sections of the continent would indicate the eventual formation of a federation of independent black states, rather than a single great Negro republic or empire."

Mr. Robeson laughed at the suggestion that the rise of black nationalism might create a menace to white civilization.

"It's not a race problem at all," he said. "Any one can see that, if he'll really think. There isn't any sharp division, with one race uniting against another. Look at the war in Africa now. What is this Italian army fighting Ethiopia? Three-fourths of them are black fellows,

fighting against other black fellows. And what goes on in Manchuria—yellow Japanese making war on yellow Chinese! The race question isn't of primary importance."

Mr. Robeson turned to the subject of Africa's native future. He ventured a prediction that within five years the theater and literature of the western world would be taking as much interest in African affairs as it now takes in the culture of the American Negro.

"I've never been to Africa," he admitted, "though I hope to visit Uganda this winter. Most of the chaps I know in England are Africans, and I've learned a great deal about their problems. I even know a couple of African dialects."

Hauled back by questions to a discussion of his own work, Mr. Robeson said that the film he hoped to do next would present "an interesting tie-up between the Negro tradition in America and Africa." The scene opens in Africa at the time of the original Portuguese conquests; the hero is taken off to the United States, and eventually returns to his homeland. "It'll have lots of music," Mr. Robeson added.[4]

"The most interesting thing I can see ahead for next season," he said, "is the musical play that Jerome Kern and Oscar Hammerstein 2d may do, based on 'Black Majesty,'[5] the story of Emperor Henri Christophe,[6] who built his great citadel in Haiti and defeated Napoleon's troops. It sounds like great material, doesn't it?"

U.S.S.R.—The Land for Me

Interview by Ben Davis, Jr.,[1] *Sunday Worker,* May 10, 1936

"Say, do I like it! Well, the best proof in the world is the fact that I intend to live there—yes sir, to make my home there. Why, it's the only country in the world where I feel at home."

This is the way Paul Robeson, internationally famous Negro actor and singer, described the Soviet Union to me during his recent sojourn in America.

I had gone to the Harlem apartment of one of Paul's friends. He and his wife, Eslanda Goode Robeson, a talented chemist,[2] always stop there when they come to this country. Paul, his wife and young son, Paul, Jr., are now residing in London.

Paul was stretched out across the bed reading the *Hand Book of Marxism,* by Emile Burns. His powerful physique still showed the ruggedness and strength which made him a football hero almost twenty years ago.

Although Paul is very modest about his fame, he has won just about all the "honors" a young man hopes for. "Oh, I was just lucky. I feel that if other young Negroes got the chance, they'd outstrip me a thousand times. But how can they with this damned system of discrimination plugging up every hole of opportunity? And then after

they get it, they can't get any recognition for what they really achieve."

At Rutgers, Paul was Phi Beta Kappa, a brilliant orator and debater. Walter Camp, the late football authority, selected Paul as All-America all-time end. A distinction which has been denied recently to such football stars as Willis Ward of Michigan, Oze Simmons of Minnesota—both recognized as a couple of the finest players in a decade.

Every five or ten years or so the football connoisseurs will select a Negro as All-America just to "prove" that there is no discrimination. But Negro colleges are never considered, although they put out some of the finest elevens. In the same spirit the "upper crust white geniuses" refuse to permit Negro colleges a chapter of the "exclusive" Phi Beta Kappa.

However, I was far more interested in obtaining Paul's views on the Soviet Union, on Communism, on fascism and on "Sanders of the River," a picture in which he played, extolling English imperialism's oppression of the natives of South Africa.

Speaking in a deep bass voice, with almost boyish enthusiasm, he continued his description of the Soviet Union.

"When I say that there's a new type of human being growing up there, I mean just what I say. For instance, I talked to a number of youngsters who were born since the Revolution. I tried to tell them about the oppression and discrimination that Negroes suffer in America and other countries. But they didn't seem to know what I meant. They couldn't seem to visualize just how one race of people would be exploited by another. They knew the basis of it though, and told me that 'we' should have 'our revolution' like they did and get rid of 'capitalist oppression.' I never saw such joy as that on the faces of the kids I saw in Moscow."

Prior to his last trip to America, Paul spent several weeks in Moscow and other parts of the Soviet Union. While there he was the guest of Sergei Eisenstein, the great Soviet film producer.

"Undoubtedly you have read in the capitalist newspapers of the 'starvation of millions' in the Soviet Union, and I know you have read the Hearst press[3] since you have been in this country—how do these stories check with what you saw, and what of the new 'bureaucratic class' which is supposed to be over and above the people?" I asked him.

"This stuff about starvation is the bunk. What else would you expect Hearst to say? Wherever I went I found plenty of food. Of course, it wasn't in every case the finest food, but it was healthful and everyone got enough to eat. Besides those so-called backward peasants are learning all the latest dietary sciences in the preparation and selection of foods.

"While in the Soviet Union I made it a point to visit some of the workers' homes—that is some that were not so famous as Eisenstein. And I saw for myself. They all live in healthful surroundings,

apartments, with nurseries containing the most modern equipment for their children. Besides they were still building. I certainly wish the workers in this country—and especially the Negroes in Harlem and the South—had such places to stay in.

"I visited the home of my brother-in-law (John Goode, a Negro mechanic and bus driver). His apartment had plenty of light, fresh air and space. Believe me he is very happy."

Paul was rolling along endlessly praising the land of Socialism. I had to remind him that I had been reading a little about it myself. He laughed amiably and said, "What next?"

"Well, about 'Sanders of the River.' This picture in which you played the leading role was a slanderous attack on African natives who were pictured as being well-satisfied with the 'benevolent' oppression of English imperialism. You, yourself, played the role of selling the natives out to the imperialists. Such a role is inconsistent with your professed love for the Soviet Union and what that country represents," I told him.

The *Daily Worker,* the *New Masses,*[4] the *Negro Liberator* (now out of print)[5] and numerous working class and liberal organizations called for a boycott of the picture.

"The twist in the picture which was favorable to English imperialism was accomplished during the cutting of the picture after it was filmed. I had no idea that it would have such a turn *after* I had acted in it. Moreover, when it was shown at its premiere in London and I saw what it was, I was called to the stage and in protest refused to perform. Since that time I have refused to play in three films offered me by that same producer," he replied.

"As evidence of your good faith, Paul, that explanation may be acceptable, but good faith alone is not enough. The picture was an out and out betrayal of the African colonials, whatever may be said of your good intentions and the imperialist twist came about in more than the cutting of the film. You became the tool of British imperialism and must be attacked and exposed whenever you act in such pictures or plays," I countered.

"You're right and I think all the attacks against me and the film were correct.[6] I was roped into the picture because I wanted to portray the culture of the African people in which I have the greatest interest. I wanted to show that while the imperialists contend that the Africans are 'barbarians and uncivilized,' that they have a culture all their own and that they have as much intelligence as any other people.

"Nothing would hurt me more than to have the African natives think that I have betrayed them. I have seen some types of natives who have gone to Cambridge and Oxford and have been won over to English imperialism. The African natives seem to have an instinctive disgust for them. I want the Negroes in Africa to know that I am their friend, that I want to help them develop their own distinctive cultures," he said.

"But 'Sanders of the River' is not the way to do it," I answered.

"And that brings me to the position of the Communist Party," Paul continued.

"I am most interested in the colonial question. I have traveled in Africa and can speak several of the native dialects. Those people have a rich culture. I am 100 per cent in agreement with the Communist Party position on self-determination for the colonies and for the Negro people in America.[7] That seems to me the only way in which these cultures can be developed. They are stifling under imperialism. Such things as the Negro spirituals in America show that the Negroes have something fundamental to contribute to civilization, which they cannot do unless they have their own cultural and political autonomy.

"It seems to me that the Soviet Union has solved this problem in the only way it can be solved, by granting self-determination in all nations within its boundaries."

"Paul, what similarities, if any, do you see with the minority nations in the Soviet Union and say the Negro people in Africa and America?" I asked.

"In the first place, there seems to be some kindred feeling between the peasants in the Soviet and the Negro people in America. It's probably because before the Russian revolution they were oppressed as the Negroes are today in the South. They thrill to the Negro spirituals and their own folk songs sound very much like the Negro spirituals. As for myself, I find it much easier to speak Russian than any other language. It seems more expressive of my feelings than any other language. It is one of my fondest hopes that I shall be able to give a recital of Russian folk songs in this country, and lecture on their similarity to the Negro spiritual," Paul said.

"Do you agree with the Communist position on war and fascism and the method and necessity of preventing them both," I inquired.

"You bet. I believe that the Soviet Union is the bulwark of civilization against both war and fascism. I think it has the most brilliant and sincere peace policy in the world today. I can see no effective means of fighting fascism except through the policies of the Communist Party. I am in whole-hearted agreement with the united front based on working class leadership."

While in America last December, Paul endorsed the American League Congress Against War and Fascism[8] and the National Negro Congress.[9]

"What are you doing to live up to your views?" I questioned.

"Not everything I could. Maybe sometimes I don't know what to do. In England they call me a 'Communist,' because of my views, but I'm certainly not a member of the Communist Party. Then, I'm a member of the Friends of the Soviet Union in London. Then, too, one reason why I have not already gone to live in the Soviet Union is because I feel that I can do something to help the cause of the working class and the Negro people before going there to sit down and rest peacefully the balance of my life."

A fire arose in Paul's eyes when I asked him what he thought of the manner in which the Soviet Union dealt with the counter-revolutionary assassins of Kirov, the great Communist leader.

He looked as if he could strangle the assassins with his own hands, and said: "They ought to destroy anybody who seeks to harm that great country."

The expression on his face reminded me of the way he showed me how to handle a prejudiced opponent on the gridiron when I used to play football.

"Primitives"

The New Statesman and Nation, August 8, 1936, pp. 190–92

When discriminating racially, popular opinion lays emphasis on the Negro's colour. Science, however, goes deeper than that and bases its arguments on the workings of the Negro mind.[1]

Man, say certain of the scientists, is divided into two varieties—the variety which thinks in concrete symbols, and the variety which thinks in abstract concepts. The Negro belongs to the former and Western man to the latter.

Now the man who thinks in concrete symbols has no abstract conception of such words as "good," "brave," "clever." They are represented in his mind by symbolic pictures. For instance, "good" in a concrete mind is often represented as a picture of a woman with a child. The drawing of this picture would be the way of conveying an idea of goodness to a person of the same mentality. Such pictures become conventionalised into a kind of written language. Now to the Western mind this may seem a clumsy way of going about things, but it is a method which has given the world some of the most delicate and richest art, and some of the profoundest and most subtle philosophy that man has ever known.

For it is not only the African Negro, and so-called primitive people, who think in concrete symbols—all the great civilisations of the East (with possibly the exception of India) have been built up by people with this type of mind. It is a mentality that has given us giants like Confucius, Mencius,[2] and Lao-tze. More than likely it was the kind of thinking that gave us the understanding and wisdom of a person like Jesus Christ.

It has given us the wonders of Central American architecture and Chinese art.

It has, in fact, given us the full flower of all the highest possibilities in man—with the single exception of applied science. That was left to a section of Western man to achieve and on that he bases his assertion of superiority.

Now I am not going to try to belittle the achievements of science. Only a fool would deny that the man who holds the secrets of those

holds the key position in the world. I am simply going to ask—having found the key, has Western man—Western bourgeois man (the reason for the distinction is made clear later)—sufficient strength left to turn it in the lock? Or is he going to find that in the search he has so exhausted his vitality that he will have to call in the cooperation of his more virile "inferiors"—Eastern or Western—before he can open the door and enter into his heritage?

For the cost of developing the kind of mind by which the discoveries of science were made has been one which now threatens the discoverer's very life.

The reason for this lies in the fact that Western man only seems to have gained more and more power of abstraction at the expense of his creative faculties. There is not much doubt that the artistic achievements of Europe, as abstract intellectualism penetrated deeper and deeper into the people, have steadily declined. It is true that this decline is partly obscured by an output of self-conscious, uninspired productions, which have a certain artificial grace; but discriminating people have little difficulty in distinguishing these lifeless imitations from the living pulsing thing.

It may be argued that preference for live art over dead imitation may be simply a question of taste and is of no fundamental importance. Neither would it be if the change was something confined to that small minority usually described as artists, but unfortunately what shows amongst these is only a symptom of a sickness that to some extent is affecting almost every stratum of the Western world.

To understand this you need to remember that by "creative ability" one means something more than the capacity of a few individuals to paint, to write, or to make music. That is simply the supreme development of a quality that exists in the make-up of every human being. The whole problem of living can never be understood until the world recognises that artists are not a race apart. Every man has some element of the artist in him, and if this is pulled up by the roots he becomes suicidal and dies.

In the East this quality has never been damaged—to that is traceable the virility of most Eastern peoples. In the West it remains healthy and active only amongst those sections of the community which have never fully subscribed to Western values—that is, the exploited sections, plus some rebels from the bourgeoisie. For the rest, mathematical thinking has made them so intellectualised, so detached and self-conscious that it has tended to kill this creative emotional side. The result is that as Western civilisation advances its members find themselves in the paradoxical position of being more and more in control of their environment, yet more and more at the mercy of it. The man who accepts Western values absolutely, finds his creative faculties becoming so warped and stunted that he is almost completely dependent on external satisfactions; and the moment he becomes frustrated in his search for these, he begins to develop neurotic

symptoms, to feel that life is not worth living, and, in chronic cases, to take his own life.

This is a severe price to pay even for such achievements as those of Western science. That the price has not been complete, and its originators have so far survived, is due to the stubborn persistence, in spite of discouragement, of the creative side. Though European thought, in its blind worship of the intellect, has tried to reduce life to a mechanical formula, it has never quite succeeded. Its entire peasantry, large masses of its proletariat, and even a certain percentage of its middle class have never been really touched. These sections have thrown up a series of rebels who have felt rather than analysed the danger and cried out loudly against it.

Many of these have probably been obscure people who have never been heard of outside their immediate circle, but others have been sufficiently articulate to rise above the shoulders of their fellows and voice their protest in forms that have commanded world-wide attention. Of such persons one can mention Blake[3] and D. H. Lawrence.[4] In fact one could say that all the live art which Europe has produced since the Renaissance has been in spite of, and not because of, the new trends of Western thought.

I do not stand alone in this criticism of the Western intellect. Famous critics support me. Walter Raleigh,[5] when discussing Blake, writes:

> The gifts with which he is so plentifully dowered for all they are looked at askance as abnormal and portentous, are the common stuff of human nature, without which life would flag and cease. No man destitute of genius could live for a day. Genius is spontaneity—the life of the soul asserting itself triumphantly in the midst of dead things.

In the face of all this can anyone echo the once-common cry that the way of progress is the way of the intellectual? If we all took this turning should we not be freeing ourselves from our earthy origins by the too-simple expedient of pulling ourselves up by the roots?

But because one does not want to follow Western thought into this dilemma, one none the less recognises the value of its achievements. One would not have the world discount them and retrogress in terror to a primitive state. It is simply that one recoils from the Western intellectual's idea that, having got himself on to this peak overhanging an abyss, he should want to drag all other people—on pain of being dubbed inferior if they refuse—up after him into the same precarious position.

That, in a sentence, is my case against Western values.

It is not a matter of whether the Negro and other so-called "primitive" people are incapable of becoming pure intellectuals (actually, in America, many have), it is a matter of whether they are going to be unwise enough to be led down this dangerous by-way when, without

sacrificing the sound base in which they have their roots, they can avail themselves of the now-materialised triumphs of science and proceed to use them while retaining the vital creative side.

One does not go so far as to say that the West will not share in this new progress. Perhaps, even yet, it will find a way to turn the key. Perhaps the recognised fact that over-intellectualism tends towards impotence and sterility will result in the natural extinction of that flower of the West that has given us our scientific achievements, and the rise of the more virile, better-balanced European, till now derided and submerged. Some people think that in the European proletariat this new Western man is already coming to birth.

It is some such solution as this which I imagine will solve the problem of the further progress of the world.

We, however, who are not Europeans, may be forgiven for hoping that the new age will be one in which the teeming "inferiors" of the East will be permitted to share.

Naturally one does not claim that the Negro must come to the front more than another. One does, however, realise that in the Negro one has a virile people of many millions, overwhelmingly outnumbering the other inhabitants of a rich and undeveloped continent.

That, when he is given a chance, he is capable of holding his own with the best Western Europe can produce is proved by the quality of his folk music both in Africa and the Americas—also by the works of Pushkin,[6] the Russo-African poet; or by the performances of Ira Aldrich—the actor who enslaved artistic Europe in the last century. Even a writer like Dumas,[7] though not in the first rank, is a person who could hardly have been fathered by a member of an inferior race.

To-day there are in existence more Negroes of the first rank than the world cares to recognise.

In reply, it will of course be argued that these are isolated instances—that the Negroes as a whole have never achieved anything. "It may be true," people will say, "that the African thinks as Confucius thought, or as the Aztecs thought; that his language is constructed in the same way as that language which gave us the wonder of Chinese poetry; that he works along the same lines as the Chinese artist; but where are his philosophers, his poets, his artists?"

Even if this were unanswerable, it would not prove that—since he has the right equipment—the African's golden age might not lie ahead. It is not unanswerable, however. Africa has produced far more than Western people realise. More than one scientist has been struck by the similarity between certain works by long-dead West African artists and exquisite examples of Chinese, Mexican and Javanese art.

Leading European sculptors have found inspiration in the work of the West African.[8]

It is now recognised that African music has subtleties of rhythm far finer than anything achieved by a Western composer. In fact the more complicated Negro rhythm cannot be rendered on Western instruments at all.

Such achievements can hardly be the work of a fundamentally inferior people. When the African realises this and builds on his own traditions, borrowing mainly the Westerner's technology (a technology—he should note—that is being shown not to function except in a socialist framework) he may develop into a people regarding whom the adjective "inferior" would be ludicrous rather than appropriate.

An Exclusive Interview
with Paul Robeson

Rev. Father J. C. O'Flaherty, A.M., *West African Review*, August 1936, pp. 12–13

Having devoted my life and labours to the Negro race, I was anxious to meet its most outstanding present-day member. Indeed, the very first thing that impressed me about Paul Robeson was how very outstanding he is—physically. He stood in the vestibule of a great hotel, and towered, massive head and shoulders, over a crowd of "fans" all eager for his autograph. His affable manager, with whom I was chatting on the landing above, told me that he never refuses, and keeps on signing until he is rescued. Rescued he speedily was, as I had an appointment, and presently we were alone in his suite.

"And so you have been to Africa and lived and worked there, you know my people; do tell me all about them!" There was no mistaking his eager sincerity. I felt that if the conversation were going to continue like this I would be interviewed, and depart without having asked my questions.

I told him all about the African as I knew him, how he is so super-sensitive that his reactions are entirely misunderstood by the superficial.

"That's exactly it," said Robeson, "we *feel* a lot, most White folk could never guess how much."

I told him about our Choir at Lagos, and the Art Class, and the Boxing Class that I started long ago against much adverse criticism. He heard all about the little plays we used to run at the Mission, and was deeply interested in all I had to tell him about Northern Nigeria, where, round Jos and Shendam, the primitive element is still prevalent.

I showed him some photographs, which drew chuckles of surprised appreciation; one little chap in particular reminded him so much of his own little son that he kept the picture to take home. The contrast between two particular pictures, one of a group of pagans in the Munchi country, and another of a Leaving Certificate Class at Lagos took his fancy very much. "Imagine," he said, "there can't be more than three generations between them."

Presently I got him down to a more serious vein, and he talked long of his hopes and fears. I will be as brief as I may with the substance of it all; but the actual talk lasted about three hours, and much, I am afraid, must be lost.

"The thing I like about you Missionaries," he said, "is that you begin at the real root of things, by insisting on the Spiritual side. Mind you, I'm afraid my idea of the Spiritual in speaking thus is not as deep as yours, but for me the soul, the spirit of the people, is everything.

"I am not talking of rabid nationalism, which I abhor; what I mean is purely cultural. Africa, like the countries of the East, has a culture—a distinctive culture—which is ancient, but not barbarous. It is a lie to say that our past is a record of mere strife between paltry tyrants. In the past, African communities developed along their own lines, in their own way, to reach a point of order and stability which may well be the envy of the world to-day.

"Also, of course, the whole system was balanced and simplified to an extent quite unknown to the White world. That's because material conditions of life in Africa never called for any prolonged or strenuous effort on the part of her people. A few months' work in the year; that was sufficient for a plentiful harvest and a fine long rest. How can anyone think it an easy thing to change all that; and introduce a modern culture of such complexity as that of the New World. And it is because such a culture must be introduced gradually and with safeguards that I think real, sincere, educated Africans from abroad are the best people to attempt it.

"In my people there is a fundamental quality, a kind of 'inner logic' I call it, which for want of a better title is often merely called mysticism. This is a trait common to the older nations of the world. A quality by which they ignore, or take little account of, the Western ideals of intellect and science and the power to reason logically, and depend on emotionalism and *feeling.* I, as an African, feel things rather than comprehend them, and this instinct working throughout my life's experience has made me convinced that our race is utterly wrong in its tendency to become Westernised.

"I think my natural gift for language has brought this more clearly home to me than has anything else. My ancestors in Africa reckoned sound of major importance; they were all great talkers, great orators, and, where writing was unknown, folk-tales and an oral tradition[1] kept the ears rather than the eyes sharpened. I am the same. I always hear, I seldom see. I hear my way through the world. I always judge by sound.

"I wonder," said Robeson, addressing me directly, "if you have noticed this in your study of my people? They 'take to you' or they do not, and, mind you, it doesn't necessarily mean that merely you did them well or ill, but that you have, or you have not, some trait of personality which appeals in a way which silences criticism."

"Something like 'Sanders of the River'?" I suggested. "The very thing," he replied. "It is a subtle thing, and it is a thing that there is no

use in trying to analyse unless you get what I mean when I say—we Africans act by an 'inner logic.'"

Now I, as a Missionary priest, have experienced all that; I have known good people, people far better than myself, who have been abject failures in dealing with the Africans. I have asked myself, time and time again, in what are they lacking? They are kind, just, accomplished, evidently very competent, they do not appear to make any glaring blunders, and yet they are barely tolerated, certainly not loved, and their passing seems to leave no regret.

But let us return to the interview. "I could tell you," continued Robeson, "from my own reactions in the comparative study of langauges which nations are more akin to us in their culture, and I find the Chinese closest of all. In fact, I have much the same emotional response to Chinese as to Effick, which is the African language that I am studying at the moment.

"Of course I shall visit Africa, of course I shall make a point of visiting all those places you have mentioned—and it won't be on a concert tour! I'd much prefer to go there incognito and see all without being seen."

Looking at him, I was back again on the Coast, chatting with one of the many Africans I have known. The same subtly-created atmosphere of careless ease, the same flashes of brilliance in the midst of seeming sleepiness. But Robeson has no illusions, neither has he any use for those "cardboard Europeans" of his own colour who strut the streets of foreign cities creating a false impression of his race.

When I Sing

A broadcast from Moscow, U.S.S.R—*Sunday Worker,* February 7, 1937 (Abridged version published in *The Negro Worker,* March, 1937, pp. 12–13)

My third visit to the Soviet Union, this time for a concert tour under the auspices of the Moscow State Philharmonic, has given me greater opportunities for seeing this wonderful country than any former shorter visits afforded.

I must say that all of my earlier impressions have been confirmed, my understanding of the Soviet ideal has been broadened and many features of Soviet society not so well understood by me, made more clear.

Our reception has been extremely gratifying.

When I sing the "Spirituals" and work songs of the Negro people to Soviet audiences, I feel that a tremendous bond of sympathy and mutual understanding unites us. The Russian folksongs and those of the Soviet National Republics, which were formerly Czarist colonies, bear a close relationship to folksongs of the Negro people.

In each instance these songs were born out of the misery and

suffering, exploitation and oppression of the people. This oppression made the name of old Russia synonymous with the term "the prison house of nations."

The warmth and obvious friendliness of the Soviet people in response to the efforts of Mr. Lawrence Brown and myself, makes me feel that it is not only we who are heard, but that it hears and sympathizes with the struggles of my people. That this feeling has a solid basis in fact is not difficult to show.

We arrived just as the Eighth (Special) All-Union Congress of Soviets completed its historic work and, on behalf of the Soviet people, adopted the new Socialist Constitution.

It is easy to understand the boundless pride and courage of the Soviet people. It is not difficult to realize the source from which their unstinted loyalty to their government and their Party flows, after one has read this unforgettable, great Socialist Constitution. It is not difficult to appreciate here the existence of a new humanism—Soviet humanism.

Mankind has never witnessed the equal of the Constitution of the U.S.S.R. Undoubtedly its provisions, which have already been realized in life, not only mark out the glorious highway to Socialism, travelled by the toilers of this country for all who desire to see, but as well they are symbolic of the future path of mankind.

I have spoken of this historic New Charter of the Rights of Man for two specific reasons. Firstly, because of the great significance it has for my people generally. Everywhere else, outside of this Soviet world, black men are an oppressed and inhumanly exploited people. Here they come within the provisions of Article 123 of Chapter X of the Constitution, which reads:[1]

"The equality of the right of citizens of the U.S.S.R., irrespective of their nationality or race, in all fields of economic, state, cultural, social and political life, is an irrevocable law.

"Any direct or indirect restriction of these rights, or conversely the establishment of direct or indirect privileges for citizens on account of the race or nationality to which they belong, as well as the propagation of racial or national exceptionalism, or hatred and contempt, is punishable by law."

This expression of democracy, broader in scope and loftier in principle than ever before expressed, is particularly appealing to Negroes for it comes at a moment when in almost all other countries, to a greater or lesser degree, theories concerning the superiority and inferiority of this or that people, and especially the inferiority of my people, are propagated even in the highest schools of learning and among the most renowned professors. This is to say nothing of the various forms of persecution these racial theories take on in practice.

Here in the Soviet Union even the propagation of such theories is punishable by law.

Secondly, I speak of this Constitution because it is impossible for me even to think of the political autonomy and the tremendous opportuni-

ties for the growth and expansion of national culture enjoyed under it by the numerous different nationalities of the Soviet Union, without making a comparison between the boundless hope and aspiration of the Soviet family of free peoples, and the tragic lot of the people of Spain,[2] fighting to maintain their independence. Their country is being ravished, fathers, sons and defenseless civilians murdered by the invading hordes of the intervention cynically condoned by some democratic European states which scarcely lift a finger to prevent the commission of this crime against humanity.

Spain, however, can be "the straw that breaks the fascist camel's back," and in this lies the great significance of the events in Spain for the Negro people.

The November issue of the magazine "Crisis," the organ of the National Association for the Advancement of Colored People, contained an editorial, entitled: "Keep Straight on Spain." I should like to call my listeners' attention to a few words from it. It said in part:[3]

> "Colored people, who are poor, landless and disfranchised, should cut through all the headlines about Spain and remember only this truth: the war is between the Spanish people, poor, landless and disfranchised, and the army which is controlled by those who want to keep the Spanish people poor, landless and disfranchised. . . . [4]
>
> "The kernel of the whole thing is the heroic struggle a people is making for a voice in shaping its own destiny."

In Spain there exist, I believe, the possibilities to give a blow to the world forces of reaction from which they will never recover. In Spain I believe a struggle is going on which is an important part of the world-wide fight of the forces of democracy against reaction. A victory in Spain for reaction cannot help but worsen the conditions of the weak and oppressed peoples everywhere.

I regard it as of the greatest importance that the Negro peoples of the world should fully appreciate the many times repeated statement that "the Spanish people are defending the whole of society against the ravages of the fascist hordes."

But the cause of Spain is not only the concern of the Spanish people. We, as a people, can no longer be indifferent to international events.

The question of whether there should be war or peace is a question of the greatest importance for us, not only for the Negro people, but for all lovers of peace. It is to our own vital interest that we should range ourselves on the side of the democratic forces of the world today and particularly those forces which are leading the struggle for peace and against war, for collective security and against wars of aggression, for freedom and against the new slavery.

As a last word, let me say that it is to their eternal glory that Negroes from America, Africa and the West Indies are to be found fighting in Spain today on the side of the Republican forces, for democracy and against the forces of reaction.

Robeson Calls for Aid to Negroes
Defending Democracy in Spain

The Negro Worker, Hamburg, Germany, June 1937, p. 9

With a donation of two hundred and fifty dollars to Dr. Arnold in Paris, Paul Robeson, the famous Negro film star, actor and singer, initiated a fund for the relief of the dependents of American Negroes fighting in defense of democracy in Spain.[1] Robeson said as he made the donation: "The freedom of all the Peoples of the world is at stake in this conflict in Spain. These men who have gone to Spain have done and are doing their part. Surely we must do ours.

"I believe that there are literally hundreds of Negroes in the theatre and musical life who understand what a hunger for equality and love of mankind impelled me to take this step."

The Artist Must Take Sides

Speech at rally sponsored by National Joint Committee for Spanish Relief in aid of the Spanish Refugee Children, Royal Albert Hall, London, June 24, 1937—*Daily Worker,* November 4, 1937

Friends. I am deeply happy to join with you in this appeal for the greatest cause which faces the world today. Like every true artist, I have longed to see my talent contributing in an unmistakably clear manner to the cause of humanity. I feel that tonight I am doing so.

Every artist, every scientist, must decide NOW where he stands. He has no alternative. There is no standing above the conflict on Olympian heights. There are no impartial observers. Through the destruction—in certain countries—of the greatest of man's literary heritages, through the propagation of false ideas of racial and national superiority, the artist, the scientist, the writer is challenged. The battlefront is everywhere. There is no sheltered rear.

The challenge must be taken up. Time does not wait. The course of history can be changed, but not halted. Fascism fights to destroy the culture which society has created; created through pain and suffering, through desperate toil, but with unconquerable will and lofty vision. Progressive and democratic mankind fight not alone to save this cultural heritage accumulated through the ages, but also fight today to prevent a war of unimaginable atrocity from engulfing the world.

What matters a man's vocation or profession? Fascism is no respecter of persons. It makes no distinction between combatants and noncombatants. The blood-soaked streets of Guernica,[1] that beautiful

peaceful village nested in the Basque hills, are proof of that as are the concentration camps full of scientists and artists which in some western lands dot the countryside, bringing back the dark ages.

The artist must take sides. He must elect to fight for freedom or slavery. I have made my choice. I had no alternative. The history of the capitalist era is characterized by the degradation of my people: despoiled of their lands, their culture destroyed, they are in every country, save one, denied equal protection of the law, and deprived of their rightful place in the respect of their fellows.

Not through blind faith or coercion, but conscious of my course, I take my place with you. I stand with you in unalterable support of the Government of Spain, duly and regularly chosen by its lawful sons and daughters.

Again I say, the true artist cannot hold himself aloof. The legacy of culture from our predecessors is in danger. It is the foundation upon which we build a still more lofty edifice. It belongs not only to us, not only to the present generation— it belongs to posterity—and must be defended to the death. May you rally every artist, every scientist, every writer in England who loves democracy. May you rally to the side of Republican Spain every black man in the British Empire.

May your inspiring message reach every man, woman, and child who stands for freedom and justice. For the liberation of Spain from the oppression of fascist reactionaries is not a private matter of the Spaniards, but the common cause of all advanced and progressive humanity.

Why I Joined Labor Theatre

Interview by Philip Bolsover, *Daily Worker* (London), November 24, 1937

"When I sing 'Let My People Go,'" said Paul Robeson slowly, feeling for words, seeking expression to convey just the emphasis he needed, "I want it in the future to mean more than it has meant before.

"It must express the need for freedom not only of my own race. That's only part of a bigger thing. But of all the working-class—here, in America, all over. I was born of them. They are my people. They will know what I mean.

"When I step on to a stage in the future," Paul Robeson said, leaning forward in his chair, "I go on as a representative of the working-class.[1] I work with the consciousness of that in my mind. I share the richness they can bring to art. I approach the stage from that angle.

"You see," he said, "this isn't a bolt out of the blue. Not a case of a guy suddenly sitting down and deciding that he wants to join a workers' theatre. It began when I was a kid—a working-class kid living in that shack. It went on from that beginning.

"Films," he added, "films eventually brought the whole thing to a head.

"I shan't do any more films after the two that are being finished now. Not unless I can get a cast-iron story—the kind that can't be twisted in the making. There's room for short independent films. I might try to do those. But for the rest, I'll just wait until the right story comes along, either here or abroad.

"I thought I could do something for the Negro race on the films: show the truth about them— and about other people too. I used to do my part and go away feeling satisfied. Thought everything was O.K. Well, it wasn't. Things were twisted and changed—distorted. They didn't mean the same.

"That made me think things out. It made me more conscious politically.

"One man can't face the film companies. They represent about the biggest aggregate of finance capital in the world: that's why they make their films that way. So no more films for me.

"Joining Unity Theatre," said Robeson, "means identifying myself with the working-class. And it gives me the chance to act in plays that say something I want to say about things that must be emphasized.

"I like singing for those audiences," he said reminiscently. "There is sympathy between us—I sing better for them. I shall like acting for them.

"I sang in drawing-rooms once, but that was different. Like being on show all the time. We didn't get on well.

"If I go into an expensive restaurant," said Robeson, suddenly taking a new angle, "I see people stiffen and sit up. They say, 'What's that colored guy doing in here.'

"They'd like to throw me out," he said simply, "but they think I'd make trouble. I should.

"But look what happens when I go into a provincial town. Drivers get off their trucks to shake hands. Guys working on buildings come and have a word. 'Hullo, Paul,' they shout.

"'I got a record of yours,' they say."

He grinned and gave a deep chuckle.

"I get on fine with those fellows. We know each other. Those are the people I come from. And they understand what I sing.

"I've managed to get some success," said Paul Robeson, "but there are thousands who haven't had the chance. It's not enough for one to be able to do it. I want everyone to have the chance.

"The way things are it seems to me that from the artistic point of view there's an immense waste of talent—a waste of people who are not allowed to develop and use all that's in them. And from every point of view there is a loss of human dignity and hope and happiness.

"So I'm joining a working-class theatre."

Paul Robeson Tells Us Why

Interview by Sidney Cole, *The Cine-Technician,* London,
September-October, 1938, pp. 74–75

At the Unity Theatre, a small home-made theatre near Mornington
Crescent run by enthusiastic left-wing amateurs, international star
Paul Robeson has just finished playing in an American play called
"Plant in the Sun."[1] The play made a strong dramatic appeal for trade
unionism. Its moral is simple. Stick together or the man at the top will
beat you in the economic bargain. The five main characters are
workers in a packing shop of a big factory who decide to stage a
sit-down strike because one of their number has been victimised for
talking unionism. One of these characters was played by Robeson. But
it was not a star part.

All this is surprising enough, but when we learn that Robeson has
shaken the dust of professional stage and studio from his feet, and
announced that he will confine himself to his concerts, except if and
when he has such stories as "Plant in the Sun," surprise becomes vocal.

"It's a long story," Robeson said. "I've always held strong opinions
about society, but I have never related these opinions to my job, I was
just another actor. I didn't see why people should worry themselves
about my outlook on other matters. At the same time I grew more and
more dissatisfied with the stories I played in. Certain elements in a
story would attract me and I would agree to play in it. But by the time
producers and distributors had got through with it, the story was
usually very different, and so were my feelings about it. 'Sanders of the
River,' for example, attracted me because the material that London
Films brought back from Africa seemed to me good honest pictures of
African folk ways. The film has been criticised on the grounds that
dressing up in a leopard skin I was letting down something or other. I
looked at it from a different angle. Robeson dressed in a leopard skin
along with half a dozen other guys from Africa, all looking more or less
the same, seemed to me to prove something about my race that I
thought worth proving. But in the completed version, 'Sanders of the
River' resolved itself into a piece of flag-waving, in which I wasn't
interested. As far as I was concerned it was a total loss.

"But I didn't realise how seriously people might take the film until I
went back to New York. There I was met by a deputation who wanted
to know how the hell I had come to play in a film which stood for
everything they rightly thought I opposed. That deputation began to
make me see things more clearly. I hadn't seen the film. I was that
interested. After talking to them I did go and see it, and I began to
realise what they'd been getting at.

"The films I've made since then? The same story. An idea that
attracted me, a result in which I wasn't interested.

"Why was the film version of 'Emperor Jones' a failure? Partly because scenes in it were changed around from the proper psychological order of the play and partly because the big episode, the long monologue in the forest, which had been built up in the theatre by the use of drums, was not played in the same way in the film. On the stage a drum became an actual character in the scene. The lines I spoke were dialogue addressed to the drum and answered by it. Only in that way could I get the necessary feeling to play the scene as O'Neill's writing of it deserved. We engaged an expert drummer for the part. But in the film, which I started with enthusiasm, I was told that of course we couldn't play the scene that way. We couldn't use the drum in the dramatic emotional way that was essential for me. Also the director had some fool notion that negroes had moods and could only play when they were in the proper mood. Consequently we played the whole sequence right through at once, which certainly didn't give me the right mood.

"Meanwhile I was beginning to connect things up. My feelings about films in general and what I did in my job—this was a long process, mind—I was beginning to feel couldn't be separated. At my concerts years back I had noticed the most genuine and enthusiastic applause always came from the gallery. The stiff shirts in the stalls liked to hear me sing, sure, but those guys in the gallery I began more and more to feel as my people. Those were the people I wanted to sing to and play to. And to play to them in stories that had some bearing on the problems they had to face in their daily lives. I was interested in those problems outside of my job. In future I wanted to concern myself with them inside of my job. That's why I decided to take no more offers until I could find that sort of story.

"Similarly, all my concerts in future will have a five shilling top. At that price I figure more of the people I want to sing to will be able to hear me. My agent was a bit worried about my political appearances, but the fact is that they haven't hurt the box office."

Robeson wants to get back into films. He feels that the film is his medium. This may seem surprising to those who have heard him fill the vastness of the Albert Hall with a cheering audience. But he feels that in the intimacy of working close to the camera he can put over his personality more sympathetically and with less strain. But if and when he does make films they've got to be about the sort of subjects he wants, and no distorting of the original intention behind them. That involves, I suggested, a degree of control over the production personnel that so far only the supreme Hollywood stars have managed to achieve. But Robeson is willing to stay outside until he can get it.

He has some good stories about the studios. "In one film I played in which also had plenty of flag-waving in it, a very well-known actor who didn't see eye-to-eye with me on social problems, turned out to be very race conscious. He was much shorter than me and subsequently always contrived when he was playing a scene with me to stand on a rock or something in order to bring himself up to my level."

Robeson has interesting advice to playwrights. "White dramatists usually go wrong when they try to write a part for a negro character. Not unnaturally they tend to see him as a specialised person. This distorts the importance given to the character and makes him unrepresentative. Consequently my advice to dramatists who want to write plays for Unity, for example, is to write about a character they know in their own experience, an Irishman or a Welshman or a Cockney, then let me play the part and give it its special but not unrepresentative negro flavour. The part, for example, that I played in 'Plant in the Sun' was written by the author as an Irishman."

And now Robeson feels that he's integrated his job and his feelings about society. Part of his feelings about films are due to this integration of outlook. To him, he says, the film industry is the clearest example of the workings of capitalism—slumps, booms, speculation, over-production, and so on. It's all there. "You've only got to ask who controls United States Steel, who controls the Chase National Bank. And then you find the same guys control the film industry. And it's the same here in England.

"The workers in the studios have the power and they ought to realise it. During one of my films I was struck by this very forcibly. There was everybody on the set, lights burning, director waiting, head of the company had just come on to the set with some big financial backer to see how things were getting along—and what happened? Everything stopped. Why? Because the electricians had decided it was time to go and eat so they just put out the lights and went off and ate. That's my moral for your readers."

Paul Robeson in Spain

Interview by Nicolás Guillén,[1] *Mediodía,* Havana, Cuba, 1938—Reprinted in *Bohemia,* Havana, May 7, 1976; English translation by Katheryn Silver, *Daily World,* July 25, 1976

At the side of democracy in Spain, and on every front of struggle for its triumph, there are men of the most diverse races, from the most diverse places in the world.[2] Silent Chinese who fire their rifles at Italians and Germans, confident that it is the same as their fight against the Japanese who profane Nanking; sad Hindus who traded the dirty banks of the Ganges for the narrow waters of the Jarama; Blacks born in the Yankee south, in Cuba, in Jamaica, in Brazil . . . Who sends them? No one; they are true volunteers, in contrast to those who pack the cold ambition of Mussolini in sad bundles, to hurl them on a land that they in fact do not hate, and in which they are forced to oppose people who have done nothing to them. These come knowing what cause they defend, what enemy they have to exterminate. They ask only a place in combat, a definite, efficient task; here, they make themselves useful with selfless simplicity, loading a machine gun,

doing guard duty on a battlement, buried for months on end, at the
service of science, in a hospital. Each according to his own possibilities,
each adjusting his aid to the measure of his own skills. Langston
Hughes,[3] the great poet of *Mulatto,* lived long days in Madrid and
visited the front to bring to men of his race and his land the simple
popular verse that flows from the blues and from spirituals; Cueria,
from Havana, son of a Black and an Asturian, commands a company of
machine gunners in the Central Front; Paul Robeson, the wonderful
American singer, child of slaves, rushes from London to enter Spanish
soil with a smile of hope. Paul Robeson? And what is Paul Robeson
doing in Spain? What, wait; he himself is about to tell us.

When I arrive at the hotel Majestic, where he is staying, I find the
famous cinema artist blockaded by a crowd of people hanging on his
most insignificant gestures. Robeson pays attention to everyone,
smiling. He poses repeatedly for photographers, answers the most
diverse questions without tiring. While the people pursue him, I
watch. He is an enormous Black, who towers loftily above the group
around him. How old is this man? His kinky hair is beginning to
lighten a little in the center of his head, and next to his temples it is
firmly whitening. Forty years old? Forty-five? He must be about
that . . . Nonetheless, his formidable physical development, the ex-
pression of happiness that always plays across his face, the deep
brilliance of his eyes, all considerably discount the singer's accounting
of years. When he talks, he talks passionately, his enormous hands
contracted and turned palms up, an invariable gesture of his when
talking. He dresses without luxury, rather one could say with great
simplicity: a dark grey suit, not very new, a cap whose long use shows
clearly, shoes that have walked about long enough to have forgotten
the day they first stepped on the ground . . . But everything in very
good taste, with a great deal of care and balance. His solid personality
projects great attractiveness, and his body moves with the elasticity of
an athlete, that makes one remember his career as a football player so
long ago. I catch bits of his discussion, in which one word, "Spain," is
repeated frequently; and while he talks, I look at his wife, a spirit of
great purity and perception, who has published a book about her
husband, attending to the visitors in the room with a pleasant smile. It
is she who finally says to me:

"Paul is waiting for you . . ."

The contact is made without formalities, in the manner of a reporter.

"I would like you to tell me yourself," I say to him. "What reasons led
you to come to Spain."

"My devotion to democracy," he answers rapidly. "As an artist, I
know that it is dishonorable to put yourself on a plane above the
masses, without marching at their side, participating in their anxie-
ties and sorrows, since we artists owe everything to the masses, from
our formation to our well-being; and it is not only as an artist that I
love the cause of democracy in Spain, but also as a Black. I belong to an
oppressed race, discriminated against, one that could not live if

fascism triumphed in the world. My father was a slave, and I do not want my children to become slaves . . . During these last months I have worked a great deal in London, singing to raise funds to send to the Spanish people, and I will continue doing it, not only there, but everywhere that I am able to do it."

"I know that you have just come from Madrid," I say. "What is your impression of what you have seen in this city and in the rest of democratic Spain?"

"It made a great impression on me. I have never seen a more courageous people, one more energetically working for victory. I confess that I feel happy to have been able to come to Spain and above all to Madrid. The people there talk to you, and everyone gives you their warmth, their simplicity, their generosity. The day I arrived, they called me 'Pablo'; two days later, they were calling me 'Pablito.' Imagine, me, Pablito, with my height! Besides, no one there ever thinks of defeat. In spite of the destruction inflicted on the city by the howitzers of the fascists, in spite of the danger of the daily bombings, in spite of the hardships that people are suffering, no one protests or complains. It's war. Everyone gives all his strength to resist and to win. No; there is no fear there . . . On one of the last afternoons, on the eve of my departure, I peacefully played a game of football with a group of boys in a site all too close to a zone of the city that was under artillery bombardment at that moment."

Robeson smiles, and is silent for a minute.

"The Madrileños are also very generous," he continued. "Shortly after I arrived, I gave a package of cigarettes to a Spanish captain, because I knew about the shortage of tobacco there. A few moments later I went with him to visit a hospital, where I sang, and I was delighted to see that man distributing his cigarettes among his comrades, without leaving anything for himself. And they do the same thing with everything else . . ."

"That's true," I say. "I have never seen a Spaniard wrangle about having a little more or less of material things, in contrast to what happens in other areas, where at times they have a fame that is in fact exaggerated. In many stores, when there is no change for the money that we have, they return it to us with the merchandise, saying, 'It doesn't matter, bring me the money another time: that little bit won't make us either richer or poorer . . .' I remember one day, walking with Langston Hughes through the streets of Madrid, when the poet's shoe broke. The sole had come loose, and it prevented him from walking. We went into a small shoe-repair shop, where an old man was fixing a man's boot. He left it; Langston showed him what he wanted; he scrupulously examined the shoe, and in less than ten minutes, he sewed it and nailed it together, leaving it in perfect condition. When we asked him what it cost, the man answered, almost angrily, 'Cost, you say? Go on, señor: ask and nothing more!' Yes, Mr. Robeson, you're right; they are very generous . . ."

The conversation moves on, from there, to film and theater.

"Some years ago," says Robeson, "the Black was a comic personage in North American theater. When *Emperor Jones,* the work of O'Neill, was brought to the stage by another Black actor, I saw the possibilities that a Black had in dramatic art. For that reason, I wanted to portray that character, first on the stage and then on film. I must tell you that for me this was only a point of departure, a means to do more basic and important things, since it was necessary in a country like mine to demonstrate first that a man of color had artistic sensibility, and could walk the stage or pose before a movie camera with the same presence as the whites, and sometimes with greater presence. That is why I later portrayed *Othello,* and I am now preparing to do *King Lear.* However, today I am convinced that the great American and English companies are controlled by big capital, especially by the steel trust, and they will never let me do a picture as I want. For that reason, I am not interested right now in film work, and less in pictures dealing with the 'Negro problem.' The big producers insist on presenting a caricature image of the Black, a ridiculous image, that amuses the white bourgeoisie, and I am not interested in playing their game . . ."

"So," I say, "your cinematographic work up to now does not satisfy you . . ."

"I never even saw those pictures after I made them," he answers.

"Then you are going to abandon films?" I ask him.

"No, not that. What I won't do any more is work for the big companies, which are headed by individuals who would make me a slave, like my father, if they could. I need to work with small independent producers, in short films with songs, until the moment comes to make something with greater breadth and a more positive meaning than has been possible so far. I would like to make a film on the life of a Black commander of the Lincoln Battalion in the International Brigades, who dies there; but this would be refused by the big Yankee movie companies . . . However, I hope to get my wish, and bring to the screen the heroic atmosphere that I have breathed in Spain, and the great participation of men of my race in this struggle."

Robeson then talks to me enthusiastically about Spanish music.

"I have been surprised and delighted by the similarity between Black music and some Spanish music. The Flamencan song is Black in its rhythm and its sad depths. In Madrid, during a concert, I asked them to play Flamencan music; the artists very courteously did so, and then I could sing a Black song without the musicians having to change the rhythm with which they had accompanied the cante jondo in the least. Because of that, I want to return to Spain when there is more calm, when we have won the war, to gather and study many songs of this kind."

"Do you know Cuban music?" I ask. "The Black contribution to that music is also enormously rich, just as it is in the case of the rest of the Antilles and in Brazil."

"Yes, I know it, and I like it enormously. In fact, I am also thinking of going to Cuba, to study its musical folklore, which I know has the

characteristics you describe. I think it would be enormously useful for my next films . . ."

Robeson begins to get restless, because he has to leave immediately, he tells me, for London, where he lives. From there he will return to Paris, in order to sing in a meeting for the support of Spain, in *La Mutualité.* I understand that the interview has ended. He offers his enormous right hand, while he smiles. I say:

"It would be very good if you came to Cuba soon. There are many surprising things to learn there as well . . ."

A Great Negro Artist Puts His Genius to Work for His People

Interview by Eugene Gordon, *Sunday Worker,* June 4, 1939

Paul Robeson stands in the middle of the large living room. His huge body towers toward the ceiling but he balances himself lightly on feet planted slightly apart. He is concentrating on an answer to the query why he is soon coming home to stay. He stares straight ahead, speaking slowly; pauses to weigh the value of his words, then continues. His voice has the timbre of a bass viol.

"Certainly in my travels in many countries of Europe, particularly in Spain, and having been close to the struggles in China, Ethiopia and the West Indies, I have seen and recognized the essential unity of this international fight for democracy and against fascism."

He sits again, hunching over the frail card table, leaning close and speaking with such intense earnestness that for a moment you forget that you are listening to one of the most beautiful voices in the world.

"Having helped on many fronts, I feel that it is now time for me to return to the place of my origin—to those roots which, though imbedded in Negro life, are essentially American and are so regarded by the people of most other countries."

It is Paul Robeson's essential love for the American people and their institutions which, on his present visit, most impresses those who speak with him. His love and understanding of the Negro people are especially impressive.

"It is my business not only to tell the guy with the whip hand to go easy on my people," he said, "but also to teach my people—all the oppressed people—how to prevent that whip hand from being used against them."

It is difficult to imagine another combination of artistic abilities equalling that of Robeson's on his campaign of education among the people: the superb figure of a man, singing in an unsurpassed bass the folksongs of the world to the common people of the cities and the countryside; this man equipped with a broad understanding of the people's needs and desires. This is Paul Robeson today.

"After three and a half years' absence, I have returned to resume my work in the theatre and to take my place in the musical life of the United States."

Robeson appears for one week beginning June 19 in a White Plains theatre in O'Neill's "The Emperor Jones." Shortly thereafter, he will return to England to wind up his affairs abroad, then will come back to stay. He feels that "The Emperor Jones" is a great play and that its author is among America's best. In playing in it again, however, he will eliminate all epithets derogatory to the Negro.

"Either that or I won't play in it."

"Jericho" was the last film made by Robeson; it was also the fairest to the Negro—only, however, because he himself demanded that certain changes be made in the script. The reason why it was the last is that no other producer has yet offered Robeson one which meets the artist's strict requirements.

I have alluded to Robeson's going out among the people and singing the world's folksongs. This is chiefly his new role as an artist. Not that he will ever abandon the acting theatre; he will play so long as he can find suitable material. In London last year he left forever the theatre of Mayfair to play in "Plant in the Sun" in the workers' Unity Theatre. Two of the best playwrights in the United States are now working feverishly on scripts they hope Robeson will like. One deals with the life of Denmark Vesey, the Negro slave insurrectionist.

"I used to think of myself as a concert artist, after the fashion, say, of Marian Anderson. From years of experience I know now that I am best as a singer of folksongs. And when I say that, I don't mean the songs of the Negro, only."

Which assertion led to a discussion of the responsibility in which every prominent Negro finds himself, no matter in what field he works. Paul Robeson has thought considerably on the matter.

"It seems that today, with things as they are, no Negro can help feeling that he represents more than merely himself. The case of Marian Anderson is a good illustration. She is truly a great artist, singing, as she does in that magnificent voice, the best songs of the whole world. She suddenly found herself, through circumstances over which she has no control, representing the whole Negro people of the United States. Her responsibility took on a decided political tinge, too—of immense importance to the Negro people."

He digressed here to praise the Roosevelt administration for rebuking the D.A.R. and other undemocratic elements through allowing Marian Anderson to sing at the Lincoln Memorial on Easter Sunday.[1] Continuing his remarks on responsibility, he said:

"In my childhood in New Jersey I was generally one of two or three Negro children in a white community. So I was always conscious, even as a child, of the fact that I had a direct responsibility as a Negro. Throughout my school life it was the same—as a student at college, especially as an athlete at Rutgers—not only in establishing records but in my conduct on the athletic field."

When Robeson at Rutgers won the Phi Beta Kappa key, however, he established himself not only as a brilliant Negro but as a brilliant representative of his college. When he was awarded Walter Camp's All-American football honor the Negro people, Rutgers and American football all got credit. So as a result of his determination while at Rutgers to represent the Negro at his best, Paul's fellow students came finally to choose him to represent the highest type of Rutgers man and the highest type of citizen.

He has from the beginning considered Negro folksongs great music, although they were generally looked upon as nothing more than simple plantation melodies.

"If there is one thing I am proud of it is that I have been able to do something, along with others, toward giving this Negro American folk music its rightful place in the world."

When he goes on concert tours hereafter his program will consist of folksongs of the people of various nations, with those of the United States predominating. There will be Negro songs of protest, revolutionary spirituals of slavery days, Spanish-American songs of the Far West, and songs of the Kentucky mountaineers, of the lumberjacks and of the cowboys.

When Robeson sang these songs in the Soviet Union he was acclaimed as more truly representative of the United States than any American artist they had heard before. I once saw the vast audience in the Great Hall of the Moscow Conservatory cheering in the middle of a number when he adapted Russian words to a Negro folk lullaby.[2]

Speaking of the theatre, Robeson asserts that the playing of Charles Gilpin in "The Emperor Jones" in 1920 "was really the advent of the American Negro actor in serious roles." He believes that plays of Negro life, "although never attaining their full potentialities as interpretations of the Negro's spirit, have nevertheless become, at their best, the norm not of Negro qualities but of American life."

He said that while the creation of plays in this country has lagged, the technique of the American actor—including, of course, the American Negro actor—has advanced tremendously. "This advance has been helped splendidly by the Federal Theatre Project."

He named players like Jack Carter, Rex Ingram, Ethel Waters, Frank Wilson and the late Rose McClendon, and such productions as "Porgy and Bess," "Four Saints in Three Acts," and the WPA productions of "Macbeth," "Mikado" and "Faust" to illustrate his point on the advance of technique in the theatre and the Negro's part in that advance. The Negro actor meanwhile has become also an American actor, Robeson said.

"The Negro, therefore, has done well by way of the stage, but the part of the Negro in American history—the epic part—can be depicted adequately only on the screen. Only on the screen can the Negro's real place in the building of the United States be properly shown. Take, for instance, the whole period of the development of the South."

He named Ingram, Fredie Washington, and Louise Beavers, among

others, to prove that the Negro actor was, technically, excellent material for motion pictures.

"One realizes that the film also is the medium through which to express the creative abilities of the masses. That is what folk culture means at this time. The genius of the Negro people lies close to the mass roots. When the screen is prepared to show the people of the United States as PEOPLE, getting away from love intrigues and from preoccupations with individualist futility and, instead, focusing on the struggles and aspirations of the Negro masses for freedom, for liberty, and for the right to live a democratic life—when the film does that, it will clearly reflect the struggles and aspirations also of the whole American people. . . ."

Yes, Paul Robeson, the Negro American, having enriched himself from the world's storehouses of art treasures, is coming home soon to give to the richness of life in the United States. America has something to look forward to.

Paul Robeson Told Me

Interview by Julia Dorn, *TAC* (issued by Theatre Arts Committee), July-August 1939, p. 23

"I feel closer to my country than ever. There is no longer a feeling of lonesome isolation. Instead—peace. I return without fearing prejudice that once bothered me. It does not hurt or anger me now, for I know that people practice cruel bigotry in their ignorance, not maliciously.

"A little incident which occurred almost the first day of my return will show you what I mean about having changed inside. I was invited to a tea in one of the city's leading hotels. When I approached the front elevator, I was told to use the freight elevator (the white employee's idea of the Negroes' way to Heaven). Several years back I would have smarted at this insult and carried the hurt for a long time. Now—no—I was just amused and explained to the elevator boy that I didn't belong with the freight, that, as I was the guest of honor at the tea, my hosts might be surprised to see me arrive with the supplies. The elevator man caught the idea very quickly. His colleagues would, too, if they were taught all the facts. They will know, someday. In the meantime, I know."

After ten years of successful concerts, movie and stage engagements abroad, Paul Robeson has come home.[1] When I spoke with Paul four years ago and thousands of miles away from New York, he was more interested in Africa and the sources of Negro art than in returning to the United States. Naturally I was curious to know what had prompted his return.

"I've learned that my people are not the only ones oppressed. That it is the same for Jews or Chinese as for Negroes, and that such prejudice has no place in a democracy. I have sung my songs all over the world,

and everywhere found that some common bond makes the people of all lands take to Negro songs, as to their own.

"When I sang my American folk melodies in Budapest, Prague, Tiflis, Moscow, Oslo, the Hebrides, or on the Spanish front, the people understood and wept or rejoiced with the spirit of the songs. I found that where forces have been the same, whether people weave, build, pick cotton, or dig in the mines, they understand each other in the common language of work, suffering and protest. Their songs were composed by men trying to make work easier, trying to find a way out. . . .

"Many of the old folk songs which are still young today echoed the terrific desire to escape bondage, such as the Negro protest song, 'How long must my people weep and mourn.' In Germany, today, when the oppressed commit suicide, or try to escape unbearable conditions, their actions cry out against the terrorized land they wish to leave. Our *Moses,* with its 'let my people go,' never meant going to Heaven—the direction was really the North. Sojourner Truth,[2] a Negro woman rebel who worked with John Brown[3] in the liberation movement in the nineteenth century, used to sing this song as she passed through the woods to a Negro settlement; and when the Negroes heard it, they knew it was a signal for a meeting.

"When I sing, 'let my people go,' I can feel sympathetic vibrations from my audience, whatever its nationality. It is no longer just a Negro song—it is a symbol of those seeking freedom from the dungeons of fascism in Europe to-day. The same is true for the refugees with 'Sometime I feel like a motherless child a long way from home—Come my brother'." Knowing Paul's devotion to folk songs, I asked him what he meant by the term 'folk,' which he used frequently.

"I mean the songs of people, of farmers, workers, miners, road-diggers, chain-gang laborers, that come from direct contact with their work, whatever it is. This folk music is as much a creation of a mass of people as language. Both are derived from social groups which had to communicate with each other and within each other. One person throws in a phrase. Then another—and when, as a singer, I walk from among the people, onto the platform, to sing back to the people the songs they themselves have created, I can feel a great unity, not only as a person, but as an artist who is one with his audience.

"This keeping close to the feelings and desires of my audiences has a lot to do with shaping my attitude toward the struggle of the people of the world. It has made me an anti-fascist, whether the struggle is in Spain, Germany or here.

"This, in turn, has made me see that the pseudo-scientific racial barriers which had been inculcated in me from cradle days upward were false. Even though I had won honors in university years, somehow these honors, instead of proving that color of skin made no difference, emphasized the difference all the more, since I was marked out as an exception to the rule.

"The feeling that all this is wrong, a feeling which has come from my

travels, from world events which show that all oppressed people cry out against their oppressors—these have made my loneliness vanish, have made me come home to sing my songs so that we will see that our democracy does not vanish. If I can contribute to this as an artist, I shall be happy."

Naturally, my next question was pointed toward what Paul expected to do in this country.

"I suppose the artist, as an actor, is a bit more removed from direct contact with his source than the singer—yet there is fine folk material in the drama. Take *Emperor Jones, Stevedore,*[4] *Mamba's Daughters,* many of the Irish dramas, *The Cradle Will Rock* and others.

"Playing in *Emperor Jones* at White Plains recently warmed me. After that reintroduction to the American stage, I am very anxious to begin work on *John Henry,* scheduled for production in the Fall. They wanted me to do *Othello* and *Macbeth* in Russia—and in Scandinavia, they suggested *Peer Gynt.*[5] Now I am happy to play the Negro counterpart of *Peer Gynt* here—*John Henry,* a real folk hero, in both song and literature.

"Incidentally, there was something about the way theatre and musical artists jumped to the help of their colleagues in the Federal Theatre,[6] to help save it, that has given me inspiration—that's another reason why I don't feel lonely any more."

Foreword to *Uncle Tom's Children: Four Novellas* by Richard Wright

Victor Gollancz Ltd, London, 1939

We have been long waiting for a book which would give a true and clear picture of the coloured man in America, especially in the deep south, where more than two-thirds of this oppressed minority of the United States live.

All kinds of sentimental novels of the nostalgic south and of the black people have appeared from time to time,—some harmless, some consciously or unconsciously libellous.

Now comes Richard Wright,[1] flesh of the flesh of these virile, hard-working, suffering, but joyous Americans of African descent, to create people who every one will feel really exist; characters straight out of the rich life of the folk who have contributed so much to the physical and cultural making of present-day America; all the humour, tenderness, tragedy (not pathos) are here, and much much more.

For Wright portrays the Negro as he was and is,—courageous, and forever struggling to better his condition; the Negro descended from Nat Turner,[2] Sojourner Truth, Veasey,[3] Frederick Douglass,[4] and countless others who fought that Americans of African blood should

also be free and (in the words of Lincoln) "enjoy their constitutional rights!"

Wright is a great artist, certainly one of the most significant American authors of his time. It is no surprise to discover that his stories have won numerous prizes. He is in the great tradition of the American Short Story. His characters spring from the social reality of which they are a part, and they are round and rich and full.

English people have wanted to know something about these Afro-Americans, of the Spirituals and of the popular music of today, the true peasantry of this great continent, the people who Bryce said had made such incredible progress in the seventy years since slavery.

Here they are. Would that everyone who has read *Gone With the Wind*[5] would read *Uncle Tom's Children!!*

Scene from Proud Valley

*As Othello in the
Theatre Guild
production, 1943*

IN THE FORTIES

Negroes Should Join the CIO

Remarks during campaign to organize Ford Motor Company[1]—
Ford Facts, December 20, 1940,[2] *CIO News,* December 23, 1940

I know about the situation at Ford's and I'll be glad to tell you what I think about it. Most Negroes think of me as a football player and song star. They do not know that before I could get through college, I worked as a bricklayer, on an ice wagon and as a waiter in a restaurant.

My first contact with the labor movement came while I was living in England, because of the problems affecting Negroes. The British Labour Party was intensely interested in problems affecting the Negro workers.

I gained the favor of the labor movement and decided I must do something about the problem of the Negro, their special problem and those that face all workers, white and colored. I came to certain conclusions while watching the movement there.

I am against separate unions for Negro workers. All should belong to the same organization. I am glad that is the policy that has been accepted by the CIO.[3]

Coming back to this country, it seemed to me that the simple right to organize into a Union was a common fact and should be accepted. I was amazed that such a right should be questioned here in the U.S. It is astounding that a man like Ford and a large industry like Ford Motor Company have been able to operate in a democracy and not have to deal with the movement. . . .

The Negro problem cannot be solved by a few of us getting to be doctors and lawyers. The best way my race can win justice is by sticking together in progressive labor unions. It would be unpardonable for Negro workers to fail to join the CIO. I don't see how that can be argued. Insofar as the AFL is concerned, A. Philip Randolph, President of the Brotherhood of Sleeping Car Porters, a Negro, had difficulty getting the floor at the AFL Convention just to present the demands of Negro workers for full rights.[4]

There is no reason in the world why Negroes should not join the CIO. If they fail to do so, they classify themselves as scab labor Negroes and cannot be a part of the American Democracy except through labor unions. A democracy cannot exist without labor unions.

In the United States today there is a terrific effort going on to take away the all too few rights of labor. If that happens, the Negroes, who have the fewest rights, will suffer most.

135

Soviet Culture

Foreword to *Favorite Songs of the Red Army and Navy,* compiled
and edited by David J. Grunes, New York, 1941

In many lands, the Arts, and especially Music, have been cut off from
the general life of the nation. They have become the source of
enjoyment for a comparatively few so-called elite—who feel that
culture should be somewhat unapproachable—except to their own
understanding—and at times, completely non-understanding—selves.

One of the great problems of our time is the making of the great
creations of mind and spirit available to all. We in America had some
idea of this cultural sharing in the finest days of the New Deal.

But those forces that even today refuse to make the slightest
sacrifice for the advancement of the good life—that do not really want
an enlightened and sensitive citizenry—those same forces made im-
possible, at that time, the continuance of this important social contri-
bution.

What a revelation when first I went to the Soviet Union, to see that
all forms of culture—the pictorial and plastic arts—the art of the
theatre—poetry—music belonged in the highest sense to the People.
They crowded the galleries—the theatres, realistic and poetic—the
opera houses—the concert halls. Here Art was closely wedded to life.

In music, all the masterworks were performed by worthy interpret-
ers before eager and enthusiastic audiences. Bach,[1] Mozart,[2] Beetho-
ven, Chopin,[3] Debussy,[4] Mussorgsky,[5] Tchaikovsky,[6] Prokofieff,[7] Sho-
stakovitch,[8] Gershwin[9]—all were daily bread and wine. But also (in a
land famed for the beauty of its folk melodies) there burst forth anew
wonderful sources of folk material (always the real foundation of any
great music) from the many truly free nationalities of the Soviet
Federated Republics. This material found new uses—opera ("Quiet
Flows the Don"),[10] ballet, folk choruses, folk orchestras (balalaika),
folk dramas (Gypsy and Uzbek Theatres). One sensed a folk art-form,
serving as a constant source for more complex (not necessarily superi-
or) forms.

Our American Negro folk songs sprang directly out of our lives—our
working lives—e.g., John Henry ballads[11] and countless others so
superbly sung by Leadbetter[12] and Josh White.[13] Songs of protest,
songs of faith in a better world, songs slow and rhythmic, tender and
gay.

So it was not surprising to find composers gathering these new and
old melodies—a Shostakovitch using them as symphonic material as
did Mussorgsky and Dvorak,[14] others setting them to lyrics of fine
poets—true creations of and for the People—expressing their joy in the
new life, in the new society, in a new conception of human liberty, of
human aspiration, of human possibilities of achievement. These songs
were sung in the factories, in the mines, at Youth Day celebrations, at

festivals, and especially by the soldier-choruses of the Red Army, trained by a great Director—Alexandroff.

No need to tell of the great part played by these songs in today's epic struggle. We have heard the phonograph records of the Red Army—we have seen many Soviet films—have listened to the singing of these brave soldiers marching to victorious battle—singing that has already become legendary.

For through them we clearly understand why today the Soviet Armies stand ready for the final blow at the heart of Nazi-scourged Europe—why the heroism—the readiness and joy of sacrifice for a new world in birth—why the firm faith in the present and the future which characterizes this brave people, who can with our deep and lasting gratitude accept the honor of having (in great part) saved our civilization.

Here in this collection are many of these songs—old and contemporary—familiar and new. Here is a rich source of direct contact with the Soviet spirit. We must know this Ally well. We in America, together with our Russian and other friends, have a great responsibility to our future generations. We must understand and, yes, treasure each other. One of the quickest ways to this understanding, friendship and mutual affection is through music (the Russians have published and perform much of ours) and most of all through the idiom of the folk song, like the common expression of a people that is so immediate in its communication to all others.

I am privileged to have the opportunity of writing this brief foreword. For I have long deeply admired and loved the Soviet people as I do my own. I sincerely hope that these songs will help inspire a deep understanding of, and an admiration for, a People who I know have the progress of all humanity so deeply at heart.

Speech at National Maritime Union Convention

July 8, 1941—*Proceedings of the Third National Convention of the National Maritime Union of America, affiliated with the CIO, held in Cleveland, Ohio, July 7th to July 14th, inclusive, 1941*, pp. 56–57

(Brother Paul Robeson arrives and is greeted with a tremendous ovation.)

THE CHAIR: At this time we will suspend the regular order of business. A privilege that we have long been waiting for has been accorded us now. Everybody here has been waiting since the Convention opened for this moment. I particularly am glad to be able to present our guest because we come from the same town in New Jersey. We grew up together in the same town.

So it is a great honor for me to be able to present to you a man, who is not only one of the greatest singers in the world today, but a man who is also known as one of the greatest fighters for civil liberties, democracy and trade unions throughout the country as well as throughout the world. (Applause) And one who has never failed to give of his time and his great voice in the cause of democracy and civil liberties.

I give you at this time Brother Paul Robeson.

(The delegates rose to their feet and thunderously applauded and cheered Mr. Robeson. It was some time before the demonstration ceased.)

Joe Curran and fellows and brothers: I needn't say how happy I am to be here, because I am here. I don't come as a singer of importance or anything like that. I come today because I feel very close to the maritime unions. I remember coming on a ship with Mr. Brown from abroad after the war began. I remember stepping on an American ship and after being on board a couple of hours, a delegation came up to me and said: "Paul, we know who you are, and anything we can do for you we shall surely do." I remember later singing for them below and having a great time.

I know the whole background of your Union, and I would like you to know that among the colored people of this country your Union stands among the foremost for giving complete equality and for the advancement of the colored people. I just want to tell you that. (Applause)

I remember when I was going through school—I had a brother I lived with out in Westfield, N.J.—he went to sea and I went to sing, (laughter) while working my way through school. I used to go down to the docks. My brother worked on the Fall River Line. And then I learned how to sling hash in one of the hotels.

I come as one who has worked very hard in the early part of his life, and I still work very hard for the things in which I believe. I don't feel a stranger; I know Joe and Ferdy Smith, and one of my best friends is here, Revels Cayton from out in San Francisco.[1] But more than personal friendship, I know that we are all one in the things for which we stand. Here at home, of course, for complete rights for labor, for complete equality for the colored people of this country, and for a right to a better life for every worker in this land of ours. (Applause) Further than that, I know that we spread out and we stand not alone, but we stand for mankind wherever it may suffer and wherever it may be oppressed. (Applause)

I have had the opportunity to work with refugees from Austria, Germany, for the Spanish people and for the Chinese people, and I saw very clearly how all of our problems come together, no matter whether we may be black or white or yellow. As long as we are struggling for a better life we have one cause, and I don't know about you, but I feel awfully happy today and awfully optimistic now that fascism has come to grips with a power that will show it no quarter. (Applause)

I have been in the Soviet Union and I know that the people of the Soviet Union know who they are fighting, why they are fighting and for what they have to fight. I know that this Union with its militant background, will come to a decision to urge the government to give the Soviet Union all aid possible in its fight against fascism, for the Soviet Union is standing four-square for the cause and the rights of all the oppressed peoples of the world.

This is my first time among you. And whenever your next convention comes—I see by the papers it may be in 1943—I will be back again. (Extended applause)

(Mr. Robeson then sang the following songs requested by the audience.) Bill of Rights, Water Boy, Joe Hill, Fatherland, Old Man River, Jim Crow, It Aint Necessarily So, Spring Song, Song to Joe, Ballad for Americans.

THE CHAIR: I know he would like to sing all day. He sings because he loves to sing, but we have to be sure that a voice like his must be saved so that all can hear him. So though we would all like to hear more, we must think of preserving his voice.

I would recommend that we give consideration to extending to Paul Robeson for all the work he has done in all fields of endeavor, an honorary membership in the National Maritime Union. (Extended applause)

M/S/C To extend to Paul Robeson honorary membership in the National Maritime Union.

(The Convention again rose amid a demonstration of applause as Paul Robeson left the hall.)

A Plea for Earl Browder

Remarks at Mass Meeting to Free Earl Browder,[1] Madison Square Garden, New York City, September 29, 1941—*The Negro and Justice: A Plea for Earl Browder by Dr. Max Yergan and Paul Robeson,* published by the Citizens' Committee to Free Earl Browder, New York, November 1941

I don't need to say why I am here tonight. In the long struggle against fascism there has been one voice raised loud and clear from the beginning, the voice of one who has been in the front lines of the fields of Spain—Earl Browder. His voice was clear in those days when collective action was necessary to defeat fascism and it is clearer today when really sincere collective action will mean the death of fascism on the soil of the Soviet Union.

I am here tonight because I know that you know that there can be no more honest evidence of a sincere decision to defeat fascism along with the sending of tanks and every possible aid to the Soviet Union, than

the freeing of Earl Browder, so that he may take his rightful place in the vanguard of the cohorts against fascism.

Let us start off with a couple of songs that mean a lot to me and I know mean a lot to you—just a few phrases from the "Bill of Rights." (Sings)

World Will Never Accept Slavery, Robeson Asserts

Interview by Richard S. Davis, *Milwaukee Journal,*
October 20, 1941

Paul Robeson, the huge black rock of a man who happens to be one of the world's most famous singers, sat in his hotel room Monday morning and talked about the meaning of the war.

It was a subject the big man has been thinking about, not in the distant and casual fashion of most Americans, but as a citizen of the world—a man who knows England, France, Spain, Germany and Russia down to the roots. As a Negro, moreover, this citizen of the world has been primarily interested in those roots. World famous, wealthy and free to bask in any country's limelight, he has chosen to rub elbows with the people who are down, not only his own people, but all who struggle in the mass.

"As I see the war," the singer explained, "it is fundamentally a collision between conservative and liberal forces. It is a clash between those who would enslave the common man and those who would give him freedom. In such a battle, the forces of slavery can never win."

The big man was speaking in a low, resonant voice that was close to a rumble. His eyes were shining with the light of deep conviction. He had the earnestness of a crusader and the eloquence of a prophet. And this was the man who, a score of years back, was recognized as one of the greatest football players ever to tear up a gridiron. This was the famous actor, the musical comedy star, the concert artist supreme in his field.

"You ask about Russia," the big man said, "and what I think of its death struggle with Hitler. I think Russia will fight on, and on, and still on until somehow victory is won. If Moscow falls, there will be another line back of the Urals. There will be no collapse.

"Yes, I do know Russia. I learned the language before I went and in the 1930s I made annual trips of from one to three months' duration. I sang to the workers in their shops. I talked to them in their homes. I think I can say that I know them.

"It is out of that knowledge that I tell you Russia will not fall. You see it is this way: The man we so glibly place in 'the masses' sees something ahead. He sees ahead and he remembers. It is ridiculous to believe that this man will ever submit to slavery. He will die, as he is dying, but he will never submit.

"If these Russians down at the roots did not have faith, they could walk over to the Germans and quietly sit down. That was what so many people in this country expected them to do and great is the surprise at their eagerness to fight, but it is no surprise to me.

"There will be the fiercest kind of guerrilla warfare in the country held by the Germans. There will be sabotage to make child's play of the destruction anywhere else in the world. It is absolutely certain, to my mind, that Hitler will meet defeat in Russia.

"Some observers babble of the chance that a new order will come in Russia after the war—re-establishment of the Kerensky regime,[1] or something like that. It is absolutely unthinkable. Any such system would not have a ghost of a chance. I tell you, and I know, that the man of 'the masses' in Russia has hope and he will not give it up."

As evidence of his faith in the Russian people, the towering Negro mentioned the fact that he had placed his son, Paul, in a Russian school. The boy had been living since he was a baby principally in England, which for years was home to the Robeson family.

"The boy," his father related, "had been taken to Austria, to France, to Switzerland. He learned to speak German with a Tyrolean accent and this was his first language. He had never, in any country, bumped up against prejudice.

"And then one day, when he was playing in London with other children, a mother snatched her child away from him. She said something that hurt him so deeply that he was almost stunned. I was afraid of what it might mean.

"I talked it over with the boy and asked if he would like to go to school in Russia. He said he would. And he did, with the result that there was no scar from that bitter wound in England. The boy now knows that prejudice against him because of his color is the product of ignorance. He can laugh it away, just as I can."

As an all-American, the senior Robeson paused a moment to disclose that his son, now in a Connecticut high school, is likely to be bigger than his father and a football player for any man's team. At 14 he is a blocking back on the first team.

"You know I had rather hoped," the father added, "that the boy would not want to play, but one look at the game and there was no holding him. I think I'll take him around for a look at Rutgers before he goes to college, but it's all up to him."

It was at Rutgers that the singer made himself one of football's immortals. It was at Rutgers, also, that he won his Phi Beta Kappa key. It was at Columbia that he studied law.

"How is the boy, a pretty good student?" the reporter asked.

"Yes, he's very bright," said the father, with the world's most disarming grin.

The singer spoke with feeling of the problems of his own people. He said he belonged to that group of Negroes who believe that the way to help the race is to make it possible for every man to make his own decent living.

"It means little," he explained, "when a man like me wins some success. Where is the benefit when a small class of Negroes makes money and can live well? It may all be encouraging but it has no deeper significance.

"I feel this way, you will understand, because I have cousins who can neither read nor write. I have had a chance. They have not. That is the difference. And I believe that no political philosophy that does not include a chance for all of them can possibly endure.

"The reason I mention the Negro problem in America is to explain my feeling about Russia. The kernels of the situation are the same. I mean this: In Russia the people who are 'the masses' feel they have been given their chance. They may be wrong, but that is their conviction.

"People who feel that way will never again be enslaved. Hitler hasn't a chance."

Hollywood's "Old Plantation Tradition" Is "Offensive to My People"

The New York Times, September 24, 1942

SAN FRANCISCO, Sept. 22 (AP)—Paul Robeson said today he was through with Hollywood until movie magnates found some other way to portray the Negro besides the usual "plantation hallelujah shouters."

In an interview the Negro baritone said he was particularly despondent over his recent return to Hollywood to play a sharecropper sequence in "Tales of Manhattan."[1]

"I thought I could change the picture as we went along,"[2] Robeson said, "and I did make some headway. But in the end it turned out to be the same old thing—the Negro solving his problem by singing his way to glory. This is very offensive to my people. It makes the Negro child-like and innocent and is in the old plantation tradition. But Hollywood says you can't make the Negro in any other role because it won't be box office in the South. The South wants its Negroes in the old style."

We Must Come South

Speech before audience of black and white men and women, seated without segregation, in Booker T. Washington School auditorium, New Orleans, Louisiana, October 29, 1942—Paul Robeson Archives, Berlin, German Democratic Republic

I had never put a correct evaluation on the dignity and courage of my people of the deep South until I began to come south myself.[1] I had

read, of course, and folks had told me of strides made . . . but always I had discounted much of it, charged much of it to what some people would have us believe. Deep down, I think, I had imagined Negroes of the South beaten, subservient, cowed.

But I see them now courageous and possessors of a profound and instinctive dignity, a race that has come through its trials unbroken. A race of such magnificence of spirit that there exists no power on earth that could crush them. They will bend, but they will never break.

I find that I must come south again and again, again and yet again. It is only here that I achieve absolute and utter identity with my people. There is no question here of where I stand, no need to make a decision. The redcap in the station, the president of your college, the man in the street—they are all one with me, part of me. And I am proud of it, utterly proud of my people.

I have travelled extensively. I have seen peoples in all parts of the world; peoples who, some of them, have not been equal to the spiritual task of retaining dignity and self-respect and courage and self-reliance. I have seen whole peoples ground down, depleted, crushed. But not so these great black people. Whatever the future holds for others, it is full of hope and brightness for them—for us. Nothing the future brings can defeat a people who have come through three hundred years of slavery and humiliation and privation with heads high and eyes clear and straight.

Again I say, I must continue to come south. I must do so to be with my people and to refresh my soul with their strength. I have heard you say that a Negro of the South who has a contribution to make is a traitor if he leaves, goes to live somewhere else. The firing line, the battle zone is here, and it is his duty to remain at his post. I agree; and I say that those of us who do not live here likewise have the responsibility, the duty.

We must come south to understand in their starkest presentation the common problems that beset us everywhere. We must breathe the smoke of battle. We must taste the bitterness, see the ugliness . . . we must expose ourselves unremittingly to the source of strength that makes the black South strong!

"Democracy's Voice" Speaks

People's Voice, New York, May 22, 1943

Paul Robeson, "democracy's greatest voice," will become Dr. of Humane Letters at Morehouse College in Atlanta, Georgia, on June 2, when he delivers the commencement address at that institution.

The only man in the world who can turn a concert into a rally for the rights of minority groups, the renowned people's artist told *People's Voice* this week that he is "much impressed" with the South, where he has appeared in 4 or 5 concerts during the past season.

"I wouldn't sing to segregated audiences, so I sang in Negro schools and white people came. I was much impressed by a youth hungry for education.

"The spirit of Negro youth in the South augurs much for the future. He is proving that he understands his role in the world-wide struggle against fascism.

"It is a source of deep pride to me that I am receiving my first honorary degree from a Negro institution, and a Southern one at that too. Unless the problems of the Negro people in the South are solved, the Negro people in the North will never be able to solve their problems.

"The Negro must view the domestic scene in its relation to the global struggle against fascism because, since we no longer live in isolation, what happens in other parts of the world also happens here.

"Once the war is over, the struggle will commence for the nationalization of our economy so that it can best serve the interests of all of our people.

"After the defeat of the fascists and their allies, the United States will have to cope with the fact that the harassed people of India and the British West Indies will be free, and that Africa will occupy a different position in the post-war world. If America is to survive in this new world, she will have to deal with millions of Negroes who will no longer be in bondage. The United States can best prepare for the future by breaking down the autonomy of the states, repeal the poll tax and put anti-lynch legislation in force. Our chief executive must act for the protection of all the people by guaranteeing all in our nation complete equality. This issue will be a major one in the post-war planning.

A Victorious War Must Free All

Remarks at Free People's Dinner in Honor of Paul Robeson, July 20, 1943, Berkeley, California—*People's Voice,* New York, August 4, 1943

The triumphant end of this war must bring a world where there can be no question of a colored people or a white people, but a question purely of human beings, a world where there can be no question of colonial exploitation of any kind.

There can be no question anywhere of a "backward" people if they are given the opportunity of complete equality. A victorious war against fascism must guarantee that they have this opportunity. We must understand that the problems of African people are symbolic of colonial peoples and that their freedom is our freedom.

The immediate objective for all Americans, white and black, is complete victory over the forces of fascism which would enslave everyone. This is every man's war; this is not a white man's war nor a

white man's victory, nor a colored man's war nor a colored man's victory. Let us make sure that the victory that follows will be one that assures full freedom for all people in this world regardless of race or color.

Interview in *PM* and Paul Robeson's Reply

PM, September 12 and 15, 1943

Paul Robeson, Negro singer who sent his son to school in Russia and to England so he could live like a "first class citizen," said yesterday that never again would he consider leaving America.

"I did a lot of thinking when the war started," Robeson, now rehearsing for the leading role in *Othello*,[1] said: "I had planned to leave the United States for good and I was living in London, shuttling over to Russia every Summer to see my boy. I thought I saw more tolerance for Negroes abroad than I did here."

But Robeson decided he was wrong when the war broke out. "I realized then that the Negro problem here is a minority group problem, not one of individuals as it is in many European countries," he said. "And I realized that America gives her minority groups more of a chance than just about any country on earth.

"Besides I was homesick and I decided that I wasn't helping the Negro problem in the United States any by running away from it."

Robeson now is preparing a treatise on African culture which he promises will demonstrate that it is as old and venerable as Chinese culture. A member of Phi Beta Kappa, honorary scholastic society, and the holder of a law degree from Columbia, Robeson said that he taught himself the Chinese language as part of preparation for writing the treatise.

"I learned the languages of Africa first," he said, adding that he had found the Chinese language very similar, and learned to speak that tongue.

"Just because I've settled down in Connecticut, don't think I'm going to stop criticizing the United States," Robeson concluded. "I'm going right on criticizing this country until Negroes can live like first class citizens."

Now growing a beard for the Moor's role in the Shakespearean play, Robeson said he enjoyed playing Othello because he was "killing two birds with one stone."

"I'm acting," he said, "and I'm talking for the Negroes in the way only Shakespeare can. This play is about the problem of minority groups. It concerns a blackamoor, who tried to find equality among the whites. It's right up my alley."

Dear Editor:

In reference to the article on Sunday, Sept. 12, the quotations attributed to me were, to say the least, inaccurate. There were two main references: one, my residence abroad, and the relation to the minority problem; and two, the reference to the play, *Othello.*

First, regarding my stay abroad, I went back and forth to Europe from 1928 to 1940. I spent much time in England and Russia. During that period there appeared various statements that I would remain abroad, and on several public occasions I stated that I so contemplated.

Then came the rise of fascism. I soon saw the connection between the problem of all oppressed peoples, and the necessity for the artist to participate fully. I worked as much as I could for the relief of the refugees from Germany, Austria, etc., for the Chinese people, Ethiopian people, and later went to Spain, that important focal point in the struggle against fascism.

During that struggle I realized the need for returning to America to become a part of the progressive forces of my own land. I felt deep obligation to the Negro people who still suffered acutely, and realized that their future was bound with the future of the great masses of the American people, including the forces of labor, the Mexicans, the Chinese, the American Indians. It would include, certainly, the "one-third of our nation"[2] of which our President has spoken as still not enjoying the full fruits of our American democracy. I realized that if America held to its democratic traditions and resolutely fought fascism, elected leaders who recognized the needs of the common struggle of the individuality of freedom for all men, the problems of the colored people would be well on the way to solution. My decision to again make my home in America was taken as early as 1937.

As I said above, during the 1934–1938 period, I visited the Soviet Union many times, and decided to send my boy there to school. There I found the real solution of the minority and racial problem, a very simple solution—complete equality for all men of whatever race.

And this leads me to hope for full co-operation between the United Nations, and full understanding of the role to be played by the Soviet Union. It is my belief that the people of this great country have much to offer to the people of other nations.

Concerning Shakespeare's *Othello,* it is an interesting point that the great dramatist as far back as 1600 posed the question of the acceptance by a society of one of alien culture and race. And therefore this is a play which is of great interest to us moderns today as we face the whole problem of relations of peoples between different races and cultures. Also, of course, it is a play of love, jealousy, pride and honor—emotions common to all men. As for the full significance of the play, one of the most competent authorities would be Miss Margaret Webster, the director and associate producer of *Othello.*

<div align="right">Paul Robeson, New York</div>

The interview with Paul Robeson was printed as released by the United Press.—Ed.[3]

American Negroes in the War

Speech at the Twelfth Annual Herald-Tribune Forum,[1]
November 19, 1943—Pamphlet, New York, 1944

I am here today to discuss the problems of the Negro American.

As for all Americans any approach to special problems must be viewed in the light of the new historical necessity dictated by our full participation in the World War II. For we live in a period of human history when the greatest, the most sacred, the most human task has become the destruction of Fascism in whatever form, wherever it may be found, and the ushering in of a new epoch in our civilized life.

As a Negro American, I can understand the importance of this task because I have seen Fascism grow from its early days—days when, as a young American abroad, I had little understanding of what was to come. Much later with the rise of Hitler, I sang for refugees, went through Germany in 1934 where I encountered trouble that might well have meant my life—saw the great antithesis of this monstrous ideology of Superior Race and the enslavement of mankind, and its eventual destroyer—for in the same year, 1934, I visited the Soviet Union where I found new life, not death; freedom, not slavery; true human dignity, not inferiority of status. Upon my return to Western Europe and to England, I saw the suffering about me with different eyes. I realized that the sufferings of my own people were related to the sufferings of equally oppressed minorities. Later I saw Austria in its dark days, Norway and Denmark on the edge of destruction. I saw Spain in its travail, and helped struggle against the policy of those who sacrificed the republican state, and by so doing made necessary the needless sacrifice of thousands of precious lives.

During this period the lessons to be learned seemed to be very clear; the danger ever present. However, in general, for good and sufficient reasons these lessons and this danger were not full comprehended.

Other peoples, however, besides the direct victims of the Axis aggression also have a genuine awareness of the democratic significance of the present conflict. Their awareness is born of their yearning for freedom from an oppression which has pre-dated Fascism, and their confidence that they have a stake in the victory of the forces of democracy.

The American Negroes have such an outlook. It dates most clearly perhaps from the Fascist invasion of Ethiopia in 1935. Since then, the parallel between his own interests and those of oppressed peoples abroad has been impressed upon him daily as he struggles against the forces which bar him from full citizenship, from full participation in American life.

There are three things in the American scene which today arouse the bitterest resentment among black Americans and at the same time represent the greatest handicap upon their full participation in the

national war effort. First, is their economic insecurity which they know to be the result of continuing discrimination in employment even now, coupled with other forms of economic exploitation and social discrimination in urban communities such as Harlem.[2]

Second, is the segregation and inferior status assigned to Negroes in the armed forces, and their complete exclusion from most of the women's auxiliary services. Added to this are the insults and acts of physical violence nurtured by the segregation policy, which have been inflicted upon them in many of the camps and camp communities, even in areas which, before the coming of the army camps, had been free from racial prejudice. This is a shameful condition. Several appeals have been made to the President, from whites as well as Negroes, urging him to issue an executive order against racial discrimination and segregation in the armed services. Such an order is as essential to the morale and fighting spirit of our war machine as to the morale and productive capacity of our industrial machine.[3]

Third, is the poll-tax system of the South, which operates to maintain undemocratic elements in places of authority not only below the Mason-Dixon line but in our national life as a whole.[4]

It is not my purpose to discuss at length these evils. I only want to say that every day Americans continue to tolerate these conditions, just that much more difficult is America's task in winning this war and that much farther removed are all Americans from winning a people's peace.

Some progress has been made in righting these wrongs. The most positive action has been in the accomplishments of the President's Committee on Fair Employment Practice.[5] And let it be said to the credit of our Commander in Chief that he has twice interceded to prevent this agency from being rendered powerless.[6] The Marines and Air Corps have abandoned their policy of excluding Negroes, the Navy has cracked the door for them, and some Army officers are doing their best to change the pattern of distinction between white and black American soldiers. But these gains are pitifully small, indeed—when measured against the loss of man power, the lowered morale, the inter-racial friction and national disunity which characterize America at war.

And yet there are some who deplore the Negro's present-day struggle for democracy and equality as endangering the national unity and our war effort. They point to the trouble (so they say) that the F.E.P.C. has stirred up in the South, and to the disgraceful race riots—insurrections or pogroms would be more accurate—in many industrial centers, which resulted (so they say) from Negro militancy.[7]

Such people do not understand the bases of this conflict. The Negro asks that we be clear about the great moral and practical issues involved. Do we want to fulfill our historic destiny and build a good world and a good life for the many (as is clearly possible)?—abolish inequalities in great measure; provide tremendous opportunities for the hitherto oppressed, or shall we follow the Fascist idea of dog eat dog and let the many starve—live endlessly in poverty—deny the

fundamental equality of all men (we'll excuse genius) and their equal
potentialities given equal opportunities?

The objectives of the first way have been well expressed by our
President and Commander in Chief, by our Vice-President, by the
great leader of the Soviet people, and much less desiredly expressed by
the great English leader, Mr. Churchill, whom, however, I sincerely
believe the English people will push on to broader and more inclusive
objectives.

Again the Negro asks that we be clear about those whose new
freedoms and new opportunities are concerned. First, the freedoms and
opportunities of the underprivileged and oppressed everywhere, the
underprivileged in many as yet not fully democratic lands, including
our own; the people laboring in mine and mill and in the field; the
minority peoples, be they white or black, yellow or brown, of whatever
religion or creed.

Attacks upon the representatives of the laboring people, upon
colored, Jewish, Spanish-American minorities are, in the last analysis,
Fascist attacks. We have seen many in recent months—vicious ones
upon labor. We can recall Detroit, Los Angeles and—so terrifying for
one who, as the son of a slave, was reared and nurtured upon the
abolitionist tradition, and for whom Boston Common and Brattle Hall
symbolize the height of human striving for free men in a free
world—we must now include Boston itself. To paraphrase a famous
statesman: "Freedom is indivisible," and to attack any one minority
group is to attack every other section of our richly differentiated, yet to
be fully unified America. All Americans must be as outraged at these
cowardly attacks as if upon themselves. Admittedly, there are deep
and constant responsibilities within all groups to find a way to
complete unity.

Today's militant protest of the Negro people, as illustrated in the
recent election of the Negro Communist, Mr. Ben Davis,[8] to the New
York City Council, and the general trend of the Negro vote toward
acceptable candidates rather than party labels—this militant protest
represents the development of a clearer understanding among Negroes
of their goals, their allies and their enemies. Negroes know that their
rights can only be achieved in an America which has realized all of its
democratic ideals. They know that their own struggle is bound up with
the struggle against anti-Semitism and against injustices to all
minority groups. They know that those sections of organized labor
which have enlisted membership on a plane of strict equality consti-
tute the Negro people's chief allies in the struggle for democratic
rights, and they know, too, that the winning of the war against
Fascism is the first and fundamental requirement toward the realiza-
tion of a democratic America.

Secondly, others concerned with new freedoms and new opportuni-
ties which must be realized as quickly as humanly possible are the
colonial peoples of the earth.

In other continents, Asia and Africa and India, and in the islands of
the Caribbean and the Pacific, black, brown and yellow peoples are

likewise alert to the issues of this war. Our Japanese enemies, taking full advantage of this fact, are seizing every opportunity to try to convince these peoples that they, the Japanese, and not we, the members of the United Nations, are their true liberators. The other half of our continent to the south, with its nations of great tradition, watches and hopes.

The great majority of these peoples, especially in Africa, are on the sidelines of the war. They have not been mobilized to any appreciable extent by their colonial administrators in either the military or production services. Their participation now in the United Nations' war effort—just as in the case of the American Negro—is the measure of the kind of victory and the kind of peace that is in store for them.

Let me read to you something that a Negro leader in South Africa recently said: "I know, like anybody else, that although we are fighting for democracy, we do not enjoy democratic rule in this country; but I look with hope to the influence that will be exerted by America and Russia toward our rights, and I think that if the Allies win, a new order of government will be brought about."

"I look with hope to the influence that will be exerted by America and Russia toward our rights"—these words represent the thought of millions of colonial peoples throughout the world.

This last quotation brings to mind that once again, as at Munich, we stand at another crossroad in this Fascist struggle but this time the lessons to be learned and the ever-present danger are much more easily comprehended, and a great responsibility lies with us here in our great United States. I feel it my duty as an American citizen to press the need for collaboration and friendship now and in the post-war world with the great peoples of Soviet Russia, for Negroes hate Fascism to the death, and of all its destroyers the Soviet peoples have been the most potent and self-sacrificing. With their blood they are washing much of this monstrous growth from the face of the earth. We either collaborate with the Soviet Union, England and China (and our decision must deeply influence the other nations concerned), or we can pursue a selfish path which can only lead to further imperialistic ambitions and wars which, in my belief, could well lead us to disaster.

In Moscow we have just made an auspicious beginning in the right direction, but already the attacks have begun and in high and powerful places. The struggle is on its way to be won, but it can be delayed, and in essence, lost, if we are not fully aware. As for Negroes and persons who, in view of the world's suffering—and on the other hand, of the possibilities of a decent life for all (measured in a purely scientific manner by our experts)—I repeat, they who still say "No" to the end of the war and its causes, and insist upon an impoverished world—these persons are in no wise anti-Fascist, and are, whatever the reasons, enemies. They are many and powerful. One of the greatest hopes today lies in the spirit of the oppressed themselves. The underground peoples in France, in Yugoslavia, in Norway, in Denmark, in Czechoslovakia. The oppressed everywhere—yes here in Boston, Detroit, Los Angeles, in the South—are determined to have

liberty, opportunity and human dignity. Thanks to the blood of our boys and that of our allies, thanks to these sacrifices, this liberty, opportunity and dignity the hitherto oppressed will have.

People can take hope from the words of their Commander in Chief, President Roosevelt, spoken on the second anniversary of the signing of the Atlantic Charter.[9] "We are determined that we shall gain total victory over our enemies, and we recognize the fact that our enemies are not only Germany, Italy and Japan; they are all the forces of oppression, intolerance, insecurity and injustice which have impeded the forward march of civilization." These words let all Americans remember.

Time to Bring Negro Baseball Players into the Major Leagues

Remarks at meeting of Negro publishers' delegation[1] with High Commissioner of Baseball Kenesaw Mountain Landis and Major League Owners, Hotel Roosevelt, New York City, December 3, 1943—Reproduced from reports in the *Pittsburgh Courier,* December 11, 1943; *Chicago Defender,* December 11, 1943; *Baltimore Afro-American,* December 11, 1943; *Daily Worker,* December 4, 1943; *The New York Times,* December 4, 1943

The Negro player question occupied first place on the agenda of this all-important meeting which was attended by the presidents, vice presidents and general managers of all the sixteen major league clubs and was presided over by Commissioner Landis.

Landis in introducing Robeson said:

"It is unnecessary to introduce Paul Robeson. Everybody knows him or what he's done as an athlete and an artist. I want to introduce him to you as a man of great common sense. I want to make it clear that there is not, never has been, and as long as I am connected with baseball, there never will be any agreement among the teams or between any two teams, preventing Negroes from participating in organized baseball. Each manager is free to choose players regardless of race, color or any other condition.

"Now Paul Robeson will speak to us."

Robeson then spoke as follows:

"This is an excellent time to bring about an entry of Negro players into organized baseball.

"The time has come that you must change your attitude toward Negroes and keep it consistent with the attitude of the entire country.

"To me, the most indicative thing that has happened in the fight against racial discrimination is the reception that I've been given in *Othello.* I was told before the play was produced that America was not ready to accept me or such a delicate theme, but I've never appeared before friendlier audiences.

"When I played football at Rutgers, we met Southern teams that

threatened to cancel games if I was in the lineup. The games were played and nothing happened. I almost was killed the first year, but I was accepted after I had proved my ability.

"I can understand the owners' fears that there would be trouble if Negroes were to play in the big leagues, but my football experience showed me such fears are groundless. Because baseball is a national game, it is up to baseball to see that discrimination does not become the American pattern.

"I come here as an American and former athlete. I urge you to decide favorably on this request and that action be taken this very season. I believe you can be assured they will reflect the highest credit upon the game and the American people will commend you for this action which reflects the best in the American spirit."[2]

After the meeting, upon hearing that Landis and the baseball magnates had agreed that there should be no barrier to participation of Negroes in organized baseball,[3] Robeson hailed it as a magnificent step forward for our country: "All America will commend Judge Landis and the magnates for this step in opening the way for the immediate signing of Negro players. This move is entirely in keeping with the progress of our nation in this war against the Axis. Its manifestations will be felt and heard in every part of the world."[4]

Robeson Remembers—Interview with the Star of "Othello" Partly About His Past

Robert Van Gelder, *The New York Times,* January 14, 1944

In his East Side house, the living room of which is well furnished with Bach records and well-selected, well-read books, Paul Robeson talked last week of some of the living, the vital experiences, that have gone into his role of Othello.

The tall man with the huge shoulders is a champion talker. He has humor, a taste for the dramatic, and at the same time is entirely natural. He brags a little but this is perfectly healthy bragging, and he can laugh at himself in a casual, easy way.

"When I set up as an actor," he said, "I didn't know how to get from one side of the stage to the other. When I started playing Othello—in London, that is—I was almost as bad. And I wasn't helped a bit when Hannen Swaffer[1]—you know about Swaff, anything for a headline—brought up the question of how will the public take to seeing a Negro make love to a white woman and throw her around the stage. Now probably most people that didn't bother a bit—but it sure bothered me.[2] For the first two weeks in every scene I played with Desdemona that girl couldn't get near to me, I was backin' away from her all the time. I was like a plantation hand in the parlor, that clumsy. But the notices were good. I got over it.

"And over here. I'm still changing things as I learn about them.

Some criticisms, naturally, I don't spend time on. For instance, a friend of mine came to see me the other night and said, 'Paul, quit fallin' on the floor in that fit.' He said that Othello was a man of too much dignity to go rolling around the floor. 'Slump in a chair, Paul,' he said, 'and keep some dignity.' Well, now, the script says that Othello falls into an epileptic fit. You tell me, what can be dignified about a fit? I go right down on the floor.

"Other criticisms, though, I pay attention to, naturally. I have quit frothing at the mouth, for instance. I never frothed a great deal but I did froth a little, and you know that if someone like Salvini frothed at the mouth everybody would say, 'Boy, he's wonderful, a wonderful actor.' But when I did it it was just too distasteful to too many people. I can understand.

"Then there are some people who think I play that part too high, that is, with too much emotion, that I try to blow the roof of the theatre right off. Well, I think it is most effective that way, and one Saturday night not long ago when I heard Dame May Whitty was in the house I really tore loose. What makes me an artist is the emotion I've got, the reservoir of emotion, and I used it all that night. I was dog tired when it was over. If I played the part only three or four times a week maybe I could do that every time, but nobody can use himself all up the way I did that night eight times a week.

"The way I play it, I'm calm, I'm quiet, through all the early part. I don't make an unnecessary move. And I think that's right. Of course, if I didn't have a mighty active Iago I couldn't get away with that massive calmness, perhaps, but with Joe (José Ferrer) all over the stage the way he is, it is an effective contrast.

"But these people who think I play the part too high, I think they're mistaken. It's Othello's play toward the end, and he's got to take it on. Their argument is that Othello, being such a great general and all, a man of so much power, would stay sort of restrained, would keep everything kind of muted. Well, now, I think that is open to question. We all know that a man can be a fine general and get a little out of hand now and then. And I think what Othello bore with. The rage—that rage he feels is maddening, he is out of his head. And I know what that is like because I felt it once myself. One time I went out of my head in a rage and night after night out there on the stage I remember it."

"When did this happen, and why?"

"Well, I used to play football," said the All-American end of the year 1919. "I played ninety-nine games out of a hundred with a smile on my face. But there was one time, the only time in my life, when I lost my temper, went out of my head with rage.

"I was 17 years old when that happened and had gone down from Princeton, where I grew up, to Rutgers. I was a freshman trying to make the football team. Rutgers had a great team that year, but the boys—well—they didn't want a Negro on their team, they just didn't want me on it.

"Later they became my friends, but every word of this is true, and

though they are my friends I think they won't mind me telling it. On the first day of scrimmage they set about making sure that I wouldn't get on their team. One boy slugged me in the face and smashed my nose, just smashed it. That's been a trouble to me as a singer every day since. And then when I was down, flat on my back, another boy got me with his knee, just came over and fell on me. He managed to dislocate my right shoulder.

"Well, that night I was a very, very sorry boy. Broken nose, shoulder thrown out, and plenty of other cuts and bruises. I didn't know whether I could take any more. Seventeen years old, it was tough going for that age. But my father—my father was born into slavery in 1843 down in North Carolina, no education, and all his life he'd worked hard—was a good man, and a strong man.[3] He had impressed upon me that when I was out on a football field or in a classroom or anywhere else I wasn't there just on my own. I was the representative of a lot of Negro boys who wanted to play football and wanted to go to college, and, as their representative, I had to show that I could take whatever was handed out.

"Well, I didn't know. My brother came to see me, and he said, 'Kid, I know what it is, I went through it at Pennsylvania. If you want to quit school go ahead, but I wouldn't like to think, and our father wouldn't like to think, that our family had a quitter in it.'

"So I stayed. I had ten days in bed, a few days at the training table, and then out for another scrimmage. I made a tackle and was on the ground, my right hand palm down on the ground. A boy came over and stepped, hard, on my hand. He meant to break the bones. The bones held, but his cleats took every single one of the fingernails off my right hand. Every fingernail off my right hand! That's when I knew rage!

"The next play came around my end, the whole first string backfield came at me. I swept out my arms—like this—and the three men running interference went down, they just went down. The ball carrier was a first-class back named Kelly. I wanted to kill him, and I meant to kill him. It wasn't a thought, it was just feeling, to kill. I got Kelly in my two hands and I got him up over my head—like this. I was going to smash him so hard to the ground that I'd break him right in two, and I could have done it. But just then the coach yelled, the first thing came to his mind, he yelled: 'Robey, you're on the varsity!' That brought me around. We laughed about it often later. They all got to be my friends.

"Oh, sure, I get mad sometimes, but not that way. Now when I'm angry I never raise my voice, and I'm very calm, never do what I don't mean to do. And that has its points too. Because one night I went to the theatre really mad about something. And I never played Othello with less flourish than I did that night. Everything I said was low toned, but I certainly felt the part that night, with my own anger, and I guess it was effective all right, because you know what happened?"

"What?"

"I scared the actors!" Robeson smiled. "They said, 'Look, Paul, don't be mad again.'"

China: Promise of a New World

Speech delivered at Sun Yat-sen[1] Day tribute meeting, New York
City, March 12, 1944—Paul Robeson Archives, Berlin, German
Democratic Republic

As a Negro, I am often reminded of the parallel between China and
Africa. Both lands have had a glorious and ancient culture. Both lands
have known the oppression and exploitation of aliens who spat upon
culture, and spread abroad the poison of racial hate and intolerance.

Today we face the promise of a new world. Today in Burma, Chinese,
Africans and Indians are fighting side by side with their British and
American allies against the Japanese enemy. Today peoples of every
color are banded together to rid the world of the Hitlerite doctrine and
practice of master and inferior races.

The difference in the objectives between World War I and World War
II can be measured by the fact that even in the midst of the present
war, at the Moscow and Cairo Conferences, China's position as one of
the four great allied powers was recognized not merely in words but in
action, and the return of all territories stolen from her by Japan was
guaranteed.

The offensive extra-territoriality rights maintained by the western
powers in China to give evidence of their superiority have been
renounced, and we have repealed the humiliating Chinese Exclusion
Act.

At the core of all that is progressive in China, and at the root of her
new eminence as a world power, are the "Three People's Principles"[2]
which China's great leader, Dr. Sun Yat-sen, preached and practiced:
nationalism and independence, democracy and advancement of the
condition of the people.

The picture of China's internal conflict as the Kuomintang vs. the
Chinese Communists is as false as Martin Dies' picture of his commit-
tee defending Congress and the government against the American
Communists.[3] The majority of the Kuomintang Party itself is progres-
sive and pro-war, and is allied with the democratic forces of the
country which include not only the Communists, but the non-
Communist guerilla fighters, practically the entire armed forces,
several minor political groupings, and the great mass of intellectuals
and students. The conflict is between the Chinese people and a small
reactionary clique which has renounced both the principles upon
which the Chinese Republic was founded and the war aims of the
United Nations.

China today is fighting with one arm tied. The arm that is tied is the
Communist-led Eighth Route and New Fourth Armies. Despite the
great work which these armies have done in defending China—not-
only in fighting, but in educating and mobilizing the people for

defense, despite the repeated pledges of allegiance to Generalissimo Chiang Kai-shek[4]; despite the frank declarations of the Chinese Communist leaders that their sole aim is the attainment of national unity, freedom from fascist aggression, and the development of democratic institutions which will provide for the participation of all parties and sections of the people in the war against the enemy and in the post-war development of their country—despite all these things, the Chinese guerilla armies have been held in check, blockaded and hunted down, and denied financial, military or economic aid from their government.

China's plight is critical. It has been made so by a small clique of appeasers, defeatists, and some outright pro-Japanese fascists, with whom are allied the reactionary segment of the landlord, usurer and profiteering class. It is this clique, unfortunately, which at present controls the government machinery.

Why am I talking about these internal problems of China? Not only because they affect the future of the Chinese nation, important though that is. But because they directly and seriously affect the duration, and the cost of human lives, of the United Nations operations against Japan. We cannot permit either selfish isolationism or a misguided and abstract sense of democratic propriety to prevent Americans and America from speaking out on this issue.

The three year's blockade against the Chinese guerilla forces must be lifted. The entire might and strength of China's 400 millions must be united.

Opening Statement at Conference on "Africa—New Perspectives"

Auspices of the Council on African Affairs,[1] April 14, 1944, at the Institute for International Democracy, New York City —*Proceedings*, pp. 10–12

As Chairman of the Council on African Affairs and on behalf of those persons who have cooperated with the Council in sponsoring this meeting, I am glad to welcome you to this Conference.

We are gathered here for the purpose of considering together our relation—the relation of the American people and their government—to Africa's place in the war and in the post-war world.

I do not think there is any need to justify our discussion of this problem on the score that the United States is not one of the political rulers of Africa. Although Americans in the past have known little about Africa beyond the caricatures occasionally represented in American movies, most of them today are beginning to realize, I think, that the welfare of 150 million Africans and other dependent peoples who make up almost half of the world's population is something that directly concerns their own welfare. This war, a large part of which

has been and is being fought in colonial areas, has brought this truth home to them.

There has been lately an increasing volume of literature dealing with Africa and colonial territories in general. In it one finds quite a variety of viewpoints expressed. I won't attempt to cite them all, but I do want to mention one or two.

The first that I have in mind I would call the "new imperialist" school of thought. Representative of this school is the author of an article in *Fortune* magazine some months ago who started off by describing Africa as "the last great continental frontier of the world for the white man to cross," and as "the jack-pot of World War II."[2] He then proceeded to paint a glowing picture of Africa's vast undeveloped wealth—with no mention, of course, of the inhabitants. Such stuff is made-to-order propaganda for the Japanese enemy.

Another school of colonial thought quite vocal at the present time I would speak of as the "yes-but apologists." These writers go so far as to acknowledge that there have been some mistakes and short-comings in colonial rule, and they admit that progress of the dependent peoples toward a better life is slow. But then come the *buts. But* look at how much has been accomplished. *But* look how backward the people are, and how complex the problems are that must be solved. *But* we must be patient and persevere. All this boils down to advocacy of the *status quo* in the colonial system.

The trouble with proponents of both these points of view is that they do not take into account what is happening in the world. Being apparently blind to the present, they see the future as merely the shadow of the past. They are chained to the past.

Let us look at the present a moment. There exists today the fact of cooperation toward common democratic goals among the nations of the world on a scale never known before in history. That fact, which was established at the Moscow, Cairo, and Teheran meetings, lays the basis for international collaboration in the development of dependent areas and peoples—an entirely new approach to colonial problems. And it means the end of imperialism, imperialist exploitation, and imperialist rivalries.

There is another important fact of the present day world which must be taken into account in thinking about the future of colonial peoples. That is the concrete demonstration which the Soviet Union has given to the world of how, with systematic planning, a vast territory can be transformed in the space of a couple of decades from the most primitive, feudal agricultural economy into a modern agricultural and industrial economy; and of how many millions of peoples of different languages and cultures can be raised from illiteracy, poverty, and degradation to a high level of development with flourishing social, cultural, and political institutions of their own.

Only in the last two or three years have most of us begun to learn the truth about the Soviet Union. Notable signs of this new understanding are the proposals of Colonel Oliver Stanley,[3] British Secretary for

Colonies, and of the delegates at the French Colonial Conference at Brazzaville to study methods of social improvement in the Soviet Union, particularly in the field of mass education, with a view toward applying these methods to African society.

These are some of the new perspectives, then, for the future of the African and other colonial peoples. Our emphasis in the discussion at this Conference will, I trust, be upon the future rather than the past, upon *what can be* rather than upon *what has been.*

And let us not, in discussing post-war plans, lose sight of the fact that the primary task still before us is the winning of the war. The whole character of the post-war world depends, first of all, upon the outcome of the war. And not simply upon victory—we have no doubts about that—but upon how quickly and decisively victory is won. If there is undue prolongation of the war or compromise with the enemy, as a result of reactionary elements here and abroad gaining ascendancy over the will of the majority, we shall have lost what we are fighting for.

The winning of the war and the winning of the peace are interrelated things, not separate. Both depend upon the maintenance of the closest unity on the national and international levels.

This conference is dedicated to promoting such unity in the interest of the African people and in the interest of American and world-wide security.

It is in this spirit that I again welcome you to the Conference.

Africa and Post-War Security Plans

Signed by Paul Robeson, Chairman, Max Yergan, Executive Director, Council on African Affairs, and others[1]—*New Africa,* December 1944

President Franklin D. Roosevelt
Secretary of State Edward R. Stettinius, Jr.
Washington, D.C.

Dear Mr. President and Mr. Secretary:

While we wholeheartedly endorse the steps taken thus far toward developing the machinery for post-war international collaboration to maintain world security and peace, it is our firm belief that the promotion of the welfare of the millions of Africans and other dependent peoples of the world must be an integral part of the projected international organization's program and function.

We, therefore, respectfully urge that the United Nations organization proposed at the Dumbarton Oaks[2] Conference accept as an objective and responsibility and make adequate provision for the progressive advancement of the people of Africa so that they may play their full part in a system of world-wide democracy and prosperity.

The following resolution, endorsed by a number of representative American citizens, is an expression of the basis of this recommendation and of the essential undertakings and principles which we believe should be advanced and supported by the United States' government in the further development of the Dumbarton Oaks plans:

WHEREAS, We recognize today the interdependence and the necessity for mutual aid among all nations and peoples, and we know that there can be no lasting prosperity for the peoples of this country as long as many millions in Africa and other areas with vast undeveloped resources are compelled, by lack of freedom and opportunity, to live in hunger, disease and ignorance.

We recognize that rapid industrialization, modernization, and the advancement of social standards in these areas, and the abolition of the inferior social, economic, and political status of the native peoples, are essential prerequisites for both the achievement of international harmony and security and the progress of the native peoples themselves.

We believe that these progressive reforms *can* be accomplished through international collaboration and systematic planning, and that Africa, a continent with immense possibilities of development but burdened with varied and conflicting political and economic interests, represents a paramount test of such collaboration and planning.

And whereas, the colonial and subject peoples of Africa have contributed greatly toward the achievement of a United Nations' victory over our common fascist enemies, and are justified in their expectation that they, as well as other peoples, will benefit by their sacrifices in this war of liberation; therefore be it

RESOLVED, (1) that the government of the United States, in view of its central responsibilities in achieving victory and likewise in maintaining world peace and security, should take the initiative in seeking the establishment, within the proposed United Nations organization for maintaining security and peace, of effective policies and procedures for the rapid and uniform advancement of the economic and social well-being of the African people in all parts of the continent.

(2) The guiding principle underlying these policies and procedures in the international, regional, and local sphere, should be that of providing the maximum opportunity for Africans to manage their own affairs within the framework of international cooperation, with a view toward achieving full democratic rights for all the inhabitants of the non-colonial territories, and toward enabling the indigenous peoples in all colonies, protectorates and mandated territories to achieve self-government and the right of self-determination within a specified time limit, pursuant with United States policy toward the Philippines.

(3) The several governments and existing or projected regional commissions within Africa should be held accountable to the United Nations organization for the abolition of all forms of economic, social or political discrimination based on race, creed, or color; and for the proper execution of policies agreed upon by the United Nations or by

agencies, such as an International Labor Organization, affiliated to that body.

(4) Within the general scope of international collaboration and in the interest of greatly expanding world trade and employment, the United States, by virtue of its great financial and technological resources, should take the lead in raising the living standards and promoting the industrialization and mechanization of the African economy, with due regard that the Africans themselves shall be principal beneficiaries of this economic progress, and that all other nations shall share equitably with this country in the advantages of increased trade with Africa.[3]

Never Again Can Colonialism Be What It Was

New Africa, March 1945

It will be a wonderful thing for Negro-white relations in the United States when the Africans show what they can do. Many Negroes think of Africa with pain, and many white people with condescension, because both believe that Africans are inferior—they're supposed to be savages. Actually, they are in the same cultural level as many millions of Chinese and Hindus and Indians. The Soviet Union has shown that these peoples can catch up with modern technology and culture within a generation.

The majority of the human race is still agricultural and herd-keeping—in Asia, in Mexico, in South America, in Africa—and these people are on the verge of a vast development due to the impact of the war on world history. Never again can colonialism be what it was.

Speech at Sixth Biennial Convention, International Longshoremen's and Warehousemen's Union

Proceedings, March 29-April 2, 1945, pp. 132–3

PRESIDENT HARRY BRIDGES[1]: At this time I am going to introduce one of those members to you, a great artist, a world leader of people, an honorary member of the ILWU,[2] Paul Robeson! (Standing ovation.)

Thanks, Harry! Thanks, fellows!

I came along today just to say "Hello" as a member coming to the Convention. There is no need to tell you how proud I am, especially here in San Francisco, to be able to walk around and know that I am a

member of a Union that has done the job and is doing the job that you are.

Just before I sing a few songs—I am not going to take much time, because "Othello" is a pretty tough job. But I had an awfully good rest last night, so I think I am going to feel a little bit like singing this afternoon. I have been excited the last couple of days at the prospect of the Charter of Agreement that is coming between business and labor, certainly with the full cooperation of the government.

That should make us pretty proud, I think, because it is a well-known fact that the charter signifies a great advance in the whole functioning of labor-management relations, and the high standard it has achieved certainly points to a future of a very different kind in this America of ours.

Most of its stimulus here has been the insistence on the part of your Union and your executives, especially Harry, to unify and really build a decent life for the working people and all the people of our country.

So, I have felt very, very proud these last couple of days, seeing that all America must now realize that this is the future pattern that we must follow if we are going to work out these problems.

I want to say again that it is quite obvious that this policy must be carried through, and carried through fast. I know that you will try to work it out, and again take the initiative in providing for this period of change and readjustment, and that you will bear in mind the necessity again of never forgetting and never relaxing in this feeling which we have here in actual fact, this necessity of complete unity of all groups in our country.

What at one time was a germ here has grown to be a national policy, so, maybe within our Union here we can solve the problems that will make it perfectly clear to colored workers and white workers and Latin American workers and Chinese workers and all that are in our Union, that we can really work in complete harmony everywhere, as we do within our Union itself.

Maybe we can have a little faith that, way down through the whole union rank and file, if it is necessary we can make some kind of sacrifice, just as in the old days we had to do when it was tough going and we had to get out and fight in a different way for our rights. We can get this bond of fellowship that will carry us through this long range thinking to a real America with a job for every American.

There is just that tough part in between, and I think this Union might be able to solve it when it seems as though business might not solve it, and government might be a little slow on the uptake. Maybe you can work it out, because certainly the record is a mighty fine one up to this point.

I am very sorry I cannot come into a lot of the sessions and get down to bed rock and sort of see how it works. One of these times I will. I have a pretty tough job over here with "Othello."

I will now run into three or four songs with my old friend, Larry Brown, who came out to the Coast three or four days ago.

As I have been singing around two or three places, somebody here

might say, "How come this guy always starts with 'Water Boy'?" That is an old favorite of mine. It sort of shows where the pipes are, how they are doing, and so forth.

> Mr. Robeson sang a group of songs. (Standing ovation as Mr. Robeson retired from the Convention Hall.)
> PRESIDENT BRIDGES: He would be a good man at the end of a "Portugee lift!"

Robeson Lauds Russia at Spingarn Medical Banquet

Pittsburgh Courier, October 17, 1945[1]

NEW YORK—Thirtieth recipient of the Spingarn Medal, annual award for outstanding achievement, presented by the National Association for the Advancement of Colored People, Actor-Singer Paul Robeson, in his acceptance speech Thursday at the Biltmore Hotel, shocked his several hundred listeners[2] by voicing frank and pronounced preferences for Soviet principles—economic, political and social.

In pointing out that the Russians have shown what backward peoples can accomplish in one generation of endeavor, Mr. Robeson said: "Full employment in Russia is a fact, and not a myth, and discrimination is non-existent." He added:

"The Soviet Union can't help it as a nation and people if it is in the main stream of change." Warning against the rebuilding of fascism, restoration of monarchies and restoration of their estates to collaborators, he said: "I feel America will choose on the basis of the democracy they represent."

He urged the creation of a world where people, whether white, black, red or brown, can live in peace and harmony, and where resources can be used for the good of all, for the advancement of mankind. Mr. Robeson also expressed the hope that the NAACP stand strong beside the people in the struggle for a real peoples' world.

The award was given to Mr. Robeson for his "distinguished achievements in the theater and on the concert stage, as well as his active concern for the rights of the common man of every race, color, religion and nationality."

Marshall Field, Chicago editor and publisher, made the presentation to Robeson in the presence of other recipients of the award, which calls attention to the existence of distinguished achievement among Americans and serves as a stimulus to the ambition of colored youths.

Robeson also paid tribute to Harry T. Burleigh, James Weldon Johnson, Dr. Louis T. Wright, Mrs. Mary McLeod Bethune, Richard B. Harrison, Walter White, Marian Anderson, Max Yergan, and previous recipients of the award, with the admission, "I am proud to be part of the work they represent." He called for re-evaluation of the world we live in lest we find ourselves "again on the edge of destruction."

In making the presentation Mr. Field pointed out the difficulty a white man experiences in grasping and appreciating the cost of outstanding accomplishment by an American Negro. "It is little wonder that the Negroes who have accomplished what is symbolized by the Spingarn Medal have had such thrilling and incredible life histories. In many cases they have endured trials that few white Americans can imagine, and even fewer have ever experienced," he said.

Some Reflections on *Othello* and the Nature of Our Time

The American Scholar,[1] Autumn 1945

It was deeply fascinating to watch how strikingly contemporary American audiences from coast to coast found Shakespeare's *Othello*—painfully immediate in its unfolding of evil, innocence, passion, dignity and nobility, and contemporary in its overtones of a clash of cultures, of the partial acceptance of and consequent effect upon one of a minority group. Against this background the jealousy of the protagonist becomes more credible, the blows to his pride more understandable, the final collapse of his personal, individual world more inevitable. But beyond the personal tragedy, the terrible agony of Othello, the irretrievability of his world, the complete destruction of all trusted and sacred values—all these suggest the shattering of a universe.

To an actor the question arose: how make personal and convincing such lines as "When I love thee not chaos is come again," "Methinks it should be now a huge eclipse of sun and moon, and that the affrighted globe should yawn at alteration," or, "It is the very error of the moon—she comes more nearer earth than she was wont and makes men mad." The desired approach was suggested by Professor Theodore Spencer in his most illuminating *Shakespeare and the Nature of Man.*[2] For in actual fact Othello's world was breaking asunder. Medievalism was ending, and the new world of the Renaissance beginning.

So now, interestingly enough, we stand at the end of one period in human history and before the entrance of a new. All our tenets and tried beliefs are challenged.

We have been engaged in a global war, a war in which the capacity of *our* productive processes and techniques have clearly presaged the realization of new productive relationships in our society—new conceptions and assumptions of political power, with all sections of the people claiming a place in the social order. And what a vista lies before us!

This can be the final war. It is possible to solve once and for all the problem of human poverty, to attain a speedy freedom and equality for all peoples.

In this shaping of our new world and amid its consequent clashes

and sharp struggles, where should we stand? What should be our domestic direction? What should be our policy toward the England of Churchill or of British labor, toward France, Italy, Greece, Yugoslavia, China, Africa, the Near East, Spain, Latin America (especially the Argentine), and most importantly, toward the Soviet Union?

A tremendous responsibility to understand these problems rests upon every American. Certainly our influence must be upon the side of progress, not reaction; upon the side of the freedom-loving peoples and the forces of true liberation everywhere—peoples and forces expressing their wills in various democratic forms, liberal, cooperative, and socialist.

An added responsibility rests upon the liberal intellectual—the scientist, the member of the professions, the scholar, the artist. They have an unparalleled opportunity to lead and to serve. But to fulfill our deep obligations to society we must have faith in the whole people, in their potential and realized abilities. This faith, in our new world of today, must include the complete acceptance of the assumption of positions of great power by true representatives of the whole people, the emergence into full bloom of the last estate, the vision of no high and no low, no superior and no inferior—but equals, assigned to different tasks in the building of a new and richer human society.

An Appeal for African Freedom

A Message to America and the United Nations, signed by
Paul Robeson, Chairman, and Max Yergan, Executive Director,
Council on African Affairs—Advertisement, *The New York Times,*
June 3, 1946

One hundred fifty million Africans and 93 percent of the continent of Africa are still in colonial subjection.

Thousands of Africans fought, labored, died to defeat fascism. Are these allies now forgotten?

The colonial peoples of Africa are barred from the United Nations. They ask not for promises of a remote freedom, but for ACTION NOW to end their enslavement and oppression.

Will the Union of South Africa's legalized fascist-like practice of racial oppression be outlawed, and that state's mandate control be revoked?

Will the peoples of the Italian colonies and the mandate territories cease to be mere pawns in the game of imperialist politics?

Will the European rulers of Africa be called upon to declare WHEN they will yield to the demand of Africans for freedom?

AND WILL AMERICA HELP FREE AFRICA? OR WILL IT SEEK INSTEAD A LARGER SHARE OF THE PROFITS SQUEEZED OUT OF AFRICA'S OPPRESSED PEOPLE?

AMERICA MUST ANSWER!

Africa—Continent in Bondage
New York Herald-Tribune, June 5, 1946

To the New York Herald Tribune:

In whatever land I have traveled, in Asia, in Europe, in Africa, wherever I have walked and talked with people, more than all else I have been impressed with the peoples' love for liberty, the hardships they will endure, the sacrifice they will make to achieve and keep it.

It is this will for freedom among the people which led President Truman to proclaim in his Navy Day address on Oct. 12 last year: "We believe that all peoples who are prepared for self-government should be permitted to choose their own form of government by their own freely expressed choice without interference from any foreign source. That is true in Europe, in Asia, in Africa, as well as in the Western Hemisphere."

The right of self-determination and equality for all people, without regard to race, creed or national origin, is written into the preamble of the Charter of the United Nations. There is, however, too often a large discrepancy between the pledge and the implementing of it. Here, in our own United States, large sections of our population are still without the right to elect their own governing legislature, and Puerto Rico and other of our own colonies are without the right "to choose their own form of government."

And while certain initial steps have been taken by some of the major powers in the direction of meeting the demands of some of the colonial peoples, notably in India, there has not been the slightest indication of any intention on the part of the European powers to declare themselves on the question of freedom for the 150,000,000 persons of the Continent of Africa.

So little that is true has been written about the African people and so little real knowledge of their life and struggles has been allowed to penetrate the press, the movies, the schools that for the great majority of Americans Africa is a vast, unknown and exotic land. Africans are not people to the American. In his dreams and plans for the one free world Africa is curiously and for all purposes absent. Yet nowhere in the world is there a people more oppressed, more deeply exploited, more thoroughly enslaved. Nowhere in the world is there a people more in need of the aid of free men everywhere in their struggle for the most meager of human rights, the least of human liberties.

Africa is a whole continent of people living in abject misery. Poverty, hunger, disease, illiteracy are rampant among them. Their land has been taken away from them; they are forced to labor under the most brutal conditions; the lack of schools, sanitation and medical care are unspeakable.

In Southern Rhodesia and in Kenya the native people, 95 per cent of the total population, are restricted to 30 per cent of the poorest land.

Wages for the Negro laboring in the Nigerian tin mines and the Rhodesian copper mines are as low as 15 and 20 cents a day. In the Gold Coast there is one hospital bed or cot for every 2,950 persons, in Nigeria one medical practitioner for every 81,000 persons and one dentist for every 2,750,000. While research has found means for eliminating several of the tropic diseases which have ravaged human life in Africa, the benefits of the research have thus far been made available only in limited areas. In certain locations the infant mortality alone reaches as high as 600–700 in each 1,000.

The State of Mississippi, which makes no apologies for its notorious Jim Crow laws and practice, in the year 1940 had an expenditure of some $7 for the education for each Negro child, against an expenditure of approximately $52 for each white child. But in Nyasaland the government expenditure on education was 38 cents for each African, against $73.60 for each white student. In Northern Rhodesia the ratio was 91 cents for the Africans and $113.73 for the whites.

The onus for this beastly destruction of human dignity, this irresponsible degradation of a whole continent of people lies with the sovereign powers, whose ruthless colonial rule and exploitation have been spread over 93 per cent of the African mainland. Belgium, Portugal, Spain and Italy have partaken of the spoils of the land and its population, but it is France and England which hold two-thirds of its wealth between them. Nor is our own country, with its growing economic and military penetrations into the continent, without responsibility. Africa is rich and millions and millions of dollars in gold, rubber, oil, diamonds are taken from its soil and its people, but the African has none of it. He is virtually and literally scarcely more than a slave to his European and American masters.

And this story of callous, inhuman government of the entire continent of a colonial Africa is intensified and most vicious in the autonomous dominion of the Union of South Africa, of which Professor James B. Leyburn, of Yale University, writes, "The discrimination against the blacks . . . is more far-reaching, more cynical than in any other self-governing country in the modern world."

The Union of South Africa (which is reaching out for Southwest Africa, Bechuanaland, Basutoland, and Swaziland) has publicly avowed the principle of white supremacy. General Smuts,[1] Prime Minister of the dominion, declared in Parliament only last March, that all South African parties are agreed on the "fixed policy to maintain white supremacy in South Africa." The African Negro is legally barred from the polls. He has no legal way of challenging this obscene declaration, nor contesting the will of the government which can state boldly in its year-book, "It is generally admitted that the prosperity of South African trade and industry depends to a very great extent on an adequate supply of relatively cheap, unskilled non-European (non-white) labor."

European industry in South Africa has taken good care to provide itself with that adequate supply of "cheap, unskilled" labor. By law, no

African Negro is permitted to work at a skilled trade, nor can he bargain collectively or strike for higher wages. By law his residence is restricted to the segregated places designated by his employer or by the government.

The conditions under which he works and lives are devised to stifle and destroy the least spark of humanity he possesses. In the municipal "locations," as many as four families live in a single one-room hut with the earth for their floor. There is no sewerage for these people; there is one source of running water for whole blocks of huts and one toilet for scores of families. Disease and hunger are their daily lot, even in normal times. And today, as the result of both their landlessness and the worst drought experienced by South Africa in the last twenty-five years, the 8,000,000 Africans there face starvation.

It is because of this desperate state of affairs that the Council on African Affairs, of which I am the chairman, has called a mass meeting in Madison Square Garden for June 6. The funds raised through the meeting will be contributed to South African relief. This relief, however, it must be recognized, can prove only temporary. When a people are hungry, we must feed them. We cannot forget, however, the medieval Fascist-like state in which they live.

We have learned bitterly, that where there is slavery, Fascist or Fascist-like, there is potential and eventual war. To mould the peace and keep it, there must be a free world, a world freed from any semblance of slavery—Jim Crow, colonial, or any other kind. That free world, that freedom can be won through the United Nations, through Big Three unity, through keeping the pledge which the major European powers and our own United States have given to all peoples everywhere: Self-determination and freedom for all peoples in one free world.

Food and Freedom for Africa

Advertisement, signed by Paul Robeson, *Daily Worker,* June 5, 1946—Contributed in the interest of South African Famine Relief by the International Workers Order, New York, N.Y.

Europe and Asia have been devastated by war and their people are hungry. Americans have been urged to make sacrifices and share their food with the unfortunate people across the Atlantic.

But Africa, too, is hungry. In the Union of South Africa alone, eight million Negro people are faced with mass starvation. Their desperate plight is practically unknown to the outside world. Will Americans ignore the need of these African millions?

Hunger and lack of freedom always go hand in hand. Even in good times the Bantu people of South Africa suffer chronic starvation. Robbed of their land, confined in "reserves" and ghettos, and reduced to the most subservient level of employment by a legal color bar, these

Africans are victims of a systematic oppression which can hardly be comprehended except by those who have lived under fascist tyranny.

In normal times the grinding poverty of these people accounts for an infant mortality rate that reaches 600 to 700 per one thousand. Today, as a result of the worst drought in the last quarter century, the Negro people of South Africa are undergoing the extremest hardship. In the rural areas they walk many miles and stand in long queues to get a meager ration of corn which is below the starvation limit of 1,500 calories. And even this dole, their only food, is often not available. In the cities Africans earning as little as 30 or 40 cents a day are forced to pay as much as 11 cents for a single slice of bread.

The Council on African Affairs has been able, through the generous response of those reached through its campaign, to send a considerable quantity of canned food and money to aid these stricken people. But more, much more, needs to be done.

We Americans, however, have the responsibility of providing something more than food for the people of Africa—the whole of Africa with its 150 million colonial subjects. We must see that their demands for *freedom* are heard and answered by America and the United Nations. For without economic and political freedom, there cannot be any abiding relief from poverty and hunger.

This is no mere theoretical obligation which rests upon America to advance African freedom. It is an obligation which stems from the millions of American dollars invested in Africa's gold, copper, diamonds and rubber. It is an obligation which stems from the lives of American soldiers sacrificed to defeat the fascist enemy in Africa. It is an obligation which stems from the position of leadership which America holds in world affairs today.

It is our solemn duty as Americans, as a liberty-loving people, to join hands with the millions upon millions of exploited and oppressed colonial peoples in Africa and throughout the world. NOW is the time for action, if we hope to build a free world.

Anti-Imperialists Must Defend Africa

Address at Madison Square Garden rally
sponsored by the Council on African Affairs, June 6, 1946

I have spoken for other causes on other occasions in this great hall. And while they were all important causes about which I was keenly concerned, I think I can say that never before have I faced such an audience as this with the sense of responsibility, of urgency, of intimacy with you that I now feel.

The Negro—and I mean American Negroes as well as West Indians and Africans—has a direct and first-hand understanding, which most other people lack, of what imperialist exploitation and oppression is.

With him it is no far-off theoretical problem. In his daily life he experiences the same system of job discrimination, segregation, and denial of democratic rights whereby the imperialist overlords keep hundreds of millions of people in colonial subjection throughout the world.

The one basic difference is that here in America the Negro has the law—at least partially and in some sections of the country—on his side, and he has powerful allies in the ranks of white organized labor directly involved in his daily fight for justice. In Africa, in the West Indies, and in Asia, the colonial peoples wage a desperate struggle for recognition simply as human beings—as human beings to whom human rights are due. And these colonial peoples fight alone in each country—alone except for the help which reaches them from afar, from world-conscious labor in free countries and from other anti-fascist, anti-imperialist forces.

And that is why we are gathered here tonight. Because our own rights and liberties—even though limited—are far, far greater than those of our brothers in colonial bondage. Because we must exercise the greater strength which we have to help win freedom for them. And also because in that very process of helping others, we add to our own strength and bring nearer full freedom for ourselves.

Besides people like those of us who are here tonight, there is another category of Americans, quite few in number, but extremely powerful, who are interested in Africa. They are concerned, however, *not* with the *people* of the continent of Africa, but with the wealth that they can extract from it, and from the labor of the people there. These American financiers and corporation heads have their own ideas about the future of Africa, and they *don't* include the idea of freedom. You can be sure of that. And another thing you can be sure of is that they're not losing any time in putting their ideas into action.

Our government, reports indicate, is getting uranium from the Belgian Congo for atomic bombs. American companies are prospecting for oil in Ethiopia and for minerals in Liberia. Mr. Firestone[1] now has competitors in the latter country. These manifestations of a new and heightened interest in Africa on the part of American Big Business represent a challenge to the rest of us.

The race is on—in Africa as in every other part of the world—the race between the forces of progress and democracy on the one side and the forces of imperialism and reaction on the other. And Africa, with its immense undeveloped and unmeasured wealth of resources, is a major prize which the imperialists covet and which we, the anti-imperialists, must defend.

We on the anti-imperialist side are handicapped by lack of money, lack of powerful organization, lack of influence in state and international affairs. But, although the enemy has all the advantage and has a head start in the race, it is yet possible for us to catch up and win. It is possible to win if the majority of the American people can be brought to see and understand in the fullest sense the fact that the struggle in

which we are engaged is not a matter of mere humanitarian senti-
ment, but of life and death. The only alternative to world freedom is
world annihilation—another bloody holocaust—which will dwarf the
two world wars through which we have passed.

We have been hearing a lot of talk about a coming war. It has been
defined by some of the bolder reactionaries in brutally clear terms as a
war of the United States and Great Britain against the Soviet Union.
This war-mongering is the logical consequence of the get-tough-with-
Russia policy preached and practiced by those who direct American
and British foreign policy.

"Stop Russia!" the brass voices cry in chorus, and the men behind the
voices hope that the people will be afraid and will turn against their
wartime ally. Their frantic cries mask the program of imperialist
aggression which these men themselves are seeking to impose upon
the world.

The "Stop Russia" cry really means—stop the advance of the colonial
peoples of Asia and Africa toward independence; stop the forces of the
new democracy developing in Europe; stop the organized workers of
America from trying to hold their ground against their profit-greedy
employers; stop the Negro people from voting and joining trade unions
in the South. "Stop Russia" means—*stop progress*—maintain the
status quo. It means—let the privileged few continue to rule and thrive
at the expense of the masses.

A day or two ago Mr. Bevin,[2] the British Foreign Minister, said, and
I quote, "If we do not want to have total war, we must have total
peace." For once I agree with him. But Mr. Bevin must be totally blind
if he cannot see that the absence of peace in the world today is due
precisely to the efforts of the British, American and other imperialist
powers to retain their control over the peoples of Asia, the Middle East,
Europe and Africa.

We must indeed win the peace—a total peace—but we can do it only
by using methods exactly the opposite of those pursued at present by
the British Foreign Office and our own State Department. To win total
peace there must be total freedom.

At San Francisco, a year ago, it was the Soviet Foreign Minister, Mr.
Molotov, who said, "From the viewpoint of the interests of internation-
al security, we must first of all see to it that dependent countries
are enabled as soon as possible to take the path of national indepen-
dence."[3]

But we are still waiting for the first European power in Africa to
declare that its African subjects may exercise the right of self-
determination and achieve self-government in the next ten years, the
next twenty years or even the next hundred years.

The colonial rulers will tell you that the Africans will not be ready
for self-government in any foreseeable future. They lie. They would
delude you into believing that the African peoples had no govern-
ments, no culture before the European came to Africa. They would

delude you into believing that Africans are content to remain under European tutelage, and that this tutelage must continue indefinitely.

You have heard from other speakers tonight what sort of tutelage the rulers of Africa provide. How can they dare pose as so-called guardians of the Africans? How can they dare claim the right to continue in that role? The Soviet Union has demonstrated how it is possible to wipe out colonialism and all that that word connotes within a single generation. No wonder the imperialists cry "Stop Russia!"

That cry must be drowned out by the voice of the American people demanding Big Three Unity for Colonial Freedom!

To arouse all sections of our population to the urgency of that demand has been the purpose of this meeting. But we do not in any sense regard our job as finished with the close of this great rally. On the contrary, my friends, the Council on African Affairs regards this job as having just begun. With your help, with the cooperation of the organizations with which you are associated and with the support of millions of like-minded peoples throughout our country and in other countries, we *shall win the fight* against the forces of imperialism.

Tomorrow is *our* day, the day of the common people. By God's grace and our united strength we *shall* win freedom and peace for ourselves and for all the oppressed peoples of the earth.

Robeson Asks Truman Action on Lynching

Daily Worker, July 29, 1946

Paul Robeson, chairman of the Council on African Affairs, sent the following telegram to President Truman on the lynching of four Negroes in Georgia yesterday.[1]

Just a few hours before your commendable message to Congress endorsing the ILO provisions for minimum working and living standards for peoples of colonial countries, four Negro citizens of this country were lynched in cold blood. This is a matter of more than tragic irony. The Council on African Affairs demands that the Federal Government take immediate effective steps to apprehend and punish the perpetrators of this shocking crime and to halt the rising tide of lynch law. Only when our government has taken such action toward protecting its own citizens can its role in aiding the progress of peoples of other countries be viewed with trust and hope.

South African Gold Mine Strike

The New York Times, September 6, 1946

To the Editor of *The New York Times:*

Unaided and with no effective organization, for the South African law prevents such, African workers in the Gold Mines of South Africa, involving over 300,000 men, are striking for an increase in their present pay of 50 cents a day.[1]

According to *The New York Times* of Aug. 15, the Government of South Africa has announced its determination to "protect" these workers from their leaders.[2] Four members of the Cabinet constitute a committee to make emergency decisions. Thus does one of the most oppressive Governments in the world give further evidence of its disregard of the rights of its people.

The Hitler-like statement of the South African Government that it is "agitators" from whom it would protect the workers will fool no one. Such a statement serves only to reveal the true character of the governing forces in South Africa now headed by General Smuts.

The owners of the South African gold mines, as is well known, represent a form of tyranny repugnant to decent practice in modern industrial employment. The conscience of the civilized world is outraged by these practices, and men of goodwill everywhere must lift their voices.

In the name of everything that is decent in human relations, I appeal to my fellow Americans to make known their protest against such conditions to the South African Ministry in Washington; to send to the Council on African Affairs, 23 West Twenty-sixth Street, New York City, an expression of support for these grievously oppressed workers in South Africa; to keep the South African situation in mind against the time when General Smuts will come to the United Nations Assembly in September to demand the annexation of South West Africa,[3] which means more Africans for him to exploit.

On the Resignation of Henry A. Wallace

Statement on behalf of the Council on African Affairs,
Daily Worker, September 21, 1946

We are shocked by the forced resignation of Wallace.[1] We join with the overwhelming majority of Americans who want peace and democracy for this country and the world, in fully supporting Wallace's criticism. We cannot avoid the painful conclusion that Truman's action represents a complete capitulation to the reactionary minority in our country who seek world domination.

American Crusade to End Lynching

[Four reports of Robeson's visit with President Truman are given here since there are facts in each one which are not present in the others.]

The New York Times, September 24, 1946—"Robeson to President Truman—'Government Must Act Against Lynching or the Negroes Will'"

WASHINGTON, Sept. 23 (AP)—A national conference on lynching[1] mapped a program today aimed at curbing mob violence and sent a delegation which told President Truman that if the Government failed to do something "the Negroes will."

Paul Robeson, a sponsor of the conference, was in the group calling on the President, and in telling reporters of the meeting said Mr. Truman had objected to parts of the proposed program.

Mr. Robeson said he read a message to Mr. Truman asking him to issue "a formal public statement" expressing his views on lynching, and recommending "a definite legislative and educational program to end the disgrace of mob violence." The President, according to Mr. Robeson, indicated that political matters made it difficult to issue a statement of his views at this time.

As to possible Federal legislation to curb lynching, Mr. Robeson said the President expressed the view that passage was a political matter in which timing was important.

The President took exception, Mr. Robeson asserted, to a suggestion by the delegation that it "seemed inept for the United States to take the lead in the Nuremberg trials[2] and fall so far behind in respect to justice to Negroes in this country."

The Presidential view, Mr. Robeson continued, was that Americans should not tie domestic matters to the international situation.

Mr. Robeson also said the President termed America and Great Britain the last refuge of freedom in the world.

"I disagreed with this," said Robeson. "The British Empire is one of the greatest enslavers of human beings."

He declared that American and British policy today were "not supporting anti-fascism."

Asked by a reporter if he was a Communist, Mr. Robeson replied that he is not, and added:

"I label myself as very violently anti-Fascist."

The organization also sent delegations to Attorney General Tom Clark and to the Republican and Democratic national committees.

In a statement, it gave this as its platform:

"The apprehension and punishment of every lyncher. Passage of a Federal anti-lynching bill. Keeping the Klan[3] out of Congress—no Senate seat for Bilbo."[4]

In a message to Clark, the conference declared that there had been forty-one reported lynchings since the war ended and "not a single arrest, indictment or conviction of any participant in any of the lynchings has been made."[5] It urged the Justice Department to use "all its authority in a determined drive" to apprehend the lynchers.

The conference told the political parties:

"We have come to demand that the national committees of the Democratic and Republican parties insist in the forthcoming election that all party candidates adhere to and support the enactment into law of an anti-lynch bill."

Philadelphia Tribune, September 24, 1946—"Robeson Tells
Truman: Do Something About Lynchings Or Negroes Will'"[6]

WASHINGTON—Paul Robeson, Negro baritone, spearhead of the American Crusade to End Lynching, said yesterday after a White House visit that he had told the President that if the Government did not do something to curb lynching, "the Negroes would."

To this statement, Robeson said, the President took sharp exception. The President, he said, remarked that it sounded like a threat. Robeson told newspaper men he assured the President it was not a threat, merely a statement of fact about the temper of the Negro people, who comprise about 10 percent of the population.

At the head of a mixed delegation, Robeson asked the President to make a formal declaration of disapproval of lynching within the next hundred days. Robeson explained the next hundred days would be an appropriate time for the President to act, because it was on Sept. 22, 1862, that Lincoln issued the proclamation freeing the slaves and it was on Jan. 1 that it became effective.[7]

The President, Robeson said, told the delegation that Government action against lynching was necessarily a political matter, and that timing was important. The President said, Robeson reported, that this was not the time for him to act.

Robeson also asked the President to send a message when Congress reconvenes urging immediate enactment of an anti-lynching bill.

The singer said he also pointed out what he considered misdirections in American foreign policy. He said it was hard to see the distinction between current lynchings and the Nuremberg war crimes trials. He explained that he meant by this that the United States could not logically take the lead in punishing Nazis for the oppression of groups in Germany while the Government here permitted Negroes to be lynched and shot.

To this he said the President objected that loyal Americans should not mix domestic problems like lynching with foreign policy. Robeson said he told the President he did not see how the two could be separated.

When he was asked whether he was a Communist, Robeson described himself as "violently anti-Fascist." He said he had opposed

Fascism in other countries and saw no reason why he should not oppose Fascism in the United States.

Chicago Defender, September 28, 1946—"Truman Balks at Lynch Action"[8]

WASHINGTON—In terms which left no doubt in the minds of the delegation from the American Crusade to End Lynching, President Truman today emphatically refused to take the initiative to end mob violence and the spread of terrorism in America.

The delegation, led by Paul Robeson, chairman, and Mrs. Harper Sibley, president of the United Council of Church Women and wife of the former president of the United States Chamber of Commerce, asked the President to make a public statement expressing his views on lynching and to recommend a definite legislative and educational program to end the disgrace of mob violence.

Despite strong urgings from several members of the delegation, President Truman insisted that the moment was not propitious for a forthright statement from the Chief Executive, and that further, the whole question of lynching and mob violence was one to be dealt with in political terms and strategy. He stated such a strategy must be worked out by responsible political leadership and patience must attend the final solution.

When Mrs. Sibley made a comparison between fascism as it manifested itself against the Jews in Europe and fascism in America as levied against Negroes, the President showed impatience and a flare of temper.

Aubrey Williams, publisher of the Southern Farmer and former administrator of the National Youth Administration, a member of the delegation, speaking from first hand knowledge told Truman a veritable reign of terror exists in the South. He warned unless the President takes action now, the whole situation is likely to become a tragedy on a scale unknown in America. He marshaled all the facts and logic at his command to coax the President into making a definite statement that would allay the fears and apprehension of the people.

Robeson tried to show the President that the mood of the Negro had changed. He said returning veterans are showing signs of restiveness and indicated that they are determined to get the justice here they have fought for abroad. Robeson warned that this restiveness might produce an emergency situation which would require Federal intervention. The President, shaking his fist, stated this sounded like a threat.

Dr. Metz T. P. Lochard, editor-in-chief of the Chicago Defender, who joined the delegation representing John H. Sengstacke, who was unable to attend, told Mr. Truman that the Defender policy was unalterably opposed to lynching and mob terror, and that he felt the moment was ripe for the President to make his position properly known.

Other members of the delegation were Dr. Charlotte Hawkins Brown, president of Palmer Memorial Institute; Dr. W. N. Jernigan, president, Federated Council of Churches; Dr. Joseph L. Johnson, president of the Washington Committee of the Southern Conference of Human Welfare; Rabbi Irving Miller, American Jewish Congress; Max Yergan, president, National Negro Congress, and H. Murphy of Chicago.

Outside, David Niles, presidental assistant and unofficial adviser to the President on Negro affairs, sought to soften the President's harsh position to waiting white newsmen. He said, "The President feels that this is a political matter and that the element of timing is important."

Niles said, "This is not the time for the Chief Executive to make a pronouncement of any new course." He added, "The President conveyed to the delegation that his general position was a matter of record." Robeson, who was listening, replied, "This is an issue that cannot be ducked."

> Louis Lautier, *Baltimore Afro-American,* October 5,
> 1946—"Robeson Proves Ability to Handle Situation"

WASHINGTON—The delegation from the American Crusade to End Lynching saw President Truman at 11:30 a.m., Sept. 23.

When they came out of the President's office, a group of reporters were waiting and ganged up on Paul Robeson, who headed the delegation and acted as spokesman.

In quiz sessions between White House visitors and the press, no holds are barred. That was particularly true with Robeson.

For example, Robeson was asked point-blank whether he was a Communist. After he replied that he was a "violent anti-fascist," he was asked whether he followed the Communist party line.

"It depends on what you mean by the Communist party line," he countered. "Right now the Communist party is against lynching. I'm against lynching."

Robeson showed that he was just as able to take care of himself in a rough-and-tumble session with the press as he was in playing a scene as Othello with the scene-stealing Jose Ferrer as Iago.

> Speech delivered over Mutual Broadcasting System,
> September 23, 1946, Washington, D.C.—Paul Robeson Archives,
> Berlin, German Democratic Republic

I stand here ashamed. Ashamed that here in the Capitol of the world's first genuine democratic government, it is necessary to seek redress of a wrong that defies the most fundamental concept of that precious thing we call democracy. Ashamed that it is necessary in the year 1946—84 years after Abraham Lincoln signed the Emancipation Proclamation, it is necessary to rekindle the democratic spirit that brought that document into being. Ashamed that it is necessary to

publicly expose and fight the horrible contradiction that renders hollow our promises to lead the people of the world to their highest aspirations of freedom. I speak of the wave of lynch terror, and mob assault against Negro Americans. Since V-J Day, scores have been victims, most of whom were veterans, and even women and children.

But I am not ashamed to stand here as a servant of my people, as a citizen of America, to defend and fight for the dignity and democratic rights of Negro Americans . . . to fight for their right to live. And I am not ashamed to join with the thousands of Americans, from all over the land, white and black, Catholic, Jewish, Protestant, of all political persuasions, who have come together in a national pilgrimage of the American Crusade to End Lynching. People of America, we appeal to you to help wipe out this inhuman bestiality, this Ku Klux Klan hooded violence, this . . . this Fascism, as we have today appealed to the President and the Attorney-General of the United States.

For one whole year, this lynch terror has been going on. The number of victims has increased in volume with each succeeding month. And, during this one year, there has not been one arrest, there has not been one indictment, there has not been one conviction. These facts would lead to the conclusion that our local, State and national law enforcing agencies are either impotent or indifferent. We can be sure that the advocates of lynching have made this interpretation, as their increased violence attests. But, I know and you know—that the American People are certainly not indifferent and certainly do not recognize any such thing as impotence on the part of their government when the fundamental rights of all are actually threatened. And lynching is undermining the fundamental democracy of all. It is not the special or exclusive concern of Negro Americans. The good Aryan who stood idly by when the German Jew was persecuted lived to learn that that was the beginning of the end of his own freedom. Let us not some day live to learn that the persecution of the Negro was the beginning of the end of all American freedom.

Democracy is the birthright of every Negro American. The defense of that birthright is the defense of every American's right to join a trade union, to practice any faith of his choice, to join any club, or fraternal organization, to exercise his voting franchise, to enjoy the privileges of the Bill of Rights and the United States Constitution. We who are gathered here today in the American Crusade to End Lynching are representative of all sections of American organizations and ideas. Assembled here are citizens from churches, organized labor, veteran, fraternal, youth, civic and women's organizations. We have met in the common determination that those who kill by lynching shall die by the law, that our Congress shall enact federal anti-lynch legislation and that our national legislative halls shall not be dishonored by the seating of a representative of the Ku Klux Klan who is elected by less than 10% of the people of his state—Theodore Bilbo of Mississippi.

Just as on this September 22—84 years ago—Lincoln gave notice to

the Southern Bourbons that 100 days later slavery would be officially abolished, so we today give notice to the present day lynch enemies of our nation that a 100 day campaign has been instituted to end their rule of rope and faggot. We call upon the American people to petition and demand in the next 100 days of their federal government that proper action be taken to achieve this. From this day to January First, all America must be alerted and mobilized. United, let us go forward together for a genuine democracy for all people of these United States, achieving that for which a great war under a great Commander-in-Chief was concluded—a democratic, abundant and full life for all citizens of all races, creeds, and color.

> *Chicago Defender,* September 28, 1946—"American Crusade Ends with Anti-Lynch Decree"

WASHINGTON—Standing at the feet of Abraham Lincoln's statue here Monday night, Paul Robeson, chairman of the American Crusade to End Lynching, climaxed a day-long rally high-lighted by a visit with the President, by reading a new Emancipation Proclamation to thousands of assembled Negro and white citizens.[9]

Citing the abolition of slavery nearly 100 years ago as the end of the slaveholding heritage only, Robeson stated that oppression of the Negro never ended in fact. The proclamation pointed up the resurgence of violence which has taken the lives of a score of men and women since the war against fascism. It called mob violence a threat to the democratic freedom of the country.

"We, more than 1,500 citizens assembled in our nation's capitol to inaugurate the continuing American Crusade to End Lynching, are determined that the duly elected government of the U.S. shall fulfill its sacred trust by using the country's every resource to end now the growing reign of mob violence in America," the proclamation stated.

The proclamation, delivered after the President told Crusade members that lynching is not a moral issue, ended with a call to all Americans, regardless of race, creed or color, to demand that the 80th Congress pass laws to put an end to the national disgrace of mob murder.

Excerpts from Testimony before the Tenney Committee

Joint Fact-Finding Committee on Un-American Activities in California,[1] October 7, 1946—Paul Robeson Archives, Berlin, German Democratic Republic

BY MR. COMBS (Richard E. Combs, committee counsel):

Q. The prime purpose, Mr. Robeson, in having you come before the committee is to ask you concerning the organization of certain groups

that the committee has in the past been interested in,[2] so that the examination will be pretty much limited to that . . .

A. Quite.

Q. . . . so that you will know what our purpose is. By way of background, Mr. Robeson, you have been a concert singer and actor for many years, have you?

A. Since 1922 or 1923, yes.

* * *

Q. Have you made several trips to the Soviet Union in connection with your profession?

A. I went to Europe about the first time in 1922, to England, and I have been several times into the Soviet Union, both professionally and non-professionally.

Q. When were you last there, Mr. Robeson?

A. I was last there about the end of 1937, the beginning of 1938.

* * *

Q. . . . Mr. Robeson, of what does your family consist?

A. It consists of a wife, son—today—brother and sister, and many cousins.

Q. Was your son educated in the Soviet Union?

A. He was in the Soviet Union from the time he was eight until he was about twelve; and then as war began, as the rumors of war began in Europe—in 1939, I was at that time living in London, and he came back to London; and as he was in one of the Soviet schools he was allowed by Mr. Maisky, at that time Soviet Ambassador in London, to attend a Soviet school in London; so he continued his Soviet education in London about another year and a half. So he has had what I would call a very basic Soviet education.

Q. Is he a citizen of the Soviet Union?

A. He is not. He was born in the United States.

Q. And he has retained his citizenship as you have?

A. That is right. He is now at Cornell and in the American Army, as a matter of fact.

* * *

Q. Now there are two organizations, comparable organizations, are there not, for the interest and benefit of the colored people: The National Negro Congress, to which you referred; and isn't there also an organization known as the National Association for the Advancement of Colored People,[3] too? . . . Are you affiliated with both of them?

A. Oh, I should say so.

* * *

Q. You know of an organization called the Joint Anti-Nazi Refugee Committee?

A. Yes.

Q. Are you an officer or were you ever an officer in that committee?

A. No. . . . I was in London in 1933 at the beginning of the Hitler regime in Germany, and my first concerts were to aid Jewish refugees who came from Germany to London, and I played in the theaters for

them. At that time artists felt they were a little apart from the
struggle. I myself have never been, because from the time I played on
the football field I felt I was struggling for the Negro people, my
people, and I was conscious of the struggle. I began to sing. I was just
an artist coming and giving my services. That was more or less the
general pattern, that I go on and sing and act and raise funds to help
people and organizations and causes that I think are worthwhile.

And whatever . . . I heard some of the remarks this morning . . . our
hopes for American democracy and democracies in other parts of the
world, as a Negro in America who is also heading a crusade against
lynching, where one-tenth of the citizens are being shut out without
redress or even a formal statement from the President of our United
States . . . I know a lot about fascism and I know what it means
because I have seen it. I have helped fight it. I helped the Norwegians
and many other people, the Danes and Frenchmen and Spaniards to
fight against fascism. I know what it is. So I might have to participate
a great deal more.

<center>* * *</center>

BY CHAIRMAN TENNEY:

Q. You don't mean to tell the committee, I am sure . . . that merely
because a man is a capitalist and has some money . . . that he becomes
a lyncher or would condone those things?

A. No. I was giving a definition of fascism; that it is not necessarily
the beast in man; it is the necessity of certain groups to protect their
interests, like a former witness said, against social change, that is all.
They want the status quo or even much less than that. That was the
essence of fascism. When people in Europe were pressing forward to
social change the Fascists said No and beat them back. I feel that is
part of what is going on maybe in our own country today . . .

Q. I may be going far afield, here, Mr. Combs. But are you a member
of the Communist Party? (Laughter) I ask it of everybody so don't feel
embarrassed.

A. No. I am not embarrassed. I have heard it so much. Every
reporter has asked me that. I will certainly answer it, Mr. Tenney.
Only you might ask me if I am a member of the Republican or
Democrat Party. As far as I know, the Communist Party is a very legal
one in the United States. I sort of characterize myself as an anti-
Fascist and independent. If I wanted to join any party I could just as
conceivably join the Communist Party, more so today, than I could join
the Republican or Democratic Party. But I am not a Communist.

Q. You are not? I suppose from your statement, would I be proper
and correct in concluding that you would be more sympathetic with the
Communist Party than the Republican or Democratic Party?

A. I would put it this way: I said I could join either one of them just
as well. . . . I have no reason to be inferring communism is evil or that
someone should run around the corner when they hear it, as I heard
here this morning, because today Communists are in control or elected
by people because of their sacrifice in much of the world. I feel that

Americans have got to understand it unless they want to drop off the planet. They have got to get along with a lot of Communists.

<p style="text-align:center">* * *</p>

Q. In answer to these matters you refer to Georgia and the South. . . . Compared to California you don't find that sort of thing, or do you in California?

A. . . . let me tell you what happened to me in California . . . this was really extraordinary to realize. In Fresno they don't like Armeni-ans. If you are not careful, to be an Armenian, it is almost as bad as being a Negro. This is really fantastic. We went into a restaurant near there with a relative of Saroyan.[4] I forgot to say we walked into the restaurant. They said, "We are not serving people." People were sitting around. I said, "But you are serving. It is four o'clock in the afternoon." He said, "What do you mean coming in here with your hat on with white folks?" . . . I started for the guy and he started to reach. And they said no, somebody said for me to be careful, so I said O.K. But in Fresno, California I could have been dead exactly like I would have been in Georgia. . . .

There is no solution to the Negro problem except by working it out together, and the Negro people must look to the people who are in that position; and that also affects me. Although I have been personally successful, I have poor sharecroppers down the list and I could be poor overnight and have to go back to work. I worked very hard as a child. My father was a slave. So all my life's interest has been with people who have been suppressed, and I know the Negro struggle intimately. I feel the guy down low, whether he knows it or not, has got to be on my side some day. So I will fight with the CIO and help the white workers or white liberals or any people. There are just a few guys, they may never be good fellows, as I say, but their interests demand that they press things down. And this has led me to doing the kind of things I do, and I do them at great sacrifice. Mr. Behymer can be so upset by this conference that he may cancel my appearance.[5] Well, let him. I face these things and I am willing to do it.

The United Nations Position on South Africa

Letter to the U.S. Delegation to the General Assembly of the United Nations, signed by Paul Robeson, Chairman, Council on African Affairs, December 6, 1946—*New Africa,* December 1946

The Council on African Affairs is deeply concerned about the position which the United States delegates . . . have taken . . . with regard to the questions of trusteeship and the two items concerning South Africa. . . .

We feel sure that a large section of the American public has been deeply disappointed in the fact that the United States, instead of

standing with those nations which urged unqualified rejection of the proposal to annex South West Africa to the Union of South Africa, assumed a conciliatory role and brought about the adoption of a resolution which makes possible approval of the proposal at a later date. The same reaction of disappointment, we feel sure, resulted from the part played by the United States in supporting the South African and British demand for disposing of the Indian Government's complaint regarding discrimination against Indians in South Africa by referring this matter to the International World Court, instead of taking an immediate and positive stand against the admitted violation of the Charter principles on racial equality.

We also urge you to reconsider . . . the question of military bases in trust territories and other aspects of the trusteeship agreements. The consequences of the action taken on these matters are extremely grave. We are convinced that the United States can gain immeasurably in terms of the larger issue of fostering mutual trust and good will among the larger powers, as well as between ruling and subject peoples, by adopting in these matters the course of action urged by several of the non-colonial powers, notably India and the Soviet Union. . . . [1]

Robeson in Honolulu Backs Wallace, Denies Communist Peril

Honolulu Star-Bulletin,[1] March 22, 1948

Singer Paul Robeson said last night he feels that President Truman was forced into demanding a federal civil rights program,[2] but he said he believes it can be carried through with Republican support.

He listed the need for justifying America's position in the United Nations and strong pressure from presidential hopeful Henry A. Wallace as two prominent reasons for Mr. Truman's stand in the civil rights battle.

"In essence the number of persons in the south opposed to the plan is not large," he said. "The poor southern white is quite close to the southern Negro," he said.

The towering concert singer covered a variety of topics at a surprise press conference called Sunday as a climax to his 27-appearance visit to the islands under the sponsorship of the ILWU.

He told reporters his trip to the Islands was one of the most stirring trips he had ever made, said he was very much impressed by the island's people, and believed there was a lesson in racial matters to be learned here.

"It would be a tremendous impact on the United States if Hawaii is admitted as a state,"[3] he said. "Americans wouldn't believe the racial harmony that exists here. It could speed democracy in the United States."

Mr. Robeson expressed the belief that there would be no war with Russia.

He said the "whole talk about Communism is absurd. Either we get along with the Communists, jump in the ocean, or blow up the whole world. Saying you can't get along with Communists is like saying you can't get along with the birds."

When the talk turned to Robeson's personal political beliefs, he said he was an "advanced new dealer."

Shown a list of organizations branded by the Thomas committee as "un-American," Robeson told reporters he had belonged to one on the list,[4] but pointed out that he also belonged to a number of other organizations, including the staff of a Phi Beta Kappa publication[5] and a number of church organizations.

Talking quietly through most of the interview, Robeson summed up his beliefs as a "fight for everybody, everywhere" who is oppressed.

He said if an all-out war was declared in the Holy Land[6] he would immediately go to Palestine to sing for Jewish troops as he did for Loyalists during the Spanish civil war in 1936.

Mr. Robeson answered recent criticism of his concert selections here as "controversial" by saying he had sung the same selections since 12 years ago when he stopped making professional concert tours.[7]

He said it is "silly for a man to criticize the concert because of the material in it."

Mr. Robeson said he plans to continue his work on behalf of Henry Wallace when he returns to the mainland. He said he is backing Wallace because "if anybody continues the new deal traditions of Franklin Roosevelt, it is Wallace."

He scoffed at the idea that Wallace is a Communist, and said he believes Wallace is a "progressive capitalist."

Jack Hall, regional director of the ILWU, told reporters at the end of the conference that he and other union members in the islands are grateful for Mr. Robeson's appearances.

Mr. Robeson himself promised to do what he could on the mainland to bring other singers and artists to the Islands to appear under ILWU sponsorship.

Speech at International Fur and Leather Workers Union Convention

May 20, 1948—*Proceedings*, 1948, pp. 201–4

I am sure that I need not say that I thank you and that I am especially proud to be here today.

I have been wandering back and forth across this America of ours trying to help where I can. I got a telegram from Ben[1] saying I would have to be here and as a member of the Union, here I am. (Applause and cheers)

It is a great privilege to be here on the day when two dear friends and two great fighters, Mr. Fast[2] and Mr. Lee Pressman,[3] are here.

It was my privilege to be in Colorado not long ago with your attorney, Mr. Pressman, and what a magnificent job he did in the cause for freedom in that part of America and I know that you have profited no end by listening to him today.

Just a few things I am going to say. They have to do with things that I think are very close to you and to me. Before that—unfortunately, Mr. Brown, my accompanist, does not fly, and I was in Louisville a day or so ago, he had to go on to California and I will catch up with him later. I am going to sing a couple of songs, unaccompanied. I used to do that, too! (Mr. Robeson sang "Water Boy," "Joe Hill.")

Since "Freedom Train" is going to reflect so much what Ben said about what I feel and what you feel very much about, I would like to finish with that and say a few words I have to say just before and then I will finish with Langston Hughes' "Freedom Train."

As you know, I have given up the last year or so of my professional career[4] to go about in many parts of America and I have seen many things.[5]

I have been, for example, in North Carolina where I stood on the very soil on which my own father was a slave. My father came to New Jersey. I was born not far from here, up around Trenton and Princeton. I know this part of the world very well. My father was a wandering minister, going from one small church to another, and I saw my cousins in North Carolina, sharecroppers, tenant farmers, trying to eke some kind of decent living from that land.

I was in the mountains of West Virginia a few weeks ago, just a couple of weeks ago, and the things that I saw shocked me beyond words. I did not know that we, the wealthy land that we are, we with our high standard of living could allow thousands and thousands of workers to live like that.

I was in Pueblo, Colorado not long ago, with Mr. Pressman, and the next morning we saw Spanish-Americans living practically under the ground in holes—in Pueblo, Colorado.

In the South, in the cotton fields, across the whole South, in the fruitful fields of California, people from the Middle West of our country, practically living at the edge of subsistence.

Now why these things? These things should make us reflect upon the kind of America that we have. Why should this be so?

The late President Roosevelt said that it was one-third of our nation that was under-privileged. Perhaps you know more about that than I. As I go about seeing things at their source, it seems it is possibly more than two-thirds, perhaps more than that, while the few control the great wealth and in some way convince us that we have this very high standard of life.

I see too much poverty for us to boast.

Now as I was in Kansas City and saw what the police did—I was in the hall a few days after the police had hit the workers over the heads,

gone in and torn up the union hall. I remember when on the Mesabi
Range, I had a concert there, I was on the picket line, and the scabs
came out protected by the sheriff, and they were bent over. I wanted to
know why they were bent over and they told me they had rifles in their
hands and they were supposed to shoot if necessary. They did shoot
just the other night, yesterday, I understand, at Waterloo, Iowa. I just
came from there, too, speaking in the home state of Mr. Wallace.
Things happened in Charleston, South Carolina just the other day.

These things mean there are forces in our life, I say they are the
forces of the few that are saying to the people as they aspire to a more
decent life not only shall we not give you more wages, not only shall
you Negroes not have any more civil rights, we will beat you down and
see that you remain in a kind of industrial serfdom as long as we have
any kind of power.

These things, unfortunately, are not new in the struggle of man-
kind. I often think how is it that we, the people, the great majority of
the people, struggling as we have for generation after generation
forward to some better life, how can it happen that everywhere in
history a few seem to take the power in their hands, confuse the people
themselves and there they remain?

But that has been the history of the world or we might not be here
because who built this America of ours? The poor from England, the
poor from Ireland, the poor from Scotland and Wales, my own people
brought as slaves to this land, those who suffered in the old Poland,
those who suffered in Czarist Russia, those who suffered in the
Balkans, in Asia, in Latin-America—we have built this America. This
has been built upon the very backs of ourselves and of our forefathers.

And the Negro people of this land must realize today, as they face a
new kind of struggle, that they must have courage; they must have
knowledge that the very primary wealth of America is cotton, built
upon the backs of our fathers; that cotton taken to the textile mills of
New England; and that we don't have to ask for crumbs to be dropped
from the few up top, but we have the right and the responsibility to
demand in a militant way a better life for ourselves and for the rest of
those Americans and the peoples of the world who still suffer and are
oppressed. (Applause and cheers)

Now, this is the essence of the struggle that we fought under
Roosevelt. No one knows it better than your Union. I have gone about
this land in many places and everywhere do I see the Fur and Leather
Workers in the vanguard of progress.

I was in Cincinnati not long ago, in a real struggle. I was in the
house of Mr. Dickerson and there the whole core of progressive
struggle was built around our Union. So I know that we understand
that somewhere things do get confused now and then. The boys on top
are pretty good at sowing the seeds of confusion, but it is very simple if
we remember our own struggle, how you have grown and how you have
built. And somewhere we had this great figure of a Roosevelt who
fought and called these people what they were, the people who control

our resources, the Economic Royalists, he called them. This struggle went on, in our favor and in the favor of the Negro workers and the Negro people throughout this land. And somewhere other forces came in and have tried to undo all the great work that he built up.

But it does not rest in big words; it rests in very simple things. It rests in the fact as to whether we sitting here, getting along pretty well, whether other Americans doing very well, consider those who yet do not have a decent life. Are they really people like ourselves?

This is the way I have tried to phrase it in the last weeks because as I said to the people in Colorado, those of the progressive movement— how could they sit there and allow people to live like these people did in Pueblo?

How can we dare face the world today knowing the suffering in many parts of the world and stand and, for example, support and allow our government to support a British Empire which supports a Smuts in South Africa, which has millions of Africans and peoples from Asia in complete serfdom?

How can we stand and allow our government to suggest that we can think more of the profits of a few people of Standard Oil of this very state, than of the lives of one of the great peoples of the world, a people who gave us the very basis of our ethics and our religion? Am I to say or to allow to say a Forrestal, who went to Princeton about the same time I went to Rutgers—I know a lot of these fellows on the board of Standard Oil—they say, "Roby, why do you take the side you do?" They care nothing for the rights of the ordinary laboring man. Let them starve, they say, just so we get the profits. But I say to them, never, for example, shall my son go to a foreign land to take up a gun to shoot a people that are close to him in the interests of any kind of oil. (Applause and cheers)

So this is the basic thing, as I see it. Just people, millions and millions of them, aspiring people, very much the same all over the world. And if we understand it in the South, if we understand that obviously nothing is perfect in this world, our struggle in America from the days of Jefferson down through Lincoln and Roosevelt and through Wallace today has been somehow to see that the many, the many can take some kind of real share of their labor, that the few shall not keep on controlling our land, that there must be an extension of this democracy to those who do not have it. And so this is so all over the world.

Can't we understand what has happened in Hungary, in Yugoslavia, in China, all over the world, where a few landlords owned all the land and told the peasants, as they tell the Negroes in the South, they must remain in slavery?

They helped to defeat the fascism that kept them under heel because they knew landlords sided with that fascism. We should understand today that when the land comes to them and they get some share of it, like we got homestead lands in the Middle-West—like the Negro people were promised forty acres and a mule, and they have not got it

yet—somewhere, some day they will get some decent share of that land in this land of ours.

But we must understand, having come from these different places in the world that they have the same aspirations as we and that there are many ways toward this freedom. We have our historic background; they have theirs. In Scandinavia they do it one way; in England they do it another way. In Russia, Yugoslavia and China they will do it their way. They have that privilege, coming from their historic base. And we must understand and have respect for the aspirations of other people and if our kind of life is so much better than the rest of the world's, let's show it to the world, let's not try to beat the backs of others. (Applause and cheers)

And from my own experience, coming up as I say, with a father who looked in his time to the major parties to solve all the problems, well, he waited a long while for the Republicans to do something. Perhaps he did not know that the people who owned those plantations in the South, the people that own the great industries, they have their interests served by these so-called major parties.

I worked in a law office with a lot of them, one a Republican, one a Democrat—they represent their interests. Like a man whom I knew in Seattle, a so-called liberal today in Washington, checking everything to stop decent housing, because he happened to represent the real estate interests. He cares nothing where the veterans live, where people live who want decent homes; he must fight for those kinds of profits.

And so it goes along, and these parties somewhere they have their interests served.

And we must be very careful today, very careful as we succumb to a kind of hysteria here and there because I ask you, what forces take our liberties away? I ask you, in Binghamton, New York, for example, when I was there some years ago, you said you must not say this in this town. Who were the men from Cornell who were coming to speak on the same platform? They were the people who owned Binghamton. Who are responsible for what happened in Kansas City? The people who own the meat packing companies, who have the nerve to say to the people of America, we, the few, are the American civilization.

They are not the American civilization! The people themselves are! (Applause)

I talked to my manager some weeks ago and he said, "Paul, in your going around defending labor, fighting for Wallace, you have no more concert career." I said, "Tell me. I am interested. How did you figure that out?" He answered, "Nobody will book you."

You know how that goes. All the little cities, you know how concerts are built up, a very fine picture how the whole thing works. Twelve hundred society bigwigs are the concert people in most of the towns. No ordinary person can buy a ticket except by subscription, fifteen dollars, twenty dollars. A closed circle. So you go around America, doing concerts, singing to about 1,200, 1,500 or 2,000 people instead of

tens of thousands and hundreds of thousands. And the managers get to
think that this is America, this is American culture.

I told him that he is just kidding. If I am not booked in Binghamton
or somewhere else, just hire the hall and I'll show him that there are a
lot of other people besides those 1,500. (Applause, cheers and delegates
arose)

I shall finish with this reading of "The Freedom Train."[6]

Remarks at Longshore, Shipclerks, Walking Bosses & Gatemen and Watchmen's Caucus

August 21, 1948—Typewritten record of Proceedings of Caucus,
ILWU Archives, pp. 229-232

I want to thank you very much for allowing me to come in to say a
word. I am traveling about the country.[1] I just came up from Dallas
enroute to the Northwest and I found that the Caucus was in session.
Certainly, as a member of the Union, knowing of the struggle that is
around the corner, I wanted to stop to say a word, to let you know that
as a member of the Union, if there is anything I can do, just let me
know.

The struggle never seems to stop. It gets sharper and sharper. I pick
up the papers today and find that we and our Union have a real job to
do.

I have been to Hawaii[2] and have been in close touch with union
matters. I cannot tell you how proud I am to be a member of this
Union. I go back to the day when I was taken in. I have been a member
of many unions.

I cannot tell you how proud I am to be with you. I have watched your
struggle, watched the consistent stand you have taken, and I know you
are going to continue to do that.

Taft-Hartley[3] means death to the trade union movement. The two
parties have been playing around, and at every moment we see that
Truman steps in and uses every provision he can to do his part of the
job. You have a real problem, I understand. It means that you are
going to tell them, as you have told them before, that you want no part
whatsoever of this kind of legislation, which not only would break the
back of the labor movement but would set back the whole struggle of
the American people for generations. And I understand that you are
going to tell them that you want no part of voting on what the
employers have offered to you, that you will set the terms yourself.
That I am very proud to see.

In traveling about the country it is quite clear that the struggle for
economic rights, the struggle for higher wages, the struggle for bread,
the struggle for housing, has become a part of a wider political
struggle. They have moved in to high places in government, and today

the enemies of labor control the working apparatus of the state. They have to be removed. There has to be a basic change. I feel that this can only be done by seeing that we put into power those who represent a political party which has the deep interests of the people at heart. I am sure you understand that this cannot be separated, that we must understand politically that Truman is in office through one party, the Republicans are in through one party and are responsible for Taft-Hartley, and that somewhere you have to see another group in there that fights for the rights of labor and for the rights of the American people.

And so I travel about today not only as a member of the Union, not only as an artist (I do concerts now and then), not only as a representative of the Negro people, but I travel as one of the Progressive Party, fighting to put Wallace in the presidential chair. Wallace is the man who might be there had he not in 1944 said "Jim Crow must go," had he not fought so hard for the rights of labor. He is the one public leader who has come out at once to say that the hiring hall must remain and that these men must be fought to the teeth: the people who are trying to break our backs.

And so I trust that you will realize the depth of that struggle, that you will not separate them, that they cannot be separated, that they go hand in hand, that the one way that this can be beaten is to give your energy, to give your time, to give your money, to see that we can put representatives in Congress and a President in the White House and a Vice-President who will represent our interests.

It has been my great privilege since I have seen you last to have been able to go to Hawaii for the Union; to have seen there working a real democratic way of life in the Union; workers from all over the world who have become a part of the American way of life, building a decent home and a decent way of life for their children and for themselves in the Islands of Hawaii.

I managed to learn some of the songs of the people from the Philippines, of the Japanese-Americans. I saw many Negroes there who have remained.

I want to thank the Union for what it is doing there. I hope pretty soon to be down in the West Indies; I hope to drop by Cuba to see some of our fellows there.

And I want to repeat that I come today mainly as one in the Union, fighting its struggle. I shall be in the area for just two or three days. I shall be back, I hope, soon again.

I am so proud to see the leadership that you have given to the whole labor movement. I want to thank your courageous leader, Harry Bridges, for his consistent stand.

The final word is that as members of the ILWU, we have a tremendous responsibility. I cannot tell you how the labor movement throughout the country looks to you as an example. And so there is added responsibility for you to carry on the fight in the next few days, in the next few weeks, in the next few months. What you do here in

this Union can very well determine the future of the whole labor movement in these United States. It can mean victory for the American people in these times. And I, as one who comes from an oppressed people, one who has identified himself with the whole progressive struggle, know that you will carry on.

I want to thank you from the depths of my heart!

Here followed rendition of "Joe Hill." (Loud and sustained standing ovation)

Freedom in Their Own Land

National Guardian, December 20, 1948

I have just returned from a concert tour through Jamaica and Trinidad.

I feel now as if I had drawn my first breath of fresh air in many years. Once before I felt like that. When I first entered the Soviet Union I said to myself, "I am a human being. I don't have to worry about my color."

In the West Indies I felt all that and something new besides. I felt that for the first time I could see what it will be like when Negroes are free in their own land. I felt something like what a Jew must feel when first he goes to Israel, what a Chinese must feel on entering areas of his country that now are free.

Certainly my people in the islands are poor. They are desperately poor. In Kingston, Jamaica, I saw many families living in shells of old automobiles, hollowed out and turned upside down. Many are unemployed. They are economically subjected to landholders, British, American and native.

But the people are on the road to freedom. I saw Negro professionals: artists, writers, scientists, scholars. And above all I saw Negro workers walking erect and proud.

Once I was driving in Jamaica. My road passed a school and as we came abreast of the building a great crowd of school children came running out to wave at me. I stopped, got out of my car to talk with them and sing to them. Those kids were wonderful. I have stopped at similar farms in our own deep South and I have talked to Negro children everywhere in our country. Here for the first time I could talk to children who did not have to look over their shoulders to see if a white man was watching them talk to me.

These people were in a land they did not yet completely own. But they were free to meet together and talk together and act together. They had the dignity of men who could make their own mistakes, men who could cut their own throats or make their own world. They did not fear that a group of white men could come to them in the middle of the night to hang them or burn them.

That freedom from fear is a new thing to American Negroes. I am never for one moment unaware that I live in a land of Jim Crow. I do not grow angry about it. I think I understand it and I understand how we must fight it. But understanding or not, the realization that I am a Negro in a land of Jim Crow does not leave me. Nor do I think it can, even for a moment, leave any American Negro.

I think that this nearness to freedom, this being on the road and so near the goal, had a great deal to do with the way they received me. It was like nothing that has ever happened to me before. If I never hear another kind word again, what I received from my people in the West Indies will be enough for me.

They crowded around my car. For hours they waited to see me. Some might be embarrassed or afraid of such crowds of people pressing all around. I am not embarrassed or afraid in the presence of people.

I was not received as an opera singer is received by his people in Italy. I was not received as Joe Louis[1] is received by our own people. These people saw in me not a singer, or not just a singer. They called to me: "Hello, Paul. We know you've been fighting for us."

I, Too, Am American

Reynolds News, London, February 27, 1949

Sometimes when I go back to my home State in New Jersey, friends of my student days say to me, "Paul, what has happened to you, you used to be such a mild sort of chap and now you are so militant and political."

I think back and wonder how my attitude has changed since my student days. I realize then that I learned my militancy and my politics from your Labour Movement here in Britain.

I came to Britain for the first time some years before the war, and I thought in those days that my sole job was to be an artist. I was made a fuss of by Mayfair.

Then one day I heard one of your aristocrats talking to his chauffeur in much the same way as he would speak to his dog. I said to myself, "Paul, that is how a southerner in the United States would speak to you."

That is how I realized that the fight of my Negro people in America and the fight of the oppressed workers everywhere was the same struggle.

These were the years of depression in Britain and I went out to sing for the Welsh miners, for the dockers of Glasgow. I took my place on the platform in those great demonstrations that you organized here for the people of Republican Spain. In that great campaign I worked with Clement Attlee[1] and Stafford Cripps.[2]

I feel at home in England. Coming over on the boat a few days ago I

went down to sing to the crew. When I arrived at Southampton the dockers came on board, called me by my Christian name. I said: "Yes, I am part of this England."

But I speak, too, for those progressive forces in America who are fighting with the progressive forces everywhere against the men who are seeking to spread imperialism over the world.

As a Negro American, I am one of the 15,000,000. I was born in America. I went to University in America. I am a product of the American social background.

My ancestors were among the first to people America. Men and women of my family were brought over as slaves in 1620.

Theirs was not the only slave labour that went to build up America. Other ships were sailing to the West in those days with bound labour in their holds. Maybe some of you who read this are descendants of English peasants who were sold as slaves to the planters after the defeat of the Monmouth Rebellion against your King James II.[3] Maybe among your ancestors are men and women shipped to the plantations as indentured servants who were little better than slaves.

There you have an aspect of American history that the advocates of race persecution like to forget: while the Negroes were sent to slavery in the cotton plantations, English, Scottish, Irish, and Welsh victims of poverty and tyranny were also slaves or near slaves in both North and South.

We are the people, black and white, whose work was the source of the first great primary wealth of America.

I see my own background against the fact that from the continent of Africa 100,000,000 Africans were torn from their land to build the wealth of "Liberal capitalism."[4]

I know that I am part of it because my own father was a slave. He was born in 1843, escaped from slavery in 1858, five years before the liberation of the slaves, and fought in the Union army.[5] I was born in 1898, the last of seven children.

A few weeks ago, during Henry Wallace's campaign for the Presidency, I stood on the very soil on which my father worked as a slave. My relatives are there still. They are poor farming Negroes, trying to eke out some kind of living from the worn-out soil. And they have no rights that the white southerner is bound to respect.

I speak for the progressive America, of which the Negro Americans are but a part, which is fighting to carry out the plain demand of the electorate for a new deal. The reason Truman is President is that he told the people he would do what Henry Wallace wanted to do.

I am part of that America today which is being persecuted for its defence of civil liberties and for the right of men and women to live as human beings.

It is important for the people of England to know that those basic rights which are part of English civilisation are under as sharp fire to-day in America as they would have been in Hitler Germany.

When I think of conditions in my country I marvel that so many

people here with a record of struggle in the progressive cause, fail to realize what is happening in present-day America, fail to realize that people like Forrestal,[6] Harriman[7] and Stettinius[8] are merely seeking the expansion of American imperialism.

In the Progressive Party we believe that Truman is still in the hands of those people and that we have an urgent duty to see that he fulfills his pledges. It will be one of my tasks over here to give your people the background to what is happening in America.

When they stop me speaking in American Universities because I am "un-American," when they persecute the best progressives in America because they are supposed to be more concerned with other nations than their own, I ask them whether they have not yet realized that to-day no nation can live by itself. Every nation is part of the world.

We are constantly told in America that we are part of the Western world. I would note in passing that this geographical designation includes Turkey and Japan.

They tell me that my son, aged 21, as an American is part of a revived Fascist Western Germany, that as an American I am part of a nation that is beginning to filter funds to Franco, that is aiding Fascist Greece and reactionary Turkey, that is about to begin another rape of Africa.

I belong to another America. I will not belong to Franco's world. I belong to the world of Republican Spain, of resistance Greece and the new democracies. I belong to the America which seeks friendship with the Soviet Union. I am a friend of Israel, not of the oil interests. I am a friend of the new China, not of a revived Fascist Japan.

I, too, am American.

Foreword to *Nigeria: Why We Fight for Freedom* by Amanke Okafor

London, 1949—Copy in Moorland Spingarn Library, Howard University

The use of the vast but as yet untapped resources of Africa for the benefit of the African peoples, and indeed of all mankind, is a lofty and noble aim.

But this can be achieved only by the Africans themselves, and only when they shake off the shackles of colonialism and are free to develop their own country. It cannot be achieved by foreign financial concerns, whose only aim is to make the greatest profit out of exploiting the Africans. Such development plans can bring nothing but untold misery for countless thousands of the African peoples.

All over the world the ordinary working people are challenging the entrenched positions of the privileged and are organising and fighting to win the rights that have so long been withheld from them. Across

Africa, too, a new powerful urge is sweeping. More men and women are becoming conscious of the need for freedom. There are emerging individuals who, while inspired by a burning love of their country and their people, will have nothing to do with racial and national hatreds, pitfalls which often trap the unwary.

One such individual is the writer of this pamphlet, who has made a deep study of the potentialities of his country. Nigeria, Britain's largest colonial possession, has a great future.[1] Immensely rich in resources, both human and material, it requires only freedom and government by its own people in order to transform it within a generation from a backward, undeveloped colonial territory into one of the leading countries of the world. Amanke Okafor points out in this pamphlet, which fulfils a long-felt want, the way forward in Nigeria to all who stand for progress.

Racialism in South Africa

Speech delivered at Protest Meeting, Friends' House, London, March 25, 1949—Paul Robeson Archives, Berlin, German Democratic Republic

We are living today in a world in which those forces which have up to now enjoyed the fruits of the labour of others are feverishly engaged in retaining a hold on their privileges fast slipping from their grasp.

We are confronted with a situation in which the citadels of reaction are being bolstered up to meet the mounting challenge of the oppressed and the down-trodden for their right to live as free men.

The great new era of social change which was ushered in with the victorious conclusion of the war against Fascism, involves not only the peoples of Europe, but also those peoples struggling to throw off the yoke of colonialism.

In China, the forces of liberation are bringing freedom to millions of people in that ancient land, freedom such as they have never known throughout the course of their long history.

The whole of South-East Asia is in a state of ferment. Burma, Malaya, Indonesia and Viet Nam are in the throes of a desperate struggle for emancipation. And the peoples of Africa, their traditional cultural and social standards in a state of ruin as a result of the impact of imperialism, are also striving to build anew on the ruins of the old. It is because of this developing struggle that the imperialist forces have been thrown into a state of near panic and are striking out in every direction in order to survive.

We are often reminded of the "cold war,"[1] said to exist between the two great sections of the world, the capitalist section led by the United States, and the socialist section at the head of which stands the Soviet Union. But little is said of the cold war of racial hatred, malice and intolerance, which is being waged with an intensified fury in an

attempt to hold millions of people of non-European race in permanent subjection. At the head of the aggressive forces in this cold war, too, stands the United States. But occupying a prominent place by its side is the Union of South Africa. They are at once agreed in their policies of racial discrimination, but they differ in their practical approach.

A Negro may be lynched in the Southern States of America if he attempts to use his vote. In South Africa he is in no such danger, only because he has no vote.

In the States since the ending of F.E.P.C.[2] a Negro whose skilled labour was valued in time of war, now finds it hard to get a job even below his capabilities. In South Africa an African may be driven, even at the point of a gun, as we learned last week, to persuade him to sell his labour.

South Africa is now the stamping ground of all the evil forces which many decent, progressive people believe the war was fought to destroy. The disciples of Streicher[3] and Goebbels[4] are unashamedly and insolently boasting about their foul creed. They are brazenly persecuting three quarters of the population. They degrade mankind by their policies and practices and consequently they are deserving of the severest censure of decent men and women everywhere.

I find it difficult to understand the mentality of these racialists of South Africa. Their entire wealth rests upon non-European labour. The functioning of their everyday life depends largely on the services rendered by the very people from whom they are withholding the right to live a normal life.

The picture South Africa presents today recalls the Germany of the years before the war. The pogroms against the Jews in those years led inevitably and inexorably to the horrors of Auschwitz and Belsen.[5] Can that be the intention of the present rulers of South Africa? Are they preparing by their present acts to commit finally the act of genocide?

They are talking of expelling the Indian minority from the country, but have not the Indians just as much right there as have the other minorities?

On the question of the treatment of the Indian subjects and on the issue of the future of South-West Africa, the South African Government has up to now successfully defied the authority of the United Nations. Although decisions have been adopted by the General Assembly of the United Nations which, as a member state and a signatory to the Charter, she is bound to respect, South Africa has stubbornly pursued her own undemocratic way. It is clear that she would not have been able to keep up this defiance of world opinion, were it not for the active support and encouragement forthcoming from certain powerful States. We demand that this support be withdrawn forthwith. A vigorous campaign must be conducted to arouse the conscience of the world to do away with what a Negro writer has rightly described as a cesspool which needs no advertisement.

To allow the present situation in South Africa to continue means the

preservation of one of the world's gravest danger spots. It is as necessary for the forces of progress to secure victory there as it is in Greece and Spain.

We in America have good reason to be alert to the danger that South Africa represents. We know that it is impossible to compromise with Jim Crowism and Anti-Semitism.

We cannot afford to tolerate the advocates of White Supremacy in South Africa, any more than we can agree to the activities of the Ku Klux Klan in Georgia or Mississippi.

We know that racialism of this kind must either be stamped out or it will spread.

We in America have, indeed, been witnessing the extension of some of the enormities of the South to the hitherto relatively liberal North. Six Negro lads, some of them war veterans, are today lying in a condemned cell at Trenton in my home state of New Jersey, awaiting execution for a crime they never committed.[6] They were simply picked up by the police and bludgeoned and tortured into making false confessions, which were then used as evidence. I have relatives still living in New Jersey. Anyone of them could have been seized in this manner. I myself might have fallen a victim to this form of bestiality. Such lawlessness, masquerading as law, is the inevitable result of the denial of the rights of a whole section of the community and the subjection of this section to a regime of discrimination and persecution. There is every evidence to show that the Nationalist Government of South Africa have every intention of extending their colour bar regime beyond the borders of the Union. The coming into power of the Malanites[7] has already resulted in a deterioration of the position of the African people in the Rhodesias and in East Africa. The West African colonies, as yet relatively free from colour bar practices, face the threat of an overflow of these base ideas and practices.

In order more effectively to subdue both the African and Indian sections of the non-European population of South Africa, the Nationalists have succeeded unfortunately in setting the Africans against the Indians in Natal. They have provoked a fratricidal clash which unless checked very quickly may have the same tragic consequences for the non-European people of South Africa as the Arab-Jewish conflicts had for the people of Palestine or Hindu-Moslem antagonisms for the people of India.

Only the avowed enemies of both the Indian and African peoples can gain by the racial disturbances which recently took place in Durban.[8] We must strengthen the forces composed of the best African, Indian and European elements in South Africa which are struggling to achieve understanding among the races and justice for the oppressed. Their fight is the concern of all progressive humanity; their's is but a sector of the great struggle for peace and progress. Their friends throughout the world are many. Here let me pay a tribute from this platform to the great Soviet Union which constantly champions the cause of the African and other oppressed peoples. Having itself

abolished colonialism, which spells domination, abject poverty, degradation and death, the Soviet Union has by right assumed the leadership of the anti-imperialist forces to end the exploitation of man by man. When that day arrives, as come it will, an endless vista of peace and prosperity will open before the peoples and man will walk the earth in his true majesty.

Paris Peace Conference

News Release, Council on African Affairs, May 11, 1949—Paul Robeson Archives, Berlin, German Democratic Republic

New York—A full explanation of what Paul Robeson actually said and meant by the statement he made at the Paris Peace Conference on April 20,[1] which has been the subject of wide editorial and other comment in the American press, is contained in the following excerpts from an interview given in Copenhagen, Denmark, May 3, as reported by Telepress. (In his tour of the Scandinavian countries Robeson sang to record audiences: 16,000 in the Forum Hall of Copenhagen, 40,000 at a May Day demonstration in Stockholm, and tens of thousands at an open-air concert in Oslo). The quotations from the interview follow:

REPORTER: How would you describe the tasks of your people in the present situation?

ROBESON: I would say that what the whole American people can do now is very decisive for the future of the world, just as decisive as what the German people could have done in 1914 and what the French people could have done in 1939, but failed to do. We have to fight what has become a colossal concentration of reactionary forces—few in numbers, but colossal in strength and influence on world affairs. However, the great bulk of what will happen will mostly be determined by what happens in Africa and the West Indies. The Asiatic problem has taken quite a different turn with the events in China, nobody can fail to see the decisive influence of that. Obviously India is very important to the British imperialists; they are trying to find a way out so far as naked exploitation is concerned, but they will have to make a deal with the Indian people. But in their own words British military strategy does not rest on India alone. They have said it and they are acting upon it, that the defense of the British Empire depends on a defense in depth in Africa, coupled with American help.

Africa has become their basis of operations. What happens in the Middle East depends on Africa. What happens to the British and American fleets in the Mediterranean depends on Africa. Africa has become a very decisive point. Therefore the attitude of the African peoples can really determine the question of peace or war. When you talk about Negroes you mostly think about the 14 million in the United States, but you are apt to forget the 40 million colored people in the West Indies and Latin America, and the 150 million in Africa. As

far as they are concerned everybody knows that their condition is such that a war in the interest of imperialism which has enslaved them for centuries can only return them to new serfdom.

REPORTER: You have been quoted as saying at the Paris Peace Congress that the Negroes would never fight the Soviet Union.

ROBESON: I was referring to all the forces I have mentioned here, but what I said has been distorted out of all recognition. The night before I left for Paris I spoke to the Coordinating Committee of Colonial Peoples in London, and they authorized me to greet the World Peace Conference with their determination to fight for peace. The emphasis on what I said in Paris was on the struggle for peace, not on anybody going to war against anybody.

Go ask the Negro workers in the cotton plantations of Alabama, the sugar plantations in Louisiana, the tobacco fields in south Arkansas, ask the workers in the banana plantations or the sugar workers in the West Indies, ask the African farmers who have been dispossessed of their land in the South Africa of Malan, ask the Africans wherever you find them on their continent: Will they fight for peace so that new ways can be opened up for a life of freedom for hundreds of millions and not just for the few; will they fight for peace and collaboration with the Soviet Union and the new democracies; will they join the forces of peace or be drawn into a war in the interest of the senators who have just filibustered them out of their civil rights; will they join Malan in South Africa who, just like Hitler, is threatening to destroy eight million Africans and hundreds of thousands of Indians through hunger and terror.

Interview by Art Shields, *Daily Worker,* June 17, 1949

Paul Robeson, Negro singer and people's leader, flew back to America yesterday to fight for peace and freedom in his homeland after a four-months tour of Europe. Robeson speaks at Rockland Palace at 155 Street and Eighth Avenue, at 3 p.m., Saturday, with the famous Negro scholar Dr. W. E. B. Du Bois.

Robeson will appear at the Foley Square Court house as a witness for the framed Communist leaders soon after.[2]

"You bet your life I'll be there," he told an inquiring reporter.

"If the Communist leaders go to the penitentiary it means that millions of Americans lose their freedom with them."

A cavalcade of automobiles, filled with Negro and white workers who had come to welcome him home, escorted Robeson through Harlem, after his arrival at La Guardia airport.

He had crossed the Atlantic by Pan American clipper after an all-night flight from Prague.

He was met by an enthusiastic crowd that included Mrs. Bessie Mitchell, sister of Collis English, one of the six framed Negroes in the death house at Trenton, N.J.

"The case of the Trenton men is very close to my heart," Robeson told her.

Robeson promised to speak for the six in Trenton itself, where meetings are now being obstructed.

First to clasp Robeson's hand were his old friends William L. Patterson, leader of the Civil Rights Congress[3] and one of the attorneys for the framed Trenton Six, and Dr. W. A. Hunton, secretary of the Council for African Affairs of 23 W. 26 St., of which Robeson is chairman and Dr. Du Bois vice chairman.

The Council is sponsoring the Rockland Palace meeting.

Patterson and Dr. Hunton and C. B. Baldwin,[4] executive secretary of the Progressive Party, sat with Robeson during the ride through Harlem yesterday.

Robeson bluntly denounced the lies in the commercial press at a press conference at the airport yesterday morning.

"Everything I said during my tour of Europe was distorted by the Associated Press and the United Press and other American press agencies," he told a half dozen reporters.

"I prefer," Robeson added, "to give what I have to say to papers like the Daily Worker."

A reporter asked him about the cabled press story that he had said in Moscow that he loved Russia more than any other country.

"That is a typical Times distortion," said Robeson.

"What I said was that I love the America of which I am a part. I don't love the America of Wall Street. I love the America of the working-class. I love the workingclass of England and France and other countries. And I very deeply love the people's democracies in Eastern Europe and the Soviet Union. I love them for their fight for freedom. They are fighting for my people and for the white working people of the world."

A girl reporter kept trying to trap Robeson, however.

"Do you deny you said it," she inquired provocatively with pencil poised.

Robeson sharply replied that he was not giving her a chance to make a headline saying: "Robeson denies." She had heard what he had actually said.

The reporters' attitude got better after these earlier rebukes.

One interviewer asked Robeson what he thought of Gerhart Eisler's return home to Germany.[5]

"It was a great victory for peace and freedom," Robeson shot back.

Robeson retorted quickly when a reporter asked him what he thought about President Truman's "fight" for "civil rights."

The Negro leader wanted to know what "fighting" the President had done. And he added that Truman was merely promising, but not giving, the Negro people "privileges, not rights."

"The privilege of not being lynched," he added caustically.

"What do Europeans think of the Marshall Plan?"[6] asked another reporter.

"I found no liking for the Marshall Plan among the common people," answered Robeson. "I found a very complete understanding of the fact that American Big Business was trying to take over Europe."

But the people of Europe will not let Wall Street take them over, Robeson continued.

"And the French people will not sit idly by while Americans rebuild Nazi Germany," he added.

Robeson's admiration for the anti-fascist peoples of Europe was expressed again and again.

His visit to Stalingrad, where the people of the United States were saved from fascism by the heroes of the Soviet Union, was a high point in his tour, he said.[7]

In Stalingrad, he said, he saw the rebuilt tractor plant turning out a new tractor every 15 minutes.

"I said a new tractor, not a new tank," he continued.

"And this new tractor was shipped at once to a collective farm to help the people build a better life."

The hysteria that a small group of warmakers is trying to rouse in America is totally absent in Stalingrad, went on Robeson.

Robeson said he expected to return to visit England, Scandinavia, France and the Soviet Union and the Eastern Democracies.

"Of course I'll go back," he declared.

"The people of Europe gave me magnificent receptions as an artist and as a friend," said the famous singer.

He sang for the people at people's prices or for just the joy of singing for them.

A statement by the Council for African Affairs yesterday described Robeson's tour as follows:

"Robeson was hailed by record audiences in the countries he visited, by packed Royal Albert Hall audiences in London, by tens of thousands at an open-air concert in Oslo, by 40,000 at a May Day celebration in Stockholm, by 16,000 in the Forum Hall in Copenhagen, by 15,000 at the International Spring Music Festival in Prague, where young workers and students returned his songs with their own; and by other vast audiences in the Soviet Union.

"He was among the guests of honor invited from abroad to participate in the Soviet jubilee, June 5, commemorating the 150th anniversary of the birth of the great Russian Negro poet, Alexander Pushkin.

"Robeson also addressed scores of political rallies throughout England, speaking of himself as a representative of 'the other side of America.' To his audiences and to British newspapers such as Reynolds' News he gave the facts concerning the fight of Negro Americans to achieve their rights as citizens, as symbolized by the campaigns to free Mrs. Ingram[8] and the 'Trenton Six.'

"At a meeting in London called to protest against South Africa's oppression of its non-white majority, Robeson declared: 'Throughout the world the oppressed peoples are struggling for freedom. China has found freedom; so must we'."

For Freedom and Peace

Address at Welcome Home Rally, Rockland Palace, New York
City, June 19, 1949, under the auspices of the Council on African
Affairs[1]—Pamphlet, issued by Council on African Affairs, New
York, 1949 (An abridged version, under the heading "I'm Looking
for Freedom," was published in *The Worker,* July 3, 1949)

Thanks for the welcome home. I have traveled many lands and I have
sung and talked to many peoples. Wherever I appeared, whether in
professional concert, at peace meetings, in the factories, at trade union
gatherings, at the mining pits, at assemblies of representative colonial
students from all over the world, always the greeting came: "Take
back our affection, our love, our strength to the Negro people and to the
members of the progressive movement of America."

It is especially moving to be here in this particular auditorium in
Harlem. Way back in 1918, I came here to this very hall from a football
game at the Polo Grounds between Rutgers and Syracuse. There was a
basketball game between St. Christopher and Alpha. Later I played
here for St. Christopher against the Alphas, against the Spartans, and
the Brooklyn YMCA, time and time again. This was a home of mine. It
is still my home.

I was then, through my athletics and my university record, trying to
hold up the prestige of my people; trying in the only way I knew to ease
the path for future Negro boys and girls. And I am still in there
slugging, yes, at another level, and you can bet your life that I shall
battle every step of the way until conditions around these corners
change and conditions change for the Negro people all up and down
this land.

The road has been long. The road has been hard. It began about as
tough as I ever had it—in Princeton, New Jersey, a college town of
Southern aristocrats, who from Revolutionary time transferred Geor-
gia to New Jersey. My brothers couldn't go to high school in Princeton.
They had to go to Trenton, ten miles away. That's right—Trenton, of
the "Trenton Six." My brother or I could have been one of the "Trenton
Six."

Almost every Negro in Princeton lived off the college and accepted
the social status that went with it. We lived for all intents and
purposes on a Southern plantation. And with no more dignity than
that suggests—all the bowing and scraping to the drunken rich, all the
vile names, all the Uncle Tomming to earn enough to lead miserable
lives.

My father was of slave origin. He reached as honorable a position as
a Negro could under these circumstances, but soon after I was born he
lost his church and poverty was my beginning. Relatives from my
father's North Carolina family took me in, a motherless orphan, while

my father went to new fields to begin again in a corner grocery store. I
slept four in a bed, ate the nourishing greens and cornbread. I was and
am forever thankful to my honest, intelligent, courageous, generous
aunts, uncles and cousins, not long divorced from the cotton and
tobacco fields of eastern North Carolina.

During the Wallace campaign, I stood on the very soil on which my
father was a slave, where some of my cousins are sharecroppers and
unemployed tobacco workers. I reflected upon the wealth bled from my
near relatives alone, and of the very basic wealth of all this America,
beaten out of millions of the Negro people, enslaved, freed, newly
enslaved until this very day.

And I defied—and today I defy—any part of an insolent, dominating
America, however powerful; I defy any errand boys, Uncle Toms of the
Negro people, to challenge my Americanism, because by word and deed
I challenge this vicious system to the death; because I refuse to let my
personal success, as part of a fraction of one per cent of the Negro
people, explain away the injustices to fourteen million of my people;
because with all the energy at my command, I fight for the right of the
Negro people and other oppressed labor-driven Americans to have
decent homes, decent jobs, and the dignity that belongs to every
human being!

Somewhere in my childhood these feelings were planted. Perhaps
when I resented being pushed off the sidewalk, when I saw my women
being insulted, and especially when I saw my elder brother answer
each insult with blows that sent would-be slave masters crashing to
the stone sidewalks, even though jail was his constant reward. He
never said it, but he told me day after day: "Listen to me, kid." (He
loved me very dearly.) "Don't you ever take it, as long as you live."

I realized years after how grateful I was for that example. I've *never*
accepted any inferior role because of my race or color. *And, by God, I
never will!*

That explains my life. I'm looking for freedom, *full freedom,* not an
inferior brand. That explains my attitude to different people, to Africa,
the continent from which we came. I know much about Africa, and I'm
not ashamed of my African origin. I'm *proud* of it. The rich culture of
that continent, its magnificent potential, gives me plenty of cause for
pride. This was true of the deep stirrings that took place within me
when I visited the West Indies in January. This explains my feeling
toward the Soviet Union, where in 1934 I for the first time walked this
earth in complete human dignity, a dignity denied me at the Columbia
University of Medina, denied me everywhere in my native land,
despite all the protestations about freedom, equality, constitutional
rights, and the sanctity of the individual.

And I say to the New York *Times* that personal success can be no
answer. It can no longer be a question of an Anderson,[2] a Carver,[3] a
Robinson,[4] a Jackson,[5] or a Robeson. It must be a question of the
well-being and opportunities not of a few but for *all* of this great Negro
people of which I am a part.

There, in my childhood, I saw my father choose allies. To him, it was the Taylor Pines' of the Wall Street millionaires. They helped the church. They spread around a little manna now and then—that was an age of philanthropy. But I recall that my father could never think of attacking these men for the conditions of those times. Always one had to bend and bow.

That was forty years ago. These present-day sycophants of big business, these supposed champions of Negro rights, can't grow up to the knowledge that the world has gone forward. Millions and millions of people have wrung their freedom from these same Taylor Pines', these same Wall Street operators, these traders in the lives of millions for their greedy profits. There is no more Eastern Europe to bleed; no more Russia, one-sixth of the earth's surface, to enslave; no more China at their disposal.

They can't imagine that our people, the Negro people,—forty millions in the Caribbean and Latin America, one hundred and fifty millions in Africa, and fourteen million here, today, up and down this America of ours,—are also determined to stop being industrial and agricultural serfs. They do not understand that a new reconstruction is here, and that this time we will not be betrayed by any coalition of Northern big finance barons and Southern bourbon plantation owners. They do not realize that the Negro people, with their allies, other oppressed groups, the progressive sections of labor, millions of the Jewish and foreign-born of former white indentured labor, north, south, east and west, in this day and time of ours are determined to see some basic change.

Roosevelt foreshadowed it. We are going to realize it! We were fooled in 1948. We aren't going to be fooled in 1949, 1950, and '51 and '52. We are going to fight for jobs and security at home, and we are going to join the forces of friendship and cooperation with advanced peoples and move on to build a decent world.

And you stooges try to do the work of your white bourbon masters, work they have not the courage to do.[6] You try to play the role of cowardly labor leaders who are attempting to do the same job in the ranks of labor. Try it, but the Negro people will give you your answer! They'll drive you from public life! The Negro people know when they're being sold down the river. They've been watching a long, long time. It's good the challenge has come. Keep on, and you'll have no magazines in which to publish your viciousness. You'll not have many more opportunities to sell into a new slavery our cousins in Liberia, our relatives in South Africa, our brothers in the West Indies. You'll get your answer—and soon! The Negro people are smoldering. They're not afraid of their radicals who point out the awful, indefensible truth of our degradation and exploitation.

What a travesty is this supposed leadership of a great people! And in this historic time, when their people need them most. How Sojourner Truth, Harriet Tubman, Fred Douglass must be turning in their graves at this spectacle of a craven, fawning, despicable leadership,

able to be naught but errand boys, and—at the lowest level—stooges and cowardly renegades, a disgrace to the Negro people and to the real and true America of which they so glibly talk. Let them get their crumbs from their Wall Street masters. Let them snatch their bit of cheese and go scampering rat-like into their holes, where, by heaven, the Negro people will keep them, left to their dirty consciences, if any they have.

Now, let's get out the record. In 1946, I declared in St. Louis on the picket line against segregation of Negro people that I would give up my professional career, then at its height, to devote my time and energy to the struggle for the liberation of the Negro people. I appeared everywhere, north, south, east, and west, for Negro colleges, churches, organizations.

I led an anti-lynch crusade to Washington. There I heard our President declare that it was not politically expedient to take any federal action against lynching.[7] You may remember that I said that perhaps the Negro people would have to do something about it themselves. But a committee stepped in—one of those committees to stop the militant Negro struggle. And lynch law is still in committee, while Negroes continue being lynched.

I entered the struggle for peace and freedom with Wallace in 1948, talking at street corner meetings four and five times a day. Without that struggle of the Progressive Party the issues before the people would not have been clarified, and we might now be at war. Wallace made a tremendous contribution time and again to the cause of peace, to Negro freedom, and to American freedom. He said peace was the issue. *Peace was, and is, the issue.* He said a war economy was an economy of scarcity and unemployment. *That it was, and is.* He said it meant the loss of civil liberties, the loss of the freedom of European countries. *It has meant just that.* He said it meant slavery for colonial people. *That it is fast becoming.* He said it meant domestic fascism. *That is just around the corner.*

Negroes rallied to Wallace's banner, the banner of their freedom. Then their trusted leaders stepped in to confuse and to frighten them. They sold them a hollow bill of goods in the Democratic Party, and a nominee that even these leaders did not trust. Remember, they wanted Eisenhower. But they were afraid of any militant struggle for our people. Where is the civil rights program? Are we still subject to terror? Ask Mrs. Mallard, ask the boys in Virginia, ask the Trenton Six: "Where are our liberties?"

As a consequence of my activities for Negro freedom, I had 86 concerts cancelled out of 86. Of course, these were very special concerts. I don't blame auto barons in Detroit for not wanting to pay to hear me when I was in Cadillac Square fighting for the auto workers. I don't blame the iron-ore owners of the Michigan and Minnesota iron-ore ranges for not wanting to hear me when I was on picket lines for the steel workers in these regions. And so with the packinghouse

owners of Chicago, or the ship-owners of the east and west coasts, or the sugar plantation owners of Hawaii.

Well, they can have their concerts! I'll go back to their cities to sing for the people whom I love, for the Negro and white workers whose freedom will insure my freedom. I'll help, together with many other progressive artists, whenever I can get the time from freedom's struggle, to show how culture can be brought back to the people. We created it in the first place, and it's about time it came back to us!

Today the fight is still on for peace and freedom. Concerts must wait. There is a fierce political struggle which must be won. However, I decided to go to Europe to resume my professional concerts for a very short period, in order to make it perfectly clear that the world is wide and no few pressures could stop my career. Let's go to the record: Albert Hall (London) with its 8,000 seats sold out twice with a five dollar top; 10,000 in the Harringay Arena; thousands turned away all over Europe—the most successful concert tour of my career.

Why? Because I came to the English people from *progressive* America, from the America of Wallace and the Progressive Party, from the America of the twelve great Communist leaders who are on trial for their devotion to the Negro people and to the American working class; because I came from Negro America whose struggle had become known to the English during the war when a folk saying grew up: "We love those American soldiers, the black and the brown ones."

I finished my professional tour at its height and announced that never again would I sing at a five dollar top, that I would sing at prices so that workers could come in comfort and dignity. I did this because I belonged to working people. I struggled as a boy in the brick-yards, on the docks, in the hotels to get a living and an education. Ninety-five per cent of the Negro people are workers. So I said that my talents would henceforth belong to my people in their struggle. And I acted on this. Thousands and thousands came. That's my answer to the bourbons who think they can end my career!

Later I toured England in peace meetings for British-Soviet friendship, did a series of meetings on the issues of freedom for the peoples of Africa and the West Indies, and on the question of the right of colored seamen and colored technicians to get jobs in a land for which they had risked their lives. Ten thousand people turned out to a meeting in Liverpool on this latter issue.

I stood at the coal pits in Scotland and saw miners contribute from their earnings $1,500 to $2,000 for the benefit of African workers. I helped build up a substantial fund in England to help the cause of African freedom, saw this whole question of the relation of English and colonial peoples raised to a new level as English workers came to understand that if cheap labor could be obtained in Africa or the West Indies or in Southeast Asia, their living standards in England would suffer accordingly. This is a lesson white workers in America must increasingly learn. For the tentacles of American imperialism are

stretched far and wide into colonial countries: Cuba, Haiti, Puerto Rico, Hawaii, Trinidad, Panama; down through Latin America; in the Philippines and some parts of the East; and all over the continent of Africa. White workers in America must be aware of this and watch it closely.

Then I moved into Scandinavia. Through a stroke of circumstance, I was booked through *Politiken*. This was an old liberal newspaper in years gone by, but the pressures of present-day American imperialism, exerted mainly through the Marshall Plan, had caused all pretense of liberalism to vanish. I read an editorial of *Politiken* in England supporting the Atlantic Pact, attacking the Eastern Democracies and the Soviet Union. I immediately asked that my contracts be cancelled. I explained to the press that it was unthinkable that I could appear under the sponsorship of a paper which had allied itself with an imperialism which had enslaved my father and forefathers and was in the process of enslaving my brothers and sisters in Africa, Latin America, the West and East Indies, and which was trying to work up a war against the greatest champion of the rights of colonial and exploited peoples,—the Union of Soviet Republics.

The contracts cancelled, I sang for the newspapers of the progressive and Communist forces of Scandinavia (papers like the *Daily Worker*). All the other press had gone the way of the Reuthers, Murrays, Careys, Townsends, et al,[8] who have betrayed American workers and the Negro people to American, British, Dutch, French, Belgian and Japanese imperialists.

Thousands upon thousands in the Scandinavian countries turned out in support of peace and against the Atlantic Pact. These countries of Scandinavia had been freed by Soviet armies, had erected monuments to Soviet heroes. It was unthinkable that they would join the fascist elements of Western Germany and Vichy France against their natural friend and ally. It was clear from the meetings that the great majority of Scandinavian people did not support their governments. I am sure American imperialism is aware of this.

My role was in no sense personal. I represented to these people Progressive America, fighting for peace and freedom, and I bring back to you their love and affection, their promise of their strength to aid us, and their gratefulness for our struggles here. They beg us to send more progressive Americans—Wallace, Marcantonio,[9] trade unionists, Negro and white. And they all sent special messages to the Negro people, assuring them of their support of the liberation of Negro peoples everywhere.

Our allies stretch far and wide and they beg us for information and for collective united action. If the originators of the vicious Atlantic Pact can get in a huddle to plot joint action against us, one by one, let us get together to see that nobody can ever take us one by one, that they will have to engage us as a strong, unbending, united force for the peace and freedom of all oppressed peoples.

Why did I take this stand on the Atlantic Pact[10]—the Arms Pact—and its forerunner, the Marshall Plan? Let us examine the

results of the Marshall Plan. We don't need to guess and theorize. Western European countries have completely lost their freedom. This was honestly acknowledged everywhere. American big business tells all of Western Europe what to do, what it can produce, where it must buy,.with whom it can trade. And finally, with the Atlantic Pact, the western Europeans are told that they must be ready to die to the last man in order to defend American Big Business.

The Eisler case illustrated the European people's revolt against American domination. For the English people decided this was too much. They still have some respect for their judicial law, extending from Magna Charta days,—different from us as yet here in America with our Foley Square travesties. The English people move from below—it was a mass movement which forced their government to retreat on Eisler and tell the United States, "Nothing doing." And the Communists of Great Britain started the defense which soon involved great sections of the British people—another important lesson for us. For British people knew that if Eisler was not freed, no longer could they themselves be protected under British law and the whole structure of British freedom would be in danger.

That is just as true here. If the twelve Communists are not freed, all Americans can say goodbye to their civil liberties. *Especially* will we Negro people be forced to say goodbye to any attempts to add to the few civil liberties we as yet have. Just as a mass movement in a few days won this tremendous victory for peace and freedom in London—I was there at the time—so we here in New York and America can do the same if we act with speed and courage in the cause of *our* freedoms, not just those of the "Twelve."

But beyond this strangling of Western Europe, the real meaning of the Marshall Plan is the complete enslavement of the colonies. For how can British, French and other Western European bankers repay Wall Street? Only in raw materials—in gold, copper, cocoa, rubber, uranium, manganese, iron ore, ground nuts, oils, fats, sugar, bananas. From where? Why, from South Africa, Nigeria, East Africa, French Africa, Belgian Congo, Trinidad, Jamaica, Cuba, Honduras, Guatemala, Viet Nam, Malaya. The Marshall Plan means enslavement of our people all over the earth, including here in the United States on the cotton and sugar plantations and in the mines of the North and South.

And the Atlantic Pact means legal sanction for sending guns and troops to the colonies to insure the enslavement and terrorization of our people. They will shoot our people down in Africa just as they lynch us in Mississippi. That's the other side of the same coin.

For who owns plantations in the South? Metropolitan Life—yes, the same Metropolitan Life Insurance Company that owns and won't let you live in the Stuyvesant Town flats in New York. It is such giant financial interests that are getting millions from the Marshall Plan. They enslave us, they enslave Western Europe, they enslave the colonies.

Many of our Negro leaders know this. But some of these so-called

distinguished leaders are doing the dirty work for Stettinius, aiding his scheme for the exploitation of Liberia and its people, or are serving as errand boys for Forrestal's cartel interests, even though the chief has now departed. And there are a few other of these so-called Negro leaders who are too low and contemptible to give the courtesy of mention.

Are these financial big boys America? No! They are the former enemies of Roosevelt. They were the ones who were glad when Roosevelt died. They are the same ones who Roosevelt said were the core of American fascism. They are the allies of the remains of the Hitler entourage, that Hitler who burned up eight million of a great Jewish people and said he would like to burn up fourteen million of us. They are the friends of Franco, the living representatives of the Spanish Conquistadores who enslaved us and still enslave us in Latin America. They are the ones who hate American democracy as did the enemies of Jefferson and Lincoln before them. *They are no part of America!* They are the would-be preservers of world fascism and the enemies of progressive America!

And they are in the government, too,—you saw them deny your civil rights on the floors of Congress; you saw them throw our promised civil rights right into our teeth, while our supposed chief defender enjoyed the sun down in Florida, a state that is the symbol, of course, of the freedom and equality of the Negro people.

And now this greedy section of democratic America, by corrupting our leaders, by shooting us as we attempt to vote, by terrorizing us as in the case of the "Trenton Six," has the gall to try to lure us into a war against countries where the freedoms that we so deeply desire are being realized, together with a rich and abundant life, the kind of life that should be ours also, because so much of America's wealth is realized from our blood and from our labor.

My last weeks abroad were spent in these countries to the East, Czechoslovakia, Poland, and finally the Soviet Union. Here thousands of people—men, women, children—cried to me to thank progressive America for sending one of its representatives, begged me so to take back their love, their heart-felt understanding of the suffering of their Negro brothers and sisters, that I wept time and time again. Whole nations of people gave me a welcome I can never forget—a welcome not for me, Paul Robeson, but in your name, the name of the Negro people of America, of the colonies; in the name of the progressive America of Wallace and the Progressive Party; and in the name of the twelve Communist leaders. Outstanding people in the government treated me with the greatest respect and dignity because I represented *you* (but there were no calls from the American embassies).

Here in these countries are *the people;* their spokesmen are in the forefront of our struggle for liberation—on the floor of the United Nations, in the highest councils of world diplomacy. Here in the Soviet Union, in Czechoslovakia, in battered but gallant Warsaw with its brave saga of the ghetto, are the nations leading the battle for peace

and freedom. They were busy building, reconstructing; and the very mention of war caused one to look at you as if you were insane.

I was in Stalingrad. I saw a letter from President Roosevelt,—no equivocation there. It said that in Stalingrad came the turning point in the battle for civilization. I stood in the little rectangle where the heroic people of Stalingrad fought with their backs to the mighty Volga—and saved us—saved you and me from Hitler's wrath. We loved them then. What has happened to us? For they are the same, only braver. Midst their ruins, they sing and laugh and dance. Their factories are restored—fifty per cent above prewar. I sang at their tractor factory and saw a tractor—*not a tank*—coming off the line every fifteen minutes. It was a factory built by Soviet hands, Soviet brains, Soviet know-how.

They want peace and an abundant life. Freedom is already theirs. The children cried, "Take back our love to the Negro children and the working class children." And they clasped and embraced me literally and symbolically for you. I love them.

Here is a whole one-sixth of the earth's surface, including millions of brown, yellow and black people who would be Negroes here in America and subject to the same awful race prejudice that haunts us. In this Soviet Union, the very term "backward country" is an insult, for in one generation former colonial peoples have been raised to unbelievable industrial and social levels. It is, indeed, a vast new concept of democracy. And these achievements make completely absurd the solemn pronouncements that it will take several generations, maybe hundreds of years, before we Negro people in the West Indies, Africa and America can have any real control over our own destiny.

Here is a whole nation which is now doing honor to our poet Pushkin—one of the greatest poets in history—the Soviet people's and our proud world possession. Could I find a monument to Pushkin in a public square of Birmingham or Atlanta or Memphis, as one stands in the center of Moscow? No. One perhaps to Goethe,[11] but not to the dark-skinned Pushkin.

Yes, I love this Soviet people more than any other nation, because of their suffering and sacrifices for us, the Negro people, the progressive people, the people of the future in this world.

At the Paris Peace Conference I said it was unthinkable that the Negro people of America or elsewhere in the world could be drawn into war with the Soviet Union. I repeat it with hundred-fold emphasis. THEY WILL NOT.

And don't ask a few intellectuals who are jealous of their comfort. Ask the sugar workers whom I saw starving in Louisiana, the workers in the cotton lands and the tobacco belts in the South. Ask the sugar workers in Jamaica. Ask the Africans in Malan's South Africa. Ask *them* if they will struggle for peace and friendship with the Soviet people, with the peoples of China and the new democracies, or if they will help their imperialist oppressors to return them to an even worse slavery. The answer lies there in the millions of my struggling people,

not only the 14 million in America, but the 40 million in the Caribbean and Latin America and the 150 million in Africa. No wonder all the excitement! For one day this mighty mass will strike for freedom, and a new strength like that of gallant China will add its decisive weight to insuring a world where all men can be free and equal.

I am born and bred in this America of ours. I want to love it. I love a part of it. But it's up to the rest of America when I shall love it with the same intensity that I love the Negro people from whom I spring,—in the way that I love progressives in the Caribbean, the black and Indian peoples of South and Central America, the peoples of China and Southeast Asia, yes suffering people the world over,—and in the way that I deeply and intensely love the Soviet Union. That burden of proof rests upon America.

Now these peoples of the Soviet Union, of the new Eastern Democracies, of progressive Western Europe, and the representatives of the Chinese people whom I met in Prague and Moscow, were in great part Communists. They were the first to die for our freedom and for the freedom of all mankind. So I'm not afraid of Communists; no, far from that. I will defend them as they defended us, the Negro people. And I stand firm and immovable by the side of that great leader who has given his whole life to the struggle of the American working class, Bill Foster; by the side of Gene Dennis; by the side of my friend, Ben Davis; Johnny Gates, Henry Winston, Gus Hall, Gil Green, Jack Stachel, Carl Winter, Irving Potash, Bob Thompson, Johnny Williamson,—twelve brave fighters for my freedom.[12] Their struggle is *our* struggle.

But to fulfill our responsibilities as Americans, we must unite, especially we Negro people. We must know our strength. We are the decisive force. That's why they terrorize us. That's why they fear us. And if we unite in all our might, this world can fast be changed. Let us create that unity now. And this important, historic role of the Negro people our white allies here must fully comprehend. This means increasing understanding of the Negro, his tremendous struggle, his great contributions, his potential for leadership at all levels in the common task of liberation. It means courage to stand by our side whatever the consequences, as we the Negro people fulfill our historic duty in Freedom's struggle.

If we unite, we'll get our law against lynching, our right to vote and to labor. Let us march on Washington, representing 14,000,000 strong. Let us push aside the sycophants who tell us to be quiet.

The so-called western democracies—including our own, which so fiercely exploits us and daily denies us our simple constitutional guarantees—can find no answer before the bar of world justice for their treatment of the Negro people. Democracy, indeed! We must have the courage to shout at the top of our voices about our injustices and we must lay the blame where it belongs and where it has belonged for over 300 years of slavery and misery: right here on our own doorstep,—not in any far away place. This is the very time when we can win our struggle.

And we cannot win it by being lured into any kind of war with our closest friends and allies throughout the world. For any kind of decent life we need, we want, and *we demand* our constitutional rights— RIGHT HERE IN AMERICA. We do not want to die in vain any more on foreign battlefields for Wall Street and the greedy supporters of domestic fascism. If we must die, let it be in Mississippi or Georgia! Let it be wherever we are lynched and deprived of our rights as human beings![13]

Let this be a final answer to the warmongers. Let them know that we will not help to enslave our brothers and sisters and eventually ourselves. Rather, we will help to insure peace in our time—the freedom and liberation of the Negro and other struggling peoples, and the building of a world where we can all walk in full equality and full human dignity.

Songs of My People

Sovietskaia muzyka (Soviet Music), No. 7, July 1949, pp. 100–104
—Translated from the Russian by Paul A. Russo

There is an old Spanish proverb that goes: sing me your folk songs and I'll tell you about the character, customs, and history of your people.

How true! Folk songs are, in fact, a poetic expression of a people's innermost nature, of the distinctive and multifaceted conditions of its life and culture, of the sublime wisdom that reflects that people's great historical journey and experience. This is as true of the very rich treasury of songs of the Russian and Ukrainian peoples, as it is of the wonderful songs of the Spanish, French, Czech, Italian, Polish, Chinese, Norwegian, Georgian, Armenian, and many other peoples of the world.

This is utterly and completely true for the song culture of my people.

I don't think I have to go into a detailed appraisal here of the great artistic merit of Negro folk music or of its unquestionable significance for all mankind. This is universally acknowledged. Even in capitalist America, where there exists racial discrimination of revolting proportions, where many "cultured" whites refuse to recognize the Negro as a human being—even there our folk songs constitute, as strange as it may seem, an object of national pride for many Americans.

I am well aware that you in the Soviet Union, as nowhere else in the world, know how to honor and appreciate every artistic manifestation of a people's spirit, every genuine national art. I know, too, that Soviet audiences love and esteem the Negro people's songs, with which they have become familiar through the performances of such outstanding artists as Roland Hayes and Marian Anderson.

I felt the full force of this passionate interest in and love of our folk songs during my own appearances in Moscow and Stalingrad.

All the same, I also know that Soviet audiences are insufficiently

acquainted with the history of Negro music and do not, perhaps, have a completely clear idea of the origins, sources, and the real content of Negro lyrics. This is all the more probable in that our official American musicology and music criticism have done everything to distort the historical truth, to conceal the real social roots of Negro art, and to depict Negro culture as imitative, as permeated by the spirit of Christian meekness and slavish submissiveness to fate.

This is why I should like to tell Soviet readers the truth about the songs created by the American Negroes, songs which bear the poetic impress of many facets of folk life, of the very nature and soul of the people, of its dreams and aspirations, of its long, hard struggle for the right to life, liberty, and independence.

The music of the American Negro has its origins in the ancient culture of Africa. American Negroes are the direct descendants of various African tribes which—from the beginning of the seventeenth century—English, Dutch, Spanish, and French merchant-plunderers began transporting en masse for sale to America. Torn from their native land and national culture, thrust into the most difficult conditions of slave existence amidst an alien and hostile population, the Negroes had to adapt themselves to an alien life, language, culture, and religion. The Christian religion, imposed by force, was one of the powerful weapons for the spiritual enslavement of the Negroes. Faith in the afterlife where all earthly sufferings would be compensated with heavenly bliss, and the preaching of meekness and submissiveness—these were the basic religious tenets which helped the white exploiters to keep in harness the mass of Negro slaves who were subjected to the most brutal treatment in their backbreaking labor for their masters.

And yet this enslaved people, oppressed by the double yoke of cruel exploitation and racial discrimination, gave birth to splendid, inspired, life-affirming songs. These songs reflected a spiritual force, a people's faith in itself and a faith in its great calling; they reflected the wrath and protest against the enslavers and the aspiration to freedom and happiness. These songs are striking in the noble beauty of their melodies, in the expressiveness and resourcefulness of their intonations, in the startling variety of their rhythms, in the sonority of their harmonies, and in the unusual distinctiveness and poetical nature of their forms.

In trying to explain this "miracle," some American musicologists are ready to ascribe the phenomenon of Negro Spirituals to the influence of English church music, Puritan psalms, etc. The unscientific nature and falsity of such explanations are easily demonstrated by pointing out that the white population among which the mass of Negroes has lived in the American South has never—not in the past, not at present—had a musical culture of song (including church singing) that is in the slightest way comparable in artistic merit to the Negro Spirituals. The so-called psalmody, that is, the Christian hymns which the Negroes could hear in church, represents primitive choral singing in a slow, strictly measured tempo with traditional cadences. Could

this sanctimonious music really be the model for inspired folk singers?

It would be wrong, of course, to deny the influence of church psalms completely, or that of the folk songs of the immigrant population of America (the Scots, the Irish, the Spanish) on the development of Negro folk music. There were such influences. But they did not determine the distinctiveness and universal significance of the folk-song culture of the American Negroes. The power and beauty of Negro songs, the indigenous features that distinguish Negro folklore from the songs of all other peoples in the world, stem from ancient African culture, from the remarkable musicality which the Negroes inherited from their African ancestors.

First of all, the idea has to be repudiated that African Negroes were "savages," people without culture. Many African peoples possessed their own distinctive and significant artistic culture long before the arrival of the European conquerors. They created their own language, distinguished—like Chinese—by the great precision and subtlety of intonational structure. They created a rich oral folklore, a distinctive decorative art (especially sculpture), and, finally, they possessed a highly developed and original musical art, distinguished by an extraordinary wealth of rhythm.

Rhythm, the most intricate polyrhythmic constructions on the invariable and uniform pulsation of a basic, clear-cut meter—this is the basis of the musical speech of African Negroes. This basis has been fully preserved in the music of their American descendants. This characteristic syncopation, with all its rhythmic freedom and infinite variety, not only underwent its own development in Negro musical folklore, but also had a quite noticeable effect on the music of those peoples of North and South America among whom the Negroes lived. It is enough to become familiar with the folk music of Cuba, where Negro rhythms blend with elements of Spanish music; with the folk music of Brazil, which is based on Portuguese folk-song traditions fused with Negro influences; with the music of Haiti, which combines French and Negro features; and so on.

I don't have to talk about the immense influence which Negro folk music has had on the development of the musical culture of the peoples of the USA. A particularly brilliant instance of this is seen in the works of the popular American composer of the middle of the last century, Stephen Foster, in whose numerous songs characteristic features of Negro music are distinctly perceptible. In still later times, these influences show up in full force in jazz.

Rhythm is not the only feature which Negro music inherited from Africa. American Negro songs are close to African songs in the structure of their intonational harmony, in the improvising nature of their performing style, and in their form.

But, of course, Spirituals are melodically far above their African forerunners. The American Negroes' sense of harmony is also highly developed.

Let me relate here a story told by the well-known American historian of Afro-American music, Natalie Curtis-Burlin (*Negro Folk*

Songs, Book III),[1] about a certain German musician who visited Hampton Institute in Virginia and heard the singing of an immense chorus of Negro students. "Who worked with this chorus? This is remarkable!" exclaimed the musician. N. Curtis-Burlin's reply that no one had ever worked with the chorus did not satisfy him. "I mean," insisted the musician, "not who trained their voices (I understand, of course, that they sing without benefit of voice school), but who taught them the choral parts, who got them ready as a choral ensemble?"—No one.

As N. Curtis-Burlin further relates, the nine hundred Negro boys and girls whose singing so impressed the German musician were not arranged and distributed by voice as in the usual chorus. The boys sat in a group on one side, the girls on the other. Each sang the part most comfortable for him within his normal range, free harmonizing the melody then and there during the singing. A first alto might turn up between two sopranos. A boy singing countertenor might be sitting next to a bass. . . .

"But the amazing, inspired singing of this immense chorus sounds utterly faultless in intonation; there is not the slightest deviation from tonality, and all without any accompaniment. . . ."

In fact, American Negroes have a remarkably developed flair for harmony. There is even a saying that aptly reflects this innate harmonic gift of the Negro people: "Put together the first four Negro fellows that come along and you've got a quartet."

This tendency to harmonize melodies, such a natural phenomenon among the people, found its fullest expression in the performances of Spirituals (spiritual hymns), as well as in the performance of work songs (the so-called Plantation Songs), the performances of these usually being choral ones.

The wealth and diversity of the melodic language of Negro songs is startling. A few examples here will suffice to show how freely and flexibly the melodic line moves, how expressive and noble is its outline, and how multifarious are the rhythmic-harmonic structures and forms of these folk songs.

Here is one of the most splendid songs of my people: "Go Down Moses," a magnificent hymn, calling the people to the struggle for freedom.

> Go down, Moses, 'way down in Egypt land,
> Tell ole Pharoah,
> To let my people go.
> When Israel was in Egypt's land,
> Oppressed so hard they could not stand . . . etc.

The forms of this song as in many other Spirituals are connected with religion. It would be a complete mistake, however, to conclude from this that the origins and content of these songs are purely religious. As I have already said, the Christian religion, propagated among the Negroes by force, was one of the strongest weapons for the spiritual enslavement of the people. The only book which the Negroes

knew before the Civil-War period and the abolition of slavery (1863) was the Bible. Oppressed and persecuted, subjected to the cruelest exploitation, the Negro people was very susceptible to the consolations promised by the Church. The Negroes sought in the Bible stories analogies with the history of their own slave existence, and drew from these stories faith in the coming retribution for their oppressors, faith in the triumph of truth and justice.

The real content of the Spirituals in the overwhelming majority of cases was far removed from religious concepts. These were folk hymns, the poetical embodiment of the sufferings and struggle of an entire people, of its philosophy of life and its character, of its hopes and aspirations. The Spirituals reflected all the manifestations of the Negro people's social life. Therefore, the song "Go Down Moses," far from being a religious hymn, is rather an impassioned call to the struggle for the liberation of the Negro people. Moses, and the pharoahs, and the Jewish people are all merely poetic symbols which inspired the unknown singer who created this amazing song.

Similarly, there is little that is religious in the song "Heab'n":

> I got a robe, you got a robe,
> All of God's children got a robe.
> When I get to heab'n goin' to put on my robe,
> Goin' to shout all over God's Heab'n.
> Ev'rybody talkin' about heab'n ain't goin' there,
> Goin' to shout all over God's heab'n.

According to the testimony of the greatest Negro historian of the nineteenth century, Frederick Douglass, the heaven mentioned in this song is the North, the northern states of America where the Negroes, in contrast to the southern states, were not in bondage. In the minds of the benighted and downtrodden slaves of Alabama, Virginia, Florida, and Georgia, the northern states constituted that promised land for which the Negro population of the South yearned heart and soul.

It seems to me that the same explanation fully reveals the real content of the song "Nobody Knows de Trouble I See":

> Oh, nobody knows de trouble I see,
> Nobody knows my sorrow . . .
> If you get there before me
> Tell them I'm comin'.

With respect to genre, Negro musical folklore is very diversified. Along with a vast quantity of spiritual hymns, the American Negroes created a multitude of work songs, songs of lyrical content (the Blues), and dance tunes. Finally, recent investigations have for the first time revealed a whole new field of Negro songs—songs of protest, songs directly calling the Negroes to the struggle for their rights, and against lynch-law, against their exploiters, against capitalists. The work songs, as well as the songs of protest, are the fruit of collective creation. Their rhythm is born out of the work process. It may be the measured beat of the crowbar or pickaxe at excavation sites. It may be

the synchronized movement of dockworkers loading barges. It may be the hard, monotonous work of the cotton pickers. These songs usually begin with an introduction by the leader that defines the rhythm of the work, and then the chorus joins in. Here is one model for such songs, "Cott'n Pickin' Song," created by the Negro cotton pickers of Florida:

Chorus:
This cott'n want a pickin'
So bad!
This cott'n want a pickin',
So bad!
Goin' clean all over this farm.[2]

Leader:
When boss sold that cott'n,
I ask for my half.
He told me I chopped out
My half with the grass.

In the song there is a regular alternation between the refrain of the entire chorus and the recitative improvisations of the leader. The content of these improvisations, connected with the life of the given group of workers, at times is permeated by a venomous irony directed at the white bosses, at times has the character of a direct protest.

A good example of a work song is the one I performed, "Water-Boy"; it, too, is built on the alternation between a free, recitative solo and a rhythmic, precise choral refrain.

A special place in the corpus of Negro songs is occupied by songs of protest, which were first collected in the southern states in the nineteen-twenties by the American journalist, L. Gellert.[3] These songs manifest in full measure the Negro workers' heroic revolutionary spirit, their hatred of their exploiters, and their yearning for the struggle for their human rights and freedom.

The hard, exhausting work with a pickaxe or shovel in hand defines the rhythm and character of the melody. The example below gives a clear idea of the content of these songs:

Sistren an' brethen, stop foolin' wid pray.
When Black face is lifted, Lord turnin' away.
Heart filled wid sadness, head bowed down wid woe,
In his hour of trouble, where's a black man to go?
We's buryin' a brudder, dey kill fo' de crime
Tryin' to keep what was his all de time.
When we's tucked him on under, what you goin' to do?
Wait till it come dey's arousin' fo' you?
Yo' head tain' no apple fo' danglin' from a tree
Yo' body no carcass for barbacuin' on a spree.
Stand on yo' feet, club gripped 'tween yo' hands,
Spill dere blood too, show 'em yo's is a man's.[4]

While Spirituals, work songs, and songs of protest are collective creations and are performed collectively among the people, the blues (that is, lyrical songs, most frequently about love) express the emotional state of the individual. In the blues you frequently hear complaints about the evil fate of separation, about one's surroundings, about the hard and dangerous existence of a lonely creature in a faraway and alien big city.

In contrast to Spirituals, many blues have authors. A popular Negro composer, for example, is William Handy, the author of many famous blues, including "Saint Louis Blues," "Florida Blues," "Memphis Blues," etc.[5]

The blues played a big role in the development of jazz and became the basis for contemporary dance (foxtrot, blues, tango).

However, this is the topic for a special article and I cannot treat it in detail here. Let me just say that under capitalist conditions, where all forms and expressions of American art must subordinate themselves to the demands of the market, our native Negro music has been subjected to the very worst exploitation. Commercial jazz has prostituted and ruthlessly perverted many splendid models of Negro folk music and has corrupted and debased many talented Negro musicians in order to satisfy the desires of capitalist society.

But, all the same, our splendid songs have survived and shall survive, enriching the real culture of America, providing my country's composers with an inexhaustible supply of material for their creative work.

Recent decades have seen the emergence of a series of talented Negro composers who have devoted their creative energies to the cultivation of the incalculable riches of our musical folklore. I list here such names as Samuel Coleridge Taylor, Henry Burleigh, Nathaniel Dett, William Dawson, William Grant-Still, Duke Ellington.

These composers, each in his own way, have tried to find the way to creating a national Negro symphonic, oratorical, and operatic music. But these are so far just the first steps. We are still awaiting our Glinka who on the basis of Negro folk music will create a great, universally significant art, who will lay the foundation for a national school of composers.

Meanwhile our serious composers find themselves in very difficult circumstances. Creatively and organizationally they are not united. Their material existence is far from secure.

We are just now making attempts to unite Negro artists, performing artists, and musicians. For this purpose a progressive organization has been created in New York—"The Committee of Negroes in the Arts."[6] Our dream is to establish creative contact with persons active in the Soviet Arts. We want to learn from your remarkable experience of building up a socialist culture; we want our art to be just as progressive and purposeful, just as national in spirit as the great art of the great Soviet people.

Statement on Un-American Activities Committee

News release, Council on African Affairs, New York City, July 20, 1949—Paul Robeson Archives, Berlin, German Democratic Republic

Quite clearly America faces a crisis in race relations. The Un-American Activities Committee moves now to transform the Government's cold war policy against the Negro people into a hot war. Its action incites the Ku Klux Klan, that openly terrorist organization, to a reign of mob violence against my people in Florida and elsewhere. This Committee attempts to divide the Negro people one from another in order to prevent us from winning jobs, security and justice under the banner of peace.

The loyalty of the Negro people is not a subject for debate. I challenge the loyalty of the Un-American Activities Committee. This committee maintains an ominous silence in the face of the lynchings of Maceo Snipes, Robert Mallard, the two Negro veterans and their wives in Monroe, Georgia, and the violent and unpunished murders of scores of Negro veterans by white supremacists since V-J Day. It is not moved to investigate the attempted legal lynchings of Mrs. Rosa Lee Ingram, Negro mother of 12 living children and her two sons, now jailed for life in Georgia for protecting her honor; or of the Trenton Six, or the Martinsville Seven,[1] or the denial of simple justice to our people in the every day life of the nation's capitol. Every pro-war fascist-minded group in the country regards the Committee's silence as license to proceed against my people, unchecked by Government authorities and unchallenged by the courts.

Our fight for peace in America is a fight for human dignity, and an end to ghetto life. It is the fight for the constitutional liberties, the civil and human rights of every American. This struggle is the decisive struggle with which my people are today concerned. This fight is of vital concern to all progressive Americans, white as well as Negro. For victory in this struggle, Americans need peace, not war on foreign fields.

No country in the world today threatens the peace and safety of our great land. It is not the Soviet Union that threatens the life, liberty and the property and citizenship rights of Negro Americans. The threat comes from within. To destroy this threat our people need the aid of every honest American, Communist and non-Communist alike. Those who menace our lives proceed unchallenged by the Un-American Activities Committee. I shall not be drawn into any conflict dividing me from my brother victim of this terror. I am wholly committed to the struggle for peace and democratic rights of free Americans.

Let's Not Be Divided

Remarks on testimony of Jackie Robinson before the House
Un-American Activities Committee, based on reports of a press
conference held at Hotel Theresa, New York City, July 20,
1949—*Daily Worker,* July 21, 1949; *Baltimore Afro-American,*
July 30, 1949; *New York Age,* July 30, 1949; *Norfolk Journal and
Guide,* July 30, 1949

In a two-hour long press conference held at the Theresa Hotel, Robeson
thwarted every effort of a battery of newsmen to get him to "answer"
Jackie Robinson's remarks before the House Un-American Activities
Committee by launching an attack on Jackie. He refused them on
every turn. At the same time, however, he declared that the Un-
American Committee's action in calling to Washington Jackie Robin-
son and other prominent Negroes "to testify as to their loyalty is a
campaign of terror and an insult to the entire Negro people."[1]

"The only other time Negroes were called on to publicly proclaim
their loyalty," Robeson said, "was when Jeff Davis called them during
the Civil War." (Davis was President of the Confederate States of
America.)

"I have no quarrel with Jackie. This whole controversy is beyond any
personal stage.

"As a matter of fact, Jackie said he was for peace,[2] and I am, too, so
let's start fighting for it."

In response to a question on whether Robeson thought Robinson's
testimony a "disservice" to the Negro people, Robeson said, "Yes,
because it helped the Un-American Committee.

"If they want some Negroes to testify on this subject why don't they
bring up some of the Negroes who were chased from their home in
Florida yesterday,"[3] Robeson said. "Why don't they call on Mrs.
Mallard."

Robeson declared he thought all Negroes should demand that they
be permitted to testify before the committee on what Negroes felt
about their conditions.

"Would you like to testify?" he was asked.

"You bet your boots I would, and I demand that Mr. Wood from
Georgia be there!" Wood pleaded "illness" and was absent when
Robinson, Lester Granger, Rev. Sandy Ray, Dr. Charles S. Johnson
and other Negroes testified Monday.

"Wood wasn't there," Robeson said, "because he doesn't want to call
Jackie 'Mister Robinson'."

Robeson said he knew reporters would have a "better story" if he
attacked Robinson, but "I am not going to permit the issue to boil down
to a personal feud between myself and Jackie. To do that, would be to
do exactly what the other group wants us to do. Let's not fall for
anything like that.

"The issue is not the loyalty of the Negro people because that is not a subject of debate. The real issue is whether the Negro people would permit themselves to be divided by a group such as the Un-American Activities Committee in their fight for peace and human dignity. The committee's efforts to make the loyalty of the Negro people an issue is an insult. How do they dare to question our loyalty. I challenge the loyalty of the Un-American Activities Committee.

"The truth is that the action of the committee is just one step from the herding of black people into concentration camps. It is therefore very important that the Negro press step forward and defend, not me, but the Negro people.

"We cannot forget that John S. Wood, chairman of the committee, once called the Ku Klux Klan an American institution. Why, then, should Negroes pick this type of committee to express their loyalty?

"Why did the committee merely question the loyalty of Negroes? How about the Italians? Did Joe DiMaggio go down there to testify?[4]

"It should be clear that Robinson, by appearing before this committee, has performed a profound political act that has aided those who would enslave the Negro. He erred too in stating to this committee that the Negro didn't need the help of the Communists. The Negro needs the help of all—Communist or non-Communist. But it does not need the aid of a man who once called the Ku Klux Klan an American institution.

"My main concern is to get at this Un-American Activities Committee. Again, I repeat I am willing to appear before the committee at any time.

"The statement I made before the Paris Peace Conference has been distorted. I am not interested in war, but in peace, and here is what I said at that conference:

"'It is unthinkable that the Negro people could be lured into any kind of war especially against the Soviet Union, where former colonial people have complete equality. The question is: Will the Negro be drawn into a war which can only extend their enslavement, or will they fight for peace?'

"If we were to go to war today, we'd be fighting for those who represent fascist Germany, the British Empire, and that one per cent of America that exploits the other ninety-nine per cent.

"I have no desire of being a 'Black Stalin.'[5] All I want to do is to sing and act. These things I feel I will be able to do always. Negroes have a chance in this period to make greater gains than ever before. They must be militant, and they will succeed.

"Jackie Robinson told the committee about his willingness to fight for his 'investment' in America. But it is not a question of going to war but a question of struggling for peace. When Jackie speaks of investment, he should remember that I too have an investment in the United States. But I can't forget what could happen to my investment overnight under present conditions.

"The truth is that eighty-five concert engagements of mine have

been cancelled of a total of eight-five. But this does not worry me in the least since I can always find places to sing. Nor will it prevent me from earning a living, because long ago I prepared myself to sing in the various languages of the world, and as a result, I can now go to Alaska or Hong Kong and make a living singing there.[6]

"But they can't scare me and they can't run me out of this country. I gave them a chance to throw me in jail. I refused to answer that certain question.

"Permit me to deny two reports. First, I did not write to Jackie Robinson asking him not to appear before the committee. Second, I did not say at Paris that colored people would not fight in a war against Russia. But when it became obvious to me that the statement I made had been purposely distorted, I said to myself, 'Okay, let it stand like that.' But now that organizations such as the House Un-American Activities Committee are attempting to use it to their advantage, I am taking the attitude, 'Let's put the statement back into context now.'"

If We Must Sacrifice

Speech at meeting to free the Trenton Six, sponsored by the
Civil Rights Congress, Newark, New Jersey, July 22, 1949[1]
—*Philadelphia Tribune,* July 24, 1949

American Negroes must not be asked ever again to sacrifice on foreign shores. If we must sacrifice, let it be in Alabama and Mississippi where my race is persecuted. Let us fight against firms like the Metropolitan Life Insurance Company that incite war so they can reap ever greater profits, build even taller apartments from which my people are barred[2] and enslave still more Negroes on Southern plantations.

The wealth of the USA was built on the backs of my people, yet we are made to crawl. We are loyal to the America of Lincoln and the abolitionists, but not to those who degrade my people. One percent of the American population gets 59 percent of the national income.

I am a radical and I am going to stay one until my people get free to walk the earth. Negroes just cannot wait for civil rights. This year it's a ball player, next year we'll have a professional basketball player. And that's only the beginning.

Robeson Dares Truman to Enforce FEPC

Lem Graves, Jr., Washington correspondent, *Pittsburgh Courier,*
August 13, 1949

WASHINGTON—Paul Robeson last week marched at the head of a picket line in front of the White House here and later, in a press conference, challenged President Truman to make good on his civil rights promises

and enforce his FEPC order by protecting Negro workers from mass layoffs and discriminations at the Bureau of Engraving and Printing.[1]

When informed that President Truman had told reporters that he had not noticed the three-week old picket line and, even if he had, would have no comment, Robeson criticized the President and accused Mr. Truman of defaulting on his civil rights pledges.

Accompanied by Charles P. Howard, Des Moines attorney who keynoted last year's Progressive Party convention, Robeson came to Washington and spent two afternoons marching in the picket line which has been maintained for three weeks in front of the White House.

The marchers protested the jim-crow working conditions which have prevailed for many years in this Federal agency which comes directly under the control of Secretary of Treasury John Snyder. These conditions have been exposed by bureau workers before the House FEPC subcommittee and have been called to the attention of Congress recently in speeches by Rep. Vito Marcantonio and Sen. William Langer in both houses of Congress. Resolutions demanding investigation of the discriminatory bureau conditions have been introduced in both houses.

Some 1,800 war-service, Negro women employes of the bureau now face loss of their jobs while being denied the opportunity to qualify for permanent status in their specialized fields, declared Mr. Robeson. He said: "If President Truman is sincere about civil rights and about the FEPC order he issued, he would do something about this."

Continuing, Mr. Robeson said: "Congress has not passed any civil rights this year. But here is something which Truman and his cabinet officer, Snyder, can do without waiting on Congress. They simply have to enforce the FEPC order which the President issued, with much fanfare, a year ago."

Officials of the United Public Workers Union which is conducting the picket line revealed that complaints filed with the Treasury's FEP board and with the board established in the Civil Service Commission by appointment of the President, have not been settled. Thomas Richardson, union official, told reporters that Guy Moffett, chairman of the FEP board, had told the union informally that it cannot direct a cabinet officer to do anything. Mr. Moffett said that the FEP board, under the President's order, is purely advisory without effective enforcement powers.

Most of the Negro workers involved in the dispute served in specialized jobs all through the war. Now, they are being displaced to make room for white workers, say union officials. While the union supports the plan to replace war service workers with permanent status employes, it contends that in the bureau of engraving, Negro workers have been systematically denied any opportunity to take examinations or to otherwise qualify for status. Replacement workers lack both the experience and training of these Negro workers, say union officials.

While here, Robeson said he would not enter into any political controversy with famed Jackie Robinson, Brooklyn baseball star. He said: "I admire him as a baseball player."

Robeson said his Paris remarks on the question of Negro loyalty to the United States were taken out of context and distorted. He said he referred, in Paris, to all of the colored people of the world instead of solely to U.S. Negroes. However, he reiterated his personal stand in opposition against taking up arms against Soviet Russia.

Message to People's Drama Group
Daily Worker, August 18, 1949

I want all the cast and production staff[1] of *They Shall Not Die* to know that I and thousands of others deeply honor them both for the splendid and challenging contributions they have made to the American theatre and also for standing firm and fighting back against fascist brutality and intimidation.[2] Carry on. The real America is with you. You can't lose.

Message to Youth Festival in Budapest
Broadcast by Moscow Radio—*Daily Worker,* August 23, 1949

I believe that the festival will still more closely rally on the side of peace millions and tens of millions of people, including the black, yellow and brown peoples of east and west.

In the present historical epoch, the tasks of the supporters of peace and democracy are clear—complete liquidation of fascism the world over and the establishment of lasting peace and cooperation with the countries of the people's democracies and the peoples of the Soviet Union.

A Message from the Chairman to Members and Friends of the Council on African Affairs
New Africa, July-August, 1949

I want to take this means of conveying a personal message and word of greeting to all my friends and all supporters of our work in the Council. Some of you I saw and talked with at the Welcome Home Rally in Harlem[1]—and I want to thank you and tell you how deeply

moved I was by that marvelous tribute. Others of you I have seen as I have gone around in New York, Chicago, and Washington, D.C., helping in the fight against Jim-Crowism in these places.

But to the many others all across America whom I have not yet seen—to all of you, my friends—I want to say that I come back from Europe more determined than I have ever been in my life to give my maximum time and energies in the fight for full freedom, full equality, for the Negro people. I will not compromise a hair's-breadth in that fight—nor will the Council. Intimidation and terrorization are increasing daily in America, particularly against the Negro. The would-be American fascists become bolder and bolder. What they did in Peekskill, N.Y. on the night of August 27 was just what Hitler's storm troopers did to German anti-fascists.[2] They were not merely attacking me personally; they were attacking the Negro people, the Jewish people and all who stand for peace and democracy in America.

But we will not be cowed. And we will not forget our fight for Negro rights here is linked inseparably not only with the struggle of all American workers, but also with the liberation movements of the peoples of the Caribbean and Africa and of the colonial world in general. This is particularly true of the present period when the Big Money Rulers of America have taken on the role of the bankers and overlords of all Western Europe and its colonial holdings. The one force which stands as the barrier to all the war-mongers, profiteers and fascists who would engulf the world in a third blood bath is the united strength of democratic and peace-loving peoples of all colors, all races, and faiths throughout the world. In England the Electrical Trades Union, whose members I addressed, has contributed $1000 for work on behalf of freedom for Africans. In Scotland I saw miners as they came out of the pits give hundreds of dollars out of their earnings to the same cause. American workers must and will do no less.

I ask you to stand with us in the Council, to help build and strengthen our organization in every community, so that it may play its most effective role against our oppressors and false leaders, and in fighting for the rights of Negroes here and in Africa and for our common freedom.

My Answer

As told to Dan Burley, *New York Age*,[1] August 6, 13, 20, September 3, 17, 1949

I'm in the headlines and they're saying all manner of things about me such as "enemy" of the land of my birth, "traitor" to my country, "dangerous radical" and that I am an "ungrateful" cur. But they can't say that I am not 100 per cent for my people. The American Press has set out on its own campaign of deliberate misquotation and distortion of the things I say and do, trying to set my people against me, but they

can't win because what I say is the unadulterated truth which cannot
be denied.

Everybody is trying to explain Paul Robeson. That isn't hard. I'm
just an ordinary guy like anyone else, trying to do what I can to make
things match, to find and tie up the loose ends. I am asked do I think
the salvation of the American Negro lies in complete integration—
social, political and economic, or in a highly developed Negro national-
ism. Let me answer it in my way.

omit

The whole Negro problem has its basis in the South—in the cotton
belt where Negroes are in the majority. That is the only thing that
explains me completely. The Negro upper class wants to know why I
am out here struggling in behalf of the oppressed, exploited Negro of
the South when I could isolate myself from them like they do and
become wealthy by keeping quiet on such disturbing subjects. This, I
have found, would not be true of me. What I earn doesn't help my
people that much. I have relatives in the South still struggling to make
a living. The other night in Newark, one relative of mine was in the
audience. He is a mason and a carpenter. What I do personally doesn't
help him. I found I have to think of the whole background of the Negro
problem. Therefore I have taken my obligations to the Negro people
very seriously.

I have asked myself just what Negro people am I fighting for. The
big Negroes take it that I am fighting for them and since they're
comfortable and living good, they don't want too much fighting or
things said that might prove embarrassing to their positions. My
travels abroad, however, have shown me what and whom I am fighting
for. During my travels, I met native Africans, West Indians, Chinese,
East Indians and other dark people who are fighting for the same
thing—freedom from bondage of the imperialistic Wall St., the bank-
ers and the plantation bosses, whether in London or in New York. The
big Negro wants somebody to fight for him, but his objectives are
purely selfish. If I am fighting for the Negroes on Strivers Row, I must
fight for every Negro, wherever he may be.

Let's return again to the fact that the whole Negro problem has its
basis in the South. Do you know that out of 15 million Negroes in the
United States, nearly 10 million live and die in the South? I've got to
be interested in basic problems, the people and conditions on the lower
levels of life. I found that Negroes constitute 98 per cent of the
population of the West Indies. Without the Negro there could be no
economic South and there could be no economic West Indies to make
the bankers and overlords of Wall St. fabulously wealthy. In the
South, Negroes do most of the work and get nothing from it in return.

I understand these things better on my travels abroad. In England I
met boys and girls from Africa working on ships, in the schools and
elsewhere and I met fellows from the West Indian Islands, all trying to
work out their destinies the best way they could. It became very clear
to me what is happening to them. The continent of Africa belongs to
them and should belong to them now. The same goes for the West

Indies which the Negro built up, only to have a few people from the United States and from England move in and take it away from them and then rule them by absentee landlordism with headquarters in Wall St. and in London. These are the people who own the sugar plantations in the West Indies and in Louisiana and the tobacco plantations in North Carolina.

It is very easy to see, as in the question of India, China, Africa and the West Indies, the future of these people in the independence of their own countries. I see the Negro's struggle as demanding great concentration on the question as to where he is going and who is leading him there. We must come together as a people, unite and close ranks and with our own unity we must try and find the right allies—those whose struggles are identical to our own. We cannot escape the fact that our struggles over the last 300 years have driven us together.

Suppose that in the South, where the Negroes are in the majority in the agricultural belt, we had the vote like everyone else? What would happen? Wouldn't Negroes be in Congress, be governors, judges, mayors, sheriffs and so on? Wouldn't they be in control in the South and run things as the minority people down there are doing at this very moment?

There you have your answer to that charge that I am fomenting strife and plotting with a foreign government to establish a Black Republic in the South. What would happen—even tomorrow—if the Negro was allowed to vote? Without any nonsense, you would have a tremendous concentration of Negro power in the United States. Many people would object and oppose it on various grounds, principally racial and economic, but you have a concentration of Irish power in Boston, Italian power in New York, and so on. Nobody has made a major issue of that, have they? What is wrong with our struggle for our right to vote, for economic liberation, for civil rights? To me, from the economic point of view, we should think of spreading our strength around so as not to put all our wealth and power into the hands of a few Negroes who would exploit that power like any reactionary banker to the detriment of Negroes in the United States.

There are two groups of people who are worried stiff about the growth of the unified power of the Negro people: one group includes the Dixiecrats[2] like Rankin of Mississippi, Wood and George of Georgia, Tom Connally of Texas and Eastland of Mississippi. The other includes the reactionary industrialists and financiers who own many of the farms and plantations in the South on which my people and your people are enslaved right now. These are the people who work to keep the Negro in bondage.

My basic point is that these are the fellows who want the Negro to be loyal to them, to die for them in war, to make a profit for them.

We Negroes must think this thing out. What America are we fighting for? Obviously we don't live alone in America, so we must choose the right allies, as I said before and these allies cannot be those Dixiecrats as named here. They cannot be those bankers and international financiers who run most of the country and own today all the

resources of the South built on the labor of the Negro people. They own the sugar, the tobacco, the mineral wealth. They own the West Indies where Negroes are 98 per cent of the population.

They are the ones who helped take Africa from the African people. Our allies must be the progressive section of the American people—the honest progressives who find kinship in the common struggle for freedom, equality and unity. And who are these progressives? They are those who swell the ranks of labor, the poor white sharecropper of the South, presently being used as a tool by the rich plantation owners and bankers to pull their chestnuts out of the fire by warring on their Negro neighbors; the small business man and others of all races, colors, creeds and national origins, including the small, independent farmer—people who are passed up when the profits are handed out but who are the first thrown into the pot to cook up those profits for someone else. The Dixiecrats, like Wood of Georgia and those powerful reactionaries who hope to stamp out the militant struggle of the Negro for complete freedom, equality and civil rights, hope to keep all the wealth for themselves.

They are the ones who are behind the House Un-American Committee. They are the ones ceaselessly pushing the persecution of those unafraid to speak out and to champion the man down under, whether he be black or white.

When some of our leading Negroes select those most guilty of exploiting their people to get thick with in their social and economic affairs, they pick the wrong people no matter what excuse might be presented. Leopards don't change their spots and neither do those who think about us adversely change their thoughts overnight. This sort of thing I'd call "20th Century Uncle Tommism"—going back to the Big House to fawn at the boss' feet—and we shouldn't tolerate it one minute if we expect to get ahead.

Me? I'm out with the field hand. That's the only way I can see it. They tell us to stay in our place. Well, I'm staying in mine—out here with the field hand—the little fellow, the guy who gets pushed around, the fellow who has to do all the hard work and gets nothing from it.

I'm talking about the sharecroppers, Negro and white, on the sprawling plantations in the South.

I'm talking about the tobacco, steel and lumber workers; the men who tote the sandbags with chains about their legs to stem the Mississippi at flood time so as to save the empire of some guy in New York, London or Paris who has never seen the land which keeps him in luxury nor met and talked with the people on whose backs his kingdom rests.

Yes, that's the only way I can see it—stay with, work with, fight with and sing with the field hand, and if we stick it out long enough—we'll get the Big House!

We must solve our problem where we find it. Not by going thousands of miles away to take up something we are not familiar with.

Why should we leave the United States without first getting what is coming to us through a militant struggle to gain the profits that have

come from our labor, our blood, our sweat, our tears?[3] I'm talking now about the various schemes that would arouse false hopes in the Negro people about taking some other land as a homeland when we already have our home right here on American soil which will be ours when we make it our own.

Think what a Federation of the West Indies would mean economically. With Negroes 98 per cent of the West Indian population, why shouldn't they control the sugar, tourist trade, the banana and rum industries and the possibilities of further industrial development of the islands? Think of the amount of base metals and the other natural wealth to be found there.

A Federation of the West Indies would give Negroes a completely integrated economy that would make the West Indies one of the most important places in the world—connected with the Latin and South American mainland. Think of the strategic position a native West Indian-controlled political and economic federation would command. Think of the weight such a setup would throw in United Nations circles?

Suppose Africa were free and a great nation like China? We must have to think for ourselves and also to include in intelligent thought those who are closest to us through the ties of blood, nationality, common interest and mutual aspirations. We want as many areas in this changing world of control as we can get as Negro people. Suppose we won the right to vote plus our proper share of the economic spoils of the South: think of the tremendous pressure Negroes could bring upon the United Nations to help kindred people in other parts of the world. There is no reason to change what have become very significant and historic facts. Certainly, any Negro in the world would have a deep feeling for his own people, wherever they are, whatever conditions they might be in.

As chairman of the Council on African Affairs, I can truthfully say that the African people are highly cultured and not savage and cannibalistic as the newspapers, radio, book and lecture propagandists would make them. That is the Dixiecrat program to keep us fighting one another and to lead us away from the true paths that lead to the doorway to freedom from which we have been detoured over the centuries.

I am proud of my African heritage. In fact, I'm so proud of it that I have made it my work to learn several African languages for conversation and musical purposes. Mrs. Robeson has been in South Africa, in the Uganda and in the Belgian Congo and the French Cameroons. She has written a book on Africa, *African Journey.*[4] I expect to be in Nigeria and French West Africa next year. There is a tremendous liberation movement now under way in Nigeria of which Azikiwe is the brilliant, capable and resourceful leader. It is very possible that Nigeria will be the first African nation to win complete liberation.[5] Understand that we over here, whether from the West Indies or from New York, should consult with the Africans about taking something

from them. This is in answer to the question: What Do You Think of the Back-to-Africa movement?

At the Paris Peace Conference which brought all the reactionaries of America down on my neck, a Negro from French Africa spoke for an organization of one million Africans formed into trade unions in West Africa. In East Africa, Uganda and Kenya, there are very powerful movements for the rights of the African peoples. We must be very much aware of our allies of this time—and here we are dealing with 150 million in Africa, 40 to 60 million in the Caribbean and Latin America. All these people are to be considered, to be thought of as strengthening their own position in the areas where they live. Likewise Negroes in the South and West Indies must think of the areas in which they live as land that belongs to them. That is where they worked or were worked to build up things—to till the soil, plant and harvest; to chop down trees and milk them of turpentine and other basic products for the industrial mills of the imperialists and warmongers.

They—the Negroes of the South—must not grow to thank John Rankin[6] for being allowed to live down there. They must realize that they are the ones who built that which has been and still is being taken from them. Maybe, they should think of someday gaining control through constitutional means of that which should have been theirs all along.

Where will the next Peekskill be? What new battle ground have the reactionary police and those behind them selected? Where will they demonstrate further the "old Southern Custom" of beating in the heads of Negroes and all those identified with the struggle to free the Negro people? I mean completely free the Negro from the shackles of the greedy exploiters of his labor and his talents. To be completely free from the chains that bind him, the Negro must be part of the progressive forces which are fighting the overall battle of the little guy—the sharecropper, the drugstore clerk, the auto mechanic, the porter and the maid, the owner of the corner diner, the truck driver, the garment, mill and steel workers. The progressive section sees no color line and views the whole problem of race and color prejudices and discrimination as a divisional tactic of those busy pitting class against class, dividing the masses into tiny, warring factions that produces nothing for them but discord and misery while a scant, privileged few takes all the wealth, holds the power and dictates the terms. This concentration of power in the hands of less than a hundred men is so strong that it can decide who shall eat and who shall not, who shall have decent homes and who shall be doomed to crowded tenements that are firetraps and rat-infested holes where children must be reared and the occupants live and die in despair.

I am well equipped now, although I have not always been so, to make the supreme fight for my people and all the other underprivileged masses wherever they may be. Here, I speak of those bereft of uncompromising, courageous leadership that cannot be bought, cannot

be intimidated, and cannot be swerved from its purpose of bringing true freedom to those who follow it. God gave me the voice that people want to hear, whether in song or in speech. I shall take my voice wherever there are those who want to hear the melody of freedom or the words that might inspire hope and courage in the face of despair and fear.

I told the American Legion that I have been to Memphis, Tennessee, the stamping grounds of such Negro-haters as Ed Crump and others of the cracker breed, and I have been to the lynch belt of Florida. I told the Legion I would return to Peekskill. I did. I will go North, South, East or West, Europe, Africa, South America, Asia or Australia and fight for the freedom of the people. This thing burns in me and it is not my nature nor inclination to be scared off.

They revile me, scandalize me, and try to holler me down on all sides. That's all right. It's okay. Let them continue. My voice topped the blare of the Legion bands and the hoots of the hired hoodlums who attempted to break up my concert appearance for the Harlem Division of the Civil Rights Congress. It will be heard above the screams of the intolerant, the jeers of the ignorant pawns of the small groups of the lousy rich who would drown out the voice of a champion of the underdog. My weapons are peaceful for it is only by peace that peace can be attained. Their weapons are the nightsticks of the fascist police, the bloodhounds of the cracker sheriffs in the backwoods of the South, the trained voices of the choirs of hate. The song of freedom must prevail.

A Tribute to Ben Davis

Daily Worker, September 4, 1949

I am inviting you to join with me in paying tribute to Benjamin J. Davis, New York City's fighting Councilman, in the recognition of his outstanding record of public service.

The Ben Davis Ball Committee is publishing a Journal this year in the pages of which will be expressed the greetings and support of progressive Americans from all walks of life.

The annual Ben Davis Ball and Celebration takes place this year during his campaign for re-election to the New York City Council. It takes place also at a time of unprecedented lynch and war hysteria in our country.

Ben Davis is a victim of this hysteria. He is such a victim because he has fought against Jim-crow, lynchings and police brutality and anti-Semitism. He has fought for housing instead of A-bombs; jobs instead of guns; peace instead of war.

Ben Davis, who is my close personal friend, deserves the full and unqualified support of every democratic, peace-loving person in our country. I am confident that you will want to be among those who will participate in this Ben Davis Ball Journal.

Robeson Testimony in Trial
of Communist Leaders Blocked

Joseph North, *Daily Worker,* September 21, 1949

"I came voluntarily to testify as a champion of civil rights," Robeson told newspapermen. "I came because there is a hysteria in this land, of which this trial is part, and I came to express my feeling that the Communist Party has done a magnificent job on behalf of the Negro people and the working-class, on behalf of peace."

Robeson told the press what McGohey and Medina had refused to allow him to state before the jury.[1] "I am here as a friend of the defendants with whom I have worked on many occasions and whom I have heard over many years and never once did I hear them advocate the overthrow of the Government by force and violence."

On the contrary, Robeson said, he had seen those prosecuting the Communists "use force and violence as at Peekskill."

The press tried several times to heckle him but his giant personality quelled most of it. He warned the nation "to look behind those who use violence against the people, and I mean the one percent of the nation who owns 60 percent of the income," he said. "In essence I mean the DuPonts, the Mellons and all the rest who own steel, who own our nation's wealth."

He described them as the "super-government" behind President Truman and Gov. Dewey who use "state power" to permit the Peeks-kills to explode upon our people.

"Franklin D. Roosevelt and others called them the super-government that controls the nation's policies," he said.

There was an excited stir in the courtroom when Robeson entered at 11:10 a.m., accompanied by Mrs. Louise Thompson Patterson and Dr. Alpheus Hunton, leaders of the Council on African Affairs which the singer heads.

Clad in gray, wearing spectacles, he took the witness-stand at 11:20, and in his resonant voice quietly spelled out his name. He was allowed to say he was born in Princeton, N.J., but McGohey objected and Medina sustained the prosecutor when Crockett asked if his father "was born in slavery."

Medina promptly lectured Robeson in the voice he reserves for Negroes, "to keep his answers brief." The judge looked into space when Robeson replied that during his education in law he had once studied under Medina.

Robeson received his doctor's degree in law. He was permitted to say he knew the defendants, most of them for many years, knew their work, had often heard them speak, but the judge sustained the prosecutor's objection when Crockett asked Robeson what he heard them say.

Robeson was not allowed to say that he was at the Communist Veterans' Encampment in Washington, May of 1947; he was not allowed to say he addressed that encampment; he was not allowed to say he was ever on the same platform with Eugene Dennis; or on the same platform with Mrs. Franklin D. Roosevelt.

The latter question irked the judge, for he chided Crockett, and said, "I think you must know that even if this witness was on a platform with former President Roosevelt, that has nothing to do with this case."

"Did you ever hear Eugene Dennis teach or advocate the duty or necessity of overthrowing the government by force or violence?" Crockett asked.

McGohey: "Objection." Medina: "Sustained."

"Did you ever hear any of the defendants advocate the overthrow of the Government by force or violence?"

"Objection." "Sustained."

Finally, Crockett asked Robeson, "What interest, if any, have you in this case?"

Robeson began, "I have a very deep interest. . . ." McGohey, who had been popping up like a jack-in-the-box, jumped up again, hesitated a moment, then objected. The judge promptly sustained him. Robeson turned to the judge to ask him if he may be heard.

The judge stared at him and said coldly he didn't want to hear him.

At this point, 11:37 a.m., Crockett said it was impossible under these circumstances to continue his direct examination and Robeson stepped down.

The press followed him down the hall, down the stairway to the press-room where a dozen photographers promptly went to work. Then Robeson spoke. "Why did you come to testify?" one reporter asked through the babble of questions.

"I have said on many occasions that the national hysteria represented in this trial goes to the roots of civil liberties for all in our nation," Robeson replied. "I would say that if the defendants were Republicans or Democrats," he answered in response to a question.

Robeson told the newspapermen that he had known the defendants for many years, some he had met in Spain, others, like Ben Davis, he had known personally, "had coached him in football," and later followed Davis' career, "his inspiring defense of Angelo Herndon, his splendid work for the Negro people and all America as a leader of the Communist Party."

Robeson said that he had studied law under Judge Harlan Stone and had thought then, that judges wanted to hear the truth. "I cannot say that after today," Robeson declared. "I don't think they want to hear the truth."

Robeson said he wanted to warn the nation "to look behind the Peekskills and discover the forces that use violence against the people."

"Who," he asked, "told Dewey to use state troopers against peaceful

concert-goers and shoot them down if necessary. And what did Truman do?"

Robeson said the Government uses state power against the people and it behooves the people to "look into that, see who is behind it."

"I say," Robeson repeated, his rich baritone voice rising, "that our people must look behind this trial, behind Peekskill, and discover that those responsible are the same few who cause one-third of our nation to go ill-clad, ill-fed, ill-housed.

"I say that the people must become part of the Government again. Why haven't we got housing?" he asked. "Look for the real estate powers in Washington. Why haven't we got civil rights? Look for the Dixiecrats. Not only are we deprived of civil rights in the South, but also in New York State." He said "powerful forces" are responsible.

Robeson said the defendants in this case are not even allowed to present their own viewpoint. He said he knew many of them very well, for many years. "I met John Gates and Bob Thompson in Republican Spain," he replied to a question. "They were then fighting a war which could have killed fascism and prevented World War II."

"I went to Spain," the Negro leader said, "with prime Minister Clement Attlee and other dignitaries of the Labor Party. But now they are ready, in their subjection to the Wall Street dollar, to come to terms with Franco."

But at Peekskill, Robeson said, he saw many of the men he had seen in the frontlines of Spain, ready to give their lives for democracy. "I saw them a few days ago, facing fascist hoodlums, saw them standing shoulder to shoulder once again. These are the kind of people the Government, federal and state, is persecuting, using the full power of the state to quiet their voices for freedom."

A reporter began to heckle him, saying he, Robeson, the famous singer, is certainly "free."

"I am not free," Robeson replied. "I am not free while the Ingram family is in prison. I can be lynched just as they can be.

"I am not free so long as any of my people are enslaved; or any people in America, like these defendants, are persecuted. When they are free, I am free."

That, Robeson said, is why he came to testify. And that, he concluded, is why they refused to allow him to testify.

I Am the Same Man

Speech before Forest Club, Detroit, October 10, 1949
—*Daily Worker,* October 12, 1949

Robeson was introduced by Dave Moore, Ford union leader, recently returned from Budapest. Robeson spoke of the different kind of atmosphere prevailing in Detroit than on his many previous visits. This time, he said, 1,000 police

surround the hall. Editorials are written telling the people to stay away. Reformists within the ranks of the Negro people work with reaction to get the meeting cancelled.

When I was here during the Ford strike in 1941 helping the workers to win, CIO president Philip Murray told me I had made a singular contribution. When I picketed and sang for the 1948 steel strikers in Ishpeming, Upper Michigan, the steel union leaders personally thanked me.

When I came here many times for concerts, I got the finest reviews from the press. When Joe Louis and Marian Anderson and I came here to speak and sing at bond rallies during the war we were given a civic reception, greeted by the mayor and governor.

What has happened? I am still the same man. I still speak and fight for justice, against fascism, for peace, like I did in those days. Just what has happened is that I am fighting for it now, that's why the atmosphere is changed.

I don't get scared when fascism gets near, as it did at Peekskill or Groveland, Fla. The spirit of Harriet Tubman, Sojourner Truth, Frederick Douglass fills me with courage and determination that every Negro boy and girl, yes and every white boy and girl, shall walk this land, free and with dignity.

Why have I changed, many people ask? My slave father always told me to shoulder my responsibilities. That's what I am doing now.

I stand ashamed before you tonight. Ashamed that 12 great leaders of the American working class face going to jail at Foley Square because we haven't done enough. William Z. Foster, leader of the steel workers—and there would never have been a strike today if it hadn't been for Foster—faces jail. Benjamin Davis, standard-bearer of his people, councilman of New York, faces jail. They must be freed.

Open Letter to President Truman

Signed by the Officers of the Council on African Affairs, Paul Robeson, Chairman, October 12, 1949—*New Africa,* October 1949. Copies were also sent to Governor Thomas E. Dewey and Attorney-General J. Howard McGrath.

Dear Mr. President:

A criminal assault was made against the American people and their rights at Peekskill, New York, on the night of August 27, 1949.

The criminal attack was repeated a week later on Sunday, September 4, in the same locality.

We declare that the record of what happened on those two occasions, as contained in on-the-scene press and radio reports, press photographs, and the testimony of assault victims and other eye-witnesses, proves conclusively that Governor Thomas E. Dewey and the responsi-

ble officials under his supervision are, at the minimum, guilty of gross negligence in the protection of the rights, property, and lives of American citizens.

We declare, further, that Governor Dewey has clearly demonstrated his unfitness to hold public office by the character of his statement of September 14 in which he made the astounding charge that the responsibility for the violence and lawlessness rested with the *victims* of the violence. Mr. Dewey sought credence for this transparently false and monstrous charge by the hackneyed reactionary expedient of characterizing the Peekskill "incident" as a Communist maneuver.

It is apparent from the terms of reference which he laid down for it that Governor Dewey would like to make the pending grand jury investigation of the Peekskill riots another anti-Communist witch-hunt. As such it will in reality be another attack upon the rights of *all* Americans.

It is now evident to all that the present administration of the State of New York can not be relied upon to protect the basic constitutional rights of its citizens, and that appeal must now be made to the federal authorities. That is why we write to you, Mr. President, and declare that it is imperative that you instruct the Attorney-General and the Civil Rights Division of the Department of Justice to launch an immediate investigation and prosecution of those who conspired, connived, and assisted in the Peekskill attacks on August 27 and September 4, in accordance with the provisions of the Federal Statutes: Title 18-Sec. 51, 52 U.S. Criminal Code; Title 8-Sec. 47-Sub. 3, and Sec. 48, U.S. Code Annotated.

We wish to emphasize, Mr. President, that Peekskill is by no means an isolated instance of the violation of the constitutional rights of American citizens. Two years ago Paul Robeson was barred under similar circumstances from giving a concert in Peoria, Illinois. Last year Presidential candidate Henry Wallace and his supporters were assaulted in many parts of the country. Most especially we call your attention to the fact that the past several months have seen lynchings and increasing mob violence and brutal atrocities against Negro citizens in Florida, Georgia, Alabama, Illinois, and other states, including New York where case after case of police brutality and murder has occurred with no punishment meted out to the guilty officers.

Peekskill demonstrated what this mounting anti-Negro violence and contempt for human rights may develop into unless speedily checked. Peekskill was a reminder of Hitlerite Germany where fascism got its start with organized mob assaults, with official sanction, against the Jewish people, in the name of German "patriotism" and "anti-Communism."

The warning is clear, Mr. President. The Peekskill outrages are the product of that perverted Americanism which brands as unAmerican those who speak out for peace, who stand up for their consti-

tutional rights and those of their fellow-men, or who are concerned
with freedom for colonial peoples rather than with the raw materials
that can be stolen from their lands.

We are convinced that the time has come to put an end to this cold
war against the American people; the time has come to utilize the
agencies of our government *in actual fact* toward promoting democra-
cy at home and peace abroad. The eyes of the world are upon you, Mr.
President.

The Negro People and the Soviet Union

Address at banquet sponsored by the National Council of
American-Soviet Friendship, Waldorf Astoria Hotel, New York
City, November 10, 1949[1]—Pamphlet, New York, 1950 (Copy in
Trevor Arnett Library, Atlanta University)

I am deeply grateful for this opportunity to join more than half the
people of the world in celebrating a great anniversary. Yes, with fully
half of humanity—and even this is an underestimation. For it would
be a mistake to assume that this 32nd anniversary of the Union of
Soviet Socialist Republics is an occasion of joy and pride and thanks-
giving only for the eight hundred million people who live in the Soviet
Union and the People's Democracies of Eastern Europe and China.

True, these eight hundred million, as *direct* beneficiaries of the
establishment of the Soviet Union and of its policies of struggle for
peace and democracy, are rejoicing because of the new economic
security and political liberty, the new promise of a fuller and richer
life for all, which they enjoy because they live in the Soviet land or in
countries of the People's Democracies. The feelings of all these people
must be very like those of the President of the Chinese People's
Republic, Mao Tse-tung.[2]

"If the Soviet Union did not exist," Mao wrote, "if there had been no
victory in the anti-fascist second World War, if . . . Japanese imperial-
ism had not been defeated, if the various new democracies of Europe
had not come into being, if there were no rising struggle of the masses
of the people in the United States, Britain, France, Germany, Italy,
Japan and other capitalist countries against the reactionary cliques
ruling over them, if this sum-total of factors did not exist, then the
pressure of the international-reactionary forces upon us would surely
be far greater than at present. Could we have been victorious under
such circumstances? Certainly not."

That is the way Mao explains how much the liberation of China is
indebted to the decisive influence of the Soviet Union in international
affairs. And so with the Romanians and Bulgarians, the Hungarians
and Albanians, the Czechs and the Polish people. It is because of this
sum-total of factors that they today are the masters of their own
lands—a sum-total which means that the world balance of power has

shifted in favor of the forces of peace and democracy. And this
portentous transformation, which has occurred within three decades,
stems mainly from the mighty impact of the events of November 7,
1917.

I traveled recently in Western Europe and Scandinavia, and I know
from what I saw and heard in those countries, that there, too, the
peoples are able to struggle against the total colonization of their
countries by Wall Street principally because of this new balance of
power. And if the Viet Namese and the Indonesians, if the Burmese
and Malay people, indeed, if the people of long-suffering India have
advanced to a higher stage of struggle for their independence, it is
because of this sum-total of factors and the decisive influence of the
Soviet Union.

We of the Council on African Affairs know well, also, that the people
of Africa and the West Indies understand who are their real friends in
the council of nations. Yes, the Nigerians who only yesterday were told
by Creech-Jones of the British Empire that their demand for full
self-rule could not be granted because they were not ready—these
Nigerians know very well that the peoples in the Asian republics of the
Soviet Union less than three decades ago stood on the same cultural
and political level as they; yet, in a single generation these so-called
"backward" peoples have been able to take their place as free,
independent peoples with their own industries and their own culture.

Yes, all Africa remembers that it was Litvinov who stood alone
beside Haile Selassie in Geneva,[3] when Mussolini's sons flew with the
blessings of the Pope to drop bombs on Ethiopian women and children.
Africa remembers that it was the Soviet Union which fought the
attempt of Smuts to annex Southwest Africa to the slave reservations
of the Union of South Africa. Africa knows it was the Soviet Union
who demanded at San Francisco that the Charter of the United
Nations contain a guarantee of self-government for the peoples of
so-called "trust" territories. And is it not the struggle of the Soviet
Union today which prevents the former Italian colonies from being
slave-warrens and military bases for Britain and the United States?

Certainly, the changed balance of power in the world today favors
the liberation struggles of the African and West Indian peoples. And if
the people of Tanganyika and Kenya are not content with the
benevolent schemes for turning their land into mass peanut planta-
tions; if the Africans of Rhodesia rebel against the theft of their copper
and the exploitation of their labor; if the Bantus and the slave-pens of
the Union of South Africa grow more defiant of the pass laws and the
forced-labor system; if the peoples of the Congo refuse to mine the
uranium for the atom bombs made in Jim-Crow factories in the United
States; if all these peoples demand an end to floggings, an end to the
farce of "trusteeship" in the former Italian colonies and all other
colonies, an end to colonial exploitation schemes hidden beneath
humanitarian pretenses; and if the people of the West Indies press for
some move leading to independence—to federation in the interests of

the West Indian people and not of absentee landlords—as in Truman's
"Point Four"[4] program—if, in a word, the peoples of Africa and the
West Indies now shout their demands for self-determination to the
entire world, is it not because they have a mighty friend and champion
who by example and repeated challenge has proved this friendship?

No, despite all the censorship and repression, the word has gotten
around.

The Soviet Union is the friend of the African and West Indian
peoples. And no imperialist wolf disguised as a benevolent watchdog,
and not Tito disguised as a revolutionary, can convince them that
Moscow oppresses the small nations. Africa knows the Soviet Union is
the defender and champion of the rights of all nations—large and
small—to control their own destinies.

The Soviet Socialist program of ethnic and national democracy is
precisely the opposite of the Nazi, fascist, South African and Dixiecrat
programs of racial superiority. One of Africa's foremost leaders,
Gabriel D'Arboussier, Vice-President of the African Democratic Union
in France's African colonies below the Sahara, leader of an organiza-
tion, millions strong—representing 21,000,000 Africans, has said this:

"All the anger of the reactionaries directed against the Soviet Union
is also directed in other forms against the colonial peoples. The latter
have learned, thanks to these reactionaries, that there is a natural
alliance between the country of socialism and the oppressed people the
world over."

But I have a deeply personal reason for speaking here tonight. And
it is more than the fact that as an artist I know what Soviet culture
means for the young artists of today, what great horizons of imagina-
tion and creativeness are being pushed back in the Soviet land. And it
is more than the fact that I have many dear friends in the Soviet Union
whom I met and grew to know during my visits there. I think the real
reason I love the Soviet Union and why I can speak personally about it
is because I am a Negro and an American.

Let me explain.

In America today the Negro people are the core of the struggle
against war and fascism. Three hundred years of oppression and terror
have brought my people to the forefront in this struggle.

There is no democracy for the masses of my people. The achieve-
ments of a few are no answer—in fact this is being used in reverse—to
cover up the injustices to our millions. The millions of Negroes who are
denied the right to vote are mountainous testimony.

Unemployment is a constant specter. Thirty-one percent of the
heads of Negro families in America earn less than $500 per year. An
additional 44 percent earn between $500 and $1000 annually. This 75
percent of my people earn less than one-third of what is necessary to
support a family of four.

We are the last hired and the first fired.

Seven-tenths of our farm people are landless, with cotton planted
right up to their very doorstep. The overwhelming mass live in houses

where the sky, the earth and the trees may be seen without going outside.

Five thousand Negroes have been lynched. Not one lyncher has been brought to justice. Not one lyncher has been made to pay for this horrible crime.

Maceo Snipes, a World War II veteran, went to vote in Taylor County, Alabama. One hour later he was killed on the doorstep of his home, within sight of his wife and children. His murderers walked away saying, "We told you not to vote." But the widow of Maceo Snipes told her children, "When you grow up, you'll vote too."[5]

Ninety Negroes have been lynched since President Truman began occupying the White House with promises of civil rights. The most horrible of the blood-lettings took place in Greenville, South Carolina, where 28 men stood in an American courtroom and admitted killing Willie Earle. Several owned to tying him up. Several others to pouring gasoline over his body. Still others to firing sixty shells into him from six feet away. Even others admitted setting matches to the gasoline, making a flaming pyre.[6]

They were all freed by the jury. And the federal government never intervened. The reason is clear. Tom Clark was the Attorney-General then, the same Attorney-General who later prosecuted any number of liberal thinkers and resorted to the worst kind of persecution and the most despicable use of our courts in indicting the 12 leaders of the Communist Party.

The Negro people know that they can expect no answer from American imperialism. American imperialism cannot relinquish its Jim-Crow terror while it pursues its Marshall Plans and Atlantic Pacts and its drive toward war.

But there is another side to this miserable picture. A hopeful side. It is the rising militancy of the Negro people's struggle for land, equality and freedom. In meetings that I have had throughout the country with tens of thousands, this rising militancy has shown itself under a new leadership, a leadership made up of Negro trade unionists, veterans, working women and youth, ministers of our churches, fraternal leaders and others. This rising militancy has emerged as the core of unity with many groups, with the Jewish people, with trade unions and the foreign born.

On my southern tour for Henry Wallace, I recall our stops in Memphis, Tennessee, where the fighting organization of the Mine, Mill and Smelter Workers joined hands with my people to guarantee that progressive thought and action could find a channel for expression.[7]

In Winston-Salem, North Carolina, I saw the tobacco workers.[8] I saw progressives and liberals like Larkin Marshall in Georgia, Mrs. Andrew Simkins of South Carolina, and Velma Hopkins—all fighters who are leading a valiant struggle for liberation.

It was during Peekskill that this unity was most sharply set forward. There, in Peekskill, trade unionists, Jewish people, foreign

born, Negro and white, stood side by side, fighting off the fascist attack of gangs led by Dewey and Dulles, the real source of force and violence.

I see this rising fighting temper of the Negro people as one of the important reasons for the granting of bail for the "eleven," for the defeat of the Ober Bill in Maryland.[9] Yes, it even forces Supreme Court Justice Jackson to proclaim the trial of Eugene Dennis as a "political" trial.

I have heard some honest and sincere people say to me, "Yes, Paul, we agree with you on everything you say about Jim Crow and persecution. We're with you one hundred percent on these things. But what has Russia ever done for us Negroes?" And in answering this question I feel that I go beyond my own personal feelings and put my finger on the very crux of what the Soviet Union means to me—a Negro and an American. For the answer is very simple and very clear: "Russia," I say, "the Soviet Union's very existence, its example before the world of abolishing all discrimination based on color or nationality, its fight in every arena of world conflict for genuine democracy and for peace, this has given us Negroes the chance of achieving our complete liberation within our own time, within this generation."

For where, indeed, would the Negro people's struggle for freedom be today, if world imperialism had not been critically wounded and its forces weakened throughout the world? Where would the fight to vote in the South be today if this new balance of power in the world did not exist?

And I know that the growing unity of these great sections of the American people with the Negro people, the growing power of their struggle to save America from fascism, the very principle of solidarity in the teeth of the enemy owes its endurance and its force in the last analysis to that sum-total of factors which have transformed the world, that sum-total in which the example and might of the Soviet Union is decisive.

To every Negro mother who has her sons to comfort her, to every young Negro girl who looks forward to marriage, to every Negro youth who enters upon the threshold of this struggle with confidence, I say: "Where would your son be, where would your sweetheart be, where would YOU be, but for Stalingrad?" For in speaking of Stalingrad, it was Roosevelt who in a letter to Stalin spoke of how civilization had been saved by the battle of Stalingrad. And it was the Soviet people and the children who said, "Carry back my love to the Negro people, to the American people for we want peace and honest cooperation."

No one need be or can allow himself to be afraid of declaring himself for real friendship with the Soviet Union Republics and the People's Democracies. Today the real patriots of every nation are exactly those who work for friendship with these great nations.

Must we go back over the last three decades to document this fact? Has not the history of every country shown that it was precisely those who sowed hatred against the Soviet Union who proved to be the real traitors to their country? Was it not those who advocated and worked

for friendship with the Soviet Union who proved to be the genuine patriots?

To those who dare to question my patriotism, who have the unmitigated insolence to question my love for the true America and my right to be an American—to question me, whose father and forefathers fertilized the very soil of this country with their toil and with their bodies—to such people I answer that those and *only* those who work for a policy of friendship with the Soviet Union are genuine American patriots. And all others who move toward a war that would destroy civilization, whether consciously or unconsciously, are betraying the interests of this country and the American people.

Finally, my friends, I want to say that I believe the great majority of the American people will come to realize their identity of interests with the people of the Soviet Union and the growing People's Democracies. In this era of change, normal trade relations and peaceful cooperation can be the only answer.

I am and always will be an anti-fascist and a fighter for the freedom and dignity of all men. We anti-fascists—the true lovers of American democracy—have a tremendous responsibility. We are not a small band—we are millions who believe in peace and friendship. If we mobilize with courage, the forces of world fascism can and will be defeated—in Europe, in Africa and in the United States.

Because of this, I am and always will be, a firm and true friend of the Soviet Union and of the beloved Soviet people.

With W. E. B. Du Bois at Paris Peace Conference, April 20, 1949

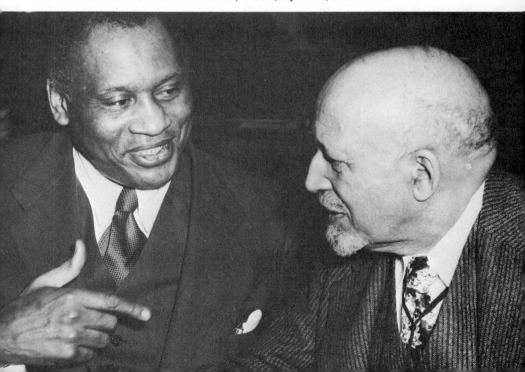

With New York City Councilman Benjamin J. Davis, Jr.
at Union Square May Day ceremonies, New York, May 1, 1947

Forge Negro-Labor Unity
for Peace and Jobs

Speech delivered at meeting of the National Labor Conference
for Negro Rights,[1] Chicago, June 10, 1950—Pamphlet, Harlem
Trade Union Council and the South Side Chicago Negro Council,
New York, 1950

I am profoundly happy to be here tonight.

No meeting held in America at this mid-century turning point in
world history holds more significant promise for the bright future
toward which humanity strives than this National Labor Conference
for Negro Rights. For here are gathered together the basic forces—the
Negro sons and daughters of labor and their white brothers and
sisters—whose increasingly active intervention in national and world
affairs is an essential requirement if we are to have a peaceful and
democratic solution of the burning issues of our times.

Again we must recall the state of the world in which we live, and
especially the America in which we live. Our history as Americans,
black and white, has been a long battle, so often unsuccessful, for the
most basic rights of citizenship, for the most simple standards of
living, the avoidance of starvation—for survival.

I have been up and down the land time and again, thanks in the
main to you trade unionists gathered here tonight. You helped to
arouse American communities to give answer to Peekskill, to protect
the right of freedom of speech and assembly. And I have seen and daily
see the unemployment, the poverty, the plight of our children, our
youth, the backbreaking labor of our women—and too long, too long
have my people wept and mourned. We're tired of this denial of a
decent existence. We demand some approximation of the American
democracy we have helped to build.

For who built this great land of ours?

Who have been the guarantors of our historic democratic tradition of
freedom and equality? Whose labor and whose life has produced the
great cities, the industrial machine, the basic culture and the creature
comforts of which our "Voice of America" spokesmen so proudly boast?

It is well to remember that the America which we know has risen out
of the toil of the many millions who have come here seeking freedom
from all parts of the world:

The Irish and Scotch indentured servants[2] who cleared the forests, built the colonial homesteads and were part of the productive backbone of our early days.

The millions of German immigrants of the mid-nineteenth century; the millions more from Eastern Europe whose sweat and sacrifice in the steel mills, the coal mines and the factories made possible the industrial revolution of the Eighties and Nineties; the brave Jewish people from all parts of Europe and the world who have so largely enriched our lives on this new continent; the workers from Mexico and from the East—Japan and the Philippines—whose labor has helped make the West and Southwest a rich and fruitful land.

And, through it all, from the earliest days—before Columbus—the Negro people, upon whose unpaid toil as slaves the basic wealth of this nation was built!

These are the forces that have made America great and preserved our democratic heritage.

They have arisen at each moment of crisis to play the decisive role in our national affairs.

In the Civil War, hundreds of thousands of Negro soldiers who took arms in the Union cause won, not only their own freedom—the freedom of the Negro people—but, by smashing the institution of slave labor, provided the basis for the development of trade unions of free working men in America.

And so, even today, as this National Labor Conference for Negro Rights charts the course ahead for the whole Negro people and their sincere allies, it sounds a warning to American bigotry and reaction. For if fifteen million Negroes led by their staunchest sons and daughters of labor, and joined by the white working class, say that there shall be no more Jim Crow in America, then there shall be no more Jim Crow!

If fifteen million Negroes say, and mean it, no more anti-Semitism, then there shall be no more anti-Semitism!

If fifteen million Negroes, inspired by their true leaders in the labor movement, demand an end to the persecution of the foreign-born, then the persecution of the foreign-born will end!

If fifteen million Negroes in one voice demand an end to the jailing of the leaders of American progressive thought and culture and the leaders of the American working class, then their voice will be strong enough to empty the prisons of the victims of America's cold war.

If fifteen million Negroes are for peace, then there will be peace!

And behind these fifteen million are 180 million of our African brothers and sisters, 60 million of our kindred in the West Indies and Latin America—for whom, as for us, war and the Point Four Program would mean a new imperialist slavery.

I know that you understand these problems—and especially the basic problem of peace. You have already outlined the issues in your sessions, and they are clear to liberty-loving men around the world.

Shall we have atom-bomb and hydrogen bomb and rocketship and

bacteriological war, or shall we have peace in the world; the hellish destruction of the men, women and children, of whole civilian populations, or the peaceful construction of the good life everywhere?

This for all men is the over-riding issue of the day. From it all other questions flow. Its solution, one way or the other, will decide the fate of all other questions which concern the human family.

For the warmakers are also the fascist-minded; and the warmakers are also the profit-hungry trusts who drive labor, impose Taft-Hartley laws and seek to crush the unions.

Depending on how we succeed in the fight for peace, then, we shall find the answers to the other two major questions of the day.

Shall we have fascist brute rule or democratic equality and friendship among peoples and nations; the triumphant enshrinement of the "master race" theories our soldiers died to destroy, or liberty and freedom for the American people and their colonial allies throughout the world?

And finally, shall we have increased wealth for the already bloated monopolies in the midst of rising hunger, poverty and disease for the world's poor; or shall the masses of toiling men and women enjoy the wealth and comforts which their sweat and labor produce?

Yes, these are the issues.

They will be resolved in our time—and you may be sure that you have met, not a moment too soon. Because in the five years since V-J Day the American trusts and the government which they control have taken their stand more and more openly on the side of a cold war which they are desperately trying to heat up; on the side of the fascist and kingly trash which they seek to restore to power all over Europe and Asia; on the side of the princes of economic privilege whose every cent of unprecedented profits is wrung out of the toil-broken bodies of the masses of men.

Mr. Truman and Mr. Acheson[3] want us to believe that they seek peace in the world. But the people's memory is not so short.

How well and how bitterly do we recall that soon after Roosevelt died American arms were being shipped to the Dutch—not for the protection of the Four Freedoms, not to advance the claims of liberty—but for the suppression of the brave Indonesian patriots in their fight for independence.

That was in 1946, and today—four years later—we have the announcement of another program of arms shipments to destroy a movement for colonial independence—this time arms for the French imperialists to use against the brave Viet-Namese patriots in what the French progressive masses call the "dirty war" in Indo-China.[4]

These two acts of the Truman Administration are significant landmarks of our time!

They cry out to the world that our nation, born in a bloody battle for freedom against imperialist tyranny, has itself become the first enemy of freedom and the chief tyrant of the mid-century world. They warn more than half the world's population who people the vast continents

of Asia and Africa that, until the course of our foreign policy is changed, they can no longer look to the U.S. government for help in their strenuous struggles for a new and independent life.

And, to be sure, they have already averted their gaze from us.

In every subject land, in every dependent area, the hundreds of millions who strive for freedom have set their eyes upon a new star that rises in the East—they have chosen as the model for their conduct the brave people and stalwart leaders of the new People's Republic of China.[5] And they say to our atom-toting politicians, "Send your guns and tanks and planes to our oppressors, if you will! We will take them away from them and put them to our own use! We will be free in spite of you, if not with your help!"

What special meaning does this challenge of the colonial world have for American Negro workers and their allies?

We must not forget that each year 4,000 tons of uranium ore are extracted from the Belgian Congo—the main source of United States supply. And that Africa also provides more than half the world's gold and chrome, 80 per cent of its cobalt, 90 per cent of its palm kernels, one-fifth of its manganese and tin, one-third of its sisal fiber and 60 per cent of its cocoa—not to mention untold riches yet unexplored.

And with this wealth, Africa produces also an immeasurable portion of the world's human misery and degradation.

But the African peoples are moving rapidly to change their miserable conditions. And 180 million natives on that great continent are an important part of the colonial tidal wave that is washing upon the shores of history and breaking through the ramparts of imperialist rule everywhere.

The Congo skilled worker extracting copper and tin from the rich mines of the land of his fathers may one day be faced with the same materials in the shape of guns provided his Belgian rulers by the Truman Administration under the Marshall Plan—but he is determined that the days of his virtual slave labor are numbered, and that the place for the Belgians to rule is in *Belgium* and *not in the Congo*.

And 25 million Nigerians—farmers, cattle raisers, miners, growers of half the world's cocoa—are determined that the land of *our* fathers (for the vast majority of American Negro slaves were brought here from Africa's West Coast)—shall belong to their fathers' sons and not to the freebooters and British imperialists supported by American dollars.

And twelve South African workers lie dead, shot in a peaceful demonstration by Malan's fascist-like police, as silent testimony to the fact that, for all their pass laws, for all their native compounds, for a continued oppression, the guiding intelligence of the independence aspirations of the Africans is invariably the organizations of the workers of the continent. Trade unions have arisen all over Africa and, as everywhere in modern times, they are the backbone of the people's struggle.

How are we to explain this new vigor of the African independence

movements? What is it that shakes a continent from Morocco to the Cape and causes the old rulers to tremble?

The core of the African nationalist movements, the heart of the resistance to continued oppression, the guiding intelligence of the independence aspirations of the Africans is invariably the organizations of the workers of the continent. Trade unions have arisen all over Africa and, as everywhere in modern times, they are the backbone of the people's struggle.

And what is true of Africa is even more strikingly true in the West Indies, in Cuba, Brazil and the rest of Latin America where 60 million Negroes are building strong trade unions and demanding a new day.

So it was a proud day in the history of the laboring men and women of the world when these African workers— railroad men, miners, mechanics, sharecroppers, craftsmen, factory workers— clasped grips with white, brown, yellow and other black workers' hands around the world and formed the World Federation of Trade Unions![7]

Abdoulaye Diallo, General Secretary of the Congress of Trade Unions of the Sudan, and a Vice-President of the WFTU, and Gabriele D'Arboussier, who was denied a visa to attend this conference, stand as signals to the world that the African worker recognizes, not only that his future lies in strong and militant trade unionism, but also in his fraternal solidarity with workers of all climes and colors whose friends are his friends and whose enemies are his also.

However much the official density of the top leadership of American labor may have prevented it from recognizing the real significance of the emergence of African labor, the American trusts and their hirelings in government have not been asleep. They have been steadily carrying forward their own plan for Africa, of which Truman's Point Four program is an essential though by no means the only part.

First, they say, we will spend the tax money of the American people to prop up the shaky empire builders of Europe who own and control most of Africa. And so the Marshall Plan sends billions to France, Italy, Belgium and Portugal.

Second, they say, as a guarantee that the money is not wasted, we will send them arms under the Atlantic Pact so that they may put down any rising of the African peoples, or any demonstrations of sympathy for colonial freedom on the part of their own working classes.

Third, say the American banker-imperialists, with these guarantees, we will launch Point Four, which opens the door for investment of capital by American big business in African raw material and cheap labor.

Fourth, as an added guarantee that the investment of American monopoly—already garnered as surplus profits from the labor of speeded-up American workers— does not run the "risk" of any changes in government or "excessive" demands for living wages by *African* workers, we will build our *own* bases in Accra, Dakar and all over the African continent.

And fifth, should all these precautions fail: should the African people eventually kick us and the British and the French and the Belgians and the Italians and Portuguese rulers out of their continent, then, says the Point Four program, we will compensate the American big business investors for their losses—again out of the public treasury, the people's tax money.

Yes, this is the Truman plan for Africa, and the Africans don't like it and are saying so louder and louder every day.

But is it only at the continent of Asia and Africa that the tentacles of the American billionaires are aimed? Indeed not!

Ask the people of Greece whose partisans continue an uneven struggle for democracy and independence as a consequence of the original Truman Doctrine![8]

Ask the Italian or French worker who, as a "beneficiary" of the Atlantic Arms Pact and the Marshall Plan, sees the ships bring American tanks and guns to his land while his children go hungry and ill-clad in the face of sky-rocketing prices!

Ask the workers in Scandinavia and Britain who are weary of governments incapable of meeting their needs because they are the slavish captives of the American money-men who seek to dominate the world!

Ask the millions in Western Germany who see American influence placing unrepentant fascists back into positions of power, before the stench of the Dachaus and Buchenwalds—the Hitler crematoriums and mass murder camps—have fully left the land.

Ask the proud citizens of the New Democracies of Eastern Europe and of the Soviet Union who suffered most in World War II and whose every yearning for peace and time to reconstruct their ravaged land is met by the arrogrant obstruction of American diplomats!

They know and they will tell you without hesitation—these people who are two-thirds of the world's population—that the seat of danger of aggressive war and fascist oppression has shifted from the banks of the Rhine to the banks of the Potomac, from the Reichchancellery of Hitler to the Pentagon Building, the State Department and the White House of the United States.

These peoples of the world look to us, the progressive forces in American life, Black and white together, to stop our government's toboggan ride toward war and destruction.

Do they look in vain? This conference answers, no!

Your tasks, then, are clear. The Negro trade unionists must increasingly exert their influence in every aspect of the life of the Negro community. No church, no fraternal, civic or social organization in our communities must be permitted to continue without the benefit of the knowledge and experience which you have gained through your struggles in the great American labor movement. You are called upon to provide the spirit, the determination, the organizational skill, the firm steel of unyielding militancy to the age-old strivings of the Negro people for equality and freedom.

On the shoulders of the Negro trade unionists there is the tremendous responsibility to rally the power of the whole trade-union movement, white and Black, to the battle for the liberation of our people, the future of our women and children. Anyone who fails in this does the Negro people a great disservice.

And to the white trade unionists present—a special challenge. You must fight in the ranks of labor for the full equality of your Negro brothers; for their right to work at any job; to receive equal pay for equal work; for an end to Jim Crow unions; for real fair employment practices within the unions as well as in all other phases of the national life; for the elimination of the rot of white supremacy notions which the employers use to poison the minds of the white workers in order to pit them against their staunchest allies, the Negro people—in short, for the unbreakable unity of the working people, Black and white, without which there can be no free trade unions, no real prosperity, no constitutional rights, no peace for anybody, whatever the color of his skin. To accept Negro leadership of men and women and youth; to accept the fact that the Negro workers have become a part of the vanguard of the whole American working class. To fail the Negro people is to fail the whole American people.

I know that you who have come from all parts of the nation will meet this challenge. I have watched and participated in your militant struggles everywhere I have been these past years. Here in Chicago with the packinghouse workers; with auto workers of Detroit; the seamen and longshoremen of the West Coast; the tobacco workers of North Carolina; the miners of Pittsburgh and West Virginia; and the steel workers of Illinois, Indiana, Ohio, Michigan and Minnesota; the furriers, clerks and office workers of New York, Philadelphia and numerous other big cities and small towns throughout the land.

I have met you at the train stations and airports, extending the firm hand of friendship. You have packed the meetings which followed Peekskill to overflowing, thus giving the answer to the bigots and the war-makers. I know you well enough to know that, once the affairs of my people are in the hands of our working men and women, our day of freedom is not far off. I am proud as an artist to be one who comes from hardy Negro working people—and I know that you can call on me at any time—South, North, East or West—all my energy is at your call.

So—as you move forward, you do so in the best traditions of American democracy and in league with hundreds of millions throughout the world whose problems are much the same as yours.

These are peoples of all faiths, all lands, all colors, and all political beliefs—united by the common thirst for freedom, security, and peace.

Our American press and commentators and politicians would discourage these basic human aspirations because Communists adhere to them as well as others. Now I have seen the liberty-loving, peace-seeking partisans in many parts of the world. And though many of them are not, it is also true that many *are* Communists. They represent a new way of life in the world, a new way that has won the

allegiance of almost half the world's population. In the last war they were the first to die in nation after nation. They were the heart of the underground anti-fascist movements and city after city in Europe displays monuments to their heroism. They need no apologies. They have been a solid core of the struggle for freedom.

Now, Mr. Truman and Mr. Acheson would have us believe that all the problems of this nation, and the chief difficulties of the Negro people are caused by these people who were the first anti-fascists.

I, for one, cannot believe that the jailing of Eugene Dennis for the reason that he contended that the House Un-American Activities Committee lacked proper constitutional authority[9] because it harbored as a member John Rankin who holds office as a result of the disfranchisement of the Negro half of the population of Mississippi and most of the white half as well—I cannot believe that Dennis' jailing will help in the solution of the grievous problems of Negro working men and women.

Mr. Truman calls upon us to save the so-called Western democracies from the "menace" of Communism.

But ask the Negro ministers in Birmingham whose homes were bombed by the Ku Klux Klan what is the greatest menace in their lives! Ask the Trenton Six and the Martinsville Seven! Ask Willie McGee, languishing in a Mississippi prison and doomed to die within the next month unless our angry voices save him.[10] Ask Haywood Patterson, somewhere in America, a fugitive from Alabama barbarism for a crime he, nor any one of the Scottsboro boys, ever committed.[11] Ask the growing numbers of Negro unemployed in Chicago and Detroit. Ask the fearsome lines of relief clients in Harlem. Ask the weeping mother whose son is the latest victim of police brutality. Ask Maceo Snipes and Isaiah Nixon, killed by mobs in Georgia because they tried to exercise the constitutional right to vote. Ask any Negro worker receiving unequal pay for equal work, denied promotion despite his skill and because of his skin, still the last hired and the first fired. Ask fifteen million American Negroes, if you please, "What is the greatest menace in your life?" and they will answer in a thunderous voice, "Jim-Crow Justice! Mob Rule! Segregation! Job Discrimination!"—in short white supremacy and all its vile works.

Yes, we know who our friends are, and we know our enemies, too. Howard Fast, author of the epic novel *Freedom Road* who went to jail this past Wednesday for fighting against the restoration of fascism in Spain, is not our enemy.[12] He is a true friend of the Negro people. And George Marshall, Chairman of the Civil Rights Congress, who went to jail last Friday[13] and whose fight for the life of Willie McGee of Mississippi is one of the great democratic sagas of our time—he is not our enemy; he is a true friend of the Negro people. And John Howard Lawson and Dalton Trumbo, Hollywood screen writers, who went to jail the day before yesterday for maintaining their faith in the sacred American doctrine of privacy of political belief—they too are friends of the people.[14]

Our enemies are the lynchers, the profiteers, the men who give

FEPC the run-around in the Senate, the atom-bomb maniacs and the war-makers.

One simple reason why I know that we shall win is that our friends are so much more numerous than our enemies. They will have to build many, many more jails—not only here but all over the world to hold the millions who are determined never to give up the fight for freedom, decency, equality, abundance, and peace.

I have just this past week returned from London where the Executive Committee of the World Partisans for Peace met to further their crusade against atomic destruction. And there, spokesmen of millions of men and women from all parts of the globe—Europe, Asia, Africa, North and South America, Australia—pledged themselves anew that the Truman plan for the world shall not prevail—that peace shall conquer war—that men shall live as brothers, not as beasts.

These men and women of peace speak not merely for themselves, but for the nameless millions whose pictures do not adorn the newspapers, who hold no press conference, who are the mass of working humanity in every land.

Did I say nameless? Not any more! For one hundred million have already signed their names in all lands to a simple and powerful pledge, drawn up at Stockholm—a pledge[15] which reads as follows:

> We demand the unconditional prohibition of the atomic weapon as an instrument of aggression and mass extermination of people and the establishment of strict international control over the fulfillment of this decision. . . . We will regard as a war criminal that government which first uses the atomic weapon against any country.

The Soviet Union and China are signing this pledge. People in all nations of the world are signing it. Will you take this pledge now? (Audience answers a loud "Yes!")

Your meeting tonight as men and women of American labor is in good time because it places you in this great stream of peace-loving humanity, determined to win a world of real brotherhood. It will enable you, I hope, to place the Negro trade unionists in the front ranks of a crusade to secure at least a million signatures of Negro Americans to this Stockholm appeal for peace.

As the Black worker takes his place upon the stage of history—not for a bit part, but to play his full role with dignity in the very center of the action—a new day dawns in human affairs. The determination of the Negro workers, supported by the whole Negro people, and joined with the mass of progressive white working men and women, can save the labor movement, CIO and AFL, from the betrayals of the Murrays and the Greens, the Careys, Rieves and Dubinskys—and from the betrayals, too, of the Townsends, the Weavers and Randolphs.[16] This alliance can beat back the attacks against the living standards and the very lives of the Negro people. It can stop the drive toward fascism. It can halt the chariot of war in its tracks.

And it can help to bring to pass in America and in the world the

dream our fathers dreamed—of a land that's free, of a people growing
in friendship, in love, in cooperation and peace.
 This is history's challenge to you. I know you will not fail.

Robeson Denounces Korean Intervention

Speech at rally sponsored by the Civil Rights Congress, Madison
Square Garden, New York City, June 28, 1950—Press release,
Council on African Affairs, June 29, 1950

NEW YORK—18,000 Americans, Negro and white, who
crowded Madison Square Garden the night of June 28 at a
rally sponsored by the Civil Rights Congress,[1] heard Paul
Robeson, Chairman of the Council on African Affairs, warn
that unless American intervention in Korea[2] and the rest of
Asia was stopped, Africa would be next in line. . . .
Speaking on the Korean crisis, Paul Robeson said:

A new wind of freedom blows in the East. The people rise to put off
centuries of domination by outside powers, by the robber barons and
white-supremacists of Europe and America who have held them in
contempt and, too long, have crushed their simplest aspirations with
the mailed fist. We may as well tell the oceans' waves to stand still as
to try to stop the tide of freedom flowing in the East. The peoples' will
for freedom is stronger than atom bombs and we may be sure the
people of Korea, Indo-China, the Philippines and Formosa will not
treat their invaders lightly any more.
 We have supported, not only the bankrupt Chiang in China, but all
the little Chiangs—equally corrupt and lacking in favor among their
peoples—all over the Far East.
 And the American people must resent this forced alliance of our
proud nation with the dishonorable quislings who stand, momentarily,
in the way of their peoples' strivings for freedom and independence.
 Our place has always been on the side of the Lafayettes, the heroes
of the French Revolution, Toussaints,[3] the Kosciuskos,[4] the
Bolivars[5]—not the Quislings[6] of Europe and the Chiangs, the Bao
Dai's[7] and the Syngman Rhee's[8] of Asia.
 The meaning of the President's order that the lives of our airmen
and sailors must be sacrificed for the government's despicable puppet
in Korea, shall not be lost to the millions in the East whose day of
freedom is not far off. And it will not be lost to the millions of
Americans who must insist louder than ever for peace in the world, for
real freedom everywhere, for security and brotherhood.
 Least of all will the meaning of the President's order be lost to the
Negro people. They will know that if we don't stop our armed
adventure in Korea today—tomorrow it will be Africa. For the maw of
the warmakers is insatiable. They aim to rule the world or ruin it.
Their slogan is all or none.

It has already meant our intervention not only in Korea, but in Formosa, the Philippines and Indo-China with arms, ships, aircraft, and men.

I have said before, and say it again, that the place for the Negro people to fight for their freedom is here at home—in Georgia, Mississippi, Alabama, and Texas—in the Chicago ghetto, and right here in New York's Stuyvesant Town!

Only this past Monday a united coalition of all the progressive forces in South Africa conducted a one-day demonstration against the government's policy of racial zoning. The people were called upon to quit their work and to devote the day to prayers, meetings and other activities against the reincarnation of Hitlerism which plagues their land.

How terrible a travesty on our democratic traditions for Negro youth to be called on one day to put down these brave African peoples! What mockery that black Americans should one day be drafted to protect the British interest in Nigeria whose proud people cannot be held in bondage for another ten years!

Fail to stop the intervention in Korea, and that day may come!

Fail to win our government to a policy of withdrawal from Indo-China, Formosa and the Philippines—a policy of recognition of the People's Republic of China—and that day may not be far off!

It is for us to take our place in history at the side of the popular masses who fight for freedom and independence. How long before we Americans shall emulate the brave freedom fighters of South Africa? How long before we shall have our FREEDOM DAY, where the people in every church and synagogue shall pray for freedom; when no one will work but all will speak and sing and talk and meet and petition for the freedom of the Trenton 6, the Martinsville 7, Willie McGee, the Groveland 3, Mrs. Ingram, George Marshall, Carl Marzani,[9] Eugene Dennis and his colleagues, the Hollywood Ten and the leaders of the Joint Anti-Fascist Refugee Committee—for AMNESTY AND PEACE?

The working masses of America stand for life, not death. We stand for the right of peoples to determine their own destinies. . . .

The people of the world are soberly determined that they shall have peace, and the people shall prevail. It falls upon our shoulders here in the United States to halt our government's intervention on behalf of the corrupt Rhee regime, no less than it was the responsibility of the British workers to prevent their government's joining the Civil War on the side of Jeff Davis' Confederates. The British workers fulfilled their jobs.[10] We will not fail in ours now.

The fight goes on all around the world—for peace, for increased activity in gathering signatures to the Stockholm petition, for letters and telegrams to the President demanding amnesty for the victims of the cold war—for a decent world and a good life for all the world's peoples!

Speech to Youth

Address delivered at First National Convention of Labor Youth
League, November 24, 1950—Pamphlet, *Paul Robeson Speaks
to Youth,* New York, 1951

I am happy and proud to take part in this first National Convention of
the Labor Youth League.[1] I am glad that my son and daughter are a
part of your vital organization and are working, through it, to make
their own contribution to a world of peace, friendship, and security.

You know, and I know, that there are people in our country who are
NOT happy about your meeting. They want you to be quiet while they
herd you off to fight the youth of Korea, China, Indonesia and Malaya,
the youth of the Soviet Union and the New Democracies—and, sooner
or later, the youth of Africa.

They want you to sit still while the Stassens and Eisenhowers turn
the universities into barracks and bludgeon your young, inquiring
minds into a meek conformity with the policies of the war-minded, the
racists, and the rich.

They want you to grow into a union-busting, scabbing generation in
order to insure their dominance over labor and their ever-mounting,
fantastic profits.

They want young America to absorb the anti-Negro and anti-Semitic
poison which their hack writers turn out in textbooks and newspapers
and radio and movie script—all for the glory of what they call the
American way of life.

But YOU say, No!

You say, No more war! Books not bullets! Bread, not cannon! Life,
not death!

You say, Peace! Friendship with the youth of the Soviet Union, of
the New Democracies and all of Europe, of China and the East, of
Africa and the West Indies, Latin America and Canada.

You say strengthen the trade unions as a means of securing
abundance for the nation and security for the youth—apprenticeship
training, adequate education, a chance for marriage without the
spectre of poverty, a well-rounded and fruitful youth and young
adulthood.

You say friendship, fraternity and equality of black and white. You
say Negro and white youth cannot and must not live in the same land
as strangers, or as enemies—that their common future depends upon
their common action, their learning to build the future together, their
social intermingling.

Thus is the issue joined between you and the men of the trusts and
monopolies.

An increasing number of the American people know that you are
right and they are wrong; that the future belongs to the youth.

For the big money men among us, and the politicians whom they control, are set in their ways. They are accustomed to a certain way of life and they do not possess the flexibility to change even though they see the handwriting on the wall.

They began at the turn of the century, in the war with Spain out of which they grabbed Puerto Rico[2]—and even before that in the predatory Mexican war a hundred years ago[3]—they began then dreaming dreams of empire and world domination and the white man's burden.

And in a hundred years they have not changed that dream. It has become a fixation with them.

But the people of the world have decided to make it a nightmare, to take their affairs into their own hands, to live in freedom, self-determination and security wherever they may be.

And then, after the bloody anti-fascist war of the '40's, the people of the Balkans said, "Our part of the world must no longer be a fuse to light the fires of war. We will transform it from a hell-hole of misery to an earthly paradise, from a tinderbox to a fraternity of peaceful lands." And so the new socialist-directed democracies arose in Czechoslovakia, Hungary, Roumania, Bulgaria and Albania.

And the imperialists again tried to put down the tide—through the Truman Doctrine in Greece, the wasting of the taxpayer's money in Turkey, the Marshall Plan all over Europe, the Atlantic Pact, the rearmament and renazification of Western Germany, insults, lies and threats of war.

But again the people would not be brow-beaten—even by the threat of the atomic bomb—and the people of Eastern Europe have gone ahead to reconstruct their shattered lands and buildings, strengthen their economies and enjoy their new life.

With the Soviet Union out of their grasp—one sixth of the earth's surface—and Eastern Europe established on a new basis of independence, American big business sought desperately to extend their holdings in the rest of the world. For they need the sources of cheap labor, the easy markets and the fields of investments in which to multiply the idle profits they have already wrung out of the toil-broken bodies of American workers, black and white.

Thirty-three years ago they decided in Russia that their economy, their culture and their very lives would no longer be the playthings of coupon-clippers, foreign or domestic, and the people set out to build socialism. Lincoln Steffens[4] saw the future there and said it worked, but the old empire builders were frightened and tried to stop it with 19 armies of intervention. They failed and were crushed upon the rock of the determination and the courage of a new Soviet people—but they have never stopped trying.

But soon there was another great rumbling in the world. And 475 million Chinese patriots said, "No more easy profits for you in our land, no more extra-territorial rights, no more insults and degradation for us! We will determine our future in our own way in spite of all the Trumans, Dulles,[5] Achesons, MacArthurs[6] or Chiang Kai-sheks whom

you can marshall against us." And with their victorious, liberating
war, the Chinese people began in earnest the transformation of all
Asia from a condition of dependence and unbelievable poverty to one of
freedom, dignity and security.

No wonder our atom-toting politicians have had few nights of easy
rest or calm conscience these past five years since the end of the
anti-Hitler war. No wonder our diplomacy has sunk to such unprece-
dented low levels and our statesmen seek the answer to the world's
problems in vain braggadocio, childish threats and, sometimes, when
no other solution presents itself, in suicide.

As I have said, they are men of the past. And, faced with a world
which is changing because it must, they shout, "Stand still! Don't move
an inch, lest you disturb our profits! Remain in your present poverty
and ignorance and disease and misery, because we like it that way! If
you insist on changing things, we'd rather not have a world at all. If we
must live with you as equals, we'll call it quits and blow the whole
world up with our weapons! We have the atom bomb, you know!"

But you, the youth of the land, are here to answer, "Oh, no you won't!
You may be tired, and afraid of a democratic world, but we, the youth,
are not. We are young and the world, for us, is young. We have a future
before us and it shall not be denied. So put your bombs away, sit down
and talk peace—or be prepared to move aside for those who will."

That's why big business and big brass fear the Labor Youth League.
Your very existence pricks their conscience, reminds them of their sins
against the welfare of the nation, increases their fear that they may
not have their way much longer as they have had in all these years.

And that's why progressive America salutes you, rallies to your side,
sees in you the guarantors of our early victory over fascism, war and
race hatred.

I hope that you will bear in mind as you proceed with this convention
and with your activities of the next year, that you are acting in the
best tradition of the young generations which have preceded you at
every critical moment of our history.

The Jefferson who wrote the Declaration of Independence was 32.
The bulk of the men with Washington at Valley Forge were teenagers
and young men in their early twenties from Connecticut, Massachu-
setts, New Hampshire and Vermont.

Denmark Vesey and Nat Turner were young men when they struck
for freedom.[7] And the incomparable Frederick Douglass was still a boy
when he whipped the slave-breaker Covey, still a minor when he broke
from Baltimore for freedom,[8] and was the outstanding figure on the
anti-slavery platform in the United States and in England as a young
man of 29.

I know that you will sweep aside—and that hundreds of thousands of
American youth will join you in rejecting the backward creed that
"youth should be seen, not heard," that you should leave world affairs
in the hands of pot-bellied, addle-headed, jingoistic elders.

Quite the opposite, you must insist, and the whole progressive

movement in America must support your contention, that the peace cannot be won, that fascism cannot be defeated, without the proper and vital contribution of the young generation of mid-century Americans.

I certainly know that the affairs of my people, the Negro people, must increasingly be placed into the hands of the forward-looking young men and women among us—and those of us older folks who share their young ideas.

No finer demonstration of this fact is needed than the role of Negro youth in the last great war against fascist brutality and in the years which have followed.

I hope that the Labor Youth League will be foremost among those in America who welcome and commemorate the glorious part which Negro young men and women are playing in our common struggles.

Let us remember, that in a lynch-ridden land, the first victims of mob violence are the young and hopeful—the Negro youth of the South (and the North, too) who have not yet learned—and I hope they will never learn—to "stay in their place"!

Remember the young couples—veterans and their wives—shot down in broad daylight at Monroe, Georgia, in July, 1946![9]

Remember the 19-year old Navy veteran at Columbia, Tennessee, who saw a white-supremacist of a storekeeper slap his mother in the face and decided that that was what he had fought a war to stop—and so knocked the white women-beater through a plate glass window, to protect his mother's honor. That, too was 1946, and as result Klan-inspired vandals killed the kin and sacked the homes of that young veteran in Columbia's ghetto.[10]

And let's remember, also in '46, Isaac Woodard, with his eyes gouged out because a South Carolina sheriff didn't like the idea of Negroes taking the war and its promises seriously.[11]

And in the same South Carolina, Willie Earle lies dead, horribly lynched by 28 self-confessed murderers who were set free by a jury of so-called free men.[12]

And when we think of sovereign Georgia we cannot forget the youth—the children of Mrs. Ingram who still suffer in bondage because they had the militancy and courage, and the humanity, to defend their mother's sacred honor.[13]

And Georgia has given us also a classic and monumental reminder of the temper and determination of Negro youth in the person of Maceo Snipes. He was of age and so went to vote as every citizen should. The Klansmen shot him down. And his mother, at his funeral, placed the hand of a younger child on his casket and had him swear that when he came of age he, too, would go to vote.[14]

And on September 8, 1948, when we were in the thick of the campaign for a man named Wallace, who seems to have forgotten all this[15]—forgotten his trip through the South and the face of American bestiality which was revealed there—on that September 8th another young Negro, Isaiah Nixon went to vote in the Georgia primaries in

Montgomery County. And he, too, was shot down when he returned to the doorsteps of his little farming shack.[16]

These heroes are but the outstanding examplars of a generation of Negro youth who are ready to pay any price for freedom NOW. They sense that their hour is at hand—after all the heartbreaking toil of their parents, after all the generations of slavery, hardship, abuse and second-class citizenship which they and their people have suffered in this great land—they know that the hour of real liberation is near and that much depends on them.

They know that if they fight now, and fight well, the segregated school will soon be a thing of the past, the NO JOBS FOR NEGROES signs will become historic relics, the Jim Crow swimming pools and playgrounds, the closed doors of professional and technical institutions, will soon be an unpleasant memory among Americans who live a real democracy.

Most important of all they know that these goals will not be achieved simply because they ought to be achieved. They have learned well the admonition of Douglass, that "Power concedes nothing without a demand. It never has and it never will."[17]

And so they, in the mass (not just a few advanced thinkers among them, not only the members of the LYL) but in the mass they are fast making up their minds that the place to fight for democracy and win is not against their young friends in Korea, China or the Soviet Union, but right where they've been fighting these last five years—in Mississippi, in Georgia, Tennessee, Texas and the Carolinas, and yes, in California, Indiana, Illinois, Michigan, Pennsylvania, Massachusetts and New York, too.

These Negro youth, then, must be regarded as invaluable sinews in the arsenals of any fighting organization of young Americans. I'm sure that you know that we cannot win without them and that with them fully and freely functioning in the membership and leadership of all our movements for progress, it's hard to see how we can lose.

I think the State Department must have had some inkling of this important historic fact when they refused to let numbers of the youth, including my own son, travel to Europe for the great World Peace Congress. For why should this proud and powerful American government be afraid of these youth? Could it be they feared they would transmit to the people of the world this burning desire of American youth, especially American Negro youth, for freedom and the good life?

Could it be they did not dare permit these youth to express their feeling of kinship with the dark-skinned youth of the colonies which Negro youth in America feel so keenly?

Could it be they were afraid that my son Pauli, for example, who spent a number of years of his childhood and youth in the Soviet Union, would certainly give the lie to the fantastic fabrication that the Soviet government and people are war-minded imperialists? Could it be they wanted to prevent his saying from a world platform that, in his

own knowledge, the people of the Soviet Union have abolished race hate and made any expression of it punishable by law, have wiped out poverty, have built a land in which people whose colors are as varied as those of all of us in this auditorium live in peace, friendship and a society of flourishing independent cultures.

I can think of no reason so cogent as these for the desperate and pitiful action of the State Department in having these youth join several of us here in their despicable program of "house arrests." But I promise you that they shall not succeed. I don't think they're going to keep the voice of any of the democratic, peace-loving people of this country from resounding all over Europe, Asia and Africa, and all up and down this land of ours.

Like Ol' Man River, I plan to keep fighting until I'm dying—or until my people are free.

And I'm sure nothing will stop the Labor Youth League from strengthening its organization, building the solidarity of the youth, and fighting for a land that's really free, in which men live in brotherhood, in security and in peace.

I look forward to the months and years ahead, in which you and I will find many occasions to join hands in pursuit of our common goals.

Paul Robeson's Column

"Here's My Story,"[1] *Freedom,* November 1950

The other day, as I walked the streets of Harlem, a well-wisher stopped to say "hello" and "good-luck." As we chatted, he paused for a moment and then, as though not quite certain he was doing the right thing, asked, "Paul, were you born in Russia?"

I laughed, of course, but then took the time to tell my friend the tale that makes up the body of this column. For what the question reflected was that, somehow, the masters of the press and radio had convinced at least this person that a person who fights for peace, for the admission of People's China to the UN, for friendship with the Soviet Union, for labor's rights and for full equality for Negroes now, cannot be a "real" American, must have been "born in Russia."

These are the objectives for which I will be fighting for some time to come, and to which this column is dedicated. So this is probably a good time to explain how I began and how I have come to feel the way I do about world affairs.

The road has been long. The road has been hard. It began about as tough as I ever had it—in Princeton, New Jersey, a college town of Southern aristocrats, who from Revolutionary time, transferred Georgia to New Jersey. My brothers couldn't go to high school in Princeton. They had to go to Trenton, 10 miles away. That's right—Trenton, of the "Trenton Six." My brother or I could have been one of the "Trenton Six."

Almost every Negro in Princeton lived off the college and accepted the social status that went with it. We lived for all intents and purposes on a Southern plantation. And with no more dignity than that suggests—all the bowing and scraping to the drunken rich, all the vile names, all the Uncle Tomming to earn enough to lead miserable lives.

My father was of slave origin. He reached as honorable a position as a Negro could under these circumstances, but soon after I was born he lost his church and poverty was my beginning. Relatives from my father's North Carolina family took me in, a motherless orphan, while my father went to new fields to begin again in a corner grocery store. I slept four in a bed, ate the nourishing greens and cornbread.

Many times I have stood on the very soil on which my father was a slave, where some of my cousins are sharecroppers and unemployed tobacco workers. I reflected upon the wealth bled from my near relatives alone, and of the very basic wealth of all this America beaten out of millions of the Negro people, enslaved, freed, newly enslaved until this very day.

And today I defy—any part of an insolent, dominating America, however powerful; I defy any errand boys, Uncle Toms of the Negro people to challenge my Americanism, because by word and deed I challenge this vicious system to the death; because, I refuse to let my personal success, as part of a fraction of one per cent of the Negro people, to explain away the injustices to fourteen million of my people; because with all the energy at my command, I fight for the right of the Negro people and other oppressed labor-driven Americans to have decent homes, decent jobs, and the dignity that belongs to every human being!

That explains my life. I'm looking for freedom, full freedom, not an inferior brand. That explains my attitude to different people, to Africa, the continent from which we came. I know much about Africa, and I'm not ashamed of my African origin. I'm proud of it.

The rich culture of that continent, its magnificent potential, gives me plenty of cause for pride. This was true of the deep stirrings that took place within me when I visited the West Indies. This explains my feeling toward the Soviet Union, where in 1934 I, for the first time, walked this earth in complete human dignity, a dignity denied everywhere in my native land, despite all the protestations about freedom, equality, constitutional rights, and the sanctity of the individual.

The present day sycophants of big business, the supposed champions of Negro rights, can't grow up to the knowledge that the world has gone forward. Millions and millions of people have wrung their freedom from the robber barons. There is no more Eastern Europe to bleed; no more Russia, one-sixth of the earth-surface, to enslave; no more China at their disposal.

They can't imagine that our people, the Negro people—forty millions in the Caribbean and Latin America, one hundred and fifty millions in

Africa, and fourteen millions here, today, up and down this America of ours—are also determined to stop being industrial and agricultural serfs. They do not understand that a new reconstruction is here, and that this time we will not be betrayed by any coalition of Northern big finance barons and Southern bourbon plantation owners. They do not realize that the Negro people, with their allies, other oppressed groups, the progressive sections of labor, millions of Jewish and foreign-born, of former white indentured labor, north, south, east and west, in this day and time of ours are determined to see some basic change.

This little paper is begun to help make that determination a reality, and I am proud to be connected with it.

I am confident that by your support, you will help us make FREEDOM the real voice of the oppressed masses of the Negro people and a true weapon for all progressive Americans.

Our People Demand Freedom

Message to Second World Peace Congress[1]
—*Masses & Mainstream,* January 1951, pp. 65–7

A century ago a great leader in the freedom struggles of my people, Frederick Douglass, stood in England as you do today and called for the support of the British people in the battle to overthrow slavery. He recognized then that the interest of his enslaved people could not possibly be served by any aggressive policy of the slaveholding government. He said to a British friend:

> Sir, you need not be afraid of war with America while we have slavery in the United States. We have three million of peacemakers there, sir, the American slaveholders can appreciate these peacemakers, three million of them stand there on the shores of America and when our statesmen get warm why these three million cool, when our legislators' tempers get excited, these peacemakers say, 'keep your tempers down, brethren.' The Congress talks about going to war, but these peacemakers suggest what will you do at home?
>
> When these slaveholders declaim about shouldering their muskets, buckling on their knapsacks, girding on their swords, and going to beat back the scourge of foreign invaders, they are told by these friendly monitors, 'Remember, your wives and children are at home. Reflect that we are at home. We are on the plantations, you'd better stay at home and look after us. . . .' The slaveholders know this, they understand it well enough.

In the same farewell speech to the British people Frederick Douglass explained his feelings on returning to the United States. He said:

But I go back to the United States not as I landed here—I came a slave—I go back a free man. I came here a thing, I go back a human being. I came here despised and maligned, I go back with reputation and celebrity, for I am sure that if the Americans were to believe one tithe of all that has been said in this country respecting me, they would certainly admit me to be a little better than they had hitherto supposed I was.

I return, but as a human being in better circumstances than when I came. Still, I go back to toil. I do not go to America to sit still, remain quiet and enjoy ease and comfort. I prefer living a life of activity in the service of my brethen. I glory in the conflict that I may hereafter exult in the victory.[2]

The life and struggles of this outstanding American of the nineteenth century afford me great inspiration as I find myself separated from you by the edict of the United States State Department.[3] You may be assured while I remain in the United States a victim of the detestable program of house arrests initiated by our government, while I cannot be in your midst and among many friends from all parts of the world, as has been my custom in years past, I do not remain quietly or to live a life of ease.

I remain in the United States as Douglass returned to it, and in his words, "for the sake of my brethren." I remain to suffer with them, to toil with them, to endure insult with them, to undergo outrage with them, to lift up my voice in their behalf, to speak and work in their vindication and struggle in their ranks for that emancipation which shall yet be achieved by the power of truth and of principle for that oppressed people. And so today at this World Peace Congress we move forward in the best traditions of world democracy, representing as we do the hundred of millions throughout the world whose problems are much the same. We are peoples of all faiths, all lands, all colors, of all political beliefs, united by the common thirst for freedom, security and peace.

Over here our American press and commentators and politicians would discourage these basic human aspirations because Communists adhere to them as well as others. Now I have seen the liberty-loving people and peace-seeking partisans in many parts of the world, and though many of them are not, it is also true that many are Communists. They represent a new way of life in the world, a new way that has won the allegiance of almost half the world's population. In the last war they were the first to die in nation after nation. They were the heart of the underground anti-fascist movement, and city after city in Europe displays monuments to their heroism. They need no apologies. They have been and are the solid core of the struggle for freedom. And today in America we proudly fight to free the eleven leaders, the Communist leaders, of the American working class, as well as many

others who suffer bitter persecution. In this struggle for peace and a decent life, I am sure that we shall win. One simple reason why we shall win is that our friends are so much more numerous than our enemies. There are millions and millions all over the world who are determined never to give up the fight for freedom, decency, equality, abundance and peace.

And surely this conference will give the deepest hope and courage as the spokesmen of the millions of people throughout the globe, the mass of working humanity in every land—in Europe, Asia, Africa, North and South America, Australia, pledge themselves anew that the Truman Plan for the world shall not prevail, that peace shall conquer war, that men shall live as brothers, not as beasts.

Unified, I am sure that we can beat back the attacks against the living standards and the very lives of the people, that we can stop the drive toward fascism, that we can halt the chariot of war in its tracks. And we will help to bring to pass in the world the dreams our fathers dreamed of lands that are free, of people growing in friendship, in love, in co-operation and peace. This is history's challenge to us. I know as do you that we shall not fail.

The Road to Real Emancipation

"Here's My Story," *Freedom,* January 1951

January is the month of emancipation. This season with its connotation of dawning freedom is close to me. My own father—not my grandfather—was a slave. He was born in 1843 in Eastern North Carolina near Rocky Mount, and escaped in 1858 over the Maryland border to Pennsylvania. He worked on farms, earned enough money and went back twice to North Carolina, to carry money to the mother he loved so dearly. So he escaped three times by the underground railroad.

Maybe he sang *Go Down Moses* as Harriet Tubman came to lead fortunate ones to a northern or Canadian "Canaan." Maybe he knew Frederick Douglass—who castigated a slave land for the caricature of democracy it claimed to be.

That father reared me—almost alone. My mother died when I was barely six years old. One thing I learned as a youth—poor, ragged, but loved and helped by my struggling aunts, uncles and cousins in New Jersey and in Robinsonville, North Carolina. I learned that Emancipation—Freedom—meant freedom for all my people, not just for a few wealthy and fortunate Negroes, but for all of us. And I knew I had a right to look for Freedom and Emancipation. Emancipation means out of the hands of—out of the hands of former masters and oppressors. And I've spent my life finding out how to use my own hands—my own talents—for this is a necessary part of the dignity of any people.

So today this struggle for full emancipation is for every little boy and girl—like the beautiful little child in the opposite column. He has a right to emancipation as yet denied, almost 100 years after his forefathers were supposed to be "henceforth and forever free."

Recently I traveled into Ohio to talk about our paper, FREEDOM, and to sit at close quarters with workers in the plants, to visit the churches and walk along the avenues, to sit around and exchange opinions in the homes of friends. I also met with business and professional men and women and said hello to many of my fraternity brothers. I saw the youth and witnessed the friendship of black and white, of native and foreign-born. I felt again the closeness of the age-long struggle of the Negro and Jewish people, peoples with the same heroes—Moses, Joshua, David.

In Toledo I had a chance to take part in building a popular struggle for the freedom of Curtis Hopkins. Here is a Negro threatened with extradition to Mississippi by Truman's Justice Department, under an outmoded fugitive slave law—after the State of Ohio has repeatedly refused to return him to the scene of his oppression! I met with Mrs. Hopkins and a committee of citizens dedicated to the task of freeing her husband. I vividly remember two brave Negro ministers from the committee and a fine newspaperman who made me feel proud of the Negro press.

In my mind I was taken back to Wales, to the England of the thirties. There I met the same kind of people, the miners' families and their leaders—inheritors of a proud and rich culture, oppressed in modern England, but fighting on. This Wales was the background of my film, "Proud Valley" or "The Tunnel."[1]

I remembered the workers of France who became the heart of the French resistance: the peasants and workers of Spain, of Norway, Denmark, Sweden. I remembered the people of the Soviet Union whom I visited in 1934. Emancipated from slavery about the same time we Negroes were in the United States, in 1863, they had, by 1934, rid themselves not only of their Jeff Davises, but of their Rankins and Lanhams, of their Reynolds and DuPonts. Their land—their 40 acres and a mule—belonged to them. They were not cheated out of them as we were by a bi-partisan Democratic and Republican betrayal.

And it is a cruel twist of history that the modern counterparts of the big-party bankers and politicians who betrayed our Emancipation in 1876 now want us to fight against peoples whose main achievement is that they have won the freedom Negro Americans still seek.

For let us be clear: that's the meaning of this Korean adventure which is costing the precious lives of our youth—the youth whom we Negro people need for our constructive future.

But we want peace, not war of any kind.

We hear a lot of talk from our diplomats about the American people's responsibility to the free nations of the West! What free nations? England which bled and still bleeds India and holds Africa in

chains? The Belgian millionaires who live off the bodies of our brothers and sisters in the Congo? South Africa which robs the Africans of billions yearly while treating them worse than Birmingham, Alabama Ku Kluxers? The "free" nations which still keep in modern selfdom a West Indies and a Puerto Rico which have been ready and eager for self-rule long ago?

No, on this anniversary of emancipation we can surely not think of sacrificing our youth and ourselves to preserve these empires built on the blood of our ancestors. And sacrifices to what end? To the world's destruction!

Well, if we want to enjoy this earth, we will have to fight for peace. We can struggle for emancipation only through peace which will allow our colonial brothers to build and grow strong. Their strength is our strength, let that be clear. Do we want a free Africa, a free West Indies? Then how can be help imperialist England or France to regain strength by shedding our precious blood in a war against colored peoples?

A strong, modern China formerly oppressed by the same people who oppressed and continue to oppress us, by the same financial robbers who have waxed fat on our fathers' cotton-field labor—this new China is and must be interested in our full emancipation. So, too, the Soviet Union, millions of whose peoples are colored (yellow, brown and black), a nation whose great poet Pushkin was unmistakably Negro and is honored today as is not even Shakespeare in England—this Soviet Union, and other nations like it, is a strong guarantee of an emancipated Africa.

We therefore help ourselves by refusing to hear any talk of war. There's no need to worry who you'll fight or not fight. Fight no one! Fight for peace, for jobs, good wages and shorter hours, for the right to vote in the South—for the future of your children. That is the road to real emancipation at the dawning of the second half of the 20th century.

Negro History—History of the Whole Negro People

"Here's My Story," *Freedom,* February 1951

Is the history of the Negro people in the United States to be measured only by the achievements of a number of outstanding individuals—as important as are these successes? I submit that our history is exactly what the words say—the history of the *whole Negro people.*

This history is not individual, but collective in its essence. It is a history of the group. Our forefathers were herded into slave ships— herded onto the Southern plantations—and throughout the 250-or-so

years of slavery we were herded and oppressed as one solid mass of humanity. We rebelled as one group, and with our allies, we fought our way to Freedom as a compact and great family unit.

No people feels more than we that what one Negro does affects the whole people. When I was playing football I had always to remember—whatever the provocation—that I represented a whole people. I had to play clean, and I did. Of course, once in a while the ambulance rolled up to take off one of the rough boys who had called me all the names in the book and slugged me every which way—but nobody ever saw me hit him. Of course he was gone, but he somehow managed to fall right into my knee or my swinging elbow or fist. 'Twasn't my fault. And I always helped pick him up—so tenderly.

And in my classes I had to stay up late to prove that Negroes could also measure up in their studies. But every Negro boy and girl knows and accepts these obligations. We all know that we have a group responsibility.

And today, by the same measurement, until the great majority of the Negro people have equal opportunities for advancement—until we all, every one of our little boys and girls all over this land—have full equality in every phase of our social life, Negro history cannot rest with the recital of personal victories, however fine.

In fact, I found that this was apt to work in reverse. The rulers of this land—keeping the millions of our people in near-serfdom and poverty: exposing us to terror and gross inhumanity—always point to the permitted achievements of a few of us in justification.

For myself, I got tired of serving as an excuse for these cruelties to my people. I felt that I and they no longer possessed simple human dignity. So I stopped—to join in the mass people's struggle of the Negro and the other oppressed groups in this nation.

Today I'll have to leave the dubious honor of being used as excuses for the daily insults and indignities to the Negro people—of being used as fronts for the failure to give my people basic rights of first class citizenship—this honor I must leave to the Walter Whites, the Lester Grangers, the Adam Powells.[1]

Imagine Powell rushing the Negro people (who ever told him he could speak for everybody!) into a war which is certainly not a war to all the rest of America—the government included—and declaring that we will not "squawk" even a whisper against the attempt to start a war, a war which even the brass hats themselves (MacArthur and all of them) can't unleash, for good and sufficient reasons. The main reason being the power of the people, Americans and others in this world, who want peace, not war.

If Mr. Powell and Mr. White are so terribly anxious to prove their patriotism, why don't they rush over to Korea and take the place of Lt. Gilbert and his other co-fighters who face white-supremacy frameups in a jimcrow army?[2] Just at the time that all over America, from every group, there is a clarion call to the Administration to get out of Korea,

to seat the new and real China in the United Nations, to find ways for peace and trade in a world of the peaceful co-existence of many ways of life, these super-patriots—looking for a soft job, diplomatic and otherwise, at the expense of the Negro group—rush in where even the Ernest T. Weirs and Walter Lippmanns[3] fear to tread.

Now, the bulk of the Negro people—the Negro worker, the struggling Negro, the aspiring but frustrated youth—realize that at this moment we must look at history anew. Against the background of a terror-ridden Martinsville, Harlem or Birmingham, he sees a changing world emerge—a free China, an India struggling to break its remaining chains, a restless, militant West Indies and Latin America, a smouldering Africa. He is beginning to understand that the full freeing of these lands will mean a free South for Negro and white poor labor—a free people's America.

In the long run, the 95% or more of the laboring and poor farming sections of our people, North and especially South, are the power. They are the power in the churches, in the fraternal organizations, in the clubs—in any of the important organs of Negro life. They support the doctors, the lawyers, the scientists, the artists. Take the base away and nothing remains.

Waiting eagerly to play their historic role are magnificently equipped Negro trade union leaders, powerful figures in the labor movement from coast to coast. These sincere, courageous men and women stand ready to accept a tremendous responsibility. The responsibility of dedicated leadership—together with important militant fighters of the Negro ministry, with potentially large sections of Negro intellectuals, who must know, or if not must learn and never forget that we Negroes will all go up or stay down together.

These Negro working people know through bitter experience in labor struggles that the true allies of the Negro people are the oppressed and hard-driven fellow white workers in steel, coal, iron, maritime, packing, tobacco, sugar, cotton, distributive trades, fur and leather, and other industries. They earnestly seek unity with foreign-born, Jewish, and poor white Southern workers—because all are victims of the same ruling class fanaticism of Anglo-Saxon superiority.

Our paper, FREEDOM, certainly receiving invaluable aid from the experience and knowledge of the trade union and progressive leaders among us, must root itself in the people of this land, especially the Negro people. It must address itself to the eagerly awaiting masses, must become a fearless fighter for our full rights, for our full dignity. It must become a voice such as does not exist in the Negro press at this time.

If we do this we will be fulfilling in a magnificent way our present historic tasks: the fight for peace, for liberation of the Negro people, for the dignity of the whole American people, for friendship with people's governments, for close ties with the advanced sections of the working peoples, white and colored, all over the world.

Set Him Free to Labor On—
A Tribute to W. E. B. Du Bois

Freedom, March 1951

W. E. Burghardt Du Bois[1] is a human being full flowered—of the highest intellectual training in most diverse fields, and with it all so direct, so devoted to the finest simplicity. His is a rich life of complete dedication to the advancement of his own people and of all the oppressed and injured.

First, let us not forget that he is one of the great masters of our language: the language of Shakespeare and of Milton on the one hand; and, on the other, of the strange beauty of the folk speech—the people's speech—of the American Negro. He is a great poet, one of whom all America is proud.

In these days of stress and struggle I often pick up one of his many volumes, most frequently *The Souls of Black Folk.*[2] How I love to give myself up to those rich cadences, to receive sustenance and strength from those lines so deeply imbedded in the folk style of our people; yet enriched and heightened by the artistic gift of this deep-feeling prophet.

For Dr. Du Bois gives us proof that the great art of the Negro has come from the inner life of the Afro-American people themselves (as is true of the art of any group)—and that the roots stretch back to the African land whence they came. He, like so many other great artists, turned to the people for the deepest fount—like Haydn, Bach, Schubert, Dvorak, Bartok, Tchaikovsky, Pushkin, Moussorgsky, and Mayakovsky, great poet of the Russian revolution.

And by his very participation in the people's political and economic struggles, he underlines the most important fact: that culture comes from and belongs to the people: that one aspect of our struggle is the obligation to bring this culture back to the people.

Du Bois has a sense—nay, a profound knowledge—of history, and striking it is that at the most decisive moment in the history of colored America Du Bois is in the ranks of the Negro people—that he is a friend of the Soviet peoples, of the Chinese people, of the new Eastern European People's Republics—that he is a part of progressive America—that he hates and exposes the shams of the ruling class of this country, together with their would-be big-shot Negro stooges who dance to any tune they're told.

Dr. Du Bois brings with him the best and most honest of his former associates and joins with the working-class leaders of the Negro people—those closest to the masses—in giving common leadership to a fierce and uncompromising struggle. Today the essence of that struggle is the fight for peace—the fight for the rights of hundreds of

millions of colonial and semi-colonial colored peoples—to choose their own ways of freedom, their own ways of life. The American Negro's liberation lies on this stream—a most powerful and untamable stream.

Puny men in important offices in our land dare attack and even indict Dr. Du Bois. The great masses will give their answer and set him free to labor on.

Dr. Du Bois, by his full participation and dedication to the people's struggle, gives new meaning to the history of the Negro in his long and courageous fight for all liberation.

Recollections of a Trip

"Here's My Story," *Freedom,* March 1951

I have just returned from a most instructive and deeply moving journey around the East and Middle West. All the cities brought back memories of concerts in the past to thousands—in the Philadelphia Academy of Music, with the Orchestra in Symphony Hall, Boston, in Orchestra Hall, Chicago, and the Mosque, Detroit, and the beginnings of *Othello* at Brattle Hall, Cambridge, outside of Boston.

Most precious of recollections was Cadillac Square, Detroit, when CIO took over Ford, and the picket lines in Packing, Farm Equipment and United Electrical, and Steel in Chicago and elsewhere.

Everywhere there was deep concern and troubled anxiety about our country's policies; about the open attacks upon honest forces of labor; deep sorrow and anger about attacks on the Negro people of this nation.

A decisive change has come, as far as I could judge. The fight is on to bring thousands and thousands of the people into militant struggle for our rights, economic, political and social—and, most of all, for our very lives.

Today Big Business is back in power in Washington, and men like the Johnstons and Wilsons[1] cackle and slap their thighs in contempt as they literally throw labor out of their offices. The big boys tell the Negro people they must not dare fight for their rights, to organize in the South, to fight for better jobs in the North, to get out of the ghettoes, to move toward full national liberation—and the Big Brass fight fiercely for a war economy and continued threats of war to beat the Negro people into submission.

This trip made me more than ever deeply proud and happy that I decided way back to give my talents and energy to the working masses.

They threw their arms around me literally and in spirit. They said, "Paul, you look fine." "Take care of yourself." They gave me the best of their experience and knowledge to bring back to our paper FREEDOM and to our common struggle. They said, "Paul, sing us a song—and take care of your voice. We've got to have some concerts soon. They

can't stop you from singing—you belong to us." And they certainly saw to that in Detroit, Boston and Philadelphia—and the other night in Chicago.

That evening I shall never forget. A packed Southside Chicago church—Metropolitan Community Church—a concert, beautifully arranged by the Southside Negro Labor Council, with its emphasis on the struggle of the Negro people for full freedom and liberation.

The church was full of workers and their families, including the children—proud working-class leaders of the Negro people helped and supported by their white working brothers and sisters, challenging the few Negro big-shots like Townsend and Dawson—challenging them in the heart of the Negro community. And there was Rev. Evans of the militant ministry, giving a stirring plea for peace, God bless him!

During this trip my mind went to the Black Belt of the South, the real heart of the problem. Measured by what happens there we Negroes in this great land survive or perish. We can move around in Harlem, the South Side, Antoine Street, Massachusetts Avenue, and South Street—terrorized, ghettoed, accepting the crumbs as they fall, being misled by a few top collaborators who boast of being go-betweens between the poor Negro and the millionaire white—but the Black Belt will decide the age-old issue of whether or not the Negro has rights that the white Bourbon is bound to respect.

For as long as any boy or girl can be denied opportunity in Alabama, Georgia, South Carolina and Mississippi—so long as one can be lynched as he or she goes to vote—so long as the precious land does not belong to the people of that area (and with land, the wealth that flows therefrom in agriculture and in industry)—so long as they do not have full opportunity to develop and enrich their cultural heritage and their lives—so long are the whole Negro people not free.

Don't say it's impossible to change this. China was "impossible" not long ago. African freedom, West Indian freedom, Puerto Rican freedom are not impossible. Neither is ours.

These are some of our tasks.

I know that I, for one, after this trip, seeing and experiencing the collective power of my people and their true and honest allies—I know that we all should and must feel "powerful strong," that we should and must feel some of the mountain-moving strength of our legendary John Henry. So let us get into the fight, let us continue steadfast, let us journey on to a Mt. Zion right here on this American earth.

The People of America Are the Power

"Here's My Story," *Freedom,* April 1951

All through my youth—in my mind and in fact—I was a part of a large family, a family to which I was responsible. And this family stretched out from Harlem to Washington, Baltimore, Richmond, North Caroli-

na, Chicago, all across the nation—wherever the Negro people lived and struggled.

My songs were the songs of my people—for five years I would sing no others. Later, when from my travels I saw the likenesses between songs of different peoples, I learned their languages and began to sing the folk-songs of the African, the Welsh, the Scotch Hebridean, the Russian, Spanish, Chinese, the Yiddish, Hebrew and others.

I loved the peoples' songs created through the ages. I felt so much more at home with these than with so-called art songs of individual composers. And today I choose those individually composed songs which are rooted in and deeply remindful of the folk tradition.

I searched and searched, listened and listened. I learned that in music, whoever the composer, the base and firm foundation was always the peoples' music.

Bach—a name a working man might run away from—Bach used the simple Lutheran chorale, simple hymn tunes such as "A Mighty Fortress Is Our God" as his point of departure. He got a little bored at the organ and began to dress them up with some fancy runs up and down, but the simple chorale was always the most beautiful core.

And the same is true for every great composer. Yet the people, the earliest creators of the sources of our art, were excluded from any real participation in the culture of the various communities.

An artist did not and could not live in some rarefied atmosphere far from the problems of the people. Certainly not the interpretive artist like the singer or the actor. By the very nature of his "hiring" he served someone. If he sang in Negro churches he served the Negro people. If he sang in the big concert halls of the nation he served the "big folks." If he sang in the commercial picture houses, on the radio or in pictures, he was a part of the "bread and circus" policy of those who owned these mediums to "keep the people happy."

These things were becoming clear to me when one day in London, in the early Thirties, I went out on picket lines to sing for workers in their struggle for better pay and working conditions.

I turned to the workers as the real allies of my people. I began to sing for them, to act for them. I gave up two years of my time then—way back in 1936–37—to help build workers' theaters in Great Britain, to help develop a working-class culture in the full meaning of that term.

I knew I was fighting for my people, the Negro people. Most of them were working people like these English workers, like the Welsh miners I knew so well. I tied all this together. I saw the same British aristocracy oppressing white English, Welsh and Scotch workers and African and West Indian seamen, and the whole of my people in these lands.

Then two years ago in England I had the pleasure of singing with magnificent choirs of workers. One was headed by Mrs. George Thompson, wife of a leading working-class scholar,[1] an outstanding authority on classic Greece. I saw bookstores, museums, theaters, actors, motion picture units and directors—all devoted consciously to

the problems and welfare of the working masses, serving the workers, not those who deprived the workers of the right to participate in culture.

Today I feel a close part of the family of the Negro people here in America among whom I was born, and I feel close also to my cousins in Africa and the West Indies and Latin America. I also feel a part of many peoples of all colors throughout the world who I know have a common bond with us, the American Negro people, in our battle for full citizenship.

And as I approach another birthday I think of the close ties of the Negro people with tens of thousands of honest American white working people and courageous liberals all over this land, North, South, East and West.

For us in Harlem this closeness, this extension of the "family" was demonstrated at Peekskill. There 25,000 people, white and colored, stood together in a real defense of our American liberties: the right of assembly, of free speech, the right of the Negro people to full citizenship. These people defied the Ku Kluxers and would-be lynchers and again I felt myself a part of a tremendous collective strength and power.

They were all bent on preserving the decent, the true America. Here was a loyalty I could understand and act upon. This America wants a chance for its children to grow up without fear. It wants them to grow up in a land which knows no poverty, slums and Jim Crow oppression; a land which recognizes a world in change, a world of different ways of life; a land which refuses to sacrifice its precious youth to the folly and greed of the few but powerful inheritors of the robber-baron, gangster-imperialist tradition of American life.

Such an America will gladly and courageously assume its grave responsibility to impose the peace upon our own home-bred would-be destroyers.

The people of America are the power. They can save their land if they will. But this means the saving of every precious life—of Willie McGee, of the Trenton Six. It means preserving the liberties and freedom of those who are most ready to sacrifice for the "family."

We must not let them be sacrificed. We need them to lead us and give us strength. So we must save the eleven leaders of the American working class. We must save Dr. Du Bois and William Patterson.[2] If we do we save thousands, yes, millions; because we remove the terror hanging over the heads and lives of all workers, of all intellectuals and liberals, of the whole Negro people.

The forces of progressive liberalism have the power, if fully united and utilized, to move the majority of the American people to the peace and friendship which they so obviously and clearly desire.

All of these deep beliefs explain my statement on behalf of peace in Paris two years ago, explain my hopes and my daily labors. I am not making great sacrifices which need fanciful explanation. I am simply fulfilling my obligation as best I can and know how, to the human family to which I proudly belong.

Conversation About the New China
"Here's My Story," *Freedom,* May 1951

"So what's this stuff about China wanting to conquer the world, Paul?" asked a friend of mine on the Avenue. "You've been all over. Tell me, is MacArthur handing out a line?"

My friend was a railroad man I have known for years. Came up from Texas about fifteen years ago. Married, settled down, trying now to keep his family of four together on $3,000 a year, which is a whole lot better than most of my folks are doing. But I figured for that very reason he had a big stake in peace. So I told him what I thought and how I came to think of it.

"Jack," I said, "I want you to go back in your mind to Texas. Think about the way our folks live down there, and not only in Texas but in Mississippi and Alabama and Georgia and the Carolinas, too.

"I'm not talking about the handful of doctors and lawyers and businessmen out in some exclusive Sugar Hill section of the ghetto. But what about the majority of the people? You know how it is— hunger always in the house, debts piling up, not a mumbling word on how they are going to be governed or who's going to be the government, and the police or the hoodlum always stalking them. That's right, isn't it?

"Well, there are 500 million Chinese, and for centuries about 499 million of them have been living just like our folks in the South. Every year millions of them used to starve to death. And right in the biggest cities of China where the big powers had concessions, there were hotels and restaurants and clubs that a Chinese couldn't go in unless he was a servant. Yessir, that big country of China was a jimcrow country, just like our country.

"Then comes along a man named Sun Yat-sen and after him a man named Mao Tse-tung, and the first thing Mao did was put an end to the big plantation system that was starving the Chinese to death. That was the first thing, and I want to tell you, brother, it's a pretty big thing when you fix it so that 499 million people will be free from hunger for the rest of their lives and their children's lives.

"The second thing Mao did was put an end to Jim Crow. And when I say 'an end,' Jack, I mean 'an end.' Never again in China will any Englishman or American kick around a Chinese rickshaw driver, or put up a sign on a building to keep Chinese out. That's gone, brother.

"Well, now, I want to ask you a question. Just suppose our folks in the South got the land they've been tilling all these centuries for the big plantation owners. Suppose they got rid of Jim Crow and started governing themselves. I'm not asking you to imagine anything fantastic, because that's going to happen someday.

"And another question is this. Suppose that after they started enjoying this new life, a slaveholders' army should suddenly attack

Cuba or Mexico, and should make it plain that they were not going to
stay in Cuba or Mexico once they get it under their control, but would
come on over to the South and restore the old ways of hunger and
jimcrow. What do you think our folks would do then? Would they just
sit still and wait till the slaveholders moved down on them, or wouldn't
they go to help the Cubans and Mexicans stop the slaveholders there?

"That's the way I see it, Jack. So I don't have to answer your question
about my opinion of what either MacArthur or Truman are saying.
Neither one means the Chinese people any good. They're fussing about
the best way to do the same thing, whether to attack the Chinese
mainland now or later. And if you have any doubt about what their
aims are, take a look at Japan since MacArthur's occupation. It's a Jim
Crow country. And so is South Korea. Why they won't even let South
Korean newspapermen have the same privileges as white American
newspapermen.

"You know how I know all this? Reading and study, partly. I've been
studying Chinese for a long time now. To learn a people's language you
have to learn their history and how they live.

"In Moscow some years ago I met three young Chinese, a fellow
named Jack Chen and his two sisters. Jack was a newspaperman, one
of his sisters was a motion picture technician and the other was a
dancer. Their father was part Chinese and part Negro. He had lived in
the West Indies and had served under Sun Yat-sen at the birth of the
Chinese Republic.

"Jack was a slight chap, medium height and soft-spoken. He spoke
beautiful English. He came to my concerts and we sat around many
nights and talked of China and its future. This was in 1936 and '37.
Later I met him in London, and we often appeared there for China
Relief.

"It was an interesting experience to see and meet a Chinese who was
part Negro and felt close to both his people. I believe he is now back in
China—the new China—helping to build a better life for his country-
men.

"Also I remember appearing for a Korean group, some years ago,
and singing an old Korean melody popular throughout that country.

"I find it ridiculous to even imagine these two peoples embarking on
predatory war to conquer other peoples. Just as I know no frameup of a
Lieutenant Gilbert could ever happen in a Chinese people's army. No
soldiers from one of the many minority peoples of China would be
driven to mass courts-martial because their skin might be a little
darker, or their language might be slightly different. No sections of
either the Korean or the Chinese armies are set apart to do all the
menial labor while others do the fighting, or whenever the going gets
really rough, are set up to be sacrificed while picked lighter-skinned
units are allowed to withdraw.

"That's why I'm for a peace right now that will call all foreign troops
out of Korea, certainly including our own boys who are not helping to
tear down one single 'Colored Only' sign by dying in Korea. As I have

suggested, no American soldiers—white or colored—should be there. And furthermore, I'm for a peace of equality, which is the only kind of peace that will endure. I positively oppose this white supremacist trick of excluding China from the United Nations. And I'm for the five great powers sitting down to negotiate an immediate peace. You see, Jack, if we're going to get anywhere against Jim Crow in our own country, we can't do it by letting the man impose Jim Crow on other peoples.

"That's what I think about China, Jack, and about MacArthur and Truman, too. You see what I mean?"

National Union of Marine Cooks and Stewards Convention
"Here's My Story," *Freedom,* June 1951

Just got back from the West Coast and an exciting visit with trade union leaders and rank and filers who are charting a new course in American labor history. The recent convention of the National Union of Marine Cooks and Stewards set a standard in labor's struggle for the full rights and dignity of the Negro people that other unions in our country might do well to emulate.[1]

Revels Cayton, the dynamic union leader who is now an organizer for the Distributive, Processing and Office Workers in New York, and George Murphy, our general manager at FREEDOM, made the trip with me and we all had an exciting and fruitful time. "Rev" has his roots deep in the Coast where for many years before coming to New York, he was the outstanding Negro labor leader in a vast area that stretches from San Diego to Seattle. He was leader of the MCS, and was closely associated with the struggles of the International Longshoremen's and Warehousemen's Union—the men who keep the cargo moving on the docks and in the huge warehouses of the coastal cities and whose president, Harry Bridges, is one of the finest union leaders of our day.

For "Rev" it was like old home week as we sat with his old colleagues in informal bull sessions which got to the heart of the problem the MCS and all unions face: strengthening the bond of unity between its Negro and white members.

The problem can be simply stated:

(1) The union faces the combined attacks of government agencies and greedy waterfront employers because of its unrelenting fight for the economic rights of its members and its progressive, pro-peace program.

(2) The union can only withstand these attacks if the membership stands solid behind a militant, uncompromising leadership.

(3) This solid unity of the membership depends more than ever on a new kind of fight against Jim Crow, not only in union affairs and contract negotiations, but in every aspect of American life.

For the Negro members know that their people are now suffering the most brutal and calculated oppression in recent memory—legal lynching, police brutality, arson, bombings, mob violence—all manner of insult and injury—and they are looking to the union not only as the guarantor of their "pork chops" but as a special defender of their rights and their very lives as well.

After one of those all-night sessions, I came away with the feeling that the MCS will certainly settle this question in the right way. And the main reason for this confidence is the splendid group of Negro leaders—men like Joe Johnson, Charlie Nichols and Al Thibodeaux—who combine with their sterling leadership in the general affairs of the union a constant battle to win the entire membership for *actions,* not just words, around the vital problems that face the hemmed-in, hard-pressed Negro communities of the nation. They are important figures in labor circles who have refused to become so "integrated" that they could forget their beginnings and their main strength—among the masses of their people. We need more labor leaders like them, and like the ILWU's Bill Chester, throughout the land.

Of all my connections with working men and women, there is none of which I am more proud than my honorary membership in MCS. I shall always cherish fond memories of the convention in the Fillmore district of San Francisco, of the wonderful audience of union men, their wives and friends, for whom I had the honor to sing and speak.

But here again, the main drama of the convention was to be found not only in the public mass meetings, but in the working sessions, committee meetings, national council discussions, and caucuses which hammered out a fighting program for peace, security, and equality. And I mean real equality, not just the paper kind!

It would be hard for MCS to have any other kind of program and survive. Fully 40 per cent of its membership is Negro and more than 60 per cent of the convention delegates were colored members. The convention took place during the last stirring days in the world-wide struggle to save the life of Willie McGee. And it was a reassuring sign to see the men from the ships "hit the deck" in the Golden Gate Commandery Hall, owned by Macedonia Baptist Church, and vow vengeance against the lynchers.

Most important, the key white leaders of the union, Hugh Bryson, president, and Eddie Tangen, secretary-treasurer, recognized that their special responsibility was, not simply to ride the wave of indignation and red-hot militancy of the Negroes, but, above all, to lead the white membership to an understanding of its stake in the fight for Negro freedom.

For one thing is becoming clearer every day. If the Negro's struggle for liberation is crushed under the hammer blows of American racists, the whole labor movement will go down with it. The racist and the labor-hater have the same face—big business. The industrialist and plantation owner who want to return Negroes to slavery also want to return all labor to the sweatshop. And if white workers want to keep

their unions and their hard-won rights they'd better move fast to see that Negro Americans gain their long-lost liberties.

That's the lesson of Hitler Germany which we must never forget and which I never tire of telling American working men and women. The labor leaders who stood aside in the early thirties and saw six million Jews set upon were soon, themselves, in exile, in the good earth, or—if their knees were flexible enough and their souls craven enough—in Hitler's phony "labor front."

And no sooner had Hitler crushed the natural opposition to his outlandish campaign to "stop Communism," save "Western civilization," and preserve "Aryan supremacy," than he plunged Germany and the world into the holocaust of World War II.

Then it was not merely the Jews or the working class of Europe that suffered, but all mankind—men and women; tall and short; black, brown, yellow and white; Mason, Pythian, and Elk; businessman, intellectual and professional Catholic, Methodist, Presbyterian, and Baptist—hard shell and soft shell, too!

How well should this history of our times be remembered! Today's would-be Hitlers are not in Germany; they are right here in the United States. They would extend the Korean war (under the banner of Confederate flags!) to the whole continent of Asia by refusing to make an honorable peace of equality with the 475 million Chinese people. Whether by the MacArthur or the Truman plan, it makes little difference—for they are both talking war, not peace; and the proud people of Asia are still "hordes" of "coolies" and "gooks" in their sight.

They would turn Africa—emerging from the status of a slave continent—into a blazing inferno in order to crush the independence movements on the West Coast, the Sudan and South Africa, and in order to increase the fabulous wealth which the Morgans, Firestones, Mellons, DuPonts and Rockefellers are extracting from the inexpressible subjugation and misery of our African brothers and sisters.

They would do all these things—if they could. To date they have been stopped in their tracks by the steel-like will of Asia's millions, by the determined liberation struggles of Africa's sons and daughters, by the stubborn resistance of the people of Europe who suffered most from Hitler's maniacal plan—and by the fact that they are not alone in possession of "the bomb."

More and more, however, the American war-minded madmen must feel the resistance of THEIR OWN COUNTRYMEN. They must be openly challenged and defeated, lest our country go down the shameful road along which Hitler led Germany to destruction and degradation.

There may be a few high-placed stooges in hand-me-down jobs who will try to get the Negro people to go along with the program of our would-be world conquerers. But they couldn't be found at the MCS convention. Instead there were hard-working union men, talking and fighting for their people's rights and for a decent life for all workingmen. They are emerging not only as union leaders, but as the rightful stewards of the affairs of our entire people in their community

organizations. And one must mention the splendid women who are fighting by the side of their men in MCS and ILWU!

The convention was a sign that the resistance to war, poverty and prejudice is growing where it needs most to grow, among working men and women who have at stake in this struggle their whole future and that of their children. The focus of the struggle today is on whether we can force payment on the promises which have been made to the Negro people for 87 years—and never kept. If we don't cash in on them, then the American promissory note of the good life, democratic government and human equality will be as phony as a nine dollar bill to everybody else.

The MCS convention meant to me that the Negro people have some wonderful allies in our job of seeing that there's some "promise-keeping" done—but quick! It was sure good to be there!

Unity for Peace

Speech at American Peoples Congress for Peace, Chicago,
June 29, 1951—*Masses & Mainstream,* August 1951, pp. 21–24

We are here for action, for the business of winning the peace. So I will take but a few moments.

The hope of the world has been alerted to the opportunity for peace afforded by the proposal for a cease-fire in Korea coming from Jacob Malik, U.S.S.R. representative to the United Nations. This hope also stirred in our hearts with the introduction of the Johnson Resolution in the U.S. Senate, which recognized the futility of continuing the carnage of the past year and proposed to do the only sensible thing about it—stop fighting and start making peace.

There is no doubt in my mind but that it is possible to find ways of agreement between nations of different economic and social systems. The peoples of the world clearly want this agreement. It rests with us here in the United States to do our share, to give the final popular push which will let our government know that the people of this great country, in their vast majority, also want peace in the world—not destruction.

We have come from all over America, representing various views, differing views of all kinds, flowing from the great diversities in our American life. But, however varied our backgrounds, we are united in the task of working out common grounds for action—action for peace, plenty, co-operation and friendship.

It is not only important, it is absolutely essential, that if we are to achieve our ends we must put aside everything which tends to divide the ranks of the peace crusaders, and accentuate the common thirst for peace—no more war—which is the universal urge in our hearts and minds.

We may not see eye to eye on all the problems of this troubled world, but we know that unless we unite in a single-minded determination to win the peace we may soon have no world in which to exercise our differences.

As for me, I see war as the major evil of our time. It is a monster which solves no problems and aggravates all. The present conflict and its danger of expansion have placed the burden of mounting armaments on the backs of the working masses of our land, have accentuated the obvious and cancerous disparity between the ill-gained profits of the wealthy few and the meagre subsistence of the multitude of producers—farmers and workers. Labor, confronted by spreading lay-offs in auto, railroad and other industries, finds that not only is there no bonanza in war but that the guns-instead-of-butter program results in lowering, not raising, standards of living. And as a labor leader warned the other day, the hopped-up war economy is hastening this nation through the preventable cycle of boom-and-bust!

In addition, our civil liberties are one of the main casualties of the war, as is already clearly evident. The First Amendment today lies temporarily gutted as a result of the validation of the Smith Act and the jailing of the Communist dissenters from American foreign policy. No other dissenter, whatever his politics, can feel safe in the exercise of the historic American right to criticize and complain so long as the Smith Act stands on the statute books and the Supreme Court decision remains unreversed.

From all parts of the land there is clear evidence that the people will respond to this challenge in the true tradition of American liberty. The heartening opinions rendered by Justices Black and Douglas;[1] the protests voiced by many newspapers, Negro and white; the paid advertisement opposing the decision signed by Roger Baldwin, Stringfellow Barr, Zechariah Chafee[2] and others; the formal dissent of the American Civil Liberties Union and other organizations—all reflect the growing and healthy alarm among the most representative circles of the American people.

In my thinking this is a peace question, for the inevitable conclusion of these persecutions, should they be allowed to continue, will be the silencing not only of the Communists but indeed of all Americans who subscribe to the principles of the New Deal and the Roosevelt grand design for peace through friendship with the socialist nations.

Just as in Europe, on the eve of World War II, we see today in America the persecution of political dissenters coupled with mounting terror against minority groups. In Europe it was the Jewish people. Here it is the Negro—with foreign language groups, the Jewish people, Mexican-Americans and other minorities numbered also among the victims.

This, too, is the price we pay for the war drive, for Operation Killer against the long-suffering peoples of Asia who are determined to be free at whatever the cost.

And as with the billion people of Asia, so with the hundreds of millions more in Africa, the West Indies and our own Americas—including the subject millions of our own colonial Southland.

The fight for peace—*resistance* against the exploiters and oppressors of mankind who want war to further their greedy ends—the fight for peace is today the center of all these struggles, of all the aspirations of working people, artists, intellectuals the world over who form the world movement for peace.

We here in America have the central responsibility to build, as the peoples of Europe and Asia have built, a powerful movement representative of *every* section of our country, which will develop from the cease-fire in Korea into a genuine and lasting peace—and freedom—for all mankind.

These are some of the reasons I am for peace, reasons which grow out of my life, my travels, my experiences with many people in many lands. They may not be—all of them—your reasons, and you undoubtedly are stimulated by experiences I have not shared. But, for whatever reasons, whatever our background, we are united here, colored and white, worker, farmer, professional and businessman, youth, men and women, in the sacred search for enduring peace.

A Letter to Warren Austin,
U. S. Delegate to the UN

"Here's My Story," *Freedom,* July 1951

One of the associations I am most proud of is my connection with the hundreds of millions of people all over the world who are members or supporters of the World Council of Peace. This international body, which is the ardent spokesman for peace-loving humanity in all lands, has for some time sought an interview with Trygve Lie[1] and other leaders of the United Nations for the purpose of presenting a few simple proposals aimed at avoiding the catastrophe of a World War III.

When Dr. Frederic Joliot-Curie, distinguished French scientist and president of the Council,[2] addressed a request for support to Warren Austin,[3] chief U.S. delegate to the UN, Mr. Austin unburdened himself of the most impolite reply.

I felt obliged as an American member of the peace committee to answer Mr. Austin; and since peace is everybody's business, I am making my letter public. Here it is, in part:

Dear Mr. Austin:

I address this letter to you as an American member of the World Council of Peace, which plans to present specific proposals on ways to peace before the United Nations at an early date. Your summary and discourteous dismissal of the request for support of this committee's

proposals constitutes a distinct disservice to the peace-loving people of the United States and the world.

Dr. Frederic Joliot-Curie, chairman of the Council, in directing a request to the United Nations for a conference, carries out the mandate of literally hundreds of millions of people in all parts of the world. And included in these millions are great sections of the American people, especially women and youth, who today are finding new courage and strength to sign petitions for peace, participate in the various peace polls, attend peace conferences, and march in magnificent peace parades and caravans. They are making it clear that they as well as the peoples of Europe and Asia, want peace and not a senseless war of mutual destruction.

The governments of the United States, Western Europe, Latin America, England and India must hearken to the voices of their people. These population majorities say: negotiate a five-power peace pact and give the new Chinese Republic of 475 million people its rightful seat in the United Nations, if the world is to have a United Nations that bears any resemblance to the intent of its founding Charter.

You may recall that M. Joliot-Curie has received the respectful and seriously-considered replies of many world organizations devoted to peace, including the world organization of Quakers and the Vatican, agreeing with the eminent scientist on the basic need for peace.

In our time, Roosevelt fought the neo-fascists, and today the American people have the deep responsibility of recapturing some part of our honest democratic heritage to hand on to those who follow. Justice Black of the U.S. Supreme Court, in his ringing dissenting opinion in the case of the eleven Communist leaders, gave evidence of this democratic honesty.

For if these military and profit-hungry men had their will, they would bequeath to our children Ku Klux Klan terror and the legal murdering of a long-suffering people. They would bequeath contempt, hatred and destruction for the working masses, colored and white, all over the world.

These modern conquerors are the spiritual descendants of the robber barons, who, a half-century ago, under the banners of Anglo-Saxon superiority and American Manifest Destiny,[4] took Cuba, Puerto Rico, Hawaii and the Philippines, and a half-century earlier robbed Mexico of Texas.

It is becoming increasingly clear that this senseless dream of American world domination will remain a dream. The colonial peoples of the world are not interested in a new serfdom. They will reject all efforts at American domination of their economies and their political institutions, even though such domination is attempted under the benevolent phrases which describe the Point Four program.

As an American of African descent born and raised in these United States of such horrible contradictions, I am certain that the people of Asia, Latin America, the West Indies and especially Africa, want us to

keep our Jim Crow practices as far away from them as possible. They say to us:

"Stop the terror and age-long oppression of 15 million of our brothers and sisters over there, and let us go our own way. We will pick and choose our own friends."

And these colonial peoples cry out to us, their brothers and sisters of African descent: "Why do you come over here to harm us; why don't you root out Jim Crow and Ku Klux Klan terror in the South of James Byrnes, Talmadge and Rankin?"

The struggle today is one of peace, not war with anyone. The people will never lose their courage and strength to shout for peace at the top of their voices, to fight fascist persecution and death, to labor diligently every moment to save themselves and mankind for the constructive building of new and rich cultures for the universal attaining of full equality and full human dignity.

Speech at Funeral of Mother Bloor

August 12, 1951—*Daily World,* February 14, 1976
(Copy furnished by Carl Reeve, Mother Bloor's son)

Just came from a workers' picnic—workers with their families—and especially the children—one a lad of five insisted time and time again on hearing Joe Hill. I could imagine Mother Bloor[1] there. We've spoken and sung so many times at the summer camps to the children. And one of my prized possessions is a phonograph record of such an occasion. And Mother would have been proud of these thousands. They were militantly fighting for the right of workers to more pay, better working conditions, better homes and most importantly for peace—world peace so that their children could be guaranteed a happy existence. And Mother would tell us that we have to fight for peace—every hour—every day—stopping people—convincing them—showing them the hypocrisy of our would-be war-makers and dangerous, too, sitting as they do in high positions of our military and government.

And Mother is betting on us to save the peace as the true inheritors of our democratic traditions and our traditions of understanding and helping to fashion a world in the process of qualitative change.

For her forebears were a part of our own Revolution of 1776 and of the French Revolution of 1789. They joined hands with those peoples of the world who helped to clear the path for democratic procedures and sound the death knell of feudal servitude. Her forebears also helped to free the Negro people—helped to free my slave father. So she fully understood the present world in change and was a firm friend of the Soviet Peoples Republics and Democracies, stretching all over the wide expanse of Europe and Asia. To them she extended, as had Jefferson, Lincoln and Roosevelt, her hand in peace and progress and cooperation with other peoples. She would have no part of that

America which fears the power of the people and their finding of new ways to their complete freedom and growth.

She was in the tradition of Sojourner Truth, Harriet Tubman, John Brown, Lincoln, Douglass and Thaddeus Stevens.[2] She was horrified when a leader of our nation, one of confederate lineage, declared that the Congress which gave the Negro people their freedom and the American people new freedom was the worst Congress in our history. No, these people were no part of her America. She wanted nothing to do with the imperialists of 1898, swaggering across the world to enslave the people of the Philippines, Cuba, Puerto Rico, Hawaii, setting their sights on the great lands of the East, especially China. She hailed China's freedom.

And she wanted nothing to do with our present day swaggerers and would-be conquerers with their callous destruction of heroic and struggling colonial peoples. And most of all she was devoted to her comrades and close co-workers. She knew them as the salt of the earth—as she fought for their right to speak—right to bail and their right to be free and continue their fight for American democracy and world friendship.

So she hands her tasks on to us. I say to Mother that never was I so proud as when she told me I was one of her sons among her countless other sons who loved her and will always honor and revere her memory. (We) will carry on—carry on fearlessly, tirelessly and courageously as she did until this land is truly the Land of the Free and the Home of the Brave.

Tribute to William L. Patterson

"Here's My Story," *Freedom,* August 1951

I think that most of the people in the United States know the name of William Patterson, head of the Civil Rights Congress, an organization which has made a magnificent struggle for the Trenton 6, Willie McGee, the Martinsville 7.

One thing that comes to my mind, in thinking of civil rights cases, is the days of the Sacco and Vanzetti case.[1] I was then finishing school and beginning to think of my career. I didn't know much of what was behind the political things of the time. I remember reading in the paper that Elizabeth Gurley Flynn and Patterson were up in Massachusetts defending the rights of Sacco and Vanzetti.

I remember also Pat's struggles around the ILD and the famous Scottsboro case. It was a long struggle again in which this young lawyer led the way. I know as a young man I was tremendously inspired by his going into the South and fighting in that area where there is the greatest oppression of the Negro people, and being successful in that struggle many, many times.

I remember that in the days just before I went to Republican Spain and understood the rise of fascism in Germany and Italy—the same

kind of fascism that is abroad in the South based on the superiority of one race over another—that Pat and I had long conversations and he was able to point out for me the basic reasons for these things; the need these people had to exploit the colonial peoples, the Negro people in America, the working masses everywhere.

And at this time as we approach the celebration of his 60th birthday, I would like to pay tribute to Pat for the great work he has done, to thank him for all the clarity he has brought not only to me but also to the many people with whom he has worked.

Negro people must understand that men and women like Pat have got to be free to work and struggle. His case is coming up in the fall, like that of Dr. Du Bois and other leaders of the Negro people, and every effort must be made to see that the case is won, that an injustice is righted and he is freed to carry on the work of his organization.

And when we speak of Pat's freedom, we have to speak also of freedom for those other leaders of the Negro people—of Winston and Davis, Perry and especially that brave colored woman, Claudia Jones, who came from the West Indies to help her people here.[2]

There's a lot of talk today about the underground.[3] We Negro people must remember that we would not be talking anywhere without the underground struggles of our forefathers in the days of our liberation here in America. I recall Frederick Douglass, Harriet Tubman, Sojourner Truth. I recall my own father, who escaped twice by the underground railroad.

We Negro people have had to make our choice at various times in this country. We didn't fight on the side of Jeff Davis and the Confederacy. We did fight on the side of those who were fighting for our freedom and for a really democratic America. And when we talk about Crispus Attucks,[4] Benjamin Banneker,[5] all those who have defended America through the years, they have defended the honest America, they didn't defend the tory America that did not want American freedom.

So we made our choice, as I say, in the time of Douglass, in the time of Lincoln. And we chose in the time of Roosevelt—we chose to stand on the side of the progressive America.

Today we must be very careful. When we support any war plans today, we support the very enemies of Roosevelt. The people who were trying to hold us back in those days are the very people who have now gained office. Read the papers any day. You see that they want to put all the New Deal people in jail, just as they put the Communists in jail.

The Negro people must understand that we in America must be on the side of the peace forces, on the side of the oppressed peoples of Asia and Africa who are also struggling for their freedom. And we must realize that we have allies in other countries who want peace and are sympathetic to our struggles here in America. That is why they persecute the leaders of the peace movement, because they know how strong we are, with our allies all over the world.

So examine the work of the Civil Rights Congress. Examine it understanding that it is an organization fighting for you. These are

honest Negroes and honest friends of the Negro people. And these
people are not able to get bail today, like Dr. Alphaeus Hunton,[6] my
friend and colleague on the Council on African Affairs, who has given
his life to the cause of the Negro people and to the understanding of
the African and the West Indian people and the colonial peoples of the
world.

We must understand in the cases of Patterson and Du Bois and the
other working class leaders that they are fighting the battles of the
Negro people. They don't expect other Negro leaders to chop them off
from behind their backs. These misleaders will and must listen to you.
So speak out for the defense of Patterson, for the defense of Du Bois,
for the defense of Hunton, of Davis, Winston and Miss Jones, Perry
and Jackson.

And wherever these things arise, know that there is something
wrong and it can only be corrected by the people's power, and
especially today, the power of the Negro people of this nation as the
countries of the world watch what happens to them. Let us exercise our
power today for our own future.

Greetings to World Youth Festival in Berlin

August, 1951—*Freedom,* September 1951

I send my warm and heartful greetings to you, the world's democratic
youth gathered in democratic Berlin in a great festival of peace,
friendship and culture.

You are and will be the inheritors and builders of a new and finer
civilization than has ever been known to men. You, young Soviet
citizens, whom I so deeply admire, you brave youth of new China,
young Korean patriots and fighters for independence throughout Asia,
you young builders of the people's democracies, you my African
brothers and sisters, engrossed in crucial struggles for self-
determination, you youth of the West Indies and of the South Ameri-
cas, the future of the world is well placed in your hands.

All hail the democratic, peace-loving youth of all the world.

Ford Local 600 Picnic

"Here's My Story," *Freedom,* September 1951

I have been in Detroit many times during my work in America. But
never was there quite such an occasion as the picnic Aug. 12 sponsored
by the foundry workers of Ford Local 600, UAW, CIO.[1]

During the recent visit I recalled previous contacts with the auto
city. As an All-American football player just out of college, I played

there with Fritz Pollard of Akron. Great sections of the Negro community came out, just as they turn out to see football and baseball stars there today. I had a brother who lived in Detroit—died there—and it was the first time he had seen me since I was a boy. I remember going around with him and later seeing the fellows from the fraternity.

When I began my concert career, I always insisted that my management present me under the auspices of Miss Nellie Watts, the fine impresario in Detroit. And often in those days I sang in the churches of the Negro community.

During the "Sojourner Truth" days I was there and spoke on many platforms before and after the riots.[2] On the opening night of *Othello* there were very few rich folks in the audience. Nobody quite knew what had happened, but I saw that the Ford workers, Negro and white, had most of the seats, and it was a memorable opening.

In recent years, meetings and concerts for the Progressive Party, for our paper, FREEDOM, and on behalf of Rev. Charles Hill's candidacy for the Common Council have kept me in close touch with friends in Detroit's Paradise Valley.

But as I said, the union picnic was something else again. It took place at Paris Park, about 20 miles outside the city limits. About 7,000 men, women and children attended and it was a real demonstration of the working people's unity. Usually the various language groups in Detroit like to go off and have their picnics by themselves, and the Negro people do the same. But here all were joined together in an audience predominantly Negro but including large sections of whites of various backgrounds: Irish, like Pat Rice, Local 600 vice-president; Scotch, Slavic, and especially Italian-Americans who had turned out in great numbers to hear Vito Marcantonio.

Marcantonio made a tremendous contribution, I thought. Eloquent as usual, he spoke in the workers' language and explained a good deal of what the present situation means to them in terms of bread and butter. He demolished the phony government "economic stabilization" program and showed that the way to win security is to fight for peace.

I sang some songs and spoke a good deal about the struggles of the Negro people. I was moved to pay tribute to the foundry workers who had sponsored the picnic with the backing of the entire local.

Under the leadership of Nelson Davis,[3] a veteran unionist who was the main organizer of the picnic, and others, the foundry workers have developed a unity which is the core of the progressive militancy of the entire local. And this unity is reflected among the general officers of the union: Carl Stellato, president; Pat Rice, vice-president; Bill Hood,[4] secretary, and W. G. Grant, treasurer. These men know that they have to work together to defend the world's largest local against the policies of UAW president Walter Reuther[5] who, in his support of the Truman war program, would tie the workers to wage freezes, escalator clauses and other gimmicks which lead to practical starvation and depression.

One of the great lessons for me was what the picnic meant in terms of the entire Negro community. I had a chance to go along with a number of the Negro labor leaders from Local 600 and meet with a group of Negro ministers. We met at the invitation of Rev. and Mrs. Ross and in their home. A number of clergymen were there including Rev. E. C. Williams and Rev. Charles H. Hill, who is running for the Common Council and spoke eloquently at the picnic.

It was wonderful to see militant, progressive labor coming to these religious leaders and saying, "We want to join with the ministry, leaders of our people, in a common struggle for our folk." Well, the ministers said that is what they had been wanting to hear for a long, long time.

And we had a luncheon with the business men. Mr. Reuben Ray, the head of the Paradise Valley business men's organization, called the group together and we discussed the necessity of small business and labor getting together. We talked about the forthcoming national convention of the Negro labor councils in Cincinnati[6] and everybody agreed that our business community must support this project. Because it is clear that whatever helps the Negro worker and strengthens his position in industry and in the unions will also help the Negro businessman who depends on him for a livelihood. And most important of all, all sections of the Negro community, business, labor, church, professionals, have a common struggle and goal—for full, equal citizenship and an end to Jim Crow *now.*

We had a long talk with one of the leading physicians and he regretted that we could not stay long enough to spend an evening with a group of the professional men and women in his magnificent home. Here was a man with a lively interest in social developments all over the world. He realized that in our search for freedom we must profit from the experiences of other oppressed and formerly oppressed peoples in lands far away.

Well, there it is. For the first time in all these years of visits to Detroit there were the real solid connections and possibilities of unity between all sections of the Negro people. And this was based on the strength demonstrated by the Negro workers, united with their white brothers and sisters, at a memorable labor picnic.

Everybody concerned was interested in our paper, FREEDOM, and promised to help sell it and get subscriptions so that they may have a consistent voice in molding the unity which is emerging.

Southern Negro Youth

"Here's My Story," *Freedom,* October 1951

We Negro people are very mature in our political understanding. We may not act at once upon all we sense and know—but we know.

Our forefathers and mothers before us sensed and correctly evalu-

ated the tremendous crisis facing the land in the pre-Emancipation years.

Finally this nation was torn apart. It had to decide, and it did, in fratricidal combat. The answer was crystal clear as it resounded across the land—this nation "conceived in liberty and dedicated to the proposition that all men are created equal"—cannot live half slave and half free.

Unfortunately, the enemies of the American people still range the country, free, wide and handsome. The Rankins, Lanhams, DuPonts, Reynolds, Morgans, are still with us—apostles of Jim Crow and wage slavery, advocates of a return of our folks and poor white folks as well to modern agricultural and industrial serfdom.

But walk in the streets of any American city among the rank and file of our people. Talk to the Negro people, the thousands and millions of us. Brother, we're bitter. We haven't been fooled. We know we don't have basic opportunities, do not enjoy our basic freedoms—as in fact do no other Americans. We sense and see the real enemies of our land for what they are, sitting as they do in lofty and powerful places.

But we know that history is at the crossroads. We see people like ourselves pressing forward and gaining freedom in the tens of millions. Truman, McCarthy,[1] Wallace, McCarran,[2] Budenz,[3] can argue and distort among themselves, but the Chinese people have their freedom and they're going to keep it. The Indian people, the Indian masses, watch and weigh their chances. The peoples of Africa are gathering at this moment in far away, yet spiritually near, South Africa, demanding an end of Malan-imposed separation (apartheid), meaning simply a vast nationalized Jim Crow. No people can sympathize more with these black African, brown Indian and mixed colored populations of South Africa than we Americans of African descent, rooted as we are in Talmadge Georgia and Rankin Mississippi, with Dewey Peekskill and Stevenson Cicero right up there with them.

And close to these shores our gallant cousins of the West Indies, suffering all manner of hardship, press onward to Federation and self-determination, and one can well prophesy that soon they will proudly represent their lands in the congress of nations and lend a helping hand to us as we struggle and strike back in Georgia and Alabama.

We in the United States must break through the wall of common terror. The world looks to us, especially the emerging, struggling hundreds of millions of the colonial peoples. All over the world tens of millions have signed the call for a Five Power Pact of Peace. They look to us here at the very heart of the attack upon the sacred rights of mankind—at this decisive historic moment—to recapture our democratic heritage and join the human race.

These thoughts flow from a moving experience I had the other day as I read what young Roosevelt Ward[4] wrote about his experiences in a Louisiana prison. He's there, as are so many brave fighters, because of the most bare-faced kind of frameup—a "draft-evasion" charge, but

they won't scare or deter him. In no time Ward became beloved in the place. The men recognized at once that here was one of the real leaders of his people, one who has deep faith in every human being. He gave aid and hope to those men who were for the most part victims of a vicious Jim Crow and half-slave economy and way of life. No wonder the Negro-baiting powers that be want to stifle the powerful voice and example of Roosevelt Ward.

If any people needs its youth, it certainly is the Negro people in the United States. The South of his birth can well be proud of Roosevelt Ward. He comes from our great traditions.

Among many, I remember especially two journeys to the South, both to conferences of Southern Negro youth—one at Tuskegee and one at Columbia, South Carolina.[5]

Never have I been so proud of my heritage, never so sure of our future here in these United States as when I stood among those young men and women. Never was I so proud as then to be an artist of and for my people, to be able to sing and inspire these proud descendants of our African forebears, standing as they were with head and shoulders high in the deepest South.

In one voice they demanded land for their struggling fathers and mothers, breathing space and free air, the full fruits of their back-breaking toil, full opportunity—full freedom.

That's what scares the powers that be in the arrogant ruling circles of this and other lands. That's the cause of the terror.

Roosevelt Ward was among these Southern youth. He has emerged as one of the young giants of our American struggle—modest but assured—trained and tried in the line of highest duty, the fight for freedom. We need him to give us the help and guidance of militant youth, unafraid of any challenge. He is one of the builders, like the young labor leaders gathering at Cincinnati, of a way of life in which his people, the Negro people, will share fully of this American earth and tread thereon in concrete realization of the fullest human dignity.

Toward a Democratic Earth
We Helped to Build

Speech at convention of National Negro Labor Council,
Cincinnati, Ohio,[1] October 27, 1951—*Daily World,* April 8, 1976

I just want to say a few words. I'm very happy to be here. I was talking to your president, Bill Hood,[2] a few minutes ago. He was saying how deeply he felt that you the trade unionists of America—from the militant side of our nation were saying to those who would stop us artists from appearing—you were saying to them tonight, "Well, Paul's going to sing, he is going to sing right here!" (Applause) So I want to thank you to begin with and say that of course not only am I here as an artist, always that—but I am here as an artist like many in

the world today who give constantly of their talents and energies to the struggles for freedom of the working masses of the world. (Applause) And so I feel that I have sort of earned my honorary membership in the Trade Union Councils.[3]

Through the years I've been on your picket lines up and down the nation, I've had many moving experiences. As I came in I saw an old friend from Winston-Salem, Mrs. Velma Hopkins. I remember going down there into the deep South, to help in their struggles.[4] I remember a very sad last time going back to say farewell to one of the great women of the labor movement, Miranda Smith.[5] (Applause) For a time they said, "Well, maybe Paul had better not come into the South," but I went in and came out all right. (Applause) And I say tonight as I've said many other times, I don't want any so-called Americans, or un-Americans to tell me that I have not the right to go back to the North Carolina (Loud applause) of my forefathers, that I have not the right to go back and stand upon the very soil where my father was a slave, that I have not the right to go about America and about the earth saying that my people upon whose backs the very wealth of this nation was built—that somewhere they must have their freedom. (Loud applause)

For that's all that I've been trying to do and say. And from many parts of the world, you would be interested to know, I get letters daily—especially from England. Just the other day one came saying, "Is it true, Paul, that you can't sing, that there is danger when you sing? That you can't play in the theater, that you can't be on the radio and television?" You would be interested to know that in every section of English opinion in the theater, in music, in every field they have begun, as in the case of the Scottish miners, to say to this government: "We want him over here to play 'Othello' again. We want to hear him sing again, and we feel that something must be wrong where one who fights as he has over here can not sing in his own land." (Applause)

As I said when I was with you in Chicago a year ago, and as I have written in the newspaper *Freedom* many times, somewhere we must see the necessity of unity between all sections of labor in this land and throughout the world. And especially today we must understand the deep struggle of the Negro people in this land for these 300 years. Already you have shown me what I was talking about in Chicago, because I am standing here tonight free with my shoulders back because you have said, "Come to Cincinnati, Paul, and sing for us!" (Loud applause) And so I can say to many Americans, "I've been to Cincinnati—to the people of Cincinnati."

The Inquirer must remember one of my last visits here.[6] I was the guest of the City of Cincinnati. (Laughter) That's right, I sang in the ball park for the city recreation fund.

Not long ago I stood in Cadillac Square for auto workers, black and white. I stood on the packinghouse line in Chicago with the packinghouse workers and I stand here tonight, therefore, saying let us find unity at this time against those who are stepping upon your necks, who step upon the backs of labor and who step especially upon the backs of

the Negro people. (Applause) And let us remember, we live in a time when hitherto colonial peoples all over the world are winning their freedom. For a long time it was a pretty easy task for England, for Belgium, for France, for our own imperialist nation—our own imperialists who started out in earnest about the year of my birth. In the year 1898 they went into Cuba, into Puerto Rico, into the Philippines. They had gotten the idea of world domination. But now we see the seething of millions and hundreds of millions of people in motion all over the world. Still some evil people in our own land say there shall be no freedom. They want to fasten a new colonialism on the masses of people.

We have a deep responsibility. Are we going to tell the Chinese people to give back their freedom? They won't, you know—no danger of that. (Laughter) (Applause) There are five hundred million of them, you know what I mean, five hundred million—a lot of people. And they are moving along in India, hundreds of millions who say to Nehru,[7] "Stand your ground for the Indian people, don't sell yourself to the imperialists wherever they may be, for you may not be there if you do." (Laughter) And, then, there's the whole continent of Africa (I'm proud to be the chairman of the Council on African Affairs). Every day we receive word by cable. That continent is just seething all over the African continent and they look to us here in Cincinnati, look to their allies in America, to the struggling workers wherever they may be, to stop this government from going over to Africa and trying to put the people back into a kind of serfdom and slavery when they are just about to emerge.

England is calling upon us to save them in Egypt. I see in the paper that our government may have to go to save the British Empire in Egypt. We Negro people and the workers in America must understand that tomorrow the English will be calling upon this government to come and save them in the Gold Coast, to come and save them in Nigeria, to come and save them in a Federation of the West Indies crying for their independence. What will we do then? Will we go? I say, NO, not move a step! (Loud applause and hurrahs)

On the other hand we have the responsibility and we have the opportunity to see that these things cannot happen, by doing what? By merging and fighting for our rights, Yes! Our day-to-day struggles for higher wages, for the rights of labor wherever they may be, for upgrading, for full dignity. And we also must understand that it will be very difficult to achieve these things if we do not enter fully today into the struggle for peace to see that somewhere war does not destroy everybody. Under the guise of war measures they can take away our rights with much more than a Taft-Hartley, much more than the kind of terror that's going around today.

We've got to understand all these things in the background of the struggle for freedom all over the world. And that's why of course, they want to imprison one of the great symbols of American unity, one of the great scholars of our time whatever his color, one who has given his whole life to the concept and ideas of our true democratic faith.

Today they would jail this great man with whom it is my privilege to work day-by-day. Why would they take Dr. Du Bois? Because he fights for peace, because he fights for freedom, because he fights for the full dignity and equality of his people to walk this earth in freedom. (Applause) And they want to jail him because they know that if they can shut him up talking about peace, then they can shut you up talking about the freedom of the working people, then they can shut you up talking about the freedom of the Negro people in America.

I just want to leave one more word, it's brought to my mind when I see Mrs. Velma Hopkins and know that many people are here from the South. When we talk about colonial struggles we sit here in certain parts in the North, on the edge of the South here in Cincinnati. I traveled in '48 all over the South. I stood in Memphis and saw the close struggles in many unions. I saw white workers in the South come out on strike to see that Negro workers would get equal pay. (Applause) I've seen great opportunities for strengthening unity in this struggle. Let us not forget, therefore, that in talking about the freedom of our people the core of it is there, where 10 million of our folk are ground under day by day. They look to us, they look to us for full understanding and when we talk about colonial and semi-colonial peoples let us not forget that we in this land, are still, without question, a semi-colonial people. We are fighting against the idea of colonization too. Also in relation to this, don't look at the oppression, look at that potential, that great potential power. Our people know what it means to fight for freedom. I walk on the streets every day and I tell you my people come up and say, "Paul, stay in there, we know you're right, we know you're right." Somebody's got to be there with the people, someone whom people can trust has got to be there to lead them. The people know what's going on. It won't do for the Sampsons, the Grangers, and the Schuylers[8] to be shouting about how good it is for Negroes in the United States today; that they're doing fine, you know. No, they won't get away with that. Somewhere they're not doing fine, but we got to see to it that they do do fine. (Applause)

We talk about fighting for FEPC, fighting against poll tax or stopping the filibuster. Do you know this Council can get behind all these drives. They're shadow-boxing right now on the Senate floor, trying to get rid of filibuster. Well, you can see that they do get rid of filibuster. Suppose there was an anti-polltax, anti-lynch bill, you know what could happen down in Mississippi and down in South Carolina, down in Georgia and Alabama and those places? There could be other Senators sitting there, you know. (Audience says "right" at that point, applause and laughter) There could be other representatives, you know, from those regions, as like in the days of Reconstruction. There were Negro representatives from those States; you know Mr. Rankin couldn't get along with them. It would have to be some different kind of a fellow to go along. (Laughter) So that the whole picture could change, so that when one talks about struggles of Negro people, the struggle for liberation, I see it not as isolating one Negro leader here, one Negro leader there, one woman there, one man there. It's a concept

of realizing that all of us are struggling for our freedom; under the same pressures, looking for freedom and some day if we are looking right, you'll see the whole thing move—the whole thing—four million, five million, six million, seven million. That's the kind of strength that our allies must see when something like the labor councils are set up.

To somewhere go into the Negro communities to win great sections, millions, to the side of the common working class people for dignity and for a decent life. I have—I can't tell you how proud I am to be with you tonight and to wish you well. To forge this unity deep, so deep that nothing can ever just even touch it a little bit let alone any chance of breaking it. I have great confidence in these councils, in the working class movement of America, white and black, to see that somewhere, in our time, this our time, we shall so labor that our children and THEIR children shall work an American earth that we can know and be proud is a democratic earth that WE have helped to build. (Applause, ovation bursts into "We Shall Not Be Moved—Robeson is Our Leader, We Shall Not Be Moved")

Sports Was an Important Part of My Life

"Here's My Story," *Freedom,* November 1951

"Freedom Festival at Rockland Palace." There is many an old friend who would immediately go back with me to a cold, windy day in late November, 1918.

Rutgers vs. Syracuse at the Polo Grounds. That year Rutgers was one of the most powerful teams in the nation. Not quite as powerful as 1917 for in that year a young team averaging less than 19 years of age had taken on at Ebbets' Field the first all-star combination comparable to the college all-stars who today play and sometimes defeat the pro champions in post-season competition.

This Rutgers team had in 1917 beaten the Newport Naval Reserve eleven. On the Reserves were Cupid Beach, 1916 All-American and ex-Yale Captain; Callahan, Yale 1919 captain; Chuck Barrett, one of the immortals of Cornell, my son's school; Schacter of Syracuse and other greats. I played my heart out that day and one of the sports writers with a flair for the dramatic wrote: "A veritable Othello ranged hither and yon on a wind-swept Ebbets' Field."

So here we are in November 1918 at the Polo Grounds in the final game of the season. Boy, the going was rough. I especially remember Joe Alexander, noted physician today, a magnificent offensive and defensive center and a true all-American if there was one. He was a great guy, clean-playing but oh, my, when he hit you!

Rutgers lost that day: I still think we were 14 points the better team, but we lost. I did pretty well, I guess, for I made All-American for the second year in succession. It was my last game as a college football player, and I did want so to win.

Incidentally, my very last appearance in Rutgers uniform was the

final baseball game against Princeton (my birth-place) in June 1919. We won, 6-1, and I have a little gold baseball as a precious memory.

But back to that November afternoon. I had no time to hope or be sorry for the sad events of the early afternoon. For I had to rush over to the present-day Rockland Palace (then Manhattan Casino) for one of the decisive basketball games of the season.

It was St. Christopher vs. Alpha—not my fraternity, but a wonderful athletic club. There was Gilmore of Howard and Loendi fame, Babe Atkins—and, on St. Christopher, that basketball marvel, little husky, lightning-fast Fats Jenkins; his brother Harold; Fred Lowery; Johnny Capers, one of the best basketball guardsmen (saw him the other day); Fred Rose, a Jewish lad, accenting the oneness of our American dream; and your humble servant.

Sports was an important part of my life in those days. Football, basketball, track (discus, javelin, shot-put and the pentathlon—best in five events), baseball. I was a catcher, not as good as Campy,[1] but played a little semi-pro ball and dared 'em to start to second base a couple of times, but I'm sure the pitchers were slow on the windup.

But of all these activities the closest to my heart remains the St. C. St. Christopher was the boy's club of St. Phillips Parish. Father Bishop (Shelton's father) was the rector. Rev. Daniels was in direct charge of the youth activities, Jimmy Ravennel, Chauncey Rowan, Chauncey Hooper, Clarence Williams, Charlie Green—I could go on and on. St. C. played Hampton, the Atlantic City team, Loendi of Pittsburgh and the Spartans with Elmer Carter, the political leader and Bob Douglas, founder of the Renaissance club, forerunner of the modern Globe Trotters.[2]

There were great ball players in those days. I recall a few more names. Huddy Oliver, Pappy Ricks, George Fall, George Capers (Johnny's brother).

So here I was in Manhattan Center playing forward for St. C. I was fast for a big six footer and played near the edge of the court while little Fats Jenkins dribbled them silly. Then some fast passing—it was hard to follow the ball—and then I'd grab seven of nine baskets often in a game.

And so this November day we went home to shower and dress and come back for a wonderful few hours of dancing.

And so I see the evening of November 1, 1951, as a return to a place that holds the dearest memories, memories of Harlem, of my youth deep in the hearts and affection of my folks.

I'm back at the Rockland Palace, at another level, having gone through a kind of spiral, still fighting for the dignity of my people, but fighting harder; saying that time is short, that my folks can't wait for full citizenship, that they want freedom—not for a few but for all, all of the 15 million of us South, North, East and West.

We want a future for our youth of constructive effort. For ourselves and all of our land, and for all the world, we want peace and friendship. I have seen many peoples, sung their songs, won their friendship and love, not for myself but for my people—for you, for your

son and your daughter, for your grandchildren. So I challenge the lies
of would-be warmakers, the same ones who still hold us in bondage
and talk about their Point Four program to supposedly raise the
standards of living of colonial peoples.

Help us, all of you, to build this paper FREEDOM. Help us to fulfill our
responsibilities to you and to those yet to come. From the expressions
of affection, from the encouragement that I get daily as I walk the
streets of Harlem, I know you will. I'll be glad to see those of our
readers who attend our Freedom Festival at Rockland Palace. And
we'll be seeing plenty of each other from here on out.

Du Bois' Freedom Spurs Peace Fight

"Here's My Story," *Freedom,* December 1951

I was in the capital city, Washington, D.C., the weekend of the
victorious and glorious conclusion of the case of Dr. W. E. B. Du Bois
and his colleagues.[1]

It was indeed wonderful to feel the underlying joy and happiness in
the hearts of all.

There were knowing smiles, handshakes, congratulations. For this
was one of the historic points in the Negro people's struggle. The
attempt to stop Dr. Du Bois from speaking for peace was at the same
time aimed to silence him in his defense of the rights of his people to
voice their grievances, to call for vast improvements and changes in
their condition of second class citizenship.

Time and again one returned to the inspiring figure of Dr. Du Bois,
to some evaluation of what this victory means and can mean. Here was
a most illuminating expression of the people's power, of the people's
will of peace.

How could the administration adversely adjudge the eminent Doctor
and his colleagues and claim in the same breath that the State
Department wanted peace? Hundreds of millions were tense, listening.
There was the threat of a world condemnation of staggering propor-
tions. The halls of the United Nations Assembly would have rung with
denunciation from representatives from every corner of the globe. This
is the reality of the universal character of the fight for peace.

For the Negro people especially here was massive evidence of our
closeness to the people of the world, the tremendous influence of world
opinion affecting our rights here in the United States. For our struggle
today is in the world arena not confined within the domestic limits of
these 48 states. Asia, Africa, the West Indies, the Middle East, Latin
America, the friendly millions of the Soviet Union and the new
People's Democracies of Eastern Europe were alerted.

To all this was brought the overwhelming support given to Dr. Du
Bois from millions of the American people. As he crossed the continent
people of all sections of various communities sprang to his defense:
independent progressive trade unions, CIO and AFL locals, scholars,

liberals, churchmen, youth. And the Negro people stood there, firm as the Rock. The organizational strength of millions among the Negro people stood ready to testify as to his sterling character, uncompromising struggle.[2] The thousand voices of Negro trade unionists at the Cincinnati convention of the National Negro Labor Council found their echoes in that court room.

Dr. Du Bois represented in his being concrete proof of the possibilities of reaching out into the great stream of American life. Here was a true broadening and deepening of the struggle. Let us hold the organizational ties linked in this noble and successful endeavor. Let us advance further the organizational forms created, the broadening process made possible. Let us bring this same unity to bear behind the American Peace Crusade for millions of signatures to the Five Power Pact petition, behind the struggles of labor, behind the just demands of the Negro people for full equality, behind the basic fight to erase from the books the modern Alien and Sedition laws[3]—the Smith-Connally Act and the McCarran Act.[4]

Let this momentum run over into every section of our life, especially into the working masses, colored and white, in steel, coal, maritime, longshore, electrical, packing and into the millions of militant Negro people, a great people of great fighting traditions.

Let us channel all these forces into the final victory of the restoration of the real democratic forces of our American life, the setting of this great nation, conceived in liberty, on its destined path of granting justice and equality to all, of striving ever honestly for genuine world cooperation and peace, of profound respect for the aspirations of all peoples everywhere.

We, together with Dr. Du Bois and his colleagues, are deeply thankful to the wonderful counsel, the lawyers who upheld magnificently the best traditions of their profession.

We wish everything good to all the five defendants—and to their families. We thank them for their courage, sacrifice and real heroism. We are all elated that Dr. Du Bois can return to his labors, can continue to give us of his matchless poetry and prose, to inspire, guide and counsel us. Certainly he can live joyously in the knowledge that he is sincerely and deeply loved by the vast millions of this earth.

Which Side Are We On?

"Here's My Story," *Freedom,* January 1952

Six months ago the truce negotiations began in Korea. But today the bloodshed continues, and American diplomats and top brass persist in carrying on the most shameful war in which our country has ever been engaged.

A hundred thousand American dead, wounded and missing have been listed in this war which nobody—not even the most cynical

politician—bothers to call a "police action" any more. And more than that, we have killed, maimed and rendered homeless a million Koreans, all in the name of preserving western civilization. U.S. troops have acted like beasts, as do all aggressive, invading, imperialist armies. North and South of the 38th parallel, they have looked upon the Korean people with contempt, called them filthy names, raped their women, lorded it over old women and children, and shot prisoners in the back.

Is it any wonder that Rev. Adam Powell,[1] N.Y. Congressman, returns from a lengthy tour of Britain, Europe, the Near East and Africa to report that the United States is "the most hated nation in the world"?

Yes, our government is well hated because it has forced on the people a policy which places this nation in deadly opposition to the liberation movements of hundreds of millions of people in all parts of the globe.

When the Iranians took back their rich oil fields from the British exploiters, whose side were we on?[2] Now that the Egyptian masses are calling for John Bull to get out of Egypt and the Suez Canal, what position do we take? With Chiang Kai-shek's mercenary troops violating the borders of Burma to achieve a springboard for attack upon the Chinese mainland, do we rush to protect the sovereignty of Burmese soil or do we lend covert and open support to Chiang's marauders?

In Indo-China, Indonesia, Malaya—which side are we on? The question almost answers itself. In each case we have been on the side of the Dutch, the French and the British colonial powers who stand arrogantly, arms akimbo, feet spread wide, blocking the road to national liberation and independence.

But the peoples of the world are determined to brush this colossus aside and move on to their cherished goals. They want food for little children who die of all kinds of horrible diseases which only require a decent social order to be wiped out. They are tired of 25-year life expectancy in India, preventable "plagues" in Africa, misery, destitution and death everywhere.

These millions in the colonial world want peace, not war. And they are joined by millions in Europe, Latin America, Canada and the U.S. who are tired of slaughter. For the people in the colonial world are not the only victims of the Truman-Eisenhower war policy. All over Western Europe, where the national economies have been taken over by U.S. capital through the Marshall plan, the standard of living for workers and farmers has worsened, prices have gone out of reach, and the governments have forfeited their right to fully determine the destiny of their peoples.

And any worker at home will tell you that something has to be done about the wage freeze, sky-high prices and unprecedented taxes which make it impossible to make ends meet.

For the Negro people, the war means all this and more. It means that Anglo-Saxon arrogance is at flood tide, and the result is death—for the

Martinsville Seven, for Willie McGee, Edward Honeycut, Mr. and Mrs. Harry Moore,[3] Samuel Shepard[4]—and hundreds more. It means a hate crazed mob at Cicero, Ill., and the bombing of Dr. Percy Julian's home in Chicago.[5] It means a government, bent on conquest, has no interest in preserving civil rights at home because civil rights imply the right to protest and war-bent rulers need conformity, not protest.

So the Negro people have a special interest in the fight for peace. And we are given the opportunity to express that interest in the campaign now being waged by the American Peace Crusade for a million signatures to a five power pact of peace.[6] Already 600 million people all over the world have signed the petition. It calls simply for the great powers of the earth—the United States, the Soviet Union, China, Britain and France, to sit down and work out a peaceful solution to outstanding differences.

Obviously the White House and Pentagon strategists want no such peace conference. They want to be left undisturbed in their plans for bigger and more profitable wars. We must demand: End War—Make Peace Now! An immediate truce in Korea! A meeting and peace agreement among the five major powers!

When a neighbor knocks on your door and asks you to sign the American Peace Crusade petition, I hope you will. In fact, don't wait. Write to FREEDOM for petitions or get them from your local peace organization to spread among your neighbors.

That's the way to help change the disastrous policy of this government. That's the way to guarantee that a few years, or months, from now the President of the United States will not be asking Negro youth to go to Africa to help maintain British rule in one of its seething colonies or "protectorates."

That's the way to peace and equality of all peoples.

The Negro Artist Looks Ahead

Speech delivered at opening session of the Conference for Equal Rights for Negroes in the Arts, Sciences and Professions, New York City, November 5, 1951—*Masses & Mainstream*, January 1952, pp. 7–14

We are here today to work out ways and means of finding jobs for colored actors and colored musicians, to see that the pictures and statues made by colored painters and sculptors are sold, to see that the creations of Negro writers are made available to the vast American public. We are here to see that colored scientists and professionals are placed in leading schools and universities, to open up opportunities for Negro technicians, to see that the way is open for colored lawyers to advance to judgeships—yes, to the Supreme Court of these United States, if you please.

It is not just a question of jobs, of positions, of commercial sales.

No—the questions at hand cannot be resolved without the resolution of deeper problems involved here. We are dealing with the position in this society of a great people—of fifteen million closely-bound human beings, of whom ten millions in the cotton and agricultural belt of the South form a kind of nation based upon common oppression, upon a magnificent common heritage, upon unified aspiration for full freedom and full equality in the larger democratic society.

The Negro people today are saying all up and down this nation (when you get on the streets, into the churches, into the bars to talk to them): "We will not suffer the genocide that might be visited upon us. We are prepared to fight to the death for our rights."

Yes, we are dealing with a great people. Their mere survival testifies to that. One hundred millions sacrificed and wasted in the slave ships, on the cotton plantations, in order that there might be built the basic wealth of this great land. It must have been a tremendously strong people, a people of tremendous stamina, of the finest character, merely to have survived. Not only have the Negro people survived in this America, they have given to these United States almost a new language, given it ways of speech, given it perhaps the only indigenous music.

One great creation, modern popular music, whether it be in theatre, film, radio, records—wherever it may be—is almost completely based upon the Negro idiom. There is no leading American singer, performer of popular songs, whether it be a Crosby, a Sinatra, a Shore, a Judy Garland, an Ella Logan, who has not listened (and learned) by the hour to Holiday, Waters, Florence Mills, to Bert Williams, to Fitzgerald, and to the greatest of all, Bessie Smith.[1] Without these models, who would ever have heard of a Tucker, a Jolson, a Cantor?

Go into the field of the dance. Where could there have come an Astaire, an Eleanor Powell and a James Barton without a Bill Robinson,[2] a Bert Williams, an Eddie Rector, a Florence Mills?[3] How could Artie Shaw and Bennie Goodman have appeared but for a Teddy Wilson,[4] Turner Latan, Johnny Dunn, Hall Johnson,[5] Will Marion Cook?[6] Whence stems even Gershwin? From the music of Negro America joined with the ancient Hebrew idiom. Go and listen to some of the great melodies. Here again is a great American composer, deeply rooted, whether he knew it or not, in an African tradition, a tradition very close to his own heritage.

I speak very particularly of this popular form. This is very important to the Negro artists, because billions, literally billions of dollars, have been earned and are being earned from their creation, and the Negro people have received almost nothing.

At another stage of the arts there is no question, as one goes about the world, of the contribution of the Negro folk songs, of the music that sprang from my forefathers in their struggle for freedom—not songs of contentment—but songs like "Go Down, Moses" that inspired Harriet Tubman, John Brown, and Sojourner Truth to the fight for emancipation.

I think of Larry Brown who went abroad, heard Moussorgsky, heard the great folk music of other lands and dedicated himself, as did Harry Burleigh before him, to showing that this was a great music, not just "plantation songs."

One perhaps forgets my own career, and that for five years I would sing nothing but the music of my people. Later, when it was established as a fine folk music, I began to learn of the folk music of other peoples. This has been one of the bonds that have drawn me so close to the peoples of the world, bonds through this likeness in music that made me understand the political growth of many peoples, the struggles of many peoples, and brought me back to you to fight here in this land, as I shall continue to do.

I remember in England in the old days (incidentally, I just heard from Kingsley Martin, of the *New Statesman and Nation,* who is concerned about my inability to travel and to function as an artist in this land, and who is beginning a campaign in England on this basis)—I remember writing several articles for the *New Statesman and Nation,*[7] going to the whole root of this matter. I think back now—the deep pride that I had and still have in the creations of my people and in seeing the links here with Africa, and with the other peoples of Asia, and taking issue with the view that Western music was the only great music in the world and that everything else was so backward.

I remember writing: "Mr. Beethoven, yes, he is a great composer, but he deals with themes. He has to develop them a bit, but he starts with a very simple theme. . . ." And I was interested in reading a book the other day on the thematic process which takes the whole Ninth Symphony and proves that in every movement it begins and stems from a kernel that really in the end is a few bars. In those days I didn't quite know it technically, but had a feeling, and I listened to all the music and I still am looking to find anywhere greater themes to start with than "Deep River" or "Go Down, Moses," or "I'm A Poor Wayfaring Stranger."

So we are dealing with a people who come from great roots. There is no need to quote the names of an Anderson or a Hayes and many more; or of the great scientists—of a Julian, of a Carver. No need today for the Negro people to prove any more that they have a right to full equality. They have proven it again and again.

The roots of this great outpouring we are talking about today in the cultural expression of my people, is a great culture from a vast continent. If these origins are somewhat blurred in this America of ours, they are clear in Brazil where Villa-Lobos[8] joins Bach with African rhythms and melodies; in Cuba and Haiti a whole culture, musical and poetic, is very deep in the Africa of its origins—an African culture quite comparable to the ancient culture of the Chinese—similar in religious concepts, in language, in poetry, in its sculpture, in its whole esthetic—a culture which has deeply influenced the great artists of our time—a Picasso,[9] a Modigliani,[10] a Brancusi,[11] an Epstein, a deFalla,[12] a Milhaud.[13] So we are today discussing the

problems of a proud people, rich in tradition, a people torn from its ancient homeland but who in 300 years have built anew, have enriched this new Continent with its physical power, with its intellect, with its deep, inexhaustible spirit and courage.

As I have said, in spite of all these contributions to our culture, the fruits have been taken from us. Think of Handy,[14] one of the creators of the Blues; think of Count Basie,[15] playing to half-filled houses at the Apollo; colored arrangers receiving a pittance while white bands reap harvests. What heartbreak for every Negro composer! Publishing houses taking his songs for nothing and making fortunes. Theatres in the heart of the Negro communities dictating to Negro performers what they shall act . . . arrogantly telling Negro audiences what they shall see.

I went to a whole group of my Negro friends. I wanted them to put down some of the things in which they were interested this morning. What did they want you to know? Here are some things that I will read:

> Negroes have carried on an important struggle in the United States throughout the history of this country, even before there was any significant progressive movement in the U.S.: this is a lesson progressives must learn—and accept it as a privilege and duty to join in the struggle. The progressive movement must understand with crystal clarity that the Negro people of the United States have never retreated or compromised in their aspirations, and progressives must follow a dynamic path with them. For if they do otherwise, they will find themselves conscious or unconscious allies of reactionaries and pseudo-liberals. Progressives must re-orient themselves to the qualitative change that has come about in the unalienable and rightful demand of the United States Negro. The Negro men and women of the United States want equality for everybody, in everything, everywhere, now.

This is awfully good, I must say.

> Whites must come forward and put up a struggle, no matter what the repercussions; struggle must be constant in unions, housing organizations and not only where Negroes are involved—whites must take action every day and not wait for Negroes to raise issues in order to come in on the struggle. . . . Peace is crucial in this question. Its maintenance depends on whether or not democracy is extended to the Negro. Support must be twofold. In order to show support politically, there must be an understanding and appreciation of Negro culture. There must be a willingness to learn. If present U.S. cultural patterns do not permit the utilization of Negro talent, then independent means must be found.

Another comment:

> The U.S. theatre must show the totality of Negro life, thereby eliminating stereotypes in either extreme. To offset the so-called objective reporting in the white press, all positive accomplishments by Negro cultural workers should be designated as such. Every Negro artist needs and must now demand free and equal opportunity to develop in fields of his or her endeavor. White progressives must recognize that in joining the Negro struggle, they join on the Negro people's terms.

Mr. Hood, in Cincinnati,[16] put it very sharply: We must work together. We are a unit—certainly we are, but to the trade union leader (we say) we seek your co-operation; we no longer ask your permission.

Let us touch for a moment on radio and television. We all know the difficulties—no major hours with Negro talent, an occasional guest appearance eagerly awaited by the Negro audience. Why this discrimination? Well, these mass media are based on advertising, commercialism at its worst, and the final answer is very simple. It goes to the root of all that has been said. The final answer is: "The South won't take it."

Now, I had a program myself in the '40's, all set up by one of the biggest advertising agencies, a very fine program, a dignified program in which I would have been doing Othello and many other things. One morning they said, "We made some inquiries and the South just won't have it. You can come on once in a while and sing with Mr. Voorhees, and so forth, but no possibility of a Negro artist having his own program." Not *that* dignity. And so we have allowed the South with its patterns to determine for all America how, when and where the Negro will be denied an opportunity.

I think that public opinion could be aroused on this issue. This is a matter of national protest, of national pressure. These media happen to be under the control of Federal Communications. We are dealing here with matters as serious as the passage of an Anti-Lynch Bill, Anti-Poll Tax and Free Voting Legislation, of F.E.P.C., of the whole issue of Federal and States rights. We can demand a change in the public interest in the pursuance of democratic procedures. Added to this, of course, can be pressure on the advertisers who wax fat today from the purchases of Negro customers. These latter, plus their allies, could have very decisive influence.

The films today are of vast significance and influence. Here, too, the South determines the attempts to camouflage, to pass off so-called progressive films, to find new approaches to the treatment of the Negro. They have been very thoroughly analyzed and exposed for what they are by V. J. Jerome in his exhaustive pamphlet on "The Negro in Hollywood Films."[17] Here, too, the mounting of the right kind of campaign could shake Hollywood to its foundations, and help would be forthcoming from all over the world. Their markets everywhere in the world could be seriously affected, if the lead came from here.

The struggle on this front could have been waged with some real measure of success at any time, but today conditions insure the careful heeding of the collective wrath of the Negro people and their allies. For today, in the struggle extending all over the world, all pronouncements of our wonderful democracy ring hollow and clearly false as soon as one points the finger at the oppression of fifteen million second- and third-class citizens of this land.

There is no way to cover that up. One day, Willie McGee; the next, Martinsville; the next, Cicero; the next, Groveland, Florida. Behind these horrors is the mounting anger of a long-suffering people, of a people that has its Denmark Veseys, its Frederick Douglasses, its Sojourner Truths, its Harriet Tubmans, its Du Bois's, its Benjamin Davis's—a people that fought for its freedom in the great Civil War and buried the hated Confederate flags in the dust.

Behind these people and their allies here in the U.S. are the tens and tens of millions of advanced workers through the world, west and east, bulwarked by the overwhelming millions of a fast-emerging colonial world hastening to final and complete control of their destinies, inspired by the events of a November 7th, thirty-four years ago, by the victories of many new People's Democracies, by the world-shattering creation of the new People's Republic of China. This world in change makes possible here new levels of action, insures victories hitherto unsuspected. The millions of India watch and Mr. Bowles will have his hands and his mouth full to convince these people that the civilization extolled by Byrnes of South Carolina, Smith of Georgia, Connally of Texas, is just the thing to bring new vistas of freedom and individual liberty to that ancient continent. I often get letters from India. They seem to be somewhat doubtful.

The Government can be pressured in this time and it certainly can be pressured on this issue. Most important for us here is the recognition of the Negro's rights to all kinds of jobs in the arts, not only the rights of the artists, but technical jobs for engineers, all sorts of opportunities in production, in scenic design, at all levels. I am very much interested in that: I've got a son, Paul, who studied engineering at Cornell, majored in Communications. I'd like to see him get a good job in television.

And so in the case of Actors Equity—we who are members of Equity must fight not only for the rights of Negro actors, we must see that the stage-hands are there. We must fight within the AFL, Equity's parent organization, for the right of Negroes to work in *every* field. And so in the American Guild of Musical Artists and in the American Federation of Radio Artists—they are shouting an awful lot these days about how democratic and American they are: Let them show it!

The final problem concerns new ways, new opportunities based upon a deep sense of responsibility in approaching the problem of the Negro people in its totality. There are despoilers abroad in our land, akin to these who attempted to throttle our Republic at its birth. Despoilers who would have kept my beloved people in unending serfdom, a powerful few who blessed Hitler as he destroyed a large segment of a

great people. Today they would recreate the image of Hitler, stifle millions of the hitherto oppressed as they struggle forth for their emancipation, destroy the People's Republics where life has been created anew, where the forces of nature have been turned to man's prosperity and good.

All these millions of the world stand aghast at the sight and the very name of *that* America—but they love *us;* they look to *us* to help create a world where we can all live in peace and friendship, where we can exchange the excellences of our various arts and crafts, the manifold wonders of our mutual scientific creations, a world where we can rejoice at the unleashed powers of our innermost selves, of the potential of great masses of people. To them *we* are the real America. Let us remember that.

And let us learn how to bring to the great masses of the American people *our* culture and *our* art. For in the end, what are we talking about when we talk about American culture today? We are talking about a culture that is restricted to the very, very few. How many workers ever get to the theatre? I was in concerts for 20 years, subscription concerts, the two thousands seats gone before any Negro in the community, any worker, could even hear about a seat. Even then, the price was $12.00 for six concerts. How could working people ever hear these concerts? Only by my going into the trade unions and singing on the streets and on the picket lines and in the struggles for the freedom of our people—only in this way could the workers of this land hear me.

We are talking about a culture which as yet has no relationship to the great masses of the American people. I remember an experience in England. I sang not only in Albert Hall, the concert halls, but also in the picture theatres, and one night I came out and a young woman was standing there with her mother, an aged lady. "My grandmother wants to thank you very much. She always wanted to hear you in person. She heard you tonight and she's going home. She just had sixpence above her bus fare." So she was able to hear me. Later, that was so in the Unity Theatre in London—now a theatre which has stretched all over England. Here in America, in 1948 in the Deep South, I remember standing singing to white workers in Memphis, workers who had come out on strike that Negro workers might get equal wages.

In the theatre I felt this years ago and it would interest you to know that the opening night of *Othello* in New York, in Chicago, in San Francisco (I never told this to the Guild), I told Langner he could have just one-third of the house for the elite.[18] I played the opening night of *Othello* to the workers from Fur, from Maritime, from Local 65.

Just the other night I sang at the Rockland Palace in the Bronx, to this people's audience. We speak to them every night. To thousands. Somewhere, with the impetus coming from the arts, sciences and professions, there are literally millions of people in America who would come to hear us, the Negro artists. This can be very important. Marion Anderson, Roland Hayes, all of us started in the Baptist

Churches. I'm going right back there very soon. If you want to talk about audiences, I defy any opera singer to take those ball parks like Sister Tharpe or Mahalia Jackson.[19] It is so in the Hungarian communities (I was singing to the Hungarian-Americans yesterday), the Russian-Americans, the Czech-Americans . . . all of them have their audiences stretching throughout this land.

The progressive core of these audiences could provide a tremendous base for the future, a tremendous base for our common activity and a necessary base in the struggle for peace. These people must be won. We can win them through our cultural contributions. We could involve millions of people in the struggle for peace and for a decent world.

But the final point. This cannot be done unless we as artists have the deepest respect for these people. When we say that we are people's artists, we must mean that. I mean it very deeply. Because, you know, the people created our art in the first place.

Haydn with his folk songs—the people made it up in the first place. The language of Shakespeare—this was the creation of the English-speaking people; the language of Pushkin, the creation of the Russian people, of the Russian peasants. That is where it came from—a little dressed up with some big words now and then which can be broken down into very simple images.

So, in the end, the culture with which we deal comes from the people. We have an obligation to take it back to the people, to make them understand that in fighting for their cultural heritage they fight for peace. They fight for their own rights, for the rights of the Negro people, for the rights of all in this great land. All of this is dependent so much upon our understanding the power of this people, the power of the Negro people, the power of the masses of America, of a world where we can all walk in complete dignity.

Act Together Now to Halt
the Killing of Our People!

"Here's My Story," *Freedom,* February 1952

Harry T. Moore died the death of a hero.[1] He is a martyr in the age-long struggles of the Negro people for full dignity and equality. His name must never be forgotten and his courageous deeds must ever be enshrined in our memories. His death must be avenged!

The bomb which took the life of this fearless fighter for freedom, made a shambles of his home at Mims, Fla., and placed his wife at death's door in a hospital 40 miles away, has shaken the peace and tranquility of every Negro household in the United States.

There can be no mistaking the meaning of this event. The murder of Harry Moore was a lynching of a special kind. It was a political assassination.

Its aim was to short-circuit the growing clamor for votes and justice in the South by beheading those who are brave enough to demand their rights or strong enough to lead the organized mass movement.

In 1948 Maceo Snipes and Isaiah Nixon both gave their lives to Georgia mobs because they sought to exercise the right to vote.

In South Carolina, Albert Hinton, NAACP state president, was kidnapped, and John McCray, head of the Progressive Democratic Party, was framed on a trumped-up libel charge—because of their leadership in the voting movement.

Only last month in Opelousas, La., John L. Mitchell was shot in cold blood by a deputized bandit because he had dared sue for his right to be registered as a voter.

Now the dastardly assassination of Moore comes as a threat to every Negro man and woman in the land:

Give up your efforts to be full citizens! Despair in your hopes to vote and hold office in the South! Remain a people apart, inferior in status, despised and trampled upon—or we will blow you all to Kingdom come!

Shall we accept this verdict of Klansmen? Shall we permit the ferocious attack of these 20th century barbarians to blunt the edge of our common strivings?

No, we cannot! We should not be true to ourselves, our forefathers, or the memory of Harry Moore if we did!

The need of the hour is for thousands of Harry Moores to rise and take the place of the fallen one. From the colleges and schools of the South, from the plantations and country districts, from the mines, mills and factories, new fighters for full freedom must take our brother's death as the signal for their unending dedication to their people's needs.

The need of the hour is for resistance to the lynchers, an end to the spilling of our precious blood!

The need is for a demand that will ring out in every home in the United States and resound around the world:

Death to the assassins of Harry Moore and to the lyncher-sheriff McCall who killed Samuel Shepard in cold blood!

Ban the Ku Klux Klan and smash this odious conglomeration of un-American bandits to smithereens!

Indemnify the bereaved families of the lynch victims!

Impeach Fuller Warren, whose conduct as governor is hostile to the interests and liberties of a majority of the people of Florida!

Guarantee, through the exercise of federal power, the unrestricted enjoyment of every constitutional privilege by all Negro people in every part of the United States!

Has the time not come for an unequivocal declaration of unremitting war against Jim Crow by the Negro people joined together in an all-embracing unity?

To be sure, it has. We shall not be forever turned from our duty by the slanderous characterizations of our common foe or by real political differences among ourselves.

What better time than now to plan for a great convocation of the leaders of the Negro people on February 14, the birthday of the immortal Frederick Douglass, to be held in the nation's capital or in a major Southern city?

There, the bishops and ministers of our churches, leaders of our fraternal life, spokesmen for women and youth, labor leaders and political figures could plan a common action for freedom.

Setting politics aside, inseparably bound by what so urgently unites us—our common peril—we could give needed hope and inspiration to the rising masses of our people, guidance to our next tasks, and pause to the enemy within the gates.

This, to me, is the first lesson of the murder of Harry T. Moore. It is a challenge to all Negro leadership. The masses look to see who will be the first to answer.

An Important Message from Paul Robeson

Spotlight on Africa, News Letter, Council on African Affairs, February 25, 1952

Imagine all sections of the Negro people in the United States, their organizational and programmatic differences put aside, joining together in a great and compelling action to put a STOP to Jim Crowism in all its forms everywhere in this land. Think how such an action would stir the whole of America, raising to a new high level the people's resistance to the mounting fascism which is bent upon wiping out the constitutional rights of ALL Americans, starting with the Negro people and other minority groups. Think how such an action would be supported by hundreds of millions of darker peoples and white enemies of racism and fascism throughout the world—how it would strengthen the world-wide struggle for freedom and peace!

A dream? No. Look at the Union of South Africa. See there how the victims of even more savage racist oppression than we know in America—eight and a half million African victims, a million Cape Colored, and a third of a million Indians—have solemnly determined that only by establishing a common front of united and resolute resistance can they escape absolute enslavement by the fascist Malan regime.

The government's only answer to the people's protests has been the enactment of more and harsher repressive measures, with the clear objective of stifling and liquidating all organized opposition from dark-skinned South Africans and democratic-spirited whites. Thus, faced with the probability of imminent extinction, the representative organizations of the ten million victims of South African Jim Crow (called "apartheid" there) have jointly resolved to start on April 6th a

national campaign of civil disobedience against the discriminatory and oppressive restrictions, such as the Pass Laws and the Ghetto (Group Areas) Act, forced upon them by a government in which they have no voice.

"Mass action will begin on April 6," was the historic decision of the African National Congress at its Bloemfontein Conference last December. "Those taking part in the mass action will defy them [the Jim Crow laws] deliberately and in an organized manner and will be prepared to bear the penalties."[1]

"The struggle which the national organizations of the non-European people are conducting," declared the Joint Planning Council, directing and coordinating the mass action campaign, "is not directed against any race or national group. It is against the unjust laws which keep in perpetual subjection and misery vast sections of the population. It is for the transformation of conditions which will restore human dignity, equality, and freedom to every South African."

Most certainly we in America must speak out in support of this heroic action. For a decade the Council on African Affairs has been active in exposing and campaigning against the vicious system of racial exploitation and oppression practiced in the Union of South Africa. Our organization now calls upon all sections of the Negro people and all friends of human freedom to rally to the support of this last-ditch resistance to fascism in South Africa.

The South African government is aiding in "preserving democracy" in Korea by sending its Jim Crow air force to help kill Koreans. South Africa is a part of President Truman's "free world." Yes, dozens of America's biggest auto, oil, mining and other trusts have highly profitable holdings in that country. And U.S. loans have been made available to Prime Minister Malan in order to accelerate the expropriation of South Africa's rich resources.

Hence it is clear that in raising our voices against the Malan regime we simultaneously strike a blow at the reactionary forces in our own land who seek to preserve here, in South Africa, and everywhere else the super-profits they harvest from racial and national oppression. United support for our brothers' struggle in Africa is an integral part of our task in achieving freedom for all Americans.

Genocide Stalks the U.S.A.

New World Review, February 1952, pp. 24–29

Out of the lessons of the barbarities of Nazi Germany, the voice of outraged mankind caused the General Assembly of the United Nations to adopt a Convention on the Prevention and Punishment of the Crime of Genocide.

The opening statement of this historic petition[1] dispels the generally

held misconception that the crime of genocide can be charged only when there is mass extermination of a people.

As defined in the United Nations Convention,[2] genocide includes "any of the following acts committed with intent to destroy, in whole or in part, a national, ethnical, racial or religious group, as such: (a) killing members of the group; (b) causing serious bodily or mental harm to members of the group; (c) deliberately inflicting on the group conditions of life calculated to bring about its destruction in whole or in part."

It is not difficult to understand why this Convention has never been ratified by the Senate of the United States. This book, in fact, reveals that a determined effort has been made by white supremacy to block U.S. signature. From the openly terrorist Ku Klux Klan to the more suave spokesmen of the American Bar Association, there has been a brazenly open recognition of the applicability of the convention to the treatment of the Negro people in the United States.

Let anyone review the history of the Negro people of these United States. Tens of millions sacrificed in the slave ships and on the plantations. Till this day terror stalking this great people, not only in the South, but in the Peekskills, Ciceros, Detroits. Constant warning to stay in "your place," accept the serf-like status imposed by a resurgent Dixiecrat South brazenly waving its Confederate flags in this year of 1952.

How parallel to the condition of another great people—the Jewish people of Nazi Germany. During the trials at Nuremberg—the very base of the genocide convention—I was chairman of a delegation to the President of these United States. A leading church-woman observed in this conference that we could not morally sit in judgment at Nuremberg while lynchings were rampant in the South (this was 1946), while an Isaac Woodard (a World War II vet) had his eyes gouged out. The President said the Nuremberg trials had "nothing to do with the South," that ours was a domestic problem. I observed that the history of Nazi thought proved that they had learned much from the South, that a straight line led from Mississippi, South Carolina, Georgia, Alabama to the Berlin and Dachau of Hitler.

I stood in Dachau in 1945 and saw the ashes and bones of departed victims. I might have seen the ashes of some of my brothers in Groveland, Florida, just the other day—or in Martinsville a few months back.

And when we come to other aspects of genocide—of stifling the growth of a whole people—of holding them in constant threat of "operations killer"—there can be no such evasive answer.

The very reason for the Genocide Convention is to prevent the destruction of a people. The daily lives of the Negro people testify as to the "intent" of their persecutors. The business of the United Nations is to exercise its powers to remove this threat and terror.

While the Voice of America beams its hypocritical concern for the welfare of the peoples behind the so-called Iron Curtain, the Genocide

Convention remains unratified by the U.S. Government. But our failure to sign could not block the adoption of the Convention. By January, 1951, the requisite number of member nations had signed and it is now binding on our government.

Now that the Convention is in effect, the State Department is trying to move it into its war arsenal. Not an issue of the *Sunday Times* seems to go by without a sob story in which some groups of fascist emigres charge genocide against the Soviet Union or the new democracies which have ended national oppression and outlawed racism.

William L. Patterson, National Executive Secretary of the Civil Rights Congress, has added still another contribution to his magnificent record in the struggle for Negro freedom by seeing that the Genocide Convention must become a weapon for liberation of his people.

The American people will some day take pride in the fact that at a time when the United States Government was the driving force behind the oppression of hundreds of millions of people throughout the world, it was boldly called before the bar of world opinion by progressive Americans who exposed its pretensions of "democracy" and proved it guilty of genocide within its own borders.

The demagogues and apologists for white supremacy will never be able to brush this document aside. The facts gathered here are irrefutable. Every assertion has been documented.

And since the publication of this petition, we can add the bloody documentation of new genocidal acts like the murder of Harry T. Moore, an N.A.A.C.P. leader, and his wife on Christmas night in Florida, and the mockery of the local authorities and the ballyhooed FBI pretending inability to apprehend those responsible for this brazen act of terror.

The *Baltimore Afro-American,* a leading Negro newspaper, has revealed that the State Department asked Walter White, executive secretary of the National Association for the Advancement of Colored People, to attack this petition. Instead, in his syndicated column, Mr. White declared, "The United States has been hit in its most vulnerable spot by *We Charge Genocide,* an appeal to the United Nations by the Civil Rights Congress. . . . The most immediate and effective step is for the United States to plead guilty to the charges." Of course, Mr. White went on to expound his usual gradualist credo about how "the other side should be given the widest possible publicity."

We, the people, charge genocide. We, Negro and white petitioners, declare that jimcrow and segregation are a genocidal policy of government against the Negro people. The proof is all in this monumental book—the lynchings condoned and encouraged by government officials, the killings by the police authorities of state, the legal lynchings by the courts of our land, the racist laws. The violence and murder are all stamped with the government seal.

Yes, and economic genocide too, the silent, cruel killer. The petition presents all the terrible data—the death toll in Negro ghettoes, the

prevention of access to medical treatment, the unemployment and the discrimination in employment, the denial of education. Out of the government's own statistics, the petition makes the accusation:

"More than 30,000 Negroes die each year in the United States who would not have died if they had been white. In addition, the Negro people are robbed of more than eight years of life on the average."

This petition does more than present facts. It digs into the meaning of these facts and bares the motivation for the anti-Negro genocide. "It is genocide for profit. The intricate superstructure of 'law and order' and extra-legal terror enforces an oppression that guarantees profit. . . . The prime mover of the mammoth and deliberate conspiracy to commit genocide against the Negro people in the United States is monopoly capital. Monopoly's immediate interest is nearly four billions of dollars in superprofits that it extracts yearly from its exploitation and oppression of the Negro people."

We have filed our petition with the United Nations not only on behalf of the 15,000,000 Negro people in the United States but, also, in the interests of all humanity. For we know that genocide at home inevitably develops into the genocide that is aggressive war. As Patterson declares in his introduction, "The Hitler crimes of awful magnitude, beginning as they did against the heroic Jewish people, finally drenched the world in blood."

While this book was still in preparation, a delegation of the Women's International Democratic Federation went to Korea and saw with their own eyes how the American government was practicing genocide against a colored people struggling for their independence.

The horrifying report of the women's delegation and this petition belong side by side. Both are weapons in the same struggle for peace and freedom.

In the short time since its publication, the charge made in this petition has already begun to be heard in Europe, Asia and Africa. But most of all, it must be heard and supported within the United States. All Americans who work for peace and civil rights must read this book, sell it in their communities, use its rich documentation and absorb its penetrating analysis of the meaning of the struggle for Negro rights in relation to the fight for world peace.

We of the true progressive America have the deepest and most sacred obligation, to our own land and to the people of the world, to preserve and hand on the honest traditions of our fathers—traditions of full equality for all, of the need to live in friendship and cooperation with all ways of life—reaching toward the fulfillment of the profoundest aspirations and hopes of all human kind.

How Not to Build
Canadian-American Friendship
"Here's My Story," *Freedom,* March 1952

Once in our history there was a Fugitive Slave Law.[1] You remember Dred Scott. Slaves who escaped to the North, were dragged back, contrary to every fundamental constitutional right of political asylum.

The infamous Supreme Court decision, delivered by Chief Justice Taney, contended that the "black man has no right that the white man is bound to respect." Clearly this was not a decision of the people of this land—of the Abolitionists, of the Frederick Douglasses. This was a decision reflecting the slave-holding South.

And now, today in 1952, we have a foreign relations committee headed by Senator Connally of Texas. We have a Smith-Connally Act, sponsored by the same Connally and Smith of Virginia. We have the denial of free speech, of the sacred right of freedom of belief. We have the denial of freedom to travel. We have a McCarran Act, denying freedom of entry, for example, to our West Indian brothers and sisters, the Statue of Liberty notwithstanding.

I went West this past month, to Seattle, just across from Vancouver, British Columbia, Canada. Here was a convention of the Canadian section of the Mine, Mill, and Smelter Workers, a fine union with black and white leadership—Ray Dennis, Asbury Howard, Harvey Murphy and that great leader of labor, Maurice Travis, secretary-treasurer of the union.

Now no American needs a passport to go to Canada, so in spite of my passport difficulties, I expected no action by the State Dept.

At the border, in Blaine, Washington, there were many Canadian acquaintances and a very friendly Vancouver press. They assured me that the Canadian Government would not refuse me entry, and that Vancouver was waiting to give me a warm welcome. I have appeared in Vancouver many times in concerts, in *Othello,* have spoken at the university there. No city has been friendlier throughout the years.

I remembered Douglass, Harriet Tubman and hundreds of our folk who escaped by the underground into Canada around Detroit—at Windsor for example. Again I felt the sympathetic understanding of the Canadian people, against a background of racial persecution in my own country.

The representative of the American State Dept. called me in and very nervously informed me that, though no passport was needed, a special order had come through forbidding me to leave the country. If I did, it might mean five years, and a fine! (I thought of my great and good friend Ben Davis—it's about time a major fight was launched to free Ben. People in Harlem continuously ask, "How is Ben? We need him.")

The Canadians were very angry and explained in no uncertain language that this was no way to build Canadian-American friendship.

John Gray of Chicago was with me, and he did go across the border into Canada for a few moments to establish his right to do so.

The next night, when the convention opened, I telephoned a message from Seattle. From this point, I will let Bert Whyte, correspondent of the Canadian *Tribune,* tell the story:

"Some 2,000 Vancouver citizens heard Paul Robeson sing and speak to an open session of the Mine-Mill national conference in Denman Auditorium Feb. 1. At the end of Robeson's speech the entire audience rose and gave the great Negro singer a thunderous ovation.

"True, Robeson wasn't there in person to receive this tribute. . . . But when Harvey Murphy, on the Vancouver end of a person-to-person telephone conversation with Robeson in Seattle, asked him, 'Can you hear that cheering and applause, Paul?' the world-famous bass-baritone chuckled and replied, 'I sure can.'

"U.S. action in barring Robeson and prominent San Francisco lawyer Vincent Hallinan, who were scheduled to appear at the Mine-Mill convention, turned the Denman Auditorium session into a protest meeting. . . .

"[Robeson] began by singing 'Joe Hill'—the song about the Western Federation of Miners' organizer who was framed on a murder charge in Utah in 1915, and whose last words as he faced the firing squad, were, 'Don't mourn for me; organize!'[2]

"Robeson's golden voice filled the auditorium. Everyone was leaning forward, faces upturned. . . . When the last soft words 'I never died, said he,' were sung, Robeson paused a moment, then began to speak.

"'Refusal to allow me to cross the border was an act of the American administration, not an act of the American people,' he said, and went on to tell of labor's struggles, of the struggles of the colonial peoples for freedom, and the struggles of the peoples of the world for peace.

"And in closing, Robeson spoke of his own childhood, and his 'pop' who told him, when he was a little boy: 'Stand firm, son, stand firm to your principles!

"Said the Robeson of 1952 speaking with depth and passion: 'You bet I will, Pop, as long as there's a breath in my body.'"[3]

"Stand Firm, Son"

"Here's My Story," *Freedom,* April 1952

At the annual dinner of the Jefferson School of Social Science in New York[1] the other night I heard Viola Brown of Winston-Salem, N.C., tell of the South and its struggles.[2] She pleaded with us to remember that down there is the core of our struggles for liberation. Down there

are the daily, nay, hourly battles for survival, for a crust of bread, for a
decent wage, for a protecting roof, for our children's future, for simple
human dignity.

The basic unity of the working masses of this land and the Negro
people must be forged there. We have the same oppression. We must
stretch out our hands and clasp them in never-ending common
struggle until victory be the people's.

And not only must this be done here in these states we have helped
to build. We must reach out across all our borders to the laboring folk
of all the world, struggling like ourselves in the so-called proud West
but controlling their own destinies and building a new life and new
human beings in the new and old people's democracies of the East, in
Europe and Asia. And our strength and aid must reach our brothers
and sisters in Puerto Rico. In all of Latin America and the West Indies,
in Africa, in Korea where our military now goes beyond the atom bomb
and uses bacteria to spread diseases such as cholera upon the colored
peoples of the earth. What a warning!

I was deeply moved by the challenging words of this modern Harriet
Tubman. Mindful of my links with the State of North Carolina, with
the courageous struggles of the tobacco workers, Negro and white,
recalling the heroic life of Miranda Smith, I read the following little
story of my youth—and of today.

In my brother's church recently a beautiful lady came up to me and
said, "You don't know me, I'm your cousin from North Carolina. I
remember you as a baby, when your mother came down to visit us. Do
you remember?"

Do I remember? Yes, rather hazily—Aunt Margaret, Uncle Jake,
tens and tens of my relatives living on the very soil where my father
had been a slave. As a matter of fact, during the years of emigration
from the South, hundreds of my relatives had come North with tens of
thousands of others of my people and many followed my father and
uncle Ben and uncle John, and cousin Carraway and cousin Chance to
Princeton, N.J.—seat of one of the oldest of American universities, its
student body predominantly Southern aristocracy.

So the South was transplanted to the North, to the center of the
State of New Jersey, 50 miles or so from New York City—and with it
the plantation relations.

My early youth was spent hugged to the hearts and bosoms of my
hard-working relatives. Mother died when I was six, but just across the
street were my cousins the Carraways, with many children—Sam,
Martha, Cecelia. And I remember the cornmeal, greens, yams, peanuts
and other goodies sent up in bags from down in North Carolina.

Here in these early years came my deep sense of belonging to my
people, to the bedrock of my people—farmers, domestic servants, hack
drivers, teachers, preachers. Here I was proud of my aunts, uncles and
cousins. I loved them, treasured them. They were strong and kind,
descendants of our African forebears, wonderful representatives of the
black and brown people of the world.

And father—what dignity, what restraint, but how concerned for his children; especially for me, the youngest, the baby. How simply he gave of his life to me and others, to the whole community. How brave he was, how uncomplaining.

I remember later in Westfield he told me to do something. I didn't do it, and he said "Come here." I ran away. He ran after me. I darted across the road. He followed, stumbled and fell.

I was horrified. I hurried back, helped Pop to his feet. He had knocked out one of his most needed teeth. I shall never forget my feeling. It has remained ever present. As I write, I experience horror, shame, ingratitude, selfishness all over again.

For I loved my Pop like no one in all the world. I adored him, looked up to him, would have given my life for him in a flash—and here I had hurt him, had disobeyed him.

Never in all his life (this was in 1908 and I was ten; he died in 1919) did he ever have to admonish me again. This incident became a source of tremendous discipline which has lasted until this day. "What would Pop think?" I often stop and ask the stars, the winds. I often stretch out my arm as I used to, to put it around Pop's shoulder and ask. "How'm I doin', Pop?"

My Pop's influence is still present in the struggles that face me today. I know he would say, "Stand firm, son; stand by your beliefs, your principles."

You bet I will, Pop—as long as there is a breath in my body.

An Evening in Brownsville

"Here's My Story," *Freedom,* May 1952

The other night I was in Brownsville, a section of Brooklyn bordering on the Bedford-Stuyvesant area. Not far away is the church where the historic conference of the African Methodist Episcopal Zion Church takes place May 7–21.

In the modest home of a friend, a Sojourner for Truth and Justice, a fighter for the freedom of her people, I met with 30 or more working folk. They had come to chat about some things I had on my mind and some matters they had on theirs.

One mother and social worker talked of the terrible housing facilities for the colored people of the area. Rat-infested homes, no decent or safe place for the children to sleep—this one illustration was the key to a total picture. It could apply to sections of Harlem, Southside Chicago, Detroit, Memphis, New Orleans—wherever (and that's everywhere!) they have herded our people into the terrible ghettoes.

It was not surprising, therefore, to suddenly remember that there in Brownsville was the scene of the brutal murder of Henry Fields not long ago. This bad housing means a neglected and oppressed community—bad schools, inferior food supplies, bad health conditions,

the taking away of eight years of the life expectancy of every one of our children.

The conversation turned on how to do something about these bread and butter, roof-over-the head problems. One basic need is the unity of the people. We need especially the unity of the churches of all denominations, because the influence of the church in the lives of our people is a powerful one. How wonderful if, mindful of this trust, the church would take the lead in the day-to-day militant struggles needed for a better life.

One working class leader in our discussion explained that the members of his union were the backbone of many of the churches, that they would go to their ministers and press them to do something about the living conditions of their flocks. The people need, not high-sounding words, but deeds—help in the daily living of our women and children, the key to our future as a people.

Another rousing discussion turned around the solidarity expressed to the colored citizens of the community by their progressive Jewish neighbors. Around many of the issues, such as the Fields murder, a close unity of purpose and action has developed.

I recalled to them how as a boy I saw my father reading Hebrew, together with my brother Ben, now the Rev. Benjamin C. Robeson of Mother Zion in New York, and a leading candidate for the bishopric at the Church's general Conference.

"Hebrew," I murmured, "the language of Moses." And how proud I was the day I could say in the language of Moses the opening words of the Bible. "In the beginning God created the heavens and the earth." ("Bresheeth bara Elohim et ha shamayim Ve et ha Arets")

This led to a discussion of my youth—a youth spent fully within the AME Zion church, and my conviction that this church would fight on such issues before us. Its history made this clear.

I recalled how Moses became a name for Harriet Tubman, a noble leader in the freedom struggles of our people. And Harriet Tubman is from Zion Church—a monument to her memory stands at Auburn, New York. Sojourner Truth was a member of Zion at one time and Frederick Douglass printed his paper in the cellar of a Zion Church.

I recounted to this little group in Brooklyn, how my whole life has been spent close to this Zion Church. My father built a little edifice which stands today in Westfield, New Jersey. He daily influenced many of the younger Zion clergymen of his area, some of whom later became Bishops, like the present senior Bishop W. J. Walls.[1] I was for many years head of the Sunday School. I studied two years for the ministry, and later changed to the law. Often I took the pulpit for my aging beloved "Pop." The influence of his character, his self-sacrificing life will never leave me. He, himself, was born a slave, but he fought his way to freedom, to an education, to a full life in the service of his people.

And today I glow with pride as I see my brother Ben following in his foot-steps. My Pop would be very proud to see his son achieve the highest opportunity for service to his Church and to his people.

My own struggles today spring from this background. I am serving in my way, have served all these years and will continue as long as strength remains. At one point I believed that my personal success alone would help my people. Many of us still look to this way of advance, still think that a few individual successes is the answer.

No! The good and welfare of all our fifteen million is at stake. That is the answer. The question is what happens to the millions living in official Jim Crow and facing "force and violence" in the deep South, the millions held back and hemmed into the Northern ghettos, all those denied opportunities. We must fight for them.

And so I left the heights of purely individual achievement to enter the day-to-day, the rank and file struggles of my people. I give of my talents and gifts to them. And I have been deeply rewarded by their solicitude, their concern for my well-being and for my right and opportunity to continue in the battle at a high level.

Not only must we have a new look at our leadership and "achievement"; we must also set new standards for our friends. Now our people have always recognized that we could not go it alone, that we must have allies in our struggle. But the question is what kind of allies? Half-hearted liberals who advocate gradualism and ride to public acclaim on the backs of "our" problem? Or modern-day abolitionists who go all-out for freedom *now*?

Our people today need friends the likes of John Brown, Garrison,[2] Lovejoy,[3] and Wendell Phillips.[4] We need friends who recognize the full stature of our struggle, who recognize as in the 1800's, that our struggle has been—and is—the very measure of American democracy. They must recognize that until there is full freedom for *all* of colored America our democracy is a myth, a bad myth, a confusing myth.

We must all assume greater and greater responsibilities in the historic battles for liberation raging in the world—at home as well as abroad. Our friends must be measured by a new measuring rod. In this the church has mountainous tasks to solve, a contribution of staggering proportions to make. Unselfish, non-partisan unity among ourselves can assure a future of real brotherhood and human growth.

I was happy at the end of the evening in Brownsville to discover I had made new friends who will join a little closer in our common struggles. And I know they wish Zion well and look to it for inspiration, help and courageous guidance.

We Can Learn from the Struggle in South Africa

"Here's My Story," *Freedom,* July 1952

The Council on African Affairs called a press conference the other day. It had to do with the present disobedience campaign in South Africa in particular and the whole question of colonial independence in general.

Dr. Du Bois, our great scholar and authority on Africa presided, ably assisted by Dr. Alphaeus Hunton, the guiding spirit of the Council. Mrs. Vicki Garvin of the Negro Labor Council and other leading community figures, including my dear friend of many years, that fine musician Dr. A. Granville Dill, were present.

What a challenge these brave African brothers and sisters of ours pose for us!

We know a bit about Jim Crow here in this land of our birth. We've had 300 years of one kind or another. Our basic campaign today is around the issue of our civil rights—FEPC, anti-poll tax and similar legislation guaranteeing our full right to vote and to representation at all levels: an anti-lynching law to see that we can vote without violence and that our lives are protected; anti-segregation laws at all levels affecting the ghettoes; education; Smith and McCarran act repeal to insure freedom of speech and protest—and this last is decisive.

Behind all of these struggles lies the need to watch the drive toward war—for with war all meaningful struggle for our rights would cease. 'Twould be "disloyal" or "subversive" you know to talk about freedom of our people, as even Mother Bethune[1] discovered.

Now, whatever our difficulties and disabilities, the South Africans are even more fiercely oppressed. Pass laws, curfew laws, unbelievable conditions in housing, jobs, all the stigmas of segregation in stations, public places, stores and so forth.

So what do they do? When Malan, prime minister of South Africa, announces complete segregation of the non-white Africans and restrictions upon the Indians and so-called colored (mixed) population, all of these three groups headed by the eight million black Africans have joined forces in what must eventually be a tremendous movement toward liberation.

They declared on April 6th their determination to oppose the new oppressive laws—and it started on June 26th. They refuse to obey Jim Crow and submit to arrest at this stage. Just imagine if we started something like that in the South—or even in New York, Chicago, St. Louis, Indianapolis, Louisville and Los Angeles.

Suppose the representatives of all of our organizations—NAACP, four million Baptists, one-half million AME Zions to which I belong, the millions of other churches and fraternal organizations, could unite long enough to confront the nation's leaders in the White House, Senate and Congress with a demand for an end to all talk (single and double) with a demand for *action now.*

Well, we wouldn't have to worry about the forthcoming political campaigns. We would not have to wait upon the hoped-for good will of politicians who must make some compromise with the Dixiecrat South. We'd *have* our civil rights. This is the challenge I see in the South African militant protest.

These South Africans aren't afraid of baiting. They march in thousands with raised clenched fists. They sing their songs of protest

(including some of mine, may I modestly add). They clamor for an end to war preparations and demand peace. They say quite sharply and plainly they want their youth alive to struggle for the independence of Africa, not dead on foreign battle fields in the interest of those bankers and factory and mine owners who have come to South Africa, especially from the U.S., to take away their land, diamonds, gold and uranium.

These South Africans—African, Indian, colored, white and black workers—see no threat from the lands of Eastern Europe, from the Soviet Union Republics, from the people of the new Chinese Republic led by the great Mao Tse Tung. Quite the opposite, all these are friendly people whose struggles give hope to the African peoples. There in South Africa it happens to be the "Western Europeans" who came generations ago to despoil the land and enslave the indigenous inhabitants, and who still rule as tyrannical masters—like our Southern Byrnes, Talmadges and Rankins.

These Africans are proud of their leaders who are making great sacrifices, leaders of every shade of opinion. They are as proud of their leaders who behave like our Ben Davis as of others who are not so advanced in their thinking. But they are joined, unified for the common purpose of their full equality and independence. How we here could learn from this—we Americans of African descent of all groups, from whatever lands we have come.

And finally, these Africans realize that the old political parties (the so-called Liberals and Conservatives, equivalents of our Democratic and Republican Parties), serve the interests of those who rule, who own. They do not and cannot serve the masses of the people, black or white. So they have had to form their own Congresses and look forward to their own party, springing from themselves and serving the people.

This, too, we of colored America might ponder as the political conventions converge on Chicago. I have already pondered, so I go to enter the struggle for Mrs. Charlotta Bass,[2] one of our bravest women and a modern Sojourner Truth, for Vincent Hallinan,[3] who is in prison because of his beliefs, for a Progressive Party led by men like Dr. W. E. B. Du Bois,[4] accepting no compromise, demanding full rights for our people, full dignity for the American worker, peace and prosperity for all of us, South and North, East and West.

Voting for Peace

Address at National Convention of the Progressive Party, Chicago, July 4, 1952[1]—*Masses & Mainstream,* August 1952, pp. 9–14

In 1947, on an N.A.A.C.P. picket line in St. Louis, I decided to retire from the concert stage and enter the day-to-day struggle of the people from whom I spring. Logically, in fighting for the full civil rights and equality of my folk, I entered the struggle for peace. I know how

critical it was in 1947 when the Truman Doctrine officially launched that major turn in the American foreign policy which has now taken us into a senseless war in Korea for over two years.

Peace was the issue in 1947 and 1948. Peace meant some opportunity to wage major battles around freedom for my people here in the United States and for an end to colonialism in Africa and elsewhere. Peace meant a fight for security and jobs. Peace meant some chance of a return to the Bill of Rights.

In 1952, after four years, how much more we know that peace is the most important issue in this election,[2] affecting bread and butter issues and every aspect of life—housing, jobs, wages of steelworkers and the conditions of oppressed minorities.

I remember our famous tour in the South in the 1948 election campaign, standing before 4,000 Negro and white citizens of Houston, Texas—the same Texas whose delegates to the Republican convention Eisenhower and Taft are fighting over, as though it made any difference which set of delegates were going to vote for "states' rights."

I remember huge meetings all over the South—white and black standing side by side in militant challenge.

Since 1948 I have been touring up and down this land for the cause of peace and for the freedom of the Negro people. As I get about, I see the men and women of labor and I see my people, the Negro people, responding to what has happened to them in four years, calling insistently for honest leadership. It is these visits with and talks with the people themselves—two or ten or twenty in Harlem, Brownsville, on the Southside, in Detroit's Paradise Valley—which have given me strength to continue the battle which led from the campaign of 1948 into my tour of 1949 and was climaxed at Peekskill.

We have come a long way since Peekskill. I come to you tonight stronger than ever in the conviction that the choice I made and the choice which almost two million Americans made in the 1948 elections slowed down the drive toward war and forced out of the Democratic Party a discussion of the real issues which affected the people. Truman's Committee on Civil Rights came almost immediately after a great mobilization in 1946 in Washington, embracing every section of Negro life and thousands of our allies.

And the response to the recent occurrence around the joint appearance of myself and Mrs. Sampson[3] shows that the Negro people are not fooled by the myth of the "tremendous progress"—the progress of a few bigshot jobs and appointments, while the great masses of our folk in the South—yes, in Chicago, Detroit, Cleveland, New York and the West Coast—struggle for every little gain in living wages, in upgrading, in dignity of leadership, while Ciceros and Martinsvilles match the terror in Korea.

So I stand before you stronger than ever in the conviction that the need is greater and the possibilities are greater today than ever for the party that we launched together four years ago in Philadelphia.

Some of us have been discouraged in the fight since four years ago. A

couple of "summer soldiers" have left,[4] but I will tell you that they were very few and that a whole host closed up the gap left by their going. The people want peace. The people want civil rights. The people want jobs and security and protection for their old age—some approximation of the democratic heritage of which we boast.

They want a return to the Bill of Rights for all of our citizens, black and white, and of whatever political opinions. They are recalling that after 1917 it was Debs[5] and that now it is Eugene Dennis and Benjamin Davis.[6] Further back it was Douglass, Tubman, Lovejoy and the Abolitionists, and earlier in our history it was Thomas Jefferson and his so-called Jacobin colleagues.

I will tell you something else, the American people are beginning to fight for these things. I know this from my recent tour of the country. Most significant events promise important developments for the life and reception of the peace and freedom ticket. I reached close to 100,000 people on the tour. And the people themselves reversed the verdict of Dewey and his State Troopers at Peekskill and they registered this by winning the right for me to sing in many municipal auditoriums throughout the country—in Seattle, Berkeley, Denver and Milwaukee—at very high levels of struggle.

The tour was climaxed at the border when 40,000 Canadian and American citizens, standing on both sides of the border at the Peace Arch, listened to a concert for peace and freedom of the Negro people and in Chicago when close to 15,000 stood on the Southside in Washington Park as I sang songs of liberation and peace to thousands of Negro people, many of them recent arrivals from the South; and all along the West Coast thousands, some of whom are delegates at this convention, joined in fighting hysteria and in fighting for the dignity of my people.

The Negro people, in magnificent leadership, were joined by great sections of the Jewish people, great sections of those who have come to our shores from all over the world to build this America—millions recently insulted by a cowardly, dastardly McCarran and a whining, fame-seeking Walter.

Again, this tour represented my taking up my function as an artist, but on a level deeper and higher and bigger than ever before, because I sang to and with the people to whom my talents and my life are dedicated, to the people who happen to be the source of all great art. Just as certain am I that this convention in 1952 brings the battle for peace and security to a deeper level than any we were able to achieve in 1948. For the forces which made possible this tour are the same forces that are now making possible new achievements in the political life of the American people.

The outstanding organizations of the Negro people clearly recognize that both old parties want to retreat on civil rights. The clear-cut demands of the Negro people for equality and particularly for the full use of the powers of the Federal Government to secure Fair Employment Practices—this straightforward demand has cut through the

rosy glow that was built up around Eisenhower; and Taft and his Dixiecrat allies only recall 300 years of genocidal slavery and serfdom for my people.

And the Democratic dilemma will not be solved by any stepped-up, double-talking by either Truman or Harriman. And it's dangerous double-talk—but our folks want *civil rights now!*

Yes, the Democrats will discover that the old dodge that "it's Congress, not Truman—the Dixiecrats, not Truman"—they will discover that this dodge won't work.

It will not suffice to put up a hedging "states' rights" Stevenson[7] and a Dixiecrat Russell. My people will notice the remarks of Mrs. Roosevelt in the Human Rights Commission of the United Nations— that these United States could not sign the human rights document against Jim Crow and discrimination because of "states' rights"[8]— Mississippi, Alabama, Georgia must decide our fate!

That's supposed to be our America! Well, well! Did Mrs. Roosevelt and Truman decide this? Please! So Truman's for "states' rights" too, when you get down to the nitty gritty.

And so again we are witnessing what we saw in 1948. In 1948 the campaign of the Progressive Party challenged the two old parties on civil rights. So in 1952 our campaign is challenging the two old parties and raising that challenge to new heights. We will force the Democratic Party in the person of Mr. Truman and his Wall Street boy Mr. Harriman to respond to the demand for genuine civil rights for the Negro people.

Eighteen organizations of the Negro people have set forth a clear-cut demand for Federal F.E.P.C. with teeth, anti-lynch legislation, anti-poll tax legislation, the end of segregation and discrimination in public facilities and housing. The Progressive Party extends its hand to these spokesmen of the Negro people. We join them in their fight for these minimum demands for full citizenship for the Negro people.

Our convention meets this challenge and addresses itself to these demands[9] in a way which neither of the two old parties can, because we have no vested interest in Jim Crow, because we have no investment in slums, because the Progressive Party does not own the railroads where Negroes have to eat in special sections of the dining rooms as on the railroad Mr. Harriman owns. On Mr. Harriman's Union Pacific Railroad, they recently sent out an order that dining-car stewards must seat Negroes with Negroes and white with white and must separate them in opposite ends of the dining car.

Our interest is in wiping out these things. Our interest is in equality. We do not make hypocritical promises for votes; we fight every day in the year for civil rights and for peace.

At this convention of the Progressive Party we see the fight for these things and the fight for equality fully united. A brave and courageous lawyer who has sacrificed everything he holds dear to defend the right of a union and its leaders to remain alive is joined in this campaign by a sturdy, fighting colored woman whose life has been a forthright struggle for the rights of her people to live in peace as first-class

citizens. She's a great woman, is Mrs. Bass—tried in struggle, forgiving, understanding in the fight for unity of black and white—a true Sojourner of Truth.

We make the fight for peace and the fight for equality indivisible. We know that we cannot expect a Tom Connally of Texas or a Russell of Georgia or a Byrnes of South Carolina or a Taft or Eisenhower, who are willing to live with oppression of the Negro people in this country, to do anything else abroad. In South Africa they stand by and support the Nazi racist theories of a Malan who oppresses millions of Negroes. In Africa they support British imperialism and in Tunisia, French imperialism, and in the Middle East and Asia they support all the decadent imperialism which would prevent the colonial peoples of the world from seeking that elementary liberty that our own colonists fought for in 1776.

The leaders of the Democratic and Republican Parties are united in preparing for war. Preparing for war means that they must destroy civil rights. Not one of them embraces the one, real, practical alternative, which is desired by all the peoples of the world—peaceful co-existence with the Soviet Union, a nation which has demonstrated that many republics can live together in peace and friendship.

Last week in the British Parliament, the British Labor Party united in violent protest against the arrogant war-making activities thoroughly approved by Taft, Eisenhower and Truman. The people of France, Italy, Denmark, want trade and peace, not destruction.

These are signs that the people of the world are revolting against a policy of war and demanding a policy of peace, survival and a promise for the future. They want their youth not dead, but *alive* to build anew. And certainly I know I want the Negro youth and working youth of this land to ever strive toward the fulfillment of our generations-long dream.

As Langston Hughes has said: "America has not yet been all *mine*—but it *will* be,"[10] because our struggles will make it so. And then and only then, my deep *hope* will turn to love embracing all of a new-born republic. Today we alone in the elections of 1952 offer a chance to vote for peace, for equality of all peoples, for true security, for freedom—full freedom and full human dignity.

We Can't Sit Out This Election

"Here's My Story," *Freedom,* August 1952

"Man, who are you telling?" said the fellow in the first chair. "First the Republicans and then the Democrats. It seemed like every time I looked at the TV here was one of them Dixiecrats right up there in front laying it down for states rights and no FEPC. And then they roll-called and polled and voted and tallied up—and I guess you know who won?"

The barber sighed. He knew.

"And I guess you know who got counted out?" the man went on.

"Yes," said the barber sadly. "You!"

A waiting customer turned to me and said: "You know, the worst part about those conventions was not so much the way the Southerners got up on their hind legs and demanded their way but it hurt me to my soul that not one of our delegates got up to straighten them out, just seconded the motion. Even when it came to nominating that man from Alabama for Vice President—nobody said a mumblin' word."

Then my neighbor cut his eyes at me and said: "But you would have said something. I bet you would."

I thanked him for that and assured him that indeed I really would have talked up for my people . . . and then I got to thinking about something I read in the morning's paper.

It seems that when Gov. Battle got back home to Virginia, a couple of thousand white folks met him with "rebel" yells, Confederate flags and a brass band playing "Dixie." It was a fixed fight, but he won all right—along with Byrd and Byrnes and Talmadge and Sparkman, with Stevenson helping.

And I wondered: where in all this land would even two dozen Negroes welcome back the Negro political leaders who sold out in Chicago? And if such a strange thing could be imagined, would the band play "Lift Every Voice" in honor of these silent ones? Or would a choir sing "Were You There When They Crucified My Lord?" But there was nothing like that in the papers.

Some of these big-shots are back home now—"explaining." But what can they say? The plain truth is that the Republican party refused even to make a platform gesture about civil rights and the Democrats showed what they intend to do by breaking their "loyalty" rule even before the ink was dry, seating the Klan-backed delegates and adding an outspoken advocate of Jim Crow to their ticket.

Now, some people are saying this month, anyway, that they can't swallow all that and Sparkman too. "Let's sit this one out," they say. "Both decks are stacked in November."

Along with all Negroes who aren't bought and paid for, I share these Democrats' disgust. But as for sitting it out—oh, no! We can't afford to sit anything out, anymore than we can afford to have so-called leaders who sit and take it.

I've got two good reasons for saying that. For one thing, there was a third convention in Chicago that didn't get all that ballyhoo. I mean the Progressive Party convention that nominated Vincent Hallinan, a fighting labor attorney, for President and one of our militant women leaders, Mrs. Charlotta Bass, for Vice President. You'll hear more about these candidates and their platform before this campaign is over, and I hope that you'll come to believe as I do that here is the only ticket for Negroes in November.

And there is another reason for not stringing along or sitting it out, regardless of what your politics are. When you look a little closer at

what happened in Chicago you'll see something that never showed up on the TV screen; the fact is that civil rights for Negroes was the central issue behind all the wringing and twisting at the big conventions. And the fact is that it was OUR DEMAND for those rights which made that the issue! And we've got to keep on demanding.

Sure, civil rights, FEPC and all the rest of our needs got kicked around out there, but brothers and sisters I'll tell you one thing: this fight is just starting good.

Truth is, you're telling me. Wherever I go about this land on the streets, in the churches, in the unions, I hear what you the people say about wanting our civil rights now. Not next year, not in some great day a-coming', but *now, this year, 1952*.

So all of us together—and there's no strings on us, no gag on us, no political boss to make us second his motions—all of us have got some talking back to do. Not on TV, not on radio, not long distance, but face to face with the powers that be. I mean mass action, and mass pressure. I mean delegations that will represent us, the 15 million Negroes and all decent progressive white Americans who know our cause is just and that equal rights for us means more democracy for them.

Sitting it out? Oh, no, I say we got some fighting and struggling and unifying to do.

A Lesson from Our South African Brothers and Sisters

"Here's My Story," *Freedom*, September 1952

The betting was all one way that day, so you know it wasn't about the Dodgers and the Giants.

"I'll bet they're going to win this time," said one.

"Can't see how they can lose the way they're going," said another.

"They mean to win, you can see that," said still another man.

"That's right," I agreed. "All the colored people have gotten together this time. The leaders too. They say Jim Crow has got to go and no two ways about it. Yes sir, it looks like this is the last go round for white supremacy, and furthermore—"

"Hold on a minute, Paul," said a man moving closer to our street corner discussion. "I don't dig all this—are you fellows talking about my folks?"

One of the men took an exaggerated look at the newcomer. "No doubt about it, chum," he answered finally. "Your folks."

"We're talking about South Africa." I explained after the laughing. "But that's USA too—Union of South Africa—and it's really the same thing as here, only more so."

Here we are pushing for civil rights now, for performances not

promises, and over there—well, they're really rolling. And it's so much the same that we ought to compare notes on these two great movements against white supremacy in the two USA's.

Take some of the laws that they're fighting against over there: the Removal of Colored Voters Act, the Group Areas Act, the Mixed Marriages Act, the Suppression of Communism Act, the Flogging Law. . . . Sounds mighty like "down home" doesn't it?—and up North too for that matter.

And what about that item in the paper the other day that told of how Dr. J. S. Moroka, president of the African National Congress, was arrested on charges of breaking the anti-Communist law because he is one of the militant leaders in the fight against segregation? Makes you think of our own brave Ben Davis, jailed for over a year now under the Smith Act because he led the fight against Jim Crow housing and for equal rights for his people.

More than 2,300 Africans and Indians have been jailed in South Africa since June 26 for such "crimes" as walking through public entrances marked "Whites Only" or for sitting on a railroad station bench reserved for "Europeans." And now we read that four African women are to be flogged.

But despite the jails and the whips, my friend on the corner is right. They are going to win because they *mean* to win.

We mean to win too, but we ought to take a lesson from our South African brothers and sisters. The lesson is UNITY. It was harder for them in many ways but now they've gotten together—the leaders and the people, the blacks and the Indians and the "coloreds" and the Trades and Labour Council, and they say: "This is it! Freedom for us now!"

Somehow we've got to get united like that and it had better be soon. Not after the elections, but today. And why not? We're united now in our insistence on civil rights, but when we unite all our strength—churches, NAACP, trade unionists, lodges, women's clubs, business and professional groups—and move together, well, we'll get our civil rights in 1952.

And there's something else we talked about on the corner along with all the rest about whips and jails. There are the invisible chains too—like denying me a passport because, as the government noted in one brief, Robeson "has been active politically in behalf of the independence of the colonial peoples of Africa."

I have for a fact, and I'm still fighting for my passport which they are still keeping from me . . . but the African freedom fight just keeps rolling along. And how it must have pained certain people down in Washington to read in the *N.Y. Times* that parading black and brown men in Johannesburg were singing "Robeson songs"!

Songs of liberation—who can lock them up?

The spirit of freedom—who can jail it?

A people's unity—what lash can beat it down?

Civil rights—what doubletalk can satisfy our need?

O my brothers and sisters of the two USA's—we are going to be free!

Happy Birthday, New China!
"Here's My Story," *Freedom,* October 1952

Our folks call it Jubilee, that longed-for time, that great day a-comin' when we will stomp and shout: Free at last. So our hearts go out to the Chinese people, 475 million strong, who this month are celebrating *their* day of Jubilee which came three years ago. "Chieh fung La," they shout. "Put me free"—and now they are truly free.

China for the first time belongs to the Chinese people; the good earth is theirs and all its riches. No more drivers' lash for them—oh no, they're in the driver's seat now.

Happy birthday, new China!

And happy is the meaning of your rising. For now Africa and all of the millions of colored peoples can see in this new star of the East a light pointing the way out from imperialist enslavement to independence and equality.

China has shown the way, no argument about that, but some people don't pay enough attention to one of the most important facts about China's successful struggle for liberation. I mean the great truth, proclaimed by the Chinese leaders and masses alike, that their victory could not have been won without the strong friendship and support of the Soviet Union.

So now Kung ren the worker and Nung fu the farmer, controlling their own country and backed by their mighty Soviet ally, can look Mr. Big Western imperialist dead in the eye and say, "Bu Yao ya Po," which might be translated as "Better not mess with us!"

And China in turn came to the aid of the heroic Korean people with the Chinese volunteers standing with their Korean neighbors, halting the imperialist invaders in their tracks, fighting for independence on the mountain sides, negotiating for peace in the conference tent.

Yes, China is a power for peace as it is for liberation. Today, as I write, the great Peace Congress of the Asian and Pacific Regions is meeting in Peking, capital of the People's Republic of China. There the representatives of the one billion, 600 million people of those areas are uniting against the threat of war.

"We believe, that by acting together for peace," they have declared, "the peoples of the Asian and Pacific countries can change this situation. . . . They can put an end to the wasteful armaments race through international disarmament and through the banning of atomic, bacteriological, chemical and all other weapons of mass destruction. They can tear down the barriers to world trade and to free cultural exchange and friendship between all people. . . ."

Indeed it is one of those barriers that has stopped me from going to China in response to several invitations I have received from their People's Committee for World Peace whose leader, Kuo-Mo-jo, is also Vice-Premier of the goverment.

The denial of my passport is especially bitter in this case because, in addition to my deep concern with the world peace movement, I have for a long time felt a close kinship with the Chinese people.

I have not had the opportunity of visiting their homeland as Mrs. Robeson did in 1950, but many years ago in London I first "reached" the Chinese people in a rather unusual way. Through my studies of African languages I came to learn of Africa's cultural kinship with China, which is shown, for example, in the remarkable similarities in the language structures.

I am continuing, of course, my study of the language of China and my singing of the songs of her people. And now with China free and Africa rising against the rule of White Supremacy, I look forward to a new flowering of those two great ancient cultures, bringing to all mankind new riches in the arts and sciences.

For that we need peace. Cease-fire in Korea—now! Withdrawal of all foreign troops from the tortured land, and withdrawal of U.S. troops from Japan. Yes, and withdrawal of U.S. support from the fascist Malan dictatorship in South Africa that is killing and clubbing and jailing our brothers and sisters there who want to be free.

Just the other day, in a restaurant on Harlem's 125th St., a tall young Negro came over to my table. His manner and words were intense. "I've been away," he said. "Korea—" and his eyes blazed in remembering the bomb-blackened villages. "I can't make speeches, but you can. Give 'em hell for me Paul!"

My people want peace, no doubt about that. Most Americans want peace. Eisenhower and Stevenson—they want peace, too. But every day U.S. bombers are blasting Korea and menacing China. And every day Koreans and Chinese and American boys (like my young friend in the restaurant) are dying.

"Peace cannot be awaited" the Asian Peace Congress calls to us. "It has to be won by the peace-loving peoples in unity."

Let us take their outstretched hand. Let us win that peace.

Land of Love and Happiness

Speech delivered at meeting of the National Council of American-Soviet Friendship, New York City, November 13, 1952, to mark the 35th Anniversary of the USSR and the 19th anniversary of American-Soviet relations—*New World Review,* December 1952, pp. 3–4

I speak tonight with a heart filled with love and happiness, and with sorrow and anger, and above all with a firm resolve.

Yes, we are here tonight to pay tribute to that land of love and happiness of which the great Chilean people's poet, Pablo Neruda,[1] has sung:

 . . . wide regions of man,
a geography of children and women, of factories,
love and songs, of schools
which gleam like violets in the forest . . .
They said 'comrade' to the world.
They made the carpenter king.
No camel shall pass through this needle's eye.
They cleansed the villages.
Divided the land.
Elevated the serf.
Eliminated the beggar.
Annihilated the cruel.
Brought light into the deep night.

So I am here to say: Happy Birthday, Land of Socialism! I send you my love. I return in full measure your love for me and my people. I remember your warmth and friendship, the shining eyes of your children, the clasp of their little hands, their sun-lit voices telling me: "Give our love, Paul Robeson, to the Negro children and all children of America, and our best wishes to them for peace and freedom."

O happy land—where Man can walk the earth so proud and free! Here people of the many nations and races—the Russians, the Ukrainians, the Georgians, together with the Uzbeks, the Buryat-Mongolians, colored peoples and all the others, live in brotherhood and equality.

And tonight, too, there is love and happiness in my heart to see, marching arm in arm with Land of Socialism, the free people of New China, and the free nations of Europe's New Democracies. And *they* rejoice, for now their way is lighted by the rosy glow that dawned 35 years ago in the great October Revolution.

A rosy glow, it was, back in 1917, and through the years it has grown brighter, through the smoke and flame of war against the cruel invaders, though the white-hot steel of Stalingrad, brighter and brighter, and now 800 million people walk in the dazzling light of freedom. And hundreds of millions more, in every part of the world, can see the blazing beacon.

But there is sorrow and anger in my heart when I look around at the rest of the world and see—the blasting and burning of Korea, the march of imperial troops into Kenya, the blackened villages of Malaya, the crack of the lash in South Africa. And here at home—the trampling of the Bill of Rights, the shadows of terror, the frame-ups, the lynchings, the war-cries.

Africa! You read what's going on. Every day the papers report the new atrocities—jail for those who want freedom; bullets for those who want bread. And if you read the financial pages, you can see behind it all the Almighty Dollar—4 billions invested since 1950 in support of the British, French and Belgian projects in Africa and the West

Indies . . . Kennecott Copper, Standard-Vacuum Oil, Ford, General Motors, and all of the other vultures of Wall Street.

Look at the United Nations—there, as ever, the spokesmen of the Soviet Union and the People's Democracies arise in defense of the oppressed colonial masses, expose and indict the Malan fascists and the imperialist powers who masquerade as the "Free West." So the Africans, the Malayans, the Viet-Namese, the Koreans, the Indians, the Burmese—all of the colored peoples of the world—know that the Soviet Union is their proven friend. Many of their leaders have declared *they will never join the wolf-pack that bays at the borders of the Soviet Union!*

It is unthinkable—as I said at Paris, and I repeat it now—that the colored peoples of the world will serve their oppressors in such a war.

We Americans, both Negro and white, have a great responsibility. There must be on our part no fearful isolation from the great world-wide movement for peace that is led by the World Peace Council.

Peace—that is the highest patriotism.

Peace—the common people of our land want an end *now* to the bloodshed in Korea; and they *thought,* so many of them, that they were voting for *peace* on Election Day.

Peace—yes, the promises must be fulfilled.

We call to all peace-loving Americans: send delegates, hundreds of delegates from all walks of life, from all political and religious beliefs, to the great World Peace Congress in Vienna on December 12th. There you will meet the representatives of that truly free world—the 800 millions—and delegates from every land. And you will realize, in Vienna, that our nation can live in peaceful co-existence with all other nations; that we can trade with them to our mutual benefit; that we can lighten the burden of armament; that our nation can share fully in a free exchange of science and culture.

Yes, tonight my heart is filled with that firm resolve. Never to cease in the struggle for peace. Never to cease in the struggle for freedom.

I have been, I am, and I shall always remain, a strong, unbending friend of the Soviet people, their wise leaders and the Land of Socialism, Equality and Peace!

The Battleground Is Here

Excerpts from an Address to the Annual Convention of the National Negro Labor Council, November 21, 1952, at Cleveland, Ohio[1]—Paul Robeson Archives, Berlin, German Democratic Republic

Officers and Members of the Council—Friends:

It's good, so good, to be here—to enjoy once again the brotherhood and sisterhood of this great body of Negro working men and women, to share with you the dream of freedom, to plan with you for its achievement not in some distance but *now, today.*

I have been in many labor battles. It has seemed strange to some that, having attained some status and acclaim as an artist I should devote so much time and energy to the problems and struggles of working men and women.

To me, of course, it is not strange at all. I have simply tried never to forget the soil from which I spring.

Never to forget the rich but abused earth on the eastern coast of North Carolina where my father—not my grandfather— was a slave and where today many of my cousins and relatives still live in poverty and second-class citizenship.

Never to forget the days of my youth—struggling to get through school, working in brick yards, in hotels, on docks and riverboats, battling prejudice and proscription—inspired and guided forward by the simple yet grand dignity of a father who was a real minister to the needs of his poor congregation in small New Jersey churches, and an example of human goodness.

No, I can never forget 300-odd years of slavery and half-freedom; the long, weary and bitter years of degradation visited upon our mothers and sisters, the humiliation and Jim Crowing of a whole people. I will never forget that the ultimate freedom—and the immediate progress of my people rest on the sturdy backs and the unquenchable spirits of the coal miners, carpenters, railroad workers, clerks, domestic workers, bricklayers, sharecroppers, steel and auto workers, cooks, stewards and longshoremen, tenant farmers and tobacco stemmers— the vast mass of Negro Americans from whom all talent and achievement rise in the first place.

If it were not for the stirrings and the militant struggles among these millions, a number of our so-called spokesmen with fancy jobs and appointments would never be where they are. And I happen to know that some of them will soon be looking around for something else to do. There's a change taking place in the country, you know. My advice to some of this "top brass" leadership of ours would be: *You'd better get back with the Folks—if it's not already too late.* I'm glad I never left them!

Yes, the faces and the tactics of the leaders may change every four years, or two, or one, but the people go on forever. The people—beaten down today, yet rising tomorrow; losing the road one minute but finding it the next; their eyes always fixed on a star of true brotherhood, equality and dignity—*the people* are the real guardians of our hopes and dreams.

That's why the mission of the Negro Labor Councils is an indispensable one. You have set yourself the task of organizing the will-to-freedom of the mass of our people—the workers in factory and farm—and hurling it against the walls of oppression. In this great program you deserve—and I know you will fight to win the support and cooperation of all other sections of Negro life.

I was reading a book the other day in which the author used a phrase which has stuck in my memory. He said, "We are living in the rapids of history" and you and I know how right he is. You and I know that for

millions all over this globe it's not going to be as long as it has been.

Yes, we are living "in the rapids of history" and a lot of folks are afraid of being dashed on the rocks. But not us!

No, not us—and not 200 million Africans who have let the world know that they are about to take back their native land and make it the world's garden spot, which it can be.

In Kenya Old John Bull has sent in his troops and tanks, and has said Mau Mau has got to go. But Jomo Kenyatta,[2] the leader of Kenya African Union, with whom I sat many times in London, has answered back. He says, "Yes, someone has got to go, but in Kenya it sure won't be 6 million black Kenyans. I think you know who'll be leaving and soon."

And, in South Africa there'll be some changes made too. FREEDOM is a hard won thing. And, any time seven thousand Africans and Indians fill the jails of that unhappy land for sitting in "White Only" waiting rooms, for tearing down jim crow signs like those which are seen everywhere in our South, you know those folks are ready for FREEDOM. They are willing to pay the price.

The struggle in Africa has a special meaning to the National Negro Labor Council and to every worker in this land, white as well as Negro. Today, it was announced that the new Secretary of Defense will be Charles E. Wilson, President of the General Motors Corporation. General Motors simply happens to be one of the biggest investors in South Africa, along with Standard Oil, Socony Vacuum, Kennecott Copper, the Ford Motor Company, and other giant corporations.

You see, they are not satisfied with wringing the sweat and sometimes the blood out of ore miners in Alabama and Utah, auto workers in Detroit and Atlanta, oil workers in Texas and New Jersey. They want super duper profits at ten cents an hour wages, which they can get away with only if the British Empire, in one case, or the Malan Fascists, in another, can keep their iron heels on the black backs of our African brothers and sisters.

Now, I said more than three years ago that it would be unthinkable to me that Negro youth from the United States should go thousands of miles away to fight against their friends and on behalf of their enemies. You remember that a great howl was raised in the land. And I remember, only the other day, in the heat of the election campaign, that a group of Negro political figures pledged *in advance* that our people would be prepared to fight any war any time that the rulers of this nation should decide.

Well, I ask you again, should Negro youth take a gun in hand and join with British soldiers in shooting down the brave people of Kenya?

I talked just the other day with Professor Z. K. Mathews, of South Africa, a leader of the African National Congress,[3] who is now in this country as visiting professor at Union Theological Seminary in New York.

Professor Mathews' son is one of those arrested in Capetown for his defiance of unjust laws. I ask you, shall I send my son to South Africa

to shoot down Professor Mathews' son on behalf of Charles E. Wilson's General Motors Corporation?

I say again, the proper battlefield for our youth and for all fighters for a decent life, is here; in Alabama, Mississippi, and Georgia; is here, in Cleveland, Chicago, and San Francisco; is in every city and at every whistle stop in this land where the walls of Jim Crow still stand and need somebody to tear them down.

The Brave Trumpets of Albert Einstein and His Fellow Scientists

"Here's My Story," *Freedom,* November 1952

Well, here is an "atomic blast" that is all to the good. I mean the recent outburst of 34 of the world's leading scientists against the passport policies of the U.S. State Department.

Headed by Dr. Albert Einstein, this group of U.S., British, Italian, French and Mexican scholars have jarred the big shots in Washington with the charge that the government is stifling intellectual and political liberty.

Their protest against "America's Paper Curtain," published in a special issue of the *Bulletin of the Atomic Scientists,*[1] cited 26 cases in which scientists and teachers were either not permitted to enter or not allowed to leave the country.

"There can be no doubt," Dr. Einstein wrote, "that the intervention of political authorities in this country in the free exchange of knowledge between individuals has already had significantly damaging effects."

So what do we have? A distinguished panel of scientists finds that the federal government, denying passports and visas under the pretext of protecting the "public interest," is itself "traducing the principles of liberty!"

Surely all democratic-minded Americans must agree with Dr. Einstein's insistence that: "The free, unhampered exchange of ideas and scientific conclusions is necessary for the sound development of science as it is in all spheres of cultural life."

Now all of this, of course, has a special meaning to me because of my struggle these last two years against the cancellation of my passport. Together with the other artists, writers, dancers, and others of the "sphere of cultural life" who have been victimized by the State Department, I am happy to greet this vigorous action of the scientists.

And then, for me, there is something inspiring about the leading part played by Dr. Einstein in this blast for freedom. Only a couple of weeks ago I had the pleasure of visiting the world-renowned scientist at his home in Princeton.[2]

It was good, once again, to clasp the hand of this gentle genius.

Recalling our previous meetings when I had appeared there in concert and in *Othello,* Dr. Einstein asked about my life today as an artist, and expressed warm sympathy with my fight for the right to travel.

We chatted about many things—about peace, for Dr. Einstein is truly a man of peace; about the freedom struggles in South Africa which interested him keenly; and about the growing shadows that are being cast over freedom of thought and expression here at home.

Though he is physically frail and not in good health, one can feel the strength of his spirit and the glowing warmth of his compassion for humanity. There was a note of deep sorrow and concern underlying his comments on what is happening in our land.

As he spoke, one could sense something of what this must mean to Einstein, the giant of science and culture, who was driven from his homeland by the Nazi barbarians and who felt the immeasurable tragedy that his people suffered at their hands.

Surely there is heart-felt earnestness in these words from his article in the scientists' bulletin:

"Interference with the freedom of the oral and written communication of scientific results, the widespread attitude of political distrust which is supported by an immense police organization, the timidity and the anxiety of individuals to avoid everything which might cause suspicion and which could threaten their economic positions—all these are only symptoms, even though they reveal more clearly the threatening character of the illness."

The brave trumpets of Albert Einstein and his fellow scientists have joined those who assail the evil Walls of Jericho. More trumpets must be sounded, more shouts of protest must be raised, more and louder, till the walls come tumbling down.

A Tale of Two Clippings

"Here's My Story," *Freedom,* December 1952

Well, here on my desk are two clippings—and a post-card.

Both clippings are from the *New York Times.* The first is a large political advertisement (you may have seen it in some other papers, too) signed by 86 prominent Negroes. It appeared on Oct. 24—before the elections—and it doesn't stack up so well next to the second clipping, a news report dated a month later (Nov. 21).

The elections are over, but the struggle for equal rights for Negro Americans goes on—and must go on harder than ever before. So it is not for the purpose of quarreling that I look back at the statement of the 86 Negro Democrats. I just want to make clear the actual situation that we Negroes face, and the need for united action by all of us.

The political advertisement boasted that, "In the past 20 years . . . Negroes, along with all other Americans, have made tremendous strides economically, socially and in the field of education."

The 86 signers insisted that "Negroes have jobs now. . . . And like

Americans generally, they're drawing good wages. . . . The Negro farmer, like all farmers, has made tremendous progress, too."[1]

But here's the other clipping,[2] a report by the Senate sub-committee on Labor and Labor-Management Relations.

Based on the figures of the 1950 census, the report reveals that family income of Negroes as compared with whites is more unequal than it was five years ago!

In the words of the report: "Their average income was $1,869 in 1950, or 54 per cent of the average income of $3,445 among white families." (In 1945 the difference was 57 per cent). Put in plain terms, apart from figures and percentages, the fact is clearly shown here that the mass of the Negro people remain impoverished, the average family getting less than one-third of what the government itself calls a minimum income for health and decency.

The report further reveals that the average yearly earnings of Negro wage and salaried workers is about $1,300—only 52 per cent of the average for white workers.

And the report tells why our hard-working people get only half the pay of white workers: "Negroes are still predominantly employed in the lower paying and less skilled occupations."

As for moving up into the higher brackets, well, the report shows that the proportion of Negroes engaged in professional occupations "remained at about 2 per cent."

So I ask: Who has been integrated into what? What is all this talk about "tremendous strides, along with all other Americans?"

It is worse than plain foolish, in the face of these facts, to be whooping and hollering that the "new world a-coming" is already here—such talk can only divert us from what we have got to do. And that is: To unite together closer and to fight harder for our rights.

FEPC? Without it we will still be kept down on the lowest levels; we will still have to work twice as hard for half the pay. FEPC must still be won.

Negro Democrats and Republicans and Progressives all must realize that whatever progress our people have made has come about not by boasting but by battling; and that the great truth proclaimed by Frederick Douglass holds good for us today: "Without struggle there can be no progress!"

Robeson on Records Again

Letter announcement, December 1952—*Freedom,* December 1952

Dear Friends:

I am writing to you about a matter that is most important to me as an artist.

For the past several years a vicious effort has been made to destroy my career. Hall-owners, sponsors and even audiences have been intimidated. Recently, in Chicago, 15,000 persons who wanted to attend

one of my concerts had to assemble in a park because the hall-owner had been threatened.

The outrageous denial of my passport bars me from accepting contracts to appear in England, France, China and many other lands.

Although I have recorded for nearly every major recording company and sold millions of records both here and abroad, these companies refuse to produce any new recordings for me.

What is the meaning of this? It is an attempt to gag artistic expression, to dictate whom the people shall hear and what they shall hear. It is an attempt to suppress not only me, but every artist, Negro and white, whose heart and talent are enlisted in the fight for peace and democracy.

There is a way to explode the silence they would impose on us. An independent record company has just been established that will make new recordings for me. This company will also release work by other artists banned because of their views, and younger artists often denied a hearing.

My first new album is now in production.[1]

But the making of records is only part of the job. *The big task is to make sure that the records will reach a mass audience in every part of the country.* To do this I need the active support of all my friends.

The first step is to assure an advance sale of thousands of albums. *So, I am asking you to subscribe now to a special $5 advance sale of my new album, which I will autograph for you.* I hope you will tell your friends about our new project and get them to subscribe now to this advance sale.

I am determined to defeat those who would imprison my voice. Your subscription will help to break through the barriers.

Thoughts on Winning the Stalin Peace Prize

"Here's My Story," *Freedom,* January 1953

Many friends have asked me how it feels to have received one of the International Stalin Prizes[1] "for strengthening peace among peoples." Usually I say—as most prize winners do—"It's a great honor." But of course, this award deserves more than just passing acknowledgment.

Through the years I have received my share of recognition for efforts in the fields of sports, the arts, the struggle for full citizenship for the Negro people, labor's rights and the fight for peace. No single award, however, involved so many people or such grave issues as this one.

The prize is truly an international award. The committee of judges includes the Soviet academician, D. V. Skobeltsyn, president; vice-presidents Kuo Mo-djo of China and Louis Aragon of France; and the following members: Martin Anderson Nexo, the greatest modern

Danish humanist; John Bernal of England; Pablo Neruda of Chile, one of the world's greatest poets; Jan Demborsky of Poland; Michael Sadovyany of Roumania; and A. A. Fadyeev, a leading Soviet novelist.

And the prize winners include outstanding figures from many lands. It is a matter of pride to share the award with such distinguished leaders as Yves Farge of France; Sayfuddin Kichloo, spokesman for the All-Indian Congress of Peace; Eliza Branco, a leader of the Fedn. of Brazilian Women; Johannes Becher, one of the foremost writers of the German Democratic Republic; Rev. James Endicott, fearless Canadian minister and fighter for peace, and Ilya Ehrenberg, the leading Soviet novelist and journalist.

Most important, it must be clear that I cannot accept this award in a personal way. In the words of an editorial written by A. A. Fadyeev in *Pravda:* "The names of the laureates of the International Stalin Prizes are again witnesses to the fact that the movement for peace is continuously growing, broadening and strengthening. In the ranks of the active fighters against the threat of war, new millions of people of every race and nationality are taking their place, people of the most widely differing political and religious convictions. . . . The awards to Eliza Branco and Paul Robeson reflect the important historical fact that broader and broader sections of the masses of the Western Hemisphere are rising to struggle for freedom and independence, for peace and progress; peoples that endure the full weight of the attempts of imperialist reaction to strangle the movement of the masses against a new pillaging war, being prepared by American billionaires and millionaires."

I accept the award, therefore, in the name and on behalf of these new millions who are moving into the organized fight for peace in our hemisphere and especially in the United States.

One of the most decisive steps in the development of the peace movement in our country was taken in connection with the Peking and Vienna Congresses of Peace.

The American Peace movement reached out its hands across the borders to join with the millions of peace fighters in the world peace movement. Gradually it has become crystal clear that the mighty strength of the world movement representing peoples of all lands is strength for us here. As Americans, preserving the best of our traditions, we have the right—nay the duty—to fight for participation in the forward march of humanity.

We must join with the tens of millions all over the world who see in peace our most sacred responsibility. Once we are joined together in the fight for peace *we will have to talk to each other and tell the truth about each other.* How else can peace be won?

I have always insisted—and will insist, even more in the future—on my right to tell the truth as I know it about the Soviet peoples: of their deep desires and hopes for peace, of their peaceful pursuits of reconstruction from the ravages of war, as in historic Stalingrad; and to tell of the heroic efforts of the friendly peoples in Poland, Czechoslovakia,

Hungary, Albania, Romania, Bulgaria, great, new China and North Korea—to explain, to answer the endless falsehoods of the war-mongering press with clarity and courage.

In this framework we can make clear what co-existence means. *It means living in peace and friendship with another kind of society*—a fully integrated society where the people control their destinies, where poverty and illiteracy have been eliminated and where new kinds of human beings develop in the framework of a new level of social living.

The telling of these truths is an important part of our work in building a strong and broad peace movement in the United States.

Like any other people, like fathers, mothers, sons and daughters in every land, when the issue of peace or war has been put squarely to the American people, they have registered for peace. Whatever the confusions, however great the hysteria, millions voted for the Stockholm petition, millions more wanted to. At every step the vast majority have expressed horror at the idea of an aggressive war.

In fact, because of this deep desire for peace, the ruling class leaders of this land, from 1945 on, stepped up the hysteria and propaganda to drive into American minds the false notion that danger threatened them from the East. This propaganda began before the blood of precious human beings stopped flowing in the mighty struggle against fascism.

I, myself, was in Europe in 1945, singing to the troops. And already one heard rumblings of the necessity of America's preparing for war against the Soviet Union, our gallant ally. And at home in the United States we found continued and increased persecution, first of leaders of the Communist Party, and then of all honest anti-fascists.

But the deep desire for peace remained with the American people. Wallace was hailed by vast throngs when he resigned from Truman's cabinet in protest against the war-mongering of the then Secretary of State James Byrnes, now the Negro-hating governor of South Carolina. Seven to eight million peace lovers put Wallace on the ballot in almost all of the 48 states in 1948. The cry for peace forced Truman to take over (demogogically, of course) the Progressive Party platform. In addition he hinted he would send Vinson, one of his trusted lieutenants, to Moscow, to talk peace.

We know how Truman betrayed the American people in their hopes for peace, how he betrayed the Negro people in their thirst for equal rights, how he tore up the Bill of Rights and subjected the whole American people to a reign of FBI-terrorization.

The Korean war has always been an unpopular war among the American people. We remember the unforgivable trickery in the use of the United Nations to further the purposes of "American century" imperialists in that land—quite comparable to the taking of Texas from Mexico, the rape of Cuba, the Philippines, Puerto Rico and Hawaii. At one point American peace sentiment helped to stop Truman from pursuing use of the atom bomb in Korea and helped force the recall of MacArthur.

Yet in 1952 the American people again allowed themselves to be

taken in—this time by Eisenhower. He, too, promised in the campaign to do all he could to end the Korean slaughter. The vote shows that millions of American believed him. But already he has betrayed their trust and moves as fast as possible toward an extension of the war. There are real threats of attempting to support France on a major scale in Indo-China. All this comes as no surprise if one looks at those who guide him—Dulles, one of the architects of the whole Far Eastern policy; Dewey, the man so feared in 1948, and certainly unchanged, and the whole array of American Big Business at its worst.

All these factors become increasingly clear to great sections of the American people and certainly present a tremendous challenge to the peace forces in this land. If we move swiftly, correctly, courageously, a mighty united front of the people can be built for peace. The latent but growing sentiment can be harnessed, organized.

I am especially confident that the Negro people can be won for the fight for peace. Having voted mainly for Stevenson, they have little to expect from Eisenhower, especially an Eisenhower partly dependent upon the Dixiecrat South—sworn enemies of the Negro people. We know that war would mean an end to our struggle for civil rights, FEPC, the right to vote, an anti-lynching law, abolition of segregation.

And today the Negro people watch Africa and Asia and closely follow the liberation struggles of the rising peoples in these lands. We watch the United Nations and see the U.S.A. join with the western imperialist nations to stifle the liberation struggles. We cannot help but see that it is Vishinsky and the spokesman of the Eastern European Peoples Democracies who defend and vote for the interests of the African and Asian peoples.

I know that if the peace movement takes its message boldly to the Negro people a powerful force can be secured in pursuit of the greatest goal of all mankind. And the same is true of labor and the great democratic sections of our population.

Yes, peace can and must be won, to save the world from the terrible destruction of World War III. The prize which I have just received will spur me on to greater efforts than ever before to serve the cause of peace and to aid in building a triumphant peace movement in the United States.

A Letter from Jamaica, B.W.I.

"Here's My Story," *Freedom*, February 1953

Among the things I cherish most are the expressions of friendship and hope for the future which come to me from youth in all parts of the world. For Negroes, as for all oppressed peoples, so much depends on the course which the young generation takes—their early involvement in the struggle for freedom—that I want to share with you parts of a letter I have just received from Jamaica, B.W.I.

"Allow me to extend to you, on behalf of the Jamaica Youth

Movement, warmest fraternal greetings from the youth of Jamaica.

"This movement, despite the inevitable red smear, is undauntedly intensifying the struggle to win freedom, dignity and a place in the sun for the youth of this country. No doubt you will be interested to hear that we are supporting the International Conference in Defense of the Rights of Youth, and we have accepted the invitation of the World Federation of Democratic Youth to send a delegation. In an effort to popularize the conference, we are calling a second National Conference on youth's rights here in Kingston, in conjunction with radio broadcasts and public meetings."

As the youth of the world prepare for a highly important conference in Vienna, we may expect the State Department to do everything possible to prevent an adequate representation of young people from the United States. While we fight for the right of our youth to have passports for this conference, it is good to know that the sentiment and problems of peoples of African descent will also be voiced by our sturdy young friends of Jamaica.

The UAW Should Set the Pace

"Here's My Story," *Freedom,* March 1953

As a great organization of American workers, the United Auto Workers, prepares for its convention in Atlantic City this month, my mind goes back to many of the bitter labor battles which have made the union movement strong and won some measure of security and dignity for millions of working men and women.

Most precious of recollections is Cadillac Square, Detroit. It was my privilege to stand there and sing to thousands of auto workers, massed in a historic demonstration, as the CIO took over Ford's.

These struggles have given me great strength and confidence, and added much to my understanding. I shall always consider it a major factor in the course which I have taken that on returning to America from abroad in the early days of the CIO, I plunged into the magnificent struggles of labor.

I had been prepared for this by my experiences abroad. In the Spanish trenches I saw workers give their lives in a struggle to soften fascism and maintain a popular democracy, only to be betrayed by U.S. big business interests who supported the butcher Franco—and still support him with the official sanction of the U.S. government! Previously, in England, I had held long sessions with leaders of the Labor Party, and had travelled all over the British isles, visiting with the Welsh miners, railwaymen, dock workers and textile workers— sharing their griefs and little triumphs, learning their songs, basking in the warmth of their generous friendship and hospitality.

I had learned, during these years, an important lesson: that the problems of workers the world over are much the same and that eventually, they must all find similar answers.

From the U.S. scene of the late Thirties and early Forties another lesson became crystal clear: as the union movement grew in strength and numbers, the fight for equal rights progressed apace. The organizing drives needed a strong phalanx of support from the whole Negro community—the church, civic, fraternal and social organizations—in short, all organized expressions of 15 million oppressed citizens. (It is not idle to recall these days how many organizing committees, faced with goon squads, city officials who were flunkies of Big Business, and a solid anti-union press, found sanctuary and their only meeting places in the confines of the Negro church!)

And thousands of white workers began to understand for the first time that in order to warrant the confidence placed in the labor movement by practically the entire Negro people, they had to fight to overcome the crimes that had been committed against Negro workers for generations. They couldn't fall for the old "divide and rule" trick and succeed in their battles with the employers. The union had to be for all workers or there would be—no union.

This was the spirit of the early days of CIO and it sorely needs reviving today. For labor faces a pitched battle, and the same sturdy alliance which brought CIO into being must be re-established and strengthened to preserve and extend its gains.

But the latest word is that Secretary of Labor Durkin[1] is going to leave all decisions regarding Taft-Hartley up to Eisenhower—which means up to the billionaires who advise the president.

So far as Negroes are concerned there was a great Republican hue and cry before the elections that the General would treat everyone fairly, regardless of creed or color. But now there are anguished howls in our press because the White House has announced the appointment of secretaries, under-secretaries, assistant secretaries, ambassadors, bureau chiefs—and all the lush political plums are being allotted with not a Negro among them. The president has not even seen fit to continue the Truman practice of appointing a Negro to the United Nations delegation!

Yes, all signs point to the fact that labor's needs and Negro rights will be expendable in the new administration unless a popular, fighting movement of great proportions develops throughout the land.

Of course, labor wants more than Taft-Hartley repeal, though that is key. It wants and needs a better social security system, wage increases now, a real housing program, a national health insurance plan, an end to the restrictions on the right of free speech, and, most important, peace.

And Negroes' goals, of course, extend far beyond a few political appointments. We want full equality—in work and play, in voting rights and school opportunities, in seeking private advancement and holding public office.

These are some of the reasons the UAW convention is so important. It can set the pace for the rest of labor. It can put new cement in the Negro-labor alliance by recognizing the rightful demands of its Negro members for long overdue places in its top councils of leadership; by

stepping up the fight against job discrimination and for FEPC; by taking a forthright position on all questions affecting our struggle for equality in the nation; and, most important, by issuing a clarion call and taking steps to implement it, for a united labor drive to really organize the South.

That's a big order. But nothing less will do if the labor movement is to live up to its responsibilities to its own membership and to the nation. Knowing thousands of rank and file members and a good section of the forward-looking leadership of this great union, I am confident they will not fail.

An Open Letter to Jackie Robinson

"Here's My Story," *Freedom,* April 1953

I notice in a recent issue of "Our World" magazine that some folks think you're too outspoken.[1] Certainly not many of our folks share that view. They think like you that the Yankees, making many a "buck" off Harlem, might have had a few of our ball players just like Brooklyn. In fact I know you've seen where a couple of real brave fellows, the Turgerson brothers, think it's about time we continued our breaking into the Southern leagues—Arkansas and Mississippi included.

I am happy, Jackie, to have been in the fight for real democracy in sports years ago. I was proud to stand with Judge Landis in 1946 and, at his invitation, address the major league owners, demanding that the bars against Negroes in baseball be dropped. I knew from my experiences as a pro football player that the fans would not only take us—but like us. That's now been proven many times over.

Maybe these protests around you, Jackie, explain a lot of things about people trying to shut up those of us who speak out in many other fields.

You read in the paper every day about "doings" in Africa. These things are very important to us. A free Africa—a continent of 200 millions of folks like us and related to us—can do a lot to change things here.

In South Africa black folks are challenging Malan, a kind of super Ku Kluxer. These Africans are refusing to obey Jim Crow laws. They want some freedom like we do, and they're willing to suffer and sacrifice for it. Malan and a lot of powerful American investors would like to shut them up and lock them up.

Well, I'm very proud that these African brothers and sisters of ours play my records as they march in their parades. A good part of my time is spent in the work of the Council on African Affairs, supervised by Dr. Alphaeus Hunton, an expert on Africa and son of a great YMCA leader, the late William Hunton. Co-chairman of the Council is Dr. W. E. B. Du Bois, one of the greatest Americans who ever lived. We raise funds for Africans and bring information to Americans about the

conditions in Africa—conditions to be compared with, but worse than, those in Mississippi and Alabama.

We bring the truth about Kenya, for example—about a man like Kenyatta, leader of the Kikiyu, a proud African people of centuries of culture. I know Kenyatta. He's a highly educated man, with many more degrees than we have, Jackie. He's getting seven years in jail because he wants his people to be free. And there are Americans of African descent who are today on trial, in jail, fugitives, or dead (!) because they fought in their own way for their people to be free. Kenyatta's sentence calls to mind Ben Davis, Henry Winston, James Jackson, Claudia Jones, Pettis Perry and, yes, Harry Moore.

What goes here, Jackie? Well, I'll tell you. The same kind of people who don't want you to point up injustices to your folks, the same people who think you ought to stay in your "place," the same people who want to shut you up—want to shut up any one of us who speaks out for our full equality, for all of our rights.

Thats the heart of what I said in Paris in 1949, for example. As a matter of fact the night before I got to Paris 2,000 representatives of colored colonial peoples from all over the world (most of them students in English universities) asked me and Dr. Dadoo, leader of the Indian population in South Africa, to greet the Congress of Peace in Paris in their name.

These future leaders of their countries were from Nigeria, Gold Coast, South Africa, Kenya, Java, Indonesia, India, Jamaica, Trinidad, Barbadoes, the Philippines, Japan, Burma, and other lands. They were the shapers of the future in the Eastern and colonial world and they asked us to say to this Congress representing about 800 million of the world's 2,000 million that they and their countries wanted peace, no war with anybody. They said they certainly did not want war with the Soviet Union and China because these countries had come out of conditions similar to their own. But the Soviet Union and China were now free of the so-called "free western" imperialist powers. They were countries which had proved that colonial countries could get free, that colored peoples were as good as any other.

All these students made it clear that they felt that the nations who wanted war wanted it in order to head off struggles of colonial peoples, as in Indo-China, Malaya, Africa and Korea, for freedom. For example, if you could start a war in Africa the authorities could clamp down completely with war measures. (It's bad enough now!)

The students felt that peace was absolutely needed in order for their peoples to progress. And certainly, they said they saw no need to die for foreign firms which had come in and taken their land, rubber, cocoa, gold, diamonds, copper and other riches.

And I had to agree that it seemed to me that the same held good in these United States. There was and is no need to talk of war against any nation. We Afro-Americans need peace to continue the struggle for our full rights. And there is no need for any of our American youth to be used as cannon and bomb fodder anywhere in the world.

So I was and am for an immediate cease-fire in Korea and for peace. And it seemed and still seems unthinkable to me that colored or working folk anywhere would continue to rush to die for these who own most of the stocks and bonds, under the guise of false patriotism.

I was born and raised in America, Jackie—on the East Coast as you were on the West. I'm a product of American institutions, as you. My father was a slave and my folks worked cotton and tobacco, and still do in Eastern North Carolina. I'll always have the right to speak out, yes, shout at the top of my voice for full freedom for my people here, in the West Indies, in Africa—and for our real allies, actual and potential, millions of poor white workers who will never be free until we are free.

And, Jackie, the success of a few of us is no final answer. It helps, but this alone can't free all of us. Your child, my grandchildren, won't be free until our millions, especially in the South, have full opportunity and full human dignity.

We fight in many ways. From my experience, I think it's got to be a militant fight. One has to square off with the enemy once in a while.

Thanks for the recognition that I am a great ex-athlete. In the recent record books the All-American team of 1918 and the nationally-picked team of 1917 have only ten players—my name is omitted.

And also thanks for the expression of your opinion that I'm certainly a great singer and actor. A lot of people in the world think so and would like to hear me. But I can't get a passport. And here in my own America millions of Americans would like to hear me. But I can't get auditoriums to sing or act in. And I'm sometimes picketed by the American Legion and other Jim Crow outfits. I have some records on the market but have difficulty getting shops to take them.

People who "beef" at those of us who speak out, Jackie, are afraid of us. Well, let them be afraid. I'm continuing to speak out, and I hope you will, too. And our folks and many others like them all over the world will make it—and soon!

Believe me, Jackie.

Paul Robeson Urges Support
for Jailed Leaders and Freedom Struggles
in Kenya and South Africa

Statement issued by Paul Robeson, Chairman of the Council on African Affairs, New York, April 13, 1953—Paul Robeson Archives, Berlin, German Democratic Republic

We Americans of African descent are fighting for our full rights as citizens, and must keep fighting until we achieve these rights. In this fight it will be well to remember that as American citizens we have interests and responsibilities abroad, as well as at home.

Our Government is very interested and active, and very busy, in Europe, Asia and Africa. We as black and brown people are especially

interested in what our Government is doing in Asia and Africa, because Asians and Africans are Colored Peoples like ourselves. In Africa our Government is actually supporting and doing business with the white colonialists, not the African people. It is supporting Malan in South Africa and the British in Kenya and Rhodesia.

We Colored Americans will especially want to support our African brothers and sisters in South Africa who are now being jailed by the Malan Government for peacefully resisting segregation and discrimination. We will especially want to support our African brothers and sisters in Kenya who are being tried and imprisoned for insisting upon the return of their land.[1]

We know that sending leaders to prison who fight for our just demands does not in any way solve our problem, but rather increases our resentment, thereby aggravating the problem. We know that trying to send to prison respected and responsible leaders like Dr. W. E. B. Du Bois and William Patterson; sending men and women like Benjamin Davis, Claudia Jones, and Jomo Kenyatta to prison; and murdering men like Harry T. Moore, will only serve to unite Americans of African descent and the African people.

Imagine all sections of our people in the United States, their organizational and programmatic differences set aside, joining together in a great and compelling action to put a STOP to Jim Crowism in all its forms everywhere in this land, and to further the struggle for land reform in the deep South. Think how such an action would stir the whole of America and the whole world. Think what support we would receive from the colored peoples and advanced white peoples of the world,—literally hundreds of millions,—strengthening in untold measure the struggle for freedom and peace.

Let us protest the jailing of the black leaders in Kenya. Let us call upon our Government this week to stop helping the Ku Kluxer Malan and help the South African people who are marching irresistably toward freedom. Let our voices be heard in thousands of telegrams and letters to the President in Washington and to Ralph Bunche[2] at the United Nations in New York City.

The Real Issue in the Case of the Council on African Affairs

Statement issued April 24, 1953, by Paul Robeson, Chairman, on behalf of the Council on African Affairs, concerning the Justice Department's order for that organization to register under the McCarran Act[1]—Paul Robeson Archives, Berlin, German Democratic Republic

The consistent job of the Council on African Affairs through the years since its establishment in 1937 has been to provide accurate information on the conditions and struggles of the peoples of Africa and to support their efforts toward liberation. In recent months the Council

has endeavored to rally American assistance for the desperate fight of black and brown South Africans against Malan's fascist oppression, and for the Africans of Kenya whose struggle for land and survival the British seek to crush with the most ruthless and inhuman punitive measures.

For such work as this the Council, I am proud to say, has received many expressions of gratitude and appreciation from African leaders. It would appear, therefore, that in branding the Council as "subversive" and ordering it to register under the notorious McCarran Act, U.S. authorities are at the same time branding as "subversive" all the millions of Africans who are today determined to be free of the stigma of colonialism and white supremacy domination.

This attack upon the Council represents an attempt to frighten and silence all those Americans, particularly the Negro people, who are in any way critical of U.S. policies in Africa.

Those policies are directed toward the establishment of military bases in Africa without consultation with or the consent of the people in the so-called strategic areas. They aim at the extraction of the maximum quantities of uranium, manganese, copper, bauxite and scores of other African raw materials for U.S. war stock-piles and industry. They entail U.S. financial and diplomatic support for the Malan regime and for the European bosses of Africa in order to maintain the white supremacy *status quo* (as in our own Dixiecrat South) and "security" for the expanding American investments in Africa.

All this may be found explicitly or implicitly stated in numerous statements of administration leaders and in such documents as "The Overseas Territories in the Mutual Security Program" issued last year by the Mutual Security Administration. These policies and practices are a matter of official U.S. record, and not simply "Communist propaganda," as is alleged.

The Council on African Affairs opposes these policies because they are detrimental to the interests of both Africans and Americans. The Government in its charge against the Council dodges the real issue of the right of American citizens to criticize policies of state and poses instead a wholly false issue. Is it "subversive" not to approve our Government's action of condoning and abetting the oppression of our brothers and sisters in Africa and other lands?

It is a matter of shame that at the recent meeting of the U.N. General Assembly it was our own country, the United States, which voted with the European colonial powers against resolutions in the interest of the peoples of Africa,—resolutions which were supported by the majority of the U.N., including India and the other Asian-Middle Eastern-African member states, Poland, Czechoslovakia, and the Soviet Union.

The real issue in our case is the right of advocacy and support for the freedom of Africa's enslaved millions,—including the descendants of Africa who have yet to achieve their full liberty and rights here in the United States.

The Council on African Affairs will continue to carry forward its work and will fight all efforts to restrict its usefulness to the cause of African freedom by means of the unconstitutional and un-American McCarran Act.

"To You Beloved Comrade"

New World Review, April 1953, pp. 11–13

There is no richer store of human experience than the folk tales, folk poems and songs of a people. In many, the heroes are always fully recognizable humans—only larger and more embracing in dimension. So it is with the Russian, the Chinese, and the African folk-lore.

In 1937, a highly expectant audience of Moscow citizens—workers, artists, youth, farmers from surrounding towns—crowded the Bolshoy Theater. They awaited a performance by the Uzbek National Theater, headed by the highly gifted Tamara Khanum. The orchestra was a large one with instruments ancient and modern. How exciting would be the blending of the music of the rich culture of Moussorgsky, Tchaikovsky, Prokofiev, Shostakovich, Khrennikov, Gliere—with that of the beautiful music of the Uzbeks, stemming too from an old and proud civilization.

Suddenly everyone stood—began to applaud—to cheer—and to smile. The children waved.

In a box to the right—smiling and applauding the audience—as well as the artists on the stage—stood the great Stalin.

I remember the tears began to quietly flow, and I too smiled and waved. Here was clearly a man who seemed to embrace all. So kindly—I can never forget that warm feeling of kindliness and also a feeling of sureness. Here was one who was wise and good—the world and especially the socialist world was fortunate indeed to have his daily guidance. I lifted high my boy Pauli to wave to this world leader, and his leader. For Paul, Jr. had entered school in Moscow, in the land of the Soviets.

The wonderful performance began, unfolding new delights at every turn—ensemble and individual, vocal and orchestral, classic and folk-dancing of amazing originality. Could it be possible that a few years before in 1900—in 1915—these people had been semi-serfs—their cultural expression forbidden, their rich heritage almost lost under tsarist oppression's heel?

So here one witnessed in the field of the arts—a culture national in form, socialist in content. Here was a people quite comparable to some of the tribal folk of Asia—quite comparable to the proud Yoruba or Basuto of West and East Africa, but now their lives flowering anew within the socialist way of life twenty years matured under the guidance of Lenin and Stalin. And in this whole area of the development of national minorities— of their relation to the Great Russians— Stalin had played and was playing a most decisive role.

l was later to travel—to see with my own eyes what could happen to so-called backward peoples. In the West (in England, in Belgium, France, Portugal, Holland)—the Africans, the Indians (East and West), many of the Asian peoples were considered so backward that centuries, perhaps, would have to pass before these so-called "colonials" could become a part of modern society.

But in the Soviet Union, Yakuts, Nenetses, Kirgiz, Tadzhiks—had respect and were helped to advance with unbelievable rapidity in this socialist land. No empty promises, such as colored folk continuously hear in these United States, but deeds. For example, the transforming of the desert in Uzbekistan into blooming acres of cotton. And an old friend of mine, Mr. Golden, trained under Carver at Tuskegee, played a prominent role in cotton production. In 1949, I saw his daughter, now grown and in the university—a proud Soviet citizen.

Today in Korea—in Southeast Asia—in Latin America and the West Indies, in the Middle East—in Africa, one sees tens of millions of long oppressed colonial peoples surging toward freedom. What courage—what sacrifice—what determination never to rest until victory!

And arrayed against them, the combined powers of the so-called Free West, headed by the greedy, profit-hungry, war-minded industrialists and financial barons of our America. The illusion of an "American Century" blinds them for the immediate present to the clear fact that civilization has passed them by—that we now live in a people's century—that the star shines brightly in the East of Europe and of the world. Colonial peoples today look to the Soviet Socialist Republics. They see how under the great Stalin millions like themselves have found a new life. They see that aided and guided by the example of the Soviet Union, led by their Mao Tse-tung, a new China adds its mighty power to the true and expanding socialist way of life. They see formerly semi-colonial Eastern European nations building new People's Democracies, based upon the people's power with the people shaping their own destinies. So much of this progress stems from the magnificent leadership, theoretical and practical, given by their friend Joseph Stalin.

They have sung—sing now and will sing his praise—in song and story. Slava—slava—slava—Stalin, Glory to Stalin. Forever will his name be honored and beloved in all lands.

In all spheres of modern life the influence of Stalin reaches wide and deep. From his last simply written but vastly discerning and comprehensive document, back through the years, his contributions to the science of our world society remain invaluable. One reverently speaks of Marx, Engels, Lenin and Stalin—the shapers of humanity's richest present and future.

Yes, through his deep humanity, by his wise understanding, he leaves us a rich and monumental heritage. Most importantly—he has charted the direction of our present and future struggles. He has pointed the way to peace—to friendly co-existence—to the exchange of mutual scientific and cultural contributions—to the end of war and

destruction. How consistently, how patiently, he labored for peace and ever-increasing abundance, with what deep kindliness and wisdom. He leaves tens of millions all over the earth bowed in heart-aching grief.

But, as he well knew, the struggle continues. So, inspired by his noble example, let us lift our heads slowly but proudly high and march forward in the fight for peace— for a rich and rewarding life for all.

In the inspired words of Lewis Allan, our progressive lyricist—

> *To you Beloved Comrade, we make this solemn vow*
> *The fight will go on— the fight will still go on.*
> *Sleep well, Beloved Comrade, our work will just begin*
> *The fight will go on— till we win—until we win.*

Africa Calls—Will You Help?

"Here's My Story," *Freedom,* May 1953

It must be tough to be a believer in "white supremacy" these days. As never before the ruling forces have to deal with the longings, aspirations and the struggle of the colored peoples of the earth for freedom; for their complete liberation and self-determination, the assuming of full control over their own destinies. Some folks still try to blink their eyes, run away from the facts and convince themselves that things are just as they were in the days of Kipling's "white man's burden."[1] But, to paraphrase Joe Louis, "They may run, but they can't hide." The area of conflict stretches wide—Asia, the West Indies, Latin America; and, high in the headlines are Indo-China and Africa. It includes—and not the least important—Alabama, Georgia, Mississippi, Arkansas, and fanning out from Washington, North, East and West in these United States of ours.

The signs have long been clear that so-called "colonial" peoples, mostly colored, were moving toward some measure of freedom.

Of all developments, the change in China has been the most significant. The overlords have gone, and forever. These are about 500 million people. Bound to them in centuries-old ties are 400 million in India; and some day as of yore the Japanese must make their common future with the Chinese.

These lands are going forward under their own leaders, allying themselves with those who are their real friends; the states where the working masses have taken over their own destiny in the East European and European world.

And what about our responsibilities to Africa? I move about in many cities among many sections of our folk, and they're deeply interested—to put it mildly—in Africa.

Kenyatta's name is on everyone's tongue, and what's going on in South Africa is of immediate concern. And of course the advancements made in Gold Coast and Nigeria are closely watched.

Tomorrow we'll know more about French West Africa where the

urge for a freer life moves on at a fast pace. We'll know of Gabriel D'Arboussier[2] and the organization he heads of roughly a million members, influencing millions more. They work in close alliance with the strong working class of France, a working class of differing political faiths.

As for South Africa, I see it's gradually becoming clear that Malan is not doing all that evil by himself. In the barber shop the other day I heard some fellows remarking that the *Wall Street Journal* had said: "Not moral, but investment, interests concern America in South Africa."

My barber shop acquaintance went on to say, "Man, these folks here have a lot of dough sunk over there in gold, copper, uranium. They want to protect it—that's the reason you don't hear any real squawk coming from here about Malan." And of course the man was right. Even in the United Nations our delegation has avoided this South African issue like poison.

And now comes Max Yergan with an article in *U.S. News and World Report*.[3] If one did not know that Yergan was a Negro (no insult intended to my folk—I'm just stating the hard fact of life!) he would have to assume that the article was written by a white State Department mouthpiece assigned to working out a formula for maintaining white rule throughout Africa.

Yergan says: "The issue is: How can the whites in Africa be relieved of their fear? How can they have a sense of security living on a little island in the midst of this *great black sea?*" (My emphasis.)

Can you imagine! Now, we know how the British used the Indian princes against the Indian people, and others like Aga Khan (father of Ali Khan) in Persia. It's that old technique of pitting the Big House servants against the folks in the hard-labor fields.

Well, maybe the British, French, and now the American ruling groups, the officialdom, have an idea they can do that to Africans? And do it to the Africans through American Negroes like Yergan and a few others of his ilk.

When Yergan was in South Africa an African paper pointed out that he stayed at a very special hotel ("for Europeans only") and conferenced only with the Malan forces. Of course the article in *U.S. News and World Report* makes his role clear. I imagine he'd better be mighty careful where he lights on African soil again.

American Negroes have a real duty to our African brothers and sisters, a sacred duty. Yergan calls it merely a "sentimental interest" but Negroes who have not lost all pride and dignity know that if we are at all serious about our full freedom here in America we must understand what the future of Africa means.

The Indian people understand it. One of the leaders of the Kikuyu, a close associate of Kenyatta, is now in India and Nehru himself has spoken out about the necessity of supporting the African and Indian people in South and East Africa.

Can we here in America fail to bring pressure upon the corporations

involved, not to sabotage the African struggle? Can we fail to point the finger at Malan? Should we not do all in our power to help the people there, speaking out in their behalf, raising funds to send them, letting them know that we are on their side?

Now I know that, being a people like any other, many of us approach problems in different ways. So, in whatever way various groups or leaders see fit, should we not all come at once to the side of the African people?

Should we not arouse the youth in the universities? Should we not swing our churches, fraternal bodies, professional groups, women's organizations and civic clubs into action. Who will go before the great labor organizations (CIO, AFL and independent) and call for actions of solidarity with the terribly exploited African workers? Will the NAACP leap into the struggle with all its resources?

Not only is this a struggle in the interests of the African people. Their freedom and dignity will be of immeasurable assistance in our final break-through here in these United States. New Africa will mean in the end a new Alabama, a new Mississippi, Arkansas, Georgia, a new Washington, D.C. for us.

African liberation calls for assistance. Our leadership is weighed in the balance. I'm confident it will not be found wanting.

How I Discovered Africa

"Here's My Story," *Freedom,* June 1953—Reprinted in *Fighting Talk,* April 1955

I "discovered" Africa in London. That discovery—back in the Twenties—profoundly influenced my life. Like most of Africa's children in America, I had known little about the land of our fathers. But in England, where my career as an actor and singer took me, I came to know many Africans. Some of their names are now known to the world—Azikiwe,[1] and Nkrumah,[2] and Kenyatta, who has just been jailed for his leadership of the liberation struggles in Kenya.

Many of these Africans were students, and I spent many hours talking with them and taking part in their activities at the West African Students Union building. Somehow they came to think of me as one of them; they took pride in my successes; and they made Mrs. Robeson and me honorary members of the Union.

Besides these students, who were mostly of princely origin, I also came to know another class of Africans—the seamen in the ports of London, Liverpool and Cardiff. They too had their organizations, and much to teach me of their lives and their various peoples.

As an artist it was most natural that my first interest in Africa was cultural. Culture? The foreign rulers of that continent insisted there was no culture worthy of the name in Africa. But already musicians and sculptors in Europe were astir with their discovery of African art.

And as I plunged, with excited interest, into my studies of Africa at the London University and elsewhere, I came to see that African culture was indeed a treasure-store for the world.

Those who scorned the African languages as so many "barbarous dialects" could never know, of course, of the richness of those languages, and of the great philosophy and epics of poetry that have come down through the ages in these ancient tongues. I studied these languages—as I do to this day: Yoruba, Efik, Benin, Ashanti and the others.

I now felt as one with my African friends and became filled with a great, flowing pride in these riches, new found to me. I learned that along with the towering achievements of the cultures of ancient Greece and China there stood the culture of Africa, unseen and denied by the imperialist looters of Africa's material wealth.

I came to see the root sources of my own people's culture, especially in our music which is still the richest and most healthy in America. Scholars had traced the influence of African music to Europe—to Spain with the Moors, to Persia and India and China and westward to the Americas. And I came to learn of the remarkable kinship between African and Chinese culture (of which I intend to write at length some day).

My pride in Africa, that grew with the learning, impelled me to speak out against the scorners. I wrote articles for the *New Statesman and Nation* and elsewhere championing the real but unknown glories of African culture. I argued and discussed the subject with men like H. G. Wells,[3] and Laski,[4] and Nehru; with students and savants.

Now, there was a logic to this cultural struggle, and the powers-that-be realized it before I did. The British Intelligence came one day to caution me about the political meanings of my activities. For the question loomed of itself: If African culture was what I insisted it was, what happens then to the claim that it would take 1,000 years for Africans to be capable of self-rule?

Yes, culture and politics were actually inseparable here as always. And it was an African who directed my interest in Africa to something he had noted in the Soviet Union. On a visit to that country he had traveled east and had seen the Yakuts, a people who had been classed as a "backwards race" by the Czars. He had been struck by the resemblance between the tribal life of the Yakuts and his own people of East Africa.

What would happen to a people like the Yakuts now that they were freed from colonial oppression and were a part of the construction of the new socialist society?

I saw for myself when I visited the Soviet Union how the Yakuts and the Uzbeks and all the other formerly oppressed nations were leaping ahead from tribalism to modern industrial economy, from illiteracy to the heights of knowledge. Their ancient cultures blossoming in new and greater splendor. Their young men and women mastering the sciences and arts. A thousand years? No, less than 30!

So *through Africa* I found the Soviet Union—a beacon, a tried and tested way for whole nations, peoples, continents to revive the mother-roots of culture, to flower in freedom.

A thousand years? No, Africa's time is now! We must see that and realize what it means to us, we American brothers and sisters of the Africans. We must see that we have a part to play in helping to pry loose the robbers' hold on Africa. For if we take a close look at the hands that are at Africa's throat, we will understand it all: *we know those hands.*

The Government's Policy and Practice of Racial Discrimination and Oppression in the Union of South Africa

Spotlight on Africa, August 13, 1953[1]

I. Apartheid Madness

Speaking in the South African Parliament on March 14, 1945, Dr. Malan's predecessor, Prime Minister Jan Smuts, remarked that everybody "except fools" was agreed on "our fixed policy to maintain white supremacy in South Africa." He was answering a charge from Opposition Leader Malan that the Government was not using the proper measures to "keep the Natives in their place." Nevertheless, Malan and the Nationalist Party won power in 1948 by outdoing the United Party in posing as the white electorate's only true saviour against "the black menace." They retained power in the 1953 election by repeating their performance.

Although the system of racial discrimination and segregation in order to maintain domination by the white minority was firmly established in all spheres of South African life long before Malan came to power, it may be said that during the five years of his administration the South African way of life which Malan calls *apartheid* has been made immensely more rigid, circumscribed and cruel for the non-white population. The spate of Malan-sponsored "apartheid" legislation enacted since 1948 includes:

The Asiatic Laws (Amendment) Act, repealing the limited Indian franchise;

The Mixed Marriages Act, making the marriage of whites and non-whites a criminal offense;

Amendment of the Immorality Act, making sexual relations between "Colored" and white persons, as well as between Africans and whites, a criminal offense;

The Population Registration Act, intended to establish the racial identity of every person over 16 years of age, so that there shall

be no question of who is subject to the various "apartheid" measures;

The Group Areas Act, empowering the Government to delimit areas in which only members of a particular racial group or sub-group may reside or own property (this Act is being enforced despite repeated recommendations of non-implementation by the U.N. General Assembly in 1950, 1951 and 1952; at the present writing 146,000 Indians in Durban face eviction from their homes, businesses and institutions, and 75,000 Africans face imminent removal from the Western Areas of Johannesburg, with no alternative housing accommodations whatever afforded);

The Bantu Authorities Act, which seeks to establish puppet tribal councils and foster tribal division of the Africans (the present limited representation of Africans—by white members—in the South African Parliament is to be abolished);

The Separate Representation of Voters' Act, which would strike some 48,000 "Colored" voters in the Cape Province from the common list of voters and establish a system of separate representation for them such as the Africans now have (declared unconstitutional by the Supreme Court, but the Government continues to seek to have it upheld).

The subservient status of non-white labor, which is the foundation of South Africa's economy, has been established in law through such measures as the Industrial Conciliation Act, No. 36 of 1937, excluding African trade unions from authorized collective bargaining and strike procedures, the Masters and Servants Act, and the Riotous Assemblies Act.

The Malan Government's policy of tightening still further the shackles on African labor is reflected in the statement of Dr. Theo Wassenaer, a Nationalist Party leader, made in the House of Assembly, September, 1948: "Africans must be re-tribalized: Zulus must remain Zulus, Swazis must remain Swazis and Xosas Xosas—this is one of the ultimate objectives of apartheid. We cannot allow the development of a mass black proletariat which would be able to muster against the whites." (*Guardian* [Cape Town] 23 September 1948). It is reflected in the Government's reply to a question from Senator W. G. Ballinger, June, 1949, acknowledging that a Departmental circular of 28 March, 1948, "reaffirms the policy outlined in its circular of the 31st October, 1924 which enjoins Departments and Provincial Administrations wherever possible to substitute civilised [white] labour for uncivilised [African] labour. The former circular also modified this Department's circular No. 8 of 1948, which authorises the employment of Natives as messengers, to the extent that Natives should only be employed as messengers where the services of a European youth are not available."

Under the Malan regime the great majority of Africans have been

excluded from the benefits of the Unemployment Insurance Act, and Africans have been legally barred from skilled labor in the building trades by the terms of the Native Building Workers Act. The Native Laws Amendment Act was passed providing for the removal of an African from an urban area, even tho he may have been born and lived there permanently, if he is unemployed for 72 hours. Legislation now pending would abolish independent African trade unions altogether and establish Government-approved "company unions" in their place. Minister of Labor B. J. Schoeman, reported *N.Y. Times* correspondent Albion Ross from Pretoria, April 18, 1953, was prepared to secure Parliament's approval of "something close to a system of concentration camps for the black proletariat."

II. Tyrannical Suppression of Opposition

". . . the Natives must be made clearly to understand and to realize that the presence and predominance of the white race will be preserved at all hazards, and that all attempts to destroy its hegemony, whether overt or covert . . . will be promptly punished. . . ."

The quotation is from page 5 of the Report of Natal Native Affairs Committee for the year 1906–7. The idea enunciated has remained the chief principle of South African statecraft down through the decades. The present Nationalist Government has observed and applied it with exceptional persistence and severity. "Any organization that does not want to acknowledge the color bar has no right to exist in South Africa," Malan's Minister of Economic Affairs, Eric H. Luow, said in 1949. The Government's record of victimization of individuals and organizations supporting democratic rights for all South Africans shows Mr. Luow's statement to be in fact state policy.

To silence opposition to its policies the Malan Government was at first content to use the expedient of having a magistrate issue an order banning a scheduled meeting. Thus, for example, Mr. Sam Kahn, Member of Parliament representing Africans and a bitter opponent of the Nationalists' "apartheid" program, was served with the following magistrate's order dated 17 March, 1949: "Whereas in terms of Section 1(4) of Act 27 of 1914, as amended, there is reason to apprehend that feelings of hostility between Europeans and Non-Europeans would be engendered by the assembly of a public gathering in any place in this town to which the public has access to hear an address by Mr. Sam Kahn M.P. on the subject of "Apartheid or Equality," acting under the special authority of the Minister of Justice, I do hereby prohibit such assembly in the municipal area of Springs for the purposes aforesaid." African and Indian critics of Malanism were similarly muzzled. The Riotous Assemblies Act and other measures were also invoked to curb free assemblage and free speech.

Then, in 1951, with mammoth public demonstrations against the Separate Representation of Voters' Bill taking place in Cape Town, the Nationalist Government pushed through Parliament, by the narrow

margin of 69 votes to 62, the so-called Suppression of Communism Act, the first of its own laws for silencing and punishing its opponents. As noted by even anti-Communist newspapers and leaders in South Africa, this law marked the establishment of police-state fascism in the country.

The implementation of the Suppression of Communism Act has demonstrated the truth of this judgment. Invoking this law the Malan Government has:

—banned the publication of the *Guardian,* the first instance of the suppression of a newspaper in South Africa;

—ousted Mr. Sam Kahn and Mr. Fred Carneson, the duly elected representatives and spokesmen for Africans, from their respective seats in the House of Assembly and the Cape Provincial Council;

—"named" Chief James A. Luthuli, President General of the African National Congress; Dr. G. Naicker, President of the South African Indian Congress; scores of other leaders of these two organizations; and white and non-white leaders of trade unions and of other organizations, ordering them (a) not to address or attend meetings, (b) not to visit certain specified areas for any purpose, (c) to resign from offices and membership in specified organizations in which they served;

—arrested, prosecuted, and sentenced African, Indian, and "Colored" leaders of the organizations which conducted the Campaign of Defiance of Unjust Laws, and others, white and non-white, who were charged with having violated the "naming" order previously cited;

—conducted police raids and searches on the offices of various organizations and on the homes of leaders of the organizations.

In a vain effort to put a stop to the Campaign of Defiance of Unjust Laws last year, the Government, in addition to arresting and prosecuting leaders of the resistance movement, imposed heavier sentences (imprisonment up to two months) upon those taking part in the defiance actions, resorted to abusive treatment of some of the volunteers jailed, and imposed humiliating corporal punishment (whipping with a cane) upon youth volunteers under 21 years of age and upon some of the women volunteers.

Next, in February, 1953, the Government introduced and secured speedy passage of the Public Safety Act and the Criminal Law Amendment Act. These laws, as Edward Hughes (*Wall Street Journal,* April 14, 1953) writes, have been "widely interpreted as removing such basic rights as freedom of speech and press in South Africa." More than this, they are laws whose excessively harsh, repressive, and fascist provisions can only be compared with Hitler's edicts. The first prosecution under the Criminal Law Amendment Act, against an African leader, Arthur Matyala, occurred in March, only a few days after the Act was gazetted.

Further to intimidate and smash all opposition, the Government has

repeatedly conducted police raids and searches on the offices of the African National Congress, South African Indian Congress, Springbok Legion, and African trade unions, and on the homes of officers of these organizations. Such raids were made July 30, 1952, and again during June and July, 1953. The search warrants used in the latter raids authorized the police to seize what they might regard as evidence of treason, sedition, or other offenses among documents relating to the affairs of 14 specified organizations (in addition to those raided the list included youth organizations, and other bodies, such as the South African Society for Peace and Friendship with the Soviet Union, the Transvaal Peace Council, and the Congress of Democrats).

Peaceful assemblages of supporters of African rights have been banned or broken up by the police. Thus, for example, a reception planned in Durban, April 25, 1953, for Chief Luthuli was banned by Mayor Osborne, and a meeting of several thousand non-white people at Umzabalazo Square, Durban, on January 30, 1953, to discuss the need of more schools for their children was interrupted and stopped by the police, who grabbed Chief Luthuli and Mr. J. N. Singh and took them off to police headquarters.

The account of the Government's suppression of peaceful and legitimate protest against racial discrimination and oppression cannot be concluded without reference to the record of wanton killing of Africans by the South African police. It is worth noting that in dispersing crowds of non-whites and in dealing with so-called disorders involving non-whites, the South African police are in the habit of using not tear-gas or streams of water from fire-hose, but their clubs and guns. 1949 saw Africans shot down by the police at Johannesburg's Western Areas, Randfontein and Krugersdorp. In January, 1950, Newclare was the scene of further police shootings. On May 1st of the same year police smashed "Freedom Day" demonstrations killing 18 Africans in the Johannesburg area. Thus the record continues down to 1952 when, in the space of a few weeks from October 18 to November 9, Africans were killed and scores wounded by police in disorders at Port Elizabeth (11 dead), Johannesburg (3 dead), Kimberley (13 killed), and East London (11 dead).

It is reported that in four and a half years of Nationalist rule, up to November 15, 1952, there were 29 outbreaks of violence involving Africans and the police, with a total of 238 persons killed and 1,146 injured (*N.Y. Times,* Jan. 3, 1953, p. 60). The tempo of police assaults has increased in ratio to the increased severity of repressive legislation. History has taught us that mass murder is the ultimate form of political repression and control under fascism.

III. The South African Government Flouts the Rule of Law

Government by arbitrary decree is more and more replacing government by law in South Africa. Such laws as the Suppression of Communism Act and Public Safety Act were enacted precisely to dispense with Parliament and enable the Government to rule by

decree. In opposing the Suppression of Communism Bill, the United Party opposition introduced an amendment (defeated by the Nationalist majority) which declared that the Bill "creates a fascist despotism, in that it clothes the Executive with unnecessarily wide and despotic powers, fails to provide for full and effective access to the courts, and makes intolerable inroads upon the freedom of the citizens, including the power to violate the sanctity of the home." By the terms of the Public Safety Act, Parliament's sanction is no longer required for the declaration of a national emergency and martial law.

Section 10(1) of the Suppression of Communism Act reads: "Whenever the Minister [of Justice] is satisfied that any person is in any area advocating, advising, defending or encouraging the achievement of any of the objects of communism . . . or is likely in any area to advocate, advise, defend or encourage the achievement of any such object . . . he may . . . prohibit him . . . from being within any area defined in a notice. . . ."

Section 3 of the Public Safety Act reads: "The Governor General may . . . make such regulations as appear to him to be necessary or expedient . . . suspend in whole or in part any Act of Parliament or any other law, . . . and any such law which is in conflict with or inconsistent with any such regulation shall be deemed to be suspended. . . ."

The Malan Government with one stroke sets aside all existing law in order to achieve its immediate ends. Thus Section 7 of the Criminal Law Amendment Act adopted this year reads: "A magistrate's court shall, notwithstanding anything to the contrary in any other law contained, have jurisdiction to impose any sentence or make any order provided for by this Act."

The world is well aware of the manner in which the Malan Government has flouted the country's Constitution in seeking to remove the "Colored" voters from the common voting list. The Separate Representation of Voters' Act was pushed to passage by the Nationalist majority despite the fact that the voting procedure did not conform with the constitutional requirement. When the Supreme Court's Appellate Division, on March 20, 1952, ruled the Act invalid and unconstitutional because it was not passed by the required two-thirds majority, Malan rejected the decision and secured passage of a bill (High Court of Parliament) establishing the members of Parliament themselves as the supreme arbiter of the law of the land, and empowered by simple majority vote to make its decisions prevail over those of any other court. Without waiting for the Supreme Court to act on the validity of the High Court of Parliament Act, Malan on August 27 had Parliament in its new role of High Court set aside the Supreme Court's March 20 verdict. On November 13 the Supreme Court declared the High Court illegal. In the April 15 election the Nationalist Party failed to get a two-thirds majority in Parliament, but Malan is still determined to have his way, courts or no courts.

Another fight between the executive and judicial branches of the

Government developed when in March, 1953, the Supreme Court cast a shadow over Malan's "apartheid" program by upholding the plea of an African that he had a right to use the Cape Town railway waiting room reserved for whites since the facilities provided for Africans were inferior. Malan indignantly stated that "The judgment draws a line through the traditional apartheid on the railways as we have always known it," making it clear that "apartheid" did *not* mean separate but equal status for non-whites. "If the Nationalist Party wins the election," said Malan, "we shall rectify the matter without delay, and in a way that will leave no court in doubt about the wish and intention of Parliament and the people." (*N.Y. Times,* March 25, 1953)

In the sphere of international conventions the stubborn and arrogant unilateral stand taken by the South African Government is well known. That Government remains the only one of the mandatory powers which has refused to abide by the trusteeship provisions of the United Nations Charter, maintaining exclusive authority and supervision over the mandate territory of South West Africa. It has year after year refused to join with the Government of India in settling the dispute over the treatment of Indians in South Africa, as recommended again and again by the United Nations General Assembly. It has consistently refused to ratify the Geneva Convention governing the use of forced labor—for the very good reason that, as pointed out in the recently published report of the Committee on Forced Labor set up by the United Nations and the International Labor Organization, "a system of forced labor of significance to the national economy appears to exist in the Union of South Africa."

Prime Minister Malan has declared war to the death against the African, Indian and "Colored" inhabitants of South Africa who, demanding equality and democracy, refuse to obey the unjust laws of the land. All liberal-minded people endorse and support their struggle for justice. *It is the South African Government itself which should be called to account for flouting the rule of law.*

IV. Incitement to Violence

The South African Government has sought to explain the causes of African unrest and protest in terms of Communist incitement, agitation by non-white "extremists" and "radicals," Mau Mau, and interference from those outside South Africa, particularly India. It is never admitted that Africans have genuine grievances, or that they have a long tradition of struggle and require no artificial incitement to arouse them to demand their rights. To admit these things is more than can be expected from those who cling to notions of white supremacy.

In the pursuit of scapegoats, the South African white ruling circles propagate elaborate fabrications, which in turn breed hysteria and fear among the whites, and in this atmosphere the Government finds sanction for its words and deeds which promote racial hate, oppression, and violence.

In playing up the bogey of Communism, the Nationalist leaders followed in the footsteps of Smuts, who tried to send 52 Communist leaders to jail on charges of conspiring to incite the great strike of African mine workers in 1946. After an extended trial, the Government found it necessary to withdraw the charge—it had no evidence. Malan's Minister of Justice Swart, urging enactment of the Suppression of Communism Act in 1950, argued that Communism was a vast and deadly conspiracy and that he had reliable information that there was a Communist-instigated plot to poison the reservoirs and water-supplies of the country. Mr. Sam Kahn immediately repudiated the allegation, comparing it to Goering's Reichstag plot, and challenged the Minister to appoint a commission to investigate and determine whether any such plot existed. Mr. Swart ignored the challenge and never launched any investigation or prosecution of the alleged "water-poisoners," but in 1952 he again repeated the fabrication and revived the other one about the Communists having incited the African mine workers to strike.

In November, 1952, it became the custom of Malan and his cabinet members to warn the country of the dangers of Mau Mau, implying that it was somehow linked with the Campaign of Defiance of Unjust Laws and with the clashes between Africans and the police at Port Elizabeth, Kimberley and East London. Mr. Swart said that the South African riots followed the Mau Mau pattern. Mr. Tom Naude, Minister of Posts, said that all whites were threatened by the present attitude of the non-whites, and added, "We have our 'skietkommandos' [volunteer vigilante corps] upon whom we can rely for defense of our country in an emergency, but the time may come when the women of South Africa may also have to be trained in the use of firearms to defend themselves." (*N.Y. Times,* Nov. 23, 1953) The Minister of Justice, Mr. F. C. Erasmus, announced that machine guns would be issued to the Skietkommandos. These and similar statements by other Government leaders precipitated a rush by the whites to buy guns (Non-whites are forbidden to purchase or own guns).

The allegations made by Nationalist newspapers that the Defiance Campaign was responsible for the police disorders in October and November, 1952, were completely without foundation. On the contrary, it was the leaders of the African National Congress who prevented the disorders from getting out of hand. The conduct of the Defiance Campaign was remarkable for its discipline—during the arrests of thousands of Defiance volunteers not a single act of violence occurred, though there were ample provocations.

The National Action Committee of the African National Congress and the South African Indian Congress charged that the riots and disturbances which occurred in October and November, 1952, at Port Elizabeth, Kimberley and East London were "deliberately incited and provoked by the Government." "We challenge the Government," the Committee's statement said, "to hold an impartial judicial inquiry into these riots as we have reason to believe that they were actually

provoked. Authentic reports strongly suggest that these disturbances were engineered by provocateurs and that the shooting order of Mr. Swart played a major part." (Minister of Justice Swart announced on November 15th that he had instructed police officials not to wait until their men were killed or injured in riots before they fired. "They have been told to shoot first," he said.)

Opposition leader J. G. N. Strauss also asked for the appointment of an impartial judicial commission to investigate the disturbances. A similar demand was made by liberal white leaders and organizations. *The Government turned a deaf ear to all these demands: it refused to order an inquiry.*

Following the disturbance at East London, which started when police attempted to break up a religious service for which official permission had been granted, the East London *Daily Dispatch* stated: "But for the imposition of the ban on public meetings there would have been no trouble yesterday in Duncan Village . . . the Minister of Justice today must feel his responsibility. It was he who gave the police their instructions and it was he who plugged the safety-valve of free speech. On his shoulders must rest responsibility for the aftermath."

There is considerable basis for the belief that the Malan Government is set upon a course of deliberately goading and inciting Africans to resort to violence. Since they have only sticks and stones to fight with, they will then be at the mercy of the armed police and skietcommandos. And the Communists, or "Native agitators," or India will be blamed for the pogroms that follow.

V. International Peace at Stake

The evil consequences of racist policies and program of the Malan Government are not confined to South Africa. India is bitterly resentful of the abuses heaped on Indians in South Africa. The Bamangwato tribe of Bechuanaland can blame Malanism for the exile of their chief, Seretse Khama. The Negro people of the United States note many parallels between Jim Crowism and Malan's "apartheid" and indignantly protest the South African Government's banning of two American Negroes, Bishops of the African Methodist Episcopal Church, from entering the Union to carry on their church duties. African leaders in the High Commission Territories of Bechuanaland, Basutoland and Swaziland are fully aware of Malan's annexation aims and have vowed that the people will resist being brought under the yoke of South African racism.

Malanism is the enemy of African liberation movements in every section of the African continent. The Prime Minister has inveighed against the Gold Coast's advance toward self-government and has warned Britain that the empire would find its "grave" in Africa unless the policy of racial equality is abandoned.

On their side the Gold Coast people say, "The expansionist policy of

the Union is arousing all Africa to the dangers of racial domination, and we wish to emphasize the importance of United Nations responsibility in deciding the fate of these [inhabitants of Basutoland, Bechuanaland, Swaziland, and South West Africa] and other African people. It is very much to be hoped that effective steps—by means, if necessary, of sanctions—will be taken at the forthcoming General Assembly to implement the decision of successive resolutions of the United Nations." (Petition to *Ad Hoc* Committee of U.N. on South West Africa, 1952, document A/2261, 21 Nov. 1952, page 19, signed by Kwame Nkrumah, Life Chairman, Convention People's Party of Gold Coast, and other officers of C.P.P.)

Nigeria has also repeatedly cried out against Malanism. An editorial in the West African *Pilot* (Lagos, Nigeria), Feb. 8, 1949, declared, "Whatever may be the handicaps of the United Nations, we refuse to believe that the big nations in that body are ignorant of how best to bring world pressure to bear on South Africa in and out of the U.N. If South Africa must brow-beat the U.N. and remain at large to pursue its heinous policy, then the Negro race will have to rely on themselves and make ready for the liquidation of 2,000,000 South African Europeans in the life and death struggle that is to come. It is unavailing to appeal to God who seems to have no hands in our affairs. It must be freedom and equality for the African race or we all—all the races—should march to mass destruction."

Finally, we may quote a statement made by General Smuts himself in 1950, after he had yielded power to Malan: "If the policy now promulgated in the Union goes through (and there is no reason to suppose it will not go through), a Mason-Dixon Line will be established in Africa along the Limpopo, between the Transvaal and the Rhodesias, and more vaguely along the line which separates South West Africa from the Union, Bechuanaland, and Angola. There will be incompatible policies on the colour question to the north and south of that line. We know what happened in America; it will happen in Africa as surely as it happened there if we do not face the problem now." (Address to the South African Institute of Race Relations, quoted in *East Africa and Rhodesia,* Nov. 9, 1950.)

Conclusion

The Council on African Affairs appeals to the United Nations to take such measures as may be necessary to halt the present oppression of the ten million non-white people of the Union of South Africa, and to avert the danger to international peace and harmony arising from the pursuit of the South African Government's policy and practice of racial discrimination and oppression. We are confident that with the aid and support of the United Nations, the people of South Africa, white as well as non-white, will willingly strive to achieve equal civil liberties, equal political rights, equal economic opportunities, and equality of social status for *all* South Africans.

Speech at the Peace Bridge Arch

August 16, 1953—Paul Robeson Archives, Berlin, German
Democratic Republic

I want to just say "Thank you" and "Thank you" again for your very
great kindness in coming here today.[1] It means much to us in
America—much to the American struggle for peace in the Northwest.
Some of the finest people in the world are under pressure today, facing
jail, facing hostile courts, for the simple fact that they are struggling
for peace—struggling for a decent America where all of us who have
helped build that land can live in decency and in good will.

As for myself, as I said last year, I remain the same Paul that you
have known throughout all these years—the same Paul—but time has
made it so that everyone—I included—must fight harder today to
preserve the basic liberties guaranteed to us Americans by our
Constitution.

If it were not so—if this were not so, I would be with you in
Vancouver. I would be traveling all over the Canada that I cherish
so deeply. And it might interest you to know that just the other day,
the Actors Association in Great Britain—the British Equity
Association—actors—I remember years ago I was in London when this
group was formed. We had an Actors Equity here in America, and a
very progressive one and a very militant one. And I had been playing
in the Workers Theater—the Unity Theater—which I helped establish
in London.[2] And I know there was quite an argument among the
actors. Some of them were rather—well "I don't quite know whether
we are workers or not and whether we should have a union." And I
remember making a speech and saying to them as a visiting artist, and
one who was very close to them: "We who labor in the arts—whether
we are singers, whether we are actors, whether we are artists—we
must remember that we come from the people. Our strength comes
from the people, and we must serve the people and be a part of them."
(Applause)

In America today, it's very difficult to play in the theater or to get a
hall to sing in. Whenever I go into a city like St. Louis or to many of the
cities, the wrath of all the powers-that-be descends upon one single
poor minister who wants to give me his church, or descends upon the
people who rent the hall. They are told by all the forces in America—
the strongest business forces—ministers are told the banks will no
longer honor their mortgages—everything to keep just one person
from appearing in a concert in this church or in this hall.

I know what it means. They don't want to hear people speak for
peace. Many of the bravest working class leaders are today in prison.
And today we fight in America on the eve of this truce—as this truce is
concluded in Korea—we fight for the amnesty and the freedom of those
leaders to come back and to lead their people. *(Applause)*

So I can't act or sing in any sort of decent place—very seldom, in my own country. So the British actors, however—there was a request, and a contract sent to me to play "Othello" in London as soon as I could get there. And they went to the British Equity Actors Association to see if I could get a labor permit. And they said there was no question of the status of Mr. Robeson—that he could come here and play "Othello." But beyond that we would like to see that production and to see him play that role which he played so well in 1930 in England, and at the end of it was a very important phrase: "And we would welcome him to this land." They would welcome me to England to play "Othello." *(Applause)*

And at the same time, I received an invitation that—I just couldn't receive an invitation that could mean more. It's from the miners in Wales—the miners in Wales—and Wales, you know, is a part of England where I first understood the struggle of white and Negro together. When I went down into the coal mines—into the Rondda Valley—went down in the mines with those workers, lived among them—later did a picture, as you know, called "Proud Valley"—and I became so close that in Wales today, as I feel here, they feel me a part of that land. And I have just received an invitation to appear at a festival in October to be given by the miners and by the workers of Wales, and I hope to be able to get there to do that. *(Applause)*

So it's very important that we are gathered here today—that our government can understand that artists—not only myself—there are so many of us—so many scientists, like Dr. Du Bois, one of the greatest Americans who ever lived, proudly a son of the Negro people, but one who has contributed to the advance of all mankind. And the idea that Dr. W. E. B. Du Bois cannot leave this country to attend peace meetings—to attend scientific gatherings—all over the earth. And that goes for so many outstanding American scientists, intellectuals, workers, trade union leaders—so that you must understand that they will hear about this today. They will hear about our gathering here. This will mean a great deal to see that many of us may be able to travel in the future.

And why do they take my passport away? They have said so in a case. They put it in a brief. They said that no matter what my political beliefs, what my standing among the Negro people of my own land in America, but they would have to take my passport away anyhow, because out of my own lips, mind you, from my own lips, for many years, I have been struggling for the independence of the colonial peoples of Africa. And that is meddling in the foreign affairs of the United States government. *(Laughter).* Now that's just too bad, 'cause I'm going to have to continue to meddle. *(Laughter and applause)*

But I stand and I say to you as you come from our land here in this American continent, I am proud of the America in which I was born. My father was a slave, reared in North Carolina. I have many friends all over the earth, and rightly so. Other Americans can choose their Francos if they want to. Other Americans can choose the refuse of Nazi

fascism. They can wander around the earth picking those who would keep mankind in perpetual slavery. I choose to stretch out my hand across the ocean to brave peoples of many lands—across the border to Latin America, to Neruda in Chile, to the brave people of Cuba and Mexico, across the ocean to the lands of Asia. And I stretch my hand to the people of the new China as they build a new life for 500 million people. *(Applause)*

As I say, as an American, as Jefferson in his time stretched his hands across to meet the great heroes of the French Revolution of 1789, I stretch my hand across the continent to shake the hand of the brave Soviet people and of the new People's Democracies. That is my right as an American. *(Applause)* And I know—I could have sung it today—I could sing so many songs—they sing only the songs of peace there in that land, and I would have liked to have sung a song today, "Peace Will Conquer War," a song composed by Shostakovich, the great Soviet composer.

But I speak as one whose roots are in the soil of my land. I speak as one, as I say, whose fathers and whose mothers toiled in cotton—toiled in tobacco—toiled in indigo—toiled to help create the basic wealth upon which the great land of the United States was built. The great primary wealth came from the blood and from the suffering of my forefathers. And I say, as I have said many times, that I have a right to speak out on their blood—on what they have contributed to that land, and on what I have contributed also, as best I can. But I say right here that because of their struggle, I will go around the world, but I'm telling you now that a good piece of that American earth belongs to me. *(Applause)* And it belongs to my children and to my grandchildren—I have two of them, you know, two grandchildren—a boy about 2¹/₂ and a little girl about six months—boy, they're sharp!

So there's a lot of America that belongs to me and to my people. And we have struggled too long ever to give it up. My people are determined in America to be, not second-class citizens, to be full citizens—to be first-class citizens, and that is the rock upon which I stand. From that rock, I reach out, as I say, across the world, to my forefathers in Africa, to Canada, all around the world, because I know that there is one humanity, that there is no basic difference of race or color, no basic difference of culture, but that all human beings can live in friendship and in peace. I know it from experience. I have seen the people. I have learned their languages. I sing their songs. And I go about America, or wherever I may go, thinking of simple things. It seems so simple that all people should live in full human dignity and in friendship. But somewhere the enemy has always been around who tries to push back the great mass of the people, in every land—we know that. But I said long ago that I was going to spend my day-to-day struggle down among the masses of the people, not even as any great artist up on top somewhere—but right here in this park, in many other picket lines, wherever I could be to help the struggle of the people. And I will never apologize for that. I shall continue to fight, as I see the truth, and I tell

you here, I hope to see you next year. Wherever I am in the world, I'll come back to be here next year. I'll come back. *(Applause)*

And I want you to know that I'll continue this year fighting for peace, however difficult it may be. And I want everybody in the range of my voice to hear, official or otherwise, that there is no force on earth that will make me go backward one-thousandth part of one little inch. *(Applause)*

Playing Catch-Up

Partial text of speech delivered at the Convention of the
National Negro Labor Council, Chicago, October 4, 1953[1]
—*Freedom,* December 1953

Some Americans have already worked out a blueprint for what the end (of the struggle against war and fascism—Ed.) will be. McCarthy, Jenner, Velde, Byrnes, Talmadge, Shivers, see in the end a world of rotting corpses on foreign battle fields, of darker peoples licking the boots of a new, American "master race," of European, Asian and Latin American nations bowing down before the power of the Yankee dollar, of Africa prostrate at their feet.

They see fabulous riches for the few while the mass of American workers, black and white, yellow and brown, live on the very edge of survival. They contend that "what's good for General Motors is good for America."

They see millions of American workers at the very bottom—Negro workers, poor white workers on the iron ore range, in the mines, in the California fruit fields, together with great sections of our Mexican, Philippine and Puerto Rican-American brothers and sisters.

Well, I think I know the temper of the delegates to this convention well enough to know that we say: "That dream of yours is out-dated gentlemen. This is the TWENTIETH century. You've put your money on the wrong horse. You're living in the wrong century. The dream that's about to be realized is not yours, but humanity's—humanity's dream of a world of brotherhood, of equality, of plenty for ALL of the working masses of this land, of colonial liberation, of full freedom for the Negro people of these United States of eternal and everlasting peace!"

And here at home, we, the Negro people, must also be partisans of peace.

For 90 years since Emancipation our people have been playing "catch-up" in American life, we have been battling for equality in education, health, housing and jobs.

And now, today, 90 years later—despite all the croaking about the great progress we're making—any Negro who's not looking for a second-string job on Eisenhower's "team" will tell you we've still got a long way to go.

How are we going to get there?

Will shooting down Chinese help us get our freedom? Will dropping some bombs on Vietnamese patriots who want to be free of French domination[2] help American Negroes reach a plane of equality with their white fellow-citizens? And, most important, will a war in support of Malan in South Africa, or the British exploiters in Kenya, or the French in Tunisia place black Americans on the same footing with whites?

To ask the question is to answer it. No!

No one has yet explained to my satisfaction what business a black lad from a Mississippi or Georgia share-cropping farm has in Asia shooting down the yellow or brown son of an impoverished rice-farmer.

Mr. Eisenhower or Senator McCarthy would have us believe that this is necessary to "save" the so-called "free world" from "communism." But the man who keeps that Negro share-cropper from earning more than a few hundred dollars a year is not a Communist—it's the landlord. And the man who prevents his son from attending school with white children is not a Communist—it's Governor Talmadge[3] or Governor Byrnes[4] of the U.S. delegation to the United Nations.

I believe, and I urge upon this convention the belief, that any Negro who carries his brains around with him and has not been bought and paid for must agree that it is time for 15 million colored Americans to disassociate themselves from a foreign policy which is based on brandishing the atom bomb, setting up hundreds of air bases all over the world, and threatening colored peoples with death and destruction unless they humbly recognize the inalienable right of Anglo-Saxon Americans to sit on top of the world.

Negroes, as I said, are still playing "catch-up." And with the kind of war that the atom-happy U.S. diplomats are planning we won't be catching up—we'll just be "catching" and relinquishing any hope for liberation and freedom.

I say that even though Eisenhower[5] is meeting at this very moment with Churchill[6] in Bermuda, we will not, and must not support the British overlords in Kenya—we will fight to free Kenyatta! I say, even though Laniel of France is right there with Eisenhower and Churchill, we must not approve the squandering of billions of American taxpayers' money on the "dirty war" in Indo-China—we must insist that the French rule in France and leave the Viet-namese to govern themselves. And I trust that this convention will record that it is against the interests of Negro workers, the entire Negro people, and the nation as a whole to pursue one step further the suicidal, blustering, threatening war-minded foreign policy which is the hallmark of this Administration. What Negroes need, and all America needs, is PEACE.

Foreword to *Lift Every Voice: The Second People's Song Book*

Edited by Irwin Silber, New York, 1953[1]

The other day in Auburn, New York, there was the dedication of the home of Harriet Tubman, the Moses of her people. Harriet Tubman, together with Frederick Douglass and Sojourner Truth, was a member of the African Methodist Episcopal Zion Church. In this church my beloved slave-born father labored long and faithfully—and today my elder brother carries on, in the mother church of New York.

When Harriet Tubman went South in the dark days to lead the slaves and perhaps my father by way of the Underground Railway to freedom, thousands of human beings—the "salt of the earth"—lifted their voices in song. And so it has been wherever these of human kind have surged toward the light of liberation—men and women of every culture, color and clime.

They have sung—and sing—songs created by the generations-old genius of the folk. And there can be no greater genius. Beautiful songs—yes—sometimes of quiet meditation—sometimes of momentary thunder—sometimes of terrifying beauty for the faint of heart. Songs bursting through the bar-lines, calling for love, for brotherhood, for sisterhood, for equality, for freedom.

It is a great privilege to greet this magnificent richly rewarding Song Book—to greet those responsible, the People's Artists. This is no mere phrase, People's Artists—it has the deepest of overtones to hundreds of millions on every continent throughout the world.

Certainly no group of artists have more devotedly dedicated themselves to the sacred task of helping to collect, preserve and LIVE the great songs not only of the American folk but of all folk.

These singers of the people—tried, tested and triumphant and ever contributing to our struggle for Peace and a better life—offer here a beautiful gift to all the world. They have our deepest thanks.

Civil Rights in '54 Depends on the Fight Against McCarthyism

"Here's My Story,"[1] *Freedom,* November 1953

The placing of the issue of segregation in education before the Supreme Court[2] represents a magnificent stride forward in the long battle of Negro Americans for full equality. It seems to me difficult to speculate as to how the Court will decide.

Certainly if the Court acts in accordance with the demands of democracy and the needs of the whole Southern people—colored and white—it will strike down segregation unconditionally and immediately.

Who will say that the Southern people, who maintained unsegregated school systems during the Reconstruction period, will not support them in 1951? In the final analysis the people—not the nine justices—are the court of last resort.

However, the still-powerful sections of the Dixiecrats are girding themselves for final struggle. The Byrnes and Talmadges, in fact the Council of Southern Governors, seem to me to be heading toward a major battle on the whole front of our right to first-class citizenship, somewhat in the tradition of Henry Clay[3] and his stubborn defense of the theory of "states' rights." The fight will still go on, especially in the South, where the bulk of our people live.

Whether civil rights bills will be passed in the coming session of Congress will depend not on the oft-heralded "good intentions" of Eisenhower, or the election-year promises of Congressmen, but on the degree to which the Negro people, labor, the poor farm population, and all lovers of democracy make an earnest, united and irresistible demand.

We must not forget that the whole civil rights program—for voting rights in the South, for the right of our people to work and to full opportunities for advancement through adequate federal fair employment practices legislation, for the right to full protection of our very lives in states like Florida, the scene of the Moore lynch-murders—this program was scuttled by the Eisenhower administration in the President's successful bid for Southern support. So our demands must not be narrowed, but broadened to include the whole of the Negro people in all-inclusive immediate demands for full citizenship.

And all of our demands will be most effective when they merge with the battle against the book-burning, thought control, "loyalty" purges, "spy" scares and character defamation which the Democrats started and the Republicans are carrying on to ominous lengths.

Let us remember that at one time in our national life the victims of hysteria were Jefferson and his colleagues, friends of the new revolutionary French republic of 1789. At another, the sufferers were Frederick Douglass, Harriet Tubman, William Lloyd Garrison, John Brown, fighters for our freedom. They happened to be abolitionists. Closer in time is 1920: the persecuted were the Socialists—men like Eugene Debs and Altgeld.[4]

Proud inheritors of these magnificent traditions are men and women like Benjamin Davis of Georgia, James Jackson, Henry Winston, Claudia Jones, Elizabeth Gurley Flynn, Eugene Dennis, Pettis Perry and their colleagues. Our history—and especially the history of our people—teaches us that all liberties must be protected or there are none.

So today there is the overriding necessity to preserve our democratic

heritage from the wholesale attacks of McCarthyism. McCarthyism is an American brand of fascism. If this administration, which is largely a political vehicle for the giant corporations and entrenched greed, embraces McCarthy fully as it seems prone to do, then the outlook for the Negro people, labor, the foreign born and other minorities will be gloomy indeed.

Foreword to *Born of the People* by Luis Taruc

New York, 1953

When I was in Hawaii a few years ago it was my privilege to sing for and with the sugar and pineapple workers, to clasp their hands in firm friendship, to share for a short time their way of life. Truly, here was unity, amazingly broad—Hawaiians, Japanese-Americans, Portugese, black and white workers from the United States, Chinese and Chinese-Americans, and many workers from the Philippines.

Not long before a noted singer from the Philippines had visited Hawaii, to appear in the usual concert series sponsored by the "Big Five" Companies. I had come as the guest of the unions. We had long discussions with my brothers and sisters from the Philippines about artists and others serving the people in their struggles toward a better life.

They talked of their land, of the Hukbalahap, of the fight to survive against Japanese fascism, and later against the vicious forces of American imperialism and against their own collaborators like Manuel Roxas and Elpidio Quirino.

My mind often went back to 1898, the year of my birth, the same year that President McKinley felt the divine call to export "freedom and liberty" to the people of the Philippines.[1] The real story of that time has been recorded, one of the most shameful periods of United States history, comparable to the British in India and South Africa, the Belgians in the Congo, or for that matter, the United States in almost any section of Latin America, beginning with Mexico and Panama.[2]

Then the talk would break off and feasting and singing would begin. They would tell me in song and story of the beautiful land set in the Eastern Sea, of the lovely mountains, of the warm, simple people, and of their hopes, longings, and firm resolve to work out and control their own destinies. Before leaving the island I was proud to be able in one concert to sing a few of their beautiful songs for them.

So with great anticipation I began to read the story of Luis Taruc, the great leader of the Hukbalahap, and of the Philippine people. For truly, as Taruc says, this is the saga of the people, for *from* them is he sprung and *to* them is he so closely bound.

Often we talk of the struggles of colonial peoples, of the early struggles here in the days of our nation's birth. We are daily in touch with the sufferings and strivings of 15 million Negro Americans for nationhood in the South and full freedom in all the land. We follow the surging forward of the emergent African nations, all over that vast continent.

What part does this great land of ours play in those world changes? We see the administration at their deadly work in Korea. We hear talk of "no imperialist ambitions," but we see the close ties with the remnants of Japanese and West-German fascism. We watch with dread the policies of a General MacArthur and a John Foster Dulles coming into ascendancy. We know that we must widen and deepen the struggle for peace, that we must fight for these United States to help civilization forward, not to attempt to check its march and even threaten to destroy it.

We ask ourselves: What can we do, what methods can we employ, what role can culture play? Can we really build a strong united front? How can we best defend our leaders? How do we stimulate the activity of the masses? In short, how can we head off a threatening but as yet unrealized domestic fascism?

And, amid all the political realities, what of the human beings involved? For we fight with and for people. How is such courage possible, such unswerving, deep belief, such devotion and sacrifice as are needed today? We live it too, through brave working class leaders in the United States—Eugene Dennis, Ben Davis, Steve Nelson, Claudia Jones, Elizabeth Gurley Flynn, Henry Winston—through courageous workers and intellectuals.

Here in Taruc's searching and moving story, the whole struggle is laid bare—the terrible suffering and oppression, the slow torturous seeking for the "basic reasons" and for the "right methods of action," the tremendous wisdom and perseverance in carrying through, the endless courage, understanding, determination of the people, of all sections of the people, for national liberation and dignity.

For in the end, says Taruc, the answer is the people, in them lies the eternal wisdom. They are like the sea, seemingly calm at times on the surface, but raging beneath. They may seem to be patient and slow to move, but once they understand, no forces can hold them back until final victory.

No one reading this book can doubt the ultimate victory of these brave, warm-hearted, joyful, sensitive people of the Philippines. They'll make it, as have tens of millions in the Soviet Union, China, and the People's Democracies, and the other millions of the earth will follow them. For freedom is a precious thing, and the inalienable birthright of all who travel this earth. And in the end every people will claim its rightful heritage.

One often speaks of the emergence of a "new kind of human being."

In this magnificent and moving autobiography we see Luis Taruc grow with the people, reach into the most basic roots of the people,

embrace and become a part of a whole people moving swiftly and unbendingly toward full national liberation. In the process, Taruc and many, many others become new kinds of human beings, harbingers of the future.

This is an intensely moving story, full of the warmth, courage, and love which is Taruc.

Here certainly is proof that the richest humanist tradition is inherited and will be continuously enriched by the working class, acting in closest bonds with the peasantry and honest vanguard intelligentsia—intellectuals who know that they must "serve the people, not enemies of the people."

How necessary that we learn the simple yet profound lessons of united action, based upon the deepest respect for the people's wisdom, understanding, and creative capacity.

Here is a rich experience in life itself, of practice and theory, theory and practice.

Know, Taruc, that like your American friend there are other brave Americans who understand, there is the other America. And to "Bio," to G.Y., to the memory of Eva Cura Taruc, to you, Taruc, and to all of your beloved comrades, we of the other America make this solemn vow. The fight will go on.[3] The fight will still go on until we win freedom, friendship among peoples, the co-existence of many ways of life, the right to live full and many-sided human lives in dignity and lasting peace.

Perspectives on the Struggle for Peace in the United States in 1954

New York, January 1, 1954—*Pravda,* January 2, 1954 (Translated by Dr. Brewster Chamberlin from the German version entitled "Die Perspectiven des Friedenskampfs in den USA in Jahr 1954" in Paul Robeson Archives, Berlin, German Democratic Republic)

The struggle for peace in the U.S., where reaction is especially strong, was difficult and developed slowly in 1953. Nonetheless reports from all corners of the United States prove that new successes were won in the peace struggle. Many trips throughout the nation I undertook confirmed this conclusion. The peace movement in the U.S. developed in the last year and I am convinced that it will develop still faster in the new year 1954.

A short time ago I attended the third annual congress of the National Negro Labor Council which has sections throughout the land.[1] This organization included the workers and trade union functionaries from all Negro groups, white workers of various nationalities and the Puerto Ricans and Mexicans living in the U.S. Representatives of the workers in the steel and iron industry, the coal miners and

the automobile industry, representatives of the farmers, the workers in the electronic industry and the railroads gathered together at this congress. Particularly important is the fact that many senior workers and trade union leaders were present.

What was the most urgent problem that interested all these people, the broad sections of the American workers—left, middle and right? Unemployment? The housing problem? Qualifications? A just law regulating wage labor? The rights of national minorities? The rights and freedoms of the citizen? Or did questions of economic demands play the most important part—wage levels, the rights of the trade unions? Naturally all of these questions are of profound importance and they were seriously discussed at the congress. Its main theme, however, was the problem of maintaining peace.

The final achievement of peace in Korea, negotiations among the big powers regarding the creation of an appropriate place in the UN for the new China, the ban on atom and hydrogen weapons—these are the questions which most concerned the congress participants.

It was different at earlier congresses. The problem of the peace struggle was given a certain amount of consideration as an important problem, but the main thrust then concerned the satisfaction of the questions regarding the immediate economic demands of the workers. Today, however, everyone knows that the most important task is the maintenance and securing of peace.

I have used this example because it is typical of all meetings held by the workers in this country. It reflects the growing striving of the whole American people for peace.

The majority of the rank and file of the trade unions are beginning to recognize that the regressive legislation dealing with labor, especially the Taft-Hartley Law, is directed to causing the workers to participate with their labor unquestioningly in the arms race. Using these laws the trade unions are being pushed into a position of becoming merely the followers of monopoly capital and put under the surveillance of the reactionary federal or state administration as is already the case with the longshoreman's trade union on the New York docks.

The knowledge of the great importance of the peace struggle also characterizes the congresses of the trade unions of the hotel and restaurant workers, the garment workers and the fur and tobbacco workers and the leather industry, the steel industry and other not nearly so progressive unions. Practically for the first time this was also the case at the congress of the farmers of the middle west and the south. The situation of the farmer has grown worse because of the sinking prices for farm produce and the accumulation of an overproduction of such produce. The monopolies reap super profits from this situation.

Ever more, various sections of the liberal intelligentsia, religious circles, artists and scientists are becoming gripped by the anxiety about war preparations. All of them demand immediate negotiations

among the great powers at the highest level which would contribute to creating an atmosphere of reciprocal understanding among peoples.

Dulles was heavily critized because of his attempt with the help of the policy of the big stick to force France and other nations to follow the dictates of the ruling circles of America.[2]

For millions of Americans peace is the goal for whose achievement we must struggle in the new year 1954.

In August 1953 I had the honor to speak to 30,000 people gathered together in the northwest on the American-Canadian border. The inhabitants of this area as well as other parts of the nation felt the need to express their desire for peace and the necessity for the achievement of peaceful coexistence between different cultures and ways of life.

And everywhere in the peace struggle the organizations of the working class are playing a leading role. In California the membership of the trade unions of the automobile industry, the trade unions of the construction workers (carpenters, etc.), the machine makers, the dock workers and warehouse workers, the sailors and the stewards on the coastal ships and high seas fleet all came out for peace. The labor leaders and the rank and file membership of these trade unions recognize that their trade unions cannot follow independent policies and they struggle for the guarantee of a necessary standard of living under the conditions of this insane arms race.

All of these conditions open up powerful possibilities for the strengthening and broadening of the peace struggle.

This growing understanding of the necessity of the peace struggle increases the interest of the American people in the peaceful proposals of the Soviet Union. Americans are being more and more convinced that the peoples of the Soviet Union, China and the democratic peoples nations are striving for peace. They are beginning to correctly evaluate the importance of the demands of the people of eastern Europe and Asia to break with the system of aggressive pacts and war. They are beginning to understand why there is resistance to the North Atlantic Treaty bloc in Europe, why U.S. policies are more and more greeted with hostility abroad. Understanding of the fact that in Africa, Asia and Latin America serious and fundamental changes are occurring, and that American big capital is not in a position to hold back the striving of those peoples for freedom and independence, is growing in America.

The peace fighters in America are aware that nothing happens by itself, that a long and hard road still lies before them, because the arsonists of war are playing a dirty game in that they try to spread confusion in our ranks and in that they constantly attempt to break our struggle.

Today, however, the peace struggle has raised itself to a higher level. With each day people are beginning to better understand that everyone who wants peace must join together, that it is necessary to

put aside every sectarian haggling over questions in the peace struggle.

In spite of the continual terror and the attempts to spread war hysteria, the American peace struggle has in this coming year great possibilities to live up to its role in the world wide struggle for peace. In my opinion we are in a position to achieve serious successes.

Finally let me say that the American peace movement has solved one of the most important questions of its activities. Everyone has come to the conclusion—and they will act in accordance with this conclusion—that our struggle for peace in the U.S. is an integral part of the world-wide peace struggle and must be tightly coupled with it.

The growing understanding that the world-wide peace struggle unites the strivings of hundreds of millions of people in all nations of the world, and the knowledge of the importance of that mighty contribution to the cause of peace which the World Council of Peace makes, will raise the level of our struggle in the U.S. even higher.

Pravda wrote on the eve of this new year: "The noble ideas of the peace struggle become increasingly popular. In the active struggle for the prevention of the danger of war many groups which a short while ago stood aside are now participating. With each passing year more and more politicians and personalities in public life in the nations of the west and east are joining the ranks of the peace struggle." This is also true of the United States. With hard work and expressing continual unconquerable boldness the workers for peace in America will live up to their historic mission.

My best wishes to the glorious people of the Soviet Union! My respect and my love to all those who are building a new life and who show millions of people the way. I am still struggling to receive permission to travel to your nation and one fine day I hope to be able to be with you again, to sing for you, to speak with you and to share with you the feeling of hearty and sincere friendship of our great peoples.

A happy new year in 1954 and many, many more years!

The "Big Truth" Is the Answer to the "Big Lie" of McCarthy

"Here's My Story," *Freedom,* January 1954

Just join me for a moment in taking a look at what kind of country this could be if peace reigned in the world. What could we do with the 40-to-50 million dollars of your money and mine which an arrogant government now spends to build up a war machine here at home and all over the world.

How many counties are there in the South with large Negro populations but not a hospital which Negroes can enter? How many

thousands of our people have had their life's blood drip away, like
Julia Dericotte (whom I knew) and Bessie Smith, one of our great
artists, because the county hospital would not take them in? Could not
some of these billions be used to build hundreds of hospitals and clinics
in rural and city areas, South and North for Negro and white
Americans who now lack adequate medical facilities?

Let's talk about schools for a moment. How many millions—no
billions—are really needed to eliminate segregation in education, or to
push the level of Southern education up to the inadequate achieve-
ment of the North? The money that's now spent for a single H-bomb
plant could do this if we really had peace.

Or take housing. Have we eliminated the unpainted rural shacks
with the rain pouring inside; the urban tenements and shanties with
inadequate plumbing or no plumbing at all, the rat-infested slums in
the major cities of the country? Nobody who has traveled through the
South or taken a look at the fire-traps here on Chicago's Southside
would say that we have. But can we replace these horrible excuses for
human habitation with comfortable, sturdy homes for all the Ameri-
can people and at the same time spend billions on war? No, obviously
not. If American workers, Negro and white, are going to have decent
homes to live in then we must have peace.

Yes, peace and vast programs of peace-time construction—hospitals,
schools, homes, roads, community centers, bridges and dams—would
mean jobs—jobs in the tens of thousands and millions for workers who
are now beginning to feel the brunt of layoffs in the electrical trades,
in the auto industry, in textile, steel and packing—and you can just
keep filling in the others.

Every consideration of the interests of the Negro people, every
concern for their security, their fight for equality, their dignity,
demands that every gathering of Negro Americans declare that we
must have peace, not war! Let Mr. George Schuyler marry Joe
McCarthy, if he wants to—we beg to be excused from the ceremony.
Let the decrepit Max Yergan lounge around in illusions of 19th
century imperialist omnipotence[1] if he will—we have other ideas. We
are convinced by everything that has happened in this nation and
abroad that the path to Negro freedom lies in firm conjunction with the
giant strides which humanity is taking in all other countries of the
world, barring none, toward enforcing the peace and silencing the
warmakers.

Now, if you preach this doctrine of peace, friendship and brother-
hood among the world's peoples—you may still run into a little trouble
in the United States. That old devil McCarthy may set out to get you!

But a lot of Americans are waking up to the fact that to be the victim
of an attack by McCarthyites may not be fatal.

In fact, the only thing fatal for the American people would be the
failure to fight the McCarthyite madness. For McCarthyism means
destruction of the constitutional rights of free speech and free press
and free religion. It means the prohibition of free assemblies. It means

the burning of books which proclaim the scientific truth that all men are created equal. It means the reign of fear, intimidation and terror.

I have no doubt that we will beat back McCarthyism and restore our traditional liberties. But to do this we must reject the Big Lie on which McCarthyism thrives. The big lie is the fairy tale that the American people are somehow threatened by "communism."

If we subscribe to this falsehood then any militant leader of labor or the Negro people's struggles may be in jail tomorrow. If we concede that the ex-city councilman of New York, the ex-lawyer from Atlanta, Ben Davis, belongs in a Terre Haute Jim Crow jail, then we concede McCarthy's right and Brownell's[2] right to jail you and me and Harry Truman, and to dig up Franklin D. Roosevelt and put him in jail too!

The defense of Davis and his colleagues, the demand for their immediate amnesty, is the very foundation of any claim we have to basic civic liberties. Certainly we of the Negro people, bombed and lynched and falsely jailed for decades, understand this.

We must counterpose to the Big Lie the Big Truth of our times—that any kind of general war will destroy all the peoples of the world, that different social systems must live together in peaceful cooperation and competition, that the American people will not be abreast of the rest of the world until we choose a government really dedicated to the needs and welfare of the working people, the poor farmers, the Negro millions and all the oppressed of this land.

Ho Chi Minh Is the Toussaint L'Ouverture of Indo-China

"Here's My Story," *Freedom,* March 1954

As I write these lines, the eyes of the world are on a country inhabited by 23 million brown-skinned people—a population one and a half times the number of Negroes in the U.S. In size that country is equal to the combined area of Mississippi, South Carolina and Alabama. It's a fertile land, rich in minerals; but all the wealth is taken away by the foreign rulers, and the people are poor.

I'm talking about Vietnam, and it seems to me that we Negroes have a special reason for understanding what's going on over there. Only recently, during Negro History Week, we recalled the heroic exploits of Toussaint L'Ouverture who led the people of Haiti in a victorious rebellion against the French Empire.

Well, at the same time that the French were fighting to keep their hold on the black slaves of Haiti, they were sending an army around to the other side of the world to impose colonial slavery on the people of Indo-China. And ever since then the Indo-Chinese have been struggling to be free from French domination.

"My children, France comes to make us slaves. God gave us liberty;

France has no right to take it away. Burn the cities, destroy the harvests, tear up the roads with cannon, poison the wells, show the white man the hell he comes to make!"[1]

Those fiery words, addressed to his people by Toussaint L'Ouverture when Napoleon sent Leclerc with an army of 30,000 men to re-enslave Haiti, are echoed today by Ho Chi Minh, who is the Toussaint of Vietnam.[2] Yes, and a French general called Le Clerc was also sent against Ho Chi Minh, but like the blacks of Haiti, the plantation workers of Indo-China have proved unconquerable.

In 1946 France was forced to recognize the Republic of Vietnam, headed by Ho Chi Minh; but like the double-crossing Napoleon in the time of Toussaint, the French colonial masters returned with greater force to re-enslave the people who had liberated themselves. The common people of France have come to hate this struggle; they call it "the dirty war"; and their rulers have not dared to draft Frenchmen for military service there.

"Who are the Vietminh?" said a French officer to a reporter from the Associated Press. "Where are they? Who knows? They are everywhere." And the reporter wrote:

"Ho Chi Minh's barefoot hordes infiltrate French-held territory at will in the guise of peasants, arms concealed under brown tunics. They have allies who hide them and feed them—allies who are not Communists but just people who hate the French, hate the foreigner and want him to go."

Now, when France wants to call it quits, Eisenhower, Nixon and Dulles are insisting that Vietnam must be re-conquered and held in colonial chains. "The Vietnamese lack the ability to govern themselves," says Vice-President Nixon.[3]

Vast quantities of U.S. bombers, tanks and guns have been sent against Ho Chi Minh and his freedom-fighters; and now we are told that soon it may be "advisable" to send American GI's into Indo-China in order that the tin, rubber and tungsten of Southeast Asia be kept by the "free world"—meaning White Imperialism.

The whole world cries out for peace; but Dulles insists that the war must go on and threatens Asians again with atomic and hydrogen bombs.

That's the picture, and I ask again: Shall Negro sharecroppers from Mississippi be sent to shoot down brown-skinned peasants in Vietnam—to serve the interests of those who oppose Negro liberation at home and colonial freedom abroad?

What are our Negro leaders saying about this? They are all too silent.

The true issues involved are well known, for only recently, *The Crisis,* official organ of the NAACP, published an article filled with factual proof that the Vietnamese are fighting against colonial oppression. The article shows that the charge of "Red Aggression" in Indo-China is a phony, and that the sympathies of our people belong with the side resisting imperialism.

Three years ago Mordecai Johnson, president of Howard University, said that "For over 100 years the French have been in Indo-China, dominating them politically, strangling them economically, and humiliating them in the land of their fathers. . . . And now it looks as though they can win, and as they are about to win their liberty, we rush up and say: 'What on earth are you all getting ready to do? . . . We are the free people of the world, we are your friends, we will send you leaders. . . .'

"And they look at us in amazement and they say: 'Brother, where have you been. Why if we'd known you was a-comin' we'd have baked a cake.'"[4]

Today, more than ever, is the time for plain speaking.

Peace can be won if we demand it. The imperialists can be halted in their tracks. And as we think about Ho Chi Minh, the modernday Toussaint L'Ouverture leading his people to freedom, let us remember well the warning words of a Negro spokesman, Charles Baylor, who wrote in the *Richmond Planet* a half century ago:

"The American Negro cannot become the ally of imperialism without enslaving his own race."[5]

Negro Americans Have Lost a Tried and True Friend

"Here's My Story," *Freedom,* August 1954

In the untimely death of Vito Marcantonio[1] progressive humanity has suffered a shocking and grievous loss. He was the people's tribune, standing often alone in defense of their rights and interests in the halls of a Congress over-run by the spokesmen of big business and corrupt old-party machines.

When all other Representatives howled and legislated for war he advocated and cast the people's vote for peace.

When Congress saddled the labor movement with the Taft-Hartley law and other oppressive measures he voted for the working majority of Americans and against the special interests of monopoly.

When the constitutional liberties of the people were taken away by the McCarran Act, the McCarran-Walter immigration law and the Smith Act, he defended their rights in the courts.

In his district—the 18th Congressional District of New York—Marc was revered and loved as a friend, a brother, a true leader, by the scores of thousands of Puerto Rican, Italian, Negro, Irish, Jewish and Slavic families—the families of the poor—whose cause he aggressively championed and whose problems he tirelessly helped to solve.

Perhaps no group of Americans is called upon to honor his name and his memory more than the Negro people, not only in East Harlem, but in all parts of this vast land.

Marcantonio was the Thaddeus Stevens of the first half of the 20th century. Consult the *Congressional Record* for the seven terms he served the people so fearlessly and brilliantly. No session of Congress during these 14 years was spared the responsibility of considering the Marcantonio bills against the poll tax, to penalize the crime of lynching, to legislate fair employment practices. No voice was raised more eloquently or frequently than his on behalf of our sorely oppressed people.[2]

Examine his voting record. He was the only Congressman in the past two decades who possessed a perfect record of votes on questions directly and indirectly affecting the special interests of Negroes.

And with it all he was the finest Congressional parliamentarian of our time. When New York first elected a Negro Congressman it was to Marc that he turned to "learn the ropes" of procedure in the House. Adam Powell must remember those early days. And scores of other Negroes, the "race relations" advisors and consultants in various government agencies—Washington's "Black Cabinet"[3]—must recall that it was to Marc's office that they found their way to work out strategy and tactics for Negro advance in NYA, WPA, housing, the armed forces, in all phases of American life.

He was one white friend who never shirked a fight on our behalf, who would not tolerate an insult to the Negro people. When the great scholar and statesman, W. E. B. Du Bois, stood trial as an alleged "foreign agent" because he leads the millions who fight for peace, Marcantonio was his counsel and won him vindication. When the Negro-hating Henderson Lanham, Representative from Georgia, called the peerless defender of civil rights, William Patterson (now confined to Danbury federal prison on another trumped-up charge), a "black s-o-b" in a Congressional hearing, Marcantonio took Patterson's case in the contempt proceedings which followed—and won him vindication.

Certain political jackals and vultures have already begun to distort, in an attempt to destroy, the real meaning of his life. To them he was an "enigma." How could he be so right on domestic, economic and social issues, they piously ask, and yet so "wrong" on international affairs?

The answer is simple—for those who are not afraid to admit it in these hysterical times. Marc's policy on foreign affairs was as true and as right as his program on domestic questions. The one flowed naturally and inexorably from the other.

He hated fascism because it robbed the people of their liberties and livelihood, made the "master race" theory a cornerstone of government policy, and sought to subject all mankind to the tyranny of a Hitler and the German bankers and industrialists he represented. Thus he worked for the total mobilization of this nation against fascist aggression and for strongest unity of the Allies, including the Soviet Union, which was necessary to win victory in World War II.

But at the war's end his keen political insight saw the unmistakable

signs—the people's victory was being appropriated by big business and the military. Negroes were thrown out of their newly-won positions in industry, executive FEPC was scuttled, "legal lynching" became the order of the day. Taft-Hartley put chains on the labor movement, freedom of thought and assembly were penalized. McCarthyism ran rampant, taxes, prices and profits soared without government hindrance. And behind the breastworks of this domestic repression the administrations of both Truman and Eisenhower proceeded to circle the world with U.S. bases and troops, oppose colonial liberation movements everywhere, brandish the A- and H-bombs, and dry up the "reservoir of good will" which the U.S. had built up during the "Good Neighbor" era of Roosevelt.[4]

The best interests of the people of the 18th Congressional District, and of the working people and Negro people of this country, demanded that Marc act and vote for peace and against war. He did, and for this the American people will honor him.

We have lost a tried and true friend, the foremost spokesman for the rights of man the Congress of the United States has produced in the 20th century. For me, a special sadness comes when I think that I will no longer share Marc's warm and principled friendship.

Italian-American, carpenter's son, he never deserted the working people from whom he sprang. As he rose to service in the political arena, their fortunes rose with him. He was the clearest embodiment in Congress of the common interests which obtain between the Negro people and the working people of this land.

Marc was never a "quitter." He would expect us to fight on, to build ever stronger the people's unity; to rout the warmakers and exploiters; to send to Congress tens and scores of men and women who will serve the people in the style and spirit of Vito Marcantonio; to win the peace, happiness and equality for all the world's people to which he dedicated his life. As we do, we will be building a living monument to him who lived so well.

Fight We Must

> Speech at meeting of the National Council of the National Negro Labor Council, Hotel Theresa, New York City, September 25, 1954—Paul Robeson Archives, Berlin, German Democratic Republic

It is always an occasion of great importance to me to take part in the activities of the National Negro Labor Council. My mind goes back to your great conventions—Chicago last year; Cleveland in 1952; the founding convention in Cincinnati in '51; and even before that the great gathering of trade unionists in Chicago in June of 1950 which gave birth to the idea of a militant, mass organization of the Negro

workers fighting courageously for their economic needs and for the rights of their entire people.

You said that this organization was called for because there was a crying need for somebody to pay consistent attention to the job problems of the breadwinners of our people. Somebody had to give *top priority* to the questions of discrimination in employment, FEPC, growing joblessness, and the shameful spectacle—in this nation which boasts of leading the so-called "Free World"—of not only single plants, but whole industries which eliminate Negroes either altogether or from the skilled, better-paying jobs. It was time, you said, not only to talk about being the last hired and first fired—but to *do* something about it.

And who could do this job for the Negro workers better than Negro working men and women themselves? The answer was obvious then, and is just as obvious now: "Who would be free, *himself* must strike the blow."

Of course, you never sought to do the job alone. You knew that the initiative had to be yours, but you knew just as surely that your crusade had to involve thousands and eventually millions of others if it was going to succeed. And so you proclaimed a doctrine in Cincinnati that got right down to the heart of the matter, and that brought the delegates right up on their feet. You said, to paraphrase a slogan which has been the rule of your organizational existence, "We do not need or ask *anybody's permission* to fight for our own livelihood, our own security, our own lives, but we seek *everybody's cooperation."*

You sought first of all the cooperation of the labor movement with its 15 million Negro and white workers in AF of L, CIO and independent unions. And of equal importance, you sought the support and cooperation of the long-established organizations of Negro life—the church, our fraternal bodies, the NAACP, the Urban League and our business institutions.[1]

And, realizing that cooperation is a two-way street, you offered the resources of your organization in support of those who were engaged on other fronts of the battle against Jim Crow. You could be counted on to join the mounting fight against segregation in education, housing, health, recreation—in all phases of American life.

But all the while you have kept your big guns turned on the fundamental issue—jobs and economic security for our people. You have realized that it's on the production line that the whole ugly practice of segregation and discrimination bears its most bitter fruit; and that in the end the battle to lick Jim Crow in production will largely determine its fate everywhere else.

When the Dixiecrats decree that Negro and white children shall not go to school together they are preparing the ground for the day when they will not be allowed to work on the same machine together. When they decree that Negroes must ride in a hot, grimy railroad car—half baggage and half coach—while whites ride in air-conditioned comfort,

they are setting the stage for public acceptance of the fact that
Negroes can be porters and waiters—servants—on the railroads, but
not engineers, conductors, trainmen and clerks.

Oh, yes, it's at the point of production and at the pay-window of the
American economy that Jim Crow pays off for those who love it most.
It pays off in $4.5 billion every year in super-profits for the monopolies,
sweated out of the toil-worn bodies of Negro workers.

That is why, though I manage to keep busy with many responsibili-
ties, I always feel a special urgency to do what I can to advance the
program of the National Negro Labor Council. That is why I have said
before, and repeat today, that whenever you call upon me for service I
will be there, shoulder to shoulder with you, the finest sons and
daughters of the Negro people and of the entire working population of
this land.

That is precisely what I meant when, in 1947 at a concert in St.
Louis, I announced that I would put aside my formal concert career for
the time being to enter the day-to-day struggles of my people and the
working masses of this country. I meant the struggle for our daily
bread—such battles as I had been part of on the picket lines on the
Mesabi iron ore range, with the auto workers in Cadillac Square, the
gallant tobacco workers in Winston-Salem, the longshoremen, cooks
and stewards in San Francisco, the furriers, electrical workers and a
host of others.

No, of course, I'm not the only one who has recognized your im-
portance and your potential. Among the first to pay tribute to you, in
their own way, have been the traditional enemies of our people and of
American democracy. They've complimented you by leveling against
the NNLC and its leaders the most vicious and unprincipled attack.

Because you fight all-out for the rights of Negro workers they say
you somehow endanger the nation's security. That's a lie.

Because you proclaim your solidarity with African and Asian
workers and call for the independence of all colonial peoples they say
you somehow betray our national interests. That's a lie.

Because you preach the truth—that the Negro's well-being is served
by peace, not war, by building schools, homes and roads, not guns,
tanks and bombs—they say you lack patriotism. And that's a lie.

They would like to hound you out of business if possible—discredit
your leaders, make you register with the so-called Subversive Activi-
ties Control Board,[2] stop you from publishing literature, holding
meetings, arousing the nation in support of your program.

They'd like to shut you up while Talmadge defies the Supreme Court
on segregated education and spouts his arrogance over nationwide
radio and TV hookups, and while a new rash of hate groups, including
the recently formed National Association for the Advancement of
White People, flood the mails with filthy "white supremacy" propa-
ganda.

But here you are meeting today—a fighting, democratic organiza-

tion, determined that "just like the tree that's planted by the water, you shall not be moved."

And while I know that nobody in this room has ever had any doubt but that you'd be here, I think this is a fitting moment to say that the NNLC—despite all the attacks, including a few from leaders of our own people who should know better—despite the difficult times we've had, always with insufficient money and often with little encouragement—despite all this the NNLC is needed today more than ever, and our best days lie just ahead of us.

I think I know how great the need is. For I live in Harlem, and as I sit in the parish house of my brother's church Mother AME Zion, and as I walk up and down the avenues or visit with friends, the signs of hard times are everywhere. In New York State the production index has dropped 10 per cent in the past year and unemployment insurance claims have steadily risen.

Even in so-called "good times" the vast majority of Negro workers live at a bare subsistence level. Our family income is still—after all the economic "progress" of the World War II period—just one-half the family income of white workers. And when the firing starts Negroes—by statistical count—lose their jobs twice as fast as anybody else.

What's true of New York is doubly true of the major industrial centers in Pennsylvania, the middle West and the West Coast. The president of the United Steelworkers of America recently announced at their convention that one out of every three steelworkers in the nation is either out of work or working part-time. And it's difficult to pick up a newspaper without reading that a couple of auto plants have merged and "merged" a few thousand workers out of jobs; or that another company has "retooled" thousands more onto the breadlines.

It's bad enough that the Eisenhower administration started out by giving away our national wealth in tideland oil, public power and tax concessions to the monopolies, but when they start *taking away* our jobs and telling us that the pain in our stomachs is not really hunger but imagination, then it's really time for something drastic to be done.

I'm glad that you raised your voice with that of the labor movement, and I know that you are unique in Negro life, in putting forward a comprehensive anti-depression program to stem the downward trend of the economy and provide jobs for the unemployed.

It seems to me that instead of giving the AF of L a political lecture, as he did at their convention, Secretary of Labor Mitchell ought to be forced to say where he stands on the AF of L proposal for a billion dollar appropriation for building public schools as a part of the implementation of the Supreme Court ruling against segregation.[3]

And when it comes to housing—why we could use the 300,000 housing units authorized annually in the administration bill among Negroes alone and we'd still be in a terrible fix for a decent place to live.

Another way to fortify our economy against depression would be to open the doors to two-way worldwide trade, which means specifically

trade with China, the Eastern European democracies, and the Soviet Union. But, oh no, says our government, we don't like their politics. Well, I'm not here to say we must like the politics of these nations, for that's not necessary for normal commercial relations. But isn't it true that our government fosters trade with fascist Spain and with Malan's South Africa. So if politics is to be the yardstick in international trade it means that the U.S. government is saying to 15,000,000 Negroes that it approves the politics of the most oppressive, racist dictatorship on the face of the globe today.

Of course, the embargo on trade with China, dictated by McCarthy, Knowland and the China Lobby,[4] is having an opposite effect from that intended. They think that by embargoing China they will starve the government out and eventually get the discredited Chiang Kai Shek off the little island of Taiwan (Formosa) and back into business as an American puppet on the mainland.

But China's trade and economy and well-being are constantly expanding. Trade delegations are constantly going to and from Britain and many other Western nations, excluding only the United States among the great powers. And the ones to feel the brunt of the policy are the American workers who, instead of walking the streets in search of work, could be making the tractors, farm implements, tools and structural steel which New China needs and is ready to buy.

Of course, a comprehensive program for the economic welfare of Negroes depends not only on fighting to hold on to what we have and to prevent unemployment. If that were the extent of our program we'd always remain at the bottom rung of the ladder.

We must always be breaking new ground. And you couldn't have picked a better place to break it than on the nation's railroads. Railroad men have always played a big part in the life and legend of our people. John Henry would certainly be proud to know that you are launching a campaign to guarantee that hiring will be color blind on the railroads which he and his fellow workers built.

This campaign should stir Negro life and the nation as few crusades in the past. Every Negro leader who has worked for a while carrying bags or waiting table while preparing for his career ought to lend the weight of his prestige to your efforts. For instance, Dr. Ralph Bunche once worked on the railroad to help pay his way through school. Now, as long as Negroes are barred from the skilled trades in the industry the implication is plain that the man who holds the highest position of any American in the United Nations is unfit to collect tickets, or yell *All Aboard* or turn the throttle on an American railroad—because he is a Negro.

I hope that Dr. Bunche and many other outstanding Negroes who at one time labored in the dirty end of railroading will consider this an insult to them personally as well as to their entire people and will throw their weight behind the Council in this campaign.

But not only are there those who once worked on the roads. There are the thousands of Negroes who work there now. They enjoy a highly

respected position in our communities throughout the nation. Their
activities touch on the lives of the millions of our people. They are to be
found in every church, lodge, club and society. It is here that we must
take our message, spread our pamphlets and other literature, secure
signatures for the petition to Vice President Nixon and the Contract
Compliance Committee. If this campaign is taken to the bed rock of
Negro life, to the heart of our organizational activities, there is no
question in my mind but that we'll stir this nation, place the railroad
magnates on the spot where they belong, and wind up with some
Negroes driving trains as well as sweeping them, selling tickets as
well as buying them, giving orders as well as taking them.

Fight we must, on this front and on many others if we are to restore
and expand this democracy of ours. I know we'll win and I intend to
keep on fighting until we do.

Floodtide of Peace

Letter to Boris Polevoi, Soviet author of *The Story of a Real Man*
—*Masses & Mainstream,* October 1954, pp. 6–10

Dear Boris Polevoi:

It is late at night, but through the open window of this room comes
the sound of people still moving about on the streets. Harlem—this
vast Negro city-within-a-city—seems always astir. Like the crowded
dwellings which can barely contain the mass of humanity that is
hemmed into this neighborhood by the invisible walls of racism, the
very hours of the day seem too cramped for the surging life of the
people. Working people, most of them are—working hard to pay the
landlord, for rents here are as high as the buildings are dilapidated:
struggling to live another week, another month; struggling to attain
some recognition of their human dignity that has been denied them so
long in this land. And laughing, too—"laughing to keep from crying,"
as they say; and snatching moments of gaiety at a dance-hall, a movie,
a street-corner tavern.

Here in this community my people come together in all of the many
organizations they have formed to serve their common needs—mutual
aid societies, churches, trade unions, athletic teams, political and
social clubs. Here are honest leaders working among the people; and
here, too are the misleaders who do the bidding of the rulers for paltry
favors. Militant leaders are persecuted, and some of the best and
bravest of them are jailed. I think of a man dear to me as a
brother—Ben Davis, whom the people of Harlem twice elected to City
Council and whom the warmongers imprisoned three years ago togeth-
er with other leaders of the Communist Party.

I think, too, of another heroic Negro champion who is known to

many in other lands—my old, dear friend, William Patterson, leader of the Civil Rights Congress, who sits tonight in a New York jail because he dares to defend the many, Negro and white, who are persecuted by the reactionaries.

Yes, this is the Harlem of Davis and Patterson, and all around are their people and mine. I, who have heard only a few miles away, at Peekskill, the baying of the lynch-mob, the cries for my life shrilled from hate-twisted mouths, feel in this neighborhood the caress of love. "Hello, Paul—it's good to see you!" the people say as I walk in their midst and as they take my hand in theirs.

Here for many years my brother, Rev. Benjamin C. Robeson, has served as pastor of one of the largest Negro churches. This church, Mother Zion, the mother church of the numerous African Methodist Episcopal Zion denomination, has a history that goes back to 1796, when it was founded by free Negroes who refused to be part of the church of the Christian slaveowners.[1] Sojourner Truth, heroine of our liberation struggle was an early member of Mother Zion; and Frederick Douglass, our greatest hero and teacher, and Harriet Tubman, our Moses of the Underground Railroad, also played their part in the freedom-striving tradition of this church.

Frequently I spend an evening with my devoted older brother, Rev. Robeson, a gentle, gray-haired man of quiet dignity. But tonight I am at my son's house: and there he is, hunched over a table on the other side of the room. The lamplight deepens the heavy frown on his youthful brow as he leans forward in his chair, chin on fist like Rodin's *The Thinker.* Indeed, it is a very serious problem my son must ponder about, for in front of him is a chess board with the black and white pieces joined in crucial combat, and his opponent is—an international grandmaster!

His opponent—is it Smyslov?—or Bronstein, perhaps?—is not actually present, but Paul is replaying the moves from one of the games in the chess tournament recently held here in New York between the visiting Soviet masters and their American hosts. Was "White's" next move—pawn to King's Bishop 4—a fatal blunder? Paul is determined to find out. Of course, if he finds a better move it won't help "White" whose game was lost in a tournament that has ended; but the more Paul learns the more he can teach me when we play each other again.

The tournament score was 20 to 12 in favor of the Soviet chess team but it seemed to me that the most meaningful score was posted before the first move was made in the opening round. I mean the victory scored by the American chess players whose federation insisted on bringing this match to our shores; and the loser was Dulles and his State Department who tried to block this gesture of friendship. What a pleasure it was for us to join in the hearty applause of the spectators when the spokesmen for each team expressed their firm desires for peace and cultural exchange between our countries!

Yes, my friends, there truly is "another America"—the America of the common people who dread the thought of another war and yearn to

live in a world of peace. Their voice is never heard on the official "Voice of America." The warmongering press and radio speak, as does Mr. Dulles, only for the handful of billionaires who dominate our country and who seek to dominate the world. Largely inarticulate, terrorized by fascists like Senator McCarthy, and often confused by the steady barrage of war propaganda which tells them that the world-cry for peace is a "communist plot," nevertheless the American people respond to the cause of peace and progress whenever that cause can get a hearing. Let me give you some examples of that truth from my own experiences during these difficult days.

Only recently I sang in a concert at the University of Chicago. The student organization which invited me was subjected to various pressures to get them to cancel the offer; local reactionary groups threatened violence against any who dared to attend; the newspapers fiercely denounced the concert as "un-American." But the students stood firm, and the result—a packed hall of 1,500 people, with hundreds more turned away for lack of room!

As always, I included on the program songs of other lands, and songs of the Russian people, like Moussorgsky's "After the Battle"; and the message of peace and democracy that I brought was warmly received. Incidentally, I met there the editor of the student newspaper who was one of the group of American college editors who visited the Soviet Union last year and learned about that all-important truth which is kept from the American people today—the fact that the Soviet people, far from being "aggressors," are passionately dedicated to the cause of peace.

Sometime soon I shall return to Chicago, for a concert on the South Side—the largest Negro community of that city. Last summer such a concert was planned and when no hall could be hired because of the terror, the gathering was held in Washington Park. Indeed, no hall in that neighborhood could have held the audience which thronged to the park that bright Sunday afternoon—ten thousand people, most of them Negro workers from the steel mills and meat-packing plants, and many of these workers were recent arrivals from the deep South, from the cotton plantations of Mississippi. A large number of the Negro middle-class also attended—doctors, lawyers, school teachers; and one of the leading clergymen was there to give his blessing.

I'm sure there were many in that great crowd who never before had heard the truth about the Soviet Union. They listened intently as I told of my visits to the Land of Socialism, of how I had found there a society in which for the first time in my life, I, as a Negro, son of a former chattel slave, had known what it feels like to be free and equal. I told them of how deeply I was moved when, on a later visit, I saw in the school books from which my son studied that the lessons of human brotherhood were being taught to the Soviet children. I told about the many nations and races that comprise the Soviet Union, and of how those peoples who had known colonial and racist oppression in the old days had achieved national liberation and were marching forward

with giant strides, firmly united with, and equal among, their Russian brothers who had led the way.

Here was good news to cheer in Chicago's South Side; which then and today still witnesses the brutal attacks which the lynchers make on Negro families that move into homes outside the Negro ghetto. And afterward, as they crowded around the platform to grip my hand, my heart was filled by this demonstration of militant support that united me with these industrial workers in the North who are closely linked with the great mass of Negroes in the South, the toilers on the land who yearn to be free from three long centuries of cruel oppression.

Soon after that wonderful day, I found myself at another memorable outdoor concert. Although I am not permitted to travel outside the United States, this concert was in fact a cultural exchange between nations. It was held at Peace Arch Park, on the U.S.-Canadian border between our state of Washington and the province of British Columbia. This concert, a mass demonstration for peace, was sponsored by the Vancouver (Canada) district of the Mine, Mill and Smelter Workers Union.

I might mention here that this union of metal-ore miners has a rich heritage of working-class struggle, for it grew out of the old Western Federation of Miners and the heroic strike struggles led by "Big Bill" Haywood[2] who, forced to flee from savage persecution after the first world war, lived out his last years in the Soviet Union and whose ashes were buried in the Kremlin wall. From the early struggles of this union came the martyred organizer, Joe Hill, killed by the copper trust in Utah—the same Joe Hill of whom I sing, and who himself was the foremost writer of songs for the American working people.[3]

Well, out there in the great Northwest, where this concert was held, the spirit of the working class—the spirit of democracy and internationalism—is rooted deep. People came from miles around, filling the roads like overflowing streams, and when they were all assembled in the park, there was an audience of 40,000 men, women and children! Never before in the history of that region, the police admitted, had there been so large a public gathering.

Peace—yes, here was the floodtide of the people's hopes! Here, at the border I am forbidden to cross, was a demonstration of that force which will surely impose the peace, as we all vowed at the World Peace Congress in Paris. Yes, here was a powerful expression of the peoples' will for a world of peaceful coexistence, of friendly relations and cultural exchange—a rally of working-class solidarity against the profiteers of war!

In a few days I am going back to the Canadian border for another such concert. In the year that has passed since that last great rally of Canadian and American workers, the peace forces of the world have grown stronger. The onrushing tide of the colonial liberation movement—in Asia, in Africa, in Latin America—brings vast new legions into the camp of peace and freedom. Dulles cries out for "united action," for war against the peoples, but those whom he counted on to

be his allies have come to see that peaceful coexistence is infinitely better than atomic disaster.

Here in America the Big Lie is still official doctrine. Repression continues and sharpens against those who speak out for civil rights and peace. New inquisitions are started daily; new fascist-like laws are being passed in Congress: new victims are being framed-up and sentenced to prison. But though Senator McCarran embraces Franco, and Senator McCarthy invokes the ghost of Goebbels, the American people are not fascists. The democratic tradition of Jefferson and Lincoln and Douglass and Whitman still runs deep among the common people.

No one could miss the popular alarm and protest that flared up all over the country when Vice-President Nixon recently suggested that American soldiers be sent to fight the Vietnamese. And lately we have seen that the idea of peaceful coexistence, almost totally suppressed in recent years, has now become a matter of public discussion, with spokesmen for broad sections of public opinion openly advocating a change in official policy on this subject. This discussion in itself is a breakthrough for peace, and I am sure that the common sense of the American people, who only a decade ago supported President Roosevelt and recognized with him that American-Soviet friendship was indispensable for world-peace, will bring them to see that truth again.

Then, instead of this miserable cold war, we will have the sunshine of a lasting peace; our artists, writers, scientists, workers, students and farmers will come to know each other, and in place of the Big Lie the great truth of human brotherhood shall prevail.

As a firm and devoted friend, I salute the great peoples of the Soviet Union, who have opened a new chapter in human history and are writing by their heroism the story of real men, of real women, and of their children who shall inherit the unlimited future.

Bonds of Brotherhood

Jewish Life,[1] November 1954

My heartfelt greetings to the Jewish people, who are now celebrating three centuries of life and work in this land. It is good for all Americans to be reminded once again that the "Anglo-Saxon" image of America is a false-face. Certainly no Negro can hear the declaration of the Committee for the 300th Anniversary of Jewish Settlement in the U.S.A.[2]—*"We have always been part of America"*—without reflecting that such has been our own insistent claim: *"We too are America!"*

Self-evident since the days of Haym Salomon[3] and Crispus Attucks, these claims have been denied by the racists and reactionaries of every generation; and never before have these foes been more powerful and arrogant than they are today. Not only is race, color and creed a continuing bar to a so-called "100 per cent American" status, but

nowadays any person or organization can be officially branded "un-American" by a one-man ruling. The McCarran-Walter immigration act compares in foulness with the worst of nazi racism.

The significant relationship of the Jewish people's interests with those of the Negro people has been pointed out by the Anniversary Committee:

> Let us make our anniversary a source of inspiration in the defense of our rights and liberties. . . . Let us act in unison with all groups in America and especially the Negro people—who suffer most from reaction and fascism—in order to defend our democratic rights." (JEWISH LIFE, September 1954.)

Yes, the cause of democracy, the rights of all other minorities, are inseparably linked with the liberation struggles of the Negro people. From the "Know-Nothing"party[4] of a century ago to the Ku Klux Klan and the McCarthys and McCarrans of today, history's handwriting on the wall has spelled out that lesson. He who would live must learn it well.

It is not likely that the first group of Jewish settlers who came to New Amsterdam in 1654 had heard about that first group of Negroes who were landed at Jamestown in 1619. The Jews came as pioneers, seeking freedom; the Negroes came as slaves, torn from their homeland.[5]

So, from this beginning it was inevitable that the history of the descendants of these two groups (and of all their kin who came in later years by slave-ship from Africa and steerage-hold from Europe) would develop on different paths. And yet, in all the diverse strands which make up the web of American history for the past three centuries, there are direct threads which link the interests of the Negro and Jewish people from the earliest days.

Peter Stuyvesant, governor for the Dutch West Indies, who wanted to drive out the first Jewish settlers,[6] has long since turned to dust, as has the Dutch slaver which brought the captive Africans; but anti-Semitism still lives and is nurtured on our soil, and the shameful heritage of slavery—Negro oppression and exploitation—still has its grip.

Indeed, right here in New York the name of the man who first proclaimed anti-Semitism in the New World is known to us in connection with anti-Negro discrimination. We recall the long and bitter struggle against Jimcrow in the Stuyvesant Town houses. Here we saw progressive sections of the Jewish people united with the Negro people in a drive to make the racist walls come tumbling down.

We remember Ben Davis, our City Councilman, who led that memorable battle, and here the thread of history leads to Foley Square where a landlord judge sentences the heroic leader to prison. And in the courtroom we see Negro and Jewish workers standing together against the Peter Stuyvesants of our time; yes, here beside Ben Davis is Irving Potash; John Gates with Henry Winston, and all their courageous colleagues.

Who can forget the awful lesson of Hitler Germany? How many of those who thought that the Reichstag Fire frame-up trial was aimed at only the Left—how many of the duped were to die?

And so we can all agree with the Anniversary Committee when it warns that "the McCarthyite attacks upon the American people bring the danger of fascism." With confidence, the Committee asserts: "In this critical moment . . . the Jewish workers and common people will find the necessary strength and wisdom to stand firm on the side of progress and peace, against McCarthyism, fascism and war."

Surely none of us who were at Peekskill can doubt that the Jewish workers will be second to none in standing firm against our common enemy. As for myself, I have always felt an especially close bond with the Jewish people; and to me, Peekskill, so terrible in its demonstration of reactionary barbarism, shall ever be a glowing symbol of the unity of Negro and Jewish workers against fascism.

Some day soon I shall write at length, in the context of my life story, about the meaningful experiences I have had with the Jewish people. Much of this would deal with my early years as an artist, for here, in this field of music and the arts, all other Americans are deeply indebted to the creativity and cultural gifts of the Jewish people.

But the story would begin even earlier—in my boyhood, when I first heard about the Children of Israel—the epics of Moses and Joshua and Gideon and the fiery Hebrew prophets—the Bible stories that gave imagery to the freedom songs of my people. Recently I was told that our great Negro spiritual, "Go Down Moses," has now been translated into Hebrew and has been sung to audiences in Israel—and one marvels again at the interweaving of people's cultures: down through the centuries, moving from language to language, crossing seas and mountains, turning, doubling back ever renewed and enriched . . . imperishable in the common aspirations of mankind!

Here is another example of this wonder-woven fabric of human culture which unites us all: Not long ago I was asked to sing a song by Anton Dvorak to be used in a film about the life of the great composer which is now being made in his homeland, Czechoslovakia. The words of his song are from the well-known biblical psalm, *"By the rivers of Babylon, there we sat down and wept"*—the searing outcry of an enslaved people against their oppressors, against *"those that carried us away captive."*

From ancient Judea these words of the 137th Psalm had crossed the vast reaches of time and distance to stir the hearts of the Negro slaves in our own Southland; and the downfall of slave-holding Babylon was cited by our Frederick Douglass in his famous address, "The Meaning of July Fourth for the Negro"[7] (1852). "I can today take up the plaintive lament of a peeled and woe-smitten people," Douglass declared, and he went on to recite the moving lines of the psalm.

Half a century later the gifted Dvorak came to our country, studied the melodies and lyrics of Negro song, and drew upon its richness for his own creations—and so, in this way, the words of this very song

must have traveled back across the ocean with him; and I am told the song was especially popular among the Czech people during their years of suffering under the terror of nazi occupation.

But history moves on: Hitler is gone; Prague lives and builds in a new people's democracy—and now I, an American Negro, sing for her this ancient Hebrew song in the language of the people of Huss[8] and Dvorak, Fuchik and Gottwald[9]:

> *Pri rekách babylonckych,*
> *Tam jsme sedávali a plakávali . . .*

If it has been true that the Jewish people, like so many other national groups for whom I have sung, have warmly understood an'd loved the songs of my people, it has also been true that Negro audiences have been moved by songs of the Jewish people. The Hassidic Chant, for example, has a profound impact on the Negro listener not only for its content—a powerful protest against an age-old persecution—but also because of its form: the phrasing and rhythm have counterparts in traditional Negro sermon-song. And here, too, is a bond that can be traced back through the centuries to a common heritage.

In the early days of my singing career and in the theater, the Jewish artists I came to know not only introduced me to the world of Sholem Aleichem[10] through the Yiddish language and folksong; but since many of these friends were Russian Jews, I also came to know the language of Pushkin and the songs of Moussorgsky. And so it happened that, before I had any knowledge of the economic or political nature of the Soviet Union, I developed an abiding love for the culture of the Russian people.

"Un-American!" say the Know-Nothing Knowlands[11] of today—and indeed, the whole world which cries out for peaceful co-existence, cultural exchange and trade between nations, seems altogether "un-American" to those here who are driving hell-bent for fascism and war.

Well, there exists that evil tradition which stretches over the years from Peter Stuyvesant to Pat McCarran, from Jefferson Davis[12] to James Byrnes. But there also exists the great tradition of democracy and of struggle to preserve and extend that democracy—in Jewish history from the resistance of the first settlers to anti-Semitism; in Negro history from the first slave revolt; in all of American history from the earliest struggle for man's inalienable rights.

Hating and fearing the war-mad rulers of our country, the people of all lands look eagerly for signs of that "other America" they know exists—the America of the common people who also yearn for relief from the burdens of armaments, "spy"-scares and witchhunts, and for the banishment of that ultimate disaster—atomic war.

So let the Tercentenary celebration of the Jewish people serve as a fitting means to let the voice of that other America be heard: for democracy and progress, for freedom and peace—for our land and for all others!

Africa and the Commemoration
of Negro History
Spotlight on Africa, January 1955

I believe the misrepresentation of the African and the distorted picture
of the American Negro still so prevalent in our American culture,
stemming as they do from the same basic cause of economic exploita-
tion, can NOT be attacked or rooted out separately. Each myth is
propped up by the other; both must be destroyed. When that happens,
the true worth of the Negro—whether in Africa or in the Americas—
and his place in the mainstream of the world's culture will be properly
understood. When that happens, no one will dare to speak of white
supremacy or Negro inferiority.

Mississippi Today—History in the Making
Freedom, February 1955

As we celebrate the heroic contributions of great leaders for the fight
for Negro freedom in the past, it is of the utmost importance to
remember that a stirring chapter in Negro history is being written
today in Mississippi.

We all recall that Mississippi is the only state in the history of the
nation which has sent Negroes to the United States Senate. How well
the Senate could use today stalwart men of the caliber and qualifica-
tions of Blanche K. Bruce[1] and Hiram Revels,[2] the Reconstruction
Senators from Mississippi. And Congressman John R. Lynch[3] was one
of the outstanding legislators and defenders of popular democracy of
that exciting period.

But when Reconstruction was defeated with Klan terror and Repub-
lican betrayal, the blows fell especially hard on Mississippi, precisely
because it was in the forefront of the bitter battle for social progress in
the South.

Mississippi, after Reconstruction, became a prison for a million
Negroes and almost as many impoverished, exploited white rural folk.

But the common people, even in the most difficult hours, never gave
up. The Negro people built their schools, churches and small business,
their fraternal orders and civic organizations. They took pride in the
struggling all-Negro town of Mound Bayou. They fought oppression
with whatever weapons they had.

It is one thing to sit in New York, Chicago, Detroit and Los Angeles
and say what Negroes in Mississippi should do or should have done,
but it is another to live one's life out in the face of the most rabid of
racists, armed with the power of the state and the actual support or

hypocritical "neutrality" of the federal government, and still survive and make progress.

But that's what the valiant Negroes of Mississippi have done. They have, as it were, for the past 80 years been preparing for major battles—husbanding their strength, preparing their leaders, mastering the tactics of popular democratic struggle. They have sent their young men and women away to schools which provide greater opportunities than those afforded in the state and many, though not enough, have returned to take up front positions in the movement for equality.

Now, after all these years, the battle has been joined on a new and higher level. The NAACP, which for years had only negligible strength in Mississippi, can now boast a considerable and growing organization. Dr. T. R. M. Howard,[4] militant surgeon of Mound Bayou, leader of the important fraternal order, the Knights and Daughters of Mount Tabor, has emerged along with others as an energetic and resourceful leader. The libertarian currents abroad in the world have stimulated the freedom-yearnings of Negroes and many veterans of World War II are impatient for the realization of the "promissory note" of equality in the name of which that great anti-Hitler conflict was waged.

So, today, Negroes of Mississippi, as of the whole South, are demanding implementation of the Supreme Court decision on segregation in education.

And as might be expected, the Dixiecrats have responded with howls of anguish and threats of retaliation. They have done this, of course, all over the South. But in Mississippi their retaliation has gone well beyond the point of threats.

The planters have organized a new Ku Klux Klan. They have laundered it a bit, given it a face-lifting, and called it White Citizens Councils.[5] But no Negro in Mississippi will be fooled. He knows the Klan when he sees it, by whatever name it's called.

The misnamed Councils have begun to exert economic pressure on the leaders and membership of the NAACP. Are you a grocer, funeral director, physician, small farmer? Then the likelihood is that you could not function without credit. But the credit is in the hands of the banks and mortgage companies, dominated by the planters and big Wall Street concerns.

So, say the Citizen Councils, since we control the credit, we'll control the Negroes! We'll starve their leaders out. We'll draw up a new kind of blacklist, and any Negro who supports NAACP or calls for equality in education will have to find his living outside of Mississippi.

But the planters have reckoned without their hosts! When Governor Hugh White called what he thought were 100 "hand-picked" Negroes to his office to euchre them into endorsing a statement opposing the Supreme Court decision, they voted 99 to one for integration of education. In Mississippi, that takes courage!

And the response to the economic boycott of the Citizens Councils has been just as dramatic. Within three weeks, under the leadership of

the NAACP national office, organizations and individuals from all parts of the country have deposited $143,000 in the Negro-owned Tri-State Bank of Memphis to provide lending capital for Negro businessmen, professionals and farmers who are being foreclosed by the "free enterprise" Dixiecrats of Mississippi.

All decent Americans are called upon to rally to the heroic Negro people of Mississippi. I should like to see the great organizations of labor deposit large sums in the Tri-State bank to help in this fight. The Brotherhood of Sleeping Car Porters has already deposited $10,000. Other groups may deposit smaller, or larger, sums.

We must support the demand that President Eisenhower intervene and prosecute those who are violating federal law and regulations by deliberately withholding economic loans for political reasons.

Messages of moral support and solidarity should pour in to Dr. T. R. M. Howard[5] at Mound Bayou, Mississippi.

Eventually as the struggle deepens, as it must, new forms of battle will be needed and found. At the moment we must use those at hand to sustain the brave Negro people of Mississippi.

We must support their movement for the right to vote so that with political power they may be armed with the guarantees of implementation of legislative enactments and judicial decrees. We must focus the attention of the entire nation on this critical front in the battle for democracy. This is Negro history in the making.

A Word about African Languages

Spotlight on Africa, February 1955, pp. 3–5

As a boy in Princeton, a small but famous New Jersey town, I dreamed and dreamed of the land of my forefathers and mothers. And in reality my bonds were undoubtedly very close. My paternal grandfather or great-grandfather, torn from his ages-old continent, had survived the dreadful passage. My own father was the embodiment of the strength, warmth, and quiet dignity of the African people.

So, of my heritage I was very, very proud. I early learned to orate, to develop my speaking voice. I sang the songs of my people—in many ways, especially rhythmically, still full of African turns of musical phrase and forms. James Weldon Johnson[1] has beautifully illustrated this particular point.

Later I began to sing the songs of many peoples, to study many languages, especially after I reached London in the late '20's and the '30's. There I met students from Asia, the West Indies, Africa. I began to listen to them as they talked with each other and finally I plunged into the learning of the languages of my ancestors. This is just a short article, but from time to time I hope to return to this very favorite subject of mine.

Today we know much of the great creative art of the African people in sculpture, in their working of metals, gold, silver, iron. We know of the marvels they have achieved in their weaving of beautiful cloths and textiles. There are now available magnificent translations of *great poetry.* Many modern musicians have composed major works based upon the African musical idiom. And finally the Bible and much great literature have been translated into numerous African languages.

The African languages are varied and complex, but in structure they resemble many of the tongues of other and similar cultures. In studying at the School of Oriental Languages at the University of London, I was startled to find Westermann,[2] an authority on African languages, grouping the West African tongues with the Chinese. But unquestionably these different groups are very similar in the use of tone, in the use of one-syllable basic words, and in the *"thinking"* behind the language.

For example, there is deep meaning in the Chinese thinking of a past event thus—"I work—finish" rather than the use of inflections like "-ed" (I worked). Again, the words "sun & moon" equal "light." The words "big & little" equal "size." The words "East & West" equal "a thing." (All things are included within the boundaries of North-South-East-West.) The African's mind works very much in the same way.

Again, both the Chinese and African people make extensive use of *tone.* In the Peking branch of Chinese there are four tones, somewhat similar to our intonations of the word "yes." For example:—

1. Yes ⎯ (What did you say?) high level tone.
2. Yes ⟶ (Do you really mean that?) from first tone upwards.
3. Yes ⟍⟋ (Well, maybe . . .) down, then up—a low tone rising.
4. Yes ⟍⟶ (I agree) a very final "Yes." From high down.

Now, a word pronounced *shoe* means "book" in the first tone, "ripe" in the second tone, "belong to" in the third, and "drum" in the fourth.

In Efik, the language of Calibar in Southern Nigeria, use of tone is much more complicated. Thus, O-*bong* (awe-*bung*) has different meanings in different tones:—

1. oo-bong (˙ ˙) 2 high—mosquito.
2. o-bong (˙ .) high to low—a cane, or he shouts.
3. o-bong (˙ •) high to middle—chief, king.

So one would get into serious trouble calling the Chief a mosquito. The African also uses tone to shape his grammar as well as to give the same word different meanings. As with the Chinese, this is a development representative of high levels of culture.

It is interesting that the Bantu tongues of East and South Africa are in structure much like the languages of Mongolia, or Hungarian, or Japanese. They are characterized by a very big word, "ag*glu*tinative,"

which simply means "a-*glu*ed-together." Instead of changes like -ed (worked), -ing (studying), -tion (illustration), as in our language, whole words are **glued** one to the other. For example, in Hungarian *"dolog"*—thing, something to do. Dolog-*talan* (without, less)—workless, idle. Drop the second "o" and dolg-*oz-ni*—to work; dolg-*oz-ok*-nak (to)—to the workers.

Now, in Yoruba, one of the languages of Nigeria and one of the great languages of the world, i fẹ́ (the marks indicate *tone* and length of *sound*)—love; a i fẹ́—disaffection; la i fẹ́—one who does not love; ni fẹ́—to have love (ni—to have). And there are many other compounds.

Now another example, very characteristic of all languages of the East: dojúbolẹ̀—to turn one's face to the ground—from dạ (to turn over), ojú (face), bò (to cover), ilẹ̀ (ground). Dẹti—to listen—from dè (to loosen) and eté (the ear). There are countless beautiful illustrations.

Here in Nigeria was the place of the great culture of the Benin, with their wonderful sculpture and very early civilization long before the development of much of European culture. The ancient philosophy of these peoples seems to me very parallel to the old Chinese concepts of the Yin and the Yang, the Male and Female principles: Light and Dark, Sun and Moon, Summer and Winter, etc. The dances, which I have seen in special films, are quite comparable to the Harvest dances of the Chinese—the accompanying African poems are quite comparable to the famous Book of Odes collected by Confucius. This similarity has been stressed by Granet, the French authority on Chinese culture and translator of many of the poems.

So this is just a beginning, all we have space for here. Much more will follow, some Swahili, for example, a branch of Bantu spoken in Kenya and all of East Africa. Of course, there are also the rich tongues of the Ethiopian people, of the Egyptians, other languages, such as Berber, of North Africa, and the language of the Falashas—which is ancient Hebrew, of times before Moses.

Greetings to Bandung

"Here's My Story," *Freedom,* April 1955

How I should have loved to be at Bandung![1] In this Indonesian city for the week beginning April 18 the hopes of mankind were centered. Of course, the State Department still arrogantly and arbitrarily restricts my movements to the continental United States, so that I could not join the representatives of more than half the world who convened in the Asian-African Conference.

I felt impelled, however, to send a message to this historic conference and am happy to share that message with you in this month's column:

Heartfelt greetings to all of you, peoples come from the shores of the Ganges and the Nile, the Yangtse and the Niger. Nations of the vast

Pacific waters, greetings on this historic occasion. It is my profound conviction that the very fact of the convening of the Conference of Asian and African nations at Bandung, Indonesia, in itself will be recorded as an historic turning point in all world affairs. A new vista of human advancement in all spheres of life has been opened by this assembly. Conceived, convoked, and attended by representatives of the majority of the world's population in Asia and Africa who have long been subjected to colonial serfdom and foreign domination, the Asian-African Conference signalizes the power and the determination of the peoples of these two great continents to decide their own destiny, to achieve and defend their sovereign independence, to control the rich resources of their own lands, and to contribute to the promotion of world peace and cooperation.

The time has come when the colored peoples of the world will no longer allow the great natural wealth of their countries to be exploited and expropriated by the Western world while they are beset by hunger, disease and poverty. It is clearly evident that these evils can be eradicated and that the economic, social and cultural advancement of whole populations of hundreds of millions of people can be rapidly achieved, once modern science and industrialization are applied and directed toward raising the general level of well being of peoples rather than toward the enrichment of individuals and corporations.

The possibility and practicability of such rapid social advancement have been attested by those who have objectively examined the history of the Soviet Union since 1917 and developments during the last decade in the countries of Eastern Europe, in China, and in newly emancipated Asian countries such as India.

I have long had a deep and abiding interest in the cultural relations of Asia and Africa. Years ago I began my studies of African and Asian languages and learned about the rich and age-old cultures of these mother continents of human civilization. The living evidence of the ancient kinship of Africa and Asia is seen in the language structures, in the arts and philosopies of the two continents. Increased exchange of such closely related cultures cannot help but bring into flower a richer, more vibrant voicing of the highest aspirations of colored peoples the world over.

Indeed the fact that the Asian and African nations, possessing similar yet different cultures, have come together to solve their common problems must stand as a shining example to the rest of the world. Discussion and mutual respect are the first ingredients for the development of peace between nations. If other nations of the world follow the example set by the Asian-African nations, there can be developed an alternative to the policy of force and an end to the threat of H-Bomb war. The people of Asia and Africa have a direct interest in such a development since it is a well known fact that thermonuclear weapons have been used only against the peoples of Asia. There is at present a threat to once more use them against an Asian people.

I fully endorse the objectives of the Conference to prevent any such

catastrophe, which would inevitably bring about suffering and annihilation to all the peoples of the world. Throughout the world all decent people must applaud the aims of the Conference to make the maximum contribution of the Asian and African countries to the cause of world peace.

One of the most important causes of world tension has been and continues to be imperialist enslavement of nations. Peace in Asia is directly linked with the problems of freedom and full sovereign rights for the nations of Asia. As for Africa, most of that vast continent, as we know, still groans in chains. In North Africa, in Kenya, East Africa, and in other areas imperialist terror has been unleashed in an attempt to keep freedom-aspiring peoples in subjection. South Africa feels the lash of the redoubled racist fury of her white ruling class. For this is the time for liberation, and Africa too shall shout in freedom. Soon. Yes, now is our day!

The demand of Africa and Asia for independence from alien domination and exploitation finds warm support among democratic-minded peoples everywhere. Although the calling of the Bandung Conference evoked bitter words of displeasure from high circles in Washington, the common people of America have not forgotten that our own country was founded in a revolution of colonies against a foreign tyranny—a revolution proclaiming that all nations have a right to independence under a government of their own choice.

To the Negro people of the United States and the Caribbean Islands it was good news—great good news—to hear that the Bandung Conference had been called "to consider problems of special interest . . . racialism and colonialism." Typical of the Negro people's sentiments are these words from one of our leading weekly newspapers: "Negro Americans should be interested in the proceedings at Bandung. We have fought this kind of fight for more than 300 years and have a vested interest in the outcome."

How I would love to see my brothers from Africa, India, China, Indonesia and from all the people represented at Bandung. In your midst are old friends I knew in London years ago, where I first became part of the movement for colonial freedom—the many friends from India and Africa and the West Indies with whom I shared hopes and dreams of a new day for the oppressed colored peoples of the world. And I might have come as an observer had I been granted a passport by the State Department whose lawyers have argued that "in view of the applicant's frank admission that he has been fighting for the freedom of the colonial people of Africa . . . the diplomatic embarrassment that could arise from the presence abroad of such a political meddler (sic!) travelling under the protection of an American passport, is easily imaginable!"

So all the best to all of you. Together with all of progressive mankind, with lovers of peace and freedom everywhere, I salute your history-making conference.

Paul Robeson Sings, Talks, Acts
—Sees Peace Basis in Culture

Tim Shopen, *Swarthmore Phoenix,* Swarthmore College,
Swarthmore, Pennsylvania, May 3, 1955

Paul Robeson sang, read from *Othello* and discussed world problems to
a near-capacity audience at Clothier last Thursday evening under the
sponsorship of the Forum for Free Speech (of Swarthmore College).

While in his political opinions he stands in a minority in this
country, the statement he is one of America's greatest artists should go
unchallenged. April 19 marked his thirtieth year as a concert singer
all over the world. As an actor his triumphs have been his portrayals of
the Emperor Jones and Othello.

The high point of the evening was the reading of the closing speech
from *Othello.* Mr. Robeson commented that, as he saw the part, Othello
was to the end a man of great dignity, not one who had lost his pride
but rather one of another culture in a strange land, who felt that he
had been betrayed. Robeson's reading was intelligently suited to this
interpretation. His physical stature and voice coupled with his acting
skill made for a tremendously powerful Othello.

Mr. Robeson's beautiful bass voice with its incredible fullness and
resonance was perfectly and sensitively controlled. His powerful
phrasing was full of warmth and understanding.

Mr. Robeson's great interest in cultures all over the world is
illustrated by the program of songs that he sang. He sang sixteen
songs, ranging from the chorale to Bach's "Christ Lag en Todesban-
den" to a Warsaw ghetto freedom song. He sang in English, German,
Russian, Yiddish, Chinese, Persian, and an African language.

The audience's response to Mr. Robeson's artistry was very enthusi-
astic. The consistently warm applause which followed each of his songs
was exceeded by the near ovation called forth by the Othello reading.

Mr. Robeson was accompanied by concert pianist Alan Booth. Mr.
Booth soloed with an interesting group of pieces: one by the Brazilian
Carmigo Guanieri, a Chopin Nocturne, and a piece by the Russian
Gretchaninoff.

During his song program, Mr. Robeson gave a musically illustrated
talk of some of his views on world cultures. He stated that Africa leads
the world in the rhythmic development of music; the Middle East, in
tonal variations; the Orient in melodies, and the West in counterpoint.
He felt that we have a rich world, full of different cultures, each with
its own strong points, each worthy of respect and appreciation. At the
same time, he has found basic similarities in music and culture among
the varied peoples he has known. Peace, he concluded, has a strong
cultural basis.

Later in the evening, Mr. Robeson went on to discuss some of the problems he finds most important to the world. His speech was followed by a question period which continued for another hour in Somerville with about fifty students. As he spoke, he referred to his experiences living abroad, which he feels have greatly shaped his views. He emphasized the fact that any position he took was that of a humanitarian and an American who loved his country.

He told the audience that their primary concern should be with the U.S., not only because they were Americans, but because he felt problems here were the key to world peace. Mr. Robeson said that the greatest danger to world peace was the American "ruling class." He feels that vested interests often lead the United States to oppose the freedom of the colonial peoples of the world and threaten to lead us into war against the communist countries which he regards as essentially peaceful.

He felt Americans should be striving for protection of their rights, particularly the rights of minority groups. He saw the Supreme Court decision on desegregation in the schools as a definite step forward, but held that Americans should press for immediate integration as urged by the NAACP in their "by 1956" stand.[1]

Mr. Robeson felt that freedom of speech has been infringed upon increasingly. He condemned all the McCarthyist persecutions of recent years. He stated that U.S. students were deeply involved in this and other problems. They are faced with the threat of war, an accelerated military program, and more particularly the loss of freedom of speech and the difficulty of finding out the truth. He said this was reflected by the fact that American students are much weaker politically than students of other countries.

Mr. Robeson said that the greatest force for good lay in the U.S. working class. Ultimately, he stated, this country should have socialism. He said further that the USSR is "building a great country."

Mr. Robeson did not accept the opinion of the U.S. press about the degree of freedom within the USSR. For working class people, he stated, there is a great deal of freedom. In order to understand the situation there, an historical view was necessary. This should include two main factors: the historical background of the present State and realization of the fact that the Western powers have been trying to destroy the USSR since its inception.

He said that slave labor camps were used for no other purpose than for the improvement in our sense of the word. He stated that while the present State inherited a problem of prevalent anti-semitism and prejudice against Turkish peoples, the government was doing everything in its power to combat and consequently, he says, the situation is improving. He was impressed that he has found complete acceptance of colored peoples in the USSR.

When asked about his view of the pacifist stand, he stated that he had Quaker heritage and that at an early point he had been a pacifist,

but that what he had learned in experience had changed his views. He supports the violence raised against the Nazis and Franco, but that with the present world situation and the destructive power of the H-bomb that "probably the Quaker view will prevail." He was also questioned about his approach to legal freedoms, his personal "loves" and "hates," British vs. Soviet, Socialism, and other issues.

From the time he arrived on campus until the end of the session at Somerville Mr. Robeson had been continually involved in singing, reading, and discussing with Swarthmore students for six hours.

Mr. Robeson often referred to his experience as typical of that of many artists and moreover the total situation of civil rights in this country. He said that certain people and the U.S. government itself was denying him the right to perform as an artist because of his political beliefs.

He was pleased that he had received invitations to perform, at Northwestern, Kansas State and Wisconsin universities as well as Swarthmore; however, aside from invitations from students and a few other groups, he said he is denied the right to perform in this country. He said that the State Department has prevented owners from hiring their theaters to him.

He said that he has invitations from all over the world which he can't accept because the U.S. won't give him a passport. The British Artist Equity Association has offered him a standing invitation to perform *Othello* with "the finest cast the British theater can afford." Several years ago, he said he had a request to sing a Concert in Canada, but the U.S. Government wouldn't let him leave the country. He said he went to a border and there sang across to a crowd of 25,000 Canadians who had gathered to hear him sing.

Swarthmore and the other institutions that still will give Mr. Robeson a chance to perform deserve much praise. That Mr. Robeson can be appreciated even though his audience disagrees with most of his political views is demonstrated by the warm and generous reception he received here. Indeed, the honor was all ours.

It is certainly a situation for Americans to take stock of when one of their greatest artists is prevented from performing because of certain political beliefs which he holds.

Free Speech at Swarthmore

"Here's My Story," *Freedom,* May-June 1955

It is good, these days, to get out to the college campuses and see the stirring of new life among the students. The Ivy Curtain of conformity, which for a decade has shut them off from the sunlight of independent thinking, is beginning to wilt. The fresh breeze of free expression is

beginning to filter into the stale atmosphere of the cold-war class-rooms.

This changing scene, noted by various progressive writers and lecturers who have visited the colleges in recent months, is renewing for me the bonds which have always connected me closely with this area of American life.

So it is a real pleasure, nowadays, to receive from student groups a growing number of invitations to appear at various universities—Northwestern, Kansas, Wisconsin, Chicago, UCLA and others. Some of these requests are for concerts such as was held here at New York's City College a few months ago, in support of my right to function as an artist; and others are for lectures sponsored by campus supporters of academic freedom.

Last month at Swarthmore College it was my privilege to appear both as artist and citizen, and this is always most gratifying because for me these roles are one and inseparable. Swarthmore, to which I had been invited by the Forum for Free Speech, has an enrollment of 900; but an overflow audience of 1,000 attended. Students came from other schools in that part of Pennsylvania—from Lincoln,[1] including some of the African students there,[2] and from Bryn Mawr.

It was a moving experience, warm with memories of my youth in nearby Princeton, and the days when I had come to play baseball against Swarthmore with the Rutgers teams. Memories of my father who was a Lincoln graduate and of my brother Bill who studied there and took me around the school. Memories, too, of my mother, for Swarthmore is a Quaker college and she was one of the Bustill family with a Quaker tradition going back to colonial days.[3]

The first part of the program consisted of songs and a scene from *Othello,* and there were piano solos by Alan Booth, the distinguished artist who accompanied me.

The musical phase of the evening was in celebration of the 30th anniversary of my concert career as a singer, but it also served as the text for my talk which followed; and with song I illustrated the root idea of my stand as a citizen for equal rights for human dignity and fulfillment, for peace among the nations.

I sought to explain to these eager young listeners how my viewpoint—which many of them thought too radical—was the natural outgrowth of my development as a Negro artist. I recalled how love for the songs of my people, the only songs for my first five years as a singer, widened to include the songs of other peoples as I grew to know them and found in them a kindred soul, a kindred beauty. I recalled how that knowledge led to an interest in other peoples, in their history and cultures, and in their lives today.

And so the talk, like the songs, seemed to move around the world, noting the epochal social changes of our times, urging an understanding of that reality, stressing the all-important need for peaceful coexistence. But inevitably the talk returned to the starting point—to the struggle and aspirations of the Negro in America.

Many questions were asked in the general discussion which followed and here, too, the focus came to bear on the outlook for Negro advancement.

There was give-and-take on various matters, and everyone seemed to enjoy the exercise of free speech on this occasion. Indeed, as many of the students told me, the important thing for them was the chance to hear another viewpoint.

Yes, a ferment is growing among America's students, both Negro and white. Many are beginning to see that if a concern for future jobs has dictated conformity, a concern for their very lives requires that they think for themselves.

The Constitutional Right to Travel

"Here's My Story," *Freedom*, July-August 1955

SAN FRANCISCO

My last few weeks, spent here in San Francisco, have been exciting ones. And I'd like to tell you about that.

I came here to give a concert honoring the 10th anniversary of the United Nations in its founding city. I found something much more than a mere celebration.

The delegates—the great men and women from all over the world who met here and gave such moving testimonials to mankind's longing for peace and brotherhood—were exciting to meet and talk with.

But I found more excitement in talking to the men and women on the street, especially in talking to the Negro people of this western city. There's a new wind a-blowing and it's as full of promise as spring.

More and more people seem to be shaking off the cold war hysteria. The American people, I'm proud to say, never did buy the "hate your neighbor" policy pushed with such intensity by our State Department and other Washington politicians.

It is saying nothing new to point out that the Negro people showed the least inclination to buy this propaganda. We know ALL about what "hate your neighbor" means. We were born and bred in that briar patch.

The good thing I found here is not so much in this as in the fact that a whole lot more of our people are willing to talk out loud about how they feel. I met a whole raft of friends who a year ago were quiet as mice—but no more. Where they used to whisper, "Paul, I'm with you," they are now standing up on the rostrum to let the people know how they feel.

I was especially glad to see so many new friends out here who are backing me in my fight for a passport. It has been five years since the State Department arrogantly and arbitrarily refused to let me travel abroad to practice my craft as a singer and actor to earn my living wherever people wanted to hear me.[1]

I've been invited to sing in a dozen countries since that time. India and France and the Soviet Union, to name but a few, have invited me to sing or to act. The British Actors Equity has invited me to do *Othello* over there again and promised, in an extraordinary action, to make available a supporting cast including the best actors in England. All of England's leading musicians and composers joined in signing another invitation for me to give a concert over there. This included Vaughan Williams, dean of British musicians.[2]

Despite all these invitations, the State Department continued to deny me a passport, refused me my Constitutional right to go where I please and when I please so long as I don't break the law.

The only reasons they gave for their refusal was that I criticize the United States when I go abroad; and that I speak up for African liberation, thereby interfering with U.S. foreign policy.

I did speak up for the African people when I was abroad. I spoke up for my people here in America, the descendants of African people. And I'll speak up again.

The answer to injustice is not to silence the critic but to end the injustice. I'm proud that I'm one of many people whose voices raised around the world in protest against Jim Crow and exploitation of the Negro people both here and in Africa helped rally the world protest that had so much to do with the recent Supreme Court ruling outlawing segregation in U.S. schools.

The right to travel is a Constitutional right. And there's nothing in that document that says you have to be muzzled before you can pack your bag.

The State Department does not want anyone to travel who is likely to speak out about the horror of Jim Crow in the South. The State Department was even nervous about letting Congressman Adam Clayton Powell go to Bandung. Instead of worrying about cleaning up their own back yard in Dixie, they want to keep me, and every other Negro who dares to speak up, under wraps.

They weren't really worried so much about keeping Paul Robeson home as they were about keeping the story of Mrs. Ingram and Robert Wesley Wells and Lieutenant Gilbert, the story of the way Negroes are treated in the Navy and have their houses burned in Chicago—stories like that from spreading around.

The fight for my passport is as simple as that. And more and more Negroes are coming to recognize that fact. In my trip to the West Coast, hundreds of my people—church leaders, fraternal leaders, women's club leaders and men and women on the street—talked to me and showed me they recognized my fight for a passport is a part of the fight of all the Negro people for first-class citizenship.

As that realization grows, as the Negro people grow more loud in protest, the Dixiecrats and their friends in Washington will have to bend and yield.

The way was opened to win that fight in two recent decisions of the U. S. Court of Appeals in Washington. In the case of Dr. Otto Nathan,[3]

and in the case of Max Schachtman, both of whom had been denied passports, the court decision made it clear that the right to travel is a "human right" . . . "which cannot be capriciously denied by government officials."

"A restraint imposed by the government of the United States upon this liberty, therefore, must conform with the provision of the Fifth Amendment that 'No person shall . . . be deprived of . . . liberty . . . without due process of law.'"

These rulings put the State Department on the spot. It means if the State Department wants to continue to deny me my passport it will have to come into open court with real evidence that such a denial is contrary to the best interests of this country.

And they have so such evidence.

The Negro people in America are already letting the government know how they feel about this. The *N.Y. Amsterdam News* and the *Afro-American* weekly papers came out with editorials supporting the fight. If enough people join in and write Washington, I'll get my passport in a hurry.

And when you're writing you might add that we need a wide exchange of singers and actors and all kinds of people all over the world. We need French and Chinese and English and Soviet artists coming over here.

We need exchange because we know that all people ARE brothers no matter what the "hate your neighbor" crowd would like to have you think.

If we sit down together, shake hands and talk things over and get to know one another, world peace will change from a growing hope to a positive fact.

Their Victories for Peace
Are Also Ours

New World Review, November 1955, pp. 16–17

Friends of peace in every land have much to celebrate this year, and on the occasion of the 38th anniversary of the October Revolution it is especially fitting to salute the peoples of the Soviet Union and their government which reflects their passionate devotion to the cause of world peace.

The many Americans who have recently visited the Soviet Union— Congressmen, farmers, clergymen, journalists, athletes and others— are unanimous in their findings that the Soviet people, far from being hostile and warlike, are openhearted and friendly. And the evil myth of "Soviet aggression" has been largely shattered by the consistent efforts of the Soviet government to remove all sources of tensions.

Those voices of discord in the world which cried out, hypocritically,

for "deeds" to match the peaceful professions of the Soviet government, are being drowned out by the popular acclaim which has greeted the numerous steps taken by that government to build a lasting peace. The Austrian treaty, the rapprochement with Yugoslavia, the establishment of relations with West Germany, the concessions to Finland—yes, the world has applauded each new breakthrough for peaceful coexistence achieved by the Soviet Union. And the past year, too, has witnessed the meeting of the Big Four, advocated for so long by the Soviet Union, and the birth in Geneva of a hopeful new spirit in international relations.

In pursuing its program to bring an end to the cold war and to banish forever the menace of atomic disaster, the Soviet Union moves with a massive strength that is altogether different from the notorious and now discredited policy of "positions of strength." Increasingly it can be seen that the foreign policy of the USSR is effective not only because it reflects the interests of her own peoples, but because it is based upon the interests of all humanity. Indeed, the spirit of Geneva is given flesh and blood by Bandung—the freedom-striving peoples of Asia and Africa, by Helsinki—the world-wide movement of the partisans of peace, and by Warsaw—great rally of world youth.

"Peace, bread and land"—the slogan under which the Russian workers and peasants marched from the darkness of tsarist oppression to establish a new way of life in the world—is now the goal of countless millions around the globe. Many differences exist, of course, as to the path to be followed, but men and women of goodwill everywhere respect and admire the heroic labors of the Soviet people who, in less than four decades, have built their socialist homeland into one of the decisive powers of the world. It was this epic advance, unprecedented in human history, that moved Prime Minister Nehru to say, after visiting the USSR this year, "I have left part of my heart behind."

And now, more than ever, the colonial peoples, straining against their chains, are strengthened and inspired by the unswerving stand of the Soviet Union, recently restated in these words of Nikita Khrushchev:[1] "The position of the Soviet people is the position of moral support and sympathy for the aspirations of the national liberation movement of the peoples."

Yes, the many millions of the colonial liberation movement, and millions more who are part of the world-wide movement for peace, will warmly greet the Soviet peoples on November 7th and say:

"*Happy birthday, dear brothers and sisters! Your victories for peace and freedom are also ours!*"

"Let Paul Robeson Sing"

Let Paul Robeson Sing Again. Brochure issued by Manchester,
England, Committee to Restore Paul Robeson's Passport

January 3rd, 1956

Dear Mr. Loesser,

I was very pleased, and deeply grateful, to receive your recent letter
and to hear of the plans for a mass meeting in Manchester in support
of my right to travel and to practice my artistic profession.[1]

Although I am persisting in my legal efforts to regain my passport
(the case is now before the U.S. Circuit Court of Appeals in Washington) it is clear that the most decisive factor for a favourable outcome is
the pressure of democratic opinion—in Britain, and elsewhere in the
world. And so nothing could be more important, or more effective, than
meetings like the one you are arranging.

I have closely followed the campaign which is being developed
throughout your country, and the splendid work that is being done has
added to the deep feelings of affection I have for the British people
through all these years, and has made me look forward with even
greater eagerness to the time when I will be free to visit your country
again.

Recorded Message to "Let Paul Robeson Sing" Meeting, Lesser
Free Trade Hall, Manchester, England, March 11, 1956—Paul
Robeson Archives, Berlin, German Democratic Republic

Heartfelt greetings, dear friends in Manchester!

It is deeply moving for me to know that you and so many others
throughout Britain are speaking out in behalf of my right to travel, my
right to resume my career as an international artist which I began
some thirty years ago. Though I must send you these words from afar, I
can say that never have I felt closer to you than I do today. The warmth
of your friendship reaches out across the barriers which temporarily
separate us and rekindles the memories of many happy years that I
spent among you.

Here, in my home in New York, I recall your own great city as
another home to me, a place where I came so often to sing and where I
always was inspired by the flourishing cultural life of Manchester—
the splendid orchestras, the outstanding contributions to classical
music and the other arts—and by the richness of the folk culture of
Lancashire which has given to England and the world the artistry of
dear Gracie Fields[2] and so many others.

I can never forget that it was the people of Manchester and of the
other industrial areas of Britain who gave me the understanding of the
oneness of people—a concept upon which I have based my career as an

artist and citizen. I recall how a Manchester friend explained to me how closely together we two were bound by the web of history and human suffering and inspiration. He told me of the life of bitter hardship and toil which his father and grandfather knew in the mills—those "dark satanic mills" which Blake[3] cried out against in words of fire—and of how the cotton which his forefathers wove linked them with other toilers whose sweat and toil produced that cotton in far-away America—the Negro slaves, my own father, my own people.

And I remember so well my last visit to Manchester in 1949—the warmth of your welcome at the Arena—the thousands who assembled to support our struggle in America to save the lives of the "Trenton Six." That struggle, as you know, was won; the Negro youths who had been sentenced to die in the electric chair were freed. The people of Manchester and other British cities, and people of many lands, had a great share in that victory.

More than a century ago you welcomed Frederick Douglass, our great Negro leader in the anti-slavery movement, when he toured your country in behalf of his people in chains. In his famous "Farewell Speech to the British People"—a classic document in Negro history and American history—Douglass, speaking on March 30, 1847, noted that people had travelled from your city to attend his last great rally in London.

"Manchester is represented on this occasion," he said, "as well as a number of other towns." And, thanking the British public for their warm-hearted support for his cause, Douglass said: "Wherever I have gone, I have been treated with the utmost kindness, with the greatest deference, the most assiduous attention; and I have every reason to love England."[4]

My own heart echoes these words of Frederick Douglass.

I deeply appreciate the concern that has been expressed in behalf of my civil rights by the *Manchester Guardian* and other British newspapers and magazines, and by all the many groups and individuals who have urged the State Department to grant me a passport.

I am looking forward to a concert appearance soon in Toronto, Canada, and to the pleasure of hearing once more the friendly accents of England, Scotland, Wales and Ireland. This partial victory—the lifting of the ban on my leaving the United States to go to Canada—strengthens my belief that the pressure of democratic opinion, here and abroad, will compel the State Department to relent in their refusal to permit me to travel to other countries; or, perhaps, the courts may insist that they relent.

I send warm greetings to my brothers and sisters among you who come from Africa—land of my fathers—and the Caribbean, places which I intend to visit at the earliest opportunity.

Yes, I have a lot of travelling to do, and I am eager to be on my way. To be free to sing, to act, to meet old friends and new ones—free to be at your side and at the side of people everywhere whose hearts sing peace and freedom, brotherhood and love!

And so I say, in the words of a great people—from their song, "Zog Nit Keynmol":
"The hour for which we yearn will yet arrive,
"And our marching song will thunder, We survive!"

Paul Robeson Sends Us His Greetings

Daily Worker(London), May 1, 1956

World-famous Negro singer Paul Robeson cabled this May Day message to the Daily Worker yesterday:
Warmest greetings to you on this historic anniversary of the aspiration and heroic struggles of labour.

It is a privilege to send an expression of my deep affection and respect for the millions in the British Isles and especially on this day for the workers from whom I learned so much and with whom I grew and developed over many years.

All success to you in your work from day to day. The will of the people shall prevail.

We shall find peace, friendship and mutual exchange in many fields among all the peoples of the earth and with your help many peoples shall gain new freedoms and full human dignity in the African lands of my forefathers.

Thanks to you of the London Daily Worker for your constant struggles on behalf of the English, Scots, Irish and Welsh workers, indeed all the people of the British Islands and of all humankind.

Again, hello, and see you soon I hope.

Message to National Conference, Manchester, England

May 27, 1956—Paul Robeson Archives, Berlin,
German Democratic Republic

Dear friends in Britain,

Since I wrote to you last, I had the great pleasure of a few weeks of freedom—a respite from six years of being a prisoner of the cold war and McCarthyism in America. Last February I sang in Massey Hall in Toronto and for the metal miners in Sudbury, Ontario. No words can describe how deeply I was moved by the warmth of those audiences, their overflowing spirit of love and brotherhood which reached out to me! Invitations came from many other Canadian cities, urging that I come to sing for them, too. And so a trans-Canada tour was planned, and last month I was scheduled to sing a score of concerts from Montreal to Vancouver—my first opportunity for a concert tour in many years!

But then on the eve of my departure, the Canadian government decided to bar me from entering Canada. The reason given was that the concert agency which was sponsoring my tour had a 'left-wing' complexion. Of course, no one could be fooled by that flimsy explanation, since it was the same agency which had previously sponsored my concert in Toronto. The immediate criticism of this decision that was made by all sections of the Canadian Press was proof that Ottawa's action was not an expression of Canadian sentiment. It is obvious that this decision, like most of the manufactured goods one sees in Canada, was 'made in the U.S.A.'

Not only is my right to travel denied, but there has been and is a deliberate policy of attempting to prevent me from making a living by practicing my profession as an artist. It is the same policy which is being used by the White Citizen Councils (the new Ku Klux Klan) in states like Mississippi, where Negroes who demand their right to vote and the right of their children to non-segregated schooling, are subjected to economic reprisals. Negro workers are denied employment; Negro farmers are denied loans for seed and their cotton is barred from the cotton gins; Negro storekeepers are denied credit and supplies.

But you know that my people are not being crushed by this ruthless pressure; their struggle for equal rights and full citizenship continues and grows stronger. The whole world has watched with admiration the courage of Autherine Lucy,[1] and the militant protest of 50,000 Negroes in Montgomery, Alabama,[2] against Jim Crow. And as you know, too—as even the men in Washington must know now—that no restrictions and pressure can budge me one inch from my stand—for peace, for Labor, for equal rights and the brotherhood of peoples everywhere.

It is good to see how surely the cause of world peace is winning victory after victory against the advocates of cold war and ultimate atomic war. And it is good to see that the British people, with whom I am bound by many years of close friendship, are helping greatly to ease the tensions of the cold war. Indeed, I know that in your deep concern for my right to travel, much more than the civil rights of a single artist and citizen is involved—that you are acting in the spirit of Geneva, which called for the lowering of all cold war barriers and for the promotion of cultural exchange among the nations.

With all my heart I thank you, dear friends in England, Wales, and Scotland for your magnificent support and solidarity, for the warm invitations you have sent me, and your petitions and protests in my behalf.

I remember so well those happier years when I was among you, and I look forward to the great joy of meeting you all once again in the land of Shakespeare and Shelley[3] and Burns,[4] and to the joy of singing freely with you of that new Jerusalem which shall be built in England's green and pleasant land—and in all the other lands of a world at peace.

The House Un-American Activities Committee

Testimony, July 13, 1956—"Investigation of the Unauthorized
Use of United States Passports—Part 3," *Hearings before the
Committee on Un-American Activities, House of Representatives,
Eighty-Fourth Congress, Second Session, June 12, 1956*,
Washington, D. C., 1956, pp. 4492–4510.

A Subcommittee of the Committee on Un-American Activities[1] con-
vened at 10 a.m., in the caucus room of the Old House Office Building,
the Honorable Francis E. Walter (Chairman) presiding.

Committee members present: Representatives Francis E. Walter of
Pennsylvania, Clyde Doyle of California, Bernard W. Kearney of New
York, and Gordon H. Scherer of Ohio.

Staff members present: Richard Arens, Director, and Donald T.
Appell, Investigator.

The CHAIRMAN: The Committee will be in order. This morning the
Committee resumes its series of hearings on the vital issue of the use
of American passports as travel documents in furtherance of the
objectives of the Communist conspiracy. During recent hearings on
this subject, it was revealed that Communists had developed a pattern
of procuring American passports by representing that they were going
to travel for business or pleasure to certain of the countries of the free
world and then, upon arriving at those countries, they used devious
methods of circumventing the travel restrictions so that they could
attend Communist-sponsored conferences and other propaganda ef-
forts in the Iron Curtain countries. One of the important facts which
the student of the Communist conspiracy recognizes is that Commu-
nists not only create front organizations to carry on their nefarious
work, but also use people who, though not actually Communist Party
members, are nevertheless witting or unwitting servants of the
Communist cause. Actual technical membership in the Communist
Party is not, therefore, the sole criterion to be used in undertaking to
ascertain whether or not a particular individual's activities are in fact
contributing to the Communist menace. Should the Government of the
United States in the exercise of its sovereign power refuse to issue
passports to United States citizens who propose to use those passports
as tickets of admission to conferences established as propaganda
efforts of the Kremlin? Should our Government require the revelation
of the specific itinerary of each citizen who proposes to travel behind
the Iron Curtain? Where should the balance be struck between the
promotion of international travel and the security risk of couriers,
propagandists, and saboteurs? These and other questions must be
resolved in the light of the realisms of today. It is in this spirit of dead
earnestness that the Committee is pursuing this investigation and
study. Call your first witness, Mr. Arens.

Mr. ARENS: Paul Robeson, will you please come forward? Please identify yourself by name, residence and occupation.

Mr. ROBESON: My name is Paul Robeson. I live at 16 Jumel Terrace, New York City, and I am an actor and singer by occupation, and law on the side now and then.

Mr. ARENS: Are you appearing today in response to a subpoena which was served upon you by the House Committee on Un-American Activities?

Mr. ROBESON: Just a minute. Do I have the privilege of asking whom I am addressing and who is addressing me?

Mr. ARENS: I am Richard Arens.

Mr. ROBESON: What is your position?

Mr. ARENS: I am Director of the Staff. Are you appearing today in response to a subpoena served upon you by this Committee?

Mr. ROBESON: Oh, yes.

Mr. ARENS: And you are represented by counsel?

Mr. ROBESON: I am.

Mr. ARENS: Counsel, will you kindly identify yourself?

Mr. FRIEDMAN: Milton H. Friedman.[2]

Mr. ARENS: The subpoena which requires your presence here today contains a provision commanding you to produce certain documents, including all the United States passports issued to you for travel outside the continental limits of the United States. Do you have those documents?

Mr. ROBESON. No. There are several in existence, but I have moved several times in the last year, and I just moved recently to Jumel Terrace and I could not put my hands on them. They probably could be produced. And I also lived in Connecticut and we have got a lot of stuff still packed, and if they are unpacked I will be glad to send them to you.

Mr. SCHERER. When was the subpoena served on you, Mr. Robeson?

Mr. ROBESON. I have forgotten. It was about a couple of weeks ago, and it was served at my house not long ago.

Mr. SCHERER. A couple of weeks ago?

Mr. ROBESON. 10 days ago.

The CHAIRMAN. What is the date of the return?

Mr. ARENS. May 22, 1956.

Mr. SCHERER. Did you look for the documents?

Mr. ROBESON. I have looked a good deal and Mrs. Robeson who has charge of all of this has looked and we have not been able to put our hands upon them. There is no reason not to produce them, certainly, if I could find them.

Mr. ARENS. Did you file a passport application on July 2, 1954?

Mr. ROBESON. I have filed several, and I have filed so many—I have filed about 25 in the last few months.

Mr. ARENS. I lay before you a photostatic copy of a passport application bearing a signature, Paul Robeson, and ask you if that is a

true and correct reproduction of the passport application which you filed on July 2, 1954.

Mr. ROBESON. An application in 1954? Yes, it is. It is just one of them, where I was going to England, Israel, and France and Scandinavian countries.

Mr. ARENS. Is this your application?

Mr. ROBESON. That is true.

Mr. ARENS. I respectfully suggest, Mr. Chairman, this document be incorporated by reference in this record marked as "Robeson Exhibit No. 1" and filed in the files of the committee.

The CHAIRMAN. It will be so incorporated.

Mr. ROBESON. My counsel suggests it may not be completed.

Mr. FRIEDMAN. May I make a statement, please, Mr. Arens, too and to the committee?

The CHAIRMAN. Counsel is permitted to accompany his client for the purpose of advising his client and not for the purpose of making statements.

Mr. FRIEDMAN. I am familiar with the rules, that is why I asked your permission.

May I make this statement to you, sir? I wish to make a protest against questioning Mr. Robeson with respect to his passport application, in view of the fact that there is litigation now pending concerning his passport application and Mr. Robeson's right to a passport. The litigation was tried in district court and it was the subject of a decision in the court of appeals in the circuit last week. There may be further hearings in the State Department and there may be a further appeal.

The CHAIRMAN. The litigation is pending at the moment?

Mr. FRIEDMAN. It is still pending.

The CHAIRMAN. Was an application made for certiorari?

Mr. FRIEDMAN. No, the time has not yet elapsed for an application for certiorari but there may possibly be. I am not his counsel in that case, and I am not speaking for counsel, but there may be a hearing somewhere with respect to this matter.

The CHAIRMAN. That is too nebulous.

Mr. FRIEDMAN. The procedure now calls for it and it is not nebulous.

Mr. ARENS. Now, during the course of the process in which you were applying for this passport, in July of 1954, were you requested to submit a non-Communist affidavit?

Mr. ROBESON. We had a long discussion with my counsel who is in the room, Mr. Boudin,³ with the State Department, about just such an affidavit and I was very precise not only in the application but with the State Department headed by Mr. Henderson and Mr. McLeod, that under no conditions would I think of signing any such affidavit, that it is a complete contradiction of the rights of American citizens. It is my own feeling that when this gets to the Supreme Court, that it is unthinkable that now this has been applied to any American who wants a passport.

Mr. ARENS. Did you comply with the requests?

Mr. ROBESON. I certainly did not and I will not. That is perfectly clear.

Mr. ARENS. Are you now a member of the Communist Party?

Mr. ROBESON. Oh please, please, please.

Mr. SCHERER. Please answer, will you, Mr. Robeson?

Mr. ROBESON. What is the Communist Party? What do you mean by that?

Mr. SCHERER. I ask that you direct the witness to answer the question.

Mr. ROBESON. What do you mean by the Communist Party? As far as I know it is a legal party like the Republican Party and the Democratic Party. Do you mean—which, belonging to a party of Communists or belonging to a party of people who have sacrificed for my people and for all Americans and workers, that they can live in dignity? Do you mean that party?

Mr. ARENS. Are you now a member of the Communist Party?

Mr. ROBESON. Would you like to come to the ballot box when I vote and take out the ballot and see?

Mr. ARENS. Mr. Chairman, I respectfully suggest that the witness be ordered and directed to answer that question.

The CHAIRMAN. You are directed to answer the question.

(The witness consulted with his counsel.)

Mr. ROBESON. I stand upon the fifth amendment.

Mr. SCHERER. I did not hear the answer.

Mr. ROBESON. I stand upon the fifth amendment of the American Constitution.

Mr. ARENS. Do you mean you invoke the fifth amendment?

Mr. ROBESON. I invoke the fifth amendment.

Mr. ARENS. Do you honestly apprehend that if you told this committee truthfully whether or not you are presently—

Mr. ROBESON. I have no desire to consider anything. I invoke the fifth amendment and it is none of your business what I would like to do, and I invoke the fifth amendment. And forget it.

The CHAIRMAN. You are directed to answer that question.

Mr. ROBESON. I invoke the fifth amendment and so I am not answering. I am answering it, am I not?

Mr. ARENS. I respectfully suggest the witness be ordered and directed to answer the question as to whether or not he honestly apprehends, that if he gave us a truthful answer to this last principal question, he would be supplying information which might be used against him in a criminal proceeding.

(The witness consulted with his counsel.)

The CHAIRMAN. You are directed to answer that question, Mr. Robeson.

Mr. ROBESON. Gentlemen, in the first place, wherever I have been in the world, and I have been in many places, Scandinavia, England, and many places, the first to die in the struggle against fascism were the

Communists and I laid many wreaths upon graves of Communists. It is not criminal and the fifth amendment has nothing to do with criminality. The Chief Justice of the Supreme Court, Warren, has been very clear on that in many speeches that the fifth amendment does not have anything to do with the inference of criminality. I invoke the fifth amendment.

Mr. ARENS. I respectfully suggest, Mr. Chairman, that the witness be ordered and directed to answer this last outstanding question.

The CHAIRMAN. He has been directed to answer it and he has invoked the fifth amendment and refused to answer.

Mr. ROBESON. I invoke the fifth amendment.

Mr. ARENS. Have you ever been known under the name of "John Thomas"?

Mr. ROBESON. Oh, please, does somebody here want—are you suggesting—do you want me to be put up for perjury some place, "John Thomas." My name is Paul Robeson, and anything I have to say or stand for I have said in public all over the world, and that is why I am here today.

Mr. SCHERER. I ask that you direct the witness to answer the question. He is making a speech.

Mr. FRIEDMAN. Excuse me, Mr. Arens, may we have the photographers take their pictures, and then desist, because it is rather nerve-racking for them to be there.

The CHAIRMAN. They will take the pictures.

Mr. ROBESON. I will see you later, and I accept my counsel's attention. I am used to it and I have been in moving pictures. Do you want me to pose for it good? Do you want me to smile? I cannot smile when I am talking to him.

Mr. ARENS. I put it to you as a fact, and ask you to affirm or deny the fact, that your Communist Party name was "John Thomas."

Mr. ROBESON. I invoke the fifth amendment. This is really ridiculous.

Mr. ARENS. Now, tell this committee whether or not you know Nathan Gregory Silvermaster.

Mr. SCHERER. Mr. Chairman, this is not a laughing matter.

Mr. ROBESON. It is a laughing matter to me, this is really complete nonsense.

The CHAIRMAN. It will be for a while.

Mr. ROBESON. It will be and it should be for you. It should be for you all.

Mr. ARENS. Will you please tell—

Mr. ROBESON. This whole committee.

Mr. ARENS. Will you please tell us whether or not you know Nathan Gregory Silvermaster.

(The witness consulted with his counsel.)

Mr. ROBESON. No; I do not.

Mr. ARENS. Have you ever known Nathan Gregory Silvermaster?

(The witness consulted with his counsel.)

Mr. ROBESON. I invoke the fifth amendment.

Mr. ARENS. Do you honestly apprehend, that if you told this committee whether or not you know Nathan Gregory Silvermaster, you would be supplying information that could be used against you in a criminal proceeding?

Mr. ROBESON. I have not the slightest idea what you are talking about. I invoke the fifth—

Mr. ARENS. I suggest, Mr. Chairman, this record show that the witness be ordered and directed to answer that question.

The CHAIRMAN. You are directed to answer the question of whether or not you have ever known Nathan Gregory Silvermaster.

Mr. ROBESON. In answer to that question I invoke the fifth.

Mr. SCHERER. The witness talks very loud when he makes a speech, but when he invokes the fifth amendment I cannot hear him.

Mr. ROBESON. I invoked the fifth amendment very loudly. You know I am an actor, and I have medals for my voice, for diction.

Mr. SCHERER. Will you talk a little louder?

Mr. ROBESON. I can talk plenty loud, yes, I am noted for my diction in the theater.

Mr. ARENS. Do you know a woman by the name of Louise Bransten?

(The witness consulted with his counsel.)

Mr. ROBESON. I invoke the fifth amendment.

Mr. ARENS. You attended a meeting in the home of Louise Bransten, in 1945, in San Francisco, did you not?

(The witness consulted with his counsel.)

Mr. ARENS. Do you have a recollection of that little session?

Mr. ROBESON. I invoke the fifth.

Mr. ARENS. I put it to you as a fact, and ask you to affirm or deny the fact, that on February 23, 1945, you attended a meeting in the home of Louise Bransten, at which were present Max Yergan, Frederick Thompson, David Jenkins, Nancy Pittman, Dr. Lena Halpern, and Larry Fanning?

Mr. ROBESON. I invoke the fifth amendment.

Mr. ARENS. Do you know any of those individuals whose names I have just recited?

Mr. ROBESON. I invoke the fifth amendment.

Mr. ARENS. Who are Mr. and Mrs. Vladimir P. Mikheev? Do you know them?

Mr. ROBESON. I have not the slightest idea but I invoke the fifth amendment.

Mr. ARENS. Mr. Chairman, the witness does not have the slightest idea who they are, and I respectfully suggest he be ordered and directed to answer that question.

The CHAIRMAN. You are directed to answer the question.

Mr. ROBESON. I answer the question by invoking the fifth amendment.

Mr. ARENS. Have you ever had contact with a man by the name of Gregory Kheifits?

Mr. ROBESON. I invoke the fifth amendment.

Mr. ARENS. Now, Gregory Kheifets is identified with the Soviet espionage operations, is he not?

Mr. ROBESON. Oh, gentlemen, I thought I was here about some passports.

Mr. ARENS. We will get into that in just a few moments.

Mr. ROBESON. This is complete nonsense.

Mr. ARENS. Tell us whether or not you have had contact and operations with Gregory Kheifets.

Mr. ROBESON. I invoke the fifth amendment.

Mr. ARENS. Who is Victor Murra—that is John Victor Murra?

Mr. ROBESON. I invoke the fifth amendment. Your questioning leaves me completely—I invoke the fifth amendment.

Mr. ARENS. Leon Josephson?

Mr. FRIEDMAN. I do not think that he heard that question.

Mr. ARENS. Leon Josephson.

Mr. ROBESON. I invoke the fifth amendment.

Mr. ARENS. Do you know a Manning Johnson?

Mr. ROBESON. Manning Johnson, I only have read in the papers that he said that Dr. Ralph Bunche was some kind of fellow, and he was dismissed from the FBI. He must be a pretty low character when he could be dismissed from that.

Mr. SCHERER. Whether he is a low character or not, do you know him?

Mr. ROBESON. I invoke the fifth amendment.

Mr. ARENS. I would like to read you now some testimony under oath before this committee, of Manning Johnson:[4]

Question. In your vast experience in the Communist Party, did you have occasion to meet Paul Robeson?

This is under date of July 14, 1949:

Mr. JOHNSON. Yes, I have met Paul Robeson a number of times in the headquarters of the National Committee of the Communist Party, going to and coming from conferences with Earl Browder, Jack Stachel, and J. Peters. During the time I was a member of the Communist Party Paul Robeson was a member of the Communist Party. Paul Robeson, to my knowledge, has been a member of the Communist Party for many years. In the Negro Commission of the National Committee of the Communist Party, we were told under threat of expulsion never to reveal that Paul Robeson was a member of the Communist Party because Paul Robeson's assignment was highly confidential and secret. For that reason he was not permitted to attend meetings of the National Committee of the Communist Party.

Mr. ROBESON. Could I protest this meeting, this reading of this? If you want Mr. Manning Johnson here for cross-examination, O. K.

Mr. ARENS. You tell us whether or not Manning Johnson was lying or whether he was telling the truth when he said that when he was a member of the Communist conspiracy he knew you as part and parcel of that conspiracy.

Mr. ROBESON. I invoke the fifth amendment.

Mr. ARENS. Have you ever been chairman of the Council on African Affairs?

(The witness consulted with his counsel.)

Mr. ROBESON. I invoke the fifth amendment.

Mr. ARENS. I lay before you now a document marked "Robeson Exhibit No. 2" for identification purposes only in this record, entitled, "For Freedom and Peace, Address by Paul Robeson, at Welcome Home Rally, in New York, June 19, 1949," with a photograph on it.

Mr. ROBESON. I have a copy myself.

Mr. ARENS. If you would look on the back of that pamphlet you will see, Paul Robeson, Chairman of the Council on African Affairs. Tell us whether or not you are the Paul Robeson alluded to in this document, a copy of which you brought with you.

Mr. ROBESON. I would be the Paul Robeson.

Mr. ARENS. Then you are or have been chairman of the Council on African Affairs.

Mr. ROBESON. I would invoke the fifth amendment.

Mr. ARENS. Do you know Max Yergan?

Mr. ROBESON. I invoke the fifth amendment.

Mr. ARENS. Max Yergan took an oath before this committee, and testified to tell the truth.

Mr. ROBESON. Why do you not have these people here to be cross-examined, and is this, Mr. Chairman—

Mr. ARENS. Under oath, this man—

Mr. ROBESON. Could I ask whether this is legal.

The CHAIRMAN. This is legal. This is not only legal, but usual. By a unanimous vote this committee has been instructed to perform this very distasteful task.

Mr. ROBESON. It is not distasteful. To whom am I talking to?

The CHAIRMAN. You are speaking to the chairman of this committee.

Mr. ROBESON. Mr. Walter?

The CHAIRMAN. Yes.

Mr. ROBESON. The Pennsylvania Walter?

The CHAIRMAN. That is right.

Mr. ROBESON. Representative of the steelworkers?

The CHAIRMAN. That is right.

Mr. ROBESON. Of the coal mining workers and not United States Steel, by any chance? A great patriot.

The CHAIRMAN. That is right.

Mr. ROBESON. You are the author of all of the bills that are going to keep all kinds of decent people out of the country.[5]

The CHAIRMAN. No, only your kind.

Mr. ROBESON. Colored people like myself, from the West Indies and all kinds, and just the Teutonic Anglo-Saxon stock that you would let come in.

The CHAIRMAN. We are trying to make it easier to get rid of your kind, too.

Mr. ROBESON. You do not want any colored people to come in?

The CHAIRMAN. Proceed.

Mr. ARENS. Under date of December 17, 1948, Dr. Max Yergan testified before this committee under oath as follows:

Was there a group in the Council on African Affairs of Communist officials, who operated as a sort of leading caucus inside the council?

Dr. YERGAN. Not as such. The relation of Communists to the council was informal, and so far as I know, not organized. Toward the end of my relation to the council it became clear to me that there was a Communist core within the council. This was very clear to me during the last months of my relations to the council.

May I ask you now, was there, to your knowledge, a Communist core in the Council on African Affairs?

Mr. ROBESON. I will take the fifth amendment and could I be allowed to read from my own statement here, while you read this statement just for a moment?

Mr. ARENS. Will you just tell this committee while under oath, Mr. Robeson, the Communists who participated in the preparation of that statement?

Mr. ROBESON. Oh, please.

Mr. ARENS. Now:

The CHAIRMAN. Could you identify that core clearly? Of whom did it consist?

Mr. ROBESON. Could I read my statement?

Mr. ARENS. As soon as you tell the committee the Communists who participated in the preparation.

Dr. YERGAN. Dr. Doxey Wilkerson[6] was a member of that core, and took the leading position. Paul Robeson was chairman of the council and certainly a part of that Communist-led core.

Now tell this committee, while you are under oath, was Dr. Yergan lying or was he telling the truth?

Mr. ROBESON. I invoke the fifth amendment. Could I say that for the reason that I am here today, you know, from the mouth of the State Department itself, is because I should not be allowed to travel because I have struggled for years for the independence of the colonial peoples of Africa, and for many years I have so labored and I can say modestly that my name is very much honored in South Africa and all over Africa in my struggles for their independence. That is the kind of independence like Sukarno[7] got in Indonesia. Unless we are double-talking, then these efforts in the interest of Africa would be in the same context. The other reason that I am here today is again from the State Department and from the court record of the court of appeals, that when I am abroad I speak out against the injustices against the Negro people of this land. I sent a message to the Bandung Conference and so forth. That is why I am here. This is the basis and I am not being tried for whether I am a Communist, I am being tried for fighting for the rights of my people who are still second-class citizens

in this United States of America. My mother was born in your State, Mr. Walter, and my mother was a Quaker, and my ancestors in the time of Washington baked bread for George Washington's troops when they crossed the Delaware, and my own father was a slave. I stand here struggling for the rights of my people to be full citizens in this country and they are not. They are not in Mississippi and they are not in Montgomery, Ala., and they are not in Washington, and they are nowhere, and that is why I am here today. You want to shut up every Negro who has the courage to stand up and fight for the rights of his people, for the rights of workers and I have been on many a picket line for the steelworkers too. And that is why I am here today.

The CHAIRMAN. Now just a minute.

Mr. ROBESON. All of this is nonsense.

The CHAIRMAN. You ought to read Jackie Robinson's testimony.[8]

Mr. ROBESON. I know Jackie Robinson, and I am sure that in his heart he would take back a lot of what he said about any reference to me. I was one of the last people, Mr. Walter, to speak to Judge Landis, to see that Jackie Robinson had a chance to play baseball.[9] Get the pictures and get the record. I was taken by Landis by the hand, and I addressed the combined owners of the American and the National Leagues, pleading for Robinson to be able to play baseball like I played professional football.

Mr. ARENS. Would you tell us whether or not you know Thomas W. Young?

Mr. ROBESON. I invoke the fifth amendment.

Mr. ARENS. Thomas W. Young is a Negro who is president of the Guide Publishing Co., Inc., publishers of the Journal and Guide in Virginia and North Carolina. He took an oath before this committee on this issue, which you have just been so eloquently discussing, and I would like to read you his testimony:

> What basis is there, if any, for believing Paul Robeson when he says that in the event of a war with Russia, the Negro would not fight for his country against the Soviets?
>
> No matter how strongly we may believe it is false, that statement coming from Robeson is not easily disposed of. His own life story is an inspiration to humble people of whom Mr. Robeson now presumes to speak. In the first place, Mr. Robeson is now so far out of touch with the Negro thinking in his everyday emotions, he can no longer speak authoritatively about or for the race. Mr. Robeson does not speak for the young men who served their country so well during the recent war. He does not speak for the common people who read and believe in the Negro newspapers. He does not speak for the masses of the Negro people whom he has so shamelessly deserted. I have heard Paul Robeson declare his own personal disloyalty to the United States. He has no moral right to place in jeopardy the welfare of the American Negro simply to advance a foreign cause in which we have no real interest. It is my firm conviction that in the eyes of the Negro people this false prophet is regarded as unfaithful to their country, and they repudiate him.

Do you know the man who said that under oath before this committee?

Mr. ROBESON. I invoke the fifth amendment. May I now read from

other Negro periodicals, which says "Paul Robeson, Negro American," and may I read from where I am a doctor of humanity from Morehouse, and may I read from a statement by Marshall Field, when I received the Spingarn medal from the NAACP?

The CHAIRMAN. No.

Mr. ROBESON. Why not? You allowed the other statements.

The CHAIRMAN. This was a question, Mr. Robeson.

Mr. ROBESON. I have answered the question, and I take the fifth amendment.

The CHAIRMAN. You have invoked the fifth amendment, and you have answered the question.

Mr. ROBESON. Now, would you give me a chance to read my statement?

Mr. KEARNEY. I would like to ask you one question. Would you mind reading from some of the citations you have received from Stalin?

Mr. ROBESON. I have not received any citations from Stalin.

The CHAIRMAN. From the Russian Government?

Mr. ROBESON. No, I received citations and medals from the Abraham Lincoln High School and medals from the NAACP and medals from many parts of the world, for my efforts for peace. It seems as though you gentlemen would be trying to contravene the waging of peace by your President here today. Are you for war, Mr. Walter, and would you be in the category of this former Representative who felt we should have fought on the side of Hitler? Are you in that category? Now can I read my statement?

Mr. KEARNEY. Were you in the service?

Mr. ROBESON. It is a sad and bitter commentary—

The CHAIRMAN. Just answer the question.

Mr. ARENS. Did you make a trip to Europe in 1949 and to the Soviet Union?

Mr. ROBESON. Yes; I made a trip to England and I sang.

Mr. ARENS. Where did you go?

Mr. ROBESON. I went first to England, where I was with the Philadelphia Orchestra, one of two American concert acts or groups which was invited to England to sing. I did a long concert tour in England and Scandinavia, and in Denmark, and in Sweden and I also sang for the Soviet people, one of the finest musical audiences in the world. Will you read what the Porgy and Bess people said? They never heard such applause in their lives, and one of the most musical people in the world, and the great composers and great musicians, very cultured people, and Tolstoy, and—

The CHAIRMAN. We know all of that.

Mr. ROBESON. They have helped our culture and we can learn a lot.

Mr. ARENS. Did you go to Paris on that trip?

Mr. ROBESON. I went to Paris.

Mr. ARENS. And while you were in Paris, did you tell an audience there that the American Negro would never go to war against the Soviet Government?

Mr. ROBESON. May I say that is slightly out of context? May I explain

to you what I did say? I remember the speech very well, and the night before in London, and do not take the newspaper, take me, I made the speech, gentlemen, Mr. So and So. It happened that the night before in London before I went to Paris, and will you please listen?

Mr. ARENS. We are listening.

Mr. ROBESON. That 2,000 students from various parts of the colonial world, students who since then have become very important in their governments and in places like Indonesia and India, and in many parts of Africa; 2,000 students asked me and Dr. Dadoo, a leader of the Indian people in South Africa, when we addressed this specific conference, and remember I was speaking to a peace conference, a conference devoted to peace, they asked me and Dr. Dadoo to say there that they were struggling for peace, that they did not want war against anybody. It was 2,000 students who came from populations that would range to six or seven hundred million people, and not just 15 million.

Mr. KEARNEY. Do you know anybody who wants war?

Mr. ROBESON. They asked me to address this conference and say in their name that they did not want war. That is what I said. There is no part of my speech made in Paris which says that I said that 15 million American Negroes would do anything. I said it was my feeling that the American people would struggle for peace and that has since been underscored by the President of these United States. Now, in passing, I said—

Mr. KEARNEY. Do you know of any people who want war?

Mr. ROBESON. Listen to me, I said it was unthinkable to me that any people would take up arms in the name of an Eastland[10] to go against anybody, and gentlemen, I still say that. What should happen would be that this United States Government should go down to Mississippi and protect my people. That is what should happen.

The CHAIRMAN. Did you say what was attributed to you?

Mr. ROBESON. I did not say it in that context.

Mr. ARENS. I lay before you a document, containing an article, I Am Looking for Full Freedom, by Paul Robeson, in which is recited a quotation of Paul Robeson.

Mr. ROBESON. That is fine.

Mr. ARENS. This article appears in a publication called the Worker dated July 3, 1949.

Mr. ROBESON. That is right.

Mr. ARENS (reading):

At the Paris Conference I said it was unthinkable that the Negro people of America or elsewhere in the world could be drawn into war with the Soviet Union.

Mr. ROBESON. Is that saying the Negro people would do anything? I said it is unthinkable. I did not say it there; I did not say that there. I said that in the Worker.

Mr. ARENS (reading):

I repeat it with hundredfold emphasis: They will not.

Did you say that?

Mr. ROBESON. I did not say that in Paris; no.

Mr. ARENS. Did you say that in this article?

Mr. ROBESON. I said that in America. And, gentlemen, they have not yet done so, and it is quite clear that no Americans or no people in the world probably are going to war with the Soviet Union, so I was rather prophetic, was I not, and rather prophetic. We want peace today and not war.

Mr. ARENS. On that trip to Europe, did you go to Stockholm?

Mr. ROBESON. I certainly did and I understand that some people in the American Embassy tried to break up my concert, and they were not successful.

Mr. ARENS. While you were in Stockholm, did you make a little speech?

Mr. ROBESON. I made all kinds of speeches; yes.

Mr. ARENS. Let me read you a quotation of one of your speeches, and see if it comes to your mind.

Mr. ROBESON. Let me listen.

Mr. ARENS. Do so, please.

Mr. ROBESON. I am a lawyer.

Mr. KEARNEY. It would be a revelation if you would listen to counsel.

Mr. ROBESON. In good company I usually listen, but you know people wander around in such fancy places, you know, and would you please let me read my statement at some point?

The CHAIRMAN. We will consider your statement.

Mr. ARENS (reading):

I do not hesitate 1 second to state clearly and unmistakably: I belong to the American resistance movement which fights against American imperialism, just as the resistance movement fought against Hitler.

Mr. ROBESON. Just like Frederick Douglass and Harriet Tubman were underground railroaders, and fighting for our freedom; you bet your life.

The CHAIRMAN. I am going to have to insist that you listen to these questions.

Mr. ROBESON. I am listening.

Mr. ARENS (reading):

If the American warmongers fancy that they could win America's millions of Negroes for a war against those countries (i.e., the Soviet Union and the peoples' democracies) then they ought to understand that this will never be the case. Why should the Negroes ever fight against the only nations of the world where racial discrimination is prohibited, and where the people can live freely? Never! I can assure you, they will never fight against either the Soviet Union or the peoples' democracies.

Did you make that statement?

Mr. ROBESON. I do not remember that. But what is perfectly clear today is that 900 million other colored people have told you that they will not, is that not so? 400 million in India and millions everywhere

have told you precisely that the colored people are not going to die for anybody and they are going to die for their independence. We are dealing not with 15 million colored people. We are dealing with hundreds of millions.

Mr. KEARNEY. The witness has answered the question and he does not have to make a speech.

Mr. ARENS. Did you go to Prague, Czechoslovakia?

Mr. ROBESON. I sang in Prague.

Mr. ARENS. And did you make a speech there?

Mr. ROBESON. I do not quite remember. Let me hear it.

Mr. ARENS. Let me read you this: This is a quotation from one of your addresses there, and see if it refreshes your recollection. You came as a representative of progressive America.

Mr. ROBESON. I did.

Mr. ARENS (reading):

Not only as a representative of progressive America, but as a representative for the 12 Communists on trial in New York. I expect to return to New York to testify on their behalf.

Mr. ROBESON. I did, and I did testify on their behalf.

Mr. SCHERER. They were convicted.

Mr. ROBESON. I feel that, like the Supreme Court decision against segregation, the minority opinion of Justice Black will one day rule this country.

Mr. SCHERER. They were convicted.

Mr. ROBESON. They were convicted certainly, and every decent American today knows that the Smith Act is a vicious document.

Mr. SCHERER. That is your opinion.

Mr. ROBESON. It is a vicious document and it is not my opinion.

The CHAIRMAN. If everyone knows that, why is it still on the statute books?

Mr. ARENS. Then you did go to Moscow, on this trip?

Mr. ROBESON. Oh, yes.

Mr. ARENS. And while you were there, did you make a speech there?

Mr. ROBESON. I spoke many times and sang.

Mr. SCHERER. What year was it?

Mr. ARENS. 1949, was it not?

Mr. ROBESON. 1949, that is right.

Mr. ARENS. Did you write an article that was subsequently published in the U.S.S.R. Information Bulletin?

Mr. ROBESON. Yes.

Mr. ARENS. In that article, did you say:

Moscow is very dear to me and very close to my heart. I want to emphasize that only here, in the Soviet Union, did I feel that I was a real man with a capital "M." And now after many years I am here again in Moscow, in the country I love more than any other.

Did you say that?

Mr. ROBESON. I would say,—what is your name?

Mr. ARENS. Arens.

Mr. ROBESON. We will take this in context, and I am quite willing to answer the question, and you are reading from a document and it is in context. When I was a singer years ago, and this you have to listen to—

Mr. ARENS. I am listening.

Mr. ROBESON. I am a bass singer, and so for me it was Chaliapin, the great Russian bass, and not Russo the tenor, and so I learned the Russian language and the Russian songs to sing their songs. I wish you would listen now.

Mr. SCHERER. I ask you to direct the witness to answer the question.

Mr. ROBESON. Just be fair to me.

Mr. SCHERER. I ask regular order.

Mr. ROBESON. The great poet of Russia, like Shakespeare of England, is of African blood.

The CHAIRMAN. Let us not go so far afield.

Mr. ROBESON. It is very important. It is very important to explain this. I know what he said.

The CHAIRMAN. You can make an explanation. Did you make that statement?

Mr. ROBESON. When I first went to Russia in 1934—

The CHAIRMAN. Did you make that statement?

Mr. ROBESON. When I first went to Russia in 1934—

The CHAIRMAN. Did you make that statement?

Mr. SCHERER. I ask you to direct the witness to answer the question. (The witness consulted with his counsel.)

The CHAIRMAN. Did you make that statement?

Mr. ROBESON. I would say in Russia I felt for the first time like a full human being, and no colored prejudice like in Mississippi and no colored prejudice like in Washington and it was the first time I felt like a human being, where I did not feel the pressure of colored as I feel in this committee today.

Mr. SCHERER. Why do you not stay in Russia?

Mr. ROBESON. Because my father was a slave, and my people died to build this country, and I am going to stay here and have a part of it just like you. And no Fascist-minded people will drive me from it. Is that clear? I am for peace with the Soviet Union and I am for peace with China, and I am not for peace or friendship with the Fascist Franco, and I am not for peace with Fascist Nazi Germans, and I am for peace with decent people in the world.

Mr. SCHERER. The reason you are here is because you are promoting the Communist cause in this country.

Mr. ROBESON. I am here because I am opposing the neo-Fascist cause which I see arising in these committees. You are like the Alien [and] Sedition Act, and Jefferson could be sitting here, and Frederick Douglass could be sitting here and Eugene Debs could be here.

The CHAIRMAN. Are you going to answer the questions?

Mr. ROBESON. I am answering them.

The CHAIRMAN. What is your answer to this question?

Mr. ROBESON. I have answered the question.

Mr. ARENS. Did you send your son to a Soviet school in New York City?

Mr. ROBESON. What is that?

Mr. ARENS. Did you send your son to a Soviet school in New York City?

Mr. ROBESON. I sent my son to a Soviet school in the Soviet Union and in England, and he was not able to go to a Soviet school in New York.

Mr. ARENS. Did you say that he went to a Soviet school in New York?

Mr. ROBESON. I would have liked him to, but he could not. He went to a Soviet school in London and one in Moscow.

Mr. ARENS. I again invite your attention to this article to which we have been referring, and speaking of your son and his studies, in a Soviet school in Soviet Russia: "Here he spent 3 years."

Mr. ROBESON. And he suffered no prejudice like he would here in Washington.

Mr. ARENS (reading):

Then studied in a Soviet School in London.

Mr. ROBESON. That is right.

Mr. ARENS (reading):

And in a Soviet school in New York.

Mr. ROBESON. He was not able to.

Mr. ARENS. Is that a mistake?

Mr. ROBESON. That is a mistake.

Mr. ARENS. That is a printer's error?

Mr. ROBESON. And a wrong statement by me.

The CHAIRMAN. Now, what prejudice are you talking about? You were graduated from Rutgers and you were graduated from the University of Pennsylvania. I remember seeing you play football at Lehigh.

Mr. ROBESON. We beat Lehigh.

The CHAIRMAN. And we had a lot of trouble with you.

Mr. ROBESON. That is right. deWysocki was playing in my team.

The CHAIRMAN. There was no prejudice against you. Why did you not send your son to Rutgers?

Mr. ROBESON. Just a moment. It all depends a great deal. This is something that I challenge very deeply, and very sincerely, the fact that the success of a few Negroes, including myself or Jackie Robinson can make up—and here is a study from Columbia University—for $700 a year for thousands of Negro families in the South. My father was a slave, and I have cousins who are sharecroppers and I do not see my success in terms of myself. That is the reason, my own success has not meant what it should mean. I have sacrificed literally hundreds of thousands, if not millions, of dollars for what I believe in.

Mr. ARENS. While you were in Moscow, did you make a speech lauding Stalin?

Mr. ROBESON. I do not know.

Mr. ARENS. Did you say in effect that Stalin was a great man and Stalin had done much for the Russian people, for all of the nations of the world, for all working people of the earth? Did you say something to that effect about Stalin when you were in Moscow?

Mr. ROBESON. I cannot remember.

Mr. ARENS. Do you have a recollection of praising Stalin?

Mr. ROBESON. I can certainly know that I said a lot about Soviet people, fighting for the peoples of the earth.

Mr. ARENS. Did you praise Stalin?

Mr. ROBESON. I do not remember.

Mr. ARENS. Have you recently changed your mind about Stalin?

Mr. ROBESON. Whatever has happened to Stalin, gentlemen, is a question for the Soviet Union and I would not argue with a representative of the people who, in building America wasted 60 to 100 million lives of my people, black people drawn from Africa on the plantations. You are responsible and your forebears for 60 million to 100 million black people dying in the slave ships and on the plantations, and don't you ask me about anybody, please.

Mr. ARENS. I am glad you called our attention to that slave problem. While you were in Soviet Russia, did you ask them there to show you the slave labor camps?

The CHAIRMAN. You have been so greatly interested in slaves, I should think that you would want to see that.

Mr. ROBESON. The slaves I see are still as a kind of semiserfdom, and I am interested in the place I am and in the country that can do something about it. As far as I know about the slave camps, they were Fascist prisoners who had murdered millions of the Jewish people and who would have wiped out millions of the Negro people could they have gotten a hold of them. That is all I know about that.

Mr. ARENS. Tell us whether or not you have changed your opinion in the recent past about Stalin.

Mr. ROBESON. I have told you, Mister, that I would not discuss anything with the people who have murdered 60 million of my people, and I will not discuss Stalin with you.

Mr. ARENS. You would not, of course, discuss with us the slave labor camps in Soviet Russia.

Mr. ROBESON. I will discuss Stalin when I may be among the Russian people some day singing for them, and I will discuss it there. It is their problem.

Mr. ARENS. I suppose you are still going to laud Stalin like you did in 1949, or have you changed your appraisal?

Mr. ROBESON. We will not discuss that here. It is very interesting, however, whether Stalin or the Soviet people, that from 1917 to 1947, in one generation there could be a nation which equals the power of

this one in one generation. That is one generation and nothing could be built more on slavery than this society, I assure you.

Mr. ARENS. Let me read you another statement by you about the Soviet Union and see if it refreshes your recollection.

Mr. ROBESON. You can keep reading about the Soviet Union and I have great friendship and great affection for the Soviet Union.

Mr. ARENS. How about your great affection now for the leader you were praising in 1949?

Mr. ROBESON. That is O.K.

Mr. ARENS. Has that affection diminished recently?

Mr. ROBESON. That is a question I will discuss among friends.

Mr. ARENS. You will hold that in reservation.

Mr. ROBESON. Yes.

Mr. ARENS (reading):

Now, the Soviet Union is the only country I have ever been in where I have felt completely at ease. I have lived in England and America, and I have almost circled the globe but for myself, wife, and son, the Soviet Union is our future home.

Mr. ROBESON. If it were so we would be there. My wife is here and my son is here, and we have come back here.

Mr. ARENS. Let me complete this paragraph and see if it helps explain why it is not your future home.

For a while, however, I would not feel right going there to live. By singing its praises wherever I go I think that I can be of the most value to it. It is too easy to go to the Soviet Union, breathe the free air, and live happily ever afterward.

Were those your sentiments?

Mr. ROBESON. I came back to America to fight for my people here, and they are still second- and third-class citizens, gentlemen, and I was born here of the Negro people and of working people and I am back here to help them struggle.

Mr. SCHERER. Did you say that?

Mr. ROBESON. I have said that many times.

Mr. SCHERER. Did you say what he read to you?

Mr. ROBESON. I do not even know what he is reading from, really, and I do not mind. It is like the statement that I was supposed to make in Paris. Now, this was not in context, but I thought it was healthy for Americans to consider whether or not Negroes should fight for people who kick them around, and when they took a vote up North they got very nervous because a lot of white Americans said, "I do not see why the hell they would."

Mr. ARENS. Did you, while you were in Moscow, make this statement:

Yes, the Communists march at the front of the struggle for stable peace and popular democracy. But they are not alone. With them are all of the progressive people of America, Wallace's party, and the Negroes of the South, and workers of the North.

Mr. ROBESON. Now you are making it up, brother. I would have to get my own copy of the speech.

Mr. ARENS. I put it to you as a fact and ask you, while you are under oath, to deny the fact that you made that statement.

Mr. ROBESON. I am not denying, but do not just read anything into something. How could I say what Wallace's party would do, or what somebody else would do? That is nonsense.

Mr. ARENS. While you are under oath, why do you not deny it?

Mr. ROBESON. The Soviet Union and the People's Democracy in China are in the forefront of the struggle for peace, and so is our President, thank goodness, and let us hope we will have some peace, if committees like yours do not upset the applecart and destroy all of humanity. Now can I read my speech?

The CHAIRMAN. You have made it without reading it. Can you tell us what Communists participated in the preparation of that speech?

Mr. ROBESON. Participated in what?

Mr. ARENS. While you were in Soviet Russia, did you make statements about your academic training in Marxism? Do you recall that?

Mr. ROBESON. I do not recall that, but I have read a lot of Marx.

Mr. ARENS. Do you know a woman by the name of Sheila Lind?

Mr. ROBESON. I do not recall.

Mr. ARENS. She wrote an article and I am going to lay it before you here so you can help me read it. This is the Daily Worker, 1949, in which she interviewed you and it tells all about your achievements. Let me read you this for the record and you can follow it here. She is quoting:

"When I crossed the border from Poland into the Soviet Union," he told me, "it was like stepping into another planet."

Mr. ROBESON. Exactly true, no more prejudice, and no more colored feeling, that is right.

Mr. ARENS (reading):

"I felt the full dignity of being a human being for the first time."

Mr. ROBESON. That is right, and that is still not here.

Mr. ARENS (continuing):

"He loved what he found there so much that until the war, he returned to Russia for each new year."

Mr. ROBESON. Every new year, and we took a little vodka.

Mr. ARENS (continuing to read):

"And he sent his son to school there. In Moscow he began to study Marxism."

Mr. ROBESON. No, I started to study that in England, and all of my political education, strange to say, came in England where I lived and worked for many years and came back here. But my Marxist education, or education as you call it, is in English background of the Labor

Party. I went to Republican Spain with Lord Atlee to visit the Atlee Battalion and I knew Sir Stafford Cripps and I knew all of the members of the Labor Party, so you cannot blame that on the Russians. You will have to blame that on the English Labor Party. They have just invited me to come to London next week to sing to 140,000 miners up in Yorkshire. Do you think that you could let me go?

The CHAIRMAN. We have nothing to do with that.

Mr. ROBESON. Could you not make a suggestion to the State Department that I be allowed to go?

The CHAIRMAN. That would not do any good because the courts have ruled that it is not in the best interests of the United States to permit you to travel.

Mr. ROBESON. They have not done that. They have ruled on a very technical problem, Mr. Walter, as to whether I sign an affidavit. That is all.

Mr. ARENS. In the summer of 1949, you came back to the United States; is that right?

Mr. ROBESON. In the summer of 1949, yes, that is right.

Mr. ARENS. And when you came back, did you make a speech in New York City, addressing a rally there? Do you recall that?

Mr. ROBESON. I do not.

Mr. ARENS. Let me quote from an article appearing in a paper, and see if you recall this speech:

I have the greatest contempt for the democratic press and there is something within me which keeps me from breaking your cameras over your heads.

Did you say that to the press people in New York City about the time you were addressing this rally in June of 1949?

Mr. ROBESON. It is sort of out of context.

Mr. ARENS. That was out of context?

Mr. ROBESON. I am afraid it is.

Mr. ARENS. Would you want to refresh your recollection by looking at the article?

Mr. ROBESON. Yes. That was not at a meeting. Why do you not say what it was? When my son married the woman of his choice, some very wild press men were there to make a sensation out of it, and this thing was at his wedding, and I did not say "democratic press," I said "a certain kind of press," and I was reaching for a camera to break it, you are quite right.

Mr. ARENS. That was a misquotation?

Mr. ROBESON. It was not at a meeting. It was when I came out of my son's wedding, and why do you not be honest about this? There is nothing about a meeting, it was a wedding of my son.

Mr. ARENS. Does not this article say, "Paul Robeson Addressing a Welcome Home Rally"?

Mr. ROBESON. I do not care what it says.

Mr. ARENS. That is wrong, too, is it?

Now I would invite your attention, if you please, to the Daily Worker of June 29, 1949, with reference to a get-together with you and Ben Davis. Do you know Ben Davis?

Mr. ROBESON. One of my dearest friends, one of the finest Americans you can imagine, born of a fine family, who went to Amherst and was a great man.

The CHAIRMAN. The answer is "Yes"?

Mr. ROBESON. And a very great friend and nothing could make me prouder than to know him.

The CHAIRMAN. That answers the question.

Mr. ARENS. Did I understand you to laud his patriotism?

Mr. ROBESON. I say that he is as patriotic an American as there can be, and you gentlemen belong with the Alien and Sedition Acts, and you are the nonpatriots, and you are the un-Americans and you ought to be ashamed of yourselves.

The CHAIRMAN. Just a minute, the hearing is now adjourned.

Mr. ROBESON. I should think it would be.

The CHAIRMAN. I have endured all of this that I can.

Mr. ROBESON. Can I read my statement?

The CHAIRMAN. No, you cannot read it. The meeting is adjourned.

Mr. ROBESON. I think it should be and you should adjourn this forever, that is what I would say.

The CHAIRMAN. We will convene at 2 o'clock this afternoon.

Mr. FRIEDMAN. Will the statement be accepted for the record without being read?

The CHAIRMAN. No, it will not.

(Whereupon, at 11 a.m., a recess was taken until 2 p.m., of this same day.)

> The statement Paul Robeson was not permitted to read before the House Un-American Activities Committee, July 13, 1956—Paul Robeson Archives, Berlin, German Democratic Republic

It is a sad and bitter commentary on the state of civil liberties in America that the very forces of reaction, typified by Representative Francis Walter and his Senate counterparts, who have denied me access to the lecture podium, the concert hall, the opera house, and the dramatic stage, now hale me before a committee of inquisition in order to hear what I have to say. It is obvious that those who are trying to gag me here and abroad will scarcely grant me the freedom to express myself fully in a hearing controlled by them.

It would be more fitting for me to question Walter, Eastland and Dulles than for them to question me, for it is they who should be called to account for their conduct, not I. Why does Walter not investigate the truly "un-American" activities of Eastland and his gang, to whom the Constitution is a scrap of paper when invoked by the Negro people and to whom defiance of the Supreme Court is a racial duty? And how can Eastland pretend concern over the internal security of our country

while he supports the most brutal assaults on fifteen million Americans by the white citizens councils and the Ku Klux Klan? When will Dulles explain his reckless irresponsible "brink of war" policy by which the world might have been destroyed.

And specifically, why is Dulles afraid to let me have a passport, to let me travel abroad to sing, to act, to speak my mind? This question has been partially answered by State Department lawyers who have asserted in court that the State Department claims the right to deny me a passport because of what they called my "recognized status as a spokesman for large sections of Negro Americans" and because I have "been for years extremely active in behalf of independence of colonial peoples of Africa." The State Department has also based its denial of a passport to me on the fact that I sent a message of greeting to the Bandung Conference, convened by Nehru, Sukarno and other great leaders of the colored peoples of the world. Principally, however, Dulles objects to speeches I have made abroad against the oppression suffered by my people in the United States.

I am proud that those statements can be made about me. It is my firm intention to continue to speak out against injustices to the Negro people, and I shall continue to do all within my power in behalf of independence of colonial peoples of Africa. It is for Dulles to explain why a Negro who opposes colonialism and supports the aspirations of Negro Americans should for those reasons be denied a passport.

My fight for a passport is a struggle for freedom—freedom to travel, freedom to earn a livelihood, freedom to speak, freedom to express myself artistically and culturally. I have been denied these freedoms because Dulles, Eastland, Walter and their ilk oppose my views on colonial liberation, my resistance to oppression of Negro Americans, and my burning desire for peace with all nations. But these are views which I shall proclaim whenever given the opportunity, whether before this committee or any other body.

President Eisenhower has strongly urged the desirability of international cultural exchanges. I agree with him. The American people would welcome artistic performances by the great singers, actors, ballet troupes, opera companies, symphony orchestras and virtuosos of South America, Europe, Africa and Asia, including the folk and classic art of the African peoples, the ancient culture of China, as well as the artistic works of the western world. I hope the day will come soon when Walter will consent to lowering the cruel bars which deny the American people the right to witness performances of many great foreign artists. It is certainly high time for him to drop the ridiculous "Keystone Kop"[11] antics of fingerprinting distinguished visitors.

I find no such restrictions placed upon me abroad as Walter has had placed upon foreign artists whose performances the American people wish to see and hear. I have been invited to perform all over the world, and only the arbitrary denial of a passport has prevented realization of this particular aspect of the cultural exchange which the President favors.

I have been invited by Leslie Linder Productions to play the title role in a production of "Othello" in England. British Actors' Equity Association has unanimously approved of my appearance and performance in England.

I have been invited by Workers' Music Association Ltd. to make a concert tour of England under its auspices. The invitation was signed by all of the vice-presidents, including Benjamin Britten, and was seconded by a personal invitation of R. Vaughn Williams.

I have been invited by Adam Holender, impresario, to make a concert tour of Israel, and he has tendered to me a proposed contract for that purpose.

"Mosfilm," a Soviet moving picture producing company, has invited me to play the title role in a film version of "Othello," assuring me "of the tremendous artistic joy which association with your wonderful talent will bring us."

The British Electrical Trades Union requested me to attend their annual policy conference, recalling my attendance at a similar conference held in 1949 at which, they wrote me, "you sang and spoke so movingly."

The British Workers' Sports Association, erroneously crediting a false report that I would be permitted to travel, wrote me, "we view the news with very great happiness." They invited me "to sing to our members in London, Glasgow, Manchester or Cardiff, or all four, under the auspices of our International Fund, and on a financial basis favourable to yourself, and to be mutually agreed." They suggested a choice of three different halls in London seating, respectively, 3,000, 4,500 and 7,000.

The Australian Peace Council invited me to make a combined "singing and peace tour" of the dominion.

I have received an invitation from the Education Committee of the London Co-operative Society to sing at concerts in London under their auspices.

A Swedish youth organization called "Democratic Youth" has invited me to visit Sweden "to give some concerts here, to get to know our culture and our people." The letter of invitation added, "Your appearance here would be greeted with the greatest interest and pleasure, and a tour in Sweden can be arranged either by us or by our organization in cooperation with others, or by any of our cultural societies or artist's bureaus, whichever you may prefer."

I have an invitation from the South Wales Miners to sing at the Miners' Singing Festival on October 6, 1956, and in a series of concerts in the mining valley thereafter.

In Manchester, England, a group of people called the "Let Paul Robeson Sing Committee" has asked me to give a concert at the Free Trade Hall in that city either preceding or following my engagement in Wales.

I have been requested by the Artistic and Literary Director of the Agence Littéraire et Artistique Parisienne Pour les Echanges Cul-

turels to sign a contract with the great French concert organizer, M. Marcel de Valmalette, to sing in a series of concerts at the Palais de Chaillot in Paris.

There is no doubt that the governments of those countries and many others where I would be invited to sing if I could travel abroad, would have no fear of what I might sing or say while there, whether such governments be allies and friends of America or neutrals or those others whose friendship for the American people is obstructed by Dulles and Walter and like-minded reactionaries.

My travels abroad to sing and act and speak cannot possibly harm the American people. In the past I have won friends for the real America among the millions before whom I have performed—not for Walter, not for Dulles, not for Eastland, not for the racists who disgrace our country's name—but friends for the American Negro, our workers, our farmers, our artists.

By continuing the struggle at home and abroad for peace and friendship with all of the world's people, for an end to colonialism, for full citizenship for Negro Americans, for a world in which art and culture may abound, I intend to continue to win friends for the best in American life.

Statement to the press on appearance before the House Un-American Activities Committee, July 14, 1956—Paul Robeson Archives, Berlin, German Democratic Republic

I am not in any conspiracy. It should be plain to everybody and especially to Negroes that, if the Government had evidence to back up that charge, they would have tried to put me *under* their jail. They have no such evidence. In 1946, at a hearing in California,[12] I testified under oath that I was not a member of the Communist Party. Since then I have refused to give testimony to that fact. There is no mystery in this. I have made it a matter of principle to refuse to comply with any demand that infringes upon the Constitutional rights of all Americans.

Some Aspects of Afro-American Music

December 1956—Paul Robeson Archives, Berlin, German Democratic Republic

Mr. Harold Courlander, well-known authority on folk lore, made an extensive field trip into the rural South some years ago in search of authentic Afro-American music. He recorded this music on the spot where he found it. Some of this music is now available in several Folkways albums of records, under the title *Negro Folk Music of Alabama.*

This Folkways collection was reviewed recently by the *New York*

Times music critic "J.B.," in the *Sunday Times* of August 19, 1956. The review was an extremely interesting and challenging discussion and analysis of the musical material. However, several of the statements made by the critic sent me off into months of fascinating and very rewarding research.

For example, "J.B." wrote that "Some authorities believe the European element to be more important in Negro music than the African." That of course I could not accept, so I went in search of documentation to support my resistance. I found an enormous volume of support which I will try to sum up briefly.

There is no more evidence that Afro-American music is based on European music, than that European music is based on African music. There is however, extensive evidence that nearly all music in the world today stems from an ancient world body of original folk music—music created, sung, and handed down through the ages by the people in all parts of the world.

The people brought this wealth of folk music with them into the early Churches when they were established, and here it was preserved, modified and eventually formalized in various ways, according to the developments and changes which took place in the Church itself.

The peoples who came into the early Church were Syrians, Jewish people, Greeks, Romans, Egyptians, Ethiopians, Nubians, and the peoples of Eastern Europe. The wonderful folk music they brought with them became the basis for much of the early Church music, including the Gregorian or Plain Chant of the Middle Ages, which still exists and can be heard in the Greek and Roman Churches, and with some changes, in the Protestant Churches as well.

This ancient body of world folk music, and much of the early Church music is based on the "Pentatonic" (5-tone) scale, which is preserved today in folk songs all over the world. Victor Belaiev, noted authority on early music, is positive about the folk base of all European Plain Chant, and Joseph Yasser, distinguished musicologist, points out in his book *The Theory of Evolving Tonality,* that this medieval Plain Chant had a Pentatonic 5-tone modal base. Music in ancient times all over the world, and much of the music of Europe up to 1500, was based on the Pentatonic 5-tone scale.

Our own J. Rosamond Johnson[1] points out that most of our Afro-American melodies, religious and secular, are also in the Pentatonic mode. Our musicians see an obvious Pentatonic scale on the black keys of the piano: F sharp, G sharp, A sharp (B), C sharp, D sharp (F), F sharp; and find another Pentatonic on the white keys: C D E (F) G A (B) C, with the F and the B (or E and B flat, etc.) used as the two auxiliary tones. There is also a Pentatonic scale with half-tones in use in Africa, Japan and other places.

We have a Pentatonic scale on the black keys, with the F sharp as *do,* or the tonic; and another on the white keys with C as *do* or tonic. Of course there are many variations of the Pentatonic.

So, as Johnson points out, we in Afro-American life see the piano as

having TWO CENTERS: an F sharp center and a C center. Johnson and Yasser also point out that it is most important to recognize that the F and the B (the 4th and the 7th) are sometimes used and sometimes not used. They are auxiliary, not substantive tones to the main Pentatonic scale. Note that F sharp and C, or F and B, are three whole tones or a "raised" or sharp 4th apart—a most important feature of the cross relations between the two Pentatonics.

A very interesting and helpful way to look at the piano, especially for those with "Pentatonic ears," is to see the tones as an interaction between the two Pentatonics—a kind of extension of major and minor interaction and contrast.

Yasser explains that he would characterize the Diatonic scale (do, re, mi, fa, sol, la, ti, do) which every child learns in school and which we all sing, as SEVEN TONES plus FIVE CHROMATICS, 7 + 5, seven white keys plus five black keys. And he characterized the Pentatonic scale as FIVE TONES plus TWO.

So in seeing the piano in terms of the two Pentatonics, we could characterize it as TWO FIVES, 5 black keys above, 5 white keys below, with TWO white keys in between and common to both FIVES:

5 + 2 + 5,
 5-F Sharp 5-F Sharp or G
 (2) (F 2 B)
 5 C 5 C

and these two Pentatonics used simultaneously, one contrasting against the other, give some clue to much of modern music. Note for example the *Mikrokosmos* of Bartok,[2] and some of the Pentatonic usages of Debussy.

Authorities agree that the early world body or mainstream of music was polyphonic, contrapuntal in character—that is to say, that several or many singers carried the melody in parallel lines, sometimes some starting at different times or at different points, sometimes with a leader and an answering or emphasizing chorus or congregation (which our musicians and nearly all our people would find entirely familiar).

Marius Schneider, one of the most distinguished of musicologists, studied the music of the peoples of Africa, Asia, South America, and established that "the highly developed sphere of certain African tribes contains 'symphonious' forms very similar to those of the early Middle Ages. There is no question here of African music influencing medieval composers; it is rather that the development of polyphony seems spontaneously to have followed very similar paths in all parts of the world."

"J.B." also comments in his review on some other characteristics of this folk music of Alabama:

> The most striking fact about Negro group singing is that it is contrapuntal in character . . . no less striking is the prominence of the "African tetrachord" which is merely the

familiar "blues chord" of American jazz . . . Grove's Diction-
ary traces this tetrachord to the West Coast of Africa,
whence it has spread not only to the United States but to
Latin America.

This contrapuntal singing, and the characteristic "Fourth" or tetra-
chord, are not only characteristic of early medieval Plain Chant, but
also of much of the modern music of Moussorgsky, Bartok, Janacek,[3]
Vaughn Williams, Duke Ellington,[4] George Gershwin and others, and
also of Chinese, Indonesian, African, Hebraic, Byzantine, Ethiopian
music, as well as Scotch Hebridean, Welsh and Irish music; that is to
say it is characteristic of Pentatonic modal music.

It would seem then, that Afro-American music is based primarily
upon our African heritage and has been influenced not only by
European but by many other musics of East and West; this is true also
of Afro-Cuban, Afro-Haitian, Afro-Caribbean, Afro-Brazilian music;
and our music has also influenced other music.

It is extraordinarily interesting to note that in recent years many
Western composers have turned to their old Pentatonic modal folk
music, finding new inspiration in this wealth, and basing many of
their new compositions upon it, just as Bach based much of his music
on the ancient modal folk chorales. These composers have found
richness in Pentatonic modal melodies because, as Yasser conclusively
demonstrates, there is also a Pentatonic harmony which has long
existed and been developed in China, Africa, Indonesia, Siam, etc., and
in Europe up to 1500. That is to say, there is a Pentatonic system of
music which preceded and co-exists with the better known Diatonic or
7-tone system—the one in general use in the classic music of Europe
after 1700. However, this Pentatonic system has always continued in
folk music. My dear friend and colleague Lawrence Brown has drawn
upon this richness, and made many beautiful arrangements of our own
folk music.

So today we are flowing back into the mainstream of world music,
which includes the music of Asia, Africa, Europe, and the Americas,
with a future potential of immense richness—all giving to and taking
from each other, through this wonderful world bank of music.

Introduction to *The American Negro and the Darker World* by W. E. Burghardt Du Bois

New York, 1957[1]

If only all America could have been at the 135th Street Branch of the
New York Public Library Tuesday Evening, May 7, 1957!

For there in the intellectual environs of the Gallery dedicated to the
Schomburg Collection—a Great American of African heritage was
honored.

A beautiful piece of sculpture by William Zorach, the noted American sculptor, was unveiled— a bronze head of Dr. W. E. Burghardt Du Bois.

Outstanding Americans in many fields participated. Dr. E. Franklin Frazier,[2] Van Wyck Brooks,[3] Judge Jane Bolin, Jean Blackwell—and many hundreds paid sincerest tribute.

In this pamphlet is a searching and profound analysis of contemporary America, of the whole world about us with special reference to the Africa of our forbears. And the challenge to each and everyone of us is inescapable.

Thanks to the Committee to Defend Negro Leadership which provided the stirring occasion for the delivery of this message—and thanks for this pamphlet so that all may read and reflect and act.

And go out at once and get *The Ordeal of Mansart*[4]—the latest book of this Great Scholar, Poet and fighter for all humanity—a book, the first of a trilogy, devoted to the tortured but courageous history of Americans of African descent. And let us all be once more deeply thankful that we are privileged to live in the same period as Dr. Du Bois, privileged to be a part of the same struggle for the full attainment of all peoples' freedoms and inherent human dignity.

My Labors in the Future
Will Remain the Same
As They Have in the Past

David Ordway, *Daily Worker,* August 15, 1957—The original
headline read, "Paul Robeson Sings to 10,000 on the West Coast"

SAN FRANCISCO—Back in the full swing of his concert career, Paul Robeson has appeared five times in California in the last month and sung to 10,000 people in Los Angeles and San Francisco.

"There were 5,000 people in the park in Los Angeles," he said, "who were there under the auspices of the Foreign Born committee. The First Unitarian Church brought in 2,400 more for two concerts, and my concert at the Third Baptist Church in San Francisco brought in 1,100 more."

All these appearances were sold out within three days after they were announced and the great American artist said he could do 15 more in the Bay Area alone, within the next six weeks, if he were not going back to New York.

"I'm going to record several long-playing records for Vanguard," he said, "and in October I will be back in California."

Response to his concerts by the Negro community, said Robeson, was "magnificent."

"When you come right down to it," he added, "where did any Negro artist begin? In the Negro churches. They represent the most basic and profound organizations of the Negro people, and they always have."

Robeson said that when he sang again in the Opera House in San Francisco—or anywhere else for that matter—it would be because "a group of Negro people hired the place to present me. And I suspect my theatrical career will be resumed in the same way and under the same auspices."

The baritone and actor said he was amused by the fact that his own people kept asking him when he would sing again under regular concert auspices.

"I don't know that I ever will," he said. "If you attend the opening of the Opera House you will see the sort of audiences the concert managements of our country cater to—the well-to-do snobs. Some of them may know something about music and some of them may not. But I have no desire to sing for them again.

"My labors in the future will remain the same as they have in the past. They will be based on my whole experience—in the anti-fascist struggle that saw its finest expression in Spain, in the worldwide struggle of working people against their oppressors.

"This struggle is going on and has reached a new height. Not only abroad—where the colonial peoples are leading the fight and where three-quarters of the human race has refused to be kicked around any longer—but also here in my own United States where the Negro people of the South—who are also a semi-colonial people—are leading the fight."

This struggle, he said, was the most important thing that has happened in the world in the last few years. "We are seeing the working people of the world joining with the colonial people, with the colonial people playing the most important role. They are in the center of the struggle and they are mostly colored people.

"And it is an interesting question to me," Robeson said, "that here in America there seem to be no Northern abolitionists. Where are they? The fight is being carried by the Negro people themselves, but where are the John Browns, the Henry Thoreaus,[1] the William Lloyd Garrisons of today?

"The President of the United States himself says there is nothing he can do to enforce the mandate of the Supreme Court in the South. He says we must under no circumstances send in troops or use force. Yet the racists have no scruples about using force on us."

The successful Robeson concerts on the West Coast have not been noticed—or reviewed—by the commercial press. "And what's more," said Robeson, "I don't care."

The resumption of his concert career has taken place under the auspices of ordinary people, working people, he said. "I will probably not go back to the regular concert or theatrical management of the past.

"My present auspices generate a certain kind of audiences—friendly audiences, not hostile audiences. But there IS an audience that will continue to be hostile to me," he added, and with emphasis. "I am hostile to them."

"I don't want to sing to them any more. I have no desire to sing to the

owners of West Coast shipping or Inland Steel. Oh, they would let me sing," he added with a smile, "but first they would say, 'May we look at your program?'

"Then they would say, 'Joe Hill? Oh, no, Mr. Robeson. You can't sing that! Modern Soviet composers? Oh, no, Mr. Robeson, that would never do. And you aren't going to SAY anything, are you?'

"Well," Robeson said, "we have had to learn the hard way that there is another way to sing—and to reach audiences who want to hear us."

He told how, despite the fact his passport is still held up by the State Department, he had bypassed his imprisonment in the United States by singing—via transatlantic cable—to a concert in London last May.

"There is a national movement in Great Britain," he said, "a national movement of people of all persuasions, to hear me sing and watch me act. And when I appear there, my concerts will be sponsored by every important British composer; and when I act there, I will be sponsored by British Equity (the actors' organization) itself."

British Equity, which has been engaged in a long struggle to exclude U.S. actors from British plays (when the role can be played by a British actor) recently passed a special resolution inviting Robeson to England to play "Othello."

Professor Doner-Wilson, professor-emeritus of English literature at Edinburgh University and a leading Shakespeare critic, called upon the State Department, "in the name of Shakespeare," to permit the people of Great Britain to see Robeson's interpretation of the Moor.

The concert "into which" Robeson sang last May was held in London's St. Pancras Hall, and his voice was broadcast and amplified under the personal supervision of the head of the British communications system, who was present in the concert hall.

"There was no static," Robeson said. "The reception, both ways, was so wonderful that I was able to converse with the British master of ceremonies on stage, and to sing with the accompaniment of a Welsh chorus.

"It was as though I were on the stage in London myself, and the whole affair was such a success that the Manchester Guardian said, 'Never has the U.S. State Department looked sillier.'"

Robeson expects to repeat this sort of "black market" performance to various countries of Europe—east and west—this fall. "It will ultimately make the State Department position look so absurd that they will have to grant me my passport."

The Robeson passport case is awaiting the disposition by the Supreme Court of two other cases, but it began before the State Department appended the "anti-Communist affidavit" to the passport application.

"We are contending, of course," Robeson said, "that this affidavit is unconstitutional, but in my own case, I want to see it argued on the merits. On the merits of the State Department's own contentions.

"The Department originally refused me my passport because they said my appearances abroad were contrary to the best interests of the

United States. They have even spelled out what this means—to them.

"It means, one, that when I was abroad I criticized U.S. treatment of my people. I have also fought for African independence, and they therefore accuse me of meddling in U.S. foreign policy.

"Is U.S. policy opposed to African independence?" he was asked, and he smiled. "You tell me," he said.

"And third," he added, "I am a member of the World Peace Council. These three acts add up—in the mentality of the State Department—to making my appearances abroad contrary to the best interests of the United States.

"It is all part of the same struggle. And it is a struggle that we are going to win."

The Related Sounds of Music

New York, September 1957—*Daily World,* April 7, 1973
(Translated by Leonard Herman from the German version in the
Paul Robeson Archives, Berlin, German Democratic Republic)

I read a very fine article about the Soviet composer Aram Khatchaturian[1] by A. Medvedev. My interest was particularly aroused by the following paragraph:

"'My cradle song,' said Khatchaturian, 'comes from the east.' And the study of his music indicates that the traces which the cradle song left behind in his sensitive soul and in his hearing were inexhaustible."

This is exactly the way it is with me, a black American of African origins, with my cradle song from Africa, and the traces which it left in my sensitive soul and in my hearing were also unlimitedly deep. All my life the music of the black and African music were in my soul and in my hearing. In my childhood the music of the black churches and the music of the black community were an integral component of my consciousness.

As a professional musician I had the great fortune to find an early ally in the exceptionally talented black composer and arranger, Lawrence Brown. Over the years our common interests developed into a good artistic partnership and personal friendship. It was Lawrence Brown who confirmed my instinctive concept and who showed me the simple beauty of the songs of my childhood, which I heard every Sunday at the church and in the black congregations, work songs and blues of my father's people from the plantations of North Carolina. These had to become an important part of my international concert material.

Lawrence Brown, the outstanding black musician, knew and played the folk music of other peoples as well as the great classics of Western song literature (in which many songs are based on the folk themes). He was convinced that our music—the black music of African and

American derivation—belonged to a great inheritance, to the great folk music of the world.

These songs, ballads and poetic church hymns are similar to the songs of the bards of the Scottish Hebrides, the Welsh bards of the Druid tradition and the Irish bards which inspired Sean O'Casey.[2] They are similar to the unknown singers of the Russian folktales, the bards of the Icelandic and Finnish sagas, singers of the American Indians, the bards of the Veda hymns in India, the Chinese poet singers, the Hassidic sects and the bards of our African forebears.

In the course of my years of forced inactivity, I found great satisfaction in research into the origins and the inner ties of the folk music of different peoples. Several interesting and exciting ideas occurred to me—supported by many world-famous musicologists—which strengthened me and Lawrence Brown in our interest in the folk music of the world, and made clear to us why they so aroused our interest. Systematic study and research seeking the origin of the folk music of different peoples in many parts of the world showed, I believe, that a world reservoir, a universal source of basic folk themes exists, from which the entire folk music is derived and to which they have a direct or an indirect tie. My interest in the universality of mankind—in the sense of a basic tie which all people have to each other—led to the idea of a universal source of folk music. The idea took deep hold of me and I pursued it over several fascinating paths. Confirmation of my speculation came from various sources. The introduction to G. Schneerson's collection, *America's Songs,* published in 1956, says:

"Many peoples of the world made their contribution to the musical inheritance of the United States of America: English, Scots, French, Italians, Poles and Czechs, Germans and Jews, Spaniards and Ukranians. They all brought their national folk songs with them to America. Mixed in the cauldron of American life, enriched with a new content, each mutually influencing the other, these songs attained new aspects of national character."

Black folk songs exerted a particularly strong influence on American music. The musical culture of the Afro-American originated in the old culture of Africa. The blacks brought with them out of Africa an individual and rich inheritance, numerous beautiful and inspired songs, profoundly unique rhythms and freedom of expression.

Further study showed that the music of Ethiopia, the music of East Africa, had centuries of contact with that of other peoples of the Middle East and Asia—with the music of Syria, Arabia, Ancient Nubia, Israel, Turkey, India, Greece and the countries of the Byzantine Empire. And the West African music is the source of the music which Schneerson writes about: it, too, had centuries of contact with the music of the Moors, the Southern Spanish, the people of the Mediterranean and South America. So I came to the view that African music is closely tied to the music which we call "Eastern ' or Oriental. African music contains much of the ornamentation of unusual rhythmic and melodic prototypes of the music of different peoples of the

East. It uses the same pentatonic (five-tone) scale as well as seven-tone, quarter-tone and microtone scales which are also customary with the peoples of the East and the Middle East.

Recently, in New York, I had the opportunity to discuss these questions with a Soviet friend, Velichanskaja. She spoke of a few old Greek and Armenian songs which she knew. These helped her to understand several of my ideas which I tried to explain to her. Later, after she returned to Moscow, she generously sent me several beautiful records of these songs, which I listened to for hours. I also listened to several recordings of old Armenian church chorales, with the intervals characteristic of the East, the "raised" seconds and thirds.

In another work on Oriental music, particularly on Armenian music, Hugo Leichtentritt wrote in his book, *Musical Form:*

"In melodic construction all Oriental music uses a number of typical, constantly recurring forms. For example, in the Indian Ragas and in the Arabic Mugams. The Gregorian chant has these forms and thereby characterize the various types of church styles, forms which identify these styles. It seems that each scale aims at creating such forms. The richer the scale is, the fuller in content are the variations of these forms. We find such forms in the primitive two- and three-tone systems of the Vedas, in the Greek tetrachords, in the pentatonic scale of the Asiatic peoples, the Indians, the Eskimos and the Scots, in the hexacords of Guido Arezzo, in the European seven-tone scale, in the Arabic quarter-tone scale, in the chromatic and in the so-called Gypsy scales with their accumulation of raised seconds, etc.

"Based on a detailed knowledge of all these scales, it would probably be possible to describe the laws of how they are composed as follows: every type of melody depends on the scale on which it is based and one can only fully understand it in the framework of this scale. In Armenian church music, for example, we often find melodies with an "e" in the lower octave and an "es" in the higher octaves. This type of melodic structure, which is foreign to European music, can be explained by the Armenian tetrachord scale which includes the three (mutually penetrating) tetrachords of similar composition (whole tone, whole tone, half tone)

C D E F G A B C D ES

The pentatonic melodic structure must be judged from the same standpoint."

My people, the blacks in America, have grown up with the pentatonic scales and with the pentatonic melodies in Africa and in America. And so we have pentatonic ears, as do other peoples who retain their folklore. Lawrence Brown familiarized me with the music of Mussorgsky and the group of great Russian composers associated with him, the music of Dvorak and Janacek, with old Irish and Scottish melodies, with flamenco and De Falla of Spain, with the music of Eastern Europe, with the Armenian, Bulgarian, Rumanian and Polish, specifically with the songs of Kodaly[3] and Bartok, with the music of contemporary Soviet composers, with the music of ancient Africa, with

the music of S. Coleridge Taylor,[4] with Ethiopian music, with the Brazilian melodies and the songs of the Caribbean Islands which are also constructed on the basis of African rhythms and melodies, with the music of North American Indians.

Thanks to my "pentatonic ears," my interest in the pentatonic basic scales developed further. In this connection the remarks of J. Rosamond Johnson about African and Afro-American music are unusually interesting. In his book *Rolling Along in Song,* he writes:

"The Negro hesitated though for a while, and then full of feeling he hung his banjo up on the wall and found the improvisation for a new style of rhythm through simply hitting the black keys on the piano. His inborn instinct led him to the pentatonic scales. Remaining at the black keys he easily found the five-tone form which is so obviously characteristic of African music."

Here also are the interesting and convincing remarks of Marion Bauer on pentatonics in her book *The Music of the Twentieth Century:*

"The pentatonic, which can be found by playing on the black piano keys, was without a doubt a universal scale which belongs to no nation or race, marks rather a stage of the development of the musical consciousness of mankind. The Chinese and Japanese tended to this for centuries; we are familiar with this through some characteristic Scottish and Irish folk songs; traces of the pentatonic can be found in the music of American Indians and Eskimos just as in the music of the Africans."

And Joseph Yasser, the renowned musicologist, writes in *The Future of Tonality:*

"Despite difficulties in getting genuine reports it is now known that the pentatonic scales are used in Scandinavia, in the British Isles (most convincingly demonstrated), Northern France (Brittany), in Germany (Minnesongs), in some European and Asian parts of the Soviet Union, in some parts of Finland, Rumania, Bulgaria and perhaps Spain.

"Yes, even in the ancient Gregorian chants pentatonic elements are clearly present. In ancient Greece Hebraic cantilena, also full of pentatonics, are among their sources. Experimentation was made with the practical application of pentatonic scales (8th century B.C.), according to Plutarch, although in the Greek theory of music the heptatonic and other scales existed at the same time."

A penetrating article on African music by E. M. Hornbostel, the important authority in the area of African music, appeared in the magazine of the International Institute of African Speech and Culture:

"The rule of the fourths as the framework of melodic phrases and the necessity of the separating in order to reach melodic steps are responsible for the setting up of melodic forms in the whole world which one generally terms pentatonic music." And Bela Bartok wrote in his book *Microcosm:*

"Pentatonic means a five-tone scale without half-tones, or a major scale with omitted seconds or sixths. They are frequently used in the

Christian monod church music and live permanently in three centers with the American Indians, with the Black Africans, and in Central Asia, the most important of these three centers. Each of these created different types on the same basis. The influence of the central Asian center reached as far west as Hungary, as far east as China, and south as far as Turkey."

If the children who still learn modal and pentatonic melodies in their childhood would become accustomed to visualizing the piano as if it were made up of two pentatonic scales or out of two folk songs (with two common helping tones) then the instruction time could be reduced and the schoolwork made easier. Every pentatonic scale is already a folk song in itself. As soon as this musical language becomes as vital to the children as the spoken word, the children can be led to experiment with these two pentatonics and their inter-relationship.

A few years ago while I was in Moscow with my family, we attended a magnificent concert of the opera ensemble from Uzbekistan, which was led by the unforgettable Tamara Khanumova. I remember this day because I was deeply interested in how the ensemble approached the solution of the problem of how to merge the music of the East and the West, and above all how to achieve "genuine" harmonization of the rich and very delicate eastern melodies. If I remember correctly, much of this music was transposed for orchestra by the talented Soviet composer Glière. At one point the Uzbekistan musicians appeared on the stage with their traditional musical instruments, of course to accompany their own folk melodies. I also enjoy remembering my own concert in Gorky Park in 1949 and Tchaikowsky Hall where I had the chance to sing with the "Folk Orchestra." How beautiful were the delicate sounds and color of the ancient folk instruments. For that reason I value so highly the paragraph in Medvedev's article on Khatchaturian which says:

"The richness of colors, unique and noteworthy rhythms, and the many melodic ideas in his handling of the themes mark Khatchaturian as an Armenian folk artist. Yet his music has not remained exclusively within the confines of national music. His compositions have a broad basis and his relentless search for new forms of expression is founded on the knowledge of classical as well as contemporary music. Khatchaturian's experiments differ from Prokofiev's and Shostakovich's because the focus of his interest is different—it is that point where so-called 'Oriental' music and 'European' music meet. His forms, therefore, arouse great interest with musicians of varied backgrounds."

A focus in which Oriental and European music meet!

It is extremely interesting to become aware that in recent years many western composers have returned to the ancient pentatonic forms of folk music and have found new inspiration in these riches, and have based their new compositions on them just as Bach based many of his works on old modal folk chorales. These composers were able to find riches in the pentatonic modal melodies because, as Yasser

definitely proved, a pentatonic harmony also existed, which had a long history, and had developed in China, Africa, and Indonesia, etc., and continued to exist also in Europe till the year 1500. This means that the pentatonic musical system exists, that it had lived before the better-known diatonic seven-tone system which the classical European music generally used after 1700. Nevertheless, this pentatonic system still lives today in folk music. My dear friend and colleague Lawrence Brown also indicated these riches and created many beautiful arrangements of our own folk music.

It is possible that today, after many notable and interesting currents, we are returning to the mainstream of world music—which includes the music of Asia, Africa, Europe and both Americas—in the great future of a musical richness to which all will contribute and from which all will together draw, as from a glorious magnificent bank of world music.

Robeson Urges Government Defend Constitution Against Racists

Daily Worker, September 23, 1957

The events transpiring in Little Rock, Ark.,[1] constitute a bold and desperate attack upon constitutional government. Our national morality and the political integrity of the nation will be tested to the greatest degree in this struggle. No man or woman who loves this country and retains faith in the ultimate realization for all of the concepts of liberty that gave it birth can remain silent. The menacing implications of the theories of white supremacy stand exposed. Little Rock is in my opinion a symptom of the evils of racism that go to the very foundation of this system of government.

The logical consequences of a half century of compromise, procrastination, passivity and uncertainty surrounding the constitutional rights of the Negro people and their dignity as human beings can now be clearly seen. The half-century's failure of the federal government to protect the lives, property and rights of the Negro has produced the imminent danger of bloody racist outbreaks against Negro citizens that cannot possibly be localized should one occur. It has jeopardized orderly constitutional procedure throughout the nation and threatens the solidarity of the Union.

There is but one answer. The issues raised in the fight for Negro rights must be resolved in favor of equal democracy, equal justice, equality of opportunity for Negroes in every phase of national life. The responsibility to institute these forms of race relations rests upon the federal government and every branch of that government. There is no alternative if our country is to be saved from grave internal disorders and our national morality is to retain the last remnants of respect it has abroad.

What excuse can there be for hesitancy? The demands of the Negro people are consistent with the highest character of morality. They have been and remain consistent with the Bill of Rights and the Fourteenth and Fifteenth Amendments to the Constitution. The demands of the Negro people are consistent with the solemn obligations attached to our membership in the United Nations. I believe that history itself has repudiated the government's tolerance of the force and violence that has been employed to prevent the full participation of Negro citizens in the political, industrial and cultural life of America.

It is in this sphere of human relations that the greatest danger to our democracy exists. The unjustifiable attempts to legally lynch the Scottsboro Boys in Alabama, and the young Negro men known as the Trenton Six in New Jersey; the railroading of Rosalie Ingram and her two sons to life imprisonment in Georgia; the legal murder of Willie McGee in Mississippi; and a host of unpunished murders of innocent Negroes logically and inevitably have led up to Little Rock.

The blows that the Department of Justice has dealt those political forces which defended the rights of these victims and persistently called for the enforcement of constitutional liberties and human rights has been as a green light to the unrestricted racists.

The Vatican press has dealt realistically with racial discrimination. "Racial discrimination," it holds, "cannot be excused from any point of view." All who profess it should be deprived of all political rights and not permitted to hold office, it held. "There is no graver crime," the Pope's press states. "It runs counter to nature, to character, to aspirations and to the laws of the United States. It runs counter to the Constitution of the United States, which exalts and sanctions equality of men."

I recall that the racial attacks upon Negroes in South Africa resulting from "apartheid" policies were the object of a resolution adopted by the General Assembly of the United Nations December 5, 1952. A commission was set up to study the racial situation in the Union of South Africa in the light of the "Purpose and Principle" of the Charter and with due regard to Articles 55 (e) and 56 which request members to co-operate with the Organization in order to promote respect for an observance of human rights. The status of the Negro in the USA violates the Charter of the UN and its Universal Declaration of Human Rights. It is my opinion that the leaders of the fight against racism in America should carry this struggle again to the UN.[2]

It is my conviction that a national conference should be called to protest against and to plan a national campaign challenging every expression of white supremacy. No voice should be denied expression regardless of political views.

We stand confronted by a program of evil men which would destroy the last remnants of democracy in America. It has caused the federal government to vacillate and procrastinate in a manner menacing to the interests of the American people. History demands united action on the part of the people of our country to put an end to the myths of

white superiority. Common sense demands that the racists be removed from office; that racism be legally declared a crime and that the Constitution of the United States be defended with all the agencies of government.

Greetings on the Anniversary
of the Great October Revolution
New World Review, November 1957

Warmest greetings on this historic day—the anniversary of the great October Revolution.

In 1934 came the first visit of my wife Eslanda and myself to the Soviet Union. For me it was like a visit to another planet—where the people had no prejudice on grounds of color— where indeed a new land was in being. And now in 1957 the scientists of this socialist land— through their collective socialist effort—open up the probability of an actual journey to other planets.

Through the years, we have watched the phenomenal development of this socialist society. We have seen the birth of the People's Republic of China, of the New People's Democracies of East and West, all immeasurably aided by the power and might of the Soviet Socialist Republics, and the change in the balance of world power between the new defenders of the rights of peoples of all colors and the centuries-long imperialist oppressors of the West.

Today we see the hope for peace striding in seven-league boots toward its realization.

Let us look ahead to years of rich cultural exchange in every field—of exchange of the people's creations of every land.

An abiding passion for me has been the inner knowledge that all peoples are much the same. Certainly their ancient music—classic and folk—stem from a similar source of deep human need.

Surely, in the deep need for our very survival, we shall finally find a way to universal peace, understanding and friendship.

Pacifica Radio Interview
San Francisco, March 15, 1958—Transcribed from tape in Black Studies Department, University of Delaware

ANNOUNCER: Mr. Robeson has been known and loved as an artist all over the world for a good many years, but he has also, I believe, attracted a good deal of attention as a world citizen and as a person who has been very deeply concerned about the society in which he

lives. I wonder, Mr. Robeson, if we could kick off by asking: When did you first become involved in the political aspects of . . .

ROBESON: May I first say how happy I am to be with you here, and how deeply I thank this station for its kindness throughout the years. I've been on two or three others in this time, but I always know that I have a welcome here. So I want to thank you.

I would say, as I indicate in a recent book which is now out—it will be on the stands pretty soon—*Here I Stand*,[1] the story of my life, as I tell it—it's not too autobiographical. It began when I was a little boy in Princeton, New Jersey. Strange to say, technically this is the shaping of my views—a Negro boy, born in Princeton, New Jersey, in a college town, where the students mainly came from the deep South. Princeton—in Princeton, Harvard and Yale—was sort of the Southern university in the North, whether you know that or not. And so I grew up in Jersey, in a rather Southern atmosphere, and my father was a minister, and I was shaped against that background. Technically, I entered the fight for social justice for my people in a concert in St. Louis in 1947. It's in the *Post-Dispatch.* I was singing at the Kiel Auditorium, one of the big auditoriums there, and the NAACP asked me in St. Louis at that time to come on a picket line, because Negro people could not sit in the theater across the street. And so I grabbed a banner, and behold, I saw Walter Huston coming down the street. He was in the play—so Walter walked out and joined the picket line, too.

A few nights later, when I was doing the concert, I said that I could not quite resolve the contradiction between singing to an audience in St. Louis, where there was no segregation, of course, but also, to my mind, the same people were not fighting to see that they could sit in the theater. It's been corrected since. And so I said that I was giving up my career, technically, for the moment, to enter the realm of the day-to-day struggle of the Negro people, especially. . . .

ANNOUNCER: And this was your first political action?

ROBESON: No, that was within this context. It's very important to get it in context. My first actual involvement—to get back to your question—was in London in 1933. It isn't very well known, which I clarify in the book, but I went to play "Show Boat" in London in 1928. Kern was with me, and Oscar Hammerstein. We had a great success. Then I did concerts in 1928, and I became domiciled and lived in England—paid my taxes there—from 1928 until 1940, after the war began.

ANNOUNCER: Does this mean, Mr. Robeson, that you spent most of your time in England during this period?

ROBESON: It meant that I came back now and then for concerts. I was here in Oakland many times. But I went back and spent most of my time in Great Britain.

ANNOUNCER: Why?

ROBESON: I was there in 1930—played "Othello"—so again, this is extremely important. At that time I said, for the public to see, that I—I would explain it today in this light. We understand why many of my

people have come to Oakland and its vicinity from Mississippi, and from the South. There have been migrations into California, you understand, today from everywhere—but for many years, many of my people have left the South, because conditions in the North were better. I felt the pressure so much in 1928 that instead of stopping in New York, I just went on to London.

ANNOUNCER: But you felt no pressure there, in the racial sense?

ROBESON: I felt nowhere near the pressure. Now, that doesn't mean that you don't have the background of the English colonies, and so forth—but I say, its the difference between right here, now, and the Mississippi of Mr. Eastland. This is quite different. America is quite different. There are great differences. So I found England that much more of a difference, that's all. I found Canada that way. When I was playing Othello some years ago, when we got to Toronto, the cast said to me after a week, "Paul, why are you so different? The play is much deeper. You seem to be freer." I said, "That's quite true—quite true. I mean, a country where—this is not a question—I'm in a theater, on a stage with many white actors. This is not a problem here. So obviously I feel freer. I don't feel the pressures that one would feel in the Deep South all the time." But it would interest you to know that I—and I feel that any Negro, if he were honest, would have to say that in our democracy at present, that he is never, for any one second, unconscious of the fact that he is a black American. He can never be unconscious of it in any part of the United States.

ANNOUNCER: Mr. Robeson, have you been back to England since the last war?

ROBESON: Oh, yes, I was back in '49.

ANNOUNCER: The point I wanted to get at is that when I was in England last year, we were aware of the large number of West Indians who were about in London, and I heard rather nasty overtones in my talks with some Englishmen that frightened me, about a change that might take place in England.

ROBESON: Again, if you want to go further, nothing could be worse than South Africa. I am only saying—and I put these things down—is that having lived many years out, and enjoying certainly the height of success in Great Britain, I decided that I must come back to my own country, to struggle in this, and to make the sacrifices that I have. That is most important in this regard, and I am here.

ANNOUNCER: Now wait—spell this out again for me. You left England because it was not as attractive, or because you have a greater mission in the United States.

ROBESON: No, no, no, no. Let's don't get into that. There are many places in the world where, personally, it would be much easier to live than in the United States, for an American Negro.

ANNOUNCER: In other words, your commitment is definitely to what you feel you can do in this country?

ROBESON: That's right. Langston Hughes, in a discussion before a book club in New York, just a while ago, said that every important

Negro novelist—not only Richard Wright, but many others—that 95%
of them live in Paris or somewhere else in the world. Why? Because the
pressures, personally, are much simpler.

ANNOUNCER: And yet in the foreword of your book that I have before
me, you quote Frederick Douglass as saying, "A man is worked on by
what he works on. He may carve out his circumstances, but his
circumstances will carve him out as well." Is this part of the reason
why you feel that you must be back in the United States?

ROBESON: I made this decision some years ago. I say certainly that I
sprang essentially from here. Like you heard the other day about the
Indians in North Carolina—if you recall, that was in Robeson County.
Now, this is a very interesting thing, which I point out in my book and
which explains a good deal, too, of how I feel. Now, I was born on the
edge of Robeson County and my father is a Robeson, and was a
Robeson, because he was a slave. My own father—a slave of the
Scottish Robesons, who still control Robeson County in North Caroli-
na. So I approach these problems from a very close point. But I have a
home and my people are tobacco workers and sharecroppers today on
plantations in that county, but a part of that soil belongs to me. These
are my roots in this country. On the other hand, I felt that I could make
some contributions from my background, traveling about the world.
However, I never expected, I am quite willing to say, that I would be
restricted from traveling.

ANNOUNCER: Tell me, Mr. Robeson, was your commitment to the
political scene, then, largely as a result of your feeling about your own
people, or our own people, let's put it, or did it have other overtones, or
political convictions?

ROBESON: First it starts as an American Negro, interested in my own
people. The other great change is very constant in my mind. I was in
the Welsh valley, and the Welsh people sing very much like we do—the
Negro people—in many of our songs—beautiful songs. And I was one
of the few outsiders who sang at their national festival, which has
gone on since the time of the Druids. And I went down into the mines
with the workers, and they explained to me, that "Paul, you may be
successful here in England, but your people suffer like ours. We are
poor people, and you belong to us. You don't belong to the bigwigs here
in this country." And so today I feel as much at home in the Welsh
valley as I would in my own Negro section in any city in the United
States. I just did a broadcast by transatlantic cable to the Welsh valley,
a few weeks ago, and here was the first understanding that the
struggle of the Negro people, or of any people, cannot be by itself—that
is, the human struggle. So I was attracted by and met many members
of the Labour Party, and my politics embraced also the common
struggle of all oppressed people, including especially the working
masses—specifically the laboring people of all the world. That defines
my philosophy. It's a joining one. We are a working people, a laboring
people—the Negro people. There is a unity between our struggle and
those of white workers in the South. I've had a white worker shake my

hand and say, "Paul, we're fighting for the same thing." And so, this defines my attitude toward Socialism and toward many other things in the world. I do not believe that a few people should control the wealth of any land—that it should be a collective ownership in the interest—

ANNOUNCER: Is that a democratic Socialism—or—?

ROBESON: It would have to be a democratic Socialism. There are many ways, however, to struggle toward democracy, as I see that—in a place like China, for example, today, or the Soviet Union, or many other places, or take our own problems of Negroes. If we were free in the South tomorrow, to carry our weight, to vote, and do everything, would we now look around and try to find the ten billionaires among our people? Would we attempt to build them up, or would we try to answer the needs of the great millions of our people? And so I see other ways of life—Socialism—as trying to solve the problems of millions, and tens of millions of peoples, at once, in a way, instead of—we would start from the individual to the masses. They start from the masses this way. Now, there are two ways, and there are difficulties each way. I have made the decision to join in a collective struggle, and the reason that my personal sacrifices mean very little, in one way, when you see the children at Little Rock—what does not giving a few concerts mean, when you can make some contribution? It's in that context. So nothing is perfect in the world. We're going toward it from different angles. I feel there's a great burden of proof on every society—on our own, as well, today.

ANNOUNCER: Mr. Robeson, some years ago, I was talking to a French member of the Communist Party, and in the course of our discussion, he said to me: "You, Mr. Winkler, are a Jeffersonian Democrat. You can afford it in your rich land. But in my land, and in other lands, we must give up our freedom now to certain men in order to achieve freedom for our children in the future. This is an act of faith for me," he said, "giving up my freedom now." Do you find yourself sympathetic with—?

ROBESON: I don't think that is—I would put it quite differently—no—nor do I think that's any part of any Socialist philosophy or Communist philosophy, as far as I know. We struck it during the war, under Roosevelt, for example. We had to give up many privileges. They're practically telling us we have to do that again—in any war economy. In England, for example, they have not eaten eggs almost for years and years, because of certain pressures. It seems to me in the Socialist lands—the Soviet Union, China, and many places—that's quite true. It's one thing to say today they don't have as shining apparel as we do, but they have made tremendous scientific progress and within one generation—so to speak—within 40 years, have become one of the most powerful countries in the world, and have done it by great sacrifices, and not by—to my mind, they feel that the country, in one sense—the man in the street—it may not, in every essence, belong to him, but he feels it's much more his than, say, I do in Charleston, South Carolina. When a Southern American Negro ex-

plained to me that I was in the state of *our* great plantations, I said, "Are you sure about that? *Our* great plantations? I don't feel that they're *my* plantations." But in one sense, some of the people of the Socialist lands feel that the country does belong to them, in a real sense. Now there are—as far as the basic concept of the dictatorship of the proletariat, and so forth, I would say again, bringing it back to our own history, there was, as we know, a dictatorship of the North over the South in the days following the Civil War. When that dictatorship was removed, the colored people reverted into a kind of servitude. I could have conceived of a dictatorship over the South for quite a longer period, from my point of view, quite frankly. So this is understandable.

ANNOUNCER: In your book, Mr. Robeson, *Here I Stand,* you have a chapter entitled, "The Power of Negro Action."[2] What are some of the specific acts which you recommend, and perhaps in the order of priority?

ROBESON: Well, it seems to me rather startling to many of my friends. Nobody would be startled, say with taking the vote—the power of Italian action, or Polish action in Detroit, or Catholic action in New York, and so forth. I mean that the vote would be a bloc. And the power of the Negro vote in the North in certain states—this is one very important aspect. We have tremendous economic power in this land today. There should be tremendous support of Negro business, of Negro banks, loan associations, and so forth.

ANNOUNCER: Taking this last illustration of yours, have you not found that as Negro bankers become richer, that they grow away from your people? Or do they remain a part of Negro action?

ROBESON: There is no way, as I said before, for any American Negro, however wealthy, however famous, to be anything at this period of our history, at some point, than an American Negro. If he doesn't know it, he'll find it out.

Millions of Us Who Want
Peace and Friendship

Moscow News, September 17, 1958

First may I express my deep pleasure in greeting the readers, the Editor, and staff of *Moscow News,* and of *Nouvelles de Moscou*—for I am a fellow-reader.

At this moment I am in Yalta.[1] I have had a wonderful visit and rest in a beautiful sanitorium, and am about to return to Moscow and then to London.

For years I have read about the Crimea—its beauty, its history—and each day has had its precious moments.

How awe-inspiring and yet heart-warming to visit the home of the immortal Chekhov,[2] to walk in the garden, to stand by the table where

he worked, to sit on the bench where he often sat with Gorky,[3] or Chaliapin,[4] or Stanislavsky.[5]

How wonderful was the opportunity to visit "Artek," to spend hours with these children of the future.

And a great honor and pleasure to meet many friends, among them the wise and devoted leaders of the Soviet people, as they build their great land.

And everywhere the deep desire to live in *Peace and Friendship* with all peoples. And how happy they are to meet us who come from America, to find that there are millions of us who want peace also and friendly cultural exchange. Many delegates are also here from England, Scotland, and Wales, and many friends from India.

And one day, who should appear but my dear friend Rockwell Kent[6] and his wife Sally. As you know Rockwell is one of the world's foremost painters and a devoted fighter for peace and understanding.

As has been clearly stated in my book *Here I Stand,*[7] my forefathers came to America with its first inhabitants. And for generation after generation they toiled and labored to create the land that we all want to be the "land of the free."

It is also common knowledge to us all that the struggle still continues. My people, the Negro people of North America, are not yet free citizens, but one day they are determined so to be.

Certainly the very essence of loyalty to one's land means the exerting of every effort to bring the fruits of their toil to all of its citizens. And there exists also a responsibility upon those in public office to be loyal to those who have chosen them to guide, in the time they are in office. Is Governor Faubus[8] fulfilling his sacred responsibility to the Negroes of Arkansas, or Senator Eastland[9] to the Negroes of Mississippi?

Can an American Negro be declared disloyal for opposing these kinds of demagogues, for insisting upon full democratic rights now for the children of his people, for demanding full human dignity?

Intertwined with the struggle of the Negro people in America is the magnificent struggle of hitherto colonial peoples for full liberation—in Africa, in the Near East, in Asia, in Latin America.

Can an American be disloyal in fighting for the very same rights that were the goal of our Founding Fathers in the days of the American Revolution?

Can one be disloyal because one fights for peace and friendship with all peoples?

In 1934, on my first visit to the Soviet Union, I felt for the first time in my life a full human being. Here was a nation whose history and future made clear that it would be the friend of colonial peoples struggling for liberation. Recent events have supported fully this deep faith and belief.

So I am proud, deeply proud of my friendship with the Soviet people, and proud to belong to that America (the real America) that wants peace and human brotherhood.

I shall hope to return many times again to the Soviet land.

And I hope to greet the readers of this paper in many lands in the near future.

All the best to you and all the best to the paper which brings us together.

"My Aim—Get British and U. S. People Together"

George Matthews, *Daily Worker* (London), May 5, 1959

Paul Robeson, in an interview with the Daily Worker yesterday, made a strong plea for the ordinary people of Britain and the United States to get together, and spoke of the part he hopes to play in bringing this about.

"Since Mr. Dulles and Mr. Macmillan[1] can get together," he said, "the American people ought to get together with those in other countries.

"There is another America besides that of Mr. Dulles—progressive America. I am very proud to be part of that America. I want to play my part in establishing contacts between that America and the people of Britain."

Dealing with other reasons which have led him to decide to make London his cultural centre, Paul Robeson said that much of his political development had taken place against the background of life in Britain.

"Here I came in contact with the struggle of the Indian people and those of other Colonial countries. I speak of these matters not as a stranger, but because I have lived and grown up with them. It is natural that, returning after nine years absence, I should plan to spend a good deal of my time working here."

Some comments in the Press had implied there was something strange about his decision. But British actors spent long periods in the States.

American violinists and conductors like Isaac Stern and William Steinberg spent long periods in Britain.

There was nothing strange in working from London and travelling to and from America.

"I have had a wonderful welcome in Britain, and have already done several concerts," said Paul. "I have received hundreds of letters, and would like to thank most warmly all my friends in Britain for their kindness.

"In addition, I have been able to appear before millions of people on television here. But for progressive American artists there are very few opportunities to appear on television."

Turning to the question of why he had been prevented from coming

to Britain all these years, Paul said that this was linked to his deep responsibility to the Negro people in the United States and their struggle to become first-class citizens—as in Little Rock or Montgomery.

"I have been very close to the working-class movement in America. I see the solution to these problems through the basic unity of the working class.

"While I am in London I am standing on call to go back at any moment to take up the struggle again, and I hope to make trips back and forward to America."

"My work as an artist," he continued, "is not in any sense divided from my political work. What I do as an artist is closely bound up with the struggle for a better world.

"As an artist my beliefs have been formed in the examination of folk songs and in discovering the likeness between the Hebridean, African and Chinese folk songs.

"This led me to an examination of the cultures of various peoples. My studies in this field led me to much of the political understanding which I have achieved over recent years."

"Before everything else I stand for peace," he went on. "We must prevent the disaster of a third world war."

The British people had helped the people of America in many ways. Outspokenness on the question of China had greatly strengthened the forces of sanity in the United States.

Such help gave strength and encouragement to millions of people who were afraid to speak out.

On Little Rock, Paul said that the Supreme Court had made its judgment.

"Faubus' actions cannot be allowed to go through. The real issue is whether the Administration and the people will defend the rights of citizens of the United States and whether they will take the necessary steps to protect those rights in the South."

Asked his opinion about the race riots in Britain, he said that he was glad that the majority of the British people, and especially the Labour movement, recognise the need is for unity of all peoples.

He was sure that they would not allow continued attacks on West Indians and Africans, since this was against the interests of white citizens also.

Since he came to Britain, said Paul, the Press had often asked him to confirm or deny that he was a Communist.

"This question of refusing to say if one is a Communist is an important part of the battle for civil rights," he said.

"If you start demanding the right to know whether a person is a Communist, or a Republican or a Democrat, then you are taking away one of his most fundamental rights.

"As I told one of the investigating committees in America—'If you want to know whether I am a Communist go and take my ballot out of the box and see.'"

The Communist Party of the United States was a legal political party, he went on. The Supreme Court had established that its members all through these past years had had the right to propagate their ideas, and that they were not conspiring to overthrow the state by force and violence.

"I have travelled in many countries, and wherever I have gone I have always laid a wreath on the tombs of those who laid down their lives in the battles against fascism. And every time I found that Communists were among the first to do so."

Paul expressed great pleasure that among the people of Harlem, N.Y., 6,000 signatures have recently been collected to support the candidature of a friend of his, the prominent Negro Communist leader Ben Davis, for the New York State Senate.

His recent visit to the Soviet Union had shown him what tremendous growth there had been since he was first there in 1934, and since his later visits in 1939 and 1949.

In Uzbekistan as much progress had been made as some people in America and Britain envisaged taking place in Africa over hundreds of years.

For Daily Worker readers and shareholders Paul had a special word. He wanted to congratulate them on the fine plant and building that they own, and was sure they would do everything to maintain it.

He expressed thanks to readers of the Daily Worker and to all the people of Britain for the help and encouragement given to the progressive movement in the United States during very critical years.

As his face lit up with that wide warm smile with which so many people in Britain are now as familiar as they have been with his voice during the years of absence, he concluded by saying: "It was the most heartening experience during those years of difficulty to know of your concern with us in America, and your readiness to help us."

With Eslanda and officials and executive committee members of the Musicians' Union of Great Britain on first visit to England after restoration of passport in 1958

After receiving honorary degree from Humboldt University,
German Democratic Republic, October 1960

THE LAST YEARS

"I'll Be There" Pledge by Robeson—
Birthday Message to DW

Bob Leeson, *Daily Worker* (London), January 14, 1960

When the Daily Worker 30th anniversary celebration takes place in the Albert Hall on March 13 Paul Robeson will be there.

In a wide-ranging interview with the Daily Worker yesterday, the great Negro singer expressed his happiness at being in Britain, and his pleasure at being able to attend the paper's birthday.

"I think it is very important for me to be with you at this time," he said. "With all that has happened in the last years in the fight for Peace I have felt very close to papers like the Daily Worker.

"I know that I would not be in Britain today but for the struggle put up by people here, and the support of all sections."

Speaking of his 18 months in Britain, and especially his season in "Othello" at the Shakespeare Memorial Theatre in Stratford, he said: "I feel I have reached the beginning of another stage of my life.

"When I was on the stage here, I always had a feeling of tremendous responsibility to my own people, the Negroes, and to the workers here in Britain and throughout the world.

"But I have never been met with more warmth than here in Britain. I felt it at Stratford, when young people who had never seen me before came to the theatre. I felt it out on the streets, in the trains."

Mr. Robeson said that during his series on the radio, he had thousands of letters from people all over the country.

They said that they felt during the programmes as if "you and Mr. Brown (his accompanist) were right there in the room with us."

He felt, he said, that he was a product of the British working-class and progressive movement. "I came here unshaped. Great parts of my working-class roots are here."

It was in Britain that he first became aware of the African struggle. Here he became a part of the struggle of the whole continent of Africa and learnt about the Indian people, the people of the East and of China.

"The reception that I have had here has passed all bounds. It is something that could not happen to some visiting artist who just dropped in after ten years.

"It is something that reaches beyond art. I feel that a battle has been fought and won. Now I feel that I can relax.

"After those ten years being chained, I feel it has been proved that those who tried to keep me down are not all-powerful. In the end the people are more powerful. That has been proved.

"I feel great. When people who have not seen me for a long time say: 'What's happened to you?', I say: 'The load's off.'"

His programme is mapped out for the year ahead, he continued. Another trip to the Soviet Union, a tour of the British Isles in the early spring, another series on the radio, and singing for the miners in Scotland and Yorkshire.

"And I want to get down to my study of music—of the teaching of music to children," he added.

"In my experience, music should not be thought of as inaccessible to the mass of people. I feel musicians have made a bit of a cult of it. They have convinced many people that to learn about it is like going into the field of atomic physics.

"I feel that modern musicians can solve the problem and get out of the corner they are in by going back to folk music, rather than trying to create a new musical language out of their own brains, for there is a language of folk music which is universal."

As one who has suffered under racial persecution, Paul Robeson expressed himself particularly strongly about the anti-semitic outrages in West Germany and elsewhere.

"When I hear of these anti-semitic acts, I feel 'This is where I came in,'" he said. "Some of my first work here in Britain, in 1933, was singing in aid of Jewish refugee children.

"I was shaped, myself, in the struggle against fascism. I was at Dachau after the war.

"As an American Negro I know what that means. For what happened there can't be dissociated from what happens in the Southern States of America and in South Africa.

"But the responsibility rests on people all over the world. I see in Britain a sharp awareness of the dangers. And what happens among the mass of British people has a very great influence in America. A new feature today is also the existence of the German Democratic Republic and its work for peace.

"The responsibility rests on us as well as the German people.

"The nazis wouldn't have the nerve if they did not know that the West German Government was being propped up by other Western Governments.

"It is a very sobering fact that the restoration of fascism should have become a central part of our foreign policy.

"This persecution is not just a Jewish problem, for it could lead to the destruction of the world.

"My grandchildren are half-Jewish, so I feel it particularly. Whoever attacks a Negro may attack a Jewish boy, and vice-versa.

"The whole business cannot just be passed off as the act of a few nitwits."

As he spoke on these questions on which he feels so deeply, Paul Robeson was vehement, urgent and serious.

But as our talk ended his face lit up again with that great warm smile, and he said: "Give my greetings to the readers of the Daily Worker and tell them I'll see them on March 13."

Come and See for Yourself

Moscow News, February 24, 1960

This has been a truly exciting visit. Most important of course has been the opportunity to see the intense concern for peace: to hear workers—peace fighters, scientists, artists, farmers—voice their full support of the Decree reducing the strength of the armed forces, as a first step toward full disarmament.

No one can ever doubt for one moment the determination of the Soviet people to find peace, to end war.

And as the days of peace are promised for the future the Soviet citizen gives all of his thought and energy to the fulfilling of the Seven-Year Plan. The success already gained within the course of one year is astounding.

Again there can be no question—nor doubt. The Soviet Union moves surely and swiftly toward the realization of a Communist society, where each one gives according to his abilities and receives according to his needs.

What an historic leap. I remember my first trip in 1934. Who could believe then, that this people would be speaking of moving into the Communist society.

Just recall the long attempts to crush this state in the early days—the sufferings in the war against Hitlerism, the long period of the Cold War always threatening to become "hot."

Dangers still remain from some few would-be-makers of war, but the people all over the world are no longer ignorant. The policies of nations are put into the public arena for all to assess. The foreign policy of the Soviet Union has seen to that. And the trip of N. S. Khrushchev to America certainly rocked the land and many others to their foundations. The Americans saw for themselves, day after day on television, in person, the dynamic, humane, warm personality of the Soviet Chairman of the Council of Ministers and Secretary of the Central Committee of the Communist Party of the Soviet Union. He is now greeting friends in many Eastern lands to cement friendly relations. Clearly he works in the interest of peace and abundance for his own people and for all of human kind.

This is the way a Socialist land moves from a "position of strength." It moves not with threats of destruction, but with deeds leading toward universal peace.

This time I have had an opportunity to meet the Soviet workers at first hand not just from the concert or theatre stage. In the factories—

in their clubs. Also to meet great sections of the youth; little children; professional and scientific workers; and I have often gone to see friends in their warm, cozy and friendly homes.

The Soviet citizen is sure of his path—of his accomplishment of a glorious future for his society. He is modest, smiling and sure.

Yes, there will be difficulties to be overcome. But just remember how many difficulties he has already overcome.

He has unbounded faith in his science, in his system of education.

He is solidly behind his government and its outstanding leadership, a leadership of world stature, and rightly so.

Come and see this exciting Socialist land. Visit other lands of Socialism. Come and see these peoples at work—talk to them. You will see something extraordinary. You will see a new kind of human being—one shaped in conditions where deep concern for others is basic, where there is a sense of real togetherness, joined with deep concern for the highest development of individual excellence and initiative.

I have been to the Soviet Union many times—the last some months ago, just before I appeared in "Othello" at Stratford-on-Avon last April. It is impossible to keep up with the swift changes and leaps.

My family and I are very happy and proud as we see the advances of the Soviet people. We know that the power and influence of the Soviet Union and the Socialist world will support the struggles of people everywhere for full rights and independence.

This we sensed and knew in the early days of 1934.

And the whole world knows today that the Soviet people only want to share their knowledge—to help create abundance for all of humanity—to create a society abundant and rich materially, spiritually and culturally.

Let us in our various countries in all lands—contribute our share to everlasting peace and friendship between nations.

Interview with Press, Berlin,
German Democratic Republic

October 1960—*Days with Paul Robeson,* published in connection with Robeson's visit to the German Democratic Republic on the invitation of the President of the German Peace Council and the Vice-President of the Academy of Sciences, Berlin—Paul Robeson Archives, Berlin, German Democratic Republic

One correspondent asked Robeson what was his impression of this particular visit to the German Democratic Republic. He answered:

I am very, very happy to be here with the press of the socialist lands. I will be able to tell my people about what I have seen here in your republic. What warmth I have received in the name of my people. You

want to see my people in America, in Africa, everywhere, able to work in full dignity. Your government and leaders speak of full disarmament and peace in the world and I am sure that we shall speak of these things today. I will treasure this programme from last night—'Paul Robeson sings for the young people of Germany'. This I have longed to do. They sang for me, and very beautifully too. It is one of the experiences I shall remember. The young people may know that not only myself but many of us, white and black and all colours in America are going to stand by them as they struggle for peace.

Answering a question from one correspondent as to who were the true representatives of America, Robeson said:

I would say, the America of Lincoln, which freed the Negro people, the struggles for independence in the Civil War, Frederick Douglass, one of the great Negro leaders, and Harriet Tubman, who built the underground railroad by which people escaped from slavery. I would also say, Franklin D. Roosevelt. The Roosevelt who said that we must recognise the necessity of the struggle against fascism, and the Roosevelt who said that on the banks of the Volga in Stalingrad (where I stood in 1958) civilisation was saved. The Roosevelt who realised that the world had changed, and that we, the American people and the people of the socialist lands would be living in friendship and in healthy competition.

The very basic thing to consider is what the forces are that want peace; who the people are that say: Get your bases out of here, you folks from the Pentagon or who say: Let's sit down with Khrushchev, we know that he is honest when he says: "We want disarmament in the world."

A very important phase is taking place in Great Britain today. There are also millions of people in America who are saying: Let's end nuclear rearmament. Indicative of this feeling is for instance the very important movement led by Dr. Linus Pauling.[1]

Another newspaperman asked: "What do you think of Mr. Khrushchev's proposal at the 15th session of the General Assembly of the United Nations to give all colonial and dependent countries their freedom and independence?"[2] Paul Robeson answered:

This is certainly one of the most important pronouncements that could be made in our time. Clearly if these nations were independent the danger of war would be lessened greatly. But from the point of view of people like my own in Asia, in Africa and in Latin America, who have been a subject people, stepped upon and persecuted literally for centuries, we are certainly deeply thankful to Mr. Khrushchev. The most important thing to do, it seems to me, is to act upon this suggestion. Of course, the colonial peoples know that it is not likely to be done, but that is all the more reason to really struggle and see that the colonial people win their freedom as soon as possible.

It is quite clear from the position of the Soviet Union as to Cuba[3] and to Africa that there can be no question how the power of the Soviet peoples and the lands of socialism is used, namely, for those struggling for peace and national independence. It is for that reason, may I add, that I am here in the German Democratic Republic, that I have visited the Soviet Union many times and will continue to spend at least half my life, that is left to me, in the socialist lands. May I repeat once more, especially from this vantage point in East Berlin, that I am, as an American, devoted to my land, to the decent traditions of America, and that I am a friend, was a friend, and always will be a friend of the Soviet people and the peoples of the democracies of socialism.

To the question: "Have you found any traces of racial discrimination in the G.D.R. or in other socialist countries?" Robeson answered:

It has been my privilege to visit many lands of socialism. And everywhere I have never found any kind or form of race discrimination.

I also know that the very basis of your society could not lead under any circumstances to such phenomena. There may be some remains of race discrimination here and there but I certainly have not seen any. I myself feel very close to the problems of the Jewish people. As a matter of fact, I was in Dachau in 1945, at the end of the war. I came over to sing for the troops who had fought against fascism.

There I saw the death chambers and the ashes of some of the victims. I remember the ashes of my people not only in Africa, but in the states of Mississippi, in Alabama, in Georgia, in the whole slave South. Hitler had a chance to learn something from them and these experiences in Germany and in the USA can never be separated in my mind.

It happens that my grand-children are part-Jewish, so that I am particularly concerned that the struggles of the Negro and the Jewish people become united.

I am very deeply grateful to you here in this part of Germany for your understanding of these problems. But we also know that there are also many brave fighters in West Germany, who fight against racial discrimination despite the greatest difficulties. I imagine it is pretty hard for you to understand that there are many people even in the deep south of my land who share similar aspirations. I wish to conclude my interview with the words of Brecht,[4] with which he addressed the Peoples' Congress for Peace in 1952:

The memories of mankind for its suffering is amazingly short. Its idea of sufferings to come is even less. The description which the New Yorkers had of the horrors of the atomic bomb apparently hardly frightened them at all. The people of Hamburg, although still surrounded by ruins, hesitate to raise their hands against the danger of a new war. The world-wide horrors of the forties seem forgotten.

It is this apathy, its extreme form being death, which we must fight against. All too often we have people today who appear as if dead, like people who have already behind them what actually is before them, because they do so little against it. Yet nothing will convince me that it is hopeless to side with reason against its enemies. Let us repeat again and again what has already been said a thousand times, because it cannot be said once too often. Let us renew the warnings even if they taste like ashes in our mouth! Because mankind is threatened with wars compared to which past ones seem like miserable attempts; and they will come without the slightest doubt, if the hands of those, who openly prepare for them, are not smashed.

"N. Z. is Marvellous, I Want to Return to Its Warmth"—says Robeson

The People's Voice, New Zealand, November 13, 1960

CHRISTCHURCH: The great Negro singer and peace-fighter, Paul Robeson, hopes to come back to New Zealand early next year—not on an expensive concert tour but to meet the working people of New Zealand and to sing to them at prices they can afford.

This is what he told the People's Voice in an exclusive interview here a few hours before he left on TEAL for Australia.[1]

"In New Zealand I have felt very close to my audiences," he said. "Here I have received the warmest receptions of my whole life.

"I believe that they have been due to a number of reasons. For over thirty years I have received letters from New Zealanders, including some from children," said Mr. Robeson. "Many people, some of them now elderly, have been waiting a long time to hear my singing.

"It has been obvious that many working people went outside their budgets to attend my concerts.

"I was very sensitive to the warmth of these receptions, and the sympathetic audiences enabled me to expand as a human being with the result that my concerts here have been the best I have ever done," he said.

He had been very glad also to find and meet the progressive peace forces and to be able to talk and sing to the workers on the waterfront and in the railway shops.

"Of especial interest was my visit to the Maori Centre[2] in Auckland," said Mr. Robeson. "I want to learn Maori songs and as much as I can of the Maori language.

"So I guess I will have to come back, and that will give me a chance of meeting many of my good friends again," he said.

New Zealand seemed to Paul Robeson to be one of the few of the dwindling countries of the West in which civil liberties still meant something, and he was glad to observe that many people came to his concerts accepting him as a human being and as an artist, although not necessarily agreeing with his views on world affairs.

For that reason he had developed a particular affection for New Zealand and this made him all the more anxious to return.

He said that he would try to come back in six months if possible, and he hoped that he might be able to stay for three to four weeks.

Mr. Robeson said that he expected to be in Indonesia possibly in the early part of next year, and this would give him a good chance of making a return visit to Australia and New Zealand.

Intimating that this was likely to be his last extensive concert tour, Mr. Robeson said that he hoped to devote much more time in the future to the progressive forces throughout the world and to world peace.

He was firmly convinced that the Soviet Union and the other socialist countries not only stood for peace but were striving to the utmost to achieve a permanent basis for peace.

As far as the Western world was concerned such a basis meant living in peace with the Soviet Union. Therefore, it was necessary for the peoples of the Western world to know as much as possible about the Soviet Union and its principles.

The only papers which told the truth about the Soviet Union were the Communist papers.

"That is why I have sung for the Daily Worker in Britain, for l'Humanité in France and for the Communist press in Scandinavian countries," said Mr. Robeson.

"If I were invited to sing at a People's Voice rally in New Zealand, I would be proud to do so," he said, when it was suggested that his next year's visit might coincide with the date of the annual People's Voice picnic.

Finally, this man, who is first and foremost a mighty fighter for human rights and human dignity everywhere, in addition to being one of the world's greatest artists, stressed the need for continuing the struggle against fascism.

Despite all the talk about NATO[3] and SEATO,[4] both these organisations were fascist in content, he said.

But there was cause for great optimism. Although the leaders of the United States were completely reactionary in outlook, he did not think they were as mad as the Hitlerites when confronted with the fact that the only kind of a world they could hope to inherit by world conquest would be a world of ashes.

And he was proud of the great struggle of the African people for freedom and independence, a struggle which could have only one ending and whose success could play a decisive part in the full emancipation of peoples everywhere in the world.

"The People Must, If Necessary, Impose the Peace"

Peace Action, Sydney, Australia, December 1960-January 1961

> The following statement, sent by Paul Robeson to the Melbourne Peace Conference, expressed in essence his message for our movement. . . .

How good that during this Conference, it is our great joy to be here with you in Australia.

The last weeks have been deeply moving and inspiring ones.

We have met so many of you who are actively engaged in making Peace on This Earth a reality.

We certainly feel ourselves a part of you on this historic occasion.

Our deepest thanks to you, here on this continent, for your untiring efforts, and for the deep and wide influence you exert upon all the people of your land.

These very days, and the days ahead, are of utmost importance.

In America, the people are groping, earnestly seeking for honest guidance in solving most perplexing and soul-searching problems.

Again the Negro people, the Americans of African descent, struggle courageously and with fierce determination toward some measure of full citizenship which is still denied them one hundred years after the so-called Emancipation.

The American labouring folk of all groups face stern economic realities, under stress and strain.

One can be certain that they will uphold their militant traditions and close ranks against the same forces which dared to challenge Franklin Delano Roosevelt.

We shall soon hear some of the songs of other days of struggle for the defence of our sacred constitutional liberties for an America of Peace and Plenty . . . songs like . . . "Which Side Are You On," "Gonna Lay Down My Sword and Shield," "Walk Together Children."

Yes, at these fateful moments in human history, in the history of the whole human family, we must gird ourselves anew, find new strength to labour incessantly in every way possible on every front. Labor, the Worker, the Scientist, the Artist, the Writer, the Women, the Youth of all lands . . . to win and to Guarantee the Peace.

As dangerous as it all seems . . . and is . . . (this no one can deny), yet in the main we are still dealing with sane and healthy people all over this earth.

They may be slow to understand, they may be timid and reluctant to challenge the seemingly "powerful"; but we have seen the people rise in their might time and time again.

We have seen in a short life span, unbelievable courage and

determination when the task is clear . . . when the challenge to stir, to move, to charge ahead is unavoidable.

As Joliot Curie said in 1949. . . .

"The people must, if necessary, impose the Peace."

In these days of 1960 it has become necessary to the peoples of many lands to impose the Peace.

As I have said on many recent occasions, I deeply and firmly believe, and know, that the people of the lands of Socialism want peace dearly, need peace.

They remember at very close hand what the terrible ravages of war mean.

Some of our people in other sections of the world have never been so hard hit.

Despite common suffering an even greater responsibility lies upon us to guarantee our children and to all children everywhere, that we shall do everything in our collective power to restrain our "would-be" hot-heads, our "would-be" world dominators, our "would-be" new masters of the century.

They must understand while we are uttering the very words "A new day has dawned in Africa, in Latin America, yes in Asia, and this light awaits just beyond the horizon."

Among the hard toiling, working masses, among the whole citizenry of all the hitherto dominant lands.

Yes, my folks march in America, crying out for liberty.

They march in thousands; they march to and from Aldermaston[1]; they march for peace in New York; they cry out for a decent America in San Francisco.

You gather today, and in days to come to let those in power understand that the human race, yes, the whole of us, Black, White, Brown, and Yellow, yes, all of us . . . are on our way to a victorious imposing of the peace . . . in the end final Peace . . . Complete Disarmament . . . on the way to living in peace, friendship and understanding with our neighbours . . . no, more than neighbours . . . with our brothers and sisters.

Is this possible and realisable? . . . A thousand times, YES.

Speech Delivered at the Funeral of Benjamin J. Davis

New York, August 27, 1964—Paul Robeson Archives, Berlin, German Democratic Republic

We are gathered here tonight to say Farewell to a great son of our people.

To me has come deep grief at the loss of a precious friend, whose courage and dedication to the Fight for Freedom has always been a glowing inspiration.

Ben and I first met here in Harlem some 35 years ago. He had gone to college at Amherst, and on to Harvard; I to Rutgers and on to Columbia. We both played football, and often passers-by on the Avenue would be startled and amused as Ben and I worked out some football tactics on the sidewalk.

Again, we would discuss our hopes as future lawyers, and where and how we would work.

Ben often talked of his home in Georgia, and of the conditions in the Deep South. He went back to fight these conditions. He defended the early brave fighters for simple justice and equality.

Later he came back to New York to join and to continue the struggle in this great metropolis. Still later, as a greatly respected member and leader of the Communist Party of the United States, he was elected by the people of Harlem to represent them on the City Council of New York. In the Council, he led the fight for justice and equality for our people in Harlem, for other minorities in our city, and for all Americans.

In a swiftly changing world, Ben was a courageous and unbending fighter for the rights of all. With his colleagues, he worked and fought, suffered and sacrificed for the sacred cause of Freedom and Peace. He was steadfastly loyal to this cause, to his country, to his people, to his Party, and to his friends.

Ben Davis lies here tonight, mourned by his folk north and south, mourned by millions of people in other lands who have long been aware of his unrelenting struggle for Humankind.

For me this has been a time of deep sorrow. For Ben Davis now goes to join another Ben I have lost—my beloved older brother; he also joins his colleague Dr. W. E. B. Du Bois,[1] one of our very great Americans.

All my family extend deepest sympathy to his family. We share their loss and their sorrow.

I say Goodbye to Ben in the words of a song he often heard:

> Farewell, Beloved Comrade,
> We make this solemn vow:
> The fight will go on,
> The fight must still go on
> Until we win, until we, the people, win.

"Thank God Almighty, We're Moving!"

Press release, August 28, 1964—Paul Robeson Archives,
Berlin, German Democratic Republic

The other day while I was out for a walk near my home here in New York, one of our folks—as it often happens—came over to pump my hand and said: "Paul, it's good to see you! Man, where have you been, and what are you doing, and how are you feeling, and what have you got to say?"

We walked along together, chatting like old friends who haven't seen each other for a long time. While I was trying to answer all the man's questions, I recalled with an inward smile that the editors of many leading magazines have had their long list of questions for reporters to ask me. However, since my return home from Europe some eight months ago I have declined to give any interviews or to make any public statements.

The fact is, I have been resting and recovering my health and strength after a rather prolonged illness. But while I am not yet able to resume public life and activities, I think it is time I said a few words through the Negro Press to the many persons who, like the friendly stranger on the street, have been wondering what has happened to me.[1]

First, let me warmly thank all those who have expressed good wishes for my recovery; your kind concern has been the best of all medicines. I am happy to say that I have re-gained the weight I had lost in my period of exhaustion, and I'm feeling better. My doctors assure me that I am on the road to recovery.

While I must continue my temporary retirement from public life, I am of course deeply involved with the great upsurge of our people. Like all of you, my heart has been filled with admiration for the many thousands of Negro Freedom Fighters and their white associates who are waging the battle for civil rights throughout the country and especially in the South. Along with the pride has been the great sorrow and righteous wrath we all shared when the evil forces of white supremacy brutally murdered the Birmingham children[2] and some of our finest heroes, like Medgar Evers[3] and the three young men of Mississippi.[4]

For me there has also been the sorrow that I have felt on returning home and experiencing the loss of persons who, for many long years, were near and dear to me—my beloved older brother, Rev. Benjamin C. Robeson, who passed away while I was gone; and my long-time colleague and co-worker, Dr. W. E. B. Du Bois, foremost statesman and scholar of our people, who died last year in Ghana. And now has come deep grief at the death of Ben Davis, a precious friend whose indomitable courage and dedication to the fight for Freedom has always been a glowing inspiration for me.

Many thousands gone . . . but we, the living, are more firmly resolved: "No more driver's lash for me!" The dedicated lives of all who have fallen in our long uphill march shall be fulfilled, for truly "We *shall* overcome." The issue of FREEDOM NOW for Negro Americans has become the main issue confronting this Nation, and the peoples of the whole world are looking to see it finally resolved. When I wrote in my book *Here I Stand* in 1958 that "the time is now,"[5] some people thought that perhaps my watch was fast (and maybe it was a little), but most of us seem to be running on the same time now.

The "power of Negro action," of which I then wrote,[6] has changed from an idea to a reality that is manifesting itself throughout our land.

The concept of mass militancy, or mass action, is no longer deemed "too radical" in Negro life.

The idea that black Americans should see that the fight for a "Free World" begins at home—a shocking idea when expressed in Paris in 1949—no longer is challenged in our communities. The "long hot summer" of struggle for equal rights has replaced the "Cold War" abroad as the concern of our people.

It is especially heartening for me to see the active and often heroic part that leading Negro artists—singers, actors, writers, comedians, musicians—are playing today in the Freedom struggle. Today it is the Negro artist who does *not* speak who is considered to be out-of-line, and even the white audiences have largely come around to accepting the fact that the Negro artist is, and has every right to be, quite "controversial."

Yes, it is good to see all these transformations. It is heartening also to see that despite all differences in program and personalities among the Negro leadership, the concept of a united front of all forces and viewpoints is gaining ground.

There is more, much more, that needs to be done, of course, before we can reach our goals. But if we cannot as yet sing: "Thank God Almighty, we're free at last," we surely can all sing together: "Thank God Almighty, we're *moving!*"

For the Celebration of the 15th Anniversary of the Founding of the GDR

Mermaid Theatre, London, October 25, 1964—Paul Robeson Archives, Berlin, German Democratic Republic (Signed by Paul Robeson and Eslanda Robeson)

The founding of the German Democratic Republic was an event of tremendous importance in the modern world, marking as it did, the founding of a new German Society based upon the welfare of all the people and dedicated to Peace and Friendship between all Nations.

It was our great privilege to see some of the development and achievements of this new Society, to benefit personally from its magnificent medical institutions, and to feel the warmth of the friendly population.

We congratulate them on this their 15th Anniversary, and wish them continuing success.

Turning-Point
American Dialogue, October-November 1964, p. 6

We Americans are now at a most important turning point in our history. To us, the Negro people, the most important point since the Emancipation Proclamation.

In our struggle for civil rights, we are not only fighting for our full freedom as citizens, we are also fighting for the whole unity of the American people. The majority of our fellow-citizens recognized this and passed the Civil Rights Bill.[1]

With Goldwater running for president[2] of our country we have a candidate who not only refused to support the Civil Rights Bill, but is against it in principle.

Goldwater also challenges the very basis of labor union organization and would endanger the gains achieved by the struggle and sacrifice of our working people.

Goldwater openly and frankly favors organized finance, and attacks the whole social welfare program.

In this period when the peoples of the world are working for peace in order to avoid a nuclear war which would destroy us all, we have in Goldwater a man who talks irresponsibly of using nuclear bombs "to defoliate the forests," etc.

A full and stable peace in our country demands that Negro and other minority Americans achieve all their civil rights, and that the American people achieve the social welfare benefits which our country can afford.

Survival of our world demands that the leaders and the peoples of all nations understand the dreadful implications of nuclear warfare, and completely reject it.

The Legacy of W. E. B. Du Bois
Freedomways, Winter 1965, pp. 36–40

Casting my mind back, my first clear memory of Dr. Du Bois was my pride in his recognized scholarship and authority in his many fields of work and writing. In high school and at college our teachers often referred us to standard reference works on sociology, race relations, Africa and world affairs. I remember feeling great pride when the books and articles proved to be by our Dr. Du Bois, and often loaned these to my fellow-students, who were properly impressed by his universally respected and acknowledged authority.

We Negro students joined the NAACP which Dr. Du Bois helped to organize and build;[1] we read religiously *The Crisis* of which he was

editor for so many years,[2] and in which he wrote clearly, constructively and militantly on the complex problems of the American scene, on the Negro question, on Africa, and on world affairs. He called upon the American people, and particularly upon the whole labor movement, to understand the need for unity in the struggle of the working masses, including the Negro, for a decent standard of living.

We spoke of Dr. Du Bois as Our Professor, The Doctor, The Dean, with great respect, paid close attention to his pronouncements, and many of us followed him proudly marching down New York's Fifth Avenue in a protest parade led by the NAACP for civil rights.

Dr. Du Bois talked and wrote and marched for civil rights.[3] He insisted upon first-class citizenship for all Americans, upon full equality of opportunity, dignity, legal rights for us all. And he directed universal interest and attention to our Negro history and our rich African ancestry, to give us solid background for our struggle.

All this was way back many, many years ago, long before I graduated from college in 1919. Our good doctor, this great man understood our situation, and our world, and was often a lone but clarion voice pointing out the urgent need for change.

Dr. Du Bois was a distinguished historian as well as a social scientist. We often talked about the wealth and beauty of our folk heritage, particularly about Negro music which he loved and found deeply moving. He often stressed the importance of this special contribution to American culture. We had interesting discussions about the likeness of our Negro folk music to many other folk musics throughout the world.

Our professor was not only a great and recognized scholar, he was also our most distinguished statesman. His knowledge of world affairs, his founding of the Pan African Congress,[4] his continuing work in many capitols of the world for African independence, made him widely known and respected abroad, and beloved in Africa. His book *The World and Africa*[5] was one of the first important books on modern post-war Africa, and helped to point out and focus attention on the continuing exploitation of Africa by the "free world."

We of the Council on African Affairs were very fortunate and proud when Dr. Du Bois joined our organization as Chairman in 1949. His knowledge, experience and wisdom, together with our very able and devoted Executive Secretary, Dr. Alphaeus Hunton, helped us to make some meaningful contribution to the struggle of the African people, particularly in South Africa.

Fifteen years ago, when we built the Negro newspaper *Freedom,* under the very fine editorship of our friend and colleague, the late Louis Burnham,[6] Dr. Du Bois was one of our very frequent and most brilliant contributors. His clear, forthright, informative articles on Africa, on the Negro in America, on the changing world situation added stature to our publication.

Association, discussion and work with this great man were always richly rewarding.

Probably as a result of his research and work in sociology, his close scientific observance of American history and social scene, his keen and continuing interest in Africa and in international affairs, Dr. Du Bois became a strong supporter of Socialism as a way of life. He followed the rise of the Soviet Union with understanding and appreciation, and made friends with the whole socialist world.[7]

He welcomed not only their rejection of racism, but also, as a social scientist, he appreciated their constructive and practical interest in, and effective governmental activity for, the welfare of the vast majority of the people. Dr. Du Bois said many times that he believed the 1917 Russian Revolution was the turning-point in modern history, and was of first importance in the shaping of a new world with the emergence of many other socialist lands.

So that it was logical, and deeply moving when, in 1961—having the whole world picture in focus—Dr. Du Bois became a member of the Communist Party of the United States, and still later became a welcome and honored citizen of Ghana, in his beloved Africa. He followed with deep concern the independence struggles in various parts of Africa, and knew that these struggles must be won, so that Africa and the African people could develop their great potential.

With his brilliant mind, his far-reaching education, his scholarly academic background, Dr. Du Bois was nevertheless a very much down-to-earth human being, with a delightful and ready wit, a keen and mischievous sense of humor, and enjoyed life to the full. I especially remember his gay spontaneous laughter.

And I remember particularly a wonderful Thanksgiving dinner at his home in Grace Court in Brooklyn about twenty years ago. He had invited some guests from the United Nations, because he knew they had heard and read about Thanksgiving, but had no personal experience and understanding of this special American holiday. So this was as typical a Thanksgiving dinner and evening as he and his wife Shirley[8] could make it, with the good Doctor a gay and witty host, explaining every step by step—from turkey and cranberry sauce to pumpkin pie and early American history. After the delicious dinner, over coffee and brandy before the log fire burning in the spacious living room fireplace, he spoke of Frederick Douglass, whose portrait hung over the mantel, and of his place in American history. That day is a happy and cherished memory.

I also remember so well the political campaigning of Dr. Du Bois when he was candidate of the American Labor Party of New York for the U.S. Senate.[9] In the usual free-for-all scramble which American political campaigns involve, Dr. Du Bois always remained calm and dignified. He never descended to shrill attack or name-calling, but discussed the real issues with brilliant speeches in which he combined his keen intelligence and trenchant humor. All of us worried about how he, at the age of 82 and seemingly fragile, would withstand the gruelling pace of the campaign. But Dr. Du Bois took care of his health as intelligently as he did everything else, and those who planned

meetings at which he would speak knew that if he was scheduled for 10 p.m. for half-an-hour, then no matter what the unpredictable state of the meeting, at 10 o'clock precisely Dr. Du Bois would walk onto the platform, speak brilliantly for half-an-hour, rest a while, then go on his way.

The more Dr. Du Bois observed and understood world events, the more he recognized that peace was a prime issue in this nuclear age. And so, typically, he became associated with peace movements all over the world, and worked actively for peace. In 1949 he became Chairman of the Peace Information Center here in our country, and was later indicted, tried and acquitted for his leadership in work for peace.

When Dr. Du Bois and Shirley came to London in 1958, we were living in a flat in Maida Vale. Soon after their arrival Eslanda and I went to Moscow for a long visit and turned our flat over to the Du Boises. We were very happy when they told us they had enjoyed their stay there, and we had thus helped to make their London visit comfortable. After they left we felt we should put a plate on the door saying "Dr. Du Bois slept here."

My last memory of Dr. Du Bois is in London, in less happy circumstances, in 1962. The doctor, then 94 years old and very ill, had been brought to London for a very serious operation. He was tired and weak, and we worried about how he could stand the ordeal.

I was ill in a London nursing home at the time, and felt very sad and helpless about the doctor's condition. So that when my wife, who visited him regularly in the hospital, told me that he wanted very much to see me and had asked especially for me, I got up and went to London University Hospital and we spent some time together. Ill as he was, he told me about his work on the Encyclopedia Africana; we talked about the progress of the Negro revolt at home in America, about the power and influence of the Socialist world, about the marvellous coming-of-age of the African people.

I visited him once again in the hospital, and was delighted and greatly relieved to find him miraculously improving. This was in August, 1962.

While I remained in the London nursing home, still ill, Dr. Du Bois recovered from his operation, got up and with Shirley traveled to Switzerland where he rested in the sun, went to Peking where they attended the October Celebration, on to Moscow[10] where they attended the November Celebration, and back again to London in late November, where Dr. Du Bois visited *me* in the nursing home! He gave a fascinating account of his trip and experiences, which he had enjoyed immensely.

That was the last time I saw him. He and Shirley went on to Ghana where a marvellous welcome awaited them.

My cherished memories of Dr. Du Bois are his brilliant and practical mind, his intellectual courage and integrity, his awareness of the world and of our place in it—which helped to make us all also aware. His fine influence on American thinking, and on Negro thinking will

continue to be incalculable. We admired, respected, appreciated and followed him because he was clear and forthright, because he was militant with a fighting strength and courage based upon wide knowledge, great wisdom and experience. I remember too his deep kindness.

Dr. Du Bois was, and is in the truest sense an American leader, a Negro leader, a world leader.

It's Good to Be Back

Excerpts from speech at welcome home meeting organized by
Freedomways[1]—*Freedomways,* Summer 1965, pp. 373–77

Well, I am certainly proud and happy to be with you tonight. I've never had a reception anything like this at any time that I can remember. And there are friends in the audience, people who went to school with me, back in New Jersey. They seem to come from many sections of our land to say hello. And I certainly want to thank you all for being here, for what we just heard. I know that all of you understand the struggles that are going on and it's been a wonderful evening to be sitting out there and listening to the beautiful singing, to the understanding of what our struggle means in this country today, and in other lands. I was also very happy to have Mr. Billy Taylor here; I felt like "getting in the jive."

I want to thank FREEDOMWAYS for making this evening possible. This particular magazine is one which many of us have followed from the beginning. It is significant to note that FREEDOMWAYS came into being along with the thrust of the Negro Freedom Movement, to express, to record, and to contribute in this history-making activity in our country. This magazine is of particular importance to all American writers, and especially to the Negro writers who are playing such a splendid role in interpreting the struggle which is going on in our lives today in Harlem, in the deep South, all over the country, and also in Africa. Negro American writers in Africa, and Africans themselves give us direct and welcome insight into the activities on that continent. The magnificent special issues of FREEDOMWAYS, for example, the one devoted to the people of the Caribbean and notably the most recent one devoted to the life and contributions of our great teacher, Dr. W. E. B. Du Bois, already serve as points of reference as well as giving deep artistic satisfaction. We hope that the quality and scope of this magazine will be appreciated by growing numbers of people in all groups in our country and in other parts of the world.

I want to especially thank the artists who have taken time out from their busy lives to come here this evening. It has been very moving to see so many of the actors that I came up with (now a little older, maybe), down in the Village long ago, in the twenties. And someone is here who was at one of the first concerts way back in 1925. It is a great

joy, certainly, to see the tremendous talent and the development of the growing numbers of our artists reaching, as they are, the highest levels. I would like for a moment to call your attention to an artist who has been closely associated with me in my career. I hope Larry is still here, my friend and colleague, Mr. Lawrence Brown, an authority on Negro and classical music who has been my partner in concerts for forty years. And I want to say, Larry, if you are still here, that when I came in and heard your protege take off there and sing, he sounded pretty good to me. Larry is teaching, and I felt when he came in, I'd better go on singing, "I'm gonna lay down my sword and shield down by the riverside, ain't gonna study war no more."

Recalling my own work in music and the theatre, as I said back in the twenties and thirties, it is encouraging today to see the ever-increasing opportunities and widening horizons for our Negro playwrights, actors and actresses in theatre, films, radio and TV; for our musicians in concert and in opera, and for our artists in almost every aspect of the cultural life of our country. It is also most interesting to see that these artists are becoming known all over the world, by records, TV and personal appearances. It is equally interesting to note that audiences all over the world understand and respond to the best of our art and our artists, even as we here appreciate the visiting artists who come from abroad.

Yes, our languages, our idioms, our forms of expression may be different, the political, economic and social systems under which we live may be different, but art reflects a common humanity. And further, much of the contemporary art reflecting our times has to do with the struggles for equality, human dignity, freedom, peace and mutual understanding. The aspirations for a better life are similar indeed all over the world and when expressed in art, are universally understood. While we become aware of great variety, we recognize the universality, the unity, the oneness of the many people in our contemporary world. In relation to this, in our travels we visited many peoples in Socialist countries. Today we know that hundreds of millions of people (a majority of the world's population) are living in Socialist countries or are moving in a Socialist direction. Likewise newly emancipated nations of Africa and Asia are seriously considering the question as to which economic system best fits their needs. Some of their most outstanding leaders agree that the best road to the people's goals is through a Socialist development, and they point to the advances made by the Soviet Union, the People's Republic of China, Cuba and the other Socialist countries as proof of their contention.

The large question as to which society is better for humanity is never settled by argument. The proof of the pudding is in the eating. *Let the various social systems compete with one another under conditions of peaceful coexistence, and the people can decide for themselves.* It is very interesting to note the support which comes from the Socialist countries for the freedom struggles everywhere. At this historic moment, it is certainly wonderful and heartwarming to see the

participation of our artists, Negro and white, in the Freedom struggle, and to note their brilliant contributions to the understanding so necessary for all sections of our American community. Yes, it's good to be back again!

Since we've been away, we've been to many countries: Britain, Hungary, France, the Soviet Union, Czechoslovakia, Rumania, the German Democratic Republic and as far away as Australia and New Zealand. Everywhere we found a warm welcome for our music, and especially for the songs expressing a deep desire for friendship, equality and peace. There was an opportunity to appear at the birthplace of Shakespeare in Stratford-on-Avon in a warmly received production of *Othello;* also to appear on television in music and drama; to sing in St. Paul's Cathedral in London, and with miners in Wales and in Scotland; and in many cities to sing for and with students from various parts of Africa. There was also occasion to participate in great rallies for peace in Paris, Moscow, in London's famous "Trafalgar Square" and in many other capitals of the world. All the while that we were abroad we kept in touch with the remarkable progress of the Freedom struggle here at home. The struggle for "Freedom Now" in the South and all over this land is a struggle uniting many sections of the American people, as evidenced in that great March from Selma to Montgomery, where thousands of black and white citizens of this country marched for the freedom of our people in the deep South and for a new kind of America. Also uniting many sections of our people is the struggle for peace, this demand to avoid any chance of nuclear war, rather to live in peace and friendship. This was evidenced by the recent march to the United Nations and the students' March on Washington. It is clear that large sections of the American people are feeling and accepting their responsibility for freedom and peace. It also is clear that from the Negro people has come a tremendous initiative and dynamic power in the forward thrust of our march toward freedom. It is clear that the Negro people are claiming their rights and they are in every way determined to have those rights and nothing can turn us back!

Most important is the recognition that achieving these demands in no way lessens the democratic rights of white American citizens. On the contrary, it will enormously strengthen the base of democracy for all Americans. So, the initiative, the power and independence of the Negro Movement are all factors which strengthen the alliance between the Negro people and the white citizens of our country at every level in our society. Now we must find and build a living connection, deeper and stronger, between the Negro people and the great mass of white Americans who are indeed our natural allies in the struggle for democracy. In fact, the interests of the overwhelming majority of the American people as a whole demand that this connection be built and that the "Negro question" be solved. It is not simply a matter of justice for a minority. Just as in Lincoln's time the basic interests of the American majority made it necessary to strike down the system of

Negro enslavement so today these interests make it necessary to abolish the system of Negro second-class citizenship.

In all of our struggles (on the marches, in the demonstrations, at the mass meetings) we see and feel that the part played by *music* is of extraordinary importance. How wonderful to hear these songs tonight and to hear the songs that serve to inspire, encourage, sustain and unite the thousands of participants, particularly the beautiful old songs which were a part of the Negro's long struggle during Slavery and Reconstruction. Today these old songs, sometimes with new words, serve the same high purpose as do the beautiful songs newly composed in the heat of the day. Songs like "We Shall Not Be Moved," "Freedom," "Ain't Gon' Study War No More," and "This Little Light of Mine, I'm Gon' Let It Shine, Let It Shine, Let It Shine, Let It Shine . . ." and "We Are Climbing Jacob's Ladder." I remember always being taken by that song as a boy. We *are* climbing "Jacob's Ladder," rung-by-rung, higher and higher, until we find our Freedoms, our complete equality in the lands of our birth. I could go on with many songs from other parts of the world. They liked our music (as our artists have found out when they went), so we sang in many of the languages in the countries we visited. We saw the unity of the struggles. There is one song that I have always said comes from struggles of the peoples, like we sang "Go Down Moses," there is another song from these great peoples that goes:

> *"Never say that you have reached the very end,*
> *When leaden skies a bitter future may portend:*
> *For sure the hour for which we yearn will yet arrive*
> *And our marching steps will thunder 'We Survive!'"*

And for all of my family I want to thank you again, Ossie, Ruby,[2] all who have been so kind. I'm happy to be with you and hope that we can act again (can't tell), sing, move again.

Be sure that you are subscribing to this wonderful magazine, FREEDOMWAYS. I certainly go home knowing and feeling more and more deeply, *"We shall overcome, deep in my heart I do believe, We Shall Overcome some day."*

Message to "Salute to Paul Robeson"

Carnegie Hall, New York City, April 15, 1973[1]—*Daily World,* April 26, 1973

Dear Friends:

Warmest thanks to all the many friends here and throughout the world who have sent me greetings on my 75th birthday. Though I have not been able to be active for several years, I want you to know that I am the same Paul, dedicated as ever to the worldwide cause of humanity for freedom, peace and brotherhood.

Here at home, my heart is with the continuing struggle of my own people to achieve complete liberation from racist domination, and to gain for all black Americans and the other minority groups not only equal rights but an equal share.

In the same spirit, I salute the colonial liberation movements of Africa, Latin America and Asia, which have gained new inspiration and understanding from the heroic example of the Vietnamese people, who have once again turned back an imperialist aggressor.

Together with the partisans of peace—the peoples of the socialist countries and the progressive elements of all other countries—I rejoice that the movement for peaceful coexistence has made important gains, and that the advocates of "cold war" and "containment" have had to retreat.

On this occasion, too, I want to say a warm hello to the many friends who have sent me encouraging messages during my long illness. I am deeply grateful to you all—classmates from high school and college days; fellow actors, singers, musicians and others from the arts, sciences and professions; church people and trade unionists, and friends from all the other areas of my life here and abroad.

Though ill health has compelled my retirement, you can be sure that in my heart I go on singing:

> "But I keeps laughing
> Instead of crying,
> I must keep fighting
> Until I'm dying,
> And Ol' Man River
> He just keeps rolling along!"

Message to Actors' Equity

June 1, 1974[1]—*Daily World,* July 13, 1974

It was deeply moving for me to learn that Actors' Equity has decided to establish an award in my name and to make me the first recipient of that honor. Though ill-health prevents my attendance at the presentation ceremony, I must say I feel so very close to you, my brothers and sisters of the acting profession.

Although I was trained to be a lawyer, it was your profession that welcomed me into a lifelong career. Just fifty years ago this spring, in 1924, the Provincetown Players—including such dear friends as Gene O'Neill, Jimmy Light, Eleanor Fitzgerald, Gig McGee and others— drew me into their midst and encouraged me onto the stage in their productions of *All God's Chillun Got Wings* and *The Emperor Jones.* Then too it was that theater group which, a year later, in 1925, first presented me as a concert singer.

So you will understand that through all the years—off Broadway, on

Broadway, across this land and elsewhere in the world—I have always felt a close kinship with fellow actors. From my earliest days in the theater, when I often heard O'Neill expound his belief in the "Oneness of Mankind," I have been blessed with the warm good fellowship of so many of you.

It has been most gratifying to me in retirement to observe that the new generation that has come along is vigorously outspoken for peace and liberation; and that the forces of bigotry, which at the outset of my career sought unsuccessfully to block our presentation of *All God's Chillun* because of its interracial theme, have since received many other setbacks. To all the young people, black and white, who are so passionately concerned with making a better world, and to all the old-timers among you who have long been involved in that struggle, I say: Right on!

On this occasion, I send my heartfelt thanks and love to you all.

Singing at demonstration against nuclear armament, Trafalgar Square, London, June 29, 1959

*With Lawrence Brown in concert at Philip Livingston Junior High
School, Albany, New York, May 11, 1947*

APPENDIX

Paul Robeson Tells of Soviet Progress

Interview, *Irish Workers' Voice,* Dublin, February 23, 1935[1]

"The workers are alive. You sense it in the streets, everywhere. You see it in their bearing. They feel that they are doing something, that they are laying the foundations of something great." Paul Robeson's enthusiasm communicated itself as he gave his impressions of the Soviet Union.

The many encores demanded by a tumultuous audience in the Capitol cinema had left him exhausted. Scores of autograph hunters swarmed around America's leading singer, the most famous Negro in the world. But when they were all disposed of, Mr. Robeson was glad to talk to the Irish Workers' Voice on his last visit to the Soviet Union, from which he returned a few weeks ago; and we sat talking in his dressing room until at last a sorely-tried Mrs. Robeson dragged him away.

He told me how he first became interested in Russia. He noted the appreciation of Russians who came to his concerts in New York. They told him of the similarity of the Negro folk-song to the peasant plaints of tsarist Russia.

He wanted to find out why this was so. His studies led him to an examination of social conditions, and he found a similarity of social roots: the American Negro and the Russian serf, both nominally freed about the same time, lived and suffered in conditions of poverty and oppression that were much the same. Later, Marxism was to co-ordinate a cultural sweep that was already amazing.

He went to Moscow not merely as an artist, but as an unresting student of cultural roots and trends, and also as a Negro and one who had been a worker.

> What is Freedom? Ye can tell
> That which slavery is too well,
> For its very name has grown
> To an echo of your own.

There can be no better judge than Paul Robeson of freedom in the U.S.S.R.!

His brother-in-law (now working as a chauffeur in Moscow) and

485

Eisenstein showed him around. But he also went to many places alone, he speaks Russian, and he talked to the workers. And he was amazed at the material and cultural advance.

"In the factories, handling the most up-to-date machines, I saw men who obviously had been ignorant peasants a few years ago. In the universities and schools were students born in savage tribes that up to a decade ago were still in the Stone Age. The theatres and opera-houses packed every night by workers. On the trams you see men and women studying works on science and mathematics."

"How," I asked, "are they handling the national and racial question?"

"In the Soviet Union today," he replied, "there is not only no racial question; in the minds of the masses there is not even the concept of a racial question." Black, white, yellow—all were part of a whole, and no one thought of the question.

More than anything, the development by the Soviet Government of the cultures of the formerly oppressed nationalities won his admiration. He paraphrased Stalin's famous formula for this development, "National in form and socialist in content," and said that the Soviet experience had finally proved to him that it was possible for the peoples of Africa not merely to "jump over" the bourgeois stage of society, but even to avoid the later feudal stage, and to pass right over into socialist society.

Mr. Robeson referred scornfully to books on the U.S.S.R. by such writers as Chamberlin. Only Duranty's "Russia Reported,"[2] he said, gave anything like a fair bourgeois account—"but I should be more enthusiastic myself."

Space prevents any noting of the amazing breadth of cultural interest revealed by this great artist: the problem of expressing in his art the aspirations of the Negro Youth, literary men's role in the revolutionary movement, the Irish language and Gaelic folk songs and their affinity with Persian and Hindustani folk-rhythm.

And he is now going to Soviet China! I have no doubt that while on his way there he will learn at least three Chinese dialects so as to be equipped for his studies.

Two Worlds—Ten Years of Struggle

Komsomolskaia Pravda,[1] June 16, 1949—Translated by Paul A. Russo

It happened in the small town of Albany, the capital of New York State. The authorities banned my performance. They set a condition: no political speeches. I agreed. I prepared for this concert as for no other. And when in the evening I approached the footlights and began simply to sing, the faces of the representatives of the local authorities attending the concert expressed their satisfaction. As well they

might—this time there would be no political demonstrations. But I also noticed something else—the embarrassment and disappointment of the supporters of the progressive movement.

Both sides knew that since I had returned to America in 1939, whenever I performed in concert, I first turned to the audience with a story about the Soviet Union. Since then, there has been no concert where I would not hold up to shame fascism of all hues.

And here Robeson was just singing.

I fulfilled the condition. There was no speech. And all the same I did make one. Before each number I made a short statement explaining the nature of the song and its contents. Indeed, many of them were in languages unknown to my listeners.

I sang the song of the Spanish Republicans. I prefaced it with words condemning Franco, reminding the audience how our American diplomats were flirting with the fascist "Caudillo."

I sang in Chinese the song of the soldiers of the National Liberation Army of China, "Arise." And before singing it, I did not neglect to tell about events in China and about the shameful things being carried out with the dollars of the American taxpayer.

From song to song the atmosphere in the auditorium became more and more tense.

I changed slightly the words of the popular song "Mississippi"[2] and explained to the audience why I did so. This allowed me once more from the concert stage in Albany to tell of the lack of rights of the Negroes in the Southern states, of the politics of a government that throws fighters for freedom and democracy into prison. The modified words of this song called for struggle and resistance.

Only for the last song I provided no introduction. It wasn't necessary. This was the song of Joe Hill, an ordinary worker, who was killed on trumped-up charges. Its words summoned the unfortunate people to organized struggle. Joe Hill is immortal, as a just cause is immortal.

Friends and foes alike understood my speech. My friends applauded and accompanied me from the concert.

Since that time I have more than once, both in America and in Europe, had to give concerts under the condition that I not organize a political demonstration. And I have performed just as I did in Albany.

And again the reactionary newspapers ranted and raved. Still, despite all the difficulties, I am proud that my art serves the people's cause. This feeling is given notable expression in the poetry of my favorite Soviet poet, Mayakovsky.[3] "A song and a poem are a bomb and a banner, and the voice of the singer lifts up a class, and whoever does not sing with us today, he is against us."

Not just poets and artists should remember this. Let no practitioner of the arts forget this. The hour of decision has arrived.

The episode in Albany is a vivid example of what those so often proclaimed rights of freedom of assembly and freedom of the individual under the protection of the stars and stripes can turn into in American reality.

Even in the years before the war when Roosevelt was President and Wallace was his intimate advisor, it was not easy to reach the broad masses with the truth about what was happening in the world. Indeed, concert halls and local authorities were everywhere the hirelings of the worst enemies of progress. When in those years I went on tour with stories about wonderful Soviet Russia, about poverty and famine in Africa groaning under the yoke of British imperialism, about fascist atrocities, every possible obstacle was put in my way.

Then the world war began in Europe. Hitler threw himself on the U.S.S.R. The best people of America then devoted all their efforts to the struggle against the obscurantism of Nazism.

Miners, farmers, representatives of the genuinely democratic intelligentsia from the Atlantic to the Pacific followed ecstatically the feats of the Russian heroes in the battlefields of Russia.

For the progressive peoples of America the memory of the hero-cities Stalingrad, Leningrad, Odessa, and Sevastopol is sacred. Sacred are the names of the defenders of Moscow. We remember them and we will never forget them!

The spring day of May 9, the day of great victory, was a holiday for all progressive humanity. I sang with special joy on that day. Hitler had been defeated by my friends the Soviet people and, along with them, by the fighters of the French Resistance, by the Norwegian underground, by the Bulgarian partisans. Even I had my share in the great victory.

The spring sky of May 9 was cloudless. The future seemed just as cloudless. It seemed that along with the fascist standards cast down at the base of Lenin's Mausoleum, the very idea of "fascism" had passed into history. But such optimism was premature. Soon the political horizon was covered with clouds.

Some reactionary Bishop Preng was once asked whether there would be fascism in America. "Of course there will be, but it will have another name," was his cynical reply.

And soon not just sprouts (they had been there long before), but stalks of the new political weed appeared on the soil of "democratic" America, abundantly fertilized for this purpose by the contributions of Wall Street financial magnates.

It was the will of the trusts and cartels that dictated the "Truman Doctrine" and the "Marshall Plan." They combined war hysteria with a ferocious hatred of the movement of progressive people.

It was necessary to expose the forces of reaction standing behind the scenes of the [House] Un-American Activities Committee and behind the campaign which American reactionaries had organized against the Communists and the entire labor movement. We could not limit ourselves to defense; we had to go over to the offensive.

"A singer has to be an expert at life, too," I say, paraphrasing Mayakovsky. I was proud of standing for days at a time with the picketers of the striking factory workers of Pittsburgh. I was glad to walk along with all those who demonstrated in the streets of St. Louis, demanding struggle against Negro discrimination.

Although I agitated from the stage during every concert, this didn't seem enough to me. I dedicated two years exclusively to political struggle. Only in 1949 did I return to the stage.

Broad strata of the American public joined with the Progressive Party in the struggle. During the election campaign of our party, an important event for me was a trip through the southern states—the citadel of conservatism. Shortly before my departure I received a threatening letter from the Ku Klux Klan. They threatened to kill me if I showed up in the South. Nevertheless, I decided to go.

I had the enormous satisfaction of seeing with my own eyes how my compatriots had changed. Only recently resigned to their fate, they were afraid of even the idea of struggle. The vision of lynch law fettered their plans and dreams. But now in every town and village they came together to protect their visiting guests.

Even the ministers of the Protestant colored churches, who had made careers out of preaching humility, followed after us. Nearly always they offered us their churches for meetings. This time the Ku Klux Klan was afraid to act. With every passing day the land of the South is emerging from under its foot.

The political consciousness of the ordinary American has grown tremendously. And the average American is no longer the person claimed to be represented by that Senator from Oklahoma with whom I had to argue at the Senate Judiciary Committee, where I had gone to protest the passage of the Mundt Bill. On behalf of the people I said this to the Senator:

"You want to ban the Communist Party. In doing so you encroach on the very civil freedoms you so like to talk about in your leisure time.

"Yes, the Communists are going forward with the struggle for a lasting peace and people's democracy. But they are not alone. All the progressive people of America are with them: the party of Wallace, the Negroes of the South, the workers of the North.

"Yes, the Communists are friends of the U.S.S.R. But the Negroes, too, knowing that the U.S.S.R. is the true friend of all peoples of the earth, will not go to fight the Soviet Union. Nor will the workers fight the Soviet Union: despite all obstacles the truth about the Soviet country does reach them."[4]

I had no intention of repudiating my views, even if they threatened me with prison. The next day, in response to my statement, I read in the Washington *Times-Herald* an editorial entitled "Why Is He Here?" I was reminded that I was the son of a slave and that "he should behave himself during his entire stay in our city, or it won't do him much good . . . He is heading on the course for a prison cell."[5] In America they threaten any progressively inclined person with prison. They threaten the leaders of the Communist Party of America with prison.

I sang of Joe Hill in all the countries of Europe. And before this song I invited all my listeners to defend Communist leaders from illegal encroachment on their freedom. I have heard Czechs and Poles, French and Norwegians unanimously applaud my words.

From Moscow I shall go to New York. On June 19 I shall speak at a demonstration in defense of the best people of America, the leaders of the Communist Party. I shall speak in the name of the ordinary Americans and the ordinary Europeans, who are struggling against war.

This is what I shall say:

If tomorrow anything should happen to those being judged today, tomorrow this will affect you, too. We cannot fail to see this. We must decisively rise up in defense of peace. We must win the peace.

And I shall tell my friends much, much more. But mainly, I shall tell them how strong the peace movement is in Europe and how successfully the Soviet people are building a peaceful life.

The Essence of Fascism and Communism

Excerpts from Testimony before the Committee of the Judiciary of the United States Senate, Eightieth Congress, Second Session, on H.R. 5852 An Act to Protect the United States Against Un-American and Subversive Activities (Mundt-Nixon Bill), May 31, 1948

Senator FERGUSON. What is the definition of fascism?

Mr. ROBESON. The essence of fascism is two things. Let us take the more obvious one first: Racial superiority, the kind of racial superiority that led a Hitler to wipe out 6,000,000 Jewish people, that can result any day in the lynching of Negro people in the South or other parts of America, the denial of their rights, the constant daily denial to any Negro in America, no matter how important, of his essential human dignity which no other American will accept, this daily insult to the human being. The reason this can be is the power of the resources of a nation in the hands of a few, and the use of the state power as Hitler or Mussolini or the police in Kansas City to beat down any attempts to strive toward any kind of democratic rights or freedom.

Senator FERGUSON. Even though it be law enforcement?

Mr. ROBESON. I say even though I would say, this is the very essence of the thing we find always, that law enforcement in this case is the protection of the property of a few people who are the potential of fascism.

Senator FERGUSON. Now, what is the essence of communism in America, in your opinion?

Mr. ROBESON. The essence to my mind, of communism here or anywhere, that is every day I read in the paper what does communism thrive on, all this kind? You tell me, Senator, where would you expect to find your Communists? Would you expect to find Mr. du Pont would be a Communist?

Senator FERGUSON. I think in America today we can expect to find them anywhere. I mean it is not a question of wealth.

Mr. ROBESON. Very much so.

Senator FERGUSON. Do you think so?

Mr. ROBESON. Just—not just—not a question of wealth in this case, a question of wealth wherein in the end—take the South, the Negro people, you tell me who controls the wealth of the South.

Senator FERGUSON. You gave me the essence of fascism. I would like to have the essence of communism.

Mr. ROBESON. This came from my experience; I didn't make these things up. I am in the South. My father was a slave. A few weeks ago I was standing in North Carolina on the very soil my father was a slave. I go to the whole history of our civilization, 100,000,000 Negroes from Africa, torn to pieces and died in the slave trade; on our backs in America the very primary wealth that America built on our backs, cotton, taken to the New England textile mills. What do we get from it today? Poverty, insult, inferior station in life, no opportunities. Who controls the wealth? A few people. Now somewhere, to me, by whatever means, at certain times like in our history these means have been revolutionary; in other times evidently not, but somewhere to me communism is interested in seeing that those people who are oppressed, who suffered this, somewhere they represent those people in their struggle toward freedom.

Senator FERGUSON. That is the essence of communism?

Mr. ROBESON. Yes.

Senator FERGUSON. The essence of communism here is the same as essence of communism in Russia?

Mr. ROBESON. I would say the same as the universe. It has to do with the struggle of the Russian people against the Czarist oppression. Exactly like universal in this sense.

* * * *

Senator LANGER. Mr. Robeson, I was interested in your answer to Senator Ferguson's question as to what the essence of communism is. First, if you had your way about it, you would have public housing for veterans and for poor people?

Mr. ROBESON. Yes.

Senator LANGER. Second, you would have social security that took care, really took care, of all those who needed help; is that right?

Mr. ROBESON. Yes.

Senator LANGER. Third, you would enforce the Sherman Antitrust Act and Clayton Act and wipe out these cartels and these monopolies?

Mr. ROBESON. Exactly.

Senator LANGER. That has gone along here 50 or 60 years without anything being done about it.

Mr. ROBESON. That is completely true.

Senator LANGER. Fourth, you would be in favor of laws enacting the FEPC?

Mr. ROBESON. I certainly would. I think they are very basic to American democracy.

Senator LANGER. You would wipe out the poll tax?

Mr. ROBESON. At once.

Senator LANGER. You would pass an antilynching law that is really an antilynching law that would be enforceable against anyone, whether a white man or a colored man?

Mr. ROBESON. That is right.

Senator LANGER. You said also that you were in favor of the nationalization of certain industries. Will you just enumerate those?

Mr. ROBESON. I say where these questions arise and where the American people—it is clear to them—like coal and railroads, I mean these, merchant shipping at certain times, maybe even airplanes, certain things, certain atomic power, where it is clear that these are public necessities and of national life or death then it seems to me they should be nationalized.

Senator LANGER. In other words, if I understand you correctly, you would take those industries out of the hands of the few and put them in the hands of the people themselves?

Mr. ROBESON. That is right, hoping that in the guidance of state where people who understand the problems—

Senator LANGER. Next, I understand you believe that under the Constitution, the Bill of Rights of this country, that every man, regardless of race, color, or creed, or language, and that includes women, is entitled to equal protection?

Mr. ROBESON. No question about it.

Senator LANGER. And equal opportunity?

Mr. ROBESON. Equal opportunity.

Senator LANGER. And similar treatment?

Mr. ROBESON. That is right.

Senator LANGER. Is that right?

Mr. ROBESON. That is right. That is the kind of necessary legislation I would seek.

* * * *

Senator FERGUSON. If this law is passed and the Supreme Court rules it constitutional, do you believe it should be lived up to?

Mr. ROBESON. If this law is passed?

Senator FERGUSON. Yes; or any law is passed.

Mr. ROBESON. First, I sincerely hope the Senate won't pass it and I sincerely hope the Supreme Court will declare it unconstitutional.

Senator FERGUSON. Do you believe that people should live up to it?

Mr. ROBESON. I am sure I would live up to it by trying in every possible way to have it taken off the books.

Senator FERGUSON. Would you not live under it? Would you not say it was the law and therefore was binding?

Mr. ROBESON. Nobody is arguing that point.

Senator FERGUSON. That is what I mean.

Mr. ROBESON. Nobody is arguing that point.

Senator FERGUSON. Mr. Foster[1] told us Friday he would not obey it.

Mr. ROBESON. In what sense would he not obey it?

Senator FERGUSON. Just that he would not obey it.

Mr. ROBESON. What do you mean he would not obey it?

Senator FERGUSON. I do not know what his thinking was but he said he would not obey it.

Senator MOORE. He would not register.

Mr. ROBESON. Neither would I register.

Senator FERGUSON. Then you would violate the law.

Mr. ROBESON. I would say this, I would fight, I would really fight it as a real piece of American fascism.

Senator FERGUSON. After it is declared constitutional by the Supreme Court then you would defy it?

Mr. ROBESON. Let me put it this way, Senator.

Let us suppose a Frenchman is now faced with the law passed by Vichy, would you expect that Frenchman to observe it?

Senator FERGUSON. Under the former Vichy government?

Mr. ROBESON. That is right.

Senator FERGUSON. No; it would not be the law.

Mr. ROBESON. Why not? They were France at that period. They were the government of France.

Senator FERGUSON. There is a new government there.

Mr. ROBESON. I am talking at that time. Would you expect those men who helped our American boys to destroy Hitler—

Senator FERGUSON. Is that the way you classify it?

Mr. ROBESON. Exactly, in that category, as a Fascist act.

Senator FERGUSON. Then you would not obey it?

Mr. ROBESON. As an anti-Fascist I would not obey it.

Senator MOORE. You stated that your father was a slave?

Mr. ROBESON. That is right.

Senator MOORE. You are now independent?

Mr. ROBESON. Am I?

Senator MOORE. You are economically independent; you occupy a high position in American society; you are proud of it; you have been of service in many ways. That has all been achieved in one generation.

Mr. ROBESON. That is right.

Senator FERGUSON. Can you think of any other country on the face of the earth where such an opportunity has been given?

Mr. ROBESON. Yes.

Senator MOORE. What is it, Russia?

Mr. ROBESON. Yes, I would say not one.

Senator MOORE. You do not mean to say that the Russian people have any opportunity at all of being any more than slaves?

Mr. ROBESON. They have incidentally more opportunity than I have in Mississippi, I assure you.

Senator MOORE. Do you approve of communism for the deeds it has done?

Mr. ROBESON. Yes. They have liberated a whole people in many countries.

Senator MOORE. They have liquidated many of them.

Mr. ROBESON. No, not nearly liquidated as the Negroes were liquidated in slavery or liquidated in many parts of the South.

Senator MOORE. There are not many being liquidated today.

Mr. ROBESON. Why should not the antilynching bill be on the calendar now?

Senator MOORE. I do not know, probably for political reasons. I say it is probably political.

Mr. ROBESON. Why all this excitement about civil rights if they are not necessary?

No, I say that this is not a perfect world and there are many ways toward the freedom of peoples. We do it our way. Other nations choose Socialist means or Communist means. If our way is so much better, let us prove that. One of the first ways to prove it is by making my people free.

I will answer your question. Though I am independent and so forth, I have a debt to my slave father. I have a debt to my relatives in North Carolina who are very poor sharecroppers today, and I won't allow my independence to be used against them. I am saying make those 10 million free, not me.

Senator MOORE. Our Government freed the slaves.

Mr. ROBESON. What is that?

Senator MOORE. Your and my Government freed the slaves.

Mr. ROBESON. We fought a good deal for our freedom.

Senator MOORE. We did.

Mr. ROBESON. My father was in the Union Army.

Senator MOORE. And the sons and daughters of slaves had an opportunity in this country, the like of which they had never known.

Mr. ROBESON. Very few. Just look all through America and find out, you will find a very small percent out of 12 or 15 million who have done this. You can't judge the Negroes, their struggles, by me or a few people. The only way it can be judged is by the mass of people. That is the lesson to me of our time. The very way you can understand Russia, Yugoslavia, and China, what they think, not a few but the great masses of people who have achieved independence in a generation. . . .

Portrait (undated)

NOTES, BIBLIOGRAPHY, INDEX

In The Hairy Ape, *London, May 1931*

Introduction

1. *Proceedings of the Twelfth Annual Herald Tribune Forum, November 16, 1943,* New York, 1944, pp. 42–43.
2. *Daily Worker,* London, January 1, 1960.
3. Lillian Hellman, *Scoundrel Time,* New York, 1976.
4. The discussion of the memo by Vice Consul Roger P. Ross is based on Terry Cannon, "Slander with a State Department Label," *Daily World,* October 13, 1977, which in turn is based on information furnished by Paul Robeson, Jr., whose suit in 1972 under the Freedom of Information Act uncovered the documents.

The discussion of the State Department's activities against Robeson in India and Ghana is based on W. James Ellison, "Paul Robeson and the State Department," *The Crisis,* vol. LXXXIV, May, 1977, pp. 184–189. Ellison obtained the documents through the Freedom of Information Act.

5. Paul Robeson, *Here I Stand,* New York, 1958, p. 32.
6. *Pittsburgh Courier,* May 17, 1958.
7. *See also* Loften Mitchell, "Time to Break the Silence Surrounding Paul Robeson," *New York Times* Arts and Leisure Section (Section 2), August 6, 1972.

Nevertheless, when Albert F. Todres of Washington, D.C., asked the National Foundation Hall of Fame why Paul Robeson, an All-American first-team selection at end by Walter Camp in 1917 and 1918 and a distinguished performer in the arts in later years, was not honored with membership, Chester La Roche, chairman of the foundation, replied that "because of Robeson's views on communism he would welcome evidence that Robeson was a citizen in good standing." (*New York Times,* February 15, 1976, Sports Section, p. 2.)

8. Robeson, *Here I Stand,* p. 64.
9. Eric Bentley, editor, *Thirty Years of Treason: Excerpts from Hearings before the House Committee on Un-American Activities,* New York, 1971.

It is doubtful, however, that Robeson would have considered the Eldridge Cleaver of 1975–1977 a brother fighter for black liberation. Since his return to the United States in 1975 after seven years of exile to avoid trial on attempted murder charges in connection with a gun battle between Panthers and the police in Oakland, California, Cleaver has been praising U. S. imperialism and castigating the socialist countries, especially Cuba. Had he lived, Robeson would have read with scorn the following item in the *New York Times* of April 2, 1977: "The former Black Panther leader Eldridge Cleaver has bought a house in the affluent Santa Clara County community of Los Altos, Calif. The purchase price was not disclosed but a former resident of Los Altos said yesterday that '$100,000 would be a modestly priced home there.'"

10. Hoyt's attack on Robeson's political ideology (pp. 112, 116, 143, 145) is of a piece with Harold Cruse's attack on Robeson in *The Crisis of the Negro Intellectual* (New York, 1967) and Dorothy Butler Gilliam's stance in her recent biography *Paul Robeson: All American* (Washington, D. C., 1976). Ms. Gilliam accepts as truth all of the testimony of paid informers who charged Robeson with being a Soviet agent, and she handles Robeson's persecutors tenderly while Robeson himself is criticized for standing up against the McCarthyites. In spite of its title, the book treats Robeson as a Soviet rather than an American citizen, a practice which did not begin with Gilliam. In his memoirs, Dean Acheson, Secretary of State under President Truman and one of the chief architects of the Cold War, calls Robeson a "Soviet citizen." (*Present at the Creation: My Years in the State Department,* New York, 1969, p. 130).

Apart from Gilliam's book, five published biographies exist on Paul Robeson: Marie Seton, *Paul Robeson* (London, 1958); Eslanda Goode Robeson, *Paul Robeson, Negro* (London, 1930); Shirley Graham, *Paul Robeson, Citizen of the World* (New York, 1946); Edwin P. Hoyt, *Paul Robeson: The American Othello* (Cleveland, 1967); Virginia Hamilton, *Paul Robeson: The Life and Times of a Free Black Man* (New York, 1975). Ms. Hamilton's biography, though written for young people aged twelve and up, is a much more mature political biography than either Hoyt's or Gilliam's.

There is also much biographical material in the special issue of *Freedomways* (Vol. XI, No. 1, 1971) entitled "Paul Robeson: The Great Forerunner." At least one Ph.D. dissertation exists on Robeson: Anatol Schlosser, "Paul Robeson, His Career in the Theater, Motion Pictures, and on the Concert Stage," New York University, 1972, and two Masters' theses, Michael Meyerson, "Paul Robeson," University of California-Berkeley, and Lamont Yeakey, "Paul Robeson: His Early National Years," Columbia University.

11. *See* pp. 173–178.

12. Among the most important works of the "revisionist" historians on the origins of the Cold War are William Appleman Williams, *The Tragedy of American Diplomacy* (Cleveland, 1959); Gar Alperovitz, *Atomic Diplomacy* (New York, 1965); Joyce and Gabriel Kolko, *The Politics of War: The World and United States Foreign Policy,* (New York, 1968); Joyce and Gabriel Kolko, *The Limits of Power: The World and United States Foreign Policy, 1945–1954* (New York, 1972); Walter LaFeber, *America, Russia and the Cold War* (New York, 1967); Lloyd Gardner, *Architects of Illusion* (Chicago, 1970); and Barton J. Bernstein, "American Foreign Policy and the Origins of the Cold War," in Bernstein, editor, *Politics and Policies of the Truman Administration,* Chicago, 1970, pp. 15–77.

While most of the "revisionists" cited above argue that the Cold War could not have been avoided because policymakers in the Truman administration were intent upon expanding the American empire after the war, the Kolkos include the Roosevelt administration in the same camp, and see no difference between the policies of the two administrations, a position with which Robeson would not have agreed; nor for that matter do I.

For a more moderate "revisionist" position, *see* Martin J. Sherwin, *A World Destroyed: The Atomic Bomb and the Grand Alliance* (New York, 1976). On the other hand, for attacks on the "revisionist" historians, often taking the form of denigrating their scholarship, see John L. Gaddis, *The United States and the Origins of the Cold War, 1941–1947* (New York, 1972); George C. Herring, Jr., *Aid to Russia, 1941–1946* (New York, 1973); Lisle Rose, *After Yalta* (New York, 1973); Robert Maddox, *The New Left and the Origins of the Cold War* (Princeton, 1973).

13. David Caute, *The Great Fear: The Anti-Communist Purge Under Truman and Eisenhower,* New York, 1978, p. 86. *See also* Robert Griffith, *The Politics of Fear: Joseph R. McCarthy and the Senate,* University of Kentucky, 1971; Alan D. Harper, *The Politics of Loyalty: The White House and the Communist Issue, 1946–1952,* Westport, Conn., 1971; Athan Theoharis, *Seeds of Repression: Harry S. Truman and the Origins of McCarthyism,* New York, 1971.

14. *See* pp. 113–115.

15. Alex Haley, *Roots,* Garden City, N. Y., 1976.

16. Alphaeus Hunton, "A Note on the Council on African Affairs," Appendix E in the original edition of Robeson, *Here I Stand,* pp. 126–28.

17. *Proceedings, Conference on Africa, New York, April 14, 1944,* Council on African Affairs, New York, 1944.

18. Alex La Guma, "Paul Robeson and Africa," in "Symposium: Paul Robeson and the Struggle of the Working Class and the Afro-American People of the USA against Imperialism, Held in Berlin, April 13–14, 1971," Berlin, 1972, p. 45. Copy in Paul Robeson Archives, Berlin, German Democratic Republic.

19. *See* "I Want to Be African," p. 91.

20. *See* "Negroes—Don't Ape the Whites," pp. 91–2.

21. Not long after I had published the first two volumes of the *Life and Writings of Frederick Douglass* in 1950, Paul Robeson told me on several occasions that he read and re-read Douglass' writings and speeches and could not but admire the remarkable insights of the former slave who became a militant abolitionist and spokesman for his oppressed people. Robeson frequently quoted from the two volumes in his own speeches and writings.

22. Bentley (*op. cit.,* note 9 *above*), p. 768.

23. W. E. B. Du Bois, *Autobiography,* New York, 1968, p. 397. Du Bois's observation, together with a mass of other material, shows how ridiculous is Harold Cruse's comment that Paul Robeson could not commune with Negro composers, and was only "an interpreter of Shakespeare, European Opera and the plays of Eugene O'Neill." (*op. cit.,* note 10 *above,* p. 197.)

24. Robeson, *Here I Stand,* p. 95.

25. For a study of Joe Hill and the events leading up to his execution, *see* Philip S. Foner, *The Case of Joe Hill,* New York, 1965.

26. Robeson, *Here I Stand,* pp. 58–60.

27. *Ibid.,* p. 67.

28. For analyses of the Great Migration, *see* U. S. Department of Labor, *Negro Migration in 1916–1917,* Washington, D. C., 1919; Ray Stannard Baker, "The Negro Goes North," *World's Work,* vol. XXXIV, July, 1917, pp. 310–20; Philip S. Foner, *Organized Labor and the Black Worker, 1619–1973,* New York, 1974, reprinted in paperback, New York, 1976, pp. 129–40.

29. Shirley Graham, *Paul Robeson, Citizen of the World,* New York, 1946, pp. 25–26.

30. *Ibid.,* pp. 238–39.

31. *Freedom,* April, 1951.

32. Robeson, *Here I Stand,* p. 53.

33. *Ibid.,* p. 54.

34. In an article, "Paul Robeson: Beleaguered Leader," Harold D. Weaver, Jr., never once mentions this transition in Robeson's development and treats him as a black nationalist from beginning to end. (*The Black Scholar,* December 1973–January 1974, pp. 41–46.)

35. *See* p. 331.

36. Charles H. Wright, *Robeson: Labor's Forgotten Champion,* Detroit, 1975, pp. 31–45. For a study of the emergence of the CIO and its relationship to

the unionization of black workers, *see* Philip S. Foner, *Organized Labor and the Black Worker (op. cit.,* note 28 *above),* pp. 215–37.

37. *See* p. 249.

38. Karl Marx, *Capital,* edited by Frederick Engels, New York, 1939, vol. I, p. 287. For evidence of Robeson's study of the writings of Marx and Engels, *see* his interview with Ben Davis, Jr., p. 105 of this volume.

39. Robeson, *Here I Stand,* p. 98.

40. Wright *(op. cit.,* note 36 *above),* pp. 49–116; Foner, *Organized Labor and the Black Worker (op. cit.,* note 28 *above),* pp. 293–309.

41. *See* p. 244.

42. Robeson, *Here I Stand,* p. 98.

43. The article by Baylor referred to appeared in the *Richmond Planet* of July 30, 1898, and was written in opposition to the annexation of overseas territory at the time of the U.S. war against Spain. Excerpts appear in Herbert Aptheker, editor, *A Documentary History of the Negro People in the United States,* vol. I, New York, 1951, pp. 823–24.

44. Robeson, *Here I Stand,* pp. 84, 86.

45. *See* p. 332.

46. Quoted in Philip S. Foner, editor, *The Voice of Black America,* New York, 1972, pp. 834–35.

47. *See* p. 332.

48. *See* pp. 377–8.

49. Lloyd L. Brown in "Symposium: Paul Robeson and the Struggle of the Working Class and the Afro-American People of the USA against Imperialism" *(op. cit.,* note 18 *above),* p. 48.

50. Robeson, *Here I Stand,* pp. 35–36, 48.

51. Foner, editor, *The Voice of Black America (op. cit.,* note 46 *above),* p. 835.

52. *See* p. 170.

53. *See* "The Negro People and the Soviet Union," p. 241.

54. Robeson, *Here I Stand,* pp. 37–38.

55. Ossie Davis, "To Paul Robeson," *Freedomways,* vol. XI, First Quarter, 1971, p. 196.

56. Sterling Stuckey, " 'I Want to Be African': Paul Robeson and the Ends of Nationalist Theory and Practice, 1941–1945," *Massachusetts Review,* Vol. XVII, Spring, 1976, p. 84.

57. *Ibid.,* p. 117.

58. *Ibid.*

59. *Ibid.,* p. 123.

60. *Ibid.,* p. 132 *n.*

61. In an interesting, free-wheeling discussion with Professor Stuckey at Northwestern University, November 7, 1977, he pointed out to me that Robeson's writings and speeches of the 1950s, in his belief, are less representative of Robeson's true point of view and tailored, to a large extent, to suit what the radical audience, mostly white, wished to hear. Since this was the only audience he could then address, this was logical in Stuckey's view, but it also tended to reduce the significance of what he had to say. Yet one who reads the pages of this volume dealing with the 1950s must, in my judgment, logically conclude that they represent Robeson's fully-developed thoughts—fully developed from all that had gone before.

62. Interview with Sterling Stuckey, June 10, 1970, quoted in Stuckey *(op. cit.,* note 56 *above),* p. 118 *n.*

63. William Shakespeare, *The Tragedy of Julius Caesar,* Act V, Scene V.

64. Davis *(op. cit.,* note 55 *above),* p. 197.

65. James M. McPherson, Laurence B. Holland, James M. Banner, Jr., Nancy J. Weiss, Michael D. Bell, *Blacks in America: Bibliographical Essays,* New York, 1971, pp. 276, 277, 278, 290, 292.

66. Indianapolis, 1971, pp. 113, 115. The editors do reprint John Lewis's observation during his interview in *Dialogue Magazine* of 1964 in which the SNCC chairman notes that "the masses and the Negro academic community really feel a great deal of understanding and love for people like Robeson and Du Bois." (pp. 357–58). But elsewhere in the book they reveal nothing by Robeson which should cause this feeling of "understanding and love."

67. Mark Solomon, "Black Critics of Colonialism and the Cold War," in Thomas G. Patterson, editor, *Cold War Critics,* New York, 1971, pp. 205, 208; Mary Sperling McAuliffe, *Crisis on the Left: Cold War Politics and American Liberals, 1947–1954,* Amherst, Mass., 1978.

Richard M. Fried in *Men Against McCarthy* has four references to Robeson but not a single Robeson statement against McCarthy and McCarthyism is included, only what others said about Robeson. (New York, 1976, pp. 96, 111, 119, 137.) Harry Haywood calls Paul Robeson "a great human being and an ardent fighter for Black liberation," but cites no examples of his work for black liberation. (*Black Bolshevik: Autobiography of an Afro-American Communist,* Chicago, 1978, p. 558.)

68. Quoted by Martha Dodd, "Paul Robeson," *Mainstream,* vol. XVI, 1963, p. 56. Anatol Schlosser evidently took Robeson's comment too seriously when he wrote that "it was through singing . . . that he best came to realize both personal and political ambitions. . . . It was not his speeches but his songs that spoke for his politics." (*op. cit.,* note 10 *above,* p. 12.) Clearly Schlosser, despite his impressive bibliography, has read few of Robeson's political speeches and articles.

Review of the 1917 Football Season

1. George Foster Sanford, the Rutgers football coach, had played an important role in permitting Robeson to try out for the team. Despite Sanford's attempt to smooth the way by a special meeting of the varsity, racist squad members ganged up on Robeson during the scrimmage. Robeson was about to fight back, but was halted by the cry from Sanford, "Robey, you're on the varsity!" "That brought me around," Robeson later revealed (see p. 154).

Nevertheless, in 1916 Sanford benched Robeson rather than forfeit a game against Washington and Lee University of Virginia, which refused to play any team with black members. While a few Rutgers faculty and students were mildly upset at Robeson's humiliation, Afro-Americans were outraged. James Carr, the first black graduate of Rutgers (class of 1892), upon hearing of the event nearly two years later, spoke for the black community when he criticized the university for having "prostituted her sacred principles, when they were brazenly challenged, and laid her convictions upon the altar of compromise." (James D. Carr to President William H. S. Demarest, L.L.D., June 6, 1918, Rutgers University Archives, uncatalogued Robeson Files.)

2. Robeson does not mention that in 1917 every major American newspaper except one listed Robeson in their All-American selections, and the *New York Tribune* found the exception guilty of a "laughable error." (Lloyd Brown in *Freedom,* August, 1954). That same year, Walter Camp, the foremost authority on the game, listed Robeson first on his roster of college stars—no official All-American was picked because of the war. In 1918–19 Robeson was named to Camp's All-American team, the first time a Rutgers man had been so

named. In Camp's words; Robeson was "the greatest defensive back ever to trod the gridiron." It was Camp himself who nominated Robeson for all-time honors with these words: "There never was a more serviceable end, both on attack and defense, than Robeson, the 200-pound giant of Rutgers." (Christy Walsh, editor, *Intercollegiate Football,* New York, 1934, pp. 14–15; *Targum,* October 30, 1935, p. 1.)

The Fourteenth Amendment

1. Next to this sentence is the professor's comment: "Extravagant." Since for most of its history the Fourteenth Amendment has been more important in safeguarding property rights (an aspect not mentioned by Robeson), than in protecting civil rights, the comment appears to be justified.

2. *Texas v. White* was decided in 1869, not during the Civil War. In the case the Supreme Court declared: "The Constitution, in all its provisions, looks to an indestructible union, composed of indestructible states."

3. Andrew Johnson (1808–1875), "poor white" tailor of Tennessee, who became vice-president of the U.S. in 1864, and President after Lincoln's assassination. He opposed the Radical Republican program of Reconstruction and favored a policy which led to the restoration of the former slaveowners to power in the South until they were displaced by Congressional action.

4. The reference is to the "Black Codes" adopted by the Southern governments under the Johnson Reconstruction program which effectively reduced Negroes to an inferior status and to semi-slavery. Among other things, they included harsh vagrancy laws and special penalties for violations of labor contracts.

5. The Fourteenth Amendment was framed by the Joint Committee of Fifteen in 1867 and adopted in 1868. Since ratification was made a condition of reinstatement into the Union, the Southern States ratified it. Delaware, Kentucky, and Maryland, however, rejected the Amendment.

6. The reference is to Section 2 under which the representation of any state was to be reduced in proportion to the number of male citizens disfranchised for any reason other than participation in rebellion or other crime. The clause was never enforced.

7. The decision of the Supreme Court held that Dred Scott, a Negro, was not a citizen of Missouri within the meaning of the Constitution of the United States, and "not entitled as such to sue in its courts."

8. The first of the major decisions of the Supreme Court in Reconstruction dealing with civil rights was the Slaughter-House Cases (1873) which did not actually involve racial discrimination nor Negroes. At issue was the constitutionality of a Louisiana statute granting to one particular slaughter-house syndicate the exclusive monopoly of butchering livestock in the New Orleans area. The suit was based on the ground that the monopoly legislation violated the equal protection clauses of the Fourteenth Amendment. The Supreme Court took the position that the Fourteenth Amendment was solely designed to protect the newly freed Negroes from discrimination based on color and that the contesting New Orleans butchers did not come within that protected class. However, the court also held that only the privileges of national citizenship were protected by the Amendment, and national citizenship encompassed a limited area according to the Court.

9. *Elk v. Wilkins* (Nov. 3, 1884) dealt with refusal of the registrar of one of the wards of Omaha to register an Indian. The Court ruled that "the plaintiff, not being a citizen of the United States under the Fourteenth Amendment of

the Constitution, has been deprived of no right secured by the Fifteenth Amendment, and cannot maintain this action."

10. In *United States v. Wong Kin Ark,* the Supreme Court ruled in the affirmative that a child born in the United States of parents of Chinese descent, who are the subjects of the Emperor of China but have a permanent domicile and residence in the United States, becomes at the time of his birth a citizen of the United States.

11. Samuel Francis Miller (1816–1890), Associate Justice, U.S. Supreme Court (1862–1890).

12. In 1869, Wyoming Territory gave women the vote but in *Minor v. Happersett* (1875) the Supreme Court ruled that the Amendment had not conferred the vote upon women.

13. Stanley Matthews (1824–1889), member of the Supreme Court, held in the case of *Yick Wo v. Hopkins* that a law, though fair on its face and impartial in appearance, was nevertheless a denial of the equal justice of the Fourteenth Amendment guarantees if administered in such a way as to make unjust discriminations.

14. In *Hurtado v. California,* the Supreme Court ruled that a grand jury indictment for crime is not essential to due process of law.

15. The reference is to Daniel Webster (1782–1852) who was the lawyer in the case of *Dartmouth College v. Woodward* (1819) which grew out of the action of the state of New Hampshire in altering a charter granted in colonial times. By a vote of 5 to 1, the Supreme Court ruled unconstitutional the New Hampshire law as impairment of the obligation of contract.

16. Joseph Story (1779–1845), member of the Supreme Court from 1811 to his death. His work *On the Constitution* was published in three volumes in 1833.

17. The Supreme Court decision in *Missouri v. Lewis* grew out of the action of the Circuit Court of St. Louis County in removing a resident from the practice of law in the state of Missouri. The Court ruled that a state has jurisdiction of its own tribunal for the different portions of its territory in such manner as it sees fit.

18. In *Murray's Lessee v. Hoboken,* the Supreme Court held that the constitutional requirement of due process of trial by jury is met if the trial is held according to the settled course of judicial proceedings.

19. *Kennard v. Louisiana* involved an act of Louisiana to regulate proceedings in contests between persons claiming a judicial office. Kennard charged he was deprived of his office without due process of law. The Supreme Court held he had a right to be heard by the courts, and had been heard and thus had not been so deprived.

20. In *Walker v. Sauvinet* the Supreme Court ruled that a trial by jury is not a privilege or immunity of national citizenship which the states are forbidden by the Fourteenth Amendment of the Constitution to abridge. The action was taken by Sauvinet against Walker, a licensed keeper of a coffee-house in New Orleans, for refusing him refreshments when called for on the ground that he was a man of color. Walker was charged with violating the equal rights provisions of the Constitution of Louisiana (Art. 13). Walker asked for a trial by jury and, when the jury disagreed, Sauvinet, by his counsel, asked the court to try the case under the act of February 27, 1871, to enforce Art. 13. A judgment was held against Walker for one thousand dollars, and he appealed saying he had not had the constitutional right of a jury trial. The court disagreed.

21. In *Twining v. State of New Jersey,* the Supreme Court ruled that

exemption from compulsory self-incrimination in the state courts is not secured by any part of the United States Constitution.

22. *Munn v. Illinois,* also known as part of the Granger cases, arose out of an act passed in 1873 by the Granger-controlled legislature of Illinois fixing the rates for the storage of grain in warehouses located in cities of 100,000 population or more. In the majority decision of the Supreme Court, Chief Justice Morrison Remick Waite (1816-1888) held that when private property is devoted to a public use, it is subject to public regulation.

23. John Marshall Harlan (1833–1911), member of the Supreme Court from December 11, 1877, to his death, during which time he was a stern defender of civil liberty and became known as the "great dissenter." He dissented in the Civil Rights Case of 1883 and the *Plessy v. Ferguson* decision of 1896, in both cases denouncing the deprivation of the Constitutional rights of Negroes under the Fourteenth Amendment.

24. In *Holden v. Hardy* (1898), the Supreme Court decided that a Utah statute limiting the hours of labor in mines to eight hours a day was not in violation of freedom of contract. By a vote of 7 to 2 the court held the law constitutional.

25. In *Lochner v. New York* (1905), the Supreme Court, by a 5 to 4 vote, invalidated the New York ten-hour law for bakers limiting the hours of labor in bake-shops to 60 hours in one week or ten hours in any one day.

26. The case of *Loan Association v. Topeka* dealt with the validity of a Kansas statute authorizing municipalities to issue bonds for the encouragement, in certain instances, of private businesses. The interest and principal of such bonds were to be paid from the public treasury. The Supreme Court found that the law in question authorized taxation for a private purpose, and so was unconstitutional and void.

27. *Norwood v. Baker* dealt with the right of Ohio to take private property for the purpose of making public roads, and related to compensation for abutting property. It was charged that the state had deprived the owner of the abutting property of due process of law, and the Supreme Court agreed, holding the state could not do what it did in this case.

28. The Supreme Court decision in *Davidson v. New Orleans* (1878) is important as indicating the growing tendency to identify due process of law with the doctrine of vested rights. For the first time a majority of the Supreme Court held that a form of property regulation by state legislation would be a violation of due process of law.

29. In the case of *Bells Gap Railroad Co. v. Pennsylvania,* it was charged that a tax by Pennsylvania on residents was in violation of the Fourteenth Amendment because the assessment was for the nominal value of the bonds and not their real value, and because the owners of the bonds had had no notice. The Court saw nothing obnoxious in the process of taxation complained of.

30. In *Magoun v. Illinois Trust and Savings Bank,* the Supreme Court ruled that the inheritance tax law of Illinois of June 15, 1895, made a classification for taxation which the legislation had the power to make, and did not conflict in any way with the provisions of the United States Constitution.

31. In *Knowlton v. Moore,* the Supreme Court held that the lower court had erred in denying the plaintiff relief from the action of the Commissioner of Internal Revenue, and that the plaintiff was entitled to recover so much of the tax as resulted from taxing legacies not exceeding $10,000. The tax did not meet the constitutional requirement of uniformity throughout the United States.

32. David Josiah Brewer (1837–1910), associate justice of the Supreme Court from 1889 until his death.

33. *Strauder v. West Virginia* (1880) was one of the few decision of the Supreme Court after Reconstruction making a concession to Negro rights by holding that laws barring Negroes from jury service were a violation of the equal protection clause and were void. However, Robeson does not point out that the Court at once destroyed the implication of this decision when it ruled in *Virginia v. Rives* (1880) that the mere absence of Negroes from a jury did not necessarily mean a denial of right. To prove a denial of due process, an accused Negro was obliged to prove that Negroes were deliberately excluded from the jury trying him. This decision paved the way for the practical exclusion of Negroes from juries.

34. In the Civil Rights Case (1883), the Supreme Court struck down as unconstitutional Sections 1 and 2, the vital accommodations sections of the Civil Rights Act of March 1, 1875. The decision, as well as others handed down since 1873, permitted the maintenance of segregation patterns throughout the nation, despite the Fourteenth Amendment.

35. The Magna Carta, "Great Charter," is a landmark in the development of constitutional guarantees, and was forced upon the English King John in 1215 by his feudal barons. It stipulated that "No freeman shall be arrested and imprisoned . . . unless by the lawful judgment of his peers and by the law of the land."

36. Noah Haynes Swayne (1804–1884), appointed justice of the Supreme Court by President Lincoln in 1862 and retired on January 25, 1881. In the Slaughter-House Cases, he took a firm nationalistic position.

37. Sir William Blackstone (1723–1780), one of the most famous English jurists, best known for his *Commentaries on the Laws of England.*

The New Idealism

1. This is actually part of a sentence from Lincoln's Gettysburg Address, November 19, 1863. The sentence reads: "It is rather for us to be here dedicated to the great task remaining before us—that from these honored dead we take increased devotion to that cause for which they here gave the last full measure of devotion—that we here highly resolve that these dead shall not have died in vain—that the nation shall, under God, have a new birth of freedom—and that government of the people, by the people, for the people, shall not perish from the earth."

2. Solon (630 B.C.-560 B.C.), Athenian statesman, known as one of the seven wise men of Greece, who ended aristocratic rule of the government, and introduced a new and more humane law code.

Paul Robeson Talks of His Possibilities

1. *All God's Chillun Got Wings* by Eugene O'Neill (1888–1953) opened on May 5, 1924. Robeson had also appeared in *The Emperor Jones* by O'Neill before this interview took place. Eugene O'Neill had won the Pulitzer Prize for *Beyond the Horizon* in 1920 and for *Anna Christie* in 1922.

An Actor's Wanderings and Hopes

1. Robeson performed Simon in the Harlem YMCA's revival of *Simon the Cyrenian.* First produced in 1917, this play is one of three one-act plays

written by Ridgely Torrence under the title of *Granny Maume,* and are entitled "Plays for a Negro Theater."

2. Robeson was studying law at Columbia University Law School.

3. The play starred Margaret Wycherly, and was retitled *Voodoo* when it was taken to England.

4. Mrs. Patrick Campbell, who brought the play to England, was rehearsing Ibsen's *Hedda Gabler* when Robeson met her, and she alternated playing *Voodoo* and *Hedda Gabler.*

5. Mrs. Campbell was impressed with her young supporting actor, and asked him to prepare for *Othello,* but Robeson refused, saying he knew nothing of singing or acting.

6. Originally the Negro actor Charles Gilpin played the role when *Emperor Jones* opened on November 3, 1920, but when O'Neill became dissatisfied with Gilpin's acting and drinking, he selected Robeson for the role of Brutus Jones, and later for that of Jim Harris in his *All God's Chillun Got Wings.*

7. The Provincetown Players was the group which had decided on a Negro for the role of Brutus Jones rather than a white actor in black face.

8. Ira Frederick Aldridge (1805-1867), American Negro tragedian, considered one of the ablest and most faithful interpreters of Shakespeare during his era. Though he was American-born, racism in this country compelled him to perform mostly in Europe, and for the last ten years of his life he acted mainly on the Continent.

9. Harry Burleigh, while never attaining the concert stage himself as a great baritone, helped place Negro artists before white and mixed audiences. He was a great musician and arranger, a friend of Dvorak, and for over fifty years soloist at Saint George's Episcopal Church in New York City.

10. Roland Hayes, born in Georgia in 1887, sang in church choirs, trained himself to become a great singer, but could obtain no bookings as a concert artist because of his color. He managed his own tours on the Negro circuit, and after a successful tour in England, where he gained a great reputation, he returned to the United States to become a professional and one of the nation's foremost singers.

11. Charles Gilpin was the best-known Negro actor of the twentieth century before Paul Robeson appeared. His first Broadway part was that of a Negro clergyman in Drinkwater's *Abraham Lincoln* (1919), and his most important role was the lead in a four-year run of Eugene O'Neill's *Emperor Jones.*

12. This is probably a reference to Bert Williams, famous Negro vaudeville comedian.

13. Noble Sissle was a member of the chorus in a Cleveland public school who, after serving in World War I, went on to become of the jazz "greats" as a band leader.

14. Eubie Blake, another jazz "great," had extensive professional training as a musician.

15. James Miller, black musician and first Negro music teacher in the public schools of Pittsburgh.

16. Florence Mills became famous as a singer in the all-Negro revues of the 1920s.

Reflections on O'Neill's Plays

1. Robeson is referring to the uproar created by the fact that in Act II, Scene 3, Alla Downey, a white woman, stops in front of Jim Harris, a young Negro, and "kisses his hand as a child might, tenderly and gratefully." The

Hearst *New York American* called for banning the play, and was supported by politicians and American Legionnaires. (*See* issues of March 12, 18, 28, 1924.) When the play opened, the *Pittsburgh Courier,* a Negro weekly, observed: "Miss Mary Blair, white actress, has kissed the hand of Paul Robeson, Negro dramatic star, and the world seems to be rolling on as usual . . ." (May 23, 1924.)

2. In publishing correspondence between Eugene O'Neill and W. E. B. Du Bois, Herbert Aptheker writes: "Cordiality marked the long relationship between O'Neill and Du Bois, with the playwright expressing the highest estimation of Du Bois's literary skill." (Herbert Aptheker, editor, *The Correspondence of W. E. B. Du Bois, Vol. I, Selections, 1877–1934,* Amherst, Mass., 1973, p. 294.)

3. James Light directed *All God's Chillun Got Wings.*

Paul Robeson and the Theatre

1. In 1936 Robeson did appear in *Toussaint L'Ouverture,* a play by C. L. R. James about the Haitian liberator.

2. Robeson was performing in *Black Boy,* a play by Jim Tully and Frank Dazey, which concerned itself with the meteoric rise and subsequent rapid fall of a Negro prize-fighter. In it Robeson played the role of Black Boy, a vagrant Negro, who wanders into the training camp of "Mauler" Murphy, a white prize-fighter, knocks him out in sparring practice, and within two years becomes champion fighter of the world. He gains fame and money and leads a wild, dissipated life. He loses a championship fight when he is made drunk by the girl he loves, Irene, who has been blackmailed into betraying Black Boy by the threat to disclose the fact that she is a Negro passing as white. *Black Boy* opened on Broadway on October 6, 1926, after an out-of-town tour. The play received lukewarm reviews, but Robeson's acting gained critical acclaim.

3. *Uncle Tom's Cabin,* the popular anti-slavery novel by Harriet Beecher Stowe, published serially in *The National Era* (1851–1852) and in book form in 1852, was dramatized the same year by George Aiken. In the dramatic version, many of the Negroes, including "Uncle Tom," were depicted as humble and servile to white people, and this gave rise to the use of the scornful epithet "Uncle Tom."

4. Carl Van Vechten (1880–1964), *New York Times* assistant music critic and Paris correspondent who became an influential figure in New York literary circles in the early 1920s and an early enthusiast for the culture of U.S. blacks. His most famous novel, *Nigger Heaven,* set in Harlem, attempted to describe the Harlem urban Negro in human, realistic terms rather than as a stereotype. But its derogatory title, its emphasis on the flamboyant and exotic, and the dissolute Negro life and characters it depicted, led to severe criticism of the book in the Negro press. Nevertheless, Van Vechten's novel had an influence on the writing of several black authors.

The Source of the Negro Spirituals

1. The article also carried the full text of the Negro spiritual, "All God's Chillun Got Wings."

Commenting on the Robeson interview, Rabbi Jacob S. Minkin declared: "Many of the negro spirituals have the melody of the synagogue in them. There was quite a large Jewish community in New Orleans, and several of its members were noted abolitionists. Maybe the negroes there heard them

singing in the synagogue. The liberation of the Jewish Bible struck deep into the soul of the negro." (*Buffalo News,* October 22, 1927.) For Robeson's additional discussion of this subject, *see above* p. 392.

Robeson in London Can't Explain His Success

1. Just what game is referred to is not clear. However, in 1916, Washington and Lee University of Virginia refused to play a football game against Rutgers with a Negro in the line-up. The Rutgers coach complied, and Robeson did not play. (*See* George Fishman, "Paul Robeson's Student Days and the Fight Against Racism at Rutgers," *Freedomways,* vol. IX, Summer 1969, p. 225.)

Paul Robeson Speaks about Art and the Negro

1. In 1925 Victor Records issued its first recordings by Paul Robeson of the Negro spirituals "Steal Away," "Were You There? (When They Crucified My Lord)," and, with Lawrence Brown, "Bye and Bye (I'm Goin' to Lay Down Dis Heavy Load)" and "Joshua Fit de Battle of Jericho."
2. *Othello,* with Peggy Ashcroft as Desdemona, opened on May 19, 1930, and ran for six weeks. The reviews, while critical of the staging, set, and lighting, hailed Robeson's performance.
3. Robeson frequently gave special performances of Negro spirituals and extracts from *The Emperor Jones,* combining his careers as singer and actor.
4. Sir Richard Terry (1865–1938), English organist, choirmaster, and musicologist.
5. Sir Jacob Epstein (1880–1959), one of the leading portrait sculptors of the twentieth century. His head of Paul Robeson is among his most famous.
6. Henri Matisse (1869–1954), one of the most important French painters of the twentieth century.
7. Marc Connelly's *The Green Pastures* featured Richard B. Harrison as "De Lawd." The play opened in 1930, won the Pulitzer Prize, and ran for five years on Broadway. The play was based on Roark Bradford's sketches, *Ol' Man Adam an' His Chillun,* and was a folk version of the Old Testament, dramatized through the lives of Southern Negroes. When it was revived in 1951, it was criticized by a number of black leaders for perpetuating unacceptable stereotypes of Negroes.

Paul Robeson and Negro Music

1. *The Hairy Ape,* by Eugene O'Neill, was originally produced in New York City in 1922 with a white man in the role of "Yank," the stoker in the hold of a transatlantic liner. O'Neill suggested Robeson for the lead role, and Robeson arrived in London in April 1931 to start rehearsals under the direction of James Light. *The Hairy Ape* opened in London on May 11, 1931.

Thoughts on the Colour Bar

1. Robeson's article was part of a series on the Colour Bar in *The Spectator,* the British weekly. The journal noted in its introduction: "Our object in publishing the series is to attempt some explanation of why the Colour Bar exists, and to emphasize the importance of the problem for the British Commonwealth." (August 8, 1931, p. 177.) Robeson was followed a week later

by Lt. Colonel E. ff. W. Lasalles, C.B.E., who in his article "Colour No Bar" described the state of affairs in New Zealand.

2. The reference is to the infamous dictum in the opinion of Chief Justice Roger B. Taney in the Dred Scott decision of 1957.

3. Peonage, or debt servitude, existed especially in the cotton belt from the Carolinas to Texas and including the Mississippi Delta, and in the turpentine areas of northern Florida, southern Georgia, Alabama, and Mississippi.

4. In most southern states Negroes were still disfranchised by a variety of devices such as the poll tax and literacy tests.

5. Appropriations for Negro segregated schools in the South were woefully inadequate and most Negro children attended school for a very limited period of time during the year.

6. Soon after the Depression began, many employers fired their Negro workers and replaced them with whites, who had normally shunned such menial work, at "Negro" wages or lower. (*See* Raymond Wolters, *Negroes and the Great Depression,* Westport, Conn., 1970, pp. 92, 103, 113–24, 139, 151, 214.)

7. This is not entirely accurate since the Northern Negro suffered almost as severely as the Southern during the Great Depression. (Wolters, *op. cit.,* pp. 32–33, 82–84.)

8. The reference is to the "Gold Star Mothers," whose sons had been killed in France during World War I, but who found themselves segregated and treated as second-class people during their visit to their sons' graves.

9. The brilliant essayist is W. E. B. Du Bois (1868–1963), and the reference is to his essays in *The Souls of Black Folk,* published in 1903.

10. *The American Commonwealth* by James Bryce (1838–1922) was published in 1888. It was an analysis of the American social and political system.

Robeson Spurns Music He "Doesn't Understand"

1. Marian Anderson was the first Negro to sing at the Metropolitan Opera in New York, making her debut in 1955 as Ulrica in Verdi's *Un ballo in maschera (A Masked Ball).*

2. Verdi's *Aida* and Meyerbeer's *L'Africaine* were operas about Africans.

The Culture of the Negro

1. Swahili, the Bantu language, spoken primarily on the east coast and islands of Africa in an area extending from Lamu Island, Kenya, in the north to the southern border of Tanzania in the south.

2. The Bantu languages form a subgroup of the Benue-Congo group of the Niger-Congo language family. Swahili is used as a lingua franca in Tanzania, Kenya, Zaire, and Uganda, and there are over one million speakers.

3. Many of the Hamitic languages were believed to constitute one of two branches of the Hamito-Semitic language family, but are now viewed as forming separate branches, such as Egyptian, Berber, Chadic, Cushitic.

4. Confucius (551–479 B.C.), China's most famous teacher of ancient times, philosopher and political theorist.

I Want to Be African

1. The ignorance of African history outside of Egypt at the time Robeson was writing was not as great as Robeson indicates. William Leo Hansberry, Joel A. Rogers, W. E. B. Du Bois, Carter G. Woodson, all black scholars, and

Melville J. Herskovits, Maurice Delafosse, and Leo Frobinus, white scholars, had already published works to destroy the image of Africa as uncivilized before the advent of the white man.

2. Taoism is one of the major religio-philosophical traditions of Chinese life, based on the ideas of the sixth century B.C. Lao-tzu.

3. Tivi is the Benue-Congo language of the Niger-Congo family and is spoken by the Nigerian people living on both sides of the Benue River in the northern region.

Negroes—Don't Ape the Whites

1. Marie Lloyd (1870–1922), foremost English music-hall artist of the late nineteenth century, famous for her Cockney low-comedy.

2. Robert Burns (1759–1796), National poet of Scotland and one of the best loved poets of all times.

3. Marc Connelly (*see* note 7, p. 508).

4. Ludwig van Beethoven (1770–1827), Viennese-born musical genius, ranked as one of the greatest figures in the history of Western music.

5. Johannes Brahms (1833–1897), Viennese-born composer, most famous of the late nineteenth century musical figures.

6. William Shakespeare (1564–1616), English poet and dramatist considered by many to be the greatest writer of all times.

7. Alexander Pushkin (1799–1837), Russian poet, novelist, dramatist, and short story writer, considered his country's greatest poet and founder of modern Russian literature.

8. Fyodor Dostoyevsky (1821–1881), famous Russian novelist, noted for his psychological penetrations into the hearts of his characters.

9. Leo Tolstoy (1828–1910), Russian writer, social reformer, and considered one of the world's foremost novelists.

10. Lao-tzu (6th century B.C.), the first philosopher of Chinese Taoism.

11. Plato (427?–347 B.C.), original name, Aristocles, student of Socrates who became the greatest of Greek philosophers.

"I Am at Home"

1. Sergei Eisenstein (1898–1948), Soviet film director, noted for some of the classics of the art of cinema, such as *Potemkin* (1925).

2. Robeson's Moscow visit was arranged by Marie Seton at the prompting of Eisenstein, who wished to collaborate with the great Negro actor in a film. The film was to be called *Black Majesty,* based on the Haitian general Jean Jacques Dessalines, but it was never produced. Robeson had also hoped to appear in a play about Dessalines in London in 1935, but the plans for the play were never realized. However, in 1936 he did appear in a play about Toussaint L'Ouverture, the Haitian liberator, by C. L. R. James.

3. Jim Crow, identified originally as a Negro slave and stable hand in Louisville, Kentucky, whose song and dance was mimicked by the minstrel Thomas D. Rice, came to be associated with all policies for excluding Negroes from contact on an equal plane with white people, such as Jim Crow laws, Jim Crow cars, etc.

4. The film was *The Song of Freedom,* and in February 1936 Robeson went to West Africa with a film unit to begin shooting background material. It was based on a story, originally titled "The Kingdom of Zinga," by Claude Wallace and Dorothy Holloway.

I Want Negro Culture

1. Geoffrey Chaucer (1342-1400), the outstanding poet before Shakespeare, famous for his *Canterbury Tales*.

Paul Robeson on Negro Race

1. The Scottsboro case began in 1931, when nine Negro youths, one barely twelve years old, were accused of raping two white girls while "hoboing" out of Alabama and into Tennessee. When the state sentenced the nine youths to death, a defense campaign was instituted and it grew to international proportions, spearheaded by the International Labor Defense and the Communist Party. The Negroes, as a result of the campaign, escaped execution, but they remained in prison for years, despite the evidence that the rape charge was a hoax.

2. The reference here too is to the dictum of Chief Justice Taney in the Dred Scott decision, but it was handed down in 1857 not in 1860.

3. On January 29, 1901, George Henry White, Negro congressman from North Carolina, stood in the House of Representatives for the last time. It was not until twenty-eight years later that Congress was to greet its next Negro member, and he was not from the South but Oscar De Priest from Chicago.

4. It was estimated in October 1933 that the American Federation of Labor had four million members, but few of them were blacks. In 1934, at the AFL convention, A. Philip Randolph, president of the Brotherhood of Sleeping Car Porters, had urged the delegates to order "the elimination of the color clause and pledge from the constitution and rituals of the trade and industrial unions," and expel all unions that maintained "said color bar." What came to be known as the "Randolph Resolution" was rejected then and repeatedly by AFL conventions thereafter. Hence Robeson exaggerated when he wrote that "officially American trade unions are open to negroes. . . ."

"I Breathe Freely"

1. Joseph Stalin (1879–1953), real name Vissarionovich Dzhugashvili, head of the Communist Party of the Soviet Union, who ruled the Soviet Union dictatorially for a quarter of a century and transformed it into a world power. One of Stalin's theoretical contributions to Marxism-Leninism dealt with the national question.

2. Ivan Turgenev (1818–1883), Russian novelist, poet, and playwright, author of *Fathers and Sons* (1862).

3. Nicolay Gogol (1809–1852), Russian novelist and dramatist, whose novel *Dead Souls* and short story, "The Overcoat," are considered the foundations of the great nineteenth-century tradition of Russian Realism.

4. The National Association for the Advancement of Colored People (NAACP) was founded in 1909 as an interracial organization to work for the abolition of racism, discrimination and second-class citizenship for Negroes. For many years W. E. B. Du Bois was the editor of its official journal, *The Crisis*.

5. The Communist position in the Scottsboro case was that legal action alone, as favored by the NAACP, would not free the condemned Negro youths (*see* note 1, "Paul Robeson on Negro Race," *above*), but that mass protest on an international scale had to be employed to supplement legal action.

Robeson Finds a Natural Link to the Songs of African Tribes

1. In 1929 Universal Films purchased the rights to Edna Ferber's novel, *Show Boat,* and prepared to transform it into a silent film. In the interim Florenz Ziegfeld had produced his highly successful stage version with music by Jerome Kern. Universal hastily appended a sound prologue and added "talkie" intervals of song. The original film cast Stepin Fetchit in the part of Joe, but in deciding to make another *Show Boat,* Universal hired the original authors of the New York success to write the scenario, and approached Paul Robeson to play the part of Joe, a part Kern had written with Robeson in mind. Robeson had been a great success in the role in the London production of the musical. He agreed to perform in the film, but set a number of conditions, all of which, except final say over the end product, were granted.

2. In 1928, while he was appearing in *Show Boat* in London, Robeson was approached with the idea of performing in a work by Edgar Wallace. Years later, he did appear in a film based on the Wallace adventure stories and the famous character of Sanders. It was produced by Alexander Korda. Originally designed to bring African culture to the screen and build a more dignified image of the Negro, it changed in the course of the filming to a glorification of British imperialism. It became, as Robeson told the anthologist Nancy Cunard, "pure Nordic bunk." (*Baltimore Afro-American,* July 6, 1935.)

Robeson Visions an Africa Free of Rule by Europeans

1. The interview includes material which appeared in the *New York World-Telegram* of January 11, 1936. A paragraph from the *Herald-Tribune* interview, however, is omitted in which Robeson is reported as expressing "the firm trust that some day the Dark Continent might become the Negro's true land, governed and developed by him without domination or exploitation."

2. The film was never produced.

3. Fascist Italy invaded Ethiopia in 1935 and occupied the country as part of Mussolini's dream of resurrecting the Roman Empire. The black community of the United States rallied to Ethiopia's defense.

4. The film was *Song of Freedom,* but the story developed somewhat differently. The plot concerns a Negro dock worker in London who has inherited from his slave forbears a medallion and a song signifying kinship. He yearns to return to Africa, the land of his origin. Picking up the clue of his past through the song and the medallion, he goes back to Africa and struggles against the backward superstition and ignorance to bring progress to his people. British colonial policy in regard to Africa is not mentioned. But in light of the tremendous interest in Alex Haley's *Roots,* the going back to African roots in a Robeson film of 1936 (revived in 1946) is impressive.

5. Robeson attempted to interest Oscar Hammerstein 2nd in producing the film originally projected by Sergei Eisenstein, but it was never made even though Hammerstein believed it could be a fine picture.

6. Henri Christophe (1767-1820), slave and lieutenant under Toussaint L'Ouverture in the war of Haitian independence (1791-1804); he established a kingdom in northern Haiti after a dispute with his opposition in the Haitian government, and built the famous Citadelle La Ferriére, a fortress south of his capital in Cap-Haïtien.

U.S.S.R.—The Land for Me

1. Benjamin J. Davis, Jr., was born in Dawson, Georgia, and attended public schools in Atlanta, but had to quit because provision for public education for Negroes ended at the sixth grade. He attended Morehouse College (the equivalent of high school), then graduated from Amherst College and Harvard Law School. He joined the International Labor Defense as a lawyer for Angelo Herndon, and the celebrated case of the young Negro victim of Georgia's slave law (convicted for the "crime" of organizing the unemployed for relief during the Great Depression) was the turning point of his life, for he joined the Communist Party. Davis went on to join the famous legal and mass defense of the nine Scottsboro boys, to defend the Atlanta Six, who faced a conspiracy charge similar to Herndon's, and to help edit the *Southern Worker,* a Communist publication. Later, he came to New York to edit the *Negro Liberator* and joined the editorial board of the *Daily Worker.* In 1943 he was elected as the Communist candidate to the New York City Council and was reelected two years later. One of his achievements while councilman was the fight he led to end Jim Crow in baseball, in which battle he and Robeson worked closely together. It was Davis who made possible the official City Hall proclamation of Negro History Week. Indicted under the Smith Act, he was imprisoned for five years for his belief in Communism. After his release from prison he returned to work in the Communist cause until his death in 1962. A close friend of Davis, Robeson spoke at his funeral. (*See* pp. 480-81.)

2. Eslanda Cardozo Goode Robeson had been a student in the chemistry department of Columbia University Teachers' College, and upon graduation, was the first black to obtain a job as an analytical chemist in the Surgery and Pathological Department of Columbia Presbyterian Medical Center.

3. William Randolph Hearst (1863–1951), newspaper publisher who developed sensationalist methods for bringing issues to the public. By 1925 Hearst had established newspapers in every section of the United States, as well as magazines. He bitterly opposed the New Deal and the Soviet Union, and praised fascism. Charles A. Beard, noted historian and social critic, once declared he would "not touch Hearst with a ten-foot pole."

4. *New Masses* was the weekly Communist Party cultural weekly which began publication in 1926 as a continuation of the old *Masses,* which had been forced to suspend in 1918 because of government repression due to its stand in opposition to American participation in World War I. *The Masses* was succeeded by *The Liberator,* which continued until 1924.

5. The *Negro Liberator* was the publication of the Harlem sections of the Communist Party and appeared from 1929 to 1934.

6. In an interview with T. R. Posten in the *Amsterdam News* of October 5, 1935, Robeson had attempted to defend his role in *Sanders of the River,* saying: "To expect the Negro artist to reject every role with which he is not ideologically in agreement, is to expect the Negro artist under our present scheme of things to give up his work entirely."

7. At the sixth congress of the Comintern (Third International) in 1928, the American delegates participated in the discussion and out of the congress emerged an analysis of the Negro question in the United States as a national question. Whereas the Marxists in the United States had traditionally considered the Negro question as that of a persecuted racial minority of

workers, more persecuted than any other group of workers, the Party now characterized the Negro people as an oppressed nation entitled to the right of self-determination. In addition to pressing as previously for full economic, political and social equality for the Negro people, the Communist Party also raised the slogan that the Negro people should have the right of self-determination in the "Black Belt" of the South which they could exercise whenever and however they saw fit to use this right.

8. The American League Against War and Fascism, a united front organization, was established on September 29, 1933, in New York, with Dr. Harry F. Ward as national chairman.

9. The National Negro Congress was founded at a convention in Chicago held on February 14–16, 1936. Present were 817 delegates representing 585 organizations; they came from 28 states and represented a combined membership of 1,200,000 people. Among those present were delegates from 81 churches and religious groups, 83 trade unions, 71 fraternal societies, 26 youth, 12 farm, 23 women's, and 14 educational groups and various political parties and professional and business organizations. The original Executive Council of 66 men and women included Ralph Bunche, Benjamin Davis, Jr., Max Yergan, James W. Ford (Communist Party leader), and Lester B. Granger of the National Urban League. The president was A. Philip Randolph, the secretary was John P. Davis, and the treasurer, Miss Marion Cuthbert.

At the 1940 convention of the National Negro Congress a split developed between A. Philip Randolph and the CIO-Communist Party delegates. After the delegates voted overwhelmingly to affiliate with the CIO's Labor Non-Partisan League and to condemn American "involvement in this imperialistic war," Randolph resigned as NNC president, charging that the organization was white- and Communist-dominated. Max Yergan was elected president in his place.

"Primitives"

1. In discussing this article briefly, Edwin P. Hoyt, without the slightest evidence, condescendingly comments that the subject was too advanced for Paul Robeson and probably it was written by Essie. (*Paul Robeson: The American Othello,* Cleveland and New York, 1967, p. 83.)

2. Mencius, Latinized form of Meng-Tzu ("Master Meng"), a famous Confucian text by the fourth century B.C. philosopher Mencius, known as the "Second Sage."

3. William Blake (1757–1827), poet, engraver, prophetic visionary in art and literature.

4. D. H. Lawrence (1885–1930), short-story writer, poet, essayist and controversial English novelist, author of *Lady Chatterley's Lover,* banned as obscene in several countries when first published in 1928.

5. Sir Walter Raleigh (1861–1922), noted British critic and man of letters, leader of the Oxford English school.

6. Pushkin's Negro blood was widely acknowledged. His mother was a granddaughter of Abram Hannibal, who, according to family tradition, was an African princeling bought as a slave in Constantinople, and adopted by Peter the Great, whose comrade in arms he became. Pushkin immortalized him in an unfinished historical novel, *Ara Petra Velikogo* (published 1837), *The Negro of Peter the Great.*

7. Alexandre Dumas (1802–1870) was the natural son of a San Domingue black.

8. This is an understatement. Around 1907 a group of painters in Paris—Picasso, Derain, Matisse, and Vlaminck—immersed themselves in the so-called primitive art of Benin, Ife, and other West African art styles, and this influenced the whole school of abstract art.

An Exclusive Interview with Paul Robeson

1. It is interesting in view of the tremendous excitement aroused by the use of the oral tradition in Alex Haley's *Roots* that Robeson stressed its significance as early as 1936.

When I Sing

1. The reference and extracts are from the second federal constitution of December 5, 1936.
2. The Spanish Civil War started with the rising of the military in Morocco on July 17, 1936, and spread to the garrison of metropolitan Spain the following days.
3. The editorial, by W. E. B. Du Bois, appeared in *The Crisis* of November 1936, pp. 337. It opened: "Everyone, including John D. M. Hamilton, the Republican campaign manager and national chairman, is telling the American people to look at what is happening in Spain. We hope the colored people are looking at the Spanish civil war, but we hope, also, that they are looking through their own eyes and not through those of William Randolph Hearst, or of the Catholic church, or of the average daily newspaper. Mr. Hearst's paper can always be relied upon for sensation, but seldom for the truth. The Catholic church has been caught up in the struggle and cruelly persecuted so that its judgment is warped (understandably) by the pain it has suffered. The average daily newspaper in this country is of sheer necessity a capitalistic enterprise, dedicated to upholding the profit system. So none of these can paint the true picture of what is happening in Spain."
4. After "disfranchised" and before "The kernel . . .," there is the following: "The prize is Spain. Keep straight on Spain. There are horrors, of course. Bloody outrages have been committed. All that goes with any war."

Robeson Calls for Aid to Negroes Defending Democracy in Spain

1. Some 3,000 Americans went to fight fascism in Spain as members of the Abraham Lincoln Battalion of the 15th International Brigade of the Spanish Republican Army. Scores of them were Negroes. More than half of the Americans, including blacks, laid down their lives at Jarama, Brunete, Quinto, Belchite, Teruel and the Ebro.

The Artist Must Take Sides

1. The reference is to the brutal, terroristic bombing of the little Basque fishing village of Guernica by the Nazi planes in aid of the Spanish fascists led by Francisco Franco. In his oil painting, "Guernica," Pablo Picasso created an unforgettable image of the inhumanity of fascism and war. The painting is in the Museum of Modern Art, New York City, but is to be sent to Spain when, as stipulated by Picasso in his will, the Spanish government is demonstrated to have become truly democratic.

Why I Joined Labor Theatre

1. In 1936 it was reported that the Trades Union Congress in England was to subsidize a Left Theatre group. The company, when established, would form a permanent theatre as well as tour the Provinces, performing plays with a labor and working class message. The Unity Theatre was established in an unused Presbyterian chapel. Based upon principles of equality, it had no star system. The actors were trade union members who rehearsed after working at their regular jobs.

Paul Robeson Tells Us Why

1. A short play by the American writer Ben Bengal, set in the United States and dealing with union organizing and a sit-down strike. The program did not list the names of the actors.

Paul Robeson in Spain

1. Nicolás Guillén, the distinguished Afro-Cuban poet, was in Spain during the Civil War and had the opportunity to meet and interview Robeson.

2. The International Brigades were volunteers from various countries who fought for the Spanish Republic against fascism. The Abraham Lincoln Brigade represented the United States.

3. Langston Hughes (1902–1967), Lincoln University graduate, who became one of the great black poets of the twentieth century and enjoyed a distinguished literary career until his death. He was a newspaper correspondent in Spain.

A Great Negro Artist Puts His Genius to Work for His People

1. In 1939 Marian Anderson was prohibited, because of her race, from singing at Constitution Hall of the Daughters of the American Revolution in Washington, D.C. As a demonstration of protest a group of citizens, including Mrs. Franklin D. Roosevelt, arranged a concert at the Lincoln Memorial, permission for which was granted by Secretary of the Interior Harold Ickes. The concert of the distinguished Negro contralto drew an audience of 75,000.

2. Words missing in the original.

Paul Robeson Told Me

1. Robeson returned to the United States just before the outbreak of World War II to appear in *John Henry* in Pittsburgh.

2. Sojourner Truth (c. 1797–1883) was born a slave in New York and freed in 1827 when the state liberated its slaves. She did domestic work and, after a period of religious revivalism, became an active Abolitionist, exchanging her name Isabella for the name Sojourner Truth. Although she remained illiterate all her life, she did valiant service in the antislavery and woman's rights cause. When she died in November 1883, the *New York Globe,* a black weekly, declared (December 1): "Sojourner Truth stands preeminently as the only colored woman who gained a National reputation on the lecture platform in the days before the war."

Robeson, however, means Harriet Tubman as the black woman who worked

closely with John Brown and was known as the "Moses of Her People." Harriet Tubman (c. 1821–1913) was the legendary "conductor" on the Underground Railroad. Born a slave on the eastern shore of Maryland, she fled from slavery when nearly thirty years of age, and devoted herself to guiding others to freedom. She made nineteen journeys into slave territory during a period of ten years, and brought back more than three hundred men, women and children. During the Civil War she served as a military scout and nurse in the Union Army.

3. John Brown (1800–1859) led fifteen men, including five Negroes and his own sons, against the federal arsenal at Harpers Ferry, Virginia, October 16, 1859, with the aim of fomenting a slave revolt and eventually establishing a Negro republic in the mountains of Virginia. Brown and his men captured the arsenal, but the next day a company of United States Marines under Colonel Robert E. Lee assaulted the group, killed ten, and took Brown prisoner. After a hurried trial, the wounded Brown was sentenced to be hanged. Brown's bravery and dignity during the trial and on the scaffold moved millions of people to regard him as a hero. Among the Negro people, he was considered a saint.

John Brown learned much from Harriet Tubman about the swamps and forests of the South.

4. In April 1935, while in London, Robeson performed in *Stevedore,* a play by Paul Peters and George Sklar, dealing with black-white labor unity.

5. *Peer Gynt* was a verse drama by Henrik Ibsen which followed the career of the legendary Norse folk hero, Peer Gynt. The play was published in 1867.

6. The Federal Theatre Project was a national theatrical movement sponsored and funded by the United States government as part of the Work Projects Administration (originally called Works Progress Administration). The purpose was to create jobs for unemployed theatrical people in the depression years of 1935–1939. Ten thousand professionals were employed in all aspects of the theatre. Among the projects was the establishment of Negro theatre. Marc Blitzstein's *The Cradle Will Rock* was produced under WPA auspices, but through fear of the radical, pro-labor content, sponsorship was withdrawn and a concert version of this opera was performed without federal backing.

Following a series of controversial investigations by the House Committee on Un-American Activities and the Subcommittee on Appropriations regarding the Federal Theatre's progressive stand on social and economic issues, the Federal Theatre Project was terminated in 1939 by congressional action.

Foreword to *Uncle Tom's Children*

1. Richard Wright (1908–1960), noted black novelist and short story writer best known for the novel *Native Son,* first came to general public attention with a volume of novellas, *Uncle Tom's Children* (1938), based on the question: How may a black man live in a country that denies his humanity? In each story but one the hero's quest ends in death.

2. The Nat Turner revolt in Virginia in 1831 was the greatest slave revolt in American history. At the head of a small band of slaves, Turner moved from plantation to plantation, murdering slaveholding families. Some sixty whites were killed and, in retaliation, more than one hundred Negroes, innocent and guilty, were murdered before the rebellion was crushed. Nat Turner was later captured and executed.

3. Denmark Vesey was a slave in Charleston, South Carolina, who bought

his own liberty after he won a $1,500 raffle. Once free himself, he was determined to aid his people in gaining their freedom, and for four years he planned a vast slave plot. The slaves involved had hidden away weapons and ammunition. In 1822 the plot was uncovered when two house slaves turned informers, and the authorities arrested 131 suspects. Federal troops were present to protect Charleston against further revolts as the leaders of the revolt were hanged.

4. Frederick Douglass (1817–1895), born a slave and completely self-taught, escaped to the North in 1838 and made his first public speech three years later. After six years as a lecturer for antislavery societies, he broke with the Garrisonians to edit his own paper, *The North Star* (later *Frederick Douglass' Paper* and *Douglass' Monthly*). As editor, orator, political figure, organizer, he led the black protest movement for almost fifty years and became the outstanding Negro figure of the nineteenth century. After the Civil War, he was an editor of *New National Era,* Recorder of Deeds for the District of Columbia, and U.S. Minister to Haiti.

5. Margaret Mitchell's *Gone With the Wind,* a novel about the Civil War and Reconstruction from a pro-slavery, anti-Negro point of view, was published in June 1936 and became the best selling novel in the history of the U.S. publishing industry up to that time. In the first six months after publication, 1,000,000 copies were sold, 50,000 in one day. Made into a motion picture, starring Clark Gable and Vivien Leigh, it held the record for gross earnings for more than two decades. By 1939 when Robeson wrote his preface, sales of *Gone With the Wind* had reached 2,000,000 copies in the United States alone.

Negroes Should Join the CIO

1. While the UAW-CIO had won major victories at General Motors and Chrysler, not many black workers were actually recruited, primarily because few were employed in these plants. The Ford plants were unorganized, and it was in these plants that a fairly large number of black workers were employed. (Of the approximately 80,000 River Rouge workers, more than 11,000 were blacks.) Indeed, Ford had created a reputation as a friend of the Negro worker. The UAW failed to organize the Ford Motor Company either in 1937 or in the following three years. The major drive which was finally capped with success did not begin until October 1940, and the winning over of the black workers in the Ford plants was an important element in that success. In this Paul Robeson made a significant contribution, together with the NAACP, led by Walter White, and the National Negro Congress, led by John P. Davis.

2. Robeson's statement was published by the UAW and thousands of copies distributed in the black neighborhoods of Detroit and environs. (Charles H. Wright, *Robeson: Labor's Forgotten Champion,* Detroit, 1975, p. 98.) Robeson returned for the UAW Rally on May 19, 1941, and spoke and sang for the workers, helping to bring the union to Ford.

3. Unlike the AFL, the Congress of Industrial Organizations (CIO), originally the Committee of Industrial Organization (1935), took a firm stand against exclusion of black workers in its constitution adopted at its founding convention in 1938. While it did not solve many of the problems of black workers, it did organize black and white together, especially in the mass production industries. (*See* Philip S. Foner, *Organized Labor and the Black Worker: 1619–1973,* New York, 1974, pp. 215–37.)

4. The reference is to the "Randolph Resolution" which A. Philip Randolph introduced at each convention of the AFL only to see it rejected. *See above,* "Paul Robeson on Negro Race," note 4, p. 511.

Soviet Culture

1. Johann Sebastian Bach (1685–1750), great German composer and organist.
2. Wolfgang Amadeus Mozart (1756–1791), Austrian composer who was one of the giants of musical history.
3. Frederic Chopin (1810–1849), greatest Polish composer, specialist in works for the piano.
4. Claude Debussy (1862–1918), French composer who initiated a new style in composition.
5. Modest Moussorgsky (1839–1881), Russian composer of operas, songs, and orchestral works, famous for his opera *Boris Godunov*.
6. Peter Ilyitch Tchaikowsky (1840–1893), composer of symphonies, operas and concertos, and considered the greatest of Russian composers.
7. Sergei Prokofiev (1891–1953), great Soviet composer of symphonies, concertos, operas and music for motion pictures.
8. Dimitri Shostakovich (1906–1975), Soviet composer, one of the great composers of the twentieth century.
9. George Gershwin (1898–1937), American composer of musical comedies, concertos, the famous "Rhapsody in Blue," and the opera "Porgy and Bess."
10. *And Quiet Flows the Don,* the great two-part novel by the Soviet writer Mikhail Sholokhov, was the most widely read novel in the Soviet Union and the source of the opera.
11. John Henry is the hero of a widely sung U.S. Negro ballad. It describes his contest with a steam drill, in which John Henry crushed more rock than the machine but died "with his hammer in his hand." The imaginative treatment by Roark Bradford in *John Henry* (1931) made his name known to many Americans.
12. Huddie Ledbetter (known as Leadbelly) (1888–1949), great U.S. black blues singer.
13. Josh White (1915-1969), black blues and folk singer.
14. Anton Dvorak (1841–1904), great Czech composer who lived for a while in the United States where he wrote his "New World Symphony."

Speech at National Maritime Union Convention

1. Ferdinand C. Smith, black leader of the National Maritime Union, was one of the most militant trade unionists of the period. In the postwar Cold War witch-hunts, Smith was branded an "undesirable alien" by the Truman Administration despite a long record of achievements for seamen and contributions to the struggle for Negro rights. Smith elected to leave the United States and return to Jamaica, his native land, in August 1951.
Revels Cayton, black leader of the Marine Cooks and Stewards, was also later a victim of the Cold War witch-hunts.

A Plea for Earl Browder

1. Earl Browder (1891–1973), U.S. Communist leader for almost twenty-five years until he was expelled after World War II. In 1919 he was imprisoned for opposing entrance of the United States into World War I. In 1940 he was sentenced to prison for four years for passport irregularities, but was released after serving fourteen months, and continued as general secretary of the Communist Party until his expulsion.

World Will Never Accept Slavery

1. Alexander Kerensky (1881–1970), moderate Socialist who served as head of the Russian Provisional Government from July to October, 1917. He supported Russia's participation in World War I, and was finally overthrown by the Bolsheviks. Kerensky escaped from Russia and, in 1940, moved to the United States.

Hollywood's "Old Plantation Tradition"

1. The film *Tales of Manhattan* consisted of six stories connected through the travels of a dress coat. Each episode featured the biggest stars of Hollywood. The coat finally falls on the plot of land tilled by a poor sharecropper couple played by Paul Robeson and Ethel Waters. The money is divided among the poor of the community, and the film ends with a chorus of "Glory Day," sung by Robeson and the Hall Johnson Choir. In general the scene was the usual stereotype of the Negro.

2. In an interview in *PM,* September 22, 1942, Robeson said: "When I first read the script I told them it was silly," but that he had hoped he could change it during the filming. Since he had not been able to, "I couldn't blame any Negro for picketing the film."

We Must Come South

1. Four years later, on October 20, 1946, W. E. B. Du Bois delivered a speech at the closing session of the Southern Youth Legislature, sponsored by the Southern Negro Youth Congress, and made precisely the same point. (*See* Philip S. Foner, editor, *W. E. B. Du Bois Speaks: Speeches and Addresses 1920–1963,* New York, 1970, pp. 195–201.)

Interview in *PM* and Paul Robeson's Reply

1. Robeson's fame in *Othello* at the Savoy Theatre in London in 1930 led to efforts to revive the play with him in the leading role. In 1942 the plans reached fulfillment. Directed by Margaret Webster, with Uta Hagen as Desdemona and Jose Ferrer as Iago, the play opened on August 10, 1942, on the tiny stage of Brattle Hall in Cambridge, Massachusetts, to a tremendous reception. It was not until October 1943 that it opened on Broadway in a Theatre Guild production.

2. The reference is to the widely-reported extract from the second inaugural address of President Franklin D. Roosevelt, January 20, 1937, which went:

"I see millions of families trying to live on incomes so meager that the pall of family disaster hangs over them day by day.

"I see millions whose daily lives on city and on farm continue under conditions labeled indecent by so-called polite society half a century ago.

"I see millions denied education, recreation and the opportunity to better their lot and the lot of their children.

"I see millions lacking the means to buy the products of farm and factory and by their poverty denying work and productiveness to many other millions.

"I see one-third of a nation, ill-housed, ill-clad, ill-nourished."

3. The same interview based on the United Press dispatch appeared in the Hartford (Connecticut) *Times* of September 6, 1943, under the headline, "Paul

Robeson Sings U.S. Praise in Fortissimo," but Robesón did not correct this account.

American Negroes in the War

1. Robeson was invited to speak as chairman of the Council on African Affairs. As early as 1939 Robeson had planned to set up an organization to assist the liberation struggles in Africa and raise funds for the victims of imperialist persecution on that continent. That same year Max Yergan, a Negro YMCA secretary, met Robeson in London after a stay in South Africa, and together they founded the Council on African Affairs in New York City. They were .joined by Alphaeus Hunton, a professor of English at Howard University. A monthly publication was issued devoted to developments in new Africa, money was raised for starving people in South Africa and striking miners in West Africa, African visitors were welcomed, and public meetings were sponsored.

2. A study by E. Franklin Frazier, black sociologist, following the Harlem Riot of 1935, disclosed that blacks conducted less than 19 per cent of the 10,300 businesses, and that there was immense unemployment in the largest black community of the nation. (Mayor's Commission on Harlem, "The Negro in Harlem: A Report on Social and Economic Conditions Responsible for the Outbreak of March 19, 1935," E. Franklin Frazier's Report, Fiorello H. La Guardia Papers, Municipal Archives and Records Center, New York City, 1936, pp. 22–23.) By August 1, 1943, when the next riot broke out in Harlem, the situation had not changed much at all. (Dominic Joseph Capeci, Jr., "The Harlem Riot of 1943," unpublished Ph.D. thesis, University of California, Riverside, 1970, pp. 18–20.)

3. U.S. Armed Forces were not integrated during World War II. In July 1948 President Harry F. Truman established the President's Committee on Equality of Treatment and Opportunity in the Armed Services, with authority to inquire into discriminatory practices and to make recommendations for change. The Report of the President's Committee, *Freedom to Serve,* offered guidelines for action. The Secretary of Defense's Directive, issued in April 1949, began the official step toward integration of the fighting units.

4. The Southern states used the device of the poll tax to disfranchise Negro voters, and even, in some instances, poor whites. The campaign in the 1940s to end the poll tax requirement in federal elections did not succeed because southern filibustering Congressmen refused to allow it to be voted on. As late as February 1949 seven Southern states (Alabama, Arkansas, Mississippi, South Carolina, Tennessee, Texas and Virginia) still had poll-tax laws. How these laws cut down the number of eligible voters, poor white as well as Negro, was demonstrated by the President's Committee on Civil Rights. It reported that in the 1944 presidential elections, only 18.31 per cent of eligible voters in southern poll-tax states (eight at that time) cast their ballots. This contrasted with 68.74 per cent of eligible voters voting in the 40 other states. Not until the adoption of the 24th amendment on February 5, 1964, was the poll tax finally eliminated. Two years later, in *Harper v. Virginia Board of Elections,* the Supreme Court held the poll tax unconstitutional in state elections as a violation of the equal protection clause of the Fourteenth Amendment.

5. As America became increasingly involved in the war already raging in Europe, Negroes resented bitterly their exclusion from the nation's defense industries and the continuation of segregation in the armed forces. In 1940, A. Philip Randolph called for a march on Washington, D.C., to demand govern-

ment action against this discrimination. Randolph's appeal led to the formation of the March on Washington Movement, which announced in June 1941 that it would rally fifty thousand Negroes on July first in the nation's capital to demand that the federal government stop discrimination in the defense industries and the armed forces. Randolph refused to call off the march until President Franklin D. Roosevelt issued his famous Executive Order 8802 on June 25, 1941, forbidding discrimination in war industries and government training programs, and establishing a President's Committee on Fair Employment Practices. The Fair Employment Practices Committee (FEPC) began to function on July 18, 1941.

6. The Committee was handicapped by inadequate funds and opposition of segregationist Congressmen. Actually, it was the Supreme Court, in upholding rulings by the Committee against discrimination, rather than the President, which gave the FEPC greater influence.

7. The two main race riots were the Detroit Riot which began on June 20, 1943, and the Harlem Riot which began on August 1, 1943. However, while the Detroit Riot was mainly an anti-Negro riot, the Harlem Riot was an uprising of frustrated and disillusioned blacks. Still, in the Detroit Riot the blacks fought back, and there were high casualties until federal troops took over.

8. Viewed as the "impossible" candidate, Benjamin J. Davis, Jr., was elected to the New York City Council in 1943 on the Communist Party ticket. Before Davis' election, the only Negro member of the Council was Adam Clayton Powell, Jr., who had been elected as the first Negro member in 1941.

9. In the Atlantic Charter of 1941, Franklin D. Roosevelt and Winston Churchill endorsed the goals in the war against the fascist Axis powers. Among the principles enunciated were: no territorial aggrandizement; no changes of territory against the wishes of the people concerned; and self-government for all peoples. Nothing, however, was said about the African or Asian colonies held by the Allied Powers.

In a comment on the article, as in the case of "Primitives," Edwin P. Hoyt again condescendingly notes that while the "sentiments were Paul's, the words were scarcely his," and were undoubtedly written by Essie. Again, there is not the slightest evidence presented to justify this conclusion. (*Paul Robeson: The American Othello,* Cleveland, 1967, pp. 122–23.)

Time to Bring Negro Baseball Players into the Major Leagues

1. The members of the Negro Publishers' Association who attended the conference with Paul Robeson were Howard H. Murphy, business manager of the *Baltimore Afro-American,* Ira F. Lewis, publisher, *Pittsburgh Courier,* Louis E. Martin, editor, *Michigan Chronicle,* Dr. C. B. Powell, publisher, *New York Amsterdam Star-News,* William O. Walker, publisher, *Cleveland Call Post,* Wendell Smith, city editor, *Pittsburgh Courier,* Dan Burley, managing editor, *Amsterdam Star-News,* and John Sengstacke of the *Chicago Defender.*

2. Following Robeson's speech, three members of the Negro Publishers' Association, Ira Lewis of the *Pittsburgh Courier,* Louis Martin of the *Michigan Chronicle* and John Sengstacke of the *Chicago Defender,* spoke on various aspects of the issue. They also set forth a four-point plan for immediate acceptance of Negroes into the major leagues which stated:

"1. We urge that steps be taken to accept qualified Negro players in organized baseball.

"2. Such players should be regularly affiliated with organized baseball and

be promoted without prejudice or discrimination from Class D to C to B to A to AA leagues.

"3. Negro players should be selected from schools, colleges, sand lots and semi-pro organizations and introduced into organized baseball in the same manner as all other players.

"4. A joint statement should be issued by this joint meeting of the two major leagues indicating that Negro players are now eligible for trial and permanent placement on their teams."

3. The major league officials issued the following statement: "Each club is entirely free to employ Negro players to any and all extent it pleases. The matter is solely for each club's decision, without restriction whatsoever."

4. Another two years had to pass before the first Negro player was signed. On October 23, 1945, Jackie Robinson and pitcher John Wright, also black, were signed by Branch Rickey, president of the Brooklyn Dodgers, to play on a Dodger farm team, the Montreal Royals of the International League. Robinson led that league in batting average in 1946, and was brought up to play for Brooklyn in 1947.

On July 19, 1947, Jackie Robinson stepped onto the field in a Brooklyn Dodgers uniform for the first time. In July 1949, Jackie Robinson testified against Paul Robeson before the House Un-American Activities Committee. In later years, however, he wrote in his autobiography *I Never Had It Made,* published in 1972: ". . . I have grown wiser and closer to painful truths about America's destructiveness. And I do have an increased respect for Paul Robeson who, over the span of that twenty years (since 1949), sacrificed himself, his career, and the wealth and comfort he once enjoyed because, I believe, he was sincerely trying to help his people." (New York, 1972, p. 98.)

Robeson Remembers

1. Hannen Swaffer was a British columnist who wrote often on Robeson's activities on the English stage.

2. In a dispatch to the *New York Times* of May 22, 1930, from London, Robeson was quoted as stating: "I was a little disturbed when we started rehearsals, and rumors of an objection to a colored actor playing with white girls came to my notice. I felt that in London trouble couldn't possibly arise on racial grounds. People here are too broadminded for that."

3. Robeson's father, William Drew, was born in 1845 on the plantation of the Robesons in Martin County, North Carolina. He escaped from bondage at the age of fifteen and fought with the Union Army during the Civil War. After the war he studied for the ministry at Lincoln University, Pennsylvania (originally Ashmun Institute, founded in 1854). William Drew Robeson became the pastor of the Witherspoon Street Presbyterian Church in Princeton, New Jersey.

China: Promise of a New World

1. Sun Yat-sen (1866–1925), leader of the Chinese Kuomintang (Nationalist Party), and known as the father of modern China. He was influential in overthrowing the Manchu dynasty (1911), and served as first president of the Republic of China (1911–1912). Not until 1923, however, did he gain actual control of the country since he was regarded as too radical.

2. Sun's doctrines are summarized in the "Three Principles of the People."

3. In 1938 a temporary investigation unit of Congress, the House Un-

American Activities Committee, was created mainly to advance the political career of its chairman, Martin Dies, Democratic Congressman from Texas. In January 1947 the Committee was revived by the Republican leadership, and one of the people it investigated was Paul Robeson. (*See* pp. 413-436).

4. Chiang Kai-shek (1887–1973), ruler of China from 1928 to 1949, and subsequently head of the so-called Republic of China on Taiwan. During World War II, Chiang concentrated on reducing the Communist threat to his authority rather than fighting the Japanese. He was finally driven from power in 1949 by the Communists.

Opening Statement at Conference on "Africa—New Perspectives"

1. The Conference on Africa held in New York on April 14, 1944, was attended by Negro and white leaders of labor, civic and women's organizations, national in scope and embracing several hundred thousand members; representatives of the church, education, and the press; and representatives of the peoples of British West Africa, the Caribbean, and India. Representatives of foreign governments present included Hon. Walter F. Walker, Consul General for Liberia, Anatole Hakovlev, member of the Staff of the New York Consulate of the Soviet Union, and Dr. Max Horn, Counsellor for the Belgian Congo Government. Among the speakers were Mrs. Amy Ashwood Garvey, wife of the late Marcus Garvey, and Mary McLeod Bethune. The main report was delivered by Dr. Max Yergan. In the preface to the published proceedings, the Council on African Affairs noted: "The way in which the United Nations collectively deal with colonial peoples and territories in the postwar period will be the clearest index of whether they can and will in fact shape a world of security, democracy and peace. And of all colonial areas, Africa, the largest and least developed, and hitherto a center of imperialist rivalries, represents the most crucial test."

2. *Fortune,* January 1943, p. 71.

3. Colonel Oliver Stanley, however, speaking as British Foreign Secretary, defended British colonial rule before the Foreign Policy Association in New York City, January 19, 1945.

Africa and Post-War Security Plans

1. Additional signers were Mary McLeod Bethune, Dr. Horace Mann Bond, Earl Browder, Louis Burnham, Peter V. Cacchione, Countee Cullen, Benjamin J. Davis, Jr., W. E. B. Du Bois, Harry Emerson Fosdick, William Leo Hansberry, Charles H. Houston, Alain Locke, Benjamin Mays, Carl Murphy, Arthur Upham Pope, Adam Clayton Powell, Jr., Arthur E. Spingarn, Harry F. Ward, Robert C. Weaver, Charles H. Wesley, and P. B. Young.

2. Dumbarton Oaks was the mansion in Georgetown, Washington, D.C., where representatives of China, the Soviet Union, the United States, and the United Kingdom met (August 21-October 7, 1944) and formulated proposals for a world organization that became the basis for the United Nations.

3. The following is the reply from Secretary of State Stettinius, January 5, 1945, as reported in *New Africa,* February 1945:

"My dear Mr. Robeson:

"Your letters of December 15, addressed to the President over your signature as Chairman and that of Mr. Max Yergan as Executive Director of the Council on African Affairs, Inc., transmitting the resolution on Africa, has

been referred to the Department of State for reply. It is with appreciation that I note your complimentary reference to the President's leadership in the promotion of international cooperation, and your endorsement of the steps taken thus far toward the development of an international mechanism to insure world peace and security.

"You are aware, I feel sure, that the Department of State recognizes the importance in world affairs of the problems of the dependent peoples, in Africa and elsewhere. It is the intent of this Government, as it is of the other governments which participated in the Dumbarton Oaks discussions, that the proposed United Nations Organization should protect and promote the welfare of all peace-loving peoples. The broad framework for this purpose was outlined at Dumbarton Oaks. The details, as these may affect specific groups and functions, will be filled in as discussions among interested governments progress.

"The Government of the United States realizes that the problems of the dependent peoples are of a unique nature, requiring special consideration and treatment. The appropriate divisions and committees of the Department of State are devoting serious attention to these problems with a view to devising practicable solutions which will insure the greatest tangible advancement possible and which will be based upon the fundamental principles of equitable and just treatment for all peoples.

"You will find particularly pertinent to the points raised in your resolution the statement incorporated in the memorandum on 'Bases of the Foreign Policy of the United States,' which former Secretary of State Cordell Hull released to the press on March 21, 1944:

"'There rests upon the independent nations a responsibility in relation to dependent peoples who aspire to liberty. It should be the duty of nations having political ties with such peoples, of mandatories, of trustees, or of other agencies, as the case may be, to help the aspiring peoples to develop materially and educationally, to prepare themselves for the duties and responsibilities of self-government, and to attain liberty. An excellent example of what can be achieved is afforded in the record of our relationship with the Philippines.'

"May I add in closing that your constructive interest in the efforts now being made to assure a better world for all peace-loving peoples of whatever race, creed, or political status is appreciated."

Speech at Sixth Biennial Convention, ILWU

1. Harry Bridges was born in Melbourne, Australia, in 1901, and became a longshoreman in San Francisco in 1922. He led the great San Francisco general strike of 1934 and headed the International Longshoremen's and Warehousemen's Union when it was organized in 1937 and affiliated with the CIO. In 1939 he began a long fight to stay in the United States after he was ordered deported as a Communist. The crusade to deport Harry Bridges was prevented in the end by the Supreme Court. In June 1943 Robeson wired the Fifth Biennial Convention of the ILWU: "Have read with great appreciation your activities on behalf Negro workers. I commend your policy—appreciate leadership Harry Bridges—wish all support behind his case." (*Proceedings, Fifth Biennial Convention, ILWU-CIO, June 4–10, 1943*, p. 191.)

2. On November 12, 1943, Harry Bridges conferred honorary lifetime membership in the ILWU on Rockwell Kent and Paul Robeson in honor of their "many years in the fight against Fascism. . . ."

Robeson Lauds Russia at Spingarn Medal Banquet

1. The *Courier*'s sub-headline read: "Speech Shocks Notables."

The *Chicago Defender* carried no report of Robeson's speech, but it did feature a picture headed "Paul Robeson Receives Award" with the caption: "Paul Robeson this week became the 30th American of African descent to win the Spingarn medal, awarded annually to an American Negro for high achievement. The award is made by the NAACP, and Marshall Field, publisher of the Chicago *Sun*, made the presentation at the Hotel Biltmore in New York. Mrs. Arthur Spingarn looks on." (November 3, 1945.)

According to the *Defender*'s London correspondent, George Padmore, Robeson was not the only one to deliver a "shocking" message at the time. At the Conference of the Foreign Ministers of the Big Five Powers in London, the Soviet delegation, headed by Commisar Molotov, stunned the British and American delegates by demanding a "Free Africa." So "scared" were the British and American delegations, Padmore reported, that "both delegations temporarily forgot their differences and united to block the Russian move." (October 13, 1945)

2. The *Courier* reported that the dinner was attended by "several hundred notables," and mentioned the following among them: Mr. and Mrs. Ira F. Lewis, Mrs. Robert L. Vann, Mr. and Mrs. Roy Wilkins, Congressman Adam Clayton Powell Jr., Max Yergan, Norman Manley, E. Kinckle Jones, Councilman Benjamin J. Davis Jr., C. B. Powell, Bishop Walls, the Rev. B. C. Robeson, Hon. and Mrs. Herbert T. Delany, Mrs. Edith Alexander, Justice Kenneth Bright and Herbert T. Miller. Walter White was toastmaster, and among those at the speakers' table were Harry T. Burleigh, Marc Connelly and Marian Anderson.

Some Reflections on *Othello*

1. *The American Scholar* was the official journal of Phi Beta Kappa, the honorary scholastic society of which Robeson was a member.

2. Theodore Spencer's *Shakespeare and the Nature of Man,* consisting of his Lowell lectures, was published in 1942 by the Macmillan Company of New York.

Africa—Continent in Bondage

1. Jan Smuts (1870–1950), South African prime minister; elected in 1919, defeated in 1924, but became prime minister again in 1939.

Anti-Imperialists Must Defend Africa

1. Harvey Firestone (1868–1938), founder of the Firestone Tire and Rubber Company. By 1937 Firestone's company was supplying one fourth of the tires used in the United States. Much of the rubber came from Liberia, which the Firestone Company dominated.

2. Ernest Bevin (1881–1951), trade unionist and statesman who rose to a prominent position in the British Labour Party. When Clement R. Attlee formed the Labour Party government on July 26, 1945, Bevin was chosen as foreign secretary. Bevin became a leading proponent of the Cold War, hence Robeson's, "For once I agree with him."

3. Vyacheslav Mikhaylovich Molotov was a major spokesman for the Soviet Union at international conferences during and immediately after World War II. The reference is to his speech delivered at the San Francisco Conference (1945), which created the United Nations.

Robeson Asks Truman Action on Lynching

1. On July 25, 1946, four Negroes, including two women, were murdered near Monroe, Wilson County, Georgia. Roger Malcolm, a farm worker, his wife, Dorothy, George Dorsey, war veteran, and his wife, May, were killed by a mob of some 25 white men with rifles and pistols on a lonely swamp road. Malcolm had been accused of stabbing a white employer. On July 28, the first Methodist Church of Monroe, Georgia, adopted a resolution "condemning the outrage against humanity" and asking "that local and county authorities co-operate with State authorities in bringing those guilty of this hideous crime to justice." The same day the National Negro Congress condemned the lynchings and rebuked President Truman for his "continued silence over the renewed wave of terror directed against the Negro people of the South." As a result of nation-wide protests, Attorney General Tom C. Clark ordered a federal grand jury probe of the four lynchings, but after a three-week investigation, the jury reported, December 19, 1946, that it was unable to find anyone "guilty of violating the civil rights statute."

South African Gold Mine Strike

1. African workers in the gold mines along the Witwatersrand averaged roughly 3s. or fifty cents a day in wages. They were quartered in compounds, which were huge walled-in structures where the men lived in dormitories sleeping in tiers on concrete bunks. Food was supplied against payment and was bought in bulk. While the African worker was serving his contract on the mines, he was virtually cut off from normal social intercourse and especially from his family, which remained behind in one of the Native Reserves from which he was recruited. His freedom of movement was restricted by the Pass Laws which lay down regulations for all adult Africans. In all, as many as 14 different passes might be required by the African worker—a pass to seek work, another to move from one place to another, another to remain out after the evening curfew which exists for him, etc. In the mines the African worker did the tough and dirty work under white overseers for miserable wages. He was very susceptible to the occupational diseases of mining, especially phthisis and silicosis.

These were the conditions which led to the great South African gold mine strike of 1946. The 50,000 strikers demanded a daily wage of $2 instead of fifty cents. In their struggle they were supported by white communists, which brought from the government the cry that the strike was simply a "communist plot." After the strike was broken, the Johannesburg magistrate's court imposed fines of $60 or two months imprisonment with hard labor on 34 of the accused for having distributed pamphlets and $200 or two months in jail with hard labor on 11 communists for having aided the strikers.

2. *New York Times*, August 15, 1946, p. 2, column 2.

3. A German colony before World War I, South West Africa was administered by South Africa after 1920 under a League of Nations mandate. The United Nations designated the area Namibia and, in 1966, the UN declared the mandate terminated, a decision unacceptable to South Africa.

On the Resignation of Henry A. Wallace

1. Henry A. Wallace (1888–1965), 33rd Vice President of the United States (1941–45), formerly Secretary of Agriculture under Franklin D. Roosevelt, who broke with the Democratic Party after World War II as he grew increasingly opposed to the Truman administration's "get-tough" Cold War policy toward the Soviet Union. In a speech at New York City's Madison Square Garden, September 12, 1946, Wallace, then Secretary of Commerce in Truman's Cabinet, called for world peace and unity, scorned the idea that Russia wanted war, and criticized the movement for "getting-tough" with the Soviet Union. In addition, he attacked British imperialism and the lynchings of four Negroes in Georgia, and called for friendly, peaceful competition between the socialist system of the Soviet Union and the private enterprise system of the United States. Even though he had cleared the speech with President Truman, the President demanded and received Wallace's resignation. In resigning, Wallace told the President: "I shall continue to fight for peace."

American Crusade to End Lynching

1. A prime legislative goal of the NAACP in the period from World War I to the end of the Truman Administration was the passage of a federal anti-lynching law. Three times—in 1922, 1937, and 1940—such a bill was passed in the House of Representatives only to die in the Senate because of a Southern filibuster, actual or threatened. To carry the movement further, the American Crusade to End Lynching, with Paul Robeson as chairman, was organized. The crusade was to be a 100-day effort—from September 22, 1946, through January 1, 1947—to end mob violence in America, and was launched with a rally in Chicago at Metropolitan AME Church attended by some 1,500 delegates from various parts of the country. A visit to President Truman was arranged, and Paul Robeson, as chairman of the American Crusade to End Lynching, announced that it would take place at 10 a.m., September 23, 1946. He also announced that the "Crusade" would move on the Capital on the 34th anniversary of Lincoln's announcement of the Emancipation Proclamation to the South giving the seceded states 100 days to return to the Union or face the granting of freedom to their slaves on January 1, 1863.

The Crusade was endorsed by hundreds of prominent church, civic, and labor figures including Dr. Albert Einstein, Bishop W. G. Walls, Joseph Curran, president of the National Maritime Union, Canada Lee, black actor, Lena Horne, and Oscar Hammerstein 2nd.

At the same time that the Crusade to End Lynching was being carried on in Washington, a small delegation headed by Walter White, NAACP Executive Secretary, also visited President Truman to discuss his taking a stand against lynching. Members of the delegation included James B. Carey, secretary of the Congress of Industrial Organizations, and Boris Shishkin of the American Federation of Labor, both notorious anti-Communists. The *Pittsburgh Courier* paid no attention to the delegation headed by Paul Robeson but played up the group led by Walter White, and noted that President Truman "heartily approved" of its gradualist approach. (September 28, 1946.)

2. A series of trials held in Nuremberg, now in West Germany, in 1945–1946 in which former Nazi leaders were indicted and tried by the

International Military Tribunal as war criminals. The trials lasted more than ten months, and on October 1, 1946, the verdicts on 22 of the original 24 defendants were handed down. Three of the defendants were acquitted; 12 were sentenced to death by hanging; 3 were sentenced to life imprisonment; and 4 were sentenced to imprisonment for terms ranging from 10 to 20 years.

3. The Ku Klux Klan, a secret terrorist organization, became after the Civil War the chief instrument of the restoration of white supremacy in the South. In 1915 it was reorganized, and added to its hostility to blacks, bias against Roman Catholics, Jews, and foreigners. It was then influential in the North as well as in the South.

4. Theodore G. Bilbo, Senator from Mississippi, was the supreme representative and symbol of racism in the United States Senate. At the same time that the Crusade to End Lynching was taking place, over 50 black and white qualified voters in the Jackson, Mississippi, area demanded Bilbo's impeachment by the Senate because his nomination in the Mississippi Democratic primary on July 2, 1946, was "tainted with fraud, duress and illegality." The request was made in a petition filed with the Senate Committee on Privileges and Election and to Investigate Campaign Expenditures. It failed.

5. For a list of lynchings after World War II through 1946, *see* William L. Patterson, editor, *We Charge Genocide: The Crime of Government Against the Negro People,* New York, 1951, reprinted New York, 1970, pp. 58–66.

6. The subhead in the *Philadelphia Tribune* account read: "Truman Resents Remark." It was reminiscent of the visit in November, 1914, of a delegation of black Americans, headed by William Monroe Trotter, militant Boston journalist, to the White House to protest segregation in the federal government under President Woodrow Wilson. The visit aroused wide attention when the press reported that the President had been insulted by Trotter's "offensive manner," and had refused to discuss any issues with the delegation so long as Trotter was a member. At a mass meeting in Washington, Trotter declared: "I emphatically deny that in language, manner, tone—in any respect, or to the slightest degree—I was impudent, insolent or insulting to the President." (*Washington Evening Star,* November 13, 1914.) For the text of Trotter's remarks to President Wilson, *see* Philip S. Foner, editor, *The Voice of Black America,* vol. II, New York, 1975, paperback edition, pp. 86–90.)

7. President Lincoln signed the preliminary Emancipation Proclamation on September 22, 1862, as President of the United States and commander-in-chief of the army and navy announcing "That on the first day of January, in the year of our Lord one thousand eight hundred and sixty-three, all persons held as slaves within any State or designated part of a State, the people whereof shall then be in rebellion against the United States, shall be then, thenceforward, and forever free. . . ." He did not state that "100 days later slavery would be officially abolished" everywhere in the United States. This did not take place until ratification of the Thirteenth Amendment after the Civil War.

8. In an editorial, "We Can Help," the *Chicago Defender* praised Paul Robeson for having headed the committee that visited President Truman, and urged the Negro people "to help elect a new Congress which if properly selected will pass anti-lynch laws that even the most rabid race hater will dare not break." (October 5, 1948). It was an over-optimistic prediction.

9. Four thousand black and white people attended the closing session in the rain and listened to Robeson speak and sing.

Excerpts from Testimony before the Tenney Committee

1. In 1946 the Tenney Committee (California Legislature's Committee on Un-American Activities) began an investigation into alleged "left-wing activities in California." Robeson was one of several entertainers called before the committee.

2. Robeson was cited by the Tenney Committee as belonging to thirty-four "Communist Front" organizations.

3. The following day Edgar G. Brown, director of the National Negro Council, testified before the Tenney Committee and declared that he considered it "pretty well understood" that Communists "had infiltrated into the National Association for the Advancement of Colored People and the National Negro Congress hoping eventually to get control of them." (*New York Times,* October 9, 1946.)

4. William Saroyan, born the son of an Armenian immigrant in Fresno, California, who became a leading short-story writer and playwright. In 1940 he refused the Pulitzer Prize for his play, *The Time of Your Life.*

5. Concert halls were closed to Robeson after his appearance before the Committee. In Peoria, Illinois, he was denied the use of the Shriner Mosque, and Albany, New York, followed suit with a cancellation of permission to use public property to perform. Robeson, however, won an injunction restraining the Albany Board of Education from interfering with a concert in the auditorium of the Philip Livingston Junior High School. But Supreme Court Justice Isadore Bookstein limited Robeson to a "musical concert and no more." (*New York Times,* May 7, 1947.)

The United Nations Position on South Africa

1. John Foster Dulles, Principal U. S. representative on the U. S. Trusteeship Committee, replied: "Dear Mr. Robeson, I have your letter of December 6. It is, I think, based on some misapprehension. The United States proposal involved unqualified rejection of the proposal to incorporate South West Africa in the Union of South Africa. There was virtually no difference in the committee in that respect. It is true that the rejection was in the United States proposal couched in more conciliatory language than in the case of some of the other proposals, but I did not feel that the United States, in view of its own record, was justified in adopting a holier-than-thou attitude toward the Union of South Africa."

Robeson in Honolulu Backs Wallace

1. Robeson went to Hawaii with Earl Robinson and Lawrence Brown in March 1948 to present a series of concerts under the auspices of the International Longshoremen's and Warehousemen's Union. During his stay the two leading Honolulu papers, the *Star-Bulletin* and the *Advertiser,* devoted column after column to the issue of whether Robeson was a Communist. "Communist Charges Revived as Paul Robeson Arrives" was a headline in the *Star-Bulletin* on March 10.

But the *Honolulu Record,* the local progressive paper, dealt with a different theme. It reported, for example, that the day before leaving for Hawaii, Robeson had made his annual visit to Wo-Chi-Ca, an interracial children's camp. The most imposing structure at the camp was the Paul Robeson

Playhouse, for which Robeson had raised the necessary funds by a concert at Carnegie Hall. Walter Warner, the *Record* correspondent, wrote from New York:

"As the pitcher delivered, the big Negro took a quick step forward and shouted, 'Here she comes!'

"The hitter wasn't Jackie Robinson—he's chunky, but not big. . . . It was a man who has struck the heaviest blows for the right of Negro ballplayers to compete on even terms with Caucasians, a man who has fought for the right of his people to eat at the same restaurants, to live in the same hotels, or attend the same theaters as John Rankin of Mississippi or Harry Truman of Missouri.

"The hitter was Paul Robeson and the ball game was at Camp Wo-Chi-Ca, one of the few interracial camps for children in these parts." (*Honolulu Record,* undated copy in Hawaii State Library, Honolulu, Hawaii.)

 2. In December 1946, responding to pressure from the black community, President Truman issued Executive Order 9808, in which he established the President's Committee on Civil Rights to investigate the status of civil rights and make recommendations. Within a year, the Committee submitted its report, which was entitled *To Secure These Rights* and called for specific joint efforts by the federal and state governments. President Truman incorporated the basic recommendations of the Committee in his special message to Congress on February 2, 1948. Congress, however, refused to act on them.

Critics then and since have charged Truman with political maneuvering in an election year, pointing out that basically what he did was "to outline (but not work for) a broad program which he knew Congress would never pass." (James T. Patterson, *America in the Twentieth Century,* New York, 1976, p. 337.)

 3. Hawaii was admitted to the Union as a state in 1959.

 4. In an editorial, "Paul Robeson and Communism," March 27, 1948, the *Honolulu Star-Bulletin* listed the names of eight organizations or "groups" which the "congressional committee on un-American activities describes as Communist 'fronts,'" and of which Robeson was or had been "a member." They were: American League for Peace and Democracy, American Peace Mobilization, Citizens Committee to Free Earl Browder, Statements Defending the Communist Party, Daily Worker, Emergency Peace Mobilization, National Federation for Constitutional Liberties, New Masses (Magazine). In addition, the paper quoted J. B. Matthews, research director for the committee, as having listed on October 4, 1944, "245 'Communist front or Communist controlled organizations' and said Robeson belonged to 34." Furthermore, it reported Matthews' conclusion that Robeson had made it quite clear "as being Communist in the sense that he favors communism, even though he may not have in his possession a party membership card."

The *Star-Bulletin* itself concluded that Robeson's failure to answer the question directly as to whether or not "he is now or has ever been a Communist" marred his appearance in Hawaii. It conceded that Robeson was "a great singer, and a man whose history and personality carry a strong appeal." It conceded, too, that during his visit to Hawaii Robeson had been "generous in his vocal contributions. He was careful also to give credit to the union which brought him here and routed him in his travels about the country." It acknowledged that "he made plain his sympathy for the working-man, and his deep personal feeling against discrimination on account of race—a quite understandable feeling, as he is a Negro and has been the helpless victim of such discrimination." But all this was beside the point since he "declined to answer a question put to him at his closing press conference—

whether he is now or has been a Communist," and had replied instead, "As far as I know, the Communist party is a legal party. You might as well ask me, 'Are you a Democrat or a Republican?'"

When readers criticized the *Star-Bulletin* for its stand, pointing out that "Mr. Robeson is truly a Wonderful American," thanking him for "his profoundness, his fortitude for total freedom for all the people," the *Star-Bulletin* could only reply that these readers missed "the point. The *Star-Bulletin* gave Mr. Robeson the opportunity to affirm or deny that he is or has been a Communist. He declined to say." (*Ibid.,* April 11, 1948.) Other readers, however, argued that Robeson had made "many new friends here" in the Islands, and that "since he joined the All-Hawaiian Association of free Americans—the Hawaii Civil Liberties Committee—while here, the islands can rightfully claim him as their very own!" (*Ibid.,* March 25, 1948.) The reference was to the fact that on March 23, 1948, the Hawaii Civil Liberties committee had made Robeson, Earl Robinson, and Lawrence Brown members of the committee after their final concert. (*Ibid.,* March 24, 1948.)

For letters defending the *Star-Bulletin* stand, *see ibid.,* March 11, 12, 17, 29, 1948.

5. The publication was *The American Scholar.*

6. On November 29, 1947, the United Nations recommended the establishment of separate Arab and Jewish states in Palestine. When the British left on May 15, 1948, the State of Israel was proclaimed. The war Robeson was referring to did not break out until after the departure of the British troops, and in it, the Arab countries, who had refused to accept the establishment of the State of Israel, were defeated by Israel.

7. In the final concert in Honolulu at the McKinley High School auditorium on March 20, 1948, Robeson sang: "Lord God of Abraham" by Mendelssohn; "L'Amour de Moi," an old French song; "O Isis and Osiris" by Mozart; "Over the Mountains," an old English song; "Silent Room" and excerpts from *Boris Godunov* by Moussorgsky; "Smol Y'Min," a Hebrew folk song; "Zog Nit Keynmol," a song of the Vilna ghetto of Poland; "On My Journey," arranged by Edward Boatner; "Swing Low Sweet Chariot," "Hammer Song," and "Joshua Fit de Battle of Jericho," arranged by Lawrence Brown. Robeson and Earl Robinson sang "Ballad for Americans" by John Latouche and Earl Robinson, and "Free and Equal Blues" by Yip Harburg and Earl Robinson.

Replying to criticism of an earlier concert, a reader wrote to the *Honolulu Advertiser:* "The program Thursday evening included a song against war, a song advocating racial equality, a union song, several songs in praise of love, and a number of spirituals. Perhaps the most blood-thirsty moment of the concert came when Mr. Robeson sang that revolutionary anthem, 'Old Man River.'" (Bill Hammond, March 18, 1948.)

Speech at International Fur and Leather Workers Union Convention

1. Ben Gold, president of the International Fur and Leather Workers Union, was born in Bessarabia, Russia. After emigrating to the United States, he worked as an operator in the fur shops of New York City. He joined the Socialist Party, then the Communist Party after the split in the SP in 1919. As manager of the New York Furriers' Joint Board, he led the great strike of 1926 for the 5-day 40-hour week. Expelled as a Communist, he became secretary of the pro-Communist Needle Trades Workers' Industrial Union, a part of the Trade Union Unity League. After the merger of left and right he was elected

president of the International Fur Workers Union in 1937, and two years later of the International Fur and Leather Workers Union of the United States and Canada. For the history of the union, *see* Philip S. Foner, *The Fur and Leather Workers Union,* Newark, New Jersey, 1950.

2. Howard Fast, progressive novelist and political activist, who later broke with the Communist Party.

3. Lee Pressman was the general counsel of the CIO and the Steel Workers Organizing Committee until he was forced to resign both posts because he supported Henry A. Wallace's presidential candidacy in 1948 on the Progressive Party ticket.

4. In introducing Robeson, President Ben Gold pointed out: "I am informed that in the past year he gave up everything else and devotes his complete talent to but one thing, going from town to town, city to city, talking to people, appealing to them, encouraging them, helping them unite and organize to maintain, preserve, and broaden out the democratic rights in our country for the benefit of the people." In March 1947, speaking to 2,000 persons who had just listened to his first rendition of Earl Robinson's ballad "Joe Hill" in the University of Utah's Kingsbury Hall in Salt Lake City, Robeson said: "You have just heard my final concert for at least two years, and perhaps for many more. I'm retiring here and now from concert work. I shall sing now for my trade union and college friends. In other words only at gatherings where I can sing what I please." He had reached the decision two weeks or so earlier, while he was participating in an NAACP picket line before the Kiel Auditorium in St. Louis to protest segregation at a dramatic performance.

5. As a founding member of the Progressive Citizens of America, the driving force for building an effective progressive movement down to the ward and precinct level, Robeson was influential in persuading Henry A. Wallace to be a candidate for President on a New Party ticket. When Wallace announced his readiness to be the candidate on December 29, 1947, Robeson stumped the country for months building up support for the New Party.

6. "Freedom Train," a poem by Langston Hughes, reads:

> I read in the papers about the
> Freedom Train
> I heard on the radio about the
> Freedom Train.
> I seen folks talking about the
> Freedom Train.
> Lord, I've been a-waitin' for the
> Freedom Train!

Way down in Dixie the only train I see's
Got a Jim-Crow car set aside for me.
I hope there ain't no Jim-Crow on the
 Freedom Train,
No backdoor entrance to the Freedom Train,
No sign FOR COLORED on the Freedom Train,
No WHITE FOLKS ONLY on the Freedom Train.
 Well, I'm goin' to check up on this
 FREEDOM TRAIN.
Who is the engineer on the Freedom Train?
Can a coal-black man drive the Freedom Train?
Or am I still a porter on the Freedom Train?
Is there ballot boxes on the Freedom Train?
Do colored folks vote on the Freedom Train?

When it stops in Mississippi, will it be made plain
Everybody's got a right to board the
 Freedom Train?
 Somebody tell me about this
 Freedom Train.
The Birmingham Station's marked
COLORED and WHITE.
The white folks go left
The colored go right.
They even got a segregated lane.
Is that the way to get aboard the
 Freedom Train?
 I've got to know about this
 Freedom Train!
If my children ask me, *Daddy, please explain*
Why there's a Jim-Crow station for the
 Freedom Train?
What shall I tell my children?
You tell me because freedom ain't freedom
 when a man ain't free.
 * * *
Her grandson's name was Jimmy, he died at Anzio
He died for real. It warn no show.
Is it for real or a show again
The freedom that they carry on this
 Freedom Train?
 Jimmy wants to know about this
 Freedom train.
I'm going to check up!

After Robeson had finished reading "Freedom Train," President Ben Gold said: "When we have Paul Robeson and others like him, we are richer than they [these fellows that have the banks and the railroads and the oil wells and everything] are. (Applause) And when our country can produce a Paul Robeson, it is still a big, great country that will overcome all the obstacles and difficulties." (Applause) Thereupon Irving Potash asked the delegates if Robeson, already an honorary member of the International Fur and Leather Workers Union, could be made "a double honorary member of our Union."

Remarks at Longshore Caucus

1. Paul Robeson and Charles Howard traveled widely as Negro Progressive campaigners to arouse support among the Negro people for the Progressive Party ticket headed by Henry A. Wallace and Glen Taylor. Howard of Iowa was widely known as a star athlete, athletic coach, lawyer, and national leader in many Negro organizations. He had broken with the Republican Party in 1932 and supported the New Deal. At the Progressive Party convention in 1948 he was the first black keynoter in American history.

2. After Robeson concluded his remarks, President Harry Bridges said: "Just for the information of the Caucus, Paul mentioned he went to Hawaii. He did. He went down there at the request of the Union, free of charge, sang and spoke all over the Islands. The money from the concerts went to the Union in Hawaii, and they used it for organizing and publicity purposes, including

sending a check for $1000 to the leader of the Sugar Workers Union in Cuba who was shot." This was followed by "Loud and sustained applause."

Robeson was sent to Hawaii by the union to counter the demoralizing effect on the plantation workers in Hawaii of the murder of sugar workers' leaders in Cuba and the Philippines. On January 22, 1948, Jesus Menéndez, leader of the Cuban Sugar Workers' Union, an organization of 350,000 workers, was murdered by Army Captain Joaquin Casillas Lumpuy. On February 24, 1948, Manuel Joven, National Secretary of Philippine Congress of Labor, was kidnapped and murdered. As a result of Robeson's concert tours of the islands, the widows of Menéndez and Joven were presented with checks of $1,250.00 by the ILWU from the proceeds of the tour. (*See* Charles H. Wright, *Robeson: Labor's Forgotten Champion,* Detroit, 1975, pp. 53-55.)

3. The Labor-Management Relations Act, commonly known as the Taft-Hartley Act, was passed by Congress over President Harry F. Truman's veto. Among other provisions, the Act forbade unions from (1) engaging in the closed shop; (2) inducing an employer to discriminate against an employee who had been discharged from a union for any reason other than the failure to pay dues; (3) inducing a strike or boycott with the purpose of forcing an employer to institute a closed shop. In addition, for the first time in American history, each union official of a national or international union was required to file an affidavit assuring the government that he was not affiliated with communism or the Communist Party; failure to comply would cause the union to lose the protection and privileges of the law.

Freedom in Their Own Land

1. In 1937 Joe Louis, a Detroit Negro, became heavyweight boxing champion, but during the twelve years when he was the world's heavyweight king he never participated in activities connected with the struggles of the Negro people.

I, Too, Am American

1. Clement Attlee (1883-1967), British Labour Party leader from 1935 to 1955, and prime minister from July 26, 1945, to October 26, 1951.

2. Sir Stafford Cripps (1889-1952), academically brilliant Labour Party spokesman who became Chancellor of the Exchequer in 1947. His rigid austerity program compelled him to resign from office and from Parliament in October 1950.

3. James Scott, Duke of Monmouth (1649-1685), claimant to the English throne who led an unsuccessful rebellion against King James II in 1685.

4. In his study *The Atlantic Slave Trade: A Census,* Philip D. Curtin estimates that nine million Africans landed in the New World during the life of the Atlantic slave trade. But he quickly adds: "The cost of the slave trade in human life was many times the number of slaves landed in the Americas. For every slave landed alive, other people died in warfare, along the bush paths leading to the coast, awaiting shipment, or in the crowded and unsanitary conditions of the middle passage. . . . Most of these losses are not measurable." (Madison, Wisconsin, 1969, p. 275.)

5. About 186,000 Negroes served in the Union Army, where they comprised about nine or ten per cent of the total enlistment. Of these, 93,000 were from the seceded states, 40,000 from the border states, and 53,000 from free states. Nearly 50,000 Negroes were in the Union Navy, amounting to about one quarter of the total naval forces.

6. James Forrestal (1892–1949), Secretary of the Navy who became first U.S. Secretary of Defense (1947–1949). He was so obsessed by fear of the Soviet Union that he committed suicide in March 1949 by plunging to his death from a window at the Bethesda Naval Medical Center.

7. Averell Harriman, leading United States diplomat in relations with the Soviet Union during the Cold War period following World War II. He supported the Truman Administration in its dismissal of Henry A. Wallace in 1946.

8. Edward Stettinius, Jr. (1900–1949), Chairman of the Board of U.S. Steel, who became the first United States delegate to the United Nations.

Foreword to *Nigeria*

1. Nigeria became independent in 1960.

Racialism in South Africa

1. The Cold War was the bitter conflict that developed between the United States and the Soviet Union and their respective allies, a war fought on various fronts without recourse to actual outbreak of major armed hostilities. The term was first used in 1947 by U.S. financier and presidential adviser Bernard Baruch.

2. After World War II FEPC was reduced to impotence by President Harry F. Truman, who countermanded a directive it had issued ordering the Capital Transit Co. of Washington, D.C., to cease discriminatory practices against Negroes. Charles H. Houston, one of the Committee's two Negro members, resigned in protest.

The Senate bill for a permanent FEPC (S. 101) was called up in January 1946. An 18-day filibuster followed and on February 9th the bill was finally displaced from consideration since its proponents had failed to get a two-thirds vote to close discussion. Repeated attempts were made to get the House bill before the House, but the Republican-Southern Democrat coalition prevented a vote.

Bills against discrimination in employment were introduced in half the 44 state legislatures meeting in 1945, but failed to pass in all but four states: New York, New Jersey, Wisconsin, and Massachusetts.

3. Julius Streicher (1885–1946), German journalist and politician, who became one of the leading anti-semites of the Nazi regime. He was eventually hanged as a war criminal.

4. Joseph Goebbels (1897–1945), minister of propaganda in the German Third Reich under Adolf Hitler.

5. Auschwitz, a town in Poland (Polish name Oswiecim), site of the infamous Nazi concentration camp in which between 1,000,000 and 5,000,000 people were massacred. Belsen was another Nazi concentration camp.

6. The Trenton Six were six Negroes condemned to death in August 1948 for allegedly murdering a white man, William Horner, on January 27, 1948. The case was appealed to the New Jersey Supreme Court by the Civil Rights Congress. The Committee to Free the Trenton Six, formed in February 1949, called it a "New Jersey Scottsboro Case." The death sentences against the six Trenton Negroes were reversed on June 30, 1949, by the New Jersey Supreme Court. The court indicated that it believed the "confessions" on which the convictions were based were illegally extorted by the Trenton police while the

men were held without warrants. Instead the six were sentenced to life imprisonment.

7. Malanites were followers of Daniel F. Malan (1874–1959), the South African politician who formed South Africa's first exclusively Afrikaner government in 1948, instituting Apartheid (separation of the races) and further enlarging the inferior status of blacks in the country.

8. There were an estimated 100 dead and 1,000 wounded in the Durban riots of January 16, 1949, between Zulus and Indians.

Paris Peace Conference

1. While abroad, Robeson attended the World Congress of the Defenders of Peace in Paris. In speaking to the Congress he uttered a "passing remark," but one which was to make headlines in the United States: "It is unthinkable . . . that American Negroes would go to war on behalf of those who have oppressed us for generations . . . against a country [the Soviet Union] which in one generation has raised our people to full human dignity of mankind." (*New York Times,* April 4, 1949.) Another black American who spoke at the Congress was W. E. B. Du Bois, who insisted that socialism was spreading everywhere, with only one real enemy—colonialism, led by the United States: "Drunk with power, we are leading the world to hell . . . and to a Third World War." (Arnold Rampersad, *The Art and Imagination of W. E. B. Du Bois,* Cambridge, Mass., 1976, p. 252.)

2. Twelve members of the National Board of the Communist Party were arrested and indicted for violation of the Alien Registration law of 1940, the Smith Act. The Board members were charged by the Federal Grand Jury: "That from on or about April 1, 1945, and continuously thereafter up to and including the date of filing of this indictment, in the Southern District of New York, and elsewhere . . . the defendants herein, unlawfully, and knowingly, did conspire with each other, and with divers other persons to the Grand Jurors unknown, to organize as the Communist Party of the United States of America, a society, group, and assembly of persons who teach and advocate the overthrow and destruction of the Government of the United States by force and violence, and knowingly, and willfully to advocate and teach the duty and necessity of overthrowing and destroying the Government of the United States by force and violence, which said acts are prohibited by Section 2 of the Act of June 28, 1940 (Section 10, Title 18, United States Code), commonly known as the Smith Act." The trial of the leading Communists took place in the Foley Square Federal Courthouse, before Federal Judge Harold R. Medina. The chief prosecutor was John F. X. McGohey, and the attorneys for the defense were George Crockett, a Negro attorney from Michigan; Abraham J. Isserman of New York; Louis McCabe of Pennsylvania; Richard Gladstein of California; and Harry Sacher of New York. Eugene Dennis, general secretary of the Communist Party, acted as his own counsel. The trial began on January 17, 1949, and lasted until October 14th of the same year, the longest "criminal" trial in American history. On October 14th, the jury brought in a verdict of guilty against the defendants. Judge Medina sentenced eleven of the defendants—William Z. Foster had not been brought to trial—to terms of five years in the penitentiary and fines of $10,000 each. Robert Thompson, a holder of the Distinguished Service Cross for bravery in the Pacific area during World War II, was sentenced to three years.

3. The Civil Rights Congress was organized in the spring of 1946 at a

conference attended by 372 delegates who responded to a call which simply stated: "Today's drive to subvert our democratic liberties is well-organized, well-heeled, insidious. It presents an emergency that emergency measures alone can meet." The founders of the CRC resolved "To strive constantly to safeguard and extend all democratic rights, especially the rights of labor, and of racial, political, religious and national minorities. To combat all forms of discrimination against these groups; to defend and aid victims of the fight for these groups; to fight against domestic fascism and all its forms—Jimcrow, anti-Semitism, red-baiting, discrimination against the foreign born." By unanimous vote, the Civil Rights Congress was formed for "united action of the democratic forces to enable each organization and individual to exert maximum effectiveness in the realization of a common program." Among the groups merging into the CRC were the International Labor Defense and the National Federation for Constitutional Liberties. Chairman of the Board was George Marshall, and William L. Patterson was its Executive Secretary.

William L. Patterson was born in California, lived three years in the Soviet Union during the 1920s, and, after his return, served as attorney for the Metal Workers Industrial Union and the National Miners Union. He was attorney in 1932 for several black Army veterans arrested following the expulsion of the Bonus Expeditionary Force from Anacostia Flats. In the fall of that year, Patterson was the Communist party's candidate for Mayor of New York City, and was National Secretary of the International Labor Defense from 1932 to 1936, years during which he played a leading role in the defense of the Scottsboro youths.

4. C. B. "Beanie" Baldwin had been one of Henry A. Wallace's top aides in the Agricultural Department as head of the Farm Security Administration, became campaign manager for Wallace during his campaign for the presidency in 1948, and functioned as head of the Progressive Party on a day-by-day basis after the election.

5. Gerhart Eisler, a German Communist, was in France when the country was overrun by the Nazis, and left for Mexico, but the ship on which he and his wife embarked was diverted to New York under the Neutrality Act regulations. In 1946, as he was preparing to return to Germany, he was arrested and accused of being the "top Communist International agent" in the United States. Facing a five-year jail sentence on flimsy charges, he stowed away on the Polish vessel, the *Batory,* in April 1949 and successfully evaded the U.S. authorities. He returned to Germany where in the new Eastern part of the country, he played a role in the socialist society.

6. The Marshall Plan (1948–1952) was the popular name for the U.S.-sponsored European Recovery Program designed to rehabilitate the economies of post-World War II European nations in order to prevent the rise of pro-communist sentiment. It was advanced in an address at Harvard University on June 5, 1947, by Secretary of State George C. Marshall, and led to the distribution of twelve billion dollars of economic aid in the next four years. It also strengthened the influence of American corporations on the economies of the European countries which were aided.

7. The Battle of Stalingrad (summer 1942-February 2, 1943) was a major turning point in World War II. The unsuccessful German assault on Stalingrad marked the limit of the German advance in the East and the beginning of a successful Soviet counteroffensive. Both President Franklin D. Roosevelt and General Douglas MacArthur hailed the Soviet victory at Stalingrad as one of the great watersheds of world history.

8. Rosa Lee Ingram, Negro sharecropper, of Ellaville, Georgia, was a

widow and mother of 12 children. On November 4, 1948, she was attacked in the field by a white sharecropper, John E. Stratford, because her hogs and three mules had strayed into his field. Stratford was armed; Mrs. Ingram was not. In the struggle her 15-year old son, Wallace, came to her rescue and struck Stratford who fell dead from the blows.

Mrs. Ingram and her four sons were arrested, indicted for murder on January 22, 1948, tried by an all-white jury on January 26, sentenced January 27 by Judge William H. Harper. Three, Mrs. Ingram, Wallace and her 13-year old son, Sammie, were sentenced to death in the electric chair. They were to be executed on February 27, 1948, but execution was stayed, pending argument for a new trial. Protests against the verdict poured in from all parts of the country, and Judge Harper commuted the sentences to life imprisonment but denied the motion for a new trial.

For Freedom and Peace

1. In the foreword to the pamphlet in which Robeson's speech appears, the Council on African Affairs noted that while in Europe, Robeson had given concerts and spoken at scores of political rallies throughout England, "speaking of himself as a representative of 'the other side of America.' To his audiences and to progressive European newspapers he gave the facts concerning the fight of Negro Americans to achieve their rights as citizens, as symbolized by the campaign to free Mrs. Ingram and the 'Trenton Six.'" It continued: "And his cutting words also stung his European listeners into a new awareness of the struggles of the African and Caribbean peoples to throw off the yoke of colonial bondage. Thus Paul Robeson followed in the footsteps of Frederick Douglass in arousing world support for the Negro's present-day struggle for freedom." (This was a reference to Douglass' tour of Ireland, Scotland, and England in 1845–1846 in the course of which he attacked American slavery and the war of the United States against Mexico.) The foreword then noted: "But here in America the forces of reaction, joined by misleaders among the Negro people, launched a campaign of vituperation against Robeson, using as their excuse his statement at the Paris Peace Conference expressing the Negro people's refusal to join in a war on behalf of the oppressors of colonial and subject peoples and against the friends and allies of the Negro people." It concluded: "In his address on June 19, here reproduced to widespread demand, Robeson explained fully what he meant and means by that statement and why he stands firmly by it."

2. Marian Anderson, famous Negro contralto singer, first black to sing at the Metropolitan Opera in New York.

3. George Washington Carver (1860–1943), Negro agricultural chemist and experimenter in agricultural research at Tuskegee Institute. Elected a fellow of the Royal Society of London.

4. Jackie Robinson (1919–1972), first black baseball player in the major leagues during the twentieth century. He began playing for the Brooklyn Dodgers in 1947.

5. It is not clear just which Jackson is referred to here: Joseph H. Jackson, Levi Jackson, Luther P. Jackson or the famous Negro singer, Mahalia Jackson.

6. Robeson here is referring to men like Walter White, Jackie Robinson, Roy Campanella and others who went out of their way to assure whites, including the House Un-American Activities Committee, that Robeson did not speak for the American Negro. Robinson, who later regretted that he had

testified against Robeson, told the Committee that Robeson's claim that the U.S. Negroes would not fight against Russia sounded "very silly" to him, but he also said that U.S. Negroes were "stirred up long before there was a Communist Party, and they'll stay stirred up long after the party has disappeared—unless Jim Crow has disappeared by then."

7. *See* p. 173.

8. Walter and Victor Reuther, Philip Murray, James B. Carey, and Willard S. Townsend, the latter black, were active in the drive to oust all unions affiliated with the CIO which had refused to support the Marshall Plan and had endorsed Henry A. Wallace in 1948. They were successful. At the 1949 CIO convention and immediately after, eleven progressive unions, with almost one million members, were expelled from the CIO as "communist dominated."

9. Vito Marcantonio (1902–1954), progressive political figure in New York, who began his career as Fiorello H. La Guardia's secretary and manager and went on to serve in Congress as candidate of the Republican and City Fusion parties and the American Labor Party. In Congress he was a consistent and militant champion of the rights of Puerto Ricans, Negroes, and labor, a spokesman for peace and an opponent of imperialism. In the 1950 congressional race, the Democrats and Republicans united to defeat him.

10. This is a reference to the North Atlantic Treaty of 1949 which sought to establish a military counterweight against the Soviet Union, and set up the North Atlantic Treaty Organization (NATO). Its members include Belgium, Canada, Denmark, France, West Germany, Greece, Iceland, Italy, Luxembourg, The Netherlands, Norway, Portugal, Turkey, the United Kingdom, and the United States.

11. Johann Wolfgang von Goethe (1749–1832), greatest German poet and dramatist, famous for *Faust.*

12. William Z. Foster was not brought to trial because of his heart condition, but the others were convicted. (*See above,* p. 537.) The constitutionality of the "advocacy" provision of the Smith Act was upheld by the Supreme Court in *Dennis v. United States* (1951). But in a later case (*Yates v. United States,* 1957), the Court construed "advocacy" to mean only urging that includes incitement to unlawful action.

13. Robeson is paraphrasing Claude McKay's famous poem, "If We Must Die":

> If we must die, let it not be like hogs
> Hunted and penned in an inglorious spot.
> While round us bark the mad and hungry dogs,
> Making their mock at our accursed lot
>
>
>
> Like men we'll face the murderous, cowardly pack,
> Pressed to the wall, dying, but fighting back!

Songs of My People

1. Natalie (Curtis) Burlin, *Hampton series Negro folk-songs,* Books I–II: Spirituals; Books III–IV: Work- and play-songs, New York, 1918–19.

2. The Russian mistranslates this line: "I'm going away from this farm."—*Translator's note.*

3. Lawrence Gellert, compiler, *Negro Songs of Protest,* New York, 1936.

4. The Russian line has "you are a man," rather than "yours is a man's (blood)."—*Translator's note.*

5. The reference is to William Christopher Handy (1873–1958), composer

who established the popularity of the blues in band music. A son and grandson of ministers, he was educated at Teachers Agricultural and Mechanical College, Huntsville, Ala., and worked as a schoolteacher and bandmaster. Though he became blind at the age of 30, he conducted his own orchestra from 1903 to 1921. His most famous work, "St. Louis Blues," was composed in 1914.

6. "The Committee for the Negro in the Arts" joined with other drama groups in Harlem, the Harlem Showcase, the Elks Community Theatre, and the Penthouse Players, to form the Council on the Harlem Theatre. The Council's aims were: "(1) to support mutually local drama groups by using actors, scenery, mailing lists and audiences, (2) to erect a calendar that would prevent a conflict in terms of production scheduling, (3) to agitate and press for the production of plays that would reflect the Negro culture in its true light." (Loften Mitchell, *Black Drama. The Story of the American Negro in the Theatre,* San Francisco, 1967, pp. 144–45.)

Statement on Un-American Activities Committee

1. At Martinsville, Virginia, seven young Negro men were convicted by an all-white jury and sentenced in May 1949 by Judge Kennen C. Whittle to die in the electric chair for allegedly raping a white woman in January 1949. The trials were rushed through in six days. The Court of Appeals in Virginia, in March 1950, upheld the lower court's verdict. The U.S. Supreme Court in May 1950 and again in January 1951 refused to hear the case. Despite worldwide and nationwide protests President Truman refused to intervene, and four of the Martinsville seven were executed on February 2, the other three on February 5, 1951. The Civil Rights Congress declared February 2nd a memorial day for the Martinsville Seven.

Let's Not Be Divided

1. In the *Pittsburgh Courier* of July 23, 1949, *Courier* Washington correspondent Lem Graves, Jr., pointed out: "Frankly, the main idea of these hearings (before the House Un-American Activities Committee) was to get Jackie Robinson to denounce Robeson and testify that the singer-artist spoke for no one but himself when he said what he did at the Paris Peace Conference. The calling of Lester Granger, of the National Urban League, Dr. Charles S. Johnson of Fisk University, Rabbi Schultz, the Rev. Sandy Ray, Thomas W. Young, Manning Johnson, and others was in the opinion of this reporter pure window-dressing to make the hearing look like a full-scale legitimate proposition. But the committee was banking largely on the publicity Jackie Robinson would get for the idea that Negroes are generally loyal."

2. In the course of his prepared statement, Robinson said: "I've been asked to express my views on Paul Robeson's statement in Paris to the effect that American Negroes would refuse to fight in any war against Russia because we love Russia so much. I haven't any comment to make, except the statement, if Mr. Robeson actually made it, sounds very silly to me. But he has a right to his personal views, and if he wants to sound silly when he expresses them in public, that's his business and not mine. He's still a famous ex-athlete and a great singer and actor." Later, however, Robinson said that most Negroes would "do their best to help their country stay out of war. . . ." (*New York Times,* July 19, 1949.) The *Times* printed the full testimony of Jackie Robinson, but had no report on the press conference held by Robeson to answer the baseball player's testimony.

3. The very same front page of the *New York Times* of July 19, 1949, carried the following headline underneath the report of Jackie Robinson's testimony before the House Un-American Activities Committee: "Florida Mobs Burn Negro Houses; Troops Set Up Wide Barricades." Then followed the report from Groveland, Florida: "Mobs of white men roamed the pine woods of Lake County early today, burning rural Negro houses. Law enforcement officers and National Guardsmen threw up barricades to save larger Negro communities."

4. Joe DiMaggio, the Italian-American "Yankee Clipper," famous outfielder and batting star of the New York Yankees.

5. In his testimony before the House Un-American Activities Committee, Manning Johnson, former black Communist turned informer, claimed that "after playing the title role in *Emperor Jones* years ago, Robeson, a member of the Communist Party, developed a complex and delusions of grandeur, and set out to become a black Stalin among the Negroes of America." (*New York Times,* July 15, 1949.)

6. However, the *Norfolk Journal and Guide* of July 23, 1949, carried the following report: "Manila. Paul Robeson, left wing singer-actor, is not wanted as a visitor in the Philippine Republic, it was made known Thursday."

If We Must Sacrifice

1. The meeting was picketed by members of the Veterans of Foreign Wars and other veteran organizations of Essex County. They carried placards urging Robeson "to go back to Russia." When asked about the picket line, Robeson told reporters, "They have their rights and I won't be drawn into that." (*Philadelphia Tribune,* July 24, 1949.) Asked about Jackie Robinson, he replied: "I have only respect for Jackie Robinson." *(Ibid.)*

2. In July 1949 the United Office and Professional Workers of America, CIO, published the pamphlet, *Metropolitan Management versus the Agents, the People and Progress.* It charged that the Metropolitan Life Insurance Company forbade its agents to solicit insurance from Negroes, that not a single Negro agent or district office clerk was employed by Metropolitan, and that the Metropolitan housing projects of Stuyvesant Town and Parkchester in New York City were restricted to whites only. The pamphlet was summarized in the *Chicago Defender* of July 2, 1949.

Robeson Dares Truman to Enforce FEPC

1. Half of the 6,000 workers in the Bureau were black, but less than .5 per cent held any but menial, unskilled jobs. In addition, there were still separate toilet facilities and segregated areas in the bureau for black employees. On August 3, 1949, Congressman Vito Marcantonio and Senator William Langer introduced resolutions calling for an investigation by Congress into the discriminatory conditions in the Bureau of Engraving and Printing. But nothing came of it. However, in January 1951, Ewart Guiner, black secretary of the United Public Workers of America, one of the eleven progressive unions expelled by the CIO, signed an agreement with the Bureau under which segregated facilities were outlawed and seventeen blacks were hired to work as apprentice plate-printers. For the first time since the Bureau was established during the Civil War, blacks were permitted to rise above the rank of unskilled labor.

who speak out for peace, who stand up for their constitutional rights and those of their fellow-men, or who are concerned with freedom for colonial peoples rather than with the raw materials that can be stolen from their lands." "We are convinced," the letter continued, "that the time has come to put an end to this cold war against the American people; the time has come to utilize the agencies of our government *in actual fact* toward promoting democracy at home and peace abroad." Federal action in the Peekskill riots was said to be "imperative" in view of the fact that "the present administration of the State of New York cannot be relied upon to protect the basic constitutional rights of its citizens." Signers of the letter included black church leaders such as Rev. James H. Robinson of New York and Rev. Charles A. Hill of Detroit, author Willard Motley, cultural figures like Charles Chaplin, songwriter E. Y. "Yip" Harburg, and conductor Dean Dixon, unions like the United Cafeteria Workers, Fur Workers, Local 65 of New York City, and also Willard B. Ransom, Indiana State President of the NAACP. (Copy of the document in Paul Robeson Archives, Berlin, German Democratic Republic.)

My Answer

1. The first article was preceded by the following Editor's Note: "The views expressed in this and subsequent articles are those of Mr. Robeson and do not necessarily reflect in any manner of interpretation the aims and policies of The New York Age. Space granted Mr. Robeson is for the purpose of public service and fair play."

2. Dixiecrats, also called States' Rights Democrats, were a right-wing splinter group in the 1948 presidential election organized by Southerners who objected to the civil rights program of the Democratic Party. They met at Birmingham, Alabama, and on July 17, 1948, nominated Governor Strom Thurmond of South Carolina for president and Governor Fielding C. Wright of Mississippi for vice-president. The Dixiecrats carried the states of South Carolina, Mississippi, Louisiana, and Alabama.

3. Here Paul Robeson is echoing the oft-repeated argument raised by blacks in American history who opposed colonization and emigration. David Walker, in his revolutionary pamphlet *Appeal to the Colored Citizens of the World (1829–1830)*, wrote: "Let no man of us budge one step, and let slave-holders come to beat us from our country. America is more our country, than it is the whites—we have enriched it with our *blood and tears.* The greatest riches in all America have arisen from our blood and tears. . . ." Two decades later, Frederick Douglass declared: "For two hundred and twenty-eight years has the colored man toiled over the soil of America, under a burning sun and a driver's lash—plowing, planting, reaping, that white men might roll in ease, their hands unhardened by labor, and their brows unmoistened by the waters of menial toil; and now . . . the mean and cowardly oppressor is meditating plans to expel the colored man entirely from the country. . . . We live here—have lived here—have a right to live here, and mean to live here." (Philip S. Foner, *Life and Writings of Frederick Douglass,* vol. I, New York, 1950, p. 320.)

4. *African Journey* by Eslanda Goode Robeson was published in 1945 by the John Day Company of New York.

5. In 1957 the Republic of Ghana became the first independent African nation.

6. Congressman John Rankin of Mississippi was the House racist spokesman whose counterpart in the Senate was Bilbo.

Robeson Testimony in Trial of Communist Leaders Blocked

1. Robeson was called as a defense witness in the trial of eleven Communist leaders, but he did not get a chance to testify on anything of importance. On objections by United States Attorney John F. X. McGohey, Federal Judge Harold P. Medina ruled out almost all questions asked by defense counsel as irrelevant. Robeson left the stand after twenty minutes, having said little more than that he knew all eleven defendants.

After the judge had sustained objections to several questions, George W. Crockett, Jr., of defense counsel, said: "In view of the court's ruling, I am convinced it will be impossible to bring before the court the testimony I had hoped." "I don't think you should have called him," the judge said. "May I—," Robeson began, addressing the court. "No, Mr. Robeson," Judge Medina said, "I don't want to hear any statement from you. I can't find from anything in these questions that you have any knowledge of the facts that are relevant in this case."

The Negro People and the Soviet Union

1. In the notice "About the Author," New Century Publishers, which published Robeson's speech as a pamphlet, wrote: "Paul Robeson is one of the foremost leaders of the Negro people and a concert artist of world renown. He has been chairman of the Council on African Affairs since the formation of that vital organization 12 years ago. In the summer of 1949 he returned from a four-month speaking and concert tour which took this beloved spokesman of the Negro people to eight countries of Europe, including the Soviet Union. While in Europe he participated as an honored guest in the celebration of the Pushkin centennial anniversary in Moscow, and in the World Peace Congress in Paris. A world-wide storm of indignation greeted the storm-troop attacks upon him in Peekskill, N.Y."

The speech was translated into Spanish and published in Cuba in the magazine *Fundamentos*, Año X, No. 102, pp. 901-7. This was the journal of the Communist Party in Cuba.

2. Mao Tse-tung (1893–1976), principal Chinese Communist leader, who led his nation's revolution that defeated the forces of Chiang Kai-shek and established the People's Republic of China in October 1949.

3. Haile Selassie (1892–1975), emperor of Ethiopia who led the resistance to the invading Italian fascist forces but was forced into exile in 1936. He was reinstated as emperor in 1941.

Maxim Litvinov (1876–1951), first Soviet Ambassador to the United States and leader of the Soviet delegation to the League of Nations.

4. The Point Four program was the U.S. policy of technical assistance and economic aid to underdeveloped countries, so named because it was the fourth point of President Harry F. Truman's 1949 inaugural address.

5. Maceo Snipes was dragged from his home in Taylor County, Georgia, and killed by four men on July 17, 1946, the night after he had voted (the only Negro to vote in that district) in the state primaries.

6. More brutal than even that of the lynching of Willie Earle was the torture-killing of John C. Jones, a 28-year-old war veteran and former Army corporal, near Minden, Louisiana, August 8, 1946. Jones, an oil refinery worker, was beaten by a mob, his hands were cut off, and a blow-torch was held to his face. He died in the arms of Albert Harris, his 17-year-old companion,

who had also been beaten and left for dead. The U.S. Department of Justice ordered a federal grand jury inquiry and six men—the Minden police chief, two deputy sheriffs and three others—were indicted for the lynching. One of the sheriffs was later released. Despite the testimony of Albert Harris, the other five were acquitted by an all-white jury on March 1, 1947.

7. The Mine, Mill and Smelter Workers, originally the Western Federation of Miners, was one of the eleven progressive unions expelled by the CIO.

8. The Food and Tobacco Workers were also one of the unions expelled by the CIO. For the role of the union among the black tobacco workers in Winston-Salem, North Carolina, and Robeson's contributions, see Philip S. Foner, *Organized Labor and the Black Worker, 1619-1973*, New York, 1974, reprinted in paperback, New York, 1976, pp. 282-83, 296.

9. The Ober Law provided for fines and prison sentences for membership in "subversive organizations," and required a loyalty oath for public employment. It was held unconstitutional by the Maryland State Circuit Court on August 16, 1949. The law was again declared "unconstitutional and invalid" in September 1949, but the Maryland Court of Appeals reinstated the law in February 1950, and it was upheld by the U.S. Supreme Court in April 1951. The law was drawn up by Frank Ober, a Baltimore corporation lawyer and chairman of the state commission on subversive activities.

Forge Negro-Labor Unity for Peace and Jobs

1. The Chicago National Labor Conference for Negro Rights grew out of the belief of a number of black trade unionists and white progressives in the labor movement that both the AFL and the CIO were failing to conduct a struggle to organize black workers and to combat racism and discrimination in industry and other aspects of American life, and that a new organization was needed dedicated specifically to defending black and other minority workers and promoting their rights. A call was issued for a meeting in Chicago, June 10, 1950. Paul Robeson, one of the organizers of the Conference, gave a benefit concert in New York City to help finance the Chicago meeting and addressed the gathering.

The Chicago Conference adopted a "model FEPC clause" to be incorporated plant by plant, union by union, local by local and incorporated, too, in every union contract. It declared that "regardless of any other contractual provision of this agreement, management agrees that there shall be (a) No discrimination in interviewing or hiring applicants for employment as well as no discrimination against employees during and after the trial period of employment because of color, race, sex, age, religious or political beliefs; (b) Guarantee against discrimination shall in addition apply to promotions, upgrading, apprenticeship, job training, and discharges; (c) In the event of layoffs, every effort shall be made to maintain gains achieved in applying this policy and in the event of disagreement in relation to any issue arising out of the application of this clause, shall be subject to the grievance machinery of this contract; (d) It is the purpose of this contract clause to guarantee in collective bargaining and by contractual rights the application of the union's policy for the protection and improvement of job opportunities for Negro workers and other minorities."

The Conference also established a Continuations Committee made up of three important black leaders: William R. Hood, recording secretary of Local 600, UAW-CIO, Cleveland Robinson, vice-president, Distributive, Processing, and Office Workers Union (independent), and Coleman Young of the Amalga-

mated Clothing Workers staff (later Mayor of Detroit). The committee was charged with the task of building chapters among black workers.

2. Indentured servants were individuals who signed contracts (indentures) committing themselves to labor for a stipulated period, usually seven years, to pay for the cost of their passage to America from Europe.

3. Dean Acheson (1893–1971), U.S. Secretary of State (1949–1953), pronounced anti-Communist, author of the Truman Doctrine and promoter of the North Atlantic Treaty Organization (NATO).

4. In September 1945, the Viet Minh, under the leadership of Communist Ho Chi Minh, established the Republic of Vietnam and proclaimed its independence from colonial rule. (The Constitution of the Republic of Vietnam incorporated the famous principle set forth in the American Declaration of Independence, proclaiming the "self-evident" truths that "all men are created equal," and were endowed with "certain inalienable rights; that among these are life, liberty, and the pursuit of happiness.") Under an agreement in March 1946, the French recognized the Republic of Vietnam as "a free state, having its own government, parliament, army, and treasury, belonging to the Indochinese Federation and the French Union."

The Vietnamese people believed that this agreement settled the issue of colonialism once and for all. However, the French, determined to reestablish domination over an area so rich in resources, moved to reoccupy Indochina. The United States massively supported French efforts to block Indochinese independence and to impose a puppet regime on the people.

5. The People's Republic of China was established by the Chinese Communists in 1949, defeating and overthrowing the Nationalist government of Chang Kai-shek.

6. The first Afrikaner government headed by Daniel F. Malan introduced the vicous Apartheid, the name given to the policies of the Afrikaner National Party after 1948 to maintain total white domination. Ownership of land by black Africans was limited to designated native reserves comprising only 13 per cent of the land surface. Sexual relations between whites and nonwhites were made illegal. The right to vote was denied to nonwhite men, and all black Africans were required to obtain permission before they could enter and remain in urban areas.

7. The World Federation of Trade Unions was organized in 1945 by the British Trades Union Congress, the U.S. Congress of Industrial Organizations, and the Soviet Union's All-Union Central Congress of Trade Unions. Early in the Cold War, the CIO and the British Trades Union Congress withdrew from the WFTU, refusing to join forces with unions of the Soviet Union. But the organization continued to function with headquarters in Prague.

8. The Truman Doctrine was a U.S. presidential pronouncement on March 12, 1947, declaring immediate economic and military aid to the armies of Greece and Turkey on the ground that they were threatened by local communists and the Soviet Union, that Great Britain could no longer supply the aid, and therefore it was up to the United States to take on the responsibility. The U.S. Congress responded to the message from President Truman by promptly appropriating $400 million for this purpose, thus opening the Cold War in earnest.

9. Eugene Dennis, general secretary of the Communist Party, was summoned to testify before the House Un-American Committee on April 9, 1947, but he refused to do so on the ground that the committee was illegal because it contained Congressman Rankin of Mississippi who won an election in which Negroes were not allowed to vote. Thus, according to Dennis, he was seated in the House illegally, in violation of the second section of the Fourteenth

Amendment, which stated that the representation of any state "shall be reduced in the proportion" the male citizens of the state were deprived of the vote for any reason except participation in rebellion or other crimes. Dennis was convicted of "contempt of Congress" in June 1947 in the Federal District Court in Washington, D.C. He was sent to jail in New York, on May 12, 1950, to serve a sentence of one year, with a fine of $1,000.

10. W illie McGee, a Negro worker of Laurel, Mississippi, was three times convicted by an all-white jury of allegedly raping a white woman in November 1945. Sentenced to death, he was four times saved from the electric chair by nationwide protests organized by the Civil Rights Congress, which conducted the legal defense and produced new evidence in the case. After the third verdict was affirmed by the state supreme court, the U.S. Supreme Court refused to review it. McGee was electrocuted on May 8, 1951, after his execution was stayed twice.

11. In the summer of 1948, Haywood Patterson, one of the Scottsboro defendants, slipped away from his work gang and fled into the nearby sugar cane fields. He made his way to Detroit, and for two years he remained in hiding, assisted by the Civil Rights Congress. When agents of the Federal Bureau of Investigation arrested him, Michigan's Governor G. Menen Williams refused to sign extradition papers, and Alabama authorities announced that they would terminate all efforts to have him returned to the state.

12. Howard Fast was imprisoned for refusing to reveal the membership lists of the Joint Anti-Fascist Refugee Committee. He and others on the Committee were charged with contempt of Congress and convicted on June 27, 1947, for refusing to turn over to the House Un-American Committee the names of their contributors and also those of Spanish Republican refugees. Robeson was scheduled to play the lead role in a film version of Fast's *Freedom Road,* but the film was never produced.

13. George Marshall went to jail for the same reason—refusing to turn over the membership lists of the Civil Rights Congress.

14. John Howard Lawson and Dalton Trumbo were two of the famous contempt-of-Congress case known as the "Hollywood Ten"—the others were Alvah Bessie, Herbert Biberman, Lester Cole, Edward Dmytryk (who later became a friendly witness), Ring Lardner, Jr., Albert Maltz, Samuel Ornitz, and Adrian Scott. On December 5, 1947, these men, noted motion picture directors and screen writers, were indicted. They were eventually sentenced to jail terms of up to a year, with fines up to $1,000, for exercising their right under the First Amendment to refuse to tell the House Un-American Activities Committee their political beliefs and affiliations.

15. Early in 1950, O. John Rogge, a former assistant attorney-general of the United States, and W. E. B. Du Bois began to organize a Peace Information Center to publicize a petition against the use and proliferation of nuclear weapons. Adopted as a resolution by a conference in Sweden, the Stockholm Peace Appeal was circulated internationally by the Paris-based World Council of the Defenders of Peace. Du Bois was elected the chairman of the American center. When Dean Acheson attacked the petition as a communist device on July 12, 1950, Du Bois replied that its articles—to ban atomic warfare, to place the ban under international supervision, and to censure the first nation to use atomic arms as a criminal against humanity—enjoyed genuine and widespread support in the United States and around the world from men of unimpeachable integrity. The Peace Appeal was "a true, fair statement of what we ourselves and many countless other Americans believed." (*New York Times,* July 17, 1950.)

On the 25th anniversary of the Stockholm Peace Pledge, a new appeal was

launched calling for destruction of nuclear stockpiles and disarmament and was circulated for signatures.

16. Philip Murray, William Green, James B. Carey, Emil Rieves, David Dubinsky, Willard S. Townsend, A. Philip Randolph, and George L. P. Weaver (the last three black trade union leaders) were all deeply engaged in supporting the Cold War and urging the elimination of left-wingers from the labor movement.

Robeson Denounces Korean Intervention

1. William L. Patterson, National Executive Secretary of the Civil Rights Congress, chaired the meeting. Other speakers included Congressman Vito Marcantonio, who challenged President Truman's usurpation of the powers of Congress by personally ordering Americans into war against the Korean people, and Gus Hall, National Secretary of the Communist Party, who said: "The colored peoples of the world, millions and millions of them are breaking down the prison walls of colonial bondage. . . . They don't want Point Four. They want Point One—the right to determine their own destiny, rule their own lands, and profit from their own labor."

2. The Korean War began in June 1950 between the Democratic People's Republic of Korea (North Korea) and the Republic of Korea (South Korea). The United Nations, with the United States as the principal participant, joined the war on the side of the South Koreans, and the People's Republic of China eventually intervened on the side of North Korea when its own territory was threatened with invasion. The war ended in a stalemate in July 1953. While traditional historical accounts assert that North Korea invaded South Korea, I. F. Stone in *Hidden History of the Korean War* (New York, 1953) challenges this interpretation.

3. Toussaint L'Ouverture (1743–1803), black slave who became the great leader of the Haitian revolution. He was tricked by Napoleon into visiting France for negotiations; there he was imprisoned, and there he died in 1803.

4. Thaddeus Kosciusko (1746–1817), Polish patriot and commander of American troops in the Revolutionary war.

5. Simón Bolívar (1783–1830), called "The Liberator," Venezuelan leader in Latin American struggles for national independence from Spain.

6. Vidkun Quisling (1887–1945), Norwegian army officer whose collaboration with the Nazis in their occupation of Norway during World War II established his name as a synonym for "traitor."

7. Bao-Dai, the playboy pro-French emperor of South Vietnam installed by the French, who ruled from 1949–1955.

8. Singman Rhee (1875–1965), first president of the Republic of South Korea (1949–1960), notorious as a reactionary and corrupt ruler who was finally deposed and exiled.

9. Carl Marzani was one of the many who were charged with contempt of Congress and imprisoned for defying the House Un-American Activities Committee.

10. Robeson is referring to the heroic role British workers played during the American Civil War. Even though they themselves were starving in the Lancashire textile region because the Union blockade of Confederate ports was keeping cotton from coming to England, they did not support efforts to intervene on the side of the Confederacy and break the blockade. For a discussion of the role of the British workers in support of the Union, *see* Philip S. Foner, *History of the Labor Movement in the United States,* vol. I, New York, 1947, pp. 312-17.

Speech to Youth

1. Robeson's address was delivered to the public session of the First National Convention of the Labor Youth League, November 24, 1950. Despite denial of one hall for the meeting and threats of intimidation, about 5,000 young people met in the St. Nicholas Arena, New York City, for the rally. In the preface to the pamphlet of Robeson's speech, *Challenge,* the publisher, declared: "Paul Robeson is known and loved in our country and throughout the world, both as a leader of the Negro people and as a great concert artist. He has just launched a new newspaper, *Freedom,* which is in the forefront of the Negro liberation movement in the United States.

"The present administration in Washington fears his voice for peace and freedom so much that he has been denied a passport to travel abroad. And on the occasion of the World Peace Congress in Europe last November, his son, Paul Jr., an elected delegate, was also denied a passport, thus joining his father under virtual house arrest." The back page of the pamphlet carried the notice "Read *Freedom.* Subscribe Today! Special Offer 10¢ a copy—$1.00 a Year. Freedom Associates, 53 West 125 St, N.Y.C."

2. The United States acquired Puerto Rico from Spain in 1898 as part of the Treaty of Paris following the war against Spain. The Puerto Ricans were not asked if they wanted to be annexed.

3. The war between the United States and Mexico was fought between April 1846 and September 1847. On February 13, 1848, the Treaty of Guadalupe-Hidalgo, which ended hostilities, gave the United States a vast part of Mexico's territory. For the payment of $15 million the United States acquired California, New Mexico, Utah, and parts of Colorado and Wyoming.

4. Lincoln Steffens (1866–1936), journalist and reformer, most famous of the "muckrakers," declared after a visit to the Soviet Union, "I have seen the future, and it works."

5. John Foster Dulles (1888–1959), Secretary of State under President Dwight D. Eisenhower and the architect of many major elements of the U.S. foreign policy in the development of the Cold War against the Soviet Union and the "People's Democracies" such as Czechoslovakia, East Germany, Hungary, Rumania.

6. Douglas MacArthur (1880–1964), commander of all U.S. Army forces in the Pacific during World War II and Allied commander of the Japanese occupation (1945–1951). At the outbreak of the Korean War in 1950, he was chosen to command the United Nations forces, but he was removed from that command by President Truman in 1951 because he wanted to expand the war into China.

7. *See above,* "Foreword to *Uncle Tom's Children,"* note 3, p. 517.

8. For Douglass' battle with Covey and his escape from slavery, *see* Foner, *Life and Writings of Frederick Douglass,* vol. I, New York, 1950, pp. 19–26.

9. *See above,* "Robeson Asks Truman Action on Lynching," note 1, p. 527.

10. The case involved the entire Negro community of Columbia, Tennessee. On the night of February 25, 1946, the Negroes organized to prevent the lynching of a war veteran and his mother, and to defend themselves and their homes against a white mob. The episode grew out of a complaint by a Negro woman, Mrs. Gladys Stephenson, that a white radio repairman had cheated her on radio repairs. The white man struck the Negro woman. The woman's veteran son struck back. The Stephensons were taken to jail and a lynch mob began to form. The Negro community raised the bail for the Stephensons and rushed them to safety out of town. The Negro community was attacked by a

white mob during the night, the business section destroyed and looted. About one hundred Negroes were arrested, and two were killed in jail. Thirty-one Negroes were indicted by the grand jury on charges of attempted murder, or being accessories to attempted murder. Defended by the NAACP and supported by the National Committee for Justice in Columbia, headed by Eleanor Roosevelt and Channing H. Tobias, the indicted Negroes came to trial in the summer of 1946. The trial lasted until October 4, and without any evidence, the prosecution's case went to the jury. To the amazement of the entire nation, the jury acquitted all but two of the defendants, who were later retried. Only one Negro of the entire group did not gain acquittal, and he was sentenced to five years in prison.

11. On February 13, 1946, Isaac Woodard, Jr., discharged from the Army only a few hours before, was traveling home on a bus from Atlanta to Winnsboro, South Carolina. About an hour out of Atlanta, Woodard had an altercation with the bus driver. At Batesburg, S.C., the driver called the police and ordered Woodard out. Chief of Police Linwood Shull struck Woodard across the head with a billy club, and in jail gouged out his eyes, blinding him for life. On November 5, 1946, however, an all-white federal jury acquitted Shull after being out for 15 minutes. Shull's attorney had told the jury: "If you rule against Shull, then let this South Carolina secede again."

12. Willie Earle, 24-year-old Negro of Greenville, South Carolina, was accused of stabbing a white taxi driver who died from the wounds. He was taken from jail on February 17, 1947, by a mob of white taxicab drivers, stabbed, shot and killed. Although 28 white men were brought to trial in Greenville in May 1947 for this lynching, all were acquitted by the all-white jury. This occurred even though all of the defendants practically admitted participation in the crime.

13. *See above,* "Paris Peace Conference," note 8, p. 538.

14. *See above,* "The Negro People and the Soviet Union," note 5, p. 546.

15. Following the outbreak of the Korean War, Wallace split with the Progressive Party and condemned the Russians for the war, arguing that the Soviet Union could have "prevented the attack by the North Koreans." From that time on he moved closer and closer to the "Truman Doctrine." On February 13, 1962, he finally recanted all of his previous positions against the Cold War when he appeared at a dinner honoring Truman, and told him: ". . . I'm glad you fired me when you did." (Richard J. Walton, *Henry Wallace, Harry Truman, and the Cold War,* New York, 1976, p. 351.)

16. On September 8, 1948, the Negro sharecropper Isaiah Nixon was shot in front of his wife and six children because he voted in the primary election at Macon, Georgia, after he had been warned not to do so. He died two days later in the hospital. The two white brothers who had shot him were not even brought to trial.

17. This is an excerpt from Douglass' West India Emancipation speech of August 4, 1857. For the entire text of the speech, *see* Philip S. Foner, *Life and Writings of Frederick Douglass,* vol. II, (*op. cit.,* note 8 *above*), pp. 426–38.

Paul Robeson's Column

1. Beginning in November 1950 and continuing for almost five years, with some interruptions, Paul Robeson published a monthly column in *Freedom,* the journal issued by Freedom Associates, 53 West 125th Street, New York City, in the heart of Harlem. These columns represent the voice of Negro protest in a period which has usually been neglected in historical accounts of

the Negro protest movement. Robeson's column was headed, "Here's My Story." Except for the first, which appears here, I have given each column a title in keeping with its content, but have also indicated that it is part of the "Here's My Story" series.

In addition to Robeson's column, *Freedom* carried articles by W. E. B. Du Bois, Shirley Graham, Lorraine Hansberry, Louis E. Burnham, who was the editor, and other black militants. It was also the organ of the National Negro Labor Council, but primarily, as Robeson pointed out in his first column, it sought to become "the real voice of the oppressed masses of the Negro people and a true weapon for all progressive Americans."

Our People Demand Freedom

1. Robeson's message was sent to Sheffield, England, where the Peace Congress was scheduled to be held. At the last minute the British Labour Government prevented this by barring most of the delegates.

2. For the full text of Frederick Douglass' "Farewell Speech to the British People, at London Tavern, London, England, March 30, 1847," *see* Philip S. Foner, *Life and Writings of Frederick Douglass,* vol. I, New York, 1950, pp. 206–33.

Douglass' freedom was purchased from his American master by British friends while he was in England.

3. On August 4, 1950, the State Department canceled Robeson's passport because of his refusal to sign the non-communist affiliation oath, and purportedly offered to restore it if he would refuse to engage in political statements when abroad. Robeson appealed to the higher courts, stating that revocation of his passport had interfered with his livelihood as a concert singer, causing him a financial loss in fees and royalties. But the U.S. Court of Appeals, August 7, 1952, threw out the appeal on the ground that it had no jurisdiction in the case.

The Road to Real Emancipation

1. *Proud Valley* was produced by Ealing Studios, a small independent film company in England. It was a film, Robeson said, in which he would "depict the Negro as he really is—not the caricature he is always represented to be on the screen." (*Glasgow Sentinel,* November 1, 1938.) The film about the life of the Welsh miners had its premiere at the Leicester Square Theatre on March 8, 1940.

Negro History

1. Walter White, executive secretary of the NAACP, Lester Granger, executive secretary of the National Urban League, and Adam Clayton Powell, black Congressman, all supported the Korean War.

2. Lt. Leon Gilbert, 31-year old Negro army officer of York, Pennsylvania, was condemned to death in August 1950 by a court-martial for allegedly refusing to obey an order on the fighting front during the Korean War. His platoon had been in action without relief for thirteen days and he himself had gone without sleep for six days and was ill with dysentery. He claimed that to have obeyed the order would have taken his men into certain death.

Gilbert was tried without being allowed to present Negro soldiers to testify in his behalf. He was sentenced to death, but owing to widespread protests from many groups all over the country, his sentence was later commuted to twenty years at hard labor.

Sixty other Negro officers and enlisted men serving in the Korean War were sentenced to harsh sentences ranging from five years at hard labor to death after having been convicted on charges ranging from being lost from their units to "disobedience" and "misbehavior" in the face of the enemy. In response to letters from Negro soldiers who claimed that they had been unjustly court-martialed, the NAACP sent Thurgood Marshall to Korea and Tokyo to investigate. After thoroughly studying the records, Marshall concluded that many of the convicted Negro soldiers had been tried under circumstances making it highly improbable that impartial justice would be dispensed. Few of the men had had adequate time to prepare their defense. In four cases in which life sentences were given, two of the trials had lasted fifty minutes each, one had lasted forty-four minutes, and one forty-two minutes. One soldier charged with "misbehavior in front of the enemy" testified that he had sprained his ankle and was unable to keep up with his outfit; he was given a sentence of fifty years. Marshall reported: "The question as to why so many Negroes were charged with misbehavior before the enemy and so few white officers were charged, remains unanswered." (Perhaps the answer lay in the discrimination Negro servicemen were subjected to during the Korean War.) Marshall reported that only eight white soldiers were accused of violating the 75th Article of War, and of these four were acquitted, one received five years, one, three years, and two had their charges withdrawn. Of the sixty Negroes so accused, fifteen received life imprisonment, one received fifty years, two, twenty-five years, three, twenty years, one fifteen years, seven, ten years, and only two received five years.

3. Walter Lippmann was the newspaper columnist for the *New York Herald-Tribune* (formerly editor of the New York *World* and co-founder of *The New Republic*) whose political columns exerted considerable influence throughout the world. A former Socialist, he repudiated Socialism.

Set Him Free To Labor On

1. In August 1950 the Department of Justice demanded that officers of the Peace Information Center register as "agents of a foreign principal," in accordance with the Foreign Agents Registration Act of 1938. Having resisted all attempts by the Attorney General's office to compel it to register, the governing body of the Center voted on October 12, 1950, to disband as an organization. But on February 8, 1951, a grand jury in Washington, D.C., returned an indictment against five members of the body including W. E. B. Du Bois. On February 16 Du Bois and his co-defendants were arraigned in Washington and released on bail; during the proceedings he was handcuffed briefly. The defendants faced a maximum sentence of five years in prison and a fine of five thousand dollars.

2. *The Souls of Black Folk: Essays and Sketches* was published in 1903 and immediately hailed as a classic.

Recollections of a Trip

1. Charles E. Wilson was head of General Motors Corporation.

The People of America Are the Power

1. George Thompson was a noted British authority on Greek classics though he never had a university education, having been born and raised in the working class.

2. In August 1950 William L. Patterson, executive secretary of the Civil Rights Congress, was called to testify before the special House committee investigating lobbying activities. When he refused to give this committee the CRC records or the names of its supporters, he was cited for "contempt of Congress." During his appearance before the committee, Patterson was insulted by Representative Henderson Lanham (Democrat of Georgia), who was about to attack him physically, and was restrained only by the quick action of those nearby. Patterson's trial was declared a mistrial.

National Union of Marine Cooks and Stewards Convention

1. For the militant stand of the Marine Cooks and Stewards, the role of black workers in the union and of Revels Cayton, and the government-industry conspiracy to destroy the union, see Philip S. Foner, *Organized Labor and the Black Worker, 1619-1973,* New York, 1974, reprinted in paperback, New York, 1976, pp. 226-31, 275-77, 286.

Unity For Peace

1. In the case of Communist Party leaders imprisoned under the Smith Act *(Dennis v. United States),* Justices Black and Douglas dissented, Black because the Smith Act violated the First Amendment, and Douglas because there was no evidence that these Communists presented a clear and present danger to the United States government.
2. These men had signed a petition criticizing the Supreme Court decision in the Dennis case.

Letter to Warren Austin

1. Trygve Lie (1896-1968), first secretary general of the United Nations (1946-1952), who resigned largely because of the Soviet Union's opposition to his support of the UN military intervention in the Korean War.
2. Frédéric Joliot-Curie (1900-1958) was the husband of Irène Curie, daughter of Pierre and Marie Curie, all recipients of the Nobel Prize in science. The couple collaborated in their research in chemistry. They also worked actively in the peace movement.
3. Warren Austin, U.S. Senator from New Hampshire, was appointed U.S. ambassador to the United Nations by President Eisenhower.
4. Manifest Destiny was the doctrine in the 1830s and 1840s that it was the clear and inevitable lot of the United States to absorb all of North America. This was expressed in the acquisition from Mexico of Texas, California, New Mexico and other areas in the 1840s. It was revived in the 1880s and 1890s to justify overseas expansion, the acquisition of Puerto Rico, Hawaii, and the Philippines.

Speech at Funeral of Mother Bloor

1. Ella Reeve ("Mother") Bloor (1862-1951), became an active Socialist in 1897 and joined the Communist Party in the early 1920s, becoming a member of the Party's National Committee. She was a tireless speaker and organizer for progressive causes and the Communist Party until her death.
2. Thaddeus Stevens (1792-1868), Republican Congressman during Radical Reconstruction. A firm believer in racial equality, he insisted that he be buried in a cemetery in Lancaster, Pennsylvania, open to Negroes as well as

whites. During Reconstruction he favored full freedom for the Negro, including confiscation of Southern lands and division among the freedmen.

Tribute to William L. Patterson

1. On August 22, 1927, two immigrant Italian anarchists, Nicola Sacco and Bartolomeo Vanzetti, died in the electric chair in Massachusetts. Arrested a year after the event for the murder during the course of a robbery of two employees of a shoe factory in South Braintree in 1920, they had been convicted by a hostile jury typifying the anti-radical feelings of the time, and sentenced by a prejudiced judge (Webster Thayer). The state supreme court and the U.S. Supreme Court refused to intervene, and an advisory committee appointed by the governor, headed by Harvard President Abbott L. Lowell, found no reason for commutation of the sentence. The execution took place despite worldwide protests.

Both William L. Patterson and Elizabeth Gurley Flynn, IWW leader and later active in the leadership of the Communist Party, were deeply involved in the Sacco-Vanzetti defense campaign.

On July 19, 1977, in an impressive ceremony in the Massachusetts Senate Chamber, Governor Michael Dukakis announced the issuance of a proclamation which, based on a study by his legal counsel, Daniel A. Taylor, concluded that "the very real possibility" existed "that a grievous miscarriage of justice occurred with their deaths." As the Governor observed, the entire trial process and appeals had been "permeated by prejudice against foreigners and hostility toward unorthodox political views."

2. The conviction of the eleven top Communist Party leaders in the Smith Act trials was followed by the arrests in June 1951 of many other Communist activists including Henry Winston, Pettis Perry, and Claudia Jones, Negro Communists.

3. The reference here is to Communist Party leaders who went underground in order to avoid going to jail in the Smith Act persecutions.

4. Crispus Attucks (1723-1770), Massachusetts fugitive slave who became a seaman and was the first American to be killed during the Revolution, being one of five shot to death by the Redcoats in the Boston Massacre of March 5, 1770.

5. Benjamin Banneker (1731-1806), free Negro mathematician, astronomer, compiler of almanacs, and inventor, who is one of the leading black figures in the early Republic.

6. Alphaeus Hunton was one of four trustees of the bail fund of the Civil Rights Congress imprisoned for contempt of court because they refused to give congressional investigators the names of contributors to the fund. One of the others was Dashiell Hammett, the well-known mystery writer and companion of playwright Lillian Hellman.

Ford Local 600 Picnic

1. For a discussion of Ford Local 600, *see* Philip S. Foner, *Organized Labor and the Black Worker,* pp. 295-96, 303-08.

2. The Sojourner Truth Housing Project in Detroit became involved in bitter controversy in the UAW. Many white members of the union objected to the housing project for black workers adjacent to a white neighborhood, and the first blacks who attempted to move in were prevented physically from so doing. The UAW stood firm in opposing the racists after first wavering, and this, with the militant determination of the black UAW members, led to the

success of the housing project. However, the conflict over the Sojourner Truth Housing Project paved the way for the anti-Negro riot in Detroit on June 20, 1943.

3. Nelson Davis was one of five black members of Local 600 who were removed from office by Walter Reuther, UAW international president, on the ground that they were "members of or subservient to" the Communist Party and were doing "irreparable harm" to the UAW. Davis, a veteran of the 1941 organization drive in the Ford plant, had been vice-president of Local 600's General Council before his removal.

4. William R. Hood was born September 29, 1910, in Whitesville, Georgia. He came to Detroit in 1942 after attending Tuskegee Institute, started work at the Chevrolet Gear and Axle Plant, and later continued at the Ford River Rouge Plant in Dearborn, Michigan. He was elected Recording Secretary of Local 600 of the United Auto Workers in 1947 and president of the National Negro Labor Council in 1951.

5. Walter Reuther (1907-1970) Socialist auto worker who had worked in the Soviet Union, became president of the United Auto Workers in 1946 and president of the CIO in 1952. Although he was later to challenge the Cold War policies of the Meany-type labor leaders, he himself was a Cold War champion and bitter anti-Communist in both the UAW and the CIO, and was one of the chief architects of the expulsion of the eleven progressive unions from the CIO.

6. The first convention of the National Negro Labor Council took place in Cincinnati, Ohio, October 27, 1951. *See below,* "Toward a Democratic Earth," note 1, p. 558.

Southern Negro Youth

1. Senator Joseph McCarthy of Wisconsin headed the post-World War II witch-hunt against Communists and all Americans of progressive thought, black and white, as head of the Senate Internal Security Committee. He gave the word McCarthyism to the language as an expression for wild charges of disloyalty. McCarthyism began in 1950, and reached its climax in 1953 and 1954. In December 1954, McCarthy was censured by the Senate for "conduct unbecoming a member."

2. Senator Pat McCarran of Nevada was the author of both the McCarran-Walter Act, which stiffened immensely the existing law relating to the admission, exclusion, and deportation of so-called dangerous aliens, and the McCarran-Wood Act, also known as the Internal Security Act, which was passed by Congress on September 23, 1950.

3. Louis F. Budenz, a former follower of the pacifist socialist A. I. Muste, became a Communist Party leader and editor of the *Daily Worker.* He left the Communist Party in 1945, was a star witness for the prosecution in the trial of the eleven Communist Party leaders, and appeared frequently as an expert anti-Communist witness before federal and state investigations into Communist and progressive organizations.

4. Roosevelt Ward, Jr., 22-year old Negro leader in the Labor Youth League, was arrested May 30, 1950, for alleged violation of the Selective Service Act. Charged with failure to give a New Orleans draft board his correct address, he was rushed back to Louisiana where a federal court sentenced him to three years in prison. On February 2, 1953, however, the U.S. Supreme Court unanimously reversed the lower court's decision, and Ward was freed.

5. Robeson had accompanied W. E. B. Du Bois to the Southern Youth Legislature in Columbia, South Carolina, an interracial effort sponsored by

the Southern Negro Youth Congress. Du Bois had told the meeting, "The future of American Negroes is in the South." (*See* Philip S. Foner, editor, *W. E. B. Du Bois Speaks: Speeches and Addresses 1920–1963,* New York, 1970, pp. 195–201.)

Toward a Democratic Earth *We* Helped to Build

1. The National Negro Labor Council's first convention was held in Cincinnati, Ohio, because it was "the place where Negroes and white met in the Underground Railroad to help the flight from slavery to freedom." The Cincinnati City Council unanimously condemned the convention as being part of the Communist Party's program to control Negroes. However, 1,098 delegates attended the convention, and, among other things, went on record to bring pressure on the government to restore Paul Robeson's passport.

2. The convention's keynote address was delivered by William R. Hood. Entitled "Uncle Tom is Dead!" it called for "a world of no Jim Crow, of no more 'white men's jobs' and 'colored only' schools, a world of freedom, full equality, security and peace." For the text, *see* Philip S. Foner, editor, *The Voice of Black America,* vol. II, New York, 1975, paperback edition, pp. 227–32.

3. The Continuations Committee, set up in Chicago, had established Negro Labor Councils in major industrial centers. Robeson was made an honorary member.

4. Under the leadership of several black militant tobacco workers, including Velma Hopkins and Miranda Smith, Local 22, Food, Tobacco, Agricultural and Allied Workers Union, CIO, had fought a bitter battle to organize R. J. Reynolds Tobacco Company in Winston-Salem, North Carolina. On July 1, 1947, Robeson spoke and sang at a mass meeting of 12,000 in Winston-Salem on behalf of Local 22.

5. In 1949, Miranda Smith became FTA Southern Regional Director, and a member of the union's national executive board, the highest position any black woman had held in the labor movement up to that time.

6. The *Cincinnati Inquirer* had launched a vicious campaign to discredit the convention and Paul Robeson. (*See* issues of October 27–29, 1951.)

7. Jawaharlal Nehru (1889–1964), first prime minister of independent India (1947–1964), who had been imprisoned several times by the British for his activities in the independence movement led by Mahatma Ghandi.

8. All three, but especially George S. Schuyler, conservative *Pittsburgh Courier* columnist, repeatedly attacked progressive black spokesmen in general and Paul Robeson in particular.

Sports Was an Important Part of My Life

1. Roy Campanella, Negro catcher on the Brooklyn Dodgers, and until he was partially paralyzed in an automobile accident, one of the greatest catchers in baseball.

2. The Harlem Globetrotters, a world-renowned Negro basketball team, famous for their dexterous handling of the ball and the humorous diversions during their play.

Du Bois' Freedom Spurs Peace Fight

1. "I have faced during my life many unpleasant experiences; the growl of a mob; the personal threat of murder; the scowling distaste of an audience. But

nothing so cowed me as that day, November 8, 1951, when I took my seat in a Washington courtroom as an indicted criminal." (W. E. B. Du Bois, *In Battle for Peace: The Story of My 83rd Birthday,* New York, 1952, p. 119.)

The chief defense lawyer was Vito Marcantonio; the chief prosecution witness was O. John Rogge, who named the Soviet Union as the ultimate foreign "principal" to which the Peace Information Center was agent. On November 21, the defense asked the presiding judge for a directed acquittal, and he ruled that while the existence had been established of the Peace Information Center and of the World Council of the Defenders of Peace, no evidence had been presented of a relationship of principal to agent between the latter and the former. Therefore the case against Du Bois and his four colleagues in the Center was dismissed.

2. At first a mildly worded appeal to the black leadership in the United States for support of Du Bois was so poorly answered that it was abandoned. But support soon began to grow among blacks; the black press came out strongly in support of Du Bois, and black workers rallied to his defense all over the country.

3. The Alien and Sedition Acts were a series of four laws passed in 1798 by the Federalist controlled Congress, providing for extension of residence as requirement of naturalization from 5 to 14 years, for deportation of aliens by the President, and for arrests of editors, writers, and speakers charged with attacking the government. Under its terms scores of Jeffersonian leaders and supporters were arrested and many were convicted. The laws were repealed by the Jeffersonian controlled Congress in 1801, and those imprisoned released by Jefferson's pardon.

4. In 1950, after several years of lobbying, Congress passed the Internal Security Act, also known as the McCarran Act. The act required the Communist Party and organizations with similar political viewpoints to register with the government as "subversive organizations." With certain exceptions the act excluded from the United States all those who had been members of the Communist Party.

Which Side Are We On?

1. Adam Clayton Powell (1908–1972), U.S. clergyman and political figure, elected to the New York City Council in 1941, and in 1945 became the first Negro from New York to be elected to Congress.

2. Prime Minister Dr. Mohammad Mossadegh nationalized the huge billion-dollar British owned Anglo-Iranian Oil Company three days after he was elected on May 1, 1951. Iranian oil was then boycotted in the West; Mossadegh's attempts to make deals with independent United States companies were frustrated by the State Department, and Iran lost all of its oil revenues. Seven months after Eisenhower took office as president in January 1952, the Mossadegh Government was overthrown by a United States planned and directed coup d'état, organized by the CIA.

3. On Christmas night, 1951, Mr. and Mrs. Harry T. Moore were sleeping in their home in Mims, Florida, when a bomb exploded under the house. Moore was killed and his wife, Harriet, died on January 3, 1952, from injuries received in the blast. Moore was state coordinator of the NAACP and executive secretary of the Progressive Voters League, an organization he founded to safeguard the right of Negroes to vote. He was posthumously, in June 1952, awarded the Spingarn Medal given each year by the NAACP to an American

whose work for Negro rights is judged the most outstanding of the year. No one was ever arrested for the bombing and killing of the Moores.

4. At the time of his death, Harry T. Moore was leading a protest movement against the murder of Samuel Shepard. On November 6, 1951, Sheriff Willis V. McCall of Eustis, Florida, shot and killed a Negro prisoner, Samuel Shepard, 23 years old, and seriously wounded his companion, Walter Lee Irvin, also 23. Both were handcuffed at the time of the shooting.

The U.S. Supreme Court had just reversed a 1949 decision against the two prisoners on the grounds that Negroes had been excluded from the trial jury. They were being taken to a nearby town for hearings on a new trial. Sheriff McCall went free and was reelected as sheriff.

5. The distinguished Negro scientist, Percy Julian, upon purchasing a fine home in Oak Park in 1951, encountered threats to his person, harassment of his children and serious attempts to bomb and burn him out. He was forced to hire private watchmen for two years to guard the place.

6. The signature campaign for the Five-Power Peace Pact was launched by the American Peace Crusade, which had gathered 2,500,000 signatures for the Stockholm Peace Pledge in the United States. By 1952 the Pact campaign had gained 600 million names throughout the world.

The Negro Artist Looks Ahead

1. Billie Holiday, Ethel Waters, Ella Fitzgerald, and Bessie Smith were all famous Negro singers, and of the four Bessie Smith is considered to be the greatest of the blues singers. She bled to death after an automobile accident when she was refused entrance to a hospital because of her color, and died en route to the Jim Crow ward of another hospital.

2. Bill "Bojangles" Robinson, of vaudeville, stage, and screen fame, was the greatest of the Negro dancers.

3. Florence Mills was famous in Harlem cabarets, on Broadway, and in London and Paris.

4. Teddy Wilson, famous modern jazz pianist, had been a music-theory major at Talladega College.

5. Hall Johnson studied at the University of Pennsylvania, and came to prominence as musical director in *The Green Pastures* and *Run Little Children,* and for his choral groups in motion pictures.

6. Will Marion Cook was a musical comedy composer at the turn of the century. He had spent a year at the Oberlin conservatory and, after studying with the renowned German violinist Joachim, tried to become a concert violinist, only to learn that there was no room for a Negro in that field. He turned to Negro musical comedies; his first success was *Clorindy,* for which the Negro poet Paul Laurence Dunbar wrote the lyrics. It was produced in 1898.

7. *See above,* "Primitives," p. 109.

8. Hector Villa-Lobos (1887–1959), foremost Latin-American composer of the twentieth century.

9. Pablo Picasso (1881–1973), Spanish-born painter, sculptor, resident in France, regarded as among the greatest of twentieth century artists.

10. Amedeo Modigliani (1884–1920), Italian-born painter and sculptor.

11. Constantin Brancusi (1876–1957), Rumanian-born French abstract sculptor.

12. Manuel de Falla (1876–1946), most distinguished Spanish composer of the early twentieth century.

13. Darius Milhaud, French composer of the twentieth century.

14. William Christopher Handy (1873–1958), Negro composer who estab-

lished the popularity of the blues in band music, famous for his classic, "St. Louis Blues."

15. William (Count) Basie, one of the outstanding organizers of big bands in jazz history.

16. *See above*, "Toward a Democratic Earth," note 2, p. 558.

17. Victor J. Jerome's *The Negro in Hollywood Films* was published in 1950 by *Masses & Mainstream*, the left-wing monthly that published Robeson's speech.

18. Lawrence Langner, head of the Theatre Guild, which produced *Othello.*

19. Mahalia Jackson, considered to be the authentic heir of the blues in the Bessie Smith tradition sang in a church choir as a young girl, then worked in a Chicago factory for l .e more than a dollar a day, before going on to fame as a singer.

Act Together Now to Halt the Killing of Our People!

1. *See above*, "Which Side Are We On?" note 3, p. 559.

An Important Message

1. Thousands of black Africans demonstrated in South Africa in protest against Apartheid on April 6, 1952, and were supported by sympathetic demonstrations in Europe and the United States. Mass arrests followed the demonstrations in South Africa.

Genocide Stalks the U.S.A.

1. The report, "We Charge Genocide: The Crime of the U.S. Government against the Negro People," was presented by the Civil Rights Congress in 1951 to the General Assembly of the United Nations. It reviewed the record of violent attacks resul ˙ng in the deaths of Negroes during six years from June 1945 through June 1951. At least 79 were killed by the police and at least 42 were killed by other individual whites, the record showed. These figures did not include at least 21 killed by mob attack and others killed by gross neglect after an accident. In summary the report pointed out: "It cannot be emphasized too often that those killings of members of the group which are recorded are a distinct minority of those actually killed."

Eslande Goode Robeson, Paul Robeson, and Paul Robeson, Jr., were among the "Petitioners" along with W. E. B. Du Bois, Benjamin Davis, Jr., Angie Dickerson, Howard Fast, William R. Hood, Alphaeus Hunton, Rosalee McGee, George Murphy, Jr., Ferdinand Smith, and Mary Church Terrell. The report was edited by William L. Patterson, executive secretary of the Civil Rights Congress. It was reprinted in 1970 by International Publishers with an introduction by Ossie Davis.

2. The Genocide Convention adopted by the General Assembly of the United Nations on December 9, 1948, defines genocide as any killings on the basis of race, or in its specific words, as "killing members of the group." But the Convention also states that "causing serious bodily or mental harm to members of the group" is genocide as well as "killing members of the group."

How Not to Build Canadian-American Friendship

1. There were actually two Fugitive Slave laws, one passed in 1793 and the second in 1850, for the purpose of achieving the return of escaped slaves. The

most notorious of these laws was the fugitive slave provision of the Omnibus Act of 1850.

2. For the story of Joe Hill and his case, *see* Philip S. Foner, *The Case of Joe Hill,* New York, 1965.

3. For further discussion of Robeson and the Canadian Mine, Mill and Smelter Workers' Union, *see below,* "Speech at Peace Bridge Arch," note 1, p. 568.

"Stand Firm, Son"

1. The Jefferson School of Social Science was founded in 1944 as a school of Marxist education. It represented a union of the Workers' School and the School for Democracy, founded by teachers dismissed from City College and Brooklyn College as a result of the Rapp-Coudert investigation of the New York State Legislature into so-called Communist influence in these institutions. The School established a branch in Harlem called the George Washington Carver School. Robeson was a regular speaker and singer at annual fund-raising dinners for the Jefferson School.

2. Viola Brown was one of the leaders of Local 22, Food and Tobacco Workers Union, of Winston-Salem, North Carolina.

An Evening in Brownsville

1. Bishop William J. Walls was chairman of the Board of Religious Education of the African Methodist Episcopal Zion Church and a member of the National Board of Directors of the NAACP.

2. William Lloyd Garrison (1805–1879), leading abolitionist who founded the *Liberator* in 1831 and the Anti-Slavery societies to battle for immediate emancipation. He also championed equal rights for free blacks.

3. Elijah P. Lovejoy (1802–1837), abolitionist editor who was shot and killed by a mob in Alton, Illinois, on November 7, 1837.

4. Wendell Phillips (1811–1884), Boston-bred and Harvard-educated, was one of the greatest of the Abolitionist leaders associated with William Lloyd Garrison. Phillips championed the rights of labor after the Civil War.

We Can Learn from the Struggle in South Africa

1. Mary McLeod Bethune (1875–1955), noted black educator active in numerous Negro affairs and special adviser to President Franklin D. Roosevelt on the problems of minority groups in the United States. In 1923 she served as president of Bethune-Cookman College.

2. Mrs. Charlotta Bass, Negro editor of the *California Eagle,* oldest Negro newspaper on the West Coast, was the vice-presidential candidate of the Progressive Party in 1952. She had been a life-long Republican before 1948.

3. Vincent Hallinan, California lawyer, had defended Harry Bridges in the government's case against the West Coast longshore union leader, and after the trial was sentenced to contempt. At the time of the Progressive Party convention in Chicago, July 4–6, 1952, at which he was nominated as the Party's candidate for president, he was serving a six-month sentence in McNeil Island Penitentiary in the state of Washington.

4. W. E. B. Du Bois was the keynote speaker at the Progressive Party convention. In 1948 Du Bois had come out boldly for Henry Wallace and the Progressive Party, and in 1950 he had run for the United States Senate from the state of New York on the American Labor Party ticket.

Voting For Peace

1. The nominating convention of the Progressive Party in Chicago was attended by more than 1,800 delegates from 41 states. It nominated by acclamation Vincent Hallinan for President of the United States and Charlotta A. Bass for Vice President. The Progressive Party was on the ballot in 45 states in 1948, but in 1952 in only 28. Total official votes for Hallinan and Bass were only 140,296.

2. In his keynote speech at the Progressive Party convention W. E. B. Du Bois said the party platform could be reduced to these planks: "Peace, stop the Korean war, offer friendship to the Soviet Union and the People's Republic of China, restore and rebuild the U.S." The first plank in the platform was headed "Peace: The Mandate of the People," and contained a ten-point program to end the Korean war, stop the rearmament and renazification of a disunited Germany, and negotiate an international agreement outlawing the A-bomb and H-bomb with effective controls and inspection of atomic stockpiles. It called on the U.S. government to ratify the Geneva Protocol outlawing the use of germ warfare. The peace plank also called for support of the demands for independence and freedom of colonial peoples; "full and immediate independence" for the Puerto Rican people; the holding of a Five-Power conference "as the only peaceful means for securing an over-all settlement of differences."

3. Edith Sampson, Negro social worker, lawyer and club woman, was the U.S. alternate delegate to the UN.

4. The expression was originated by Thomas Paine in *American Crisis I* during the War for Independence where he spoke of the "winter soldiers and sunshine patriots."

5. Eugene Victor Debs (1855–1926), Socialist Party leader who was imprisoned for having opposed participation of the United States in World War I. In 1920, though still in prison, he received 999,000 votes for President on the Socialist Party ticket.

6. The verdict against the eleven Communist leaders having been upheld by the Supreme Court, Benjamin J. Davis, Jr., surrendered on July 2, 1951, to serve a five-year sentence for alleged violation of the Smith Act. He had been out on bail along with nine of the other defendants on the basis of a ruling of Associate Justice Jackson. Eugene Dennis, however, was already serving a year's sentence for "contempt" of Congress, and so had continued in prison while the appeal was taken to the Supreme Court.

7. Adlai Stevenson (1900–1965), governor of Illinois, was the Democratic presidential candidate in 1952 against Dwight D. Eisenhower, the victorious Republican candidate.

8. Mrs. Eleanor Roosevelt (1884–1962) was appointed a delegate to the United Nations by President Harry S. Truman and served as chairperson of the UN Commission on Human Rights (1946–1951). In 1946 W. E. B. Du Bois organized an appeal to the United Nations Commission on Human Rights on behalf of black Americans, in the form of a pamphlet edited and introduced by him, comprising pieces written by legal and other experts within the NAACP and sponsored by the association. First declined by the world body for publication or debate, the "Appeal to the World" was finally accepted in October 1947. Embarrassed by its criticism of their country, the United States delegation, including Eleanor Roosevelt, prevented its scheduled discussion at a meeting of the commission in Geneva that year.

9. In its second plank, "Jobs and Security for America," the Progressive Party platform, among other demands, called for equal job opportunities for Negroes and other minority groups; establishment of nation-wide job training centers and other facilities for youth; legislation forbidding discrimination against women. The third plank, on Negro and minority group rights, entitled "End American Shame," demanded a Federal Fair Employment Practice Law, an anti-poll tax and anti-lynch law, and immediate issuance by the President of an order to prohibit discrimination in employment under any federal contract; prosecution of violators of the civil rights of Negroes and other minorities; end of segregation and discrimination in housing and in the armed forces and all federal departments; end of every form of discrimination in the District of Columbia; full representation of Negroes and all minority groups at all levels of public office; full citizenship for the American Indians.

10. The reference is to Langston Hughes' poem, "Let America Be America Again," which includes the lines:

"O, yes,
I say it plain,
America never America to me,
And yet I swear this oath—
America will be!"

Land of Love and Happiness

1. Pablo Neruda (1924–1973), Chilean poet and diplomat, winner of the Nobel Prize for Literature in 1971 and one of the greatest poets in the Spanish language. Neruda wrote a poem in honor of Paul Robeson.

The Battleground Is Here

1. The two-day convention, held in Cleveland's Municipal Auditorium, was attended by 1,500 delegates representing thirty chapters.

2. Jomo Kenyatta, general secretary of the Kikuyu Central Association (African political-protest movement), had worked and studied at the University College, London, and the London School of Economics where Robeson met him. He returned to Kenya in 1946 to become president of the Kenya African Union in June 1947. In 1952 he was arrested, and in 1953 imprisoned for "managing the Mau Mau terrorist organization." He became president of independent Kenya in 1963 and was elected president in 1964.

3. The African National Congress, a South African political party founded in 1912, became especially prominent after World War II when it demanded the abolition of racially discriminatory laws. The Congress was outlawed in 1960.

The Brave Trumpets

1. The *Bulletin of the Atomic Scientists,* "A Magazine for Science and Public Affairs," was founded in 1945 by H. H. Goldsmith and Eugene Rabinowitch. Its main purpose was "to provide a monthly commentary upon the revolutionary—and the evolutionary—changes brought about or portended by the present impact of science upon society—and the equally important impact of society-in-crisis upon science." In its minutes-to-midnight emblem, the movable minute hand has been used to symbolize the increasing or decreasing danger of a new nuclear war.

2. In 1933 Albert Einstein (1879–1955), physicist, Nobel laureate, champion of world peace and humanist, had taken up residence at the Institute for Advanced Studies in Princeton, New Jersey, where he pursued his research toward unifying the laws of physics. But he also involved himself in the cause of peace and social reform; he was prepared to testify for W. E. B. Du Bois in the trial against the great Negro scholar.

A Tale of Two Clippings

1. The advertisement was headed, "MR. DEWEY. AMERICAN NEGROES HAVE GROWN UP POLITICALLY . . . and it's time that you grew up too." It was an affirmation that Negroes would vote for Adlai E. Stevenson and John J. Sparkman, the Democratic Party ticket in the 1952 presidential election. Robeson omitted the introductory sentence to the assertion that Negroes "have jobs now" which read: "Like all other Americans, Negroes no longer are haunted by the spectre of unemployment and hunger." This must have been news to millions of black Americans. The advertisement also boasted that the Negroes would always fight and die when their country called upon them. "They're fighting and dying in Korea right now."

Among the signers were Congressman Adam Clayton Powell, Jr., and Kenneth Clark, author of *Dark Ghetto,* who appears to have forgotten in the advertisement what he wrote in the book.

2. The same November 21, 1952, issue of the *New York Times* carried the following: "The City College Student-Faculty Committee on Student Affairs, whose decision to bar Paul Robeson from using the college's Great Hall led the Student Council to call the act an 'abridgement of academic freedom,' declared last night that 'these charges are distortion of facts.'" The rest of the article actually proved the Student Council's charge to be accurate.

Robeson on Records Again

1. Robeson's letter was followed by the notice: "Here is the renowned People's Artist, greater than ever. . . . Here is the lifting strength, the thrilling beauty and dramatic sweep of his world-famous vocal voice! ROBESON SINGS, a new album of high fidelity recordings with Orchestra and Chorus, presents him—as never before—in a wide range of compositions . . . songs of power and protest . . . tenderness and love . . . soul-stirring songs of the people!" The album, issued by Othello Recording Corp, 53 West 125th Street, New York City, included: (1) The Four Rivers—song of peace and brotherhood; (2) Night—soulful Russian folk song (in English and Russian); (3) Witness—rousing Negro spiritual; (4) My Curly-Headed Baby—beloved lullaby; (5) Wanderin'—poignant folk song of American labor; and (6) Hassidic Chant—eloquent Jewish prayer of protest (in English and Hebrew). Each album ordered for $5 in advance would be autographed by Robeson.

Thoughts on Winning the Stalin Peace Prize

1. The Prize was awarded on December 22, 1952, and formally presented by W. E. B. Du Bois at a special ceremony on September 23, 1953.

In the one-man play *Paul Robeson* by Phillip Hayes Dean, starring the noted actor James Earl Jones, Robeson is depicted as viewing the award of the Stalin Peace Prize cynically. This is a distortion of Robeson's reaction.

The UAW Should Set the Pace

1. Martin Patrick Durkin (1894–1955), head of the Chicago Building Trades Council and Illinois State Director of Labor, was named U.S. Secretary of Labor in the Administration of Dwight D. Eisenhower in 1953, but resigned eight months later because of Eisenhower's refusal to support his suggestions for amending the Taft-Hartley Act.

An Open Letter to Jackie Robinson

1. The article was entitled "Does Jackie Robinson Talk Too Much?" (*Our World,* April, 1953, pp. 10, 13–14.) Asked if he was trying to use his sports prestige to crusade, Jackie Robinson replied: "Not really. Even when I spoke before the House Un-American Activities Committee in 1949 I made it plain that I was speaking only for Jackie Robinson. Even so, some sections of the Negro press criticized me. If you'll remember, I said that Paul Robeson's statement (about Negroes refusing to fight Russia in the event of a war) sounded silly to me. But I added, 'He has a right to his personal views . . . and he's still a famous ex-athlete and a great singer and actor.'" (p. 12.)

Paul Robeson Urges Support for Jailed Leaders

1. On October 21, 1952, Jomo Kenyatta was arrested at his home at Gatundu, Kenya. Police seized documents and rounded up 98 other African leaders. In April 1953 Kenyatta was sentenced to seven years imprisonment for "managing the Mau Mau terrorist organization." He denied the charge, maintaining that the Kenya African Union's political activities were not directly associated with the Mau Mau. Even after he had completed his sentence, Kenyatta was kept in detention by the British until August 1961.

2. Ralphe Bunche (1904–1971), Negro scholar, founder and key diplomat of the United Nations for more than two decades and winner of the 1950 Nobel Peace Prize for negotiating an Arab-Israel truce in Palestine. He was the first black man in history to be so honored.

The Real Issue in the Case of the Council on African Affairs

1. "Nothing illustrates more clearly the hysteria of our times than the career of the Council on African Affairs," W. E. B. Du Bois wrote in his *Autobiography* (New York, 1968, p. 344). The Attorney General's designation of the group as "subversive" led to the resignation of one of its founders, Max Yergan, and litigation by Yergan against the other leaders of the Council. The Council was financed largely by Frederick V. Field, a member of the wealthy Chicago department store family with socialist ideas and a great interest in African culture. But the attacks by the witch-hunters caused a serious loss in membership and funds. The Council on African Affairs continued the support of the struggle for independence in Africa and against imperialism until November 1956, when it was forced to close down.

Africa Calls—Will You Help?

1. Rudyard Kipling (1865–1936), British novelist, short-story writer, and poet. His major works celebrated British imperialism, which he hailed as

bringing civilization to the backward peoples of Africa and Asia thereby carrying the "white man's burden."

2. Gabriel D'Arboussier was the Marxist leader of the Réassemblement Démocratique Africain in the Ivory Coast. He was displaced by the conservative pro-French Felix Houghouet Boigny.

3. The article was actually an interview with Dr. Max Yergan who was described by the *U.S. News & World Report* as "America's Foremost Authority on Africa." It was entitled, "Africa: Next Goal of Communists," and it was an apology for the South African government's Apartheid policies, defending the repression in that country on the ground that it was needed to eliminate Communist influence. "I think the Government is completely justified in its policy of suppressing Communist influence," Yergan told the interviewer. He added that "it is easy enough to criticize white South Africa . . . but any person in Europe or America who levels criticism against white South Africa has to ask himself what he would do under similar circumstances. The white population there is dominated by fear. . . ." Yergan ventured the prediction "that when all the other European powers are out of Africa, the Portuguese would still be there," and praised the Portuguese for drawing "no social lines." (May 1, 1953, pp. 52–63.)

How I Discovered Africa

1. Nnamdi Azikiwe, founder of a nationalist political party in Nigeria, and president of Nigeria. He gained much of his early education in the United States (1925–1934), returned to the Gold Coast, became a newspaper editor and owner of a chain of newspapers, and also became directly involved in politics.

2. Kwame Nkrumah (1909–1972), first prime minister of Ghana and president of the republic from independence in 1957 to 1966. After studying in England and the United States (where he attended Lincoln University, Pennsylvania), he returned to his country. In 1949 he formed the Convention People's Party and in 1950 initiated a campaign of non-cooperation with the British authorities. In the first general elections in 1951 Nkrumah's party won, and he became the first prime minister in 1952.

3. H. G. Wells (1866–1946), British novelist, journalist, sociologist, and popular historian who exerted a powerful influence in the development of twentieth century ideas. Wells was one of the early members of the British Fabian Society. His most popular work was *The Outline of History,* published in 1920.

4. Harold J. Laski (1893–1950), British political scientist, educator, and prominent member of the British Labour Party. Laski embraced Marxism in the latter part of his life.

The Government's Policy and Practice of Racial Discrimination

1. The memorandum of the Council on African Affairs was drawn up and forwarded to the UN Commission on Racial Discrimination in South Africa set up by the UN General Assembly in December 1952. The Commission resolved that it would "hear representatives of governments, and, when appropriate, representatives of non-governmental organizations or private individuals, and to examine any written testimony which may be submitted by them." The memorandum was forwarded on July 23, 1953, to the UN Commission.

Speech at the Peace Bridge Arch

1. In February 1952 Paul Robeson and Vincent Hallinan had been invited by Harvey Murphy, president of the Mine, Mill & Smelter Workers' Union of British Columbia, to come as special guests to their Vancouver convention. Union officials knew Robeson's passport had been canceled two years before by the U.S. State Department, but also knew that "no native-born American ever needed a passport to enter Canada before." (Charles Wright, *Robeson: Labor's Forgotten Champion,* Detroit, 1975, p. 133.) But when an honor-guard of convention delegates came to the Blaine (Washington)-Douglas (British Columbia) portal, the site of the Peace Arch Park, to escort Robeson to Vancouver, they discovered that border officials refused to allow him to go with them to the packed convention hall. It was revealed that President Truman had signed an executive order warning that (on the basis of a law passed in 1918 and used only once before), if Robeson crossed the border, he would be fined $5,000. After hours of legal wrangling, Robeson returned to Seattle and the delegates to Vancouver. The Marine Cooks & Stewards Union of Seattle, of which Robeson was an honorary member, helped arrange a long-distance telephone hook-up with the convention in Vancouver. The next evening, Robeson sang songs of freedom to the 2,600 angry delegates. *See also* "How Not to Build Canadian-American Friendship," pp. 312–313.

Robeson later responded to a second call of the Mine, Mill & Smelters' Union of British Columbia to return to the Peace Arch Park, May 18, 1952. There 40,000 men, women and children from British Columbia and the State of Washington listened to Robeson's speech and heard him sing folk songs. Union officials taped the program and released an LP recording. The record jacket, after summarizing the events that led to the concert, stated: ". . . this is a recording of one of the most amazing concerts ever held on this continent. For some forty-five minutes, accompanied by his friend, Lawrence Brown, Robeson sang to an audience of approximately 40,000 men, women and children, mostly Canadians. Roads were blocked for miles around and the border was closed for hours. Canadians thereby delivered a crushing blow to the United States' State Department whose refusal to allow him (Robeson) to sing to 2,600 people in Vancouver had resulted in fifteen times that number traveling many miles to see him. . . ."

The International Peace Arch at the Western extremity of the Canadian-American border is a sixty-seven foot tower surrounded by fourteen acres of landscaped parkland. Dedicated in 1921, the Peace Arch commemorates the Rush-Bagot Agreement entered into by the British king and President Monroe in 1817 under which the whole line from the Straits of Juan de Faca has been ungarrisoned and unfortified for more than 200 years. The Peace Arch also commemorates an earlier provision in the Treaty of Ghent (negotiated between the U.S. and Great Britain ending the War of 1812) in which the desire of the signatories is expressed for a "firm and lasting peace." The Monument proclaims that the peace then established has never been broken.

2. *See above,* pp.119–20.

Playing Catch-Up

1. This was the third annual convention of the National Negro Labor Council. Only 800 delegates were in attendance. From its first convention the NNLC had been the object of abuse, and that abuse grew steadily. The Council

was communistic, its foes declared, its leaders were "Party stooges and hacks," its demands were synonymous with Communism, and its real objective was to cause trouble for the true friends of blacks. Between the second and third conventions, the Council had been placed on the Attorney General's list as a "subversive organization."

2. The war in Indochina between the French and the Republic of Vietnam, headed by Ho Chi Minh, resulted in the defeat of the French and was officially ended with the Geneva Conference of 1954.

3. Herman Talmadge, pro-segregationist governor and senator of Georgia, was a leading racist in Congress.

4. James F. Byrnes (1879–1972), Democratic Party Senator from South Carolina, U.S. Supreme Court Justice (1941–1942), Secretary of State (1945–1946), United Nations representative (1947), was a leader of the anti-Soviet Cold War policies. An outspoken racist, Byrnes defended racial segregation in the schools of the South.

5. Dwight D. Eisenhower (1891–1960), supreme commander of the Allied forces during World War II and 34th president of the U.S. (1953–1961). Eisenhower's Secretary of State John Foster Dulles was a prime exponent of the Cold War, and while Eisenhower did not favor sending American military forces to aid the French in Indochina and the British and Israel in Egypt, he did dispatch marines into Lebanon, and on January 5, 1957, proclaimed the Eisenhower Doctrine promising military or economic aid to any Middle Eastern country needing help to resist communism.

6. Winston Churchill (1874–1965), Conservative Party statesman who, as prime minister from 1940 to 1945, led Britain from near defeat to victory in World War II. He was voted out of power in a labor sweep in 1945, but was returned as Prime Minister in 1951. He retired in 1955. A leading champion of the Cold War, in his address at Westminster College, Fulton, Missouri, March 5, 1946, he coined the phrase "Iron Curtain" to describe the Soviet Union and the People's Democracies.

Foreword to *Lift Every Voice*

1. On January 31, 1946, People's Songs Inc. was incorporated in New York City with the goal and purpose of stimulating and developing an understanding and appreciation of worthy American music, songs, and cultural and civic traditions, and of carrying on these objectives in a nonpartisan way. People's Artists Inc. was founded that same year by progressive entertainers to service labor unions, political action groups, and political organizations. People's Artists issued *Sing Out,* a journal of folk songs and culture, and *People's Song Book,* both edited by Irwin Silber. The first *People's Song Book* had been seized in 1948 by the Quebec government as a subversive publication.

Civil Rights in '54

1. In the summer of 1953 Paul Robeson was on a cross-country concert tour, and his column "Here's My Story" in *Freedom* was written by guest columnist Eslanda Goode Robeson. In the July 1953 guest column, Mrs. Robeson wrote that there was evidence of a new determination on the part of Negroes in the United States to fight back and that this was linking up with the upsurge of the independence struggles in Africa. "We Negroes have an important role to play," she concluded, "and I'm glad that we have leaders coming up who are ready to help us play it. Paul is one of them, and I'm mighty

proud of him." In her September 1953 column, Mrs. Robeson described having been summoned to appear before the Senate Investigating Committee headed by Senator Joseph McCarthy, and told how the Senator wanted only to discuss "the Communist question. But I wanted to discuss the Negro question, which is of very great and very immediate interest and importance to me." She then observed: "Some of our friends, Negro and white, wonder why we Paul Robesons don't just sit down and be quiet, make the big money and enjoy Paul's fabulous success, instead of raising so much sand about our constitutional rights as American citizens.

"Well, it's all a question of what you mean by ENJOY.

"Personally, I wouldn't enjoy being all dressed up in Paris gowns, mink coats and diamonds, and presiding over a gorgeous mansion, if any old unAmerican could come along and lynch or rape or kill me—as they tried to kill Paul at Peekskill—or could bomb or dynamite me and my mansion as they did to the Harry Moores in Florida and other Negroes in Alabama, Chicago, and other points North, East, South and West in these United States.

"No, indeed, I'd rather be all dressed up and living in my Civil Rights. I would feel safe and very well dressed if I wore my first-class citizenship; that would be more stylish and becoming and more comfortable than anything else any American could wear."

In her final column, October 1953, Mrs. Robeson asked, "How About the Government Being Loyal to the People of the U.S.A.?" She observed: "When every citizen of the United States can enjoy full constitutional rights, then—and not until then—will OUR GOVERNMENT BE LOYAL TO OUR CITIZENS." She herself would never be loyal to Malan in South Africa, to the British in Kenya, the French and Belgian governments in Africa, to Franco in Spain, and Chiang Kai-shek on Formosa, no matter how much such a position would displease the unAmericans. "And last, but most important, I'm not going to be loyal to the unAmericans right here in our own United States, in government or out, who discriminate against, segregate, persecute and kill the Negro people.

"So much for my loyalty. Let the Committees go chew on that and digest it. Meantime, I'd rather not hear another peep out of them on the subject."

2. On February 28, 1951, a case of school segregation was filed with the United States District Court for Kansas. Its title was *Brown v. Board of Education of Topeka*. It was this case that was to be decided by the Supreme Court. On May 17, 1954, the Supreme Court, in the landmark unanimous decision, declared: "We conclude that in the field of public education the doctrine of 'separate but equal' has no place. Separate educational facilities are inherently unequal." In overruling the *Plessy v. Ferguson* decision of 1896, which had established the "separate but equal" doctrine as Constitutional, the Supreme Court opened a new era in the legal struggle for Negro rights.

3. Robeson here means John C. Calhoun (1782-1850), Senator from South Carolina, famous as a champion of states' rights and proponent of the pro-slavery point of view. The States' Rights Party of 1948 supported states' rights in opposition to federal regulation, advocated maintenance of the Taft-Hartley Act, and attacked fair employment practices proposals.

4. John Peter Altgeld (1847-1902), wealthy Illinois lawyer who became the most progressive governor of the state in its entire history. Altgeld fought for anti-monopoly and pro-labor laws. He pardoned the survivors of the Haymarket Riot frameup in 1893, earning thereby the hatred of the established and wealthy groups in the nation, which was intensified the next year

when he opposed the sending of federal troops to his state by President Cleveland to break the Pullman strike.

Foreword to *Born of the People*

1. President William McKinley told a group of ministers who visited him at the White House that, after much prayer, he had decided he had but four choices with respect to the Philippine Islands: he could not return the Philippines to Spain, "that would be cowardly and dishonorable"; he could not turn them over to another power, "that would be bad business and discreditable"; he could not leave them to themselves, for they were unfit for self-rule; "there was nothing left for us to do but to take them all, and to educate the Filipinos and uplift and civilize and Christianize them. . . ." Then he went to sleep and slept soundly. (Quoted in Philip S. Foner, *The Spanish-Cuban-American War and the Birth of American Imperialism,* vol. II (1898–1902), New York, 1972, p. 410.) But as Timothy McDonald points out: ". . . the decision to keep Manila and its environs had been made long before McKinley informed the Almighty and his fellow Mid-Westerners of his plans for the Philippines." ("McKinley and the War with Spain," *Midwest Quarterly,* vol. VII, Spring, 1966, p. 234.)

2. The reference is to the Filipino-United States war during which the United States waged war against the Philippine independence forces, and employed brutal methods to conquer the Filipinos. To carry out the war of agression against the Filipinos more effectively, General "Jake" Smith took over the job of pacifying Samar. His first move was to order all civilians out of the interior and into concentration camps where they died like flies. "I want no prisoners," General Smith told his troops. "I wish you to kill and burn; the more you burn and kill the better it will please me." All persons who had not surrendered and were capable of carrying arms were to be shot, and this included Filipino boys of ten years of age! Finally, Smith gave his infamous order that Samar be converted into a "howling wilderness." The order was carried out to the letter. By such methods the Filipinos were conquered.

3. Luis Taruc, Philippine Communist, Hukbalahap leader, ended his book on the same note: "It is necessary now to get on with the work that needs to be done." It is dated June 1949.

Perspectives on the Struggle for Peace

1. *See above,* "Toward a Democratic Earth," note 1, p. 558.

2. John Foster Dulles urged France not to sign the Geneva Convention ending the Indochina War, and when he was rebuffed, saw to it that the United States did not sign the Convention. The term "big stick" was applied first to the advocacy by President Theodore Roosevelt of using strong methods to push through American policies abroad. Its origin lies in his expression "Speak softly and carry a big stick," and it developed into the "Roosevelt Corollary" which involved direct American intervention in several Latin American states.

The "Big Truth" Is the Answer to the "Big Lie" of McCarthy

1. Max Yergan was now a paid apologist for South Africa's Apartheid.

2. Attorney General Herbert Brownell was a leader in the witch-hunts of the 1950s.

Ho Chi Minh Is the Toussaint L'Ouverture of Indo-China

1. For a good study of Toussaint L'Ouverture and the battle he led for the liberation of the black slaves and the founding of the Republic of Haiti, which he did not live to see, *see* C. L. R. James, *Black Jacobins,* New York, 1963.

2. Ho Chi Minh (real name Nguyen That Thanh) (1890–1969), president from 1945 to 1969 of the Democratic Republic of Vietnam (North Vietnam), one of the greatest patriotic leaders of all time who is considered the George Washington, Thomas Jefferson and Abraham Lincoln of his country, and one of the most influential Communist leaders of the twentieth century.

3. The French government negotiated with the Hanoi government. An agreement was reached between Ho Chi Minh and the French delegate Jean Sainteny on March 6, 1946, which stipulated that the French would recognize the Viet Minh government, and would consider Vietnam a free state within the French Union. The Indochina war opened on December 19, 1946, when the French repudiated the agreement. From 1952 on, in spite of increasing U.S. financial and military aid, the French kept losing the "dirty war." In March 1954, with the French forces at Dien Bien Phu encircled by Viet Minh forces under General Giap, and facing certain defeat, Vice President Richard M. Nixon called for U.S. intervention to save the French, even urging the use of atomic weapons. But Congress rejected the appeal, and when Dien Bien Phu fell on May 7, 1954, France was at last ready to negotiate an agreement to end the war at an international conference at Geneva.

The Geneva Conference of 1954 ended the war between France and the Republic of Vietnam. Vietnam was divided into two sections, the dividing line being the 17th parallel. However, it was recognized that Vietnam was one country, and it was agreed that in 1956 elections would be held in both North and South to determine the composition of a single government for the united nation. The United States, although present at the Geneva Conference, refused to sign the final agreement. However, it did agree that it would "refrain from use of force to upset the agreement." This was immediately repudiated.

4. Mordecai Johnson's speech was delivered at the 1950 CIO convention. The complete statement cited by Robeson read: "Now, suppose you were Indo-Chinese, wouldn't you be amazed at us? For over 100 years the French have been in Indo-China, dominating them politically, strangling them economically, and humiliating them in the land of their fathers. We (the United States) haven't ever sat down with the French and demanded that they change that system. And in the defect of leadership on our part, they have turned to the Communists, and the Communists have given them leaders, they have trained their troops, and given them money and now it looks as if they can win, and as they are about to win their liberty we rush up to the scene and say, 'Dear Brothers, what on earth are you getting ready to do? Are you going to throw yourselves into the hands of this diabolical conspiracy under the false notion they can bring you freedom? Why, they aren't free; we are the free people of the world, we have democratic institutions, we are your friends, we will send you leaders, we will send you ammunition, we will send you bread.'

"And then they look at us in amazement and they say, 'Brother, where have you been? Why, if we'd a-known you was a-coming we'd have baked a cake." (*Proceedings,* CIO Convention, 1950, pp. 24–28.)

5. Charles G. Baylor, a black attorney of Providence, Rhode Island, made this statement in the Negro weekly *Richmond Planet,* July 30, 1898. For an extended excerpt from the article, *see* Herbert Aptheker, editor, *A Documen-*

tary History of the Negro People in the United States, vol. I, New York, 1951, pp. 823–24.

Negro Americans Have Lost a Tried and True Friend

1. Vito Marcantonio campaigned for an eighth term in the 18th congressional district of New York City as the American Labor Party candidate. He was defeated by a combination of the forces of the Republican, Democratic, and Liberal Parties. After his defeat, he worked as an attorney for progressive organizations and causes until he died suddenly of a heart attack in 1954.

2. For a good summary of the positions he took while in Congress, *see* Annette Rubinstein, editor, *I Vote My Conscience: Debates, Speeches and Writings 1935–1950 of Vito Marcantonio,* New York, 1956.

3. The "Black Cabinet" was formed under President Franklin D. Roosevelt to advise the president on issues related to black Americans. Ralph Bunche and Mary McLeod Bethune were two of the members.

4. The "good neighbor policy" was the popular phrase applied to the early Latin American policy of the administration of Franklin D. Roosevelt. It implied the reversal of the earlier "big stick" and "dollar diplomacy" foreign policies. It was first announced at the Seventh Pan American Conference at Montevideo in 1933.

Fight We Must

1. This was an answer to the charge that the National Negro Labor Council was a "dual organization." This despite a record of assistance of unions in a number of key labor struggles.

2. In a pamphlet entitled "The American Negro in the Communist Party," issued in December 1954, the House Committee on Un-American Activities listed the National Negro Labor Council as a communist-front organization. In 1956 the NNLC was called before the Subversive Activities Control Board to defend itself against being listed as a "Communist-front organization."

3. The reference is to the decision of the Supreme Court in the case of *Brown v. Board of Education. See above,* note 2, p. 570.

4. The "China Lobby" referred to certain lobbying organizations which represented the so-called Republic of China on Formosa, supported by American Republican and Democratic Congressmen and Senators, and which mounted an extensive public relations campaign to prevent the seating of the People's Republic of China in the United Nations and the development of normal relations between that country and the United States.

Floodtide of Peace

1. The African Methodist Episcopal Zion Church was actually founded on August 11, 1820, as an autonomous all-black church, and the following year Peter Varick was elected as its bishop.

2. William D. ("Big Bill") Haywood (1869–1928), militant trade unionist, secretary-treasurer of the Western Federation of Miners and one of the founders of the Industrial Workers of the World (IWW), which he headed as general secretary for a number of years. Haywood was convicted in 1918, along with many other Wobblies, for violating the Espionage Act and sentenced to 20 years in prison. He was released in 1919 pending an appeal, jumped bail, went to the Soviet Union and died there on May 18, 1928.

3. Joe Hill (1879–1915), born in Sweden, became famous as the song writer of the IWW. He was executed before a firing squad in Utah on the charge of

murder which he claimed was a frame-up and which many believed to be true at the time and since. Robeson frequently sang the song by Earl Robinson, "I dreamed I saw Joe Hill last night. . . .," which included the words, "The copper bosses killed you Joe. . . ."

Bonds of Brotherhood

1. The article appeared in the Tercentenary anniversary edition of *Jewish Life,* the progressive Jewish monthly edited by Morris U. Schappes. It was later reprinted in a *Jewish Life* anthology. It is reprinted here with the permission of *Jewish Currents,* successor to *Jewish Life.*

2. The first group of Jews to seek to colonize what is now the continental United States arrived in the first week of September, 1654. Twenty-three Jews came to New Amsterdam on the *St. Charles.*

3. Haym Salomon (1740–1785), merchant, banker, Revolutionary financier, who was born at Lissa, Poland, of Jewish-Portuguese ancestry.

4. The Know-Nothing Party was organized as the American Party in 1850. It particularly opposed foreigners, especially Roman Catholics and Irish-Americans. The name derives from the fact that upon being questioned as to their motives, purpose, and program, the members would reply, "I know nothing."

5. The twenty Negroes who were landed at Jamestown, Virginia, in 1619, were indentured servants, not slaves. Black slavery did not emerge in Virginia until 1640.

6. Peter Stuyvesant (1592–1672), Dutch administrator in America, wrote to Amsterdam urging that the Jews not be allowed to settle in New Amsterdam, but the Amsterdam Chamber of the West India Company, not ready to offend Jewish stockholders, reluctantly overruled him and allowed the Jews to remain so long as they did not become public burdens.

7. For the full text of this, perhaps the greatest of Douglass' speeches, *see* Philip S. Foner, *Life and Writings of Frederick Douglass,* New York, 1950, vol. II, pp. 181–204. It has also been issued as a recording by Folkways Records, edited by Philip S. Foner and narrated by Ossie Davis.

8. John Huss (1369–1415), Bohemian religious reformer, tried as a heretic and burned at the stake.

9. Clement Gottwald (1896–1953), Czech Communist politician, premier (1946–1948), and president (1948–1953) of Czechoslovakia.

10. Sholem Aleichem (pseudonym of Sholem Yakov Rabinowitz) (1859–1916), popular Yiddish classical author, known as the "Jewish Mark Twain." The longest-run musical play *Fiddler on the Roof* is based on his stories.

11. William Knowland, Oakland, California, publisher and reactionary Senator from California.

12. Jefferson Davis (1808–1889), U.S. Senator from Mississippi who left the Senate in 1861 when Mississippi seceded from the Union, and was elected President of the Confederate States.

Mississippi Today

1. Blanche Kelso Bruce, the first Negro to serve a full term as a U.S. Senator, was born a slave near Farmville, Virginia, on March 1, 1841. He was tutored by his master's son, but when the Civil War began, he left his master. He taught school for a time in Hannibal, Missouri, and later attended Oberlin College, Ohio. After the war he became a planter, sheriff, and tax collector in Mississippi. In 1874 he was elected Senator from the State of Mississippi and

served from March 4, 1875, to March 3, 1881. In the Senate, Bruce defended the rights of all minority groups, including those of the Chinese and the American Indian. After he completed his term in the Senate, Bruce held several federal government posts until his death on March 17, 1888.

2. Hiram Rhodes Revels, the first Negro ever to sit in the U.S. Senate, was born in Fayetteville, North Carolina, on September 27, 1828. He attended the Quaker Seminary, Union County, Indiana, and Drake County, Ohio, Seminary. He graduated from Knox College in Bloomington, Illinois, and was ordained a minister in the African Methodist Episcopal Church at Baltimore, Maryland, in 1845. He served congregations in Tennessee and Missouri, and in 1860 accepted a pastorate in Baltimore. At the outbreak of the Civil War, Revels assisted in organizing the first two colored regiments in Maryland. He served in Vicksburg, Mississippi, as chaplain of a colored regiment in 1864, and settled in Natchez in 1866. His political career began when he was elected alderman of Natchez in 1868. Upon the readmission of Mississippi to representation in Congress, he was elected as a Republican to the U.S. Senate and served from February 23, 1870, to March 3, 1871, taking the seat that had belonged to Jefferson Davis, the former president of the Confederate States of America. In the Senate, Revels served on the Committees of Education and Labor, and the District of Columbia. Following his retirement from active politics, Revels served as president of the Alcorn Agricultural College in Rodney, Mississippi, from 1876 to 1882. He died on January 16, 1901.

3. John Roy Lynch, the first Negro Congressman from Mississippi, was born a slave in Concordia Parish, Louisiana, September 10, 1847. In 1863 he was taken to Natchez, Mississippi, and after emancipation, took up the profession of photography. By attending night school, he managed to obtain an education. In 1869 Lynch was appointed justice of the peace for Adams County, Mississippi, by Governor Ames, and that same year he was elected a member of the State house of representatives. He served until 1873, and was speaker during his last term. Lynch won the Republican nomination for Congressman of Mississippi's Sixth District. He was elected and served in the 43rd and 44th Congress. He served again from April 29, 1882, to March 3, 1883, but was defeated for reelection in 1882. Lynch continued active in Republican Party affairs after his congressional career, and became a lawyer and an historian before he died in Chicago on November 2, 1939. Two of his books are *The Facts of Reconstruction* and *Some Historical Errors of James Ford Rhodes.*

4. Racists in Mississippi organized White Citizens Councils which aimed to maintain a segregated school system and otherwise restrict the rights of Negroes. Soon the Councils spread across the South. Their chief weapon was economic pressure. Negroes (and whites) suspected of favoring integration lost their jobs and, if they were sharecroppers, were thrown off the land, were denied credit, and were refused services in shops and stores.

On February 28, 1957, in testimony before a Congressional committee studying the need for civil rights legislation, Gus Courts, a Negro from Mississippi, revealed that he and his wife had had to leave that state because they had tried to vote. "My wife and I and thousands of Mississippians have had to run away," he told a Senate Judiciary subcommittee. "We had to flee in the night. We are the American refugees from the terror in the South, all because we wanted to vote." He pointed out that only 8,000 Negroes were on the registration rolls in Mississippi, "although there are 497,000 potential colored voters in the state." He blamed the situation on the White Citizens Councils, pointing out: "Not only are they killing the colored people, who want to vote and be citizens, but they are squeezing them out of business, foreclosing

their mortgages, refusing them credit from the banks to operate their farms."
(*New York Times,* March 1, 1957.)

5. Dr. Theodore R. M. Howard of Mound Bayou, Mississippi, was an active
figure in trying to bring to trial the lynchers of fourteen-year-old Emett Till,
who was kidnapped and lynched at Money, Mississippi, in the summer of 1955,
for allegedly whistling at a white storekeeper's wife. He failed.

A Word about African Languages

1. James Weldon Johnson (1871–1938), distinguished poet, novelist, gov-
ernment official and secretary of the NAACP, was born in Jacksonville,
Florida, and received his early education there. He subsequently attended
Atlanta University and was admitted to the Florida bar. In 1901, he and his
brother, Rosamond, went to New York and entered the field of musical comedy
with great success. From 1906 to 1913, Johnson was United States consul, first
in Venezuela and later in Nicaragua. While he was in the consular service, he
wrote his well-known novel, *The Autobiography of an Ex-Colored Man,*
dealing with the theme of passing into the white community. It was published
in 1912. Upon his return to the United States, Johnson did newspaper work in
New York and then became associated with the NAACP, serving from 1916 to
1920 as field secretary, and from 1920 to 1930 as general secretary. Johnson
was a leading figure in the Harlem Renaissance, and his poetry and his
anthology of Negro poetry, published in 1922, were very popular. One of his
earlier poems, "Lift Every Voice and Sing," was set to music by his brother
Rosamond; it is widely known as the Negro national anthem.

2. Diedrich Westermann (1875–1956), German scholar in African culture
and anthropology, and leading researcher on African linguistics.

Greetings to Bandung

1. The Bandung Conference was a meeting of Asian and African states,
organized by Indonesia, Burma, Ceylon, India, and Pakistan, which met April
18–24, 1955, in Bandung, Indonesia. Twenty-nine countries, representing over
half of the world's population, sent delegates. A ten-point "declaration on
the promotion of world peace and cooperation," incorporating the principles
of the UN charter and Nehru's principles, was adopted unanimously.

Paul Robeson Sings, Talks, Acts

1. For a presentation of the NAACP position at the 1955 convention, *see*
Roy Wilkins' speech to the delegates, "The Conspiracy to Deny Equality," in
Philip S. Foner, editor, *The Voice of Black America,* vol. II, New York, 1975,
paperback edition, pp. 276–86. Wilkins both hailed the significance of the 1954
Supreme Court decision and reminded the delegates that there was no room
for complacency. Already the foes of Negro equality were organizing to resist
the 1954 decision, and renewed efforts and struggles were necessary to prevent
them from achieving their goals.

Free Speech at Swarthmore

1. Lincoln University, Pennsylvania, the first black college in the United
States, established in 1954 as Ashmun Institute.

2. Lincoln University had a long tradition of educating African students.

3. Cyrus Bustill, who launched the Bustill family in Philadelphia, was

born a slave at Burlington, New Jersey, in 1732. Freed in 1769 by his second owner, the Quaker Thomas Pryor, Jr., he later removed to Philadelphia, where he ran a bakery, was engaged in the building construction business, and became in 1796 the first Negro school teacher in the city. He was an active member of the Free African Society, and was a member of the Religious Society of Friends until his death in 1806. For the text of Cyrus Bustill's "Address to the Blacks of Philadelphia," *see* Philip S. Foner, editor, *The Voice of Black America*, vol. I, New York, 1975, paperback edition, pp. 13–20.

The Constitutional Right to Travel

1. It was not until June 16, 1958, that the Supreme Court ruled that a passport could not be withheld from a citizen because of his beliefs or associations.

2. Ralph Vaughan Williams (1872–1958), dominant English composer of the first half of the twentieth century, founder of the nationalist movement in English music.

3. Dr. Otto Nathan sought a court order for a passport to allow him to fulfill the trust imposed on him as Dr. Albert Einstein's executor; the State Department had denied him a passport in 1952. Judge Schweinhaut ordered the State Department to issue the passport, and criticized the Department sharply for evading its March 15, 1955, court order. The State Department having challenged the court order, the Appeals Court ordered that Nathan be granted a hearing, and the State Department was ordered to reveal the reasons for the passport denial. The State Department replied that Nathan had been a Communist in Germany before 1933, was linked with the Civil Rights Congress, had sponsored the "Communist" peace conference in New York City, associated with Communists and Iron Curtain country officials. Nathan refused to answer any questions on his links with alleged Communists, and the State Department on June 7, 1955, issued Nathan a passport without a hearing, avoiding a court test of its procedure, and asked the Appeals Court to dismiss the case.

Their Victories for Peace Are Also Ours

1. Nikita S. Khrushchev (1894–1971), first secretary of the Communist Party of the Soviet Union and premier of the Soviet Union who launched the de-Stalinization campaign. He was removed from leadership in 1964.

"Let Paul Robeson Sing"

1. A tremendous movement arose in England to persuade the American government to grant Paul Robeson his passport so that, among other activities, he could revisit England and sing and act for the people of that country. The following petition to President Eisenhower, signed by distinguished citizens of Great Britain, trade unionists, and ordinary citizens, read: "We, the undersigned men and women of Lancashire and Cheshire, urge you to intervene and to restore Robeson's passport. Such an intervention on your part would correspond to your welcome declaration at the Geneva Conference of Heads of State last July, 'That all curtains whether of guns or regulations should begin to come down.'

"Paul Robeson is an artist of world renown and we are sure that the restoration of his passport would be of great value in creating better understanding between the people of Britain and of the United States of America."

In Manchester a "Let Paul Robeson Sing" Committee organized a public meeting, Sunday, March 11, 1956, at the Lesser Free Trade Hall. The chairman was Logan-Petch, and the speakers included Cedric Belfrage, author and editor, *National Guardian* of the United States, a progressive weekly; R. Cassasola, President, Amalgamated Union of Foundry Workers, W. Griffiths, M.P., K. Zilliacus, M.P., and H. Newbold, Secretary of the Manchester and Salford Trades Council. Robeson made a special recording for the meeting consisting of an Address to the People of Manchester followed by his singing of the "Ode to Joy" from Beethoven's 9th Symphony, with new lyrics set to the music. Under the title given to it by Robeson, "The Song of Peace," it was performed for the first time at the Manchester meeting.

2. Gracie Fields (Grace Stansfield), English music-hall comedienne. Records and work in radio, films, and television spread her name throughout the world.

3. William Blake (1757-1827), poet, painter, engraver, recognized not only for his poetry and painting but for his prophetic vision.

4. *See* Philip S. Foner, *Life and Writings of Frederick Douglass,* vol. I, New York, 1950, p. 229.

Message to National Conference, Manchester

1. When the state of Alabama was ordered to admit Autherine Lucy, a Negro applicant, to the University of Alabama, the students and townspeople of Tuscaloosa resorted to violence to prevent her from remaining at the university. When she was suspended because of the rioting, she accused university officials of conspiring to keep her out of the university. As a result she was expelled by the board of regents. But Autherine Lucy's refusal to bow before the racist mob gave courage to the entire Negro population.

2. On December 1, 1955, Rosa Parks refused to move to the back of the bus in Montgomery, Alabama, and accommodate white passengers getting on. Rather than accept this form of discrimination, she was ready to go to jail. Her action brought on the great Montgomery bus boycott and brought into prominence a new and dynamic black leader—the Reverend Dr. Martin Luther King, Jr., chosen as president of the Montgomery Improvement Association formed after the arrest and conviction of Mrs. Parks. On November 13, 1956, almost a year after the boycott had started, the U.S. Supreme Court affirmed the decision of a lower federal court and declared Alabama's state and local laws requiring segregation on buses unconstitutional.

3. Percy Bysshe Shelley (1798-1822), one of England's greatest poets, and a political radical in his day.

4. Robert Burns (1759-1796), the most famous Scottish poet.

The House Un-American Activities Committee

1. The Committee was a standing committee of the House of Representatives. It was originally an ad hoc committee in 1938, becoming permanent in 1947. Throughout its history, the committee was denounced for its recklessness in bringing accusations of Communism against various public figures including President Franklin D. Roosevelt, and because its methods were arbitrary and truly unconstitutional.

2. Milton H. Friedman was a well-known civil rights lawyer.

3. Leonard Boudin, a noted civil rights lawyer.

4. Manning Johnson, a black Communist who broke with the Party and

appeared for several federal and state investigating committees as a "friendly witness," naming names of so-called Communists. But even Wilson Record in his anti-Communist work, *The Negro and the Communist Party,* concedes that Johnson proved to be unreliable: ". . . his story is so confused and told in such an off-the-cuff fashion that one is disposed to put little stock in it." (Chapel Hill, N. Car., 1951, p. 182*n.*)

5. The reference is to the McCarran-Walter Act, the law which stiffened the existing immigration law relating to the admission, exclusion, and deportation of so-called dangerous aliens, a feature which was denounced as being subject to arbitrary administration.

6. Doxey Wilkerson, Professor of Education at Howard University, was a leading black educator and joined the administration and teaching staff of the Jefferson School of Social Science.

7. Sukarno (1901–1971), leader of the Indonesian independence movement, and his country's first president.

8. For Jackie Robinson's testimony, *see Hearings before the Committee on Un-American Activities, House of Representatives, Eighty-Fourth Congress, Second Session,* Washington, D.C., 1956, pp. 450–88. While disagreeing with Robeson, and even attacking him for his activities, Robinson did add the following point:

". . . one other thing the American people ought to understand, if we are to make progress in this matter; the fact it is a Communist who denounces injustice in the courts, police brutality, and lynching when it happens doesn't change the truth of his charges. Just because Communists kick up a big fuss over racial discrimination when it suits their purposes, a lot of people try to pretend that the whole issue is a creation of Communist imagination.

"But they are not fooling anyone with this kind of pretense, and talk about 'Communists stirring up Negroes to protest' only makes present misunderstanding worse than ever. Negroes were stirred up long before there was a Communist Party, and they will stay stirred up long after the party has disappeared—unless Jim Crow has disappeared by then as well." (p. 481.)

9. Kenesaw Mountain Landis (1866–1944), federal judge and first commissioner of baseball.

Jackie Robinson was signed by Branch Rickey, president of the Brooklyn Dodgers, to play on a Dodger farm team, the Montreal Royals of the International League, and was brought up to play for Brooklyn in 1947.

10. Mississippi Senator James Eastland, chairman of the Internal Security Subcommittee of the Senate Judiciary Committee, which supplemented the work of the House Un-American Activities Committee and aroused the same type of criticism.

11. The Keystone Kops were incompetent police dressed in ill-fitting uniforms, appearing regularly in Mack Sennett's slapstick silent film farces from 1914 to the early 1920s.

12. *See above,* p. 180.

Some Aspects of Afro-American Music

1. J. Rosamond Johnson, black musical comedy composer and brother of James Weldon Johnson, set the music to the Negro National Anthem.

2. Bela Bartok (1881–1945), pianist, teacher, ethnomusicologist, and composer, who fused the essence of Hungarian folk music with traditional music.

3. Leos Janacek (1854–1928), Czech composer, one of the leading exponents of musical nationalism.

4. Duke Ellington (1899–1974), composer, pianist, jazz orchestra leader, and one of the most eminent jazz musicians of his day.

Introduction to *The American Negro and the Darker World*

1. *The American Negro and the Darker World* was originally an address Dr. Du Bois delivered on the occasion of the celebration of the Second Anniversary of the Asian-African (Bandung) Conference and the Rebirth of Ghana. It was reprinted by the National Committee to Defend Negro Leadership, established in 1953 as the intensity of the McCarthy era mounted and more and more black Americans came under attacks as "subversive" because they dared to speak up for freedom. For an address by a leading spokesman for the National Committee, Reverend Edward D. McGowan, see Philip S. Foner, editor, *The Voice of Black America*, New York, 1972, pp. 860–66.

2. E. Franklin Frazier, distinguished black sociologist and professor at Howard University, was the author of *The Negro Family in the United States, The Negro in the United States,* and the controversial *Black Bourgeoisie,* as well as other books, articles, and governmental reports including the report on the Harlem Riot of 1935.

3. Van Wyck Brooks (1886–1963), critic, biographer and literary historian, author of *The Ordeal of Mark Twain,* which caused considerable controversy.

4. *The Ordeal of Mansart,* published in 1957, was the first of a trilogy under the heading of *The Black Flame.* It was followed by *Mansart Builds a School* (1959), and *Worlds of Color* (1961). All three were issued by Mainstream Publishers of New York City.

My Labors in the Future

1. Henry David Thoreau (1817–1862), social rebel best known for his refusal in 1848 to pay a poll tax because the money went to a government which was waging a war on behalf of slavery against Mexico. His essay *Resistance to Civil Government,* published in 1849, influenced Ghandi and Martin Luther King, Jr. Thoreau was a militant abolitionist, and defended John Brown after Harpers Ferry in brilliant speeches.

The Related Sounds of Music

1. Aram Khatchaturian, Soviet-Armenian composer, famous for his effective use of folk music in his compositions.

2. Sean O'Casey (1880–1964), Irish playwright and Communist, renowned for his realistic dramas of the Dublin slums and for his autobiographies.

3. Zoltan Kodaly (1882–1967), Hungarian composer and authority on Hungarian folk music.

4. Samuel Coleridge Taylor (1875–1912), black musician who was one of England's foremost composers, teachers, and conductors.

Robeson Urges Government Defend Constitution Against Racists

1. On September 3, 1957, when Arkansas Governor Orval E. Faubus ordered National Guard units to Central High School to prevent desegregation, Little Rock became a storm center of the fight for Negro equality and a national and even international issue. Three weeks later President Dwight D.

Eisenhower authorized the use of federal troops to enforce desegregation of the Little Rock school. Soldiers stood on the high-school steps to escort nine Negro children to their classes and protect them from jeering racist mobs on their way to and from school.

2. The idea of an appeal by black Americans to the United Nations began soon after the international organization was formed. The NAACP presented the document "An Appeal to the World" to the UN in 1947. Written under the editorial supervision of W. E. B. Du Bois, the document was subtitled "A Statement on the Denial of Human Rights to Minorities in the Case of Citizens of Negro Descent in the United States of America and an Appeal to the United Nations for Redress." In 1951 the petition "We Charge Genocide" was presented to the UN by William R. Patterson and others, among whom were Paul and Eslanda Goode Robeson. The petition was a catalog of lynchings and other acts of violence against Negroes and asked for UN action under Article II, the Genocide Convention. In 1964, Malcolm X attended the conference of the Organization of African Unity to urge African nations to bring the question of Negro rights in the United States to the United Nations. On July 19, 1964, Jesse Gray, leader of the Harlem Rent Strike, told the press that he planned to lead a demonstration at United Nations Plaza "to ask the UN to intervene in the 'police terror in the United States.'" In 1970, the Committee to Petition the United Nations announced a plan to submit another petition to the UN to end United States genocide against black, yellow, red and brown Americans. A million signatures were sought for the petition. Members of the committee which drafted the petition included Ossie Davis, actor and playwright; Huey P. Newton, Minister of Defense of the Black Panther Party; black Congresswoman Shirley Chisholm; Dr. Nathan Wright; Roger Littlehorn, of the Indians of All Tribes; Dick Gregory, activist comedian; and Carl Blakely, of the Saulteaux tribe.

Pacifica Radio Interview

1. *Here I Stand* was published in August 1958: in New York by Othello Associates; in London by Dennis Dobson; in Bucharest by Editura Politica; in East Berlin by Congress-Verlag; in Moscow by Molodaia Guardiia.

2. "The Power of Negro Action" was chapter 5. In this chapter, Robeson recommended community action—"we have the right and, above all, we have the duty, to bring the strength and support of our entire community to defend the lives and property of each individual family"—a "central fund, not only for legal purposes, for all the purposes of Negro coordinated action," "the power of spirit" of the Negro people, "effective Negro leadership," with "a single-minded dedication to their people's welfare," more women in the ranks of Negro leadership, and for Negro trade unionists and rank-and-file workers to play a leading role in the struggle for full freedom.

Millions of Us Who Want Peace and Friendship

1. On June 6, 1958, in the Kent-Briehl decision, the Supreme Court ruled that the travel of Americans cannot be restricted because of political views. The State Department then had to grant Paul Robeson a passport, after which he was abroad till 1963. On the receipt of his passport, Robeson announced that he would use London as the center of his activities, including concerts and television work. He expected to concertize in Prague, East Berlin, and the Soviet Union.

2. Anton Chekhov (1860–1904), Russia's major playwright and foremost master of the modern short story.

3. Maxim Gorky (1868–1936), Russian short-story writer, playwright, and novelist who was a leading figure in the Soviet Union.

4. Fyodor Ivanovich Chaliapin (1873–1938), famous Russian operatic bass who won international fame, especially for his performance in *Boris Godunov*.

5. Konstantin Stanislavsky (1863–1938), actor, director, and producer, founder of the Moscow Art Theatre and best known for his theory of acting, "the method."

6. Rockwell Kent (1882–1971), American progressive painter and illustrator and champion of world peace and other causes.

7. Robeson's brief autobiography, published in 1958.

8. *See above,* "Robeson Urges Government," note 1, p. 580.

9. *See above,* "House Un-American Activities Committee," note 10, p. 579.

My Aim—Get British and U. S. People Together

1. Harold Macmillan, British prime minister from January 10, 1957, to October 18, 1963, supporter of a Cold War foreign policy and conservatism at home.

Interview with Press

1. Linus Pauling (1901–), chemist who contributed enormously to the understanding of molecular structures, particularly with regard to chemical bonding, and a leading peace advocate. Pauling received two Nobel Prizes— one for Chemistry in 1954 and the Nobel Peace Prize in 1962 for his efforts on behalf of the international control of nuclear weapons, against nuclear testing, and other campaigns for the cause of peace.

2. The reference is to Premier Khrushchev's United Nations address of September 1960 in which he clearly outlined a program for general and complete disarmament.

3. This appears to be the first reference by Robeson to the great revolution in Cuba inaugurated with the victory of the forces led by Fidel Castro over the brutal dictator Fulgencio Batista. The Soviet Union supported the Cuban Revolution when it was threatened with destruction by the United States.

4. Bertolt Brecht (1898–1956), poet, playwright, and theatrical reformer whose epic theatre departed from convention, shaping the drama as a social and ideological forum. In his last years (from 1949) he directed the Berliner Ensemble, a company of actors in East Berlin, German Democratic Republic. During his stay in the United States (1941–47), Brecht was hounded by the House Un-American Activities Committee because of his belief in Marxism.

N. Z. Is Marvellous

1. This trip to Australia and New Zealand was to be Robeson's last major tour.

2. The Maori were the Polynesian people of New Zealand who resisted British conquest and were defeated in the Maori wars of the 1860s.

3. *See above,* "For Freedom and Peace," note 10, p. 540.

4. Southeast Asia Treaty Organization (SEATO), the regional defense organization created by the Southeast Asian Collective Defense Treaty signed at Manila on September 8, 1954, by the representatives of Australia, France,

New Zealand, Pakistan (withdrew November 8, 1972), the Philippines, Thailand, the United Kingdom and the United States. The treaty went into force on February 19, 1955, and through it, John Foster Dulles, its parent, brought the Cold War into Southeast Asia. But it was never fully implemented.

"The People Must, If Necessary, Impose the Peace"

1. The Aldermaston march was against atomic explosions and the use of atomic weapons.

Speech Delivered at the Funeral of Benjamin J. Davis

1. W. E. B. Du Bois died on August 27, 1963, the very same day the great 250,000-strong "March on Washington For Jobs and Freedom" took place in Washington, D.C. Du Bois died in Ghana. In 1961 he had joined the Communist Party, and moved to Ghana with his wife Shirley Graham at the invitation of Premier Nkrumah to work on the *Encyclopedia Africana,* aided by W. Alphaeus Hunton. In February 1963 Du Bois became a citizen of Ghana.

Thank God Almighty, We're Moving

1. In declining health, Robeson was inactive both politically and artistically after his return from abroad. However, on the first anniversary of the great "March on Washington," August 28, 1963, the largest demonstration in the history of the nation's capital, he issued this statement "exclusively for the Negro Press."

2. On September 15, 1963, four black girls—Denise McNair, 11 years old, and Cynthia Wesley, Carol Robertson and Addie Mae Collins, all 14—were killed in the bombing of a Birmingham, Alabama, church used as headquarters for civil rights demonstrators. The 16th Street Baptist Church was rebuilt after the bombing, and fourteen years later, Robert E. Chambliss, once an active member of the Ku Klux Klan, was found guilty of the murders by a jury in Birmingham. The jury conviction on November 18, 1977, was the beginning of a series of trials which aimed not only at punishing those guilty for the terrorist bomb explosion but also to erase Birmingham's reputation as one of the most racist cities in the United States.

3. Medgar Evers, field secretary of the Mississippi NAACP, was assassinated on June 12, 1963, by a white racist in the driveway of his home in Jackson.

4. In the summer of 1964, three young civil-rights workers, James Chaney, Andrew Goodman, and Michael Schwerner—the first a Negro from Meridian, Mississippi, and the others whites from New York City—were brutally murdered in Philadelphia, Mississippi. The three had been suddenly released from detention in the county jail so that they might be shot by an alerted white mob, which included the town officials.

5. Chapter Four of *Here I Stand* is entitled "The Time is Now." It opens: "As I see it, the challenge which today confronts the Negro people in the United States can be stated in two propositions: 1. Freedom can be ours, here and now; the long-sought goal of full citizenship under the Constitution is now within our reach. 2. We have the power to achieve that goal; what we ourselves will do will be decisive."

6. Chapter Five of *Here I Stand* is entitled "The Power of Negro Action." In it Robeson asks: "How long?" and continues: "The answer is: *As long as we*

permit it. I say that Negro action can be decisive. I say that we ourselves have the power to end the terror and to win for ourselves peace and security throughout the land." In the rest of the chapter Robeson calls on Negroes to defend their lives and property against mobs as well as participate in mass demonstrations, organize boycotts, and go on strike.

Turning-Point

1. The Civil Rights Act of 1964, adopted after a long Southern filibuster in the Senate, was the most far-reaching and comprehensive law in favor of racial equality ever enacted by Congress. It gave the Attorney General additional power to protect citizens against discrimination and segregation in voting, education, and the use of public facilities. It forbade discrimination in most places of public accommodation and established a federal Community Relations Service to help individuals and communities solve civil rights problems. It established a federal Equal Employment Opportunity Commission and extended the life of the Commission on Civil Rights to January 1968.

2. Barry Goldwater, U.S. Senator from Arizona and conservative Republican candidate for President, was decisively defeated by Lyndon Johnson, the Democratic candidate. Goldwater carried only Arizona and five states in the Deep South.

The Legacy of W. E. B. Du Bois

1. The National Negro Conference held in New York City May 31-June 1, 1909, marked the founding of the National Association for the Advancement of Colored People. Among the decisive figures in this effort were Du Bois, representing the Niagara Movement which he had founded in 1905, Oswald Garrison Villard, Mary White Ovington, and William English Walling.

2. Volume I, Number 1, of *The Crisis,* with Du Bois as editor, was issued November 1910 as the official organ of the NAACP.

3. This may be a reference to the great "Silent Protest Parade" on Fifth Avenue in New York on July 28, 1917, headed by Du Bois and staged by the NAACP in protest against the East St. Louis riots and other violence to Negroes.

4. The Pan-African Congress organized by Du Bois met four times—in 1919, 1921, 1923, and 1927. Through the Congresses the African independence movements were united.

5. *The World and Africa: An Inquiry into the part which Africa has played in World History* was first published in 1947, and enlarged editions were issued in 1955, 1961, and 1965.

6. Louis E. Burnham was a leader of the Southern Negro Youth Conference and later editor of *Freedom.* He died at a young age.

7. For Du Bois' position on the Soviet Union, *see* Philip S. Foner, editor, *W. E. B. Du Bois Speaks: Speeches and Addresses, 1920–1963,* vol. II, New York, 1970, pp. 294, 295, 296, 300, 303, 307, 308, 309, 312, 314, 317, 318, 319.

8. Shirley Graham Du Bois was Dr. Du Bois' second wife. They were married on February 14, 1950, when Du Bois was 83.

9. Du Bois ran for the U.S. Senate in 1950.

10. In 1958–1959 Dr. Du Bois visited China and the Soviet Union. He celebrated his ninety-first birthday in Peking. For the speech he broadcast from Peking to the world, *see* Foner, *W. E. B. Du Bois Speaks,* vol. II, pp. 316–21.

It's Good to Be Back

1. *Freedomways* was the progressive Negro monthly edited by John Henrik Clarke.
2. Ossie Davis and Ruby Dee are husband and wife. He is an actor and playwright who has appeared on stage, film, and TV and is the creator of *Purlie Victorious* (later the musical *Purlie*), a brilliant satire of black stereotypes. She is an actress with a long career that includes magnificent performances in *Raisin in the Sun, Boesman and Lena,* and *The Taming of the Shrew.* Together they have done readings of black prose and poetry at innumerable gatherings, large and small.

Message to "Salute to Paul Robeson"

1. This was one of numerous celebrations in many parts of the world marking Robeson's 75th birthday.

Message to Actors' Equity

1. This is Paul Robeson's last public communication before his death in Philadelphia, January 23, 1976, at the age of seventy-seven.

Paul Robeson Tells of Soviet Progress

1. This interesting interview from the *Irish Worker's Voice* appears in the Appendix because it arrived too late to be included in its chronological place in the main body of the book. I am indebted to John Swift, President of the Irish Labour History Society, and Sean Noal of New Books, Dublin, for furnishing me with a copy of the interview.
2. Walter Duranty, of *The New York Times,* was one of the few correspondents in the Soviet Union representing commercial newspapers who sent fairly objective reports on life in that country. His autobiography, published in 1935, was entitled *I Write As I Please.*

Two Worlds—Ten Years of Struggle

1. This is the last of three articles Robeson wrote for *Komsomolskaia Pravda,* Moscow, under the title "Two Worlds." In the first two articles ("The First Joy" and "My Name is Robeson") he discussed experiences dealt with elsewhere in this volume. But in the third, he touched on several new issues not otherwise covered, and I believed it worth including in this collection although, since it also arrived too late for placement in proper chronological order, it had to be relegated to the Appendix. I am grateful to Mark Lapitsky of the Institute of the International Labor Movement, Moscow, for providing copies and summaries of the three articles in the Russian language, and to my colleague, Professor Paul A. Russo of the History Department of Lincoln University, Pennsylvania, for translating the article published here.
2. The reference here is probably to the change Robeson made in the last verse of "Ol' Man River."
3. Vladimir Mayakovsky (1893-1930), the leading poet of the Russian Revolution and of the early Soviet period. Mayakovsky was also in his lifetime the most dynamic figure of the Soviet literary scene.

4. Here Robeson is paraphrasing the testimony he gave, which was not exactly as quoted although the essence is the same.

5. This is not entirely accurate. The Washington *Times-Herald* carried no editorial on Robeson's testimony on June 1 or 2, 1948, but the Washington *Evening Star* did have one on June 1. Entitled "Paul Robeson's Case," it concluded: "Here is a man whose father was born in slavery in this country. Yet the son, endowed with exceptional talents, has gone far. A graduate of Rutgers, an all-American football player, an outstanding artist—these are achievements that not many Americans have been able to equal. Yet Mr. Robeson pays homage to the Communists and to Russia, and says that Russia has produced more freedom for the people than has the United States.

"In the light of this expressed opinion what difference does it make whether he actually is a Communist or not. He has said enough to show that he is wholly biased and that in his testimony before the committee he appeared, not as a witness, but as a propagandist."

The reference to jail by Robeson may have been to the report in the Washington *Evening Star* of June 1, 1948, quoting Robeson as having told the Senate Committee that the question whether or not he was a member of the Communist Party was " 'an invasion of my right of secret ballot.' He said he would go to jail if necessary before he would answer. Oklahoma Senator Moore promptly adopted the idea with the suggestion that 'sometimes a year in jail cools some of these people off.' "

The Essence of Fascism and Communism

1. William Z. Foster (1881-1961), general secretary of the Communist Party of the United States and its presidental candidate in 1924, 1928, and 1932.

With Foreign Minister Andrei Vishinsky at Soviet Embassy celebration of October Revolution, New York, November 1950

SELECTED BIBLIOGRAPHY
about Paul Robeson

There are three major bibliographies dealing with Paul Robeson: (1) "Paul Robeson: A Bibliography (1968)," prepared by Artists United of the South Side Community Art Center, Chicago; (2) Ernest Kaiser, "A Bibliography By and About Paul Robeson," *Freedomways,* First Quarter, 1971, pp. 125–33; (3) "Bibliography" in Anatol I. Schlosser, "Paul Robeson: His Career in the Theatre, in Motion Pictures, and on the Concert Stage," Ph.D. dissertation, School of Education, New York University, 1970, pp. 401–75. This last is the most complete.

UNPUBLISHED STUDIES

Schlosser, Anatol I. "Paul Robeson: His Career in the Theatre, in Motion Pictures, and on the Concert Stage," Ph.D. dissertation, School of Education, New York University, 1970.

Yeakey, Lamont H. "The Early Years of Paul Robeson: Prelude to the Making of a Revolutionary," M.A. thesis, Department of History, Columbia University, 1971.

BOOKS, SECTIONS IN BOOKS, AND PAMPHLETS

Brown, Lloyd L. *Lift Every Voice for Paul Robeson,* New York: Freedom Associates, 1951.

——————— *Paul Robeson Rediscovered,* Occasional Papers No. 19 (1976): American Institute for Marxist Studies, 1976.

Cruse, Harold W. *The Crisis of the Negro Intellectual,* New York: William Morrow and Company, Inc., 1967. Pp. 285–301 contain chapter on Paul Robeson. For a critique of the chapter, *see* Ernest Kaiser, "The Crisis of the Negro Intellectual," *Freedomways* reprint, February, 1970.

Embree, Edwin R. "Paul Robeson, Voice of Freedom," in *13 Against the Odds,* New York: The Viking Press, 1944, pp. 243–61.

Fast, Howard M. *Peekskill: U.S.A.—A Personal Experience,* New York: Civil Rights Congress, 1951.

Gilliam, Dorothy Butler. *Paul Robeson: All-American,* Washington, D.C.: New Republic Book Company, Inc., 1976.

Graham, Shirley. *Paul Robeson, Citizen of the World,* New York: Julian Messner, Inc., 1946.

Hamilton, Virginia. *Paul Robeson: The Life and Times of a Free Black Man,* New York: Harper & Row, 1974.

Himber, Charlotte. "Let My People Go, Paul Robeson," in *Famous in Their Twenties,* New York: Association Press, 1942, pp. 91–101.

Hoyt, Edwin P. *Paul Robeson: The American Othello,* Cleveland & New York: The World Publishing Co., 1967.
Lamparski, Richard. *Whatever Became of . . . ?* second series, New York: Crown Publishers, 1968, section on Paul Robeson, pp. 80–89.
Miers, Earl Schenck. *Big Ben,* Philadelphia: Westminster Press, 1942.
Ovington, Mary White. *Portraits in Color,* New York: Viking Press, 1927, pp. 205–27.
Paul Robeson on Film. The Paul Robeson Film Retrospective, 1947.
Redding, J. Saunders. *The Lonesome Road,* New York: Doubleday, 1958, pp. 275–88.
Rogers, J. A. "Paul Robeson, Intellectual, Musical and Histrionic Prodigy," in *World's Great Men of Color,* vol. II, New York (published by the author), 1947, pp. 672–78.
Robeson, Eslanda (Goode). *Paul Robeson, Negro,* New York: Harper & Brothers, 1930.
——————— *Paul Robeson Goes to Washington,* Salford, Lancashire: National Paul Robeson Committee, 1956(?).
Robeson, Paul. *Here I Stand,* New York: Othello Associates, 1958; reprinted Beacon Press with preface by Lloyd L. Brown, Boston, 1971.
Sergeant, Elizabeth. *Fire Under the Andes,* New York: A. A. Knopf, 1927, pp. 193–209.
Seton, Marie. *Paul Robeson,* London: Dennis Dobson, 1958.
Woollcott, Alexander. "Colossal Bronze," in *Portable Woollcott,* New York: Viking Press, 1946, pp. 158–69.
Wright, Charles H. *Robeson: Labor's Forgotten Champion,* Detroit: Balamp Publishing, 1975.

ARTICLES

Beatty, Jerome. "America's No. 1 Negro," *American,* vol. CXXXVII, May, 1944, pp. 142–44.
Bonofsky, Phillip. "Robeson's Book Still Points the Way to Freedom," *Daily World,* November 6, 1971, p. 8.
Cripps, Thomas. "Paul Robeson and Black Identity in American Movies," *Massachusetts Review,* vol. XI, Summer, 1970, pp. 468–85.
Edmonds, Randolf. "Some Reflections on the Negro in American Theatre," *Opportunity,* vol. VIII, October, 1930, pp. 303–05.
Ellison, W. James. "Paul Robeson and the State Department," *Crisis,* vol. LXXXIV, May, 1977, pp. 184–89.
Fishman, George. "Paul Robeson's Student Days and the Fight Against Racism at Rutgers," *Freedomways,* vol. IX, Summer, 1969, pp. 221–29.
Freedomways, "Paul Robeson: The Great Forerunner," A Special Issue, vol. XI, First Quarter, 1971.
Garvey, Marcus. "Paul Robeson and His Mission," *The Black Man,* vol. II, January, 1937, pp. 26–29.
Gilman, Mildred. "Profile: King of Harlem," *New Yorker,* No. 37, September 29, 1928, pp. 26–29.
Hentoff, Nat. "Paul Robeson Makes A New Album," *Reporter,* April 12, 1958, pp. 12–15.
Hutchens, John L. "Paul Robeson," *Theatre Arts,* October, 1944, pp. 579–85.
James, C.L.R. "Paul Robeson: Black Star," *Black World,* vol. XX, November, 1970, pp. 106–15.

Kolodin, Irving. "Paul Robeson in Carnegie Hall," *Saturday Review,* August 24, 1958, pp. 112–13.
La Guma, A. "Paul Robeson and Africa," *African Communist,* 3rd Quarter, 1976, pp. 113–19.
Lewis, John. "Paul Robeson, Inspirer of Youth," *Freedomways,* vol. V, Summer, 1965, pp. 369–72.
Miers, Earl Schenck. "Paul Robeson," *Negro Digest,* October, 1950, pp. 21–24.
———— "Paul Robeson—Made in America," *Nation,* vol. CLXX, May 27, 1950, pp. 523–24.
Mitchell, Loften. "Time to Break the Silence Surrounding Paul Robeson," *New York Times,* Arts and Leisure Section (Section 2), August 6, 1972.
Moos, Elizabeth. "Free Paul Robeson," *Masses & Mainstream,* October, 1951, pp. 108–10.
Patterson, William L. "In Honor of Paul Robeson," *Political Affairs,* vol. XLVII, May, 1968, pp. 18–21.
"Paul Robeson, Right," by W.E.B. Du Bois, **"Wrong,"** by Walter White, *Negro Digest,* March, 1950, pp. 8–18.
Pittman, John. "Mount Paul," *New World Review,* February, 1962, pp. 24–28.
Robeson, Rev. B.C. "My Brother, Paul Robeson—An Appraisal," *Quarterly Review of Higher Education Among Negroes,* October 1954, pp. 199–204.
Rowan, Carl T. "Has Paul Robeson Betrayed the Negro?" *Ebony,* October, 1957, pp. 31–42.
Shechter, Amy. "Paul Robeson's Soviet Journal," *Soviet Russia Today,* vol. XVII, August, 1949, pp. 9–11, 24.
Smith, Anna Bustill. "The Bustill Family," *Journal of Negro History,* vol. X, October, 1925, pp. 638–47.
Stevens, Hope R. "Paul Robeson—Democracy's Most Powerful Voice," *Freedomways,* vol. V, Summer, 1965, pp. 365–68.
Stuckey, Sterling. "Paul Robeson, Revisited," *New York Times* Book Review, October 21, 1973, pp. 40–41.
———— " 'I Want to be African': Paul Robeson and the Ends of Nationalist Theory and Practice, 1914-1945," *Massachusetts Review,* Vol. XVII, Spring, 1976, pp. 81–138.
Weaver, Harold D. "Paul Robeson: Beleaguered Leader," *Black Scholar,* vol. V, December 1973-January 1974, pp. 25–33.

RECORDS AND TAPES

Shakespeare's *Othello.* Paul Robeson, Jose Ferrer, Uta Hagen and Edith King (1943 Theatre Guild production in New York) Columbia Masterworks: SL 153. (CPL) Also still available in record stores—3 LP set.
Robeson, Paul *Spirituals.* Columbia Masterworks: ML 4105. (CPL) Includes: Water Boy, Shenandoah, Deep River, John Brown's Body, Jerusalem, Londonderry Air (Danny Boy), Sometimes I feel Like a Motherless Child, Get On Board Little Children, The House I Live In, Loch Lomond, Drink To Me Only With Thine Eyes, Joshua Fit de Battle of Jericho, All Through the Night.
Paul Robeson at Carnegie Hall. Columbia Masterworks. (CPL)
Paul Robeson. *Songs of Free Men* and *Spirituals.* Legendary Performances: Columbia-Odyssey: 32–16–0268. (Recent reissue, available for $1.98) Includes: From Border to Border (From *Quiet Flows the Don*), Oh How

Proud Our Quiet Don, The Purest Kind of Guy, Joe Hill, The Peat-Bog
Soldiers (song from a German concentration camp), The Four Insurgent
Generals (Spanish Loyalist song), Native Land, Song of the Plains (Red
Army song), Go Down Moses, Balm in Gilead, By an' By, Sometimes I Feel
Like a Motherless Child, John Henry, Water Boy, Nobody Knows de
Trouble I've Seen, Joshua Fit de Battle of Jericho.

Tape of Tributes to Paul Robeson and Robeson's Acknowledgement at
 Freedomways Salute, Americana Hotel, New York, April 22, 1965.
 (Available from Artists United, c/o South Side Community Art Center,
 3831 S. Michigan, Chicago.)

Tapes of songs, including "Ol' Man River." (Available from Artists United, c/o
 South Side Community Art Center, 3831 S. Michigan, Chicago.)

Tape of radio program, 1966, WBAI, New York. (Available from Artists
 United)

On visit to Budapest, Hungary, August 30, 1959

Honeycut, Edward, 298
Honolulu, 182–83, 530–31, 532
Honolulu *Advertiser,* 530, 532
Honolulu Record, 530–31
Honolulu Star-Bulletin, 182, 530, 531, 532
Hood, William R., 286, 289, 302, 547, 557, 558, 561
Hopkins, Curtis, 264
Hopkins, Velma, 239, 290, 292, 558
Horn, Max, 524
Hornbostel, E. M., 446
Horne, Lena, 528
House Committee on Un-American Activities, 4, 6–7, 38, 41, 218–21, 227, 250, 413–36, 488, 517, 523–24, 531, 539–540, 541, 542, 548–49, 550, 566, 573, 578, 579, 582
House of the Kine (Moscow), 94
House Subcommittee on Appropriations, 517
Housing, for Negroes, 315, 376, 384
Houston, Charles H., 524, 536
Howard, Asbury, 312
Howard, Charles P., 222, 534
Howard, Theodore R. M., 395, 396, 575
Howard University, 6, 34, 379
Hoyt, Edwin P., 7, 498, 514, 522
Hughes, Langston, 41, 124, 125, 184, 323, 452, 516, 533, 564
Hukbalahap, 370–72, 571
Hull, Cordell, 525
Human Rights Commission, 322, 563
Humboldt University (GDR), 43
Hungary, 186, 255, 338, 480
Hunton, W. Alphaeus, 9, 199, 231, 285, 318, 342, 475, 499, 521, 556, 561, 583
Hunton, William, 342
Hurtado v. California, 56, 57, 58, 503
Huss, John, 393, 574
Huston, Walter, 451

Ibsen, Henrik, 517
ILD, *see* International Labor Defense
ILWU, *see* International Longshoremen's and Warehousemen's Union
"I'm a Poor Wayfarin' Stranger," 300
Imperialism, 17, 106, 157, 168–71, 193, 194, 205–8, 225, 238, 240, 244, 246–47, 255, 265, 291, 329–30, 370, 378–79, 512, *see also* British imperialism, United States imperialism
Indentured servitude, 192, 244, 548, 574
India, 5, 42, 144, 165, 182, 196, 197, 226, 237, 264, 281, 288, 291, 303, 330, 349, 350, 359, 361, 497, 558
Indians (U.S.), 55, 84, 146
Indians (South Africa), 182, 195, 196, 318, 326, 343, 359, 361, 424

Indo-China, 18, 245, 252–53, 297, 339, 367, 377–79, 571, 572, *see also* Vietnam
Indonesia, 194, 237, 245, 254, 297, 398, 421, 576, 579
Industrial Workers of the World (IWW), 573
Ingram, Rex, 129
Ingram, Rosa Lee, 200, 218, 233, 253, 257, 406, 449, 538–39
"Inner logic" of Negroes, 114–15
Institute for International Democracy, 156
Internal Security Act, *see* McCarran Act
Internal Security Subcommittee, 579
International Brigade, 12, 32, 126, 515, 516
International Conference in Defense of the Rights of Youth, 340
International Fur and Leather Workers Union (IFLWU), 183, 532–33, 534
International Institute of African Speech and Culture, 446
International Labor Defense (ILD), 283, 511, 513, 538
International Labor Organization, 359
International Longshoremen's and Warehousemen's Union (ILWU), 34, 36, 41, 42, 160, 182–83, 188–90, 275, 277, 525, 530, 534–35
International Military Tribunal, 529
International Peace Arch, *see* Peace Arch Park
International Workers Order (IWO), 167
Iran, 297, 559
Ireland, 485–86
Irish Workers' Voice, 21, 485, 585
"Iron Curtain," 243, 309–10, 413, 569
Israel, 193, 392, 435, 532
Isserman, Abraham J., 527
Isvestia, 94
"It Ain't Necessarily So," 139
Italian language, 85, 86
Italians, in Spanish Civil War, 123
Italy, 104, 151, 164, 166, 237, 247, 248, 283, 323, 512, 546
Ivory Coast, 567

Jackson, James, 343, 369
Jackson, Mahalia, 305, 561
Jackson, Robert H., 8, 240, 563
Jamaica, 100, 123, 190–91, 207, 209, 339–40, 519
James, C. L. R., 22, 31, 507
Jamestown, Virginia, 391, 574
Janacek, Leos, 439, 445, 579
Japan, 150, 151, 155, 156, 157, 193, 274, 328, 349
Japanese, in China, 105, 123

*At meeting of Congress of Socialist Culture in Prague,
Czechoslovakia, June 19, 1957*

BY PHILIP S. FONER

History of the Labor Movement in the United States (4 vols.)
The Life and Writings of Frederick Douglass (5 vols.)
A History of Cuba and Its Relations with the United States (2 vols.)
The Complete Writings of Thomas Paine (2 vols.)
Business and Slavery: The New York Merchants and the Irrepressible Conflict
W. E. B. Du Bois Speaks (2 vols.)
The Fur and Leather Workers Union
Jack London: American Rebel
Mark Twain: Social Critic
The Jews in American History: 1654–1865
The Case of Joe Hill
The Letters of Joe Hill
The Bolshevik Revolution: Its Impact on American Radicals,
 Liberals, and Labor
American Labor and the War in Indochina
Helen Keller: Her Socialist Years
The Autobiographies of the Haymarket Martyrs
The Black Panthers Speak
The Basic Writings of Thomas Jefferson
The Voice of Black America: Major Speeches of Negroes
 in the United States, 1797–1973 (2 vols.)
The Spanish-Cuban-American War and the Birth of American Imperialism,
 1895–1902 (2 vols.)
When Karl Marx Died: Comments in 1883
Organized Labor and the Black Worker, 1619–1973
American Labor Songs of the Nineteenth Century
Labor and the American Revolution
We the Other People: Alternative Declarations of Independence by
 Labor Groups, Farmers, Women's Rights Advocates, Socialists, and Blacks
Formation of the Workingmen's Party of the United States
The Democratic-Republican Societies, 1790–1800
Inside the Monster: José Martí on the United States and American Imperialism
Our America: José Martí on Latin America and the Struggle for
 Cuban Independence
The Factory Girls
The Great Labor Uprising of 1877
American Socialism and Black Americans: From the Age of Jackson
 to World War II
History of Black Americans: Vol. 1—From Africa to Emergence of
 the Cotton Kingdom
Frederick Douglass and Women's Rights